On Dangerous Ground

Psychoanalytic Horizons

Psychoanalysis is unique in being at once a theory and a therapy, a method of critical thinking and a form of clinical practice. Now in its second century, this fusion of science and humanism derived from Freud has outlived all predictions of its demise. **Psychoanalytic Horizons** evokes the idea of a convergence between realms as well as the outer limits of a vision. Books in the series tests disciplinary boundaries and will appeal to scholars and therapists who are passionate not only about the theory of literature, culture, media, and philosophy but also, above all, about the real life of ideas in the world.

Series Editors:
Esther Rashkin, Mari Ruti, and Peter L. Rudnytsky

Advisory Board:
Salman Akhtar, Doris Brothers, Aleksandar Dimitrijevic, Lewis Kirshner, Humphrey Morris, Hilary Neroni, Dany Nobus, Lois Oppenheim, Donna Orange, Peter Redman, Laura Salisbury, Alenka Zupančič

Volumes in the Series:

Mourning Freud
Madelon Sprengnether

Does the Internet Have an Unconscious?: Slavoj Žižek and Digital Culture
Clint Burnham

In the Event of Laughter: Psychoanalysis, Literature and Comedy
Alfie Bown

On Dangerous Ground: Freud's Visual Cultures of the Unconscious
Diane O'Donoghue

Born After: Reckoning with the German Past (forthcoming)
Angelika Bammer

The Analyst's Desire: Ethics in Theory and Clinical Practice (forthcoming)
Mitchell Wilson

At the Risk of Thinking: An Intellectual Biography of Julia Kristeva (forthcoming)
Alice Jardine

On Dangerous Ground

Freud's Visual Cultures of the Unconscious

Diane O'Donoghue

BLOOMSBURY ACADEMIC
NEW YORK • LONDON • OXFORD • NEW DELHI • SYDNEY

BLOOMSBURY ACADEMIC
Bloomsbury Publishing Inc
1385 Broadway, New York, NY 10018, USA
50 Bedford Square, London, WC1B 3DP, UK

BLOOMSBURY, BLOOMSBURY ACADEMIC and the Diana logo are
trademarks of Bloomsbury Publishing Plc

First published in the United States of America 2019
Paperback edition first published 2020

Cover design: Daniel Benneworth-Gray
Cover image: *Relief of Vienna*, 1683, by Frans Geffels (1624–1694),
© Wien Museum, photo by Andrew Nash

Library of Congress Cataloging-in-Publication Data
Names: O'Donoghue, Diane Mellyn, author.
Title: On dangerous ground : Freud's visual cultures of the unconscious /
Diane O'Donoghue.
Description: New York, NY, USA : Bloomsbury Publishing, Inc., 2019. |
Includes bibliographical references and index.
Identifiers: LCCN 2018033604 | ISBN 9781501327957 (hardback : alk. paper) |
ISBN 9781501327971 (epdf)
Subjects: LCSH: Subconsciousness. | Psychology. | Art.
Classification: LCC BF315 .O365 2019 | DDC 154.2–dc23
LC record available at https://lccn.loc.gov/2018033604

ISBN: HB: 978-1-5013-2795-7
PB: 978-1-5013-6304-7
ePDF: 978-1-5013-2797-1
eBook: 978-1-5013-2796-4

Series: Psychoanalytic Horizons

Typeset by Integra Software Services Pvt. Ltd.

To find out more about our authors and books visit www.bloomsbury.com
and sign up for our newsletters.

For Charlie

Contents

List of Figures

Acknowledgments

The ideas in this book are indebted to encounters with objects, places, and texts, and the many individuals and institutions that made it possible for me to perceive connections among them. There are contributors without whom this book would be much diminished, but if it were not for the Boston Psychoanalytic Society and Institute, it certainly would not exist at all. Welcoming me first as a one-year affiliate scholar and extending that tenure to several more years of studying alongside the analytic candidates ultimately resulted in my becoming a scholar member and part of the Institute's faculty, making a book like this possible. That said, this work remains close to my own fields—art history and archaeology—but does so through an engagement with Freud's early psychoanalytic project that would not have happened without this opportunity to learn, grapple, and critique. To my teachers, fellow students, colleagues, and those I have taught, I owe an inestimable debt. I hope that all of you consider this book an attempted repayment. I am especially appreciative of the support of Sanford Gifford (my first teacher), Bennett Simon, Ayelet Barkai, and particularly Humphrey Morris, who has remained a valued interlocutor and, through his ongoing seminar at Harvard's Mahindra Humanities Center, has provided me with a monthly opportunity to discuss readings with a lively, committed group of academics and analysts. Many conversations and texts from these gatherings have helped to shape and sharpen my thinking.

The book begins and concludes on Vienna's urban ground, where much of the research, and no small part of the writing, was done, supported by colleagues and friends who showed remarkable generosity and support for intellectual and archival excursions that must at times have at least mildly perplexed them. Many of those acknowledged here are, or were, affiliated with one of three institutions—the University of Vienna, the Freud Museum, and the Vienna Psychoanalytic Society—that provided me with support and places to present portions of this book as it developed. As readers or as respondents to my questions, those I have met there were invaluable: Sophia Asperger, Karl Bruckschwaiger, Christine Diercks, Michael Diercks, Christian Huber, Joanna King, Andreas Mayer, Maya McKechneay, Edith Saurer, Elisabeth Schlebrügge, Johannes Schlebrügge, Johann Schulein, Hemma Rössler-Schulein, Daniela Seebacher, Hubert Szemethy, Tina Walzer, Sylvia Weinzettl, Gudrun Wlach, and Dieter Zoubek. Arthur and Gila Perach Hirsch were dear friends from the start, and through them,

the Moskovics and Zinner families provided me with hospitality and a sustaining sense of home beyond what they could ever realize. Lydia Marinelli, in her capacity as curator of the Freud Museum, offered much practical wisdom during my early days in Vienna, along with a model of scholarship that balanced adventurous inquiry and critical rigor. Her tragic death cut short what certainly would have continued to be a remarkably productive career.

Many have informed my thinking through the provocation of their writing, but here I mention only a very small number cited in this book, those whose work addresses issues especially relevant to my inquiries: Richard Armstrong, Jay Geller, Sander Gilman, Ranjana Khanna, Laura Marcus, and Spyros Papapetros. Mary Bergstein and I have been fellow travelers on paths that converged and diverged in ways very fruitful and important, like our long friendship. I am grateful to Peter Rudnytsky for his valued support of my work and the importance of his own, along with his ability to appreciate my need to keep in mind both the forest and the trees. An excellent series editor, he introduced this project to Bloomsbury where Haaris Navqi and Katherine de Chant guided the book through production with considerable attention and care.

Earlier versions of the chapters here have greatly benefited from both readers and listeners who offered important inquiries that strengthened this text. Organizers and members of the Richardson History of Psychiatry Seminar at Weill Cornell Medical School welcomed me on several occasions to present papers, and I am appreciative of the opportunity to bring new work to this very knowledgeable and engaging group. In a similar way, connections to audiences at the Vienna Psychoanalytic Society, the American Psychoanalytic Association, and the New York Psychoanalytic Society and Institute deepened the clinical implications of this work. Invitations to participate in conferences in visual and cultural studies both in the United States and Europe enriched the transnational scope of this study.

Support that enabled the research and writing of this book is sincerely acknowledged, most especially the Fulbright Scholars Program, which, in awarding me two grants (one as the Fulbright/Sigmund Freud Scholar of Psychoanalysis) enabled the sustained time in Vienna and Central Europe that allowed this work to take its initial shape. The gift of a semester of writing in the Berkshires was afforded through the opportunity to be the Erikson Scholar at the Austen Riggs Center, and additional time in Vienna was made possible by my appointment as the Ortner-Chopin Visiting Professor at Webster University Vienna. Valuable research support was provided by the American Psychoanalytic Association, the Boston Psychoanalytic Society and

Institute, and Tufts University. Archives and libraries have played a crucial role in providing the necessary material. Margaret McAleer, senior archives specialist at the Library of Congress, was an extremely knowledgeable and helpful guide to the Sigmund Freud Collection there. And I owe very special thanks to Ingrid Ramirer of the University Library in Vienna, who has been a remarkable resource in finding sources both in her collection and beyond, always welcoming my inquiries as challenges she never seemed unwilling to enthusiastically accept. Jean Turfa, along with Ann Blair Brownlee, made the Etruscan collection in the University of Pennsylvania Museum of Archaeology and Anthropology and its archives available to me, thus allowing an understanding of Freud's early acquisitions that would otherwise have been impossible to reconstruct. Through a kind introduction from Catherine Harding, I met Lucio Riccetti, who both facilitated my work in Orvieto and graciously shared his own scholarship on Freud's experiences there. Moving from Umbria to Tuscany, sincere thanks are due to two colleagues at the University of Siena, Alessandro Leoncini and Giulia Pagni, who allowed me access to archival records and images.

Later versions of two previous publications appear in Chapter 5. I am appreciative of permission to include them here: "Lingua Flora: Deciphering the 'Dream of the Botanical Monograph,'" copyright © Johns Hopkins University Press, an article first published in *American Imago* 62, no. 2 (2005), 157–177; and "The Magic of the Manifest: Freud's Egyptian Dream Book," copyright © Johns Hopkins University Press, first published in *American Imago* 66, no. 2 (2009), 211–230. Both of these articles are reprinted with permission by Johns Hopkins University Press.

Gratitude for those who sustain you, in innumerable ways, can only faintly be expressed in an acknowledgment, although, of course, it is the most crucial to include. Mariagnese Cattaneo graciously extended a dear friendship to include occasional forays into assistance with deciphering *Fraktur*, and Lin Reicher shared linguistic unravelings of many sorts. K. E. Duffin brought to this text a poet's appreciation of the weight of each word and an editor's willingness to jettison those in excess of a permissible weight limit. Her commitment to this book inspired me to create a text that would locate the reader in proximity to the narratives and individuals introduced here, allowing for some of their ambiguities and indeterminacies to remain, as revenants, barely visible. To the Rohan, Scanlon, and Wolf families, with links both past and present, gratitude travels alongside the memories of all our parents. But my greatest thanks are reserved for Kimbell DiCero, who generously allowed for the distractions and disappearances that an endeavor like this requires, but who also would never allow me to slip away into a world where life was lived removed from its pleasures and challenges. Her

presence is certainly here in the book's arguments and images, but it is also in all that occurred beyond the text, and yet would return, reinvigorated, to it.

This book is dedicated to our son Charlie Kalil, whose adolescence was lived among the stories told on these pages, and whose ability to perceive the intricacies of both objects and ideas was a gift he offered to this project. His influence is very much here, in ways both ineffable and profound.

Introduction

Questions of materiality and meaning—matter and what matters—are compelling both as contemporary and as historical inquiries inseparable from the tangled, and at times tragic, determinations of who and what would merit value and worth. This book places these concerns at the fore of a series of narratives examining the relationships between visual culture and Sigmund Freud's construction of an "unconscious." Such a locus is not a common one, as material objects have tended to be the subject of psychical analysis; here their physical presences will be more vividly drawn, and drawn into, the making of psychoanalysis itself. To embark on such an endeavor, one must first determine when and how to enter into this dynamic, complex, and—as I will argue—exquisitely particular story. I locate my inquiries in the earlier half of Freud's long life, which spanned eight decades, from 1856 to 1939: the book's final chapter focuses on *The Interpretation of Dreams*, published just as the twentieth century was to begin. Much of what will be discussed occurred in the 1890s, when Freud first formulated ideas that would become foundational to the work to follow: fantasy, defense, repression, childhood sexual wishes given credence by the story of *Oedipus Rex*, and the functioning of dreams. My chapters introduce into this consequential and highly scrutinized period for psychoanalysis certain travelers who were also part of this journey yet whose roles have been largely unexamined. Some are individuals whose lives intersected with Freud's, but their experiences are all inextricably aligned here with other presences, not of flesh, but of stone, clay, pigment, or paper. These latter objects, and those persons associated with them, participated in what we might call, inspired by the title of one of Freud's well-known works, his "psycho-materiality of everyday life."[1] Specific buildings, "antiquities" (objects removed and transferred from various early cultural sites), paintings, and books are located here as constitutive, rather than illustrative, of Freud's early notion of an unconscious.

Attributes Freud would associate with psychical functioning—not infrequently described using a rhetoric of "discovery"—were often considered innovative and consequential because they were enunciated as operating autonomously, separate from both conscious awareness and investments in power located within physical objects. Freud's origin narratives invariably

gesture inward, recounted in the language of instincts and drives, of residual, phylogenic legacies from an often-colonialist creation of a "primitive" past.[2] To give the beginnings of the Freudian unconscious a cultural and visual history in their own moment, as discursive formations, opens a productive space for these seemingly intrapsychic mechanisms to "materialize," and as a concurrent and coeval gesture, for certain buildings and objects, significant to Freud, to be reckoned as sites of affective experiences, albeit not among those he accorded much attention analytically. Peter Galison has described this as a "re-literalization" in his work identifying how synchronized clocks were really "at the heart" of the "more abstract reasoning" of Albert Einstein and Henri Poincaré.[3] He has also applied this inquiry to Freud, considering the role of censorship in political practices, specifically by the Viennese press, in the shaping of psychical processes. Galison's "abstract concreteness" and "concrete abstractions"[4] find parallels here as I suggest aspects of visual culture whose practices and representational capacities may have animated—whether because embraced or disavowed—Freud's formulations.

One strategy for such an inquiry is to begin our investigation as certain of Freud's ideas are coming into being, before they appeared in published form and thus become productive of what is posited as *a priori* functioning. Much of this thinking is found in letters to Freud's intimate interlocutor during much of the 1890s, the Berlin otolaryngologist Wilhelm Fliess.[5] There are often disparities between what Freud expressed privately, especially in his earliest sharing of experiences later to become exemplars of psychical functioning, and in published work. Once iterated, these ideas quickly naturalized, and what began as descriptive speculation became descriptors of functions and mechanisms; as imagined constructions, following precedents of both European empiricism and empire, they were claimed to have been "found." Freud's thinking of course shifted over the ensuing decades, and to hold him to these originary musings would be untenable in a study of his psychoanalytic project as a whole. However, returning to the start is particularly relevant for considering the place and provocation of visual and cultural objects, as this is a time before their importance was subsumed within the mechanisms to which, as I argue, they significantly contributed. In the chapters to follow, I consider certain physical presences—built structures, paintings, illustrated books—as generative of affects and associations that preceded what Freud will "discover" as psychical attributes.

To hold the originary moments of Freud's ideas is a bit like grasping at the imagery of a dream as one awakens. In this case, the encompassing "reality" our eyes fix upon is what has become known as psychoanalysis. I attempt to hold open some space not made accessible solely by what we know will follow in Freud's oeuvre. If this is a challenging enterprise, then identifying

the meaning we can grant particular objects and structures—those existing in the world, or as memories or dreams about them—within these nascent ideas is an even more elusive operation. For to suggest that visual culture was *productive* of psychical value contrasts sharply with how much of it came to be reckoned "psychoanalytically": this imagery frequently was cast as meaning-*less*, made to not "matter" in both readings of the term. We can identify an instance in Freud's understanding of the visuality of dreams, where the imagery recalled from sleep is relegated to a hallucinatory function ("manifest content") in the service of repression, and thus mediated by the intention to disguise the dream's "latent meaning." Another form of "not mattering" involves physical objects themselves whose impact is rendered inconsequential within Freud's project. I argue that such disavowal was a way for Freud to contain experiences of vulnerability, betrayal, and danger, and the feelings they may have elicited in him. While Freud's pursuits have become known through John Kerr's descriptor of a "dangerous method,"[6] those foregrounded here are associated with objects and experiences whose perils lay upon the ground, and often in plain sight. We will encounter certain irreducible threats and disruptions that, as such, would be destined to remain beyond reach. But if we stand outside of analytic meaning, we are better able to see its borders. Readers of this book are asked to imagine what Freud considered inconsequential as defining yet another entity that only becomes visible when our attention shifts to it, as in viewing an illusionistic image, when mere background is revealed as itself formative of an often quite different picture. My hope is that by identifying how certain claims to value were established, we are able to resist the ontologizing tendencies around the discourse of the "unconscious," and to see how the impact of exclusionary ideologies, to which Freud was both subjected and in which he participated, shaped the contours and mechanisms of his psychoanalytic project.

The book opens ("The Lost Language of Stones") on Vienna's urban ground, from which a vast architectural program arose in the course of Freud's youth and young adulthood as a striking array of buildings along the newly constructed Ringstrasse. His early visual and affective responses to the city's new structures are little known, although we consider ways in which these surroundings, into which he came as a three-year-old, may have been meaningful to him. It will be in another European city and in the unlikely surroundings of arguably its most notable church—Paris's Notre Dame—that Freud, now nearly thirty, will leave evidence of the ways in which he could enter into a relationship with architecture. The Neogothic edifice served as a haven for him, an unexpected role, given that Freud, as a Viennese Jew, regarded his own city's medieval cathedral as an object of considerable scorn. Yet, while in Paris on a fellowship in the winter months of 1885–1886, Freud

found in Notre Dame both an enclave and an extension of the lectures he attended at his sponsoring institution, a vast public hospital, the Salpêtrière. Its director, Jean-Martin Charcot, focused much of his work at that time on the construction known as "hysteria," whose representations in clinical displays and photographs of patients—Charcot was very aware of the hysteric as a trope of medieval visualizations—Freud may have seen as akin to the statuary, the architect's fantasy of gargoyles, on his frequent visits to viewing platforms on the church's roof.[7] That Freud was so in thrall to this building suggests insights into meanings that he may have associated more widely with its architectural idiom. While one thinks of this nineteenth-century phantasm of a medieval edifice—most of what stood in Freud's time was a reconstruction—as melded to Paris, there was a very distinctive and important *Neugotik* presence in Vienna in the last decades of that century. I will introduce two buildings in this style, both the work of the German-born architect Friedrich von Schmidt, and chart Freud's relationship to them, their very specific meanings within Vienna's civic topography, and ways in which this architecture may have become, for Freud, the site of betrayal. One example will be an apartment building where he moved, setting up his residence and practice there, soon after returning from Paris and at the time of his marriage to Martha Bernays. Schmidt and his family would be the Freuds' neighbors, living in the building as well. The other is the architect's most notable edifice in the Habsburg capital: the Rathaus, Vienna's City Hall.

These buildings each held different narratives for Freud. Connected with his residence was the loss to suicide of Pauline Silberstein, a patient whose death was made possible by specific structural particularities of the building, itself a memorial to tragic deaths. The City Hall, with its assertions of a secular vision of a "free" polis, was occupied, by the mid-1890s, by a mayor whose reactionary ideologies turned the building's founding vision into a ruin, without damaging a stone. I read these experiences alongside two points in Freud's work during that period when architectural imagery enters, materializing aspects of his conceptualizations of "hysteria," and suggesting how betrayal, defense, and protection may have moved from stone to psyche in unexpected ways, and once naturalized as internal functions become difficult to re-trace.

The relationships between Freud and the structures introduced earlier have been largely overlooked; when he is associated with a building, the narrative has focused, with good reason, on the place that succeeded Schmidt's apartments as his home and working space for over four decades. This latter building did not in fact betray him until the very end of the family's residence there, when its owner displayed Nazi symbols on it, as Freud, now gravely ill and over eighty, Martha Freud, and their youngest child, Anna,

were forced to emigrate to London, in the spring of 1938, where Freud would die the following year. It is in this long-time residence that he would find an interiority both architecturally—his home at Berggasse 19 in the ninth district had little in the way of a distinctive façade or civic presence, unlike his previous dwelling—and in the increasing elaborations of the workings of an unconscious and its intrapsychic mechanisms. It is in certain rooms there that Freud's connection to visual culture is also most commonly located, in his vast collection of "antiquities": well over 2,000 objects from various early sites associated with Egypt, the Greek and Roman empires, and areas in the eastern Mediterranean. They were gathered exclusively in his working spaces, filling every surface of his consulting room and study. Edmund Engelman would create his well-known photographs of these rooms just as the Freud family was forced to leave, with the merger of Austria and Germany (*Anschluss*); these images thus reveal the assemblage in its final moments as participants in the scene of Freud's psychoanalytic work. There has been a considerable body of scholarship on the collection as it was in these rooms, where the objects were a striking presence for patients and visitors. Once relocated to London, the contents have become the holdings of the Freud Museum and thus removed from the role they may have played in the therapeutic encounters and writing that they quite literally encircled.

But even while still in Vienna, Freud's "antiquities" are usually imagined as a somewhat static collection, and with no visual record to match that of Engelman, the assemblage of these objects is melded to the contours of these small spaces, to each other, and the work that Freud did among them in the first decades of the twentieth century. His deliberate choice to contain the objects exclusively within his psychoanalytically charged space certainly suggests their roles as companions and agents provocateurs, but little has been said about how these functions may have emerged, although their sheer number alone would make those claims highly credible. The collection's beginnings have remained obscure, linked frequently with a comment Freud made to Fliess in December of 1896, in the months after Freud's father, Jacob, had died: he mentioned placing plaster casts of Renaissance statuary in his office, and the comfort they afforded him. These were reproductions, and as such could gesture quite specifically back to well-known "originals" whose narratives, as notable "works of art," were an inextricable part of the copies.

But what Freud turned to collect was a different "matter": small objects whose meaning referred less to a specific moment or creator, but more to an amalgam of historicized sherds, the criterion for their acquisition being a discernment of their value; it has been suggested that Freud was able by this time to afford "authentic" objects, and this economic factor is not to be dismissed. But the earliest history of the collection, as we are able to

reconstruct, suggests a genealogy considerably more specific, and locates Freud's turn to such objects at a time of profound transition, in September 1897, in his thinking from the role of traumatic events in early life to the effects of repressed childhood sexual fantasies, directed primarily at parents. Prompted by this coincidence, I explore the very beginnings of the collection ("Phantasmal Fragments") and ask whether the inauguration of this assemblage can be associated with a change in Freud's understanding of the efficacy and value of singular evidential remains of an "ancient past." I focus on the circumstances under which Freud purchased among the first of his objects—an Etruscan storage container—from a dealer's shop in the Italian town of Orvieto, presenting his acquisition as the inaugural gesture validating performative acts of selection and the prerogatives of ownership. The object is examined not in relation to the rest of the collection that accrued at Berggasse 19, but as it was transformed into an "antiquity" by excavator/ dealer Riccardo Mancini in Orvieto, and the role this process played in the period immediately following the acquisition, as Freud was amassing evidence in his self-analysis, picking and choosing his psychical assemblage.

The phantasm of Freud's Etruscan vessel (falsely sold to him as a "cinerary urn")—it only survives as it appeared in a dream he had about it—will be read alongside a particular psychical fragment that Freud claims to have found in his cluttered storeroom, an image he does indeed use at this moment, of his recollections and dreams in the autumn of 1897. This recollection was a golden treasure indeed, as it provided Freud with evidence of the exact moment and place that he first experienced sexual desire, at age three, for his mother, at a time when he was speculating to Fliess about the universalized possibilities of familial desires he would associate with the story of *Oedipus Rex*. Freud mentions that this revelatory experience took place as he and his family were traveling to Vienna, when he supposedly had the opportunity to see his mother naked, in the final portion of a migratory experience that had begun in his Moravian birthplace and was punctuated by a brief and difficult residency in Leipzig. I reinvest this story of the activation and agency of childhood eroticism back into the circumstances of its original moment ("Libido Awakened: In Transit and Enframed"), before it entered into the specifics of meaning registered only in a psychical realm. By doing so, a different story is revealed, not of desiring, but instead of a vulnerable, dislocated child, experiencing multiple moves that at times must have felt interminable: by the age of ten Freud had lived in nine places in three different central European locations.[8] But by turning his story of arriving in Vienna into an Oedipal "antiquity," giving it much vaunted value, he leaves the remaining aspects of the narrative unspoken, just as the objects in his office, taken from their specific sites, lose

memory of that violence done to them, and instead become exemplars of narratives created by those who traffic in and collect them.

Freud would extract much of the early life detailed in this chapter from visibility, making such omissions a condition of an unconscious forgetting that he imagined as universal and extending through nearly the first decade of childhood. He would come to call this "infantile amnesia," whose first exemplar would be his own assessment of his first years in Vienna, when "nothing was worth remembering," a statement that suggests intentionality and particularity. His psychical enactment of this, however, becomes a non-remembering bound up with a mechanism and singular motive, assuring the inaccessibility of repressed incestuous desires in childhood. Threading through this book is a tension between what is deemed "forgotten"—a repression identified with unconscious functioning—and a second form of omission of memory within Freud's work, crucial but unspoken, which allows his psychical model to function: the "forgettable." What was forgotten, as repression, is not irreparably lost; in fact, this kind of forgetting signaled the location of unconscious processes, and the repressed could, through psychoanalysis, potentially be made accessible; this was the currency of analytic work. The forgettable, by contrast, is not intended ever to return to view, much less scrutiny. Although Freud placed such extraordinary importance on the internal vicissitudes of childhood fantasies and sexual desires, he utterly detached them from the forces at work around him in his own early life.

We turn in the last two chapters to examples where Freud's mechanism of repression and its evidence in the workings of displacement, in speech and sleep, bring us back to visual culture and the makings of psychoanalytic "forgetability." Freud would have us turn away, both from the sight of an object holding certain childhood "sorrows" and from representations of anti-Semitism, by relegating their presence to the periphery of meaning. While the surface imagery was posited as being at the service of prediscursive operations of the psyche, the unconscious was far from ideologically innocent. I trace how Freud fueled the workings of repression in his first published exposition of a psychical mechanism through allusions to thoughts about the "peculiarity" of the "Bosnian Turks" in matters of sexuality and death, imagining his readers would find such stimulus credible to set these mechanisms in motion.

Although Bosnia is a crucial aspect of Freud's 1898 essay on the "psychical mechanism of forgetfulness," the story begins a year earlier, in Orvieto, and on the same trip in which Freud purchased his Etruscan vessel. In Chapter 4 ("The Painting of Everyday Life"), I locate another aspect of visual culture—a series of Renaissance-period paintings—at the center of his inaugural publication

on an example of a common occurrence—forgetting a name—that attested
to the workings of repression. Freud recounts to Fliess a conversation he
had while on holiday in the Balkans, when he was speaking about paintings,
specifically those seen the year before in the Orvieto cathedral, and could
not recall the artist's name, Luca Signorelli. It is significant that although the
story is based on his experience of a very compelling series of frescoes of
the Last Judgment, Freud takes great pains to resituate his memory lapse
away from these objects. The psychical meaning is contained exclusively to
the operation of the mechanism that he charts here, with the memory lapse
cast as the result of a repression of thoughts he directs toward the "Moslem"
communities of Bosnia. But by examining aspects of this story that have not
mattered, I offer a quite different reading of this incident, suggesting that the
paintings turned suddenly from an affirmation of Freud's enfranchisement
as a cultured Viennese traveler to a source of vulnerability and threat. His
vivid memory of the artist's self-portrait is recounted at the moment he loses
the artist's name. This image stands as the hinge between two chapels, each
with prominent examples of anti-Jewish imagery, referring to fabricated and
horrific accusations against medieval Jews that had returned in the 1890s,
after being dormant for centuries, to parts of Europe as accusations of ritual
murders and host desecrations. Freud was, by this time, rather desperate to
find evidence of normative examples of psychical functioning. This instance
of a memory slip offered one, albeit only after he had extracted the most
affectively powerful aspect of the story, the paintings themselves, turning
attention as far away from them as possible, a deflection facilitated by a
construction of Islamic alterity and exotification.

As we turn to Freud's last area of unconscious "revelation" appearing in the
late 1890s—culminating in the publication of *The Interpretation of Dreams* at
the very moment of the turn of the century—we encounter another attempt to
manage uncontainable threats by again disavowing the importance of visual
imagery. Freud would construct a binary structure within the "dream work":
the remembered surface as manifest content that served to veil the far more
consequential latent meaning. A psychical apparatus of repression was thus
solely responsible for the dream's visuality, a hallucinated façade allowing
unacceptable wishes to be shielded from "view." As an internal derivative,
inseparable from the unconscious, any "day residues" that occur within the
memory content of the dream are frequently dismissed as "indifferent" to its
actual meaning, so it has been difficult to wrest the dream's surface free from
its purported generative sources in the mechanisms of repression. But it *is*
possible to extract the "manifest" and here I give it two genealogical strands:
one within the dream in *The Interpretation* where the latent and manifest
functioning was first articulated and then came to be emblemized; and

contemporary, alternate understandings of the uses of dream imagery at the moment when Freud's dream book was just one among others in Vienna, a fact long forgotten ("The Magic of the Manifest: Paper Dreams").

My analysis of the dream that Freud puts forth as typifying his latent/ manifest bifurcation shows that the "surface" image—a book on plants— carries considerable significance from his childhood, being connected with experiences painful and poignant, and is very much part of the "meaning" here, although Freud makes it utterly invisible by locating the significance of the dream in a register far from any physical object. This distancing was intentional and protective, although the volition and motives that made it possible were erased when "indifferent" imagery was incorporated into the processes of dreaming. I extend this "genealogy of the manifest" to the political and cultural ramifications—and dangers—of investing in dream imagery in late nineteenth-century Vienna, when the "dream book" was a popular medium for the transmission of stereotypes, most prominent among them anti-Semitic ones, naturalizing such images through the "universal" act of sleep.

How Freud equated meaning with value was no ordinary empirical process, despite being presented as such. Because his extraction of phenomena from scrutiny—the psychical disguise, the utterly forgettable memories—was powerfully formative for what was retained, absence was necessary to create a presence: there could be no latent meaning to uncover without the indifferent "manifest content" attempting to obscure it. It is possible, in scrutinizing Freud's extractions, to identify how this process of removal was then made part of psychical mechanisms themselves. Because this assigning of worth then became part of the *a priori* working of the unconscious—obscuring its actual function as the originary gesture—its presence was absorbed into the configuration that it created, and thus lost from view.

This book is not an attempt to accord a new place of privilege to art historical objects within Freud's psychical project, although this story is being told by an art historian. These chapters are narratives intended to suggest the complexities that surrounded Freud's navigation of visual cultures. Such an inquiry required new material—and a new reading of materiality—to enter into the beginnings of psychoanalysis in a more robust way than in the past. Because much that is discussed here is outside the margins of histories of the Freudian unconscious or of Freud himself, it is fortunate indeed that we have no lack of scholarship on both of these topics, evidence being the many and diverse texts cited throughout this book, a small portion of a vast literature. Here the relationship between surface and depth is up-ended, the often-dangerous ground beneath Freud's feet revealed as not inconsequential, but instead uncontainable. In constructing the psychoanalytic process, Freud

decided what would not matter, but in fact what he conceptualized was often the wish that it would not matter.

Notes

1 My choice of phrase plays upon the title of Freud's *Zur Psychopathologie des Alltagslebens* (The Psychopathology of Everyday Life), first published in 1901. The English version appears as volume 6 of the *The Standard Edition of the Complete Psychological Works of Sigmund Freud*, ed. James Strachey (London: Hogarth, 1953–1974) [hereafter *SE*]. The first two chapters of this text will be discussed here in detail.
2 An excellent analysis of the points of connection between psychoanalysis and ethnology is offered by Ranjana Khanna in *Dark Continents: Psychoanalysis and Colonialism* (Durham, NC; London: Duke University Press, 2003), particularly 66–83.
3 Peter Galison, "Blacked-out Spaces: Freud, Censorship, and the Re-territorialization of Mind," *British Journal of the History of Science* 45, no. 2 (2012): 237. My thanks to Elizabeth Lunbeck for calling this article to my attention. For Galison's work on Einstein and Poincaré, see his *Einstein's Clocks, Poincaré's Maps: Empires of Time* (New York; London: W.W. Norton, 2003).
4 Galison, "Blacked-out Spaces," 238.
5 The complexities and eroticism of the Freud–Fliess relationship are best rendered in Daniel Boyarin's chapter, "Fliess's Baby, Freud's Maybe: Or, Male Hysteria, Homophobia, and the Invention of the Jewish Man," in his *Unheroic Conduct: The Rise of Heterosexuality and the Invention of the Jewish Man* (Berkeley, CA: University of California Press, 1997), 189–220.
6 John Kerr, *A Most Dangerous Method: The Story of Freud, Jung, and Sabina Spielrein* (New York: Alfred A. Knopf, 1993). The book was the basis for the 2011 film *A Dangerous Method*, directed by David Cronenberg.
7 The vividness of Freud's engagement with Notre Dame, and especially its rooftop assemblage of statuary, is very much indebted to Michael Camille's posthumously published *The Gargoyles of Notre-Dame: Medievalism and the Monsters of Modernity* (Chicago, IL; London: University of Chicago Press, 2009).
8 An accounting of all of Freud's residences in childhood is provided by Georg Augusta in "'Dann kamen die langen, harten Jahre': zur Situation der Familie Freud nach ihrer Ankunft in Wien im Jahr 1859," *Luzifer-Amor: Zeitschrift zur Geschichte der Psychoanalyse* 56 (2015): 213–215.

1

The Lost Language of Stones

In the autumn of 1859, three-year-old Sigmund, then known as Sigismund, Freud arrived in Vienna, just as one of his new home's most distinctive landmarks, the medieval wall and towers that had delimited the inner city, was in the final stage of demolition. Small portions of the *Basteien*—the bastions created at points along the enclosure—were in places preserved as part of the new city landscape, although little survives today. The family—Freud, his parents, and his younger sister, Anna—began their journey in the children's birthplace in Moravia, leaving due to what Freud would later characterize as a "catastrophe" that befell "the branch of industry in which my father was concerned," a circumstance from which the elder Freud appears never to have recovered financially.[1] They arrived in Vienna in the midst of its transformation. The fragmentary bulwark in Freud's first neighborhood stood as a mute participant in the uneasy alliance of Emperor Franz Joseph and local political elites, one that nevertheless would result in an unprecedented urbanism at the heart of Mitteleuropa. The simultaneity of Freud's youthful arrival and the old walls' departure was not coincidental. The Freud family had originally intended to settle in Leipzig, arriving there first, but after about two months, they were denied a residency permit and ordered to depart immediately from that city.[2] Their move to Vienna placed them among the thousands of Franz Joseph's subjects taking advantage of the Habsburg capital opening to them, with its new vision of *Freiheit*—a freedom that, for the new Jewish residents, marked one of the most promising results of movements for emancipatory rights that emerged from the revolutionary upheavals of 1848.[3]

In the year before the Freud family's migration, a competition was announced for Vienna's grand architectural expansion, with German-born Ludwig von Förster selected as a principal to oversee the project. His Danish son-in-law Theophil Hansen—who would go on to design four major buildings in the city, including the massive neoclassical Parliament—and an array of other major figures of the era were involved in the construction. The demise of the circular fortification brought about a new vision in stone: the Ringstrasse, an expansive boulevard built outside the enclosure marked by the old city walls, and lined with buildings, some already in place, but many

others created along its route that would mark the passage of Vienna into modernity and metropolis. During the decades following the demolition of the city walls, the buildings that arose around and beyond their footprint created a visually compelling landscape claiming to serve the Habsburg citizenry and, far more for its male residents, offering the promise of unparalleled opportunity.

How might this new construction have given Freud a different understanding of how architecture could produce meaning than if he had remained in his small market-town birthplace of Freiberg (now Příbor) in the foothills of the Carpathian Mountains, or among the centuries-old Saxon buildings of medieval Leipzig? K. Michael Hays's assertion that architecture attempts the ontological project of an "inquiry into what is, what might be, and how the latter can happen," and thus functions as "a way of attaining the verb 'to be'"[4] would certainly have resonated with the architects and ideologues of Vienna's striking urban display. And indeed, as I argue in this chapter, Freud, throughout his younger adulthood, appeared to embrace the elision of a built environment and the formation of a civic subjectivity, choosing to live and begin his professional life amid some of the Ringstrasse's most notable new buildings. Such identificatory tendencies probably began in his childhood; as Ranji Devadason has argued with respect to those arriving in European cities today, "affective attachment to place" forges an "imagined identification with the political community," providing a spatial dimension to aspirations, particularly those involving the privileges of citizenship.[5] Although her analysis addresses contemporary urban environments, those who shaped mid-nineteenth-century Vienna also relied upon their buildings to convey the Habsburg version of "vernacular cosmopolitanism," a term borrowed from Stuart Hall,[6] that would create a similar, attachment-freighted reception. As a child, Freud had a connection to his surroundings that was not unmediated; he did not respond to architecture in isolation. Instead we can speculate that his response emerged from, and was an extension of, his familial—and in his case, particularly maternal—transmission of what constituted "be-ing" in Vienna. Studies such as those of Devadason and others alert us to the meaning that places may have for children who are dislocated, at an early age, from one geo-cultural environment to another, and thus offer insight into how they may experience the built environment.[7]

It is important to recognize that the Freud family in all likelihood chose Vienna, when forced to leave Leipzig, because it was the home city of Freud's mother, Amalia, and where her parents still resided. Opportunities for Jews were also far more propitious there than in Saxony. Thus, Freud would have understood and experienced the city, at least in part, through his mother's connections to it. His maternal grandparents—Sarah (Wilenz)

and Jacob Nathansohn—lived in the Roberthof, a solidly middle-class apartment building that still stands along the Danube Canal in what was then the predominantly Jewish second district,[8] a residence that may have had meanings of stability given the likelihood that Freud's grandparents provided financial support for their daughter's family. While it is not possible to ascertain all its complexities, Freud's earliest relationship to Vienna, whose initial phases of urban transition would have coincided with his mother's later adolescence there, was probably indebted to her and her family in significant ways.[9] The early processes of meaning-making and connection are locational as well as relational: the caregiver forges affective connections to children within spaces, both domestic and public. Merleau-Ponty famously asserted that the phenomenological register of space is an embodied one: "I am not in space and time, nor do I conceive space and time; I belong to them, my body combines with them and includes them."[10] This sense of subjectivity can also extend to the physical settings in which this process takes place, constituting what the environmental geographer David Seamon characterizes as "the indivisible, normally unnoticed phenomenon of person-or-people-experiencing-place."[11]

The need to make new meanings of one's-body-in-place can be a lens for viewing the upheavals of Freud's transition from his Moravian birthplace to his new city, which he later reworked into a narrative of internal desire that strikingly recasts his mother's impact and changing role. This approach will be revisited in a subsequent chapter when I discuss the proof test that Freud offered for his "Oedipal" construction: his sexual awakening at the sight of his naked mother while traveling between Leipzig and Vienna. That Freud foregrounded his erotic feelings for his mother, displacing the story of his migration[12] and early years in Vienna (of which he claimed nothing was worth recalling), had striking consequences for the development of his theories of childhood sexuality and fantasy. But what if that "memory," whose veracity I will challenge, actually functioned as a screen for this story of transition and transit? Vienna will be reckoned here as a city experienced by a child who came there under duress, a place to which he attached as part of shifting familial dynamics. Like many children who undergo such a transition, Freud was a party to parental realignments after the move to Vienna, with the Nathansohns appearing now to assume a more prominent role. In Moravia, the center of the family had decisively been Freud's father, paterfamilias to two generations of children: both young adult sons from the first of two previous marriages and the first of his children with Amalia.

If Yiddish was the *mama loshen*, the "mother tongue" that Freud's mother reportedly spoke,[13] then for Freud Vienna could be seen as the "mama locus." Amalia apparently selected her birth date in the Gregorian calendar to be

the same as that of the city's most notable inhabitant, none other than Franz Joseph himself.[14] The very choice of her eldest child's given name, Sigismund, may also have been an aspirational gesture to the current regime: Freud's father supposedly wished to honor the memory of Polish ruler Sigismund I (1467–1548), son of a Habsburg mother whose protection of the Jews Jacob Freud admired.[15] However, this choice may not have been idiosyncratic, nor Jacob Freud's alone. Sigismund was not an uncommon name for Jewish boys born in the Habsburg realm during this period. If it was associated with a tradition of imperial support for Jewish subjects, its increased popularity in Freud's time may suggest the desire of a new generation of citizens to receive civic protection from the current royal household. Amalia (Malka) Nathansohn Freud recalled living in Vienna—she would have been thirteen at the time—through the tumult of 1848[16] and the assumption that she was not involved in choosing her first child's vernacular name—his Hebrew name, Schlomo, was given in memory of Jacob Freud's father[17]— speaks more to assumptions about gender than to what may have been her interest in safeguarding her child's future. Freud would shorten the name to Sigmund during his adolescence[18]—several authors argue that this was a more "German-sounding" one. For despite its long association with various European imperial houses, Sigismund, by the 1860s in Vienna, was considered a "Jewish" name because so many of its Jewish citizens bore it. In reflecting the aspirations of Jews to protect their sons, the name came to figure in anti-Semitic jokes, and this has been offered as a reason why Freud chose to abandon it.[19] Thus, a name initially considered apotropaic may have ended up rendering those with it vulnerable rather than protected.

Adam Phillips, in writing about Freud's life and work until mid-life, makes an important point as he discusses his early professional years: "Describing what he would ultimately call the Unconscious was to be Freud's way of talking about why we can never settle down, and why we can't stop wanting to."[20] This articulation of the tension between transience and durability may also be understood as an affective index of Freud's urban experience. Much scholarship has focused on Freud's more visible relationship to his "surroundings," specifically the antipathy, rather than attachment, that he frequently expressed toward Vienna, as anti-Semitism became increasingly acceptable in public discourse and political hegemonies, eroding the opportunities that had once seemed very much available to him. But the complexity of that loss, commonly reckoned in terms of his diminished access to professional advantages, can also be read as a disruption of a previous connection. This later betrayal was thus more exquisitely painful; Freud would write to Fliess in 1900 that "I hate Vienna; almost personally,"[21] going on to suggest that its impact on him is registered in his own physicality, for

he gains strength as soon as he is away from it. Yet there are buildings where traces of an identificatory relationship can still be found, and they gesture to dimensions of "experiencing place" that could have informed not only Freud's understanding of architectural meaning but how certain affective residues derive from it; these experiences, notably involving protection and betrayal, may have influenced the "structuring" of Freud's earliest psychoanalytic formulations. But Freud will not be of help in clarifying their role, for he reveals little of this loss: in one case, concerning the so-called "House of Atonement" (*Sühnhaus*) where he lived and practiced at the start of his professional life in Vienna, there is utter silence about the tragic suicide there of a patient, ironically—as the person jumped into the core of the building—enabled by its very distinctive architectural features. In the case of the Rathaus, or City Hall (whose architect designed the Sühnhaus and was Freud's neighbor), another loss is veiled that when recognized strikingly recasts the introductory scenario to one of Freud's most consequential early papers on the traumatic causality of the construction that he enunciates as "hysteria."[22]

This chapter will conclude with perhaps the most revealing of these early "architectural" moments, as Freud gathers his thoughts, in a series of "drafts" appended to letters written to Wilhelm Fliess in May of 1897, about fantasy, pathology, and protection under the title of the "architecture of hysteria."[23] Freud extends his ideas in his own rendering of such an edifice, depicted rather schematically as an overlapping series of pyramidal forms topped by smaller triangular ones. While his drawing references no specific building, the term he uses to describe its function suggests a Viennese structure of a very particular kind: a weir created to protect against flooding, a kind of enclosure that is an attempt to make a safe haven. The moment is certainly worth noting; the appearance of this sketch in May 1897 closely followed Karl Lueger's mayoral inauguration, in late April, which was a victory for the political ideologies that Freud abhorred. When crowds gathered at that moment to shout anti-Jewish slogans in front of the Rathaus—the spired, neo-Gothic edifice that had been dedicated only twenty-five years before— the building's intended meaning as an architectural presence imagined as the municipal centerpiece of this "open" city was reduced to little more than a ruin.[24] Freud provides in his drawing and the texts that accompany it a representation of the prediscursive functioning of defense as it erects its protective barriers; this is a structure very much of Freud's making, with all the master builder's prerogatives, but also bricolated with the experiences of architecture beyond such control.

Freud and portions of Vienna's Ringstrasse grew up in tandem, the enclosure of the medieval city crumbling beneath him in earliest childhood and several of its large architectural projects marking both the maturing of the city and his passage through youth to young adulthood. In these years, evidence suggests that he saw the urban landscape as a space of potential, the continuation of his childhood aspirations to stake a claim there. He recalled that he carried—like "every industrious diligent Jewish schoolboy" of his generation—a minister's portfolio in his school satchel, and that a "strolling poetaster" predicted that he would grow up to be a "cabinet minister."[25] There were Jewish ministers at this time, so it was in the realm of possibility. His father adorned their residence with pictures of these political appointees: "we had illuminated the house in their honor," Freud would recall.[26] Thus, these figures resided within their modest domestic space as a reminder that the most important governmental buildings were seemingly within reach. Indeed, the first of Freud's two residence and office spaces on the Ring—long after medical studies had replaced his interest in attaining a minister's portfolio— was nestled against the City Hall, a very short distance from the Parliament. He chose to quite literally surround himself with these newly hewn civic stones. This is not to suggest that Vienna was not rife with inhospitable anti-Jewish elements at this time, but rather that Freud may have regarded its architectural development as part of a more progressive ethos. The notion of pushing out beyond old enclosures, an image that would have marked the topography of his earliest years in Vienna, seemed to remain vivid for him. In his first book-length publication, a monograph on the neurological condition of speech known as aphasia, published in 1891, he spoke of further investigations that would need to move beyond the anatomical topographies that had characterized studies of this condition.[27] To suggest that neural functioning transcended specific brain localities—an idea anticipating his later understanding of psychical processes—he chose to evoke the image of a city that needed to expand beyond its walls (*Ringmauern*).[28] Valerie Greenberg, in her illuminating study of Freud's aphasia book, comments on his use of this latter image: "This peculiar metaphor, which is strikingly out of place in its neuroscientific context, could have been derived from the impression made by Vienna's dramatic expansion in the 1860s and 1870s beyond its former fortified walls."[29]

Yet Freud's response to one of Vienna's most notable buildings, one considerably older than those along the Ring, is well known, and perhaps as a result has consigned Vienna's architecture—certainly that associated with Christian elements—to something of an anathema for him. In a line penned to his future wife Martha Bernays in 1886, he writes of the "detestable tower"[30] of St. Stephen's Church, the medieval cathedral that occupies a prominent

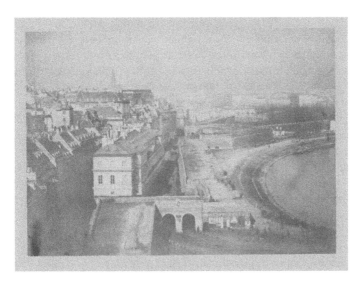

Figure 1.1 Photographer unknown. View of Vienna's city walls with the Rotenturmtor and Gonzaga *Bastei* (bastion) before demolition, March 1858. ©Wien Museum.

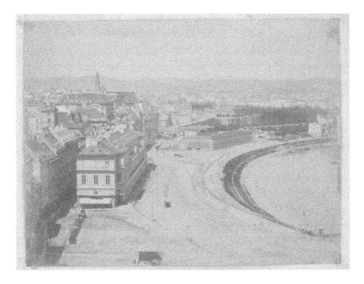

Figure 1.2 Photographer unknown. View of the area after demolition, May 1858. ©Wien Museum.

place in the center of the city. Given that the church was the most powerful embodiment of Catholic Vienna, with its long history of Jewish persecution and current deep associations with clerical adherence to reactionary and nationalist politics, such a comment would be hardly unusual, or unjustified. But Freud's relationship to the architectural style associated with this church—the Gothic and its *Neugotik* revival—needs to be separated from his disdain for Viennese *ecclesia*. In the months prior to evoking the cathedral's prominent south tower, he had written to Bernays about another medieval church whose towers would elicit quite a different response. In the winter months of 1885–1886, Freud had a traveling fellowship in Paris to work with the well-known neurologist Jean-Martin Charcot, and here he would fall, by his own admission, under the spell of the cathedral of Notre Dame. In his letters to Martha, we are able to see how Freud made use of this site in ways that suggest how later buildings may have functioned for him, and how such architectural precedent may have been meaningful as he sought to discursively shape the infrastructure of an unconscious.

Charcot's clinic/museum was the Salpêtrière, an institution with a centuries-old legacy of holding some of Paris's most vulnerable and disenfranchised citizenry, many placed there due to their designation as possessing "mental afflictions."[31] Having begun there as an intern in 1852, Charcot first was drawn to patients suffering from physiological disorders such as joint disease; he would return a decade later as the Salpêtrière's chief medical officer, and devote the next three decades to the patient pathologies of the psychical rather than skeletal kind, becoming one of the best-known neurologists of his day. In Freud's fellowship application, he stressed his desire to pursue his current interests in neuroanatomy and pathology with Charcot.[32] Receiving the travel grant was a recognition that elated Freud, and the four months spent at the Salpêtrière would occasion a seismic shift for him, to psychopathologies. In his report to the fellowship board upon returning to Vienna, it is Charcot's work in two areas, "hysteria" and hypnotism, that Freud cites as the major benefit to him of his time in Paris.[33]

Charcot was interested in a wide variety of neurological conditions, most of which he considered hereditary. But of all the various afflictions that could be identified at the Salpêtrière, he came to focus upon what had been called "grand nervosa," which Charcot renamed the "*grande hystérie*." "Hysteria," a construction that by the twenty-first century has amassed a vast literature of critique, was for Charcot an "experimental neurosis" that was primarily inherited and, although he still very much gendered its representation, could appear in both men and women.[34] In order to understand the functioning of these seemingly erratic, uncontainable attacks, Charcot created a sequence borrowed from the one he had developed for epilepsy. He identified either

three or four stages of the hysterical attack, and these could be accessed—but only with someone possessing a severe form of the "illness"—by what was called the "grand hypnotism." The final stage, one that Charcot regarded as "mental derangement," was hysteria in its extremis, the realm of "madness" and one that might suggest the presence of other conditions such as epilepsy, syphilis, or alcoholism.[35] Charcot's project was to identify the symptom, universalize its progression, and document it. Because of his commitment to the idea of heredity, seen here as a manifestation of familial or, as Sander Gilman has convincingly documented in the case of Jewish males at the Salpêtrière, a very specific anti-Semitic discourse of disease and degeneracy,[36] a cure was less crucial than some epistemological containment that could be empirically reproduced. This approach thus enabled a condition long misunderstood, along with other forms of seizures, as demonic possession, common in the visual and literary traditions of Catholic Europe, to be comprehended as a medical phenomenon.

Andreas Mayer has characterized Charcot's hospital—extending to several museums and the books of photographs that he published—as a "spatial framework"[37] in which these pathologies could be made visible and manageable. The genealogy of his clinical performance was partly drawn from his colleagues' earlier experiments with patients categorized as having "nervous afflictions"—many actually were suffering from epilepsy—whose symptoms were said to respond to metal objects placed on the skin or to the application of pressure to certain places on the body. But Charcot's turn to hypnosis also had roots in practices outside of laboratory and hospital settings, extending to popular amusements, and embracing such practices as animal magnetism, mesmerism, and séances. He argued that all of these involved the dynamics of energy and motion in the body, and as such, hypnotism could be understood as "a synonym for a set of psychical procedures whose effects on the body of the experimental subject could be understood in purely mechanical terms."[38] By the additional offering of hypnotic suggestion, stressed more by other French practitioners, Charcot hoped that symptoms might be eased.

Freud, like many, was thoroughly drawn into Charcot's "laboratory of hypnosis" and to what Charcot considered an ontological proof of the workings of hysteria. At this same time, Freud also fell under another spell, an architectural attachment that would become something of an extension of the Salpêtrière. In a letter of November 19, after about six weeks in Paris, Freud would recount to Martha his first visit to the cathedral of Notre Dame;[39] after that, he would become a frequent and ardent visitor. The first weeks of Freud's Paris sojourn were apparently difficult, and he would recall them as a time when he was lonely and in need of a protector[40]—as we will later see, he

longed for Charcot to assume that role. The more accessible figure who would fill that function for him was the person who accompanied Freud to Notre Dame on his first visit, Giacomo Ricchetti, a Venetian physician whom Freud had met in Vienna.[41] Giacomo and his wife Louise deepened their friendship with the considerably younger Freud during the couple's ten-week stay in Paris, where Ricchetti also had come to attend the lectures of Charcot, whom he knew as a friend, which served as an initial connection for Freud. Ricchetti, well versed on churches although he may have been Jewish (we know that his wife, Louise Hohenemser, who also would become Freud's friend during this time, was from a prominent Jewish banking family from Frankfurt),[42] had been in Paris only a few days when he and Freud went to the cathedral. Since Freud had been there for some time without entering this renowned site, it is likely that the visit was initiated by his companion. However, once inside, Freud appeared to share the response of "wonder" with him; indeed, he tells Martha that he exclaims to his friend, "this is a church."[43] The statement came at a moment in a building that he found "so movingly serious and somber, quite unadorned and very narrow."[44] He resolved then to read Victor Hugo's *Notre-Dame de Paris*, for "this is the place to properly understand it."[45] Indeed, Hugo's text opens with the narrative of the church, before introducing the cast of characters whose lives will be played out there, placing it as the most important participant in the narrative and perhaps fostering Freud's sense of the capacity of an edifice to exist, as Hugo's work clearly argued, between stone and psyche. But there was also a reverse effect, one that Freud would not have realized on his first visit. Freud's association with Hugo's novel was very apt: the great restoration of the cathedral by Eugène Viollet-le-Duc in the 1840s—back to an imagined structure of medieval origins—also reflected the influence of this book.

Thus, the church that Freud knew had very much resulted from a literary phantasm; certainly one of the striking examples of this influence was the evocation of Quasimodo, the so-called "hunchback of Notre Dame" (this phrase is, in fact, the English title of Hugo's text), in the remarkable architectural details of the gargoyles that adorned the upper balconies of the church's exterior façade.

Freud entered into an ongoing relationship to the cathedral, with their encounters linked to Charcot and the routines of the Salpêtrière. On his free afternoons, often after attending one of various clinical encounters, he would make his way up to the viewing platform, where he would be surrounded by fantastic creatures that, despite their medieval antecedents, were gargoyles inspired by Hugo's hero.[46] He would recount to Martha that he kissed her on each step[47]—there were over 300 of them—and the church's capacity to evoke the sacral, demonic, and erotic thus nicely matched Charcot's vision of the

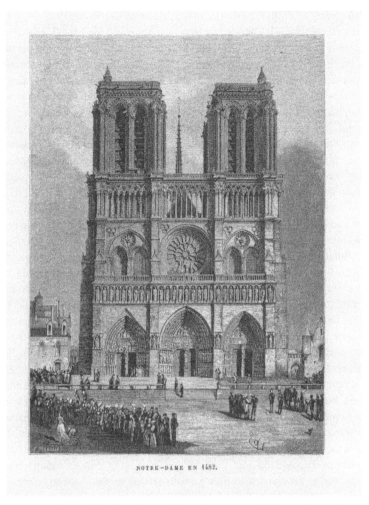

NOTRE-DAME EN 1482.

Figure 1.3 Eugène Viollet-le-Duc. "Notre Dame in 1482." From Victor Hugo, *Notre-Dame de Paris* (Paris: Hughes, 1877), vol. 1, p. 136. Typ 815.77.4571, Houghton Library, Harvard University.

history of hysteria. Arriving at the roof, Freud reported that he would feel "wild." His description also resonated with another of his fantasies—where he imagines Martha repeatedly kissing him—that he had shared in the spring before going to Paris. Freud tells her that on future hiking trips, she "will have to give me a kiss at every resting place." But the preface to that statement might

also give insight into Freud's state in the cathedral: he tells her that "You'll be fed with cocaine."[48] It was during this period, the mid-1880s, that his research interests in coca leaves for medicinal purposes existed alongside his own use of the drug.[49] We know from letters to Martha that he would turn to cocaine to elevate his mood during his Paris days, using it prior to social gatherings, perhaps to increase his confidence. But the drug's capacities to create a sense of exhilaration and heightened sexual arousal may have also been part of Freud's pleasures on his journeys to the viewing platform. This may have contributed to making the site even more alluring. That Freud would choose, when he and Martha married, to live in the building in Vienna with features that may have most resembled Notre Dame is of course noteworthy. And while we cannot trace all of the positive, identificatory associations Freud may have brought to the architectural distinctiveness of his first home after his marriage, that the building subsequently enabled tragedy was surely a shocking contrast.

Whatever the enhancements of his visits to the cathedral, Freud would equate the building and Charcot's lectures, considering them both as offering him "an entirely new idea of perfection."[50] In this way, Charcot became melded to the edifice, and in mimetic relationship, the church would be there to enclose Freud upon leaving the Salpêtrière; it seemed to extend the experiences in the hospital and also offer him a refuge. He would later recall that in the streets of Paris he often felt bereft and in need of protection. His vulnerability appears to have been mitigated when, as he notes, "the great Charcot took me into his circle,"[51] but he would elsewhere concede that these hopes "were never fulfilled."[52] Although in the seemingly convivial surroundings of the Charcots' evening home soirees, the company extended to those who held anti-Semitic views, Freud appeared, at that point, to be unaware of this.[53] And as evidence suggests that Charcot himself was positively disposed to Freud, the latter's wish for a protector, a longing rooted in an earlier time, was thus only partially related to his disappointments of that moment.

When Freud returns to these concerns in *The Psychopathology of Everyday Life* he adds, in the 1924 edition, comments concerning his disappointment in Charcot's care with a description of an earlier appearance of a "rescue fantasy" with its longing for a "protector." Freud notes that he had been sent a children's book, a volume from Franz Hoffmann's library of stories for young readers (the series was titled *Jugendbibliothek*) that he claimed contained a "rescue scene" similar to the one he had imagined experiencing in Paris.[54] He had access to these books in his school library, and dates reading them to between the ages of eleven and thirteen. That was a time of considerable uncertainty for him, and one could imagine that such a story would be captivating. The

family had weathered several crises just prior to this time, including the death of Freud's maternal grandfather, Jacob Nathansohn, who, as noted earlier, appears to have been a financial protector of the Freud family. This grandfather figures in the only dream dating from his childhood that Freud included in *The Interpretation*. In it, he recalls seeing his sleeping mother borne aloft "by two (or three) people with birds' beaks" that carried her into a room and "laid [her] upon the bed," and he associates these creatures to illustrations of "gods with falcons' heads from an ancient Egyptian funerary relief," illustrated in his childhood Bible.[55] He also aligns the scene and his affect of anxiety concerning his mother with having visited the deathbed of his grandfather Nathansohn prior to having the dream. It would appear that his time in Paris brought back his wishes from this much earlier period of life; in both instances he experiences being bereft of guardians. If he did not find this longing fulfilled in Charcot, he may have found some comfort and company at every visit to the cathedral once he reached the top of the stairs.

Through the duration of Freud's stay, Paris always remained inaccessible and somewhat frightening to him, and yet he appeared to find solace among the most notable of Parisian grotesquerie: the stone gargoyles and chimeras atop Notre Dame. Michael Camille, in his captivating study devoted to the cathedral's sculptural display of fanciful and hybrid creatures that traditionally served as the terminus of drainpipes, draws a compelling image of Freud amid this statuary.[56] Although indebted to medieval precedent, and with some of these beasts sharing the original functioning as downspouts, the vast assemblage was actually part of Viollet-le-Duc's mid-nineteenth-century restoration. These stone creatures became Freud's close companions: "Every free afternoon I used to clamber about there in the towers of the church between the monsters and the devils."[57] A photograph from the early 1890s, in all likelihood attributable to Séraphin-Médéric Mieusement, offers a glimpse into what may have been Freud's experience, with a solitary male figure standing among a trio of surrounding gargoygles.

Mieusement would have been on the roof in an official capacity, however, as he had been charged with photographing all the cathedrals of France, Notre Dame among them, for the Ministry of Culture.[58] Like the *Neugotik* revival along the Ringstrasse, these seemingly medieval forms gestured, as Camille points out, to "contemporary styles, ideas, and political concerns."[59] For Viollet-le-Duc these were not the ecclesiastical harbingers of evil, but rather "signs of ideal democracy"—some were conceived "in the fateful year of 1848"—where those once relegated to the margins, as Camille states, are here placed in the center.[60] One imagines that Freud's experience would have been just what the architect would have hoped. He stood there among the forms as a marginal subject, but clearly derived some pleasure from

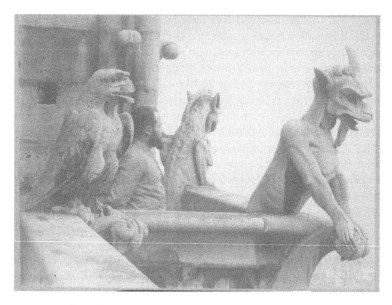

Figure 1.4 [Séraphin-Médéric Mieusement]. A Figure on a Viewing Portico, Cathedral of Notre Dame, Albumen print, *c.* 1892. Andrew Dickson White Architectural Photograph Collection, Cornell University Library.

their shared command of the view. The images were not based on Biblical characters, but the association to this text could have been indirect: one of the creatures was a human-sized and bird-headed rendition of Horus, the Egyptian god of Freud's youth and his childhood dream.[61]

Also, as Camille argues, Freud's connection to these figures might have served as an extension of his experiences with Charcot, as the grimacing figures, especially the female ones, resonated with the current popular preoccupation with pathologies such as hysteria, that would manifest in facial and body distortions;[62] Charcot exploited both the authority and dramatic potential of photography, as Mary Bergstein's important work has shown,[63] and images from the Salpêtrière were published in book form for public consumption.[64] And thus the gargoyles too may have been, in a way, a continuation of Charcot's lectures and presence. Camille asks about Freud and Notre Dame, "Why did he feel so 'at home' here?"[65] and suggests that Freud's visits presaged his later feeling of the "uncanny" ("unhomey") female body in a church dedicated to the most holy of Christian women and with a striking range of female figural images—from the divine to the demonic. But Freud's apparent familiarity and connection may speak less to affects

surrounding sexual difference than to the illusion of agency: these seemingly marginal figures are, as the architect intended, endowed with power that defies any historical precedent; there is an assertion of a thoroughly modern amalgam of subjectivity, albeit in a medieval guise. Freud could have also invested some apotropaic power in these forms, which resemble the hybrid creatures that he encountered on visits to the Louvre.[66] His feeling of connection may speak to associations he already had to spaces in Vienna, to "profane" architecture, whose turn to the Middle Ages in various declensions of influence was inspired by Viollet-le-Duc's revisioning of the idiom of the French Gothic. As previously noted, Freud will in fact select as his residence, upon his return from Paris, a building on the Ring whose façade was indebted to Notre Dame, and thus he would attempt to truly be "at home" there. He would move into this building only six months after leaving Paris, when he and Martha married in the fall of 1886. This architectural turn would be in striking contrast to Freud's view of St. Stephen's. What is equally striking is that the neo-Gothic building where Freud made his first home after his marriage was the work of the same architect who had restored that very spire of Vienna's cathedral. Friedrich von Schmidt was also responsible for the City Hall, beside which Freud chose to his locate his office on returning from Paris, at 7 Rathausstrasse (lit: "City Hall Street"), literally in the shadow of the vast Gothic-like spires that dominated the new building's façade.

Schmidt can be credited with spearheading the ascendency of the Viennese *Neugotik* style.[67] Architecture that gestured to the Middle Ages was not in favor in the first years of the Ring expansion. Classical and Renaissance precedents seemed better suited to the tastes of the bourgeoisie, many of whom found the medieval to be synonymous with the specter of past clerical hegemony; in addition, liberal sentiments were not considered compatible with this style, as it enjoyed current favor among the German and Bohemian aristocracy.[68] But Schmidt would tirelessly argue that the Gothic revival, although associated in many parts of Europe with nostalgia for spiritualism and political conservatism, was actually suitable for secular buildings and the values of Viennese modernism. For five years after returning from Paris, Freud literally surrounded himself with Schmidt's vision in stone. Freud opened his first office in a new, mixed-use building of apartments, offices, and shops—the "Arkadenhaus"—next to what was arguably Vienna's most important edifice at that moment, Schmidt's newly completed Rathaus, one of the largest such municipal buildings in all of continental Europe.

The new Vienna City Hall contained the most modern of conveniences, including ventilation, heat, and electricity, but the edifice was based on medieval precedent, and also had spires, clerestory windows, and barrel vaults.[69] Schmidt was very clear that this building was not meant to be

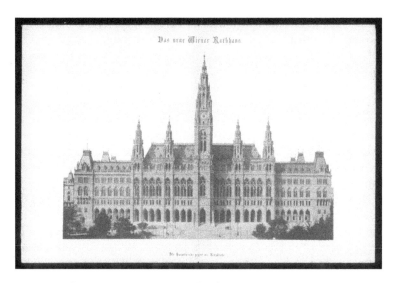

Figure 1.5 "Das neue Wiener Rathaus" (The new Vienna City Hall) as viewed from the Ringstrasse. From Max Fleischer und Friedrich von Schmidt, *Das neue Wiener Rathaus* (Wien: Bambach und Grebner, 1884), plate 1. Wienbibliothek im Rathaus, Druckschriftensammlung, C-156568.

seen as a church architecturally, but rather his plan was inspired by town halls of the Middle Ages, notably those in Brussels, Antwerp, and Bruges. He believed that he saw in the most visible municipal buildings in these important commercial cities a new "secular" architecture that gave the first evidence of individual freedom and self-determination in Europe—"icons of free citizenry"[70]—and what Schmidt termed the "spirit of a new age."[71] For him, the engineering feats, soaring symmetries, and innovative guild system for stonemasons all spoke to the Gothic as the vanguard of epochal change. His architectural interpretations, in that spirit, retrospectively earned him the title of *ein gotischer Rationalist*; of the dozens of buildings he designed, in Vienna and beyond, the Habsburg capital's Rathaus would become his most ambitious assertion of this. Its site—a swampy area along the Ring that had yet to be developed—had not even been decided upon when the call for proposals was issued in 1868. Over sixty submissions were received and it would be a meticulously rendered entry, assigned the number 14, that, after considerable debate, would be named the winner. Schmidt's architectural renderings for the new City Hall bore the submission name of *Saxa Loquuntur* ("the stones are speaking").[72]

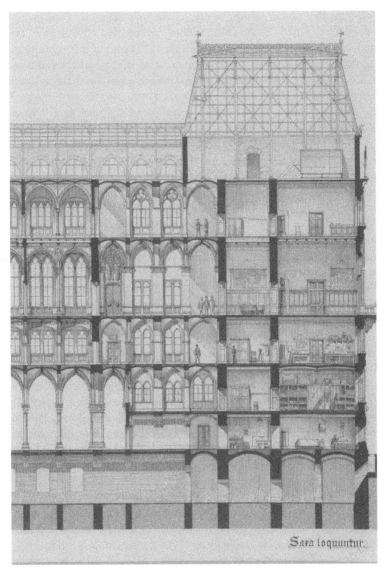

Figure 1.6 Friedrich von Schmidt. Elevation drawing for the interior of the Rathaus ("*Saxa loquuntur*"), Submission portfolio, 1869. Wiener Stadt- und Landesarchiv, P13/4: 105218.1.6.

Schmidt's vision of *Freiheit* seems to have been shaped the most not by his work with either his patrons, including bishops and politicians, or the stonecutters whom he organized according to Gothic workshop practices, but rather by his pedagogy. A glimpse at the roster of those who attended his classes attests not only to the reach of his influence but also to the diversity within his studio. Students—all male until 1920—came from throughout the Habsburg realm, from Viennese families of long standing as well as those that had arrived in more recent decades with the opening of the city.[73] Schmidt's influence on his students manifested in different ways, some more predictable than others. Many went on to work on projects associated with the Ring—those the master deemed most gifted during the Rathaus project worked on that—and the expansion of commercial and residential architecture; others specialized in designing new churches and restoring older ones. The trajectory of Schmidt's impact extended beyond Vienna, as students went back to Budapest and Bohemia, as József Sisa has shown,[74] and carried on Schmidt's legacy there. An unexpected turn in *Neugotik's* reach was its prominence in religious architecture that was not Christian; it is noteworthy that through some of Schmidt's Jewish students it became the style of choice for synagogues and burial monuments, in Vienna and beyond.

The most influential among these students was Max Fleischer, who, like Freud, was Moravian-born from a Jewish family, and became one of Schmidt's closest associates. In a photograph of the architects of the Rathaus, a youthful Fleischer sits at Schmidt's right side, and for his contributions to the project he received an imperial order.[75] Fleischer would adopt the architecture of the City Hall project to his designs for three synagogues in the later 1880s, none of which survived the destruction that came with the *Anschluss*, the merging of Germany and Austria in 1938.[76] But in this earlier time, exposure to Fleischer's buildings inspired members of the Jewish community to commission him to design burial monuments that would reflect their identification with his Viennese *Neugotik*. Arguably, the most striking of these is the mausoleum Fleischer built for Wilhelm von Gutmann, an extremely successful coal merchant, who in later life had served as a "chairman of the Jewish congregation."[77] In the years immediately before his death in 1895, he worked with Fleischer to design a burial monument that embodied the current spirit of Jewish architecture, one that would be distinguished from what Gutmann associated with older burial traditions, such as those he knew from the same Moravian region that he shared as a birthplace with Freud and Fleischer. Gutmann and his family rest in an elaborate structure that includes features reminiscent of the Rathaus, with its spires and arcades.

Figure 1.7 Max Fleischer. Mausoleum of the von Gutmann family, Zentralfriedhof (Central Cemetery), Vienna, 1895. (Photo: author.)

But other architectural elements, such as the tomb's window tracery, appear to be a direct appropriation from a medieval building. One of the most striking additions here probably spoke to the architect and patron of both the past and the present: Fleischer included gargoyles to serve as the

structure's downspouts. He was undoubtedly familiar with Viollet-le-Duc's restoration of Notre Dame, and may have added these fanciful creatures in the spirit of their Parisian counterparts. As markers of the power of the periphery, these figures may have embodied Gutmann's sense of his own enfranchisement in the era of Vienna's *Neugotik*. He acquired land at what was then the sole entrance to the Jewish section of the Zentralfriedhof, thus creating an unmistakable assertion of the ways in which medieval-inspired architecture could function as a visual extension of the Jewish presence in Vienna. When Freud and his family buried his father in this cemetery in October of 1896,[78] they would have reached his grave by going past the Gutmann mausoleum.

Freud and Fleischer appeared to have had their most sustained connection through membership in Vienna's B'nai B'rith lodge, where Freud had first presented some material from his yet-to-be-published dream book and whose support he recalled many decades later.[79] Fleischer, too, gave various talks there; in 1899, Freud offered his second lecture on dream interpretation—the first occurred soon after he joined the lodge, in December of 1897. In the spring lecture series of 1899 both Fleischer and Freud were participants.[80] Freud's topic, presented on April 24, was Zola (for which he recounts to Fliess he was ill-prepared and dreamt it would have a poor reception, although he makes no mention whether it actually did).[81] Fleischer had spoken the month before "On my memories of the Rathaus"; it is regrettable that no record, other than the title of this lecture listed in the organization's annual report, remains.[82] The title is interesting, as it would appear to suggest that Fleischer is offering his own recollections of his involvement in the project, and considering the current fate of the building—as the centerpiece of the Lueger administration—he was likely to have spoken of the building as he knew it in the past.

But for Freud, an avid reader of the *Neue Freie Presse*, Fleischer's name would perhaps have been associated with the Rathaus considerably earlier. When Schmidt died, in late January of 1891, his student would write a lengthy tribute to him in this paper.[83] Fleischer would then go on to self-publish this essay as a small book, which stands as the only biographical account of Schmidt authored by someone who worked with him in Vienna.[84] In it, the reader finds descriptions of the master architect's working methods and pedagogic skills; the laudatory recollections underscored Schmidt's spirit of inclusion and valuing of the individual capacity of the student. For the readership of the *Presse*, this would unmistakably, in a piece authored by the foremost synagogue architect of the day, be read as Schmidt's commitment to promoting equality for his Jewish colleagues and students. But this newspaper had not always been so hospitable toward Schmidt and his Gothic revival. In

an editorial published at the time of the announcement of his commission for the Rathaus, in October of 1869, there was far less enthusiasm about the winning design for the new city hall: "After we took so much trouble to expel the spirit of the Middle Ages on the glorious 13 March, we cannot allow it to sneak in through the back door."[85] This view surely resonated with many in the Jewish community, a significant portion of the readership, for whom a medieval building would readily reflect the ideologies and history of the Roman church. But it is apparent that this did not remain an idée fixe in the decades to follow, when the imagery of the Middle Ages—gargoyles and all— would be perceived as compatible with Jewish architectural expectations. Fleischer, interestingly, would address his B'nai B'rith brothers in 1902 on the topic of the "Art of the Middle Ages"[86] perhaps asserting the use of a "secular" medieval idiom, even as the City Hall was increasingly cast as a Christian building, particularly in light of the sanction of Lueger's move there by Pope Leo XIII.[87]

One learns through such reconstructions that Freud's investments in the building projects of the Ring, notably those of *Neugotik,* were not inconsequential. He situated himself squarely among these arches and traceries, as we see in his first address upon returning from Paris. The Arkadenhaus, built in 1882, was designed by Dionys Milch and Heinrich Hellin to echo the medieval urban antecedents of the Rathaus beside it. Its proximity to Schmidt's building was reflected in the constituency of liberal politicians and bourgeoisie who resided in this apartment building. Here, Freud saw patients and worked on his translation of Charcot's lectures after returning from Paris, announcing the opening of his office there on Easter Sunday—April 25th—of 1886; it is probable that he lived in the building as well.[88] Freud was to keep this address for only a short period of time; immediately after marrying Martha Bernays, in September of 1886, he moved into what was one of the most discussed buildings of the day in Vienna. Officially called the Kaiserliches Stiftunghaus ("Imperial (Charitable) Foundation House"), it was immediately dubbed the Sühnhaus, the "House of Atonement," a strange moniker for what was perhaps the most elegant new apartment building along the Ring.[89]

The atonement here was for what had occurred on this piece of land five years before. A terrible fire devastated a very popular theater—the Ringtheater—on the evening of December 8, 1881. During a performance of Offenbach's *The Tales of Hoffmann,* a fire erupted on stage—its origins have never been conclusively identified—that spread with ferocious speed throughout the building; forensic evidence suggests that about 450 people died that evening.[90] In a period that saw the expansion of the Habsburg capital, with the tearing down of the old city walls and the creation of the

Figure 1.8 Friedrich von Schmidt. "Sühnhaus" at Schottenring 7 (Kaiserliches Stiftungshaus) *c.* 1900. ©Wien Museum.

wide boulevard of the Ringstrasse in its place, this theater, completed nine years before its destruction, was to have been yet another exemplar of this new metropolis. Unlike the Vienna Opera House, the theater was devoted exclusively to the popular repertory, aimed at attracting large, diverse audiences. It had a capacity of 1700 people—far too many—on a fairly

small parcel of land and was built dangerously tall for its foundation, with its seating too close. In a moment of expansion of the city, with buildings like this reflecting an opening of cultural institutions to the citizenry of the Habsburg realm, this fire caused not only an unprecedented loss of life on the Ring, with casualties both from the fire itself and from people frantically jumping out from the exterior balustrades of the building, but also a shock to the immutability ascribed to both the physical structures of these new buildings and their civic and cultural values. Freud may have had a particular relationship to the fire, as suggested by his sister Anna Freud Bernays. The reliability of her recollections has been questioned, however, so the story she tells—that she, her fiancé Ely (Eli) Bernays (the brother of Martha), her brother Sigmund, and his fiancée all had tickets to the performance that evening, but opted to accept an invitation to another event[91]—may not be accurate.

The emperor, Franz Joseph, acted quickly and decided not to replace the theater on this spot—it would be relocated—but rather to use the land to create an architectural entity to serve as a living charity. The site would become a building with apartments, to be some of the finest on the Ring. Although it is commonly thought that the rental monies from them went to the large number of children orphaned by the fire, this was not the case; the families were paid from other funds, and the revenue from this building went to other local charities.[92] The cost of the building's construction was shouldered by the emperor himself, and he exercised considerable control over the rebuilding process in the service of assuring that the choices made would themselves be a source of structural contrition.[93] Legal culpability was borne by some of the contractors, who were imprisoned, and fire officials saw new fire regulations implemented.[94] For all those invested in the rapid growth of the city, this disaster was felt as a public responsibility.

Franz Joseph must have been clear about who should create this site of memorialization and habitation: Friedrich Schmidt, as there is no evidence that this project was ever open for any competition. Among his other commissions, Schmidt also built a new home for one of the city's most storied educational institutions, the Akademisches Gymnasium, a secondary school of then 600 students, whose foundations dated to 1555. Schmidt used features in its façade that gestured to Gothic elements, but the interior differed from that of the usual school buildings of the day, as he arranged two floors of classrooms around an open court. He imagined this gave the space the feel of a classical lyceum, one he felt appropriate to an institution that prided itself on having the classical canon as its foundation.[95]

Schmidt brought this precedent to his design of the House of Atonement, although the building's façade, facing the Ring, displayed a distinctive "rose"

window whose circular form and intricate tracery were very reminiscent of the French Gothic, exemplified most famously at Notre Dame. This feature formed the outside wall of a chapel of remembrance and thus could be allowed this more ecclesiastical quotation, whose presence certainly distinguished this well-appointed residential space from any other new apartment building in Vienna. Sixteen apartments were located on four floors. Those that faced the back, away from the Ring, were accessed from an entrance on the street behind the building—at Maria Theresienstrasse 8—where one entered and ascended a rear stairway. When he moved in, Freud was the only medical practitioner; he requested that, as a condition of his lease, a bronze plaque be placed by the door, announcing his specialty: *neurologie*.[96]

This edifice, like the theater before it, would ultimately be destroyed by fire, one that spread from the structure next door, a government office set ablaze by Nazi officers who wished to obliterate records held there. The building, damaged but not destroyed, was demolished five years later; today that block holds a dour headquarters of the Vienna Police Commission. While still extant, the building offered an experience of its interior that would have been striking: on entering there was a soaring, open core at the center.

This had precedent in Schmidt's Gymnasium design, but here the open courtyard extended through all the floors; in the earlier building it was only on two levels. At the Sühnhaus this choice was part of the memorial, a conscious architectural atonement for the scandalously overcrowded and ill-planned inner space of the theater.[97] If an evacuation was necessary here, it could be easily afforded through the building's two wide stairways. They created an open airy space in which to move between the courtyard entrance and the upper stories, in stark contrast to the narrow, dangerous passages that trapped many of the theater-goers. The center of the building was then left undisturbed, and open to the sky.

When the building was completed and ready for occupants, in the summer of 1886, many Viennese balked at the idea of living on the site of such death and destruction. But Freud, just back from a fellowship in Paris, about to be married and setting up a practice, eagerly signed a lease.[98] Freud's sister Anna recalled that despite the close brush with disaster in this location—according to her story of the unused theater tickets—he was "far from sharing the general superstition" about the replacement building and "did not hesitate to establish himself there with his young wife."[99] Part of this was certainly the desire to live on the Ringstrasse, an assertion of Freud's prerogative to participate in the center of Vienna's urban life after an early, transient existence in the predominantly Jewish, and poor, second district, as his family struggled with continuous economic woes. But this would also be a site of his private practice, shaped by his time in Paris, where Freud

Figure 1.9 "Im Innern des Stiftunghauses," *Illustriertes Wiener Extrablatt*, January 26, 1886, 26. 1891.

imagined he would replicate aspects of those experiences in Vienna, in what he called these "beautiful rooms created by Master Schmidt"[100] that he described to his future sister-in-law as in "the most beautiful house in Vienna."[101] The architect lived in the building as well, a neighbor of Freud, and it was in all likelihood he who told the emperor, with whom Schmidt was quite close, that the ultimate atonement had occurred, a year after the Freuds moved in. At the birth of their first child, Mathilde, Sigmund and Martha were presented with a letter and gifts from Franz Joseph.[102] In a place of such death—especially one that might have counted him and Martha among its victims—the birth of this child was to be celebrated.

While Freud will retell the story of this imperial recognition of the reparative meaning of a child born in this particular structure, he never wrote a surviving word about his involvement in bringing a tragic death there, when a patient of his, Pauline Theiler Silberstein, presumably jumped over one of the stairway's balustrades on the third floor, where his office was located (although a few reports record the site as the fourth floor), and fell through the building, in May 1891.[103] The impact of this young woman's plunge—she was nineteen at the time—through a space created to atone for tragic deaths, when it was unimaginable that such horror could or would ever occur there again, was never mentioned in any surviving text written by Freud; the closest to an utterance that we can find is the account of a meeting in 1982 between Anna Freud and Silberstein's granddaughter from his second marriage, when Anna reports that Pauline plunged to her death out a window "in Freud's apartment building."[104] On May 15, 1893, a day after the anniversary of her death, he mentions in a letter to Fliess, without referring in any way to this tragedy, that he had been suffering from an "incomprehensible" case of *Dysgraphie*—dysgraphia[105]—the inability to write anything. His disavowal can be charted in his departure, in the autumn of 1891, from the Sühnhaus to Berggasse 19, the site of his residence and working spaces for the next nearly five decades. Once there, many of the clinical instruments and practices— he was by then beginning to distance himself from certain clinical lessons he had learned in Paris—that he had brought to his previous working space would be left behind; if they constitute the dimly illuminated prologue to psychoanalysis, Pauline's plunge is its unrepresentable void. But from that chasm the inquiry—"Who is responsible?"—that John Forrester saw as imbricated in Freud's scrutiny of sexuality and physician–patient relations from the start[106] may have emerged in deafening silence.

We do not know anything about Freud's treatment of this patient—no correspondence about it survives from any of the parties involved. The only known date of the relationship is May 14, 1891, when Pauline fell to her death from the third floor of the Sühnhaus.[107] Pauline, who had probably not

been married long before her death, and Eduard, her husband, a childhood friend of Freud, were natives of Jassy, then a bustling city with a considerable Jewish population in what is now northeastern Romania. After marrying, they had settled in Braila, also in Romania, where Eduard was involved in his family businesses.[108] Although he was sent to Vienna as a boy, where he and Freud attended the same gymnasium, and then Leipzig, for schooling in law, Eduard eventually returned to Romania, to Freud's disappointment, to work with his father. The two men had been passionate correspondents in their late teens, when they wrote letters in Spanish—they were both self-taught in that language—and formed a secret society of two, the "Academia Española."[109] Rubén Gallo, in his incisive work on Freud's relationship to the Spanish language and culture and its trajectories such as this correspondence, suggests that these letters evidence the powerful erotic attraction that wove through their youthful relationship, although only Freud's letters survive—it appears that Freud destroyed his friend's correspondence—so it is somewhat skewed.[110] But this medium of libidinal exchange may have presaged Freud's years-long exchange of letters with Wilhelm Fliess, themselves carrying considerable sexual innuendo, as Daniel Boyarin has very convincingly argued.[111]

Both adolescents appeared to have had female love interests, but Freud frequently reveals what seems to be jealousy and resentment of the young women attracted to, and of interest to, Eduard. By the time Freud was engaged to Martha, he would portray his connection to Silberstein as being in the past. Eduard's marriage to Pauline was apparently described in the Silberstein family as marked by great passion and love, but soon afterward she "became mentally ill"[112] to such a degree that Silberstein sent her to Vienna to be attended to by his schoolboy friend. The extent of the treatment—Freud mentions once, years later, that he treated her, but says nothing of her death—is not known, but the overwhelming evidence at the time of her fall was that it was a suicide, and she is buried in a very simple grave, in the Jewish portion of the Zentralfriedhof. When her headstone was put in place, in all likelihood a year after her death (in accordance with Jewish custom), it would appear, poignantly, that she had already been forgotten. There is no birthdate inscribed and her death was etched vaguely as "May 1891." The only other inscription, "twenty years old," is also incorrect, as she died several months before what would have been that birthday.

Pauline's death, although silent among Freud's archives, has not gone completely unexamined in the psychoanalytic literature. James Hamilton, a clinician, devoted an article to it in 2002,[113] where one can find the few references—cited in Gallo's subsequent work as well—to Pauline from Freud's lifetime or that of his daughter, Anna, who, as mentioned earlier, at the end of

her life apparently summoned Silberstein's granddaughter (from his second marriage, as he and Pauline had no children) to confirm that Freud had attempted to treat Eduard Silberstein's first wife. Hamilton attributes to this loss, which occurred when Freud was at a "vulnerable" place in his nascent understanding of the unconscious, Freud's turn away from his mission of healing to one of hermeneutics,[114] although there is little evidence that can directly link that bifurcation—if it ever truly existed for Freud—to Pauline's death. At the paper's conclusion, Hamilton mentions Freud's work on the death drive, and also suggests the influence of this suicide on that work, but no support is given for this claim. Although Freud would himself die of physician-assisted suicide, when his cancer became intolerable in the autumn of 1939, he wrote almost nothing about suicide psychoanalytically. In a two-page essay of 1910, "Contributions to a Discussion on Suicide," he states that "the reason that we have failed to answer" the psychical questions concerning the taking of one's life is because "we have no adequate means of approaching it."[115] Thus, arguably the most conclusive analytic impact of Pauline's death was Freud's apparent silence about it, at least within any surviving documentation.

There is a gap in the published Freud–Fliess correspondence in the days following Pauline's death, which may represent Freud's withdrawal from communication or a retrospective expunging, by him or someone else. Freud's letters to Silberstein have been published, but whatever writing was exchanged between the two friends at the time appears to have been lost, assuming it ever existed. As noted earlier, Freud would claim he had experienced dysgraphia on the second anniversary of her suicide, and again, six years later and very near the anniversary, in the aftermath of authoring a text and image that he would entitle the "Architecture of Hysteria."

Our only extant sources of information on what occurred at the Sühnhaus on May 14, 1891, are found in the various reports published in Viennese newspapers. There were at least five stories, several quite brief notices, with the most detailed to be found in the widely read *Neues Wiener Tagblatt*, appearing the next day:

> Suicide. Yesterday at about 4:30 in the afternoon, a young woman made her way to one of the rear wings of the institutions in Maria Theresa St. where doctors reside to go in for a course of treatment. The patient left the girl accompanying her to wait, climbed up three flights and threw herself down over the balustrade. Having shattered her skull, the unlucky girl was immediately dead. The ensuing police inquiry has revealed that the deceased was a foreigner who was seeking treatment due to a severe nervous disorder. The deed was most likely conceived in a moment of mental derangement.[116]

The police inquiry would have undoubtedly led to Freud's door, and whether Pauline actually saw him that day or not, it is likely that he soon would have been present at the scene. In only one published account is he mentioned, but his name, interestingly, was recorded incorrectly—he appears in the account published in *Die Presse* as "Dr. Frey," the neurologist who was treating her and with whom she had an appointment that day.[117] Many details are now unknown, as there no longer exists a police report on the case. The most extant, reliable record is that of the ambulance service that took her body to the city's Schottenring morgue, where she is cited as a patient from a hospital in Hacking, a section of the thirteenth district, whose chief psychiatrist, Alexander Holländer, was Freud's colleague.[118] Holländer is also mentioned in the *Die Presse* notice, with Pauline reported to be from his *Heilanstalt* (sanatorium). The duration of her stay prior to her death is difficult now to ascertain. Neither her name nor that of the young woman, identified in newspaper reports only as her "maid," who presumably accompanied her from Romania, can be found on steamship logs of routes that would have connected her home city with Vienna during that period, so it is most likely that they traveled by rail, although there is no documentation.

Because of the open courtyard and the stairways at its corners, her fall would have been into the building rather than, as Anna Freud recounted to Eduard Silberstein's granddaughter, from a window.[119] The record of the impact upon the Freud family, their neighbors, and other physicians, as well as Pauline's family, appears to be nonexistent. But if we look at the letters that Freud and Pauline's husband Eduard exchanged in their youth there is an eerie foreshadowing, one that Gallo has rightly noted as significant, and one that is hard to imagine Freud not recalling at some point after Pauline's death. In August of 1874, as he and Eduard finished their first year of university, Freud suggested that the two friends—now living in different cities—adhere to "an old superstition [which] has it that no building is sound whose foundations have not cost a human sacrifice. We should sacrifice two victims—two princesses—to the renewal of our consolidation."[120] Freud would have in all likelihood been referring to young women they wrote about to each other, but as Gallo notes, "what had begun in jest would ultimately end in tragedy."[121] This tragedy could not have been separated from the deaths and mortal falls that were so much part of the narrative of the building's history: the fire less than a decade before, and the transformation of the ruins into this building would have remained vivid for many. Each year, on the anniversary of the disaster, a large mass for the families of those killed was celebrated in the memorial chapel that Schmidt had created, with its striking rose window.

In his detailed *Autobiographical Study*, published in 1925 when Freud was nearly sixty, he specifically cites the five years that he spent in the Sühnhaus: "During the period of 1886 to 1891 I did little scientific work, and published scarcely anything. I was occupied with establishing myself in a new profession."[122] This would suggest that the period that opens in his new residence in 1891 was a continuation of what had preceded it, a seamless narrative offering no specific details, nor indicating that any of note actually existed. How Freud made meaning of this tragedy—its implication of professional failure, as well as the personal dimensions of losing someone entrusted to his care—was, if ever committed to paper, not preserved. Equally unknowable is the way in which this loss of a life, occurring literally at Freud's doorstep, may have shattered, along with Pauline's body, what that building had claimed to mean: a place where death was to be expiated and where the birth of his first child had been made into an imperial occasion. But the Sühnhaus, as the unwitting agent for an interior suicide facilitated by the building's distinctive architectural design, could not have remained what it had first been for Freud. There was something of a double betrayal: the building's promise of the restoration of life was tragically subverted, and Freud may have imagined that in the eyes of his neighbors and fellow physicians his "neurologie" had brought about a shocking replay of the deadly plunges associated with the fire.

Freud and his growing family (he and Martha had three children by early 1891) moved out in September, a few months after the incident. Existing records indicate that he gave his notice several days before Pauline's death. We cannot know if this fact was known to her or if his decision in any way contributed to the events of May 14. On the day immediately following her death a document was issued that released Freud from his lease; again, it is not possible to know if this was in response to the death or not.[123] We do know that Freud went on to establish himself in a very different kind of building, at 19 Berggasse in the ninth district, that was as understated as the "House of Atonement" had been architecturally striking.

Freud worked in three different places at the Berggasse address during the course of his nearly fifty years there, from 1891 to 1938.[124] In November 1896—the year after the birth of Anna, the Freuds' sixth and youngest child, and weeks after the death of Freud's father—he would move into rooms on the ground level, remaining there for twelve years.[125] Soon after that, he reports to Fliess that he is "adorning" this new space with plaster casts of Florentine statues,[126] a gesture, as we will see in the next chapter, that continues as he begins to amass a vast collection (over two

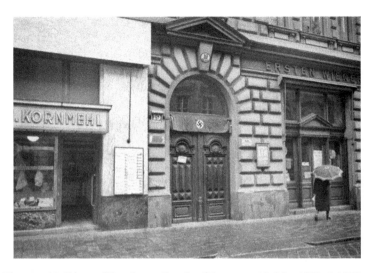

Figure 1.10 Edmund Engelman. Facade of Berggasse 19, May 1938. © 1976 Thomas Engelman.

thousand items) of objects of a far earlier date, from Egypt, the classical Mediterranean, western Asia, and other cultures. At the time of his move into his first office at Berggasse 19, the techniques Freud had practiced in the House of Atonement—electrotherapy, hydropathy, and most significantly, hypnosis—were being abandoned.[127] This is also when a patient, identified recently by Christfried Tögel as Josephine Benvenisti,[128] presented him with a "*diwan*," a couch that would become the focus of his therapeutic encounters.[129] The gift was offered in gratitude and, as records suggest, to instill confidence in Freud's patients.[130] The motivation may have been to provide some elegant form of domestic comfort, but perhaps Benvenisti intended to restore, rather than build, trust by suggesting a different kind of space and treatment modality to mitigate any damage to Freud's reputation from Pauline's death. But the couch, which became the ultimate embodiment of Freud's "psychoanalysis," actually preceded the word itself by five years. The term only appeared earlier in the year that Freud moved into his downstairs office space, where it was first mentioned in an article in March of 1896.[131] But in his initial period at Berggasse 19, what the couch meant to Freud may have been imbricated with the events and circumstances immediately preceding his arrival. When we turn to his working spaces in Berggasse 19 in the next chapter, we will see that Freud's spatial identification was with a "room" as a contained totality,[132] rather than an architectural element—these spaces were not to be extolled

like the "beautiful rooms" of Master Schmidt, where the interior gestured to the larger structure containing them. Perhaps the legacy of Schmidt did in fact continue; less than a year after the family's move, the Freuds' third son, Ernst, was born. He would become a distinguished architect and recall conversations, from early childhood, with his father about buildings.

In contrast to Pauline's death at the Sühnhaus, that of its architect, in late January of that year, had a far less tragic cast. Friedrich Schmidt had died in his apartment at sixty-eight after declining health. A photograph of Schmidt, in his coffin, was taken at the time of the funeral in the memorial chapel of his building[133]; it is not known whether his was the first funeral performed in that neo-Gothic space. He left precise instructions that his grave—also in Vienna's central cemetery, where Pauline Silberstein would be buried in the spring—be very simple. Representatives of the city government, however, in the months after his death, dedicated a larger memorial site there, casting a burial plaque bearing the words he had requested for his headstone: "Here rests with God a German stonemason."[134] Above this epitaph was added another phrase, one that had become virtually synonymous with Schmidt, as it was the name he gave to the Rathaus and then adopted as his personal motto: *Saxa Loquuntur.*

Five years after Schmidt's death, in a paper titled "The Aetiology of Hysteria," Freud included a scenario of archaeological "discovery" that was intended to parallel his analytic process of unearthing the hidden evidence of trauma that in 1896 he believed was the result of sexual abuse in childhood.[135] It is revealing that in this connection he also unexpectedly brought Schmidt and his architecture into view. Freud detailed a buried city, uncovered by a visiting "scientist" who comes upon it as an "expanse of ruins," reminiscent of colonialist representations of such scenes, and encounters the "semi-barbaric" contemporary occupants; he characterizes them as unable to recall the meaning of the stones that surround them. His story becomes less predictable, however, when seen through another, far more local, lens. Freud concludes his narrative with a double entendre by exclaiming "*Saxa loquuntur!*"—a Latinized term used in Freud's time to designate the study of ancient inscriptions.[136] But of course it also held a specific meaning in Vienna, connected to the Rathaus and Schmidt, one that unexpectedly shifted this scene from an expanse of generic "ruins" to that of the residues of the City Hall, and the buildings—perhaps his Sühnhaus as well—that were around it. Freud delivered his paper in the days immediately after a meeting between the emperor and Karl Lueger, one that saw the ruler acquiesce to mounting

pressure for recognition of the latter's mayoral election victories. The year before, Freud had written to Fliess that he had celebrated the emperor's refusal to accept Lueger's appointment with an extra portion of cigars.[137] When ultimately that did occur and Lueger and his cohort took control of the Rathaus, the original civic expectations for the building, as noted earlier, did indeed lay in ruins.

Freud chose to include that building in a paper introducing a new and controversial idea, one that identified sexual assault by a trusted adult in childhood as the origin of hysteria. First presented to a medical gathering in Vienna in late April of 1896, Freud's "The Aetiology of Hysteria" was then published in serialized form in a weekly Viennese medical bulletin in late May and June.[138] Freud opens his text with a scenario of a landscape of ruins, whose inhabitants—"*halbbarbarischen*," whose construction we will return to in a later chapter—cannot remember the history of these remains. At this juncture, the protagonist—in a very early glimpse into the working of the psychoanalyst—begins to work alongside these "semi-barbaric" people to unearth a vast architectural assemblage beneath them:

Imagine that an explorer [*Forscher*] arrives in a little-known region where his interest is aroused by an expanse of ruins, with the remains of walls, fragments of columns, and tablets with half-effaced and unreadable inscriptions. He may content himself with inspecting what lies exposed to view, with questioning the inhabitants—perhaps semi-barbaric [*halbbarbarischen*] people—who live in the vicinity, about what tradition tells them of the history and meaning of these archaeological remains, and with noting down what they tell him—and he may then proceed on his journey. But he may act differently. He may have brought picks, shovels, and spades with him, and he may set the inhabitants to work with these implements. Together with them he may start upon the ruins, clear away the rubbish, and, beginning from the visible remains, uncover what is buried. If his work is crowned with success, the discoveries are self-explanatory: the ruined walls are part of the ramparts of a palace or treasure-house; the fragments of columns can be filled out into a temple; the numerous inscriptions, which, by good luck, may be bilingual, reveal an alphabet and a language, and, when they have been deciphered and translated, yield undreamed-of information about the events of the remote past, to commemorate which the monuments were built. *Saxa loquuntur!*[139]

In both this passage and his drawing, in the following May, of the "architecture of hysteria," Freud imagines that symptoms—the ruins on the

surface or, a year later, the small pyramidal cupola—occur above structures considerably vaster, but less accessible. In the "Aetiology" narrative, the scientist (*Forscher*) digs down to find the hidden edifices; in the later sketch, done the next year, Freud drew broken lines in red that descended from the small triangular pinnacle along the face of the larger "building" beneath it. Freud introduces his conviction about sexual assault as hysteria's cause in its most elaborated form to date in this paper, and he maintains this causality into the following year, as he speaks of attempting to access the originary traumatic scene. We will see, however, that this conviction is short-lived; by the autumn of 1897, it is in substance abandoned (although Bennett Simon and Rachel Bass remind us that Freud still considered it a factor),[140] as Freud turns from sexual trauma in childhood to sexual fantasy in children. By endowing the unconscious with a dynamic function, as in the "architecture of hysteria," Freud is already beginning to move away from a belief in a recoverable past. That architecture figures, in quite different guises, in both years certainly suggests that a shift in Freud's understanding of hysteria may also be informed by a change in his understanding of the meaning of architecture.

At the time of the "Aetiology" lecture, presented in late April of 1896, the Rathaus, and the values of the architect who built it, must have been, from Freud's perspective, forsaken. This "double" meaning—one that could bring the audience suddenly to the realization of Vienna itself as the ruin—created an emotional response that may not be adequately understood simply by characterizing it as a "political" gesture. It might be said that in Freud's passage, the archaeological intentions were subverted by an architectural flashback: the association to a contemporary building, albeit with a classical name, that suddenly shifted, for a moment, the site of trauma. "*Saxa loquuntur*" may have been a rather spontaneous remark that evening, whose date, still in dispute, due in part to the fact that there was no published summary of Freud's lecture or the comments, may have coincided with what was widely seen as the emperor ceding the City Hall to Lueger and his Christian Social party, when he accepted Josef Stol as mayor, with Lueger, who would succeed him.[141] When Freud then quickly prepared the paper for publication, he obviously included the phrase, presumably knowing that its readership, in the Vienna medical community, would also recognize the allusion being made. The archaeological analogy was meant to valorize his analytic procedures, which at this juncture were little known. He did this by association with a field that, at this moment particularly, enjoyed a considerable degree of recognition in Vienna. It is useful, then, to reconstruct the major sources of the talk briefly, as they provide the context within which Freud's gesture to the Rathaus occurred.

The lecture given that evening drew on certain of Freud's earlier writings, some already published in journals that would have been accessible to members of the audience. Two articles, which were completed in February 1896, were particularly formative.[142] In "Heredity," in print since March, Freud had specifically noted that although hereditary determinism had "subordinated" sexual factors in neurotic symptomatology, his work would not do so: "What gives its distinctive character to my line of approach is that I elevate these sexual influences to the rank of specific causes."[143] About the cause of hysteria, Freud is then unequivocal: "sexual abuse committed by another person," occurring "in earliest youth—before the ages of eight to ten."[144] An elaboration of this thesis, with case studies, constituted his "Further Remarks." However, the audience did not respond favorably, according to a letter Freud wrote to Wilhelm Fliess in the following days; he reports that the lecture "was given an icy reception by the asses."[145] Yet it is doubtful that the content caught his listeners unawares. It is likely that many of those who chose to attend were already acquainted with Freud's position. The rather baroque outcries of incredulity that Freud claims were voiced after the lecture would seem (if they were as reported) quite disingenuous in retrospect. Freud was eager to have the work get into print, despite feeling increasingly shunned by his colleagues ("a void is forming around me")[146] and, as he would write to Fliess in the days to follow, perhaps prompted by both the lecture and the events in the city, he was in a state of moral depletion.

Freud's decision to include an archaeological scenario at the start of his paper has occasioned much attention, readings of the passage deriving from various vantage points. Sabina Hake's paper, titled "*Saxa loquuntur*: Freud's archaeology of the text,"[147] brought considerable insight about the gendered overlay in the opening passage, with archaeological imagery that appropriated the female body and psychoanalysis's discursive mastery over it. Although she includes the final phrase in her article's title, she does not discuss its meaning beyond that of its Latin derivation. Ranjana Khanna's impressive text on psychoanalysis and colonialism,[148] while not addressing this scene specifically, suggests an "archaeological feminine" that imagines the female as carrying the residue of "an evolutionary anterior phase," one that can, within Khanna's formulation, be joined with the "earthing" (rather than worlding) of the Heideggerian colonial subject.

The practices of archaeology have resonances with a violence done to the subject that are shared between the victims of adventurism and the often-female sufferers of "hysteria." Richard Armstrong, in his multivalent reading of the passage, describes it as "rife with self-assertion and romantic imagery."[149] Indeed, Freud's identification with Schliemann and his exploits at Troy must have informed his portrayal of the excavator, as Armstrong goes

on to detail. Also, as Armstrong well observes, Freud had a connection to archaeology much closer at hand, in his friend from adolescence, Emanuel Löwy, whose presence in Freud's life will be explored in the next chapter.

Just prior to presenting this scene of arrival at a place of ruins, as Freud begins his paper on hysteria's cause, he has told his audience that he wishes to introduce an "advance" that has already been made in the science of historical retrieval and reconstruction. Thus, it is not surprising that the notion is also present in the actual advance into the scene, and in the hierarchy of positions accorded to those among the ruins and those who have come to "explore" them. Here the term Freud uses is "*Forscher*"—Armstrong suggests that this person is very much based on Löwy and his youthful excavations as a student in Turkey[150]—suggesting a scientific explorer rather than an adventurer although Freud will not shy away from ultimately claiming that moniker as well. The scene detailed is offered as "an analogy from another field,"[151] rather than a parallel to a particular site, thus allowing Freud to take considerable license in its construction. We can identify a set of intentions that may have informed how these pieces were assembled. This imagined site needed to be presented as a credible excavation in order to provide a legitimization of the process of psychical unearthing, and its description would need to resonate with certain workings of the psychical mechanisms of trauma that Freud would detail.

If the ostensible purpose of this archaeological passage was to set up a respectable discipline with which to compare Freud's then nascent analytic practices, he must have assumed that his listeners were both familiar with excavations and held the belief that such an encounter as he described was credible. Here, Freud relied on knowledge of two sites, both of which he must have imagined were known to his constituency and his readers. He probably assumed that all of his gymnasium-trained colleagues would have been well versed in the legends of Troy, and, given much attention in the popular press and various publications, with the processes of its "discovery" by Heinrich Schliemann. In the popular imagination, the site was striking verification for the actual existence of Troy, where acts of excavation, in their systematic retrieval of material evidence, were capable of verifying early objects and places either long forgotten or thought not to have actually existed. In arguing for the veracity of events of sexual violation, long buried in the past, Freud decided that the transformation of the pastoral landscape of the coastal Turkish area around the plateau of Hisarlik into what lies beneath it as Troja would provide the convincing stuff of analytic analogy.[152]

Perhaps equally persuasive, as I have argued elsewhere, was the allusion here to a more recent archaeological endeavor, and one, from the perspective of those directing the digging, considerably closer to home. In the years from

1894 to 1896, the Austrian Archaeological Institute, under the directorship of the German-born Otto Benndorf—Löwy's teacher—succeeded in crafting what would become perhaps Benndorf's most memorable contribution: a credible Viennese response to Schliemann's Troy. With emissaries from the Habsburg and the Ottoman domains present and with funds proffered by members of the Austrian aristocracy, Benndorf was given the rights to excavate due south of Troy, at the ancient site of Ephesus, in June of 1894.[153] Even though the British had been a presence there since the 1870s, the Austrians were granted a far more formal licensure, one that would link Vienna to this Turkish city for the next century. Ephesus, first settled by the Ionians as early as the tenth century BCE, seemed to possess a particular capacity for the remarkable. The city had the distinction of housing the late classical period Temple of Artemis (known as the Artemision), a structure so magnificent that it was accorded ancient recognition as one of the Seven Wonders of the World. In the late second century BCE, a Roman visitor noted that this exceptional city was actually famed for three things: "the size of the temple, surpassing all buildings among men, the eminence of the city of the Ephesians, and the renown of the goddess who dwells there."[154] Its fame as a great cult center, with impressive wooden statuary of Artemis (she had originally been associated with the tree from which it was made) and massive temples and civic buildings, contributed to its allure as a challenging and exotically charged archaeological treasure. However, the *Kultstatue* was destroyed by the Goths in the third century CE, and thus the decisive focus of much of the architectural program of Ephesus would never be recovered, accessed only through all that had been built to surround it.

The second season of excavation, involving some of the most significant ruins of the Artemision, virtually coincided with Freud's lecture of April 1896; much important archaeological work had taken place in March, only weeks before his presentation. It therefore seems highly plausible that to refer to archaeology at this time would, for both Freud and his audience, relate to a heightened awareness among educated Viennese of their particular contributions to this emerging science. Since the concept of an archaeological "advance"—as produced through photography, stratigraphic mapping, and surveying devices[155]—may have appealed to nationalist sentiment, associating psychoanalysis with that advance may have been a decisive motivation for Freud.

Recognizing the salience of archaeological events occurring in tandem with his paper's presentation would seem only to serve Freud's desired elision of one valued and timely empirical discourse of unearthing with his own. A disruption in this narrative stream is detectable only in his choice of the phrase that concludes his scenario of excavation, and that, too, could remain

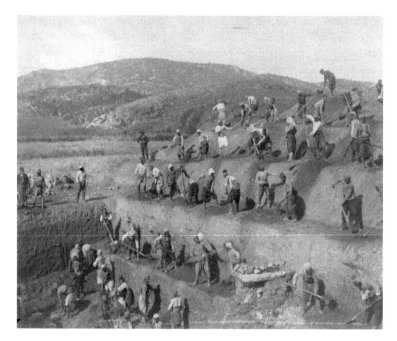

Figure 1.11 Photographer unknown. Workers unearthing the Artemision at Ephesus, photograph, 1895. Permission of the Austrian Archaeological Institute, Vienna. ÖAW-OeAI, A-W-OAI-N IV 0038.

utterly unrecognized by subsequent readers. Indeed, the exclamation of "*Saxa loquuntur!*" would appear to be a very apt conclusion, following his lauding of the deciphering of inscriptions, because it had currency at that time as a synonym for studies in classical epigraphy, which played a role in discovering the events commemorated by the architectural program of this buried city. At the start of the archaeological passage, Freud appears to offer his listeners a comfortable site of identification—ostensibly to prepare them for the introduction of the more controversial revelation of sexual trauma. But, in imagining that the Latin phrase had a particular, localized meaning, the colonialist landscape in which Freud placed his audience is suddenly subverted, the scene's organizing perspective, the trope of a terrain of alterity, one that would have been familiar from visual representations of the period, suddenly upended. This occurs as a flash of recognition that can be read as revealing the ruins to be Vienna itself, and best understood as actually enacting a moment for Freud of traumatic repetition, one that strikingly,

as a scene of betrayed trust, also presages what he is about to present. This topography of fragmentary remains was just beyond the window that April evening (*saxa loquuntur*—the Rathaus—was not far from view), populated by "semi-barbaric" people—meant perhaps as a reference to the considerable numbers supporting Lueger—who had forgotten what the city once was, what it had been built to do. The discovery of the archive in Freud's scenario— seemingly the truth proof—offers the triumphant decoding of why the buildings were created. However, the surplus meaning of the Rathaus, as Vassiliki Kolocotroni observes in an essay on ruins and modernity, where she sees the opening of Freud's "Aetiology" as speaking to another function that acknowledges the doubling of meaning for *saxa loquuntur*, serves as "the persistence of memory in the vanguard of personal and political struggles."[156] How might this affect of struggle be understood? As a "counterpolitical ingredient," as Kolocotroni characterizes it (adopting Carl Schorske's term),[157] it offers a striking coda to Freud's descriptive passage. An examination of the experience of this recognition deserves fuller consideration, as it functions in the realms of both polis and psyche.

Freud's comment went beyond his archaeological analogy, and characterizing it as in part a political gesture, as I also have done,[158] must be read as not foreclosing the possibility of the comment's very embodied effects: the experiences of vulnerability and betrayal. In fact, these topics were very much part of a paper that focused on the ramifications of sexual assault of a child by a trusted adult. The trauma as framed by Freud focused on the psychical ramifications of premature sexual experiences; yet, the manner in which the attendant feelings of loss, anger, and duplicity contributed to the psychical toll of the abuse was never elaborated, although certainly implied. Freud made clear in his paper that a majority of his patients suffered, often repeatedly, at the hands of trusted family members and were only rarely the victims of unknown assailants. Although Freud specifies this environment of dependency and attachment, he presents a triumphant scene of the deciphering of evidence on the part of the audacious excavator.

Perhaps Freud was attempting to hold both of these meanings—triumph and trauma—together that evening in his double entendre. But in doing so, he offers us an additional insight into a slippage that occurred at that point, revealing his feelings about the capacity of buildings to fail us. On one level, it is quite easy to identify a wish that the speaking stones will provide plenitude and analytic fulfillment; this is evident in the successful finale of the archaeological episteme in Freud's excavation narrative. But the meaning of "*saxa loquuntur*" exceeded, in Vienna, that of a more generalized usage: not only was it specific to a prominent building and its architect, but it also identified a past promise of fullness recently revealed as illusory.

What happens when that investment in one's subjectivity, as experienced among and perhaps through buildings, is taken away, when the "ruin" that results is an entirely internal one, while the structures themselves remain unchanged? Might we posit that the buildings of Vienna became implicated for Freud in calamity—the suicide of an early patient within his Ringstrasse office and, in the decade to follow, the increasing discrimination and exclusion from Ringstrasse privilege that turned youthful expectation into a feeling that Vienna was a place where nothing could come to fruition? It is change in perception that makes the complexities of architectural reception especially intriguing in Freud's case. We have instances, especially effectively rendered in film, of buildings suddenly becoming actively involved in the narrative. Slavoj Žižek writes of this in Hitchcock's cinematic oeuvre, citing the house in *Psycho*, a well-known example of an architecturally anthropomorphic effect, as though the house is already gazing outward, waiting, as the visitor approaches. [159] But in the case of the buildings that Freud, in the final years of the 1890s, had known in an early chapter of Vienna's history, the affective response is quite different. The architecture is not, as characterized by Žižek, "some mysterious, 'uncanny' object"[160] in the Hitchcockian sense; rather the unsettling revelation is how a building can remain utterly unchanged externally, and yet evoke very different responses—as though one is encountering something both very familiar and utterly altered. This is more akin to a betrayal: an individual structure once known and trusted appears unchanged, yet the familiar is revealed as dangerous. Spyros Papapetros's reading of F.W. Murnau's staging of the death scene in *Nosferatu* provides an even clearer example: when the title character stands beside a window, expecting a nearby building to fully shield the vampire from sunlight, it fails to do so: "the architecture that is supposed to protect him contributes instead to his ruin."[161]

A recent collection of papers on betrayal edited by Salman Akhtar opens by noting how absent that concept is from the psychoanalytic literature, although it is an experience that often appears in clinical work.[162] This lacuna begins with Freud himself, who, as Akhtar notes, almost never used the term "betrayal": there are only four instances in all his published work where the term is applied to a perception of being wronged by another.[163] This is striking when one considers Akhtar's definition: "betrayal is both a specific trauma and a constituent of all psychic trauma."[164] But it is also very notable when one considers how often Freud felt wronged by those around him, most notably colleagues and protégées. In these instances, and those in Akhtar's collection, the betrayals are visited upon one person by another. But how does one imagine such a betrayal in stone? The building lies in ruins—but solely in the perception of treachery experienced by its viewer. Can traumatic

losses and political regimes *ruin* architecture—that is, turn it into a heap of refuse, without touching a stone? Yes, if, as I will suggest, prior to Freud's turn to the archaeological ruin as authorizing image for his psychoanalytic project, there was another image, other spaces of loss and perfidy that are no longer visible, but still were essential for the setting of the analytic encounter, filled with its over two thousand "antiquities" and its pictures of ruins: the space outside the window—and the borders of analytic meaning—that became, in the course of the 1890s, "insufferable" for Freud, where the promise of possibilities had been withdrawn, leading him to feel that nothing he tried to create within this current urban landscape could succeed.

Jacques Lacan offers a helpful provocation for thinking about these issues, although, like Freud, he wrote little about buildings directly. Lacan imagined architecture and painting—specifically perspectival representation, with its organization of the gaze—as meeting at a fascinating nodal point: both "can be defined as something organized around emptiness,"[165] a characterization that has a chilling resonance with the architectural configuration, and resulting lethal potential, of the Sühnhaus. Lacan saw both media as projecting a sense of fullness that is revealed as a deceit enacted upon the flatness of the painted surface, or in the empty space marked by the built environment: the appearance of a created structure when in actuality "this enclosure encloses nothing."[166] In the seminar where he discusses the connection between painting and architecture, he elaborates upon their shared indebtedness to illusion by identifying their commonality as an "anamorphosis," defined as an "optical transposition" that makes something that "wasn't visible at first sight" ... into a "readable image."[167] In architecture this occurs in the illusion of an organized space, as in the work of Renaissance architects, where a perspective similar to that of painting mandates the ordering of an emptiness that can never be filled. Lacan cites an anamorphic image placed within a conventional perspective field in a painting, which results in a doubling of the distortion and two different points of view: one orchestrated to meet the visual expectations of pictorial representation, and one that intrudes upon them. He cites the well-known example of the sixteenth-century German painter Hans Holbein's double portrait dubbed "The Ambassadors."[168]

Its composition appears at first glance to be highly symmetrical and orderly, with a pair of male figures—the diplomat Jean de Dinteville, at left, beside the bishop Georges de Selve—surrounded by an array of objects; here all the imagery relates to the work's overarching theme: admonitions against vanity. The imagistic field is comparable to Freud's archaeological passage, with its sequential narrative evoking a pictorial precedent featuring all the requisite representations of ruin and capacity for recovery, gesturing to

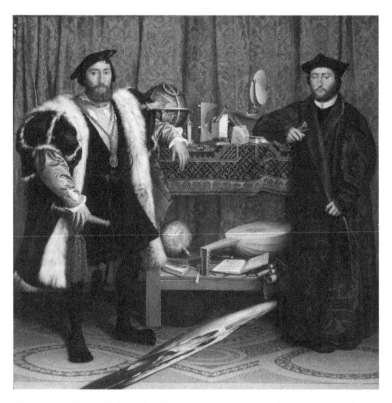

Figure 1.12 Hans Holbein the Younger. *Jean de Dinteville and Georges de Selve* ("The Ambassadors"), 1533. Oil on oak. ©National Gallery, London/Art Resource, NY.

the analytic process. In the Holbein, as Tom Conley observes, the objects of mapping and navigation that surround the figures produce fantasies of meaning and memory "for" the non-European world,[169] just as Freud's archaeological scenario offers another form of recuperative "remembering" for those who are deemed unreliable in charting their own past. In the Holbein painting there is an anamorphic inclusion, at first so unexpected as to be a blind spot, that is a mysterious elongated form in the lower third of the scene. If one adjusts one's position to view it—the only way its form can be deciphered—it produces a chilling effect: it is a skull, quite literally piercing the pictorial space with the specter of death. Lacan reads the form not only as the materiality of the skull itself but also as darkened passages

within it, emphasizing emptiness and the absence of flesh.[170] Thus, we can say that the distance established by the allegorical construction is pierced by an image hauntingly familiar to viewers, engulfing them in the imagery and suggesting just how close to the illusionistic surface this other presence, capable of revealing its deceit, resides.

Freud's allusion to the Rathaus may be thought of here as operating anamorphically, as it tilted the perspectival unity within the frame of Freud's text. The architectural image, like Holbein's pictorial disjuncture, reveals the emptiness by showing what surrounds it: it could be said that this void is what circulated, in the spring of 1896, through Schmidt's building. But there is also in Lacan's text a reference to the experience of architecture that is perhaps even more apt. As a kind of gloss offered to accompany his seminar on ethics in psychoanalysis, he speaks about the myth of Daphne, the wood nymph who was transformed into a tree in order to escape the unwelcomed advances of Apollo, and then endured that confinement, a condition that Lacan calls "petrified pain."[171] From this, Lacan asks if the "realm of stone" has this capability: in building and fixing something, "isn't there in architecture itself a kind of actualization of pain?"[172] As Papapetros elaborates, as part of his fascinating work on the animation created at the intersection of architecture and psychoanalysis, Daphne's branches evoke equivalency to the neural "pathways" (*Bahnungen*), serving as a very early notion of a "protective shield" against excessive stimulus.[173] Freud, in 1895, had drawn such mechanisms as they branch in ways reminiscent of Daphne's limbs.[174] What this may say about architecture and affect is striking: "Lacan's Daphne challenges Enlightenment presuppositions regarding the functionalist origins of architecture."[175] It is not to protect, but to "preserve and elaborate pain, to make the subject vulnerable to it." While this may describe Freud's own experiences of architecture, the internal edifice he will create intrapsychically will succeed as a protective enclosure where stony presences failed.

Just over a year later, as the Rathaus was newly occupied by Lueger and its medieval guise reinterpreted as a validation of the Christian claim to the space, Freud constructed his new psychical edifice. As the content of unconscious functioning became more generative and less causal as the months passed in 1897—less about the reconstruction of a traumatic historical event and more the creation of defenses against it—vulnerability to vagaries of external forces was, at least in Freud's imagining, potentially mitigated. The specific concept of "protection"—and what Freud would term "protective

structures" (*Schutzbauten*) and "protective fictions" (*Schutzdichtungen*)—
would enter into the working of the unconscious.[176] The implications of the
Lueger election for the originary chapter of psychoanalysis have already been
cast in spatial terms in earlier scholarship, which posits Freud's work in this
period as turning ever more inward, increasingly focused upon psychical
mechanisms that operated in response to intrinsic desires and wishes, rather
than privileging the traumatic impact of external events, notably that of sexual
violation in childhood. But as Freud's once-promising urban terrain turns
into dangerous ground, can we better reckon this loss—a particular kind of
betrayal imbricated in his understanding of Vienna's architecture—as present
in his constructions of the psyche, indeed as potentially constitutive of it?

Evidence of this is found in several letters to Fliess where Freud outlined
what he imagined as the prolegomena to a comprehensive "great" work—and
it is this work that he named in drafts of letters of May 1897 the "architecture
of hysteria" (*Architecktur der Hysterie*). In the second draft ("M"), appended
to a letter of May 25, a month after Lueger's inauguration as mayor, Freud's
thoughts were accompanied by the simple sketch noted at the beginning of
this chapter. The cursory nature of the drawing belies the importance of the
thoughts it was to elucidate.

It was within this correspondence—three letters, each with an
accompanying longer, appended "draft," written over the month of May in
1897[177]—that Freud first speculated on the functioning of what he termed
"hysterical fantasies" as a dynamic psychical mechanism. He pictured them
as a structure that shielded the memories of early sexual abuse, whose
pernicious legacy he identified in the previous year as the source of the
pathological symptoms associated with "hysteria." Fantasy, whose primacy as
a constituent of the Freudian unconscious is first visualized here, is endowed
with the capacity to protect from access to traumatic experiences. But in
revealing its workings as the "architecture of hysteria" there is also a clear
alignment between structure and symptom that may reflect as much on the
first word in this phrase as the last. I argue that Freud's experiences with
buildings informed his understanding of protection, betrayal, and ultimately,
fantasy. These attributes may have been as *architectural* for him as the façades
and weirs that he evoked within his drafts to Fliess.

As we turn to those letters written to Fliess, the question also arises of what
or who is being protected by this structure. Originating with the pathologies
of "hysteria," Freud in these months will turn increasingly to enunciations of
"normative" functioning. Psychoanalysis thus emerges within the structures
whose limits he has constructed, and, in doing so, is shielded from content that
could not be contained within his project. Yet, by this very exclusion, Freud
defined the edges of the unconscious. In May 1897, as Freud thus claimed

Figure 1.13 Sigmund Freud. "*Architektur der Hysterie*" (Architecture of Hysteria), appended to letter to Wilhelm Fliess, May 25, 1897. Sigmund Freud Papers, Library of Congress.

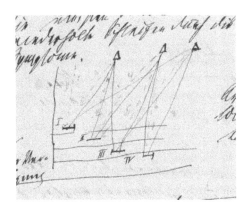

Figure 1.14 Detail: Freud's sketch.

to understand how hysteria is structured, he was moving away from an architecture of trauma that existed on a historicized terrain, as in "Aetiology." Instead, he is beginning to visualize the psyche's capacity to structure itself, with its prediscursive impulses to build, generated by intrapsychic stimuli. This is seen in the first moments of what will become Freud's turn away from his theory of sexual trauma toward a focus on children's capacity to create fantasies that he will identify, by the autumn of 1897, as their own repressed sexual wishes directed toward their parents, which then become part of his "Oedipal" narrative. As this turn begins to occur, Freud identifies the individual's ability to intrapyschically structure what he terms "protective fictions"—something quite different from the "fiction of protection" that the child realizes in the event of childhood abuse—and he gives these fantasies a capacity for a dynamism that was lacking in his earlier understanding of psychical responses. The action here also will be considered as another dynamism, that of motive—suggesting that the impulse possesses volition—that enabled Freud to shape how he would formulate psychical functioning in this period.

Freud's visual and affective experiences of his surroundings were more significant for the creation of psychoanalysis than has been recognized to date. Just as I argue that his landscape of ruins from 1896 is actually two scenes—one of a colonial trope of an excavation site that may reference the contemporary Austrian excavation at Ephesus, and the other Vienna itself—I will also argue that his "architecture of hysteria" is actually two structures: one identified as an autonomous work of an unconscious, and another as a version of protection, posited here as preceding his enunciation of a psychical process and motivating Freud as he discursively forms these inner workings of psychical life.

William McGrath's efforts of three decades ago—in his study *Freud's Discovery of Psychoanalysis*, with its subtitle of *The Politics of Hysteria*—remain rare in pointing out the near simultaneity of Freud's "architecture of hysteria" and the tumultuous political landscape of Vienna in 1897.[178] McGrath concludes that Freud's thinking about this psychical formation and his visual rendering of a series of structural forms were indebted to a trip undertaken to the medieval city of Nürnberg (Nuremberg) by Freud and Wilhelm Fliess in the spring of 1897.[179] Freud would later chide his traveling companion for his apparent lack of enthusiasm about the architecture, writing him that "you were unable to take any pleasure at all in the Middle Ages."[180] There, Freud was surrounded by towers and fortifications at a

moment when he felt acutely vulnerable to the stark realities of Lueger's politics and their ramifications for his professional aspirations. He would return from the trip and then quickly write to Fliess of a new "sure notion of the structure of hysteria," now imagined in terms of fantasies that serve as what is commonly translated as "defensive structures" (*Schutzbauten*) set up in front, as a façade, of "scenes" that relate to an originary experience of early sexual assault.[181] For McGrath, Freud saw "a parallel between hysterical defense and the medieval fortifications of Nürnberg"[182] and drew several lines of connection here. Nuremberg's urban landscape results from "intense political struggles" within itself, between the ruling elite and the empowered middle-class populace, and the towers and turrets, which McGrath believes Freud is citing here, were intended to maintain control. Because Freud had been thinking about symptoms as a form of defense for some time, what shifted in this moment was what McGrath terms "emotional impulses," an inherent dynamic force whose presence had been lacking in Freud's earlier thinking, and one that McGrath and others consider the first articulation of what would become known as the "id." McGrath links this turn to an inherent response to the "emotional shock" that Freud experienced with the Lueger election. But because McGrath premises his work on the belief, as his title suggests, that "Freud's accomplishment was a discovery rather than a theory of invention," the politics in the subtitle are always presented as in service of the revelation of an *a priori* psychic functioning. Therefore, McGrath reads Freud's turn from trauma toward fantasy as an advance precipitated by his greater focus on interiority, which led him to comprehend the independent working of the unconscious.

It is important to explore the intellectual lineage of McGrath's methodology and in doing so perhaps explain how discussions of architectural meanings for Freud did not become a more compelling discourse. McGrath's study was written very much under the influence of the book on fin-de-siècle Vienna by Carl Schorske, a work with a consequential and complex trajectory, whose full measure of significance goes beyond the focus of this study. What is relevant here is Schorske's overarching premise that the florescence of Vienna's intellectual and aesthetic cultures around 1900 was a manifestation of the political disenfranchisement of the bourgeoisie, in the wake of the rise of Lueger's Christian Social Party. This manifested itself, for Schorske, in the flight of Vienna's educated urban class into the havens of culture that had been part of the Ring legacy and their educations, although by now they had become a generation that held in contempt many of these external trappings of the Habsburg capital. For the architecture of the Ring, it would be the visions of modernist architects, such as Otto Wagner and Camillo Sitte, whose

crisp, unadorned façades would offer a very visible contrast to the ornately wrought buildings of the preceding decades. Schorske contends that this architectural vision casts aside much of the ethos of the Ringstrasse; he characterizes Sitte's buildings as resulting from turning away from the "historicist culture he had so striven to transcend."[183] The same model would be applied to Freud's *The Interpretation of Dreams*, published literally on the eve of the new century, and a work that Schorske argued resulted from Freud's feeling of the loss of the aspirations and promises of his youth, and in this retreat, coupled with the death of his father in the autumn of 1896, he delved into his own inner resources. As in the architectural turn to modernism, Freud's work was a reaction, its own version of Sitte's transcendence. In both cases, the efforts, the residues of the earlier investment and engagement, are read through the lens of their ultimate disavowal. Because Schorske sees the assimilated Jewish contribution to this turn as part of the broader social construction, the possible ways in which a reception of the urban landscape of Vienna would have been perceived from a Jewish perspective, and perhaps one in which Freud participated, are never developed. Freud's move from an apartment on the Ring is read by Schorske as a retreat from his earlier aspiration to that of an ordinary middle-class neighborhood, and within such forgettable surroundings, Freud was "devising an epoch-making interpretation of human experiences in which politics could be reduced to an epiphenomenal manifestation of psychic forces."[184] When McGrath discusses Freud's architecture of hysteria, the influential buildings for him are not in Vienna at all; it is as though Freud's inward turn allows for external influence only beyond the limits of Vienna.

In Michael Steinberg's incisive comments on the tenth anniversary of the publication of Schorske's classic text, his discussion extends to McGrath's study, suggesting it as "a volume of Mishnah to Schorske's Septateuch"[185] in its attempt to surround the latter's single chapter on Freud with a considerably fuller accumulation of narratives (and thus reminiscent to Steinberg of the functioning of a Talmudic commentary) that brought a wealth of biographical details into an elaboration upon Freud's psychoanalytic thinking. McGrath's suggestion that the Nürnberg fortifications were the inspiration for Freud's architectural turn in the spring of 1897 is an example of what brings Steinberg to think of McGrath as a "material archaeologist," unearthing an assemblage of details that, because they are not examined in light of various critical strategies both in the Freud literature and beyond, result in his desire for rigorous intellectual—and I would add, psychoanalytic—excursus to become flattened into "linear" biography.

That Freud chose to particularize the type of architecture he linked to hysteria as a *Schutzbauten*—as already noted, commonly translated as a "defensive structures"—suggests that McGrath's source of the image for the "architecture of hysteria" was not exclusively the fortifications of medieval Nürnberg. Rather, Freud drew upon a structural precedent that, like his choice of *saxa loquuntur*, had a significance in gesturing to Vienna. In translating this as a "defensive" structure, the possible link to castles and bulwarks seems convincing, although the word itself has no direct association to these buildings. This term is better read as a "protective" building, with its most common usage referring to enclosures constructed to prevent flooding, and not military incursion.[186] This type of structure then did not have the nuance of defense implied by its association with the ramparts of Nürnberg. Rather, as with a weir erected to prevent flooding, there is a need to contain something that will otherwise overwhelm that which is being protected. In the 1892 edition of the *Brockhaus' Konversations-Lexicon*,[187] the term appears a number times within the entry for *Hafen* ("haven, refuge") both as a general term for such a construction and then in its particular relationship to water control and flooding. In von Förster's plans for the Ring, proposed just at the time that Freud arrived in Vienna, he uses the term on a number of occasions to discuss structures to be built along the Danube canal, in an area near Freud's boyhood residences.[188]

When additional high water threatened, in the 1890s, the phrase was in frequent use in Vienna, and it was at this time that Freud first coined the term. By then, political threats also rose to a new level and it is thus noteworthy that Freud at that moment installs *Schutzbauten* within the workings of inner life. The protective nature of fantasy, posited by Freud as safeguarding and containing trauma experiences, will come ultimately to shelter him as well. While the transition in his thinking from trauma to fantasy is usually posited in terms of sexuality—from external assault in childhood to the child's own inner imaginings—the issue of protection is also being transformed here, from evidence of a lack of safeguarding to a mechanism that installs it within a vigilant psyche; this structure also allows Freud to protect himself, as he determines what is admissible as psychically meaningful. It is important to note that the term "defense" (*Abwehr*) was one that Freud had used to signify repulsing or blocking off, and had a considerable history of usage in his understanding of the psychopathology of hysteria.[189] As noted earlier, his "The Aetiology of Hysteria" had been prefaced by writings on symptoms as defense. He saw the term as descriptive of both mechanism and function. Significant is that the language of *Schutz*—of refuge or shelter—was not used in his psychical formulations before 1897, although it would proliferate in the years to follow. Its only presence prior to the "architecture of hysteria," in the

context of understanding the hysteria, was to be found in Freud's occasional use of what he called protective maxims or formulae (*Schutzformel*) that he apparently gave to patients to recite when faced with the onset of distress.[190] Now Freud has created another form of protective amulet: with his move to an inner "*Schutzbauten*," he posits a formula that he would repeat about psychical functioning, which served to ward off unwanted content that he did not wish to examine or admit to the space of psychical value. Thus, the issue of protection emerges as a way to compensate for lost protectors, and to protect against himself. It will be his fantasies for psychoanalysis, rather than a discovery of psychoanalytic fantasies, that create the desired proofs for his construction of the unconscious.

Not long after returning from their journey to Nürnberg, Freud writes to Fliess, on May 2 of 1897, that he has been in a state of "continual euphoria and have been working like a young man." The reason for this burst of energy is that he has "gained a sure inkling of the structure of hysteria. Everything goes back to the reproduction of scenes." Here, he uses the familiar word *Szenen* ("scene," the experience of trauma) but also will shift to a new term, "*Urszenen*." This word first appears in what he appends to the letter as "Draft L," another in a series of papers that he has written to Fliess, elaborating his theories. The "Christmas Fairy Tale," written on the first day of 1896 and detailing the role of fright in hysteria and its accompanying "gap in the psyche," had been called "Draft K."[191] Thus, some time passed between these texts, although the pace would now quicken, and "M" and "N" would follow in short order. The separation in these drafts is not only temporal; while the "Christmas Tale" was a narrative of trauma and its effects, the later papers told the story of hysteria with a new component, one that Freud shared with Fliess just prior to their holiday, in a letter of April 6: "the point that escaped me in the solution of hysteria lies in the discovery of a different source, from which a new element of the product of the unconscious arises."[192] He will identify this as "hysterical fantasies," and will then return to this construction with this letter and draft of the following month.

Freud describes within the letter accompanying "Draft L" the most salient aspects of his new "structure"; it is in this draft that he first used the phrase the "Architecture of Hysteria."[193] It introduces Fliess to a much more elaborated notion of fantasies than in the letter announcing their "discovery" weeks earlier. Freud writes of imagining them as akin to defensive edifices that are set up "in front" of memory. He specifies their origin in things that are held in aural remembrance—he believed that this was the earliest place where experiences were preserved—and only understood retrospectively, and notes that "all their material is of course genuine." In contrast to these memories, the fantasies are "protective structures, sublimations of the facts,

embellishments of them." He also reveals his belief that "psychic structures are not in reality memories—since no one indulges in memory activity without a motive—but impulses that derive from primal scenes." This is a crucial statement, as psychical mechanisms are characterized by two constituents that Freud introduces here for the first time. The source for his concept of impulses, according to Laplanche and Pontalis, can be traced to the notion of "endogenous stimuli" that appeared in his highly speculative, and abandoned, vision of a metapsychology that he shared with Fliess in 1895, although his notion of instinctual impulse does continue to appear in later work.[194] There, he identified internal experiences of "hunger, respiration, sexuality," whose discharge "must be realized in the external world."[195] But there is a significant distinction between this precedent and what follows from this first enunciation. Freud will be less interested in the release of energy than in "instinct," and goes on to name "instinctual impulses" as derivative of animal behaviors and thought to be phylogenic.[196] Thus, his use of "impulse" would appear to be more closely aligned to the same sense of the primordial that informed his choice of the "*Urszene*," suggesting that he is now juxtaposing an historical memory with a psychical structure that operates on internal, and archaic, mechanisms. While many readers have assumed that the "*Urszene*" is here the abuse of the child, the choice of the prefix would suggest, in light of this analysis, that the specificity of the event is potentially being subverted. The primal scene occupies a place of temporal ambiguity, and the usage of the preface "*Ur*" here suggests Freud's move toward an alternative relationship between psyche and history.

Within the draft itself, fantasies are termed "psychical facades" that prevent immediate access to memories. But Freud also says that fantasies "simultaneously serve toward refining the memories, toward sublimating them." The creation of fantasies arose, Freud again notes, from things that were heard and "utilized subsequently." However, he then observes that these early experiences combine with "past events (from the history of parents and ancestors)." We do not know what precisely informed his notion of "an ancestor," although his choice of word, *Voreltern*, is a rare usage for him. It appears in only one of his texts, and that at the very end of his life. In *Moses and Monotheism*, written in the year before his death in 1939, he twice will use the phrase "*Voreltern Erlebte*" ("experience of the ancestors").[197] The phrase is introduced in a discussion of transmission of "memory-traces" and has a specific reference to a primordial legacy. He cites here "the Oedipus and castration complex" as examples of this, because they only become "intelligible phylogenically by their connection to the experience of earlier generations."[198] The first articulation of such an idea of an archaic and archetypic residue that informs the early experience appears to emerge here

in this draft, as personal history "combines" with some kind of phylogenic experience that exists in the unconscious. Therefore, fantasies are implicated not only in a protection against memories of an early trauma, but also in another past, one that is always already present in the unconscious. In the first two drafts sent in May, Freud in both sections specifically identified his thinking about "protective fictions" as "architecture," suggesting a structural distinction between the memories of past experiences and the fantasies that emerge in front of them. These fantasies—whose building materials were an amalgam drawn from the victim's adult sexual experiences and these traces of one's "prehistory"—serve as a protection against the capacity to remember early sexual experiences.

This dual notion of one's "history" had been percolating in letters to Fliess for several months. We see this turn in the days after his father's death in October 1896, when Freud would tell his friend that in his "inner self the whole past has been awakened by this event." In the line to follow he concludes, "I now feel quite uprooted (*Gefühl*)."[199] In the months that follow, however, Freud's focus seemed on a paternal legacy that would access what he would call the "genuine" memories, even if painful ones. His conviction about the identity of the sexual abuser came to focus exclusively on the child's male parent, and Freud does not shrink, in a letter to Fliess of February 1897, from implicating his own father among them.[200] But soon after that, he starts to shift into a new territory, one that would begin to craft his structural imaginings and his introduction of protection. The indictment of his father is soon followed by musing about earlier, archaic histories that could gesture to a way to imagine a different form of generational inheritance. He would begin to write to Fliess of various archaic or originary (*Ur*) phenomena that he would align with hysteria, and by the time he speaks of the legacy of ancestors in his draft of the following spring, one sees a subtle but sustained move away from external agents of suffering to those that collude with what is already carried within. In Patricia Cotti's close reading of the correspondence between Freud and Fliess in the months after Jacob Freud's death, there are, as she notes, "plenty of '*ur*'s" in the letters.[201] Some of these refer to Freud's return to an interest in archaic manifestations of evil in the form of devils and witches, whose presence he suggests can be identified in the fantasies of the ill. Of these patients he writes, "the victims think of the same old cruel story in fictionalized form."[202] He will come to see these stories as fictions—invented. So, it is unclear if these are the work of fantasy to change and refine what has indeed occurred or if the fantasies have created them without outside agents.[203] It is noteworthy that they are given the same prefix as his architectural attribute—in his draft they become "*schutz Dichtung*" ("protective fictions").

As we will see, by the final draft in his May series, Freud may have been protecting himself not only from any incestuous actions of his father, but from his own potential for such transgressions. And by the end of 1897, the presence of memories that have any relationship to an external presence, paternal or otherwise, had all but disappeared. There will be no distinction between memory and fantasy, so the integrity of an "architectural" structure, as a unifying façade, will fall away. But its function—protection—remains, now as an *a priori* intrapsychic mechanism, and also as the way in which the "external" events of history are removed and extracted from meaning. In a note added to the second edition of *The Interpretation of Dreams*, Freud would identify this book as "a portion of my own self-analysis, my reaction to my father's death—that is to say, to the most important event, the most poignant loss, of a man's life."[204] But as we will see, this self-analysis also serves to move toward shaping a past less defined by event than by fantasy, a transition that can be charted in the May drafts.

It is in this passage of "Draft L" that Freud makes the first association between fantasies and dreams, noting that the latter are about things seen, with fantasies arising from what is heard. In the next letter, two weeks later, he tells Fliess that "things are fermenting and bubbling in me," and that he is "thinking about the dream (book) again."[205] Didier Anzieu notes that this was Freud's first indication of his intention to write on this topic.[206] When he does indeed do this, it is interesting that many of the dreams date to the early months of the 1897, a period when his putative "self-analysis" would preoccupy him. Thus, it would appear that the impetus to write on dreams was provided by the introduction of a structure for hysterical fantasies. The manifest content of the dream ultimately became the fantasy that is defensively generated to prevent access to the latent meaning. After 1897, it could be said that dreams replaced Freud's interest in the symptomatology of hysteria, a transition documented by his decision to retain the "motto" from Virgil—*Flectere si nequeo superos Acheronta movebo* ("If I cannot bend the higher powers, I will move the infernal regions")—originally intended to preface a chapter on "symptom formation" in a (never-realized) work on hysteria, imagined in a letter to Fliess of 1896, as the epigram for *The Interpretation of Dreams*.[207]

In returning to the draft appended to his letter of May 2 to Fliess, we see that Freud's entry on the "architecture of hysteria" is immediately followed by "The Part Played by Servant Girls," seemingly referring to the creation of hysterical fantasies. He focuses on the issue of women, engaged in work as domestic laborers, whom Freud characterizes as "people of low morals," notably the "servant girls" whose relationship with his female patients' fathers or brothers creates daughter or sister identificatory fantasies that lead

to imaginings of illicit activities; these women were viewed by his patients, according to Freud, as "worthless female material."[208] There is no indication that these daughters were engaged in sexual activities with their male relatives—unfortunately, it was not uncommon for working class women and young girls to be hired in households primarily for this purpose[209]— but rather their exposure to these sexual involvements in their household caused their "self-abasement." What Freud suggests is that there is a "tragic justice" for the sins of the father being delivered onto the suffering of his child; also, of course, there is the tacit blame that the neuroses of his patients were caused by paternal actions resulting from the presence of their domestic workers. His choice of this scenario perhaps speaks more to Freud's own fantasy life than that of his female patients. Sander Gilman notes that "class and family interconnect to provide the model for the male's projection," whose imaginings are then installed into the daughter. Gilman then observes that this example may "parallel his [Freud's] sense of anxiety in his seductive desire for his daughter."[210] We will see that this issue emerges soon after this draft, and suggests another reason for Freud to wish for the ascendancy of fantasy.

"Draft M. The Architecture of Hysteria" was written soon after and was added onto a letter to Fliess of May 25.[211] Here Freud includes his sketch of such an edifice, composed of pyramidal forms of increasing scale that represent the fantasies and are "arranged in order of increasing resistance." In the text accompanying the drawing, Freud speaks of fantasies as "tendencies" (hard to know if he is speaking here of heredity or phylogenesis) that operate to make "inaccessible the memory from which symptoms have emerged or might emerge." He contends that fantasies give the example of "falsification of memory through fragmentation." In this case, the temporal relationship between experiences is "neglected" and bits of what may have been seen or heard join together in a way that renders the "original connection" as "untraceable." In the case of these fantasies, Freud believed that such "unconscious fictions" deter the formation of "mnemic symptoms" because the amalgam that now exists has "not been subjected to defense." Therefore, what is suggested here is that fictions are extracted from the temporal specificity of memory and constitute an intrapsychic mechanism that splinters experiences and does not allow, as in the archaeological paradigm, these fragments to be reconstructed. The fact that Freud cites, as his leading example, the function of fantasies to subvert "chronology" follows along with the construction of primal phenomena that has been weaving through his thinking at this time. The balance appears to tilt here, as Freud begins to explore the capacity of fantasy to operate independently of the traumatic memory that, in his previous draft, he had seen as generative of its protective

façades. But in this description, the fortress builds itself, as though its plans were already drawn.

Freud writes the word "*Arbeit*" (Work) beside his drawing, and in dotted lines that run alongside its structures he charts the analyst's process of treatment, beginning with psychical material that is readily accessible and moving to the rising spires of increasing resistances and deepening of symptoms; Freud envisioned the clinical interventions as ever-deepening "loops" that take the work to increasingly hidden registers. Whitney Davis argues that the interplay of the solid and broken lines "potentially represents *two* separate diagrams of 'hysterical' repression"—one the patient's and the other the analyst's. Davis reads the dashes as the interpretative process's "*own* history of stimulation, selection, delay, repression and discharge," a revelation that only his close reading makes evident.[212] In a similar fashion, one can follow the two narratives within the texts that surround this image. Freud reveals his discoveries of fantasies, while simultaneously, visually and textually, constructing them. He also adds a phrase to accompany the sketch that sheds light on his descriptor of *Schutzbauten*. He writes of the analytic "work"—that which goes on beneath the symptom cupola, and that one must "immerse" oneself deeper and deeper. The term for this depth differs from that of the archaeologist whose work he had mimed the year before. Here, *tauchenden* relates to experiences of immersion in water, although the more colloquial usage of "dipping" into something appears occasionally in Freud's later writings. Thus, he imagines the analytic work as going into the psychical "waters" that presumably would be resting against the inner walls of the *Schutzbauten*. His conjoining of architecture and safety is made explicit here; this building was created to serve a singular function: to preserve a specific area against an agent of destruction. While drawn here to visualize a process of psychopathology, the privileging of new forms of protective functioning, as a broader, normative psychical capacity, is beginning to germinate. As we will see, the explicitly architectural descriptors will soon be replaced by terms that enunciate what is *worth* saving.

Only six days after "Draft M," on May 31, 1897, its successor ("Draft N"), which would conclude the series, was written. Freud writes that he has not heard from Fliess, and is clearly concerned. Perhaps to stir an interest that he senses may be waning, he announces at the letter's opening that he feels he will soon "uncover the source of morality,"[213] but does not yet know what that will be. His turn to this topic may have been prompted by two dreams he then recounts to Fliess, both of which depict him in morally compromising positions. In one case, the dream involves the action of going up a staircase "with very few clothes on" and meeting an unidentified woman "coming after me." He attributes this to an exhibitionistic wish, and acknowledges the affect

as one of "erotic excitement." The other dream also has a powerful sexual content, but with a far more complicated subject. He tells Fliess of dreaming of his daughter Mathilde, and of experiencing "overly affectionate feelings" for her. In the dream he identifies her by the name "Hella," and sees the word present in the dream "printed in heavy type." Freud notes that this is the name of a niece, the daughter of his sister Anna and Ely Bernays, whose picture they have recently received, and the choice would also refer to his eldest daughter's attachment to "the mythology of ancient Hellas and [how she] naturally regards all Hellenes as heroes."[214] She had recently shed tears over the defeat of the Greeks in the contemporary moment, by the army of the Ottoman sultan in the spring of 1897.

It is only in concluding his interpretation that Freud addressed the incestuous content of this dream. He contends that its content "of course shows the fulfillment of my wish to catch a *pater* as the originator of neurosis and thus (the dream) puts an end to my ever-recurring doubts."[215] It is strange that in all his letters to Fliess, he had not voiced this uncertainty about the paternal perpetrator; rather, he reported various cases that appeared to support his claim, and he asserted at the conclusion of the previous year, in December of 1896, that his own father was to be implicated. One wonders if what was ever-recurring were his concerns, as Gilman suggests, about his own incestuous desires. This possibility is supported by the fact that among the various dreams Freud reports to Fliess during this period, the so-called "Hella dream" will be the only one that will not appear in *The Interpretation.*

Although Freud will seemingly forget this dream, there is evidence that it had a powerful effect in the moment. After announcing his turn to the source of morality and before telling Fliess this dream, Freud comments on his current state. He complains that he "doesn't want to work on anything any longer; I have laid aside even the dream book."[216] The so-called "Hella dream" may have been disarming and problematic, with an interpretation that sidesteps the obvious sexual affect by considering it as a manifest content, with the quest for the etiology of hysteria as its latent meaning. If indeed he caught a father, what he discovered was the presence of sexual desire for a child, the requisite preface to an actual assault. Anzieu provided the explanation that Freud needed to "eliminate the unbearable thought" of his own father as an abuser. Thus, he says, Freud's "unconscious cleverly transposes it." Anzieu believes that Freud "could not be suspected of the slightest sexual impropriety" and thus this is a "wish, not an act."[217] What is striking here is that the wish will soon become re-placed onto the child, thus allowing for the devaluing of a dream with a clear representation of his own incestuous wishes. We see this occur within the draft that accompanies the letter, written

less than a week after the one before. This dream must have occurred in the interim, and what appears to result from it is a subtle, but decisive, rethinking of the relationship of memory and fantasies, and with this, the formulation of an autonomously functioning psychical "reality" where protective function comes to replace the earlier decisive issue of "structure."

Freud begins "Draft N," accompanying a letter to Fliess dated May 31, with a section entitled "impulses," and speaks first of hostile feelings toward parents that are "also an integrating constituent of neurosis."[218] He considers identification as a defense against such feelings, such as acquiring the symptoms of a parental illness. One wonders if Freud is thinking here of his incestuous dream as such an act of pathological remembrance. He then goes on to propose a relation between impulse and fantasy that is more mechanistic and determined than in his previous discussion of them: "memories appear to bifurcate: one part is put aside (*verlegt*) and replaced by fantasy; another accessible part seems to lead directly to impulses."[219] This is a significant shift, as here memory, in toto, splits, and becomes inhabited by fantasy and impulse. In Freud's first discussion of hysteria's architecture, he wrote of *vorgelegte Phantasien*—fantasy as in front of something, that is, as a façade. Freud had used the word *vorgelegte* to describe the presentation of his doctoral thesis—the putting forward of his work. The breaking apart that he introduces here differs from his earlier notion of fragmentation, which suggested that a portion of memory retained what he had previously called its "genuine" quality. In this model, the external experience is inhabited by fantasy and instinctual impulses from the start. Indeed, the portion that appears to relate to an historical "reality" is extracted. Freud's use of the verb *verlegen* is significant, as it carries the sense of being postponed, moved, or deferred; it can also suggest something that is no longer in its place. So, while the earlier vision of fantasy was a protection based on a "*Vorbau*"—a structure placed in front—here the gesture is to remove it from its place, but with no sense of where that content actually goes. One is reminded of a term that Davis used to characterize the analyst's history, as this word carries the sense of a delay and removal. It is Freud who splits memory and puts it aside, then articulates it as an intrapsychic function. His process creates a new space of meaning, one where emphasis on the location of value has shifted from trauma to fantasies in the course of these drafts. In the first rendition, he imagines the latter as barring access to memories; in this final draft, it is the two intrapsychic mechanisms of impulse and fantasies that operate as though they precede any particular memory. They are not defending memory so much as overpowering and replacing it, a gesture that mirrors what Freud will do when he replaces paternal abuse with infantile fantasies. He will go on in this draft to make the sweeping statement that "the

mechanism of fiction is the same as that of hysterical fantasies,"[220] therefore suggesting a metastructure within the psyche that can be utilized in either the pathological or the normative realm. This will open the possibilities of a universality of fantasies that will follow in the months ahead.

The center of gravity has tilted discursively, and one motivation may be embedded in the very word that has helped produce this turn. There is also another set of meanings associated with *verlegen*, a verb that Freud does not use subsequently to describe psychical functioning. When preceded by *sein* (to be), the compound refers to being embarrassed, awkward, or perplexed; it also was used to describe a condition of being ruined through lying. When this usage is applied to a memory, in light of the Mathilde dream, it might suggest Freud's own discomfort, and his wish to put it aside, to have it get lost. He designates as the hidden meaning that which he claims to wish for—the abstracted, culpable *"pater"*—while he relegates to oblivion the implications of himself in that role. Harald Weinrich notes that the word "latent,"[221] the term Freud uses to describe the underlying motivation for the dream, is derived from the same Latin component as Lethe, one of the rivers of Hades in classical mythology, whose waters, when drunk, would eradicate all memory. For Freud, unconscious forgetting is retrievable through the analytic process, while the functioning of a "liquidation" (Weinrich's term) of memory is left unacknowledged. Psychoanalysis operates on the necessity of repressed material becoming forgotten yet retrievable. What must also be recognized in this process is that it is predicated on categories of experiences that do not return and are, as Freud said of his early years in Vienna, "not worth remembering."

What is perhaps most crucial in this portion of the draft is that Freud now claims that defense against libido "has made room for itself in the Uns (unconscious)"; indeed, *he* has made room for it, as he accords increasing importance to it in the operation of intrapsychical mechanisms. His use of a spatial conceptualization is significant, as what it pushes up against are the traumatic contents that he had previously identified as occupying this space, and creating the stimulus for defensive edifices. It is not a co-existence here, as he claims that "more complicated psychic formations," which he identifies as "impulses, fantasies, motives," are pushed forward (*Vorschieben*) from memory.[222] Although Masson translates this as displacement, it differs from the Freudian term *Verschiebung*. This latter word refers to an alternation of movement along a pathway; its origin drives from the language of the railway system, where it was used to commonly describe a place where the tracks divide. *Vorschieben* is less about the transfer than about a distinct direction, the pushing ahead; it differs from Freud's architectural terms, such as *Schutzbauten* or *Vorbau*—where there is a structural integrity

that distinguishes the two. These psychical formations do not arise from the memory, but rather memory acts upon what is already there. His new structure derived from inner determinants and was increasingly at a distance from the primacy he had previously invested in the actions of adults toward children. But to achieve this, Freud would need to jettison from relevance things that he previously believed had occurred. That would require the final push to the realm of fantasy, and also to that of oblivion.

Freud understood that a change was occurring, and in a letter in the weeks after "Draft N," he says "I believe I am in a cocoon, and God knows what sort of beast will crawl out."[223] He writes that "something from the deepest depths of my own neurosis set itself against any advance in the understanding of the neurosis." He writes Fliess that his "writing paralysis" may operate to undermine their communication;[224] he had complained of this condition, one that he had called dysgraphia, four years before this, also in May. That instance, as has been noted, coincided nearly to the day with the second anniversary of Pauline's death. It seems that when Freud discovers "something from the deepest depths" he again manifests this symptom. He also writes that he has "learned new things about the characteristics of the processes of the unconscious." Dreams continue to serve as a point of comparison to neurotic functioning, as in both we encounter "falsification of memory and fantasy." The complexity of defenses, now against fantasy as well as memory, reveals that the former is "stronger than genuine memories." Fantasies are growing more complex and becoming connected to normative reveries. The veracity of memories of paternal abuse is weakening in Freud's model and although he does not report the clinical reason for this, he does tell Fliess in August, however, that he is "tormented by grave doubts about my theory of the neurosis." He writes of "agitation in my head and feelings," and looks forward to his upcoming visit to Italy, because this is the only place where his anxieties can be quelled.[225] His model of fantasies increasingly eclipsed what he had called "genuine memories." This phrase never appears again in Freud's work, suggesting that this phenomenon, as he knew it in the spring of 1897, would soon disappear. As he plans for his trip, architecture returns to his thoughts, and there, too, one senses his desire to put aside. He tells Fliess that he will embark on a new aesthetic program in Italy—one that he was "still far from seeing in Nuremberg,"[226] with his "cultural-historical interest" that he now wishes to supplant. Freud says here that he will turn to "absolute beauty in the harmony between ideas and the form in which they are presented, and in the elementary pleasing sensations of space and color";[227] the affective reception of architecture imagined here is completely extractable from the particularity and value of its specific functions and meanings. Once in Italy, he would write of that wish, noting that "as you

know, in Italy I am seeking a punch made of Lethe."[228] It would appear that
Freud is turning away from what he associated with his earlier interests, and
thinking about ways in which visual experience, as we will examine in the
chapters to follow, could be equated with forgetting.

Notes

1 Freud's most detailed account of his earliest life appears, interestingly, in
 the guise of a purported case history of a patient. Included as part of his
 1899 essay, "Screen Memories," it offers details of what Freud presented as
 a comfortable life of seeming familial prosperity "in that little corner of the
 provinces," a reference to his birthplace in the Moravian town of Freiberg.
 *The Standard Edition of the Complete Psychological Works of Sigmund
 Freud*, ed. James Strachey (London: Hogarth, 1953–1974) [hereafter *SE*]
 3, 309–322. Freud's father Jacob had been settled there for some time;
 records suggest he had been married twice, with two adult sons from his
 first marriage at the time that he wed twenty-year-old Amalia Nathansohn,
 Freud's mother. As a young man, the elder Freud often traveled to Moravia
 from his birthplace in Tysmenitz, a Galician town with a considerable
 Jewish population, with his paternal grandfather, a merchant dealing in
 wool and other products. Securing domicile rights in Freiberg in 1848,
 Jacob could then permanently establish residency there. Marianne Krüll,
 Freud and His Father, trans. Arnold J. Pomerans (New York: W.W. Norton,
 1979), 91–95. But when he was "about three," Freud reports changes
 in Jacob Freud's profession, dealing primarily in the finishing of wool
 products, that resulted in the loss of "all his means." Because of this, the
 family was "forced to leave the place and move to a large town" ("Screen
 Memories," 312). Whether Jacob's livelihood foundered in Freiberg due
 to adverse economic changes or his own inability to adjust his business
 practices to changing times is not certain. It appears that upon arriving in
 Vienna a source of support came from Amalia's family. Ernest Jones, *The
 Life and Work of Sigmund Freud, 1856–1900: The Formative Years and the
 Great Discoveries*, vol. 1 (New York: Basic Books, 1953), 17.
2 Documents found in the City Archives in Leipzig have shed considerable
 light on the Freud family's brief residency there and the events surrounding
 their sudden departure for Vienna in October of 1859. A more detailed
 discussion of this will follow in Chapter 3.
3 For important historical, cultural, and political analyses of Jewish
 experiences in Vienna, refer to Steven Beller, *The Jews of Vienna 1867–1938:
 A Cultural History* (Cambridge: Cambridge University Press, 1989); Marsha
 Rozenblit, *The Jews of Vienna 1867–1914: Assimilation and Identity* (Albany,
 NY: State University of New York Press, 1983); and Robert S. Wistrich, *The
 Jews of Vienna in the Age of Franz Joseph* (New York: Oxford University
 Press, 1989).

4 K. Michael Hays, *Architecture's Desire: Reading the Late Avant-Garde* (Cambridge, MA; London: MIT Press, 2010), 2.

5 Ranji Devadason, "Place Attachment, Community Cohesion and the Politics of Belonging in European Cities," in *Social Capital, Political Participation and Migration in Europe: Making Multicultural Democracy Work?*, ed. Laura Morales and Marco Guigni (Basingstoke: Palgrave Macmillan, 2011), 238–261.

6 Stuart Hall, "Political Belonging in a World of Multiple Identities," in *Conceiving Cosmopolitanism: Theory, Context, and Practice*, ed. Steven Vertovec and Robin Cohen (Oxford: Oxford University Press, 2002), 30, quoted in Devadason, "Place Attachment," 242.

7 The work of Mirjana Lozanovska is especially notable in its understanding of architecture's role in migratory experiences, particularly within the new location of settlement. Her most recent edited volume is *Ethno-Architecture and the Politics of Migration* (London; New York: Routledge, 2016). A recent collection of essays that discuss the spaces of new "utopic" cities in India offers some interesting insights into the reception of newly created urban environments by those migrating there: *Mega-Urbanization in the Global South: Fast cities and new urban utopias of the postcolonial state*, ed. Ayona Datta and Abdul Shaban (London; New York: Routledge, 2017).

8 The Nathansohns' home, at the time of their daughter's return to the city, was in a building named after the industrialist who had it built in 1855, Camille Florent von Robert (1795–1870). The "Roberthof" has a significant architectural pedigree: it was designed by August Sicard von Sicardsburg and Eduard van der Nüll, who would go on within a few years to design what is arguably one of the best-known buildings on the Ring: the Vienna State Opera. The Roberthof was a large, open-court structure notable for being among the first to create a Viennese multi-family apartment building whose space and detailing placed it between the standard city apartment building of the time and the grand houses that were appearing along the Ringstrasse. Wolfgang Czerny et al., *Wien: II. bis IX. Und XX. Bezirk,* Dehio-Handbook die Kunstdenkmäler Österreich: Topographisches Denkmälerinventar ([Vienna]: Verlag Anton Schroll 1993), 36. This would suggest that the Nathansohn family had prospered in Vienna and that their home—the same through Freud's childhood—would have been a place of stability in years marked by numerous moves. The Roberthof (Untere Donaustrasse 45) is cited as Jacob Nathansohn's address in a commercial directory where he remained listed even in the years immediately following his death, in 1865. See Ferdinand v. Fiala, ed., *Wiener Handels-und Gerwerbe-Schematismus pro 1867–1868*, vol. 1 (Wien: Leopold Sommer, 1868), 14.

9 Evidence suggests that the family did not arrive together, but that Amalia and the two children preceded Freud's father, and the three stayed with the Nathansohns until being joined by Jacob and moving into a nearby residential hotel, in December 1859. Georg Augusta, "'Dann kamen

die langen, harten Jahre': zur Situation der Familie Freud nach ihrer Ankunft in Wien im Jahr 1859," *Luzifer-Amor: Zeitschrift zur Geschichte der Psychoanalyse* 56 (2015): 113. Until February 1860, when the family moved into their own apartment just across the Danube Canal from Freud's grandparents, residency records suggest they moved between the Hotel Schröder—now the Hotel Stephanie—on Taborstrasse and the Nathansohn home at Untere Donaustrasse 45 (until 1860 known by the earlier designation of Leopoldstrasse 726). Jacob Freud was part of a legal proceeding against him, involving an outstanding debt, within a month of his arrival, and this may have necessitated the transience of this first period of his son's life in Vienna. Augusta, "Dann kamen die langen," 113–115.

10 Maurice Merleau-Ponty, *Phenomenology of Perception*, trans. Colin Smith (London: Routledge and Kegan Paul, 1962), 140.

11 David Seamon, "Place Attachment and Phenomenology: The Synergistic Dynamism of Place," in *Place Attachment: Advances in Theory, Methods and Applications*, ed. Lynne C. Manzo and Patrick Devine-Wright (London; New York: Routledge, 2014), [11].

12 I consider Freud's departure from his birthplace because of his family's economic situation, the several months spent in Leipzig, probably in a residential hotel prior to being denied residence, and his final move to Vienna a "migration" rather than, as more commonly imagined, a move or journey. Settling in Vienna after originating in Habsburg Moravia can be considered an "internal migration," a phrase that characterizes transitions between different geo-cultural and economic settings within the Empire. See Josef Ehmer, Annemarie Steidl, and Hermann Zeitlhofer, "Migration Patterns in Late Imperial Austria," Working Paper No. 3, KMI Working Paper Series (Vienna: Österreichische Akademie der Wissenschaften, 2004), 6–7.

13 Theodor Reik recalled this; see Erika Freeman, *Insights: Conversations with Theodor Reik* (Englewood Cliffs, NJ: Prentice Hall, 1971), 80. Freud claimed on several occasions not to know Hebrew or Yiddish. Yosef Hayim Yerushalmi, *Freud's Moses: Judaism Terminable and Interminable* (New Haven, CT; London: Yale University Press, 1991), 68–69. Yet it is in Freud's monograph-length *Jokes and Their Relation to the Unconscious* (*SE* 8) where his deftness with Yiddish usage is perhaps most apparent. Christopher Hutton, "Freud and the Family Drama of Yiddish," in *Studies in Yiddish Linguistics*, ed. Paul Wexler (Tübingen: Max Niemeyer Verlag, 1990), [9]–22.

14 Jones, *Life and Work of Sigmund Freud*, 1:192ncc.

15 The first mention of the choice of Freud's given name was published a dozen years after his death, when Suzanne Cassirer Bernfeld, who with her husband, the psychoanalyst Siegfried Bernfeld (the couple lived for a considerable time in Vienna and knew Freud) published that Freud was named after Holy Roman Emperor Sigismund (1368–1437), who

"conquered Bohemia and was a protector of the Jews." Suzanne Cassirer
Bernfeld, "Freud and Archaeology," *American Imago* 8, no. 2 (1951): 125.
But this is probably a confusion of monarchs bearing the same name,
as this ruler's treatment of his Jewish subjects could be characterized as
mercurial at best. See Raphael Patai, *The Jews of Hungary: History, Culture,
Psychology* (Detroit, MI: Wayne State University Press, 1996), 68–75. It
was Earl Grollman, in 1965, who attributed the source of the name to the
"tolerant Polish monarch who lived between 1467 and 1548" who was
selected because "of his parents' great admiration for Sigismund." See Earl
Grollman, *Judaism in Sigmund Freud's World* (New York: Bloch, 1965),
47. This namesake makes better sense: along with his well-known edicts
of religious tolerance, Sigismund was associated with Poland, the area of
Jacob Freud's birth, and this ruler's Habsburg lineage may have made the
connection meaningful for Amalia, and probably associated the name with
Franz Joseph, Sigismund's descendant.

16 Jones, *Life and Work of Sigmund Freud,* 1:3. Jones does not offer any
published source for this information, but speaks in the same paragraph of
spending considerable time with Freud's mother, and thus we can assume
that her "vivid memories of the 1848 revolution there"—she apparently
preserved a picture "with shot holes in it" from that time—came from one
of their exchanges. Amalia was born in the northern Galician city of Brody,
and the Nathansohns spent time in Odessa, where family also resided,
before settling in Vienna.

17 The name "Schlomo Sigismund" was recorded in German and Hebrew
by Jacob Freud in the family Bible shortly after his son's birth on May 6,
1856. His Hebrew name was given to honor the memory of his new son's
paternal grandfather, Schlomo Freud, who had died shortly before his birth.
The choice of the non-Hebrew name would share the first letter with the
Hebrew name—in many cases, there is agreement between the first letters,
although in selecting Sigismund and Schlomo, Jacob was selecting different
Hebrew letters; there is agreement when both were written in German. For
the transcription and translation of Jacob's inscription, see Emanuel Rice,
Freud and Moses: The Long Journey Home (Albany, NY: State University
of New York Press, 1990), 31–[35]. "Sigismund" appeared on documents,
such as his mother's passport and school records, until about 1870, during
his years at the Leopoldstädter Communal-Real-und Obergymnasium in
Vienna's second district. There is occasional evidence that Freud continued
to use the original version of his name in his early university years. See
Lucille B. Ritvo, "Carl Claus as Freud's Professor of the New Darwinian
Biology," *International Journal of Psycho-Analysis* 53 (1972): 277.

18 Dennis B. Klein, *Jewish Origins of the Psychoanalytic Movement* (New York:
Praeger, 1981), 46n22.

19 Ibid., and Sander L. Gilman in *Freud, Race, and Gender* (Princeton, NJ:
Princeton University Press, 1993), 70 refer to the frequent occurrence of the

name Sigismund in humor related to Jews. One source for this connection is the Austrian cultural historian Friedrich Heer (1916–1983), who cited that Freud had changed his name because Sigismund was "Vienna's favourite term of abuse in anti-Semitic jokes." "Freud, the Viennese Jew," trans. W.A. Littlewood, in *Freud: The Man, His World, His Influence*, ed. Jonathan Miller (London: Weidenfeld and Nicolson, 1972), 6.

20 Adam Phillips, *Becoming Freud: The Making of a Psychoanalyst* (New Haven, CT; London: Yale University Press, 2014), 67.

21 This comment appeared in a letter to Fliess of March 11, 1900. *The Complete Letters of Sigmund Freud to Wilhelm Fliess, 1887–1904* [hereafter cited as the *Freud-Fliess Letters*], trans. and ed. Jeffrey Moussaieff Masson (Cambridge, MA; London: Belknap Press of Harvard University Press, 1985), 403.

22 Sigmund Freud, "The Aetiology of Hysteria," 1896, *SE* 3, 191–221.

23 Freud had the habit in 1897 of attaching "drafts" sequenced by letters of the alphabet. "Draft L" was enclosed with a letter dated May 2, 1897, and it opens with a paragraph titled the "Architecture of Hysteria," and "Draft M," of May 25, continues the title, and includes his drawing. *Freud-Fliess Letters*: "Draft L," 240–242; "Draft M," 246–248. This latter draft, containing the sketch, is accessible online in the Sigmund Freud Papers at the Library of Congress at https://www.loc.gov/resource/mss39990.OV0226/?sp=2

24 The *Neue Freie Presse*, the liberal newspaper that Freud read attentively, reported on the day that Lueger was sworn into office (April 21, 1897) that "a mob" gathered outside the city hall and chanted "*Der Dr. Lueger soll regieren und die Juden sollen krepieren*" ("Dr Lueger should rule and the Jews should die wretchedly"). In Lueger's inaugural speech, he claimed that there was a swelling attendance at Catholic church services, citing this as "a welcome sign of the Christian spirit of the population of Vienna." See "*I Decide Who Is a Jew!*": *The Papers of Dr. Karl Lueger*, ed. Richard S. Geehr (Washington, DC: University Press of America, 1982), 206, 208.

25 These remembrances of his school years appear in the section on "infantile material" as the "material and sources of dreams," in Freud's *The Interpretation of Dreams, SE* 4, 1900, 192–193.

26 Ibid., 193.

27 Sigmund Freud, *Zur Auffassung der Aphasien: Eine kritische Studie* (Leipzig: Franz Deuticke, 1891). The English edition, translated by Erwin Stengel, is titled *On Aphasia: A Critical Study* (London: Imago Publishing, 1953).

28 Freud, *Zur Auffassung der Aphasien*, 61.

29 Valerie Greenberg, *Freud and His Aphasia Book: Language and the Source of Psychoanalysis* (Ithaca, NY; London: Cornell University Press, 1997), 28.

30 *Letters of Sigmund Freud*, ed. Ernst L. Freud, trans. Tania and James Stern (New York: Basic Books, 1960), 98.

31 Mark Micale, "The Salpêtrière in the Age of Charcot: An Institutional Perspective on Medical History in the Late Nineteenth Century," *Journal of Contemporary History* 20, no. 4 (1985): 703–731. Georges Didi-Huberman,

The Invention of Hysteria: Charcot and the Photographic Iconography of the Salpêtrière, trans. Alisa Hartz (Cambridge, MA; London: MIT Press), 2003.

32 Sigmund Freud, "Reisestipendiumsgesuch," *Gesammelte Werke* [hereafter *GW*], Nachtragsband (Frankfurt am Main: Fischer Taschenbuch Verlag, 1999), 48–49.

33 Sigmund Freud, "Report of My Studies in Paris and Berlin," *SE* 1, 1886, 13.

34 In the vast literature on the constructions of hysteria, genders, and Charcot's role, two very different perspectives offer valuable insight into the trajectories of this topic: "Charcot's Vampires" in Elisabeth Bronfen's *The Knotted Subject: Hysteria and Its Discontents* (Princeton, NJ: Princeton University Press, 1998) and Mark S. Micale, *Hysterical Men: The Hidden History of Male Nervous Illness* (Cambridge, MA; London: Harvard University Press, 2008), esp. Chapter 3.

35 Andreas Mayer, *Sites of the Unconscious: Hypnosis and the Emergence of the Psychoanalytic Setting* (Chicago, IL; London: University of Chicago Press, 2013), 38–39.

36 Sander Gilman, *The Jew's Body* (New York; London: Routledge, 1991), 72–76. Gilman includes illustrations of two Jewish men (Plates 17,18) from a text of Charcot's colleague Henri Meige: *Le juif-errant à la Salpêtrière: Étude sur certains névropathes voyageurs* (Paris: L. Battaille, 1893).

37 Mayer, *Sites of the Unconscious,* 18.

38 Ibid., 28.

39 Freud, *Letters of Sigmund Freud,* 183.

40 Sigmund Freud, *The Psychopathology of Everyday Life, SE* 6, 1901, 149.

41 Toby Gelfand, "Sigmund-sur-Seine: Fathers and Brothers in Charcot's Paris," in *Freud and the History of Psychoanalysis,* ed. Toby Gelfand and John Kerr (Hillsdale, NJ; London: Analytic Press, 1992), 40–41.

42 Ibid., 41n19; Freud, *Letters of Sigmund Freud,* 183–184.

43 Freud, *Letters of Sigmund Freud,* 183.

44 Ibid.

45 Ibid.

46 Freud, *The Interpretation of Dreams, SE* 5, 469.

47 Unpublished letter of Freud to Martha Bernays, December 5, 1885, Sigmund Freud Papers, Box 7, Folder 9, Library of Congress.

48 Unpublished letter of Freud to Martha Bernays, May 4, 1885, Sigmund Freud Papers, Box 6, Folder 15, Library of Congress.

49 Frederick Crews's recent biography of Freud offers what is arguably the most sustained discussion of Freud's involvement with cocaine. *Freud: The Making of an Illusion* (New York: Metropolitan Books; Henry Holt and Company, 2017), [57]–73. Crews cites a number of authors whose texts he contends avoid the topic by "hurrying past" it (60), but there are others, such as Louis Breger's *Freud: Darkness in the Midst of Vision* (New York: John Wiley and Sons, 2000), that have in fact accorded Freud's involvement with cocaine considerable attention (66–73).

50 Freud, *Letters of Sigmund Freud*, 185.
51 Freud, *The Psychopathology of Everyday Life, SE* 6, 1901, 149.
52 Ibid., 150n.
53 Gelfand, "Sigmund-sur-Seine: Fathers and Brothers in Charcot's Paris," 52n7.
54 Freud, *The Psychopathology of Everyday Life, SE* 6, 150n.
55 Freud, *The Interpretation of Dreams, SE* 5, 583–584.
56 Michael Camille, *The Gargoyles of Notre-Dame: Medievalism and the Monsters of Modernity* (Chicago, IL: University of Chicago Press, 2009), 257–268.
57 Freud, *The Interpretation of Dreams, SE* 5, 469.
58 Camille, *The Gargoyles of Notre-Dame*, 248, fig. 233.
59 Ibid., 45.
60 Ibid., 21.
61 Ibid., 49–50; Freud, *The Interpretation of Dreams, SE* 5, 583.
62 Camille, *The Gargoyles of Notre-Dame*, 260–262.
63 Mary Bergstein, *Mirrors of Memory: Freud, Photography, and the History of Art* (Ithaca, NY; London: Cornell University Press, 2010), 86–93.
64 Désiré-Magloire Bourneville and Paul-Marie-Léon Regnard, *Iconographie photographique de la Salpêtrière*, 3 vols. (Paris: Bureaux du progrès médicale and Bibliothèque de la faculté de médecine, 1876–1880).
65 Camille, *The Gargoyles of Notre-Dame*, 268.
66 Freud's first letter to Martha Bernays from Paris, dated October 19, 1885, mentions a brief visit to the Louvre, and among the details of what he saw were "winged human animals … real sphinxes, a dreamlike world." Freud, *Letters of Sigmund Freud*, 173–174.
67 The most comprehensive discussion of Schmidt's vision for the *Neugotik* is found in the catalogue of an exhibition organized in Vienna to commemorate the hundredth anniversary of his death: *Friedrich von Schmidt (1825–1891): Ein gotischer Rationalist*, ed. Peter Haiko and Renata Kassal-Mikula (Vienna: Museen der Stadt Wien, 1991).
68 József Sisa, "Neo-Gothic Architecture and Restoration of Historic Buildings in Central Europe: Friedrich Schmidt and His School," *The Journal of the Society of Architectural Historians* 61, no. 2 (June 2002): 170–171.
69 For a detailed account of the Rathaus project, consult Ulrike Planner-Steiner, "Friedrich von Schmidt," in *Die Weiner Ringstrasse: Bild Einer Epoche*, ed. Renate Wagner-Rieger, vol. 8 (2) (Wiesbaden: Franz Steiner, 1978), 20–51.
70 Anthony Alofsin, *When Buildings Speak: Architecture as Language in the Habsburg Empire and Its Aftermath, 1867–1933* (Chicago, IL; London: University of Chicago Press, 2006), 22.
71 Ákos Moravánszky, *Competing Visions: Aesthetic Invention and Social Imagination in Central European Architecture, 1867–1918* (Cambridge, MA: MIT Press, 1998), 73.

72 Planner-Steiner, "Friedrich von Schmidt," 30. For illustrations of Schmidt's submissions for the Rathaus project, see Haiko and Kassal-Mikula, *Friedrich von Schmidt (1825–1891)*, 105–112.

73 For a list of Schmidt's students, with brief biographical details when known, see Haiko and Kassal-Mikula, *Friedrich von Schmidt (1825–1891)*, 231–238.

74 Sisa, "Neo-Gothic Architecture," 178–183.

75 Haiko and Kassal-Mikula, *Friedrich von Schmidt (1825–1891)*, 129–130 (fig 2.80).

76 Bob Martens et al., *Wiener Synagogen: ein Memory=Viennese Synagogues: A Memory* (Vienna: Jüdisches Museum Wien, 2016), 71.

77 Fredric Bedoire, *The Jewish Contribution to Modern Architecture: 1830–1930* (Stockholm: KTAV Publishing House, 2004), 328, 330.

78 Freud wrote to Fliess on October 26, 1896, that "yesterday we buried the old man, who died during the night of October 23" (*Freud-Fliess Letters*, 201). There is a photograph of the family at the Zentralfriedhof, attributed to Freud's younger brother Alexander and dated to the summer of 1897, on the occasion of the dedication of Jacob Freud's gravestone. Michael Molnar, *Looking through Freud's Photos* (London: Karnac, 2015), 10. For a reproduction of the photograph, in the collection of the Freud Museum, London, refer to Janine Burke, *The Sphinx on the Table: Sigmund Freud's Art Collection and the Development of Psychoanalysis* (New York: Walker, 2006), pl. 40.

79 Sigmund Freud, "Address to the Society of B'nai B'rith," *SE* 20, 1926, 273–274. The dates and topics of Freud's lectures preface this, on p. 272.

80 Wilhelm Knöpfmacher, *Entstehungsgeschichte und Chronik der Vereinigung "Wien": B'nai B'rith in Wien: 1895–1935* (Vienna: C. Pick, 1935), 33. My appreciation to Dr. Markus Patka, of the Jewish Museum Vienna, for making the records of the B'nai B'rith in the Israelitische Kultusgemeinde available to me.

81 *Freud-Fliess Letters*, 410–411.

82 Knöpfmacher, *Entstehungsgeschichte*, 33. Fleischer spoke on the Rathaus on March 8; Freud addressed the group on Zola the following month, on April 24.

83 *Neue Freie Presse*, January 30, 1891 (evening edition), 2. An earlier obituary, perhaps also authored by Fleischer, was published in the *NFP* on the day after Schmidt's death, January 24 (6).

84 Max Fleischer, *Friedrich Freiherr v. Schmidt als Mensch, Lehrer und Chef* (Vienna: Selbstverlag des Verfassers, 1891).

85 *Neue Freie Presse*, Oct 31, 1869, 1, quoted by Alofsin, *When Buildings Speak*, 20n8. March 13, 1848, was the date of an important demonstration in Vienna.

86 Knöpfmacher, *Entstehungsgeschichte*, 41.

87 Richard S. Geehr, *Karl Lueger: Mayor of Fin de Siècle Vienna* (Detroit, MI: Wayne State University Press, 1990), 89.

88 Freud placed a notice in at least two Viennese newspapers announcing the opening of his practice at Rathausstrasse 7: *Kleine Chronik* on April 24, the day prior to beginning his practice there, and *Neue Freie Presse* on the next day. Peter Gay, *Freud: A Life for Our Time* (New York: Doubleday, 1988), 662n, referring to 53.

89 Planner-Steiner, "Friedrich von Schmidt," 58–61; Haiko and Kassal-Mikula, *Friedrich von Schmidt (1825–1891)*, 144–147.

90 While the toll of the fatalities remains contested, the figure cited here seems the most accurate. A. Klein, "Die Identifizierung durch die Zähne bei Brandkatastrophen. Ihre forensische Bedeutung," *Schweizerische Monatsschrift für Zahnheilkunde* 38, no. 10 (1929): 607–628.

91 Anna Freud Bernays, "My Brother, Sigmund Freud," in *Freud as We Knew Him*, ed. Hendrik M. Ruitenbeek (Detroit, MI: Wayne State University Press, 1973), 146.

92 Administration des k. Stiftungshauses. Papers. Haus-, Hof- und Staatsarchiv, Vienna.

93 Ibid.

94 Julius von Newald et al., *Der Prozess über die Ringtheater-Katastrophe* (Vienna: Verlag Moritz Perles, 1882).

95 Haiko and Kassal-Mikula, *Friedrich von Schmidt (1825–1891)*, 86–89.

96 Among leases issued by the "Administration des k. Stiftunghauses Wien" for its first occupants, one can find Freud's agreement, dated July 19, 1886. He stipulated as a condition of the signing that the plaque be placed on the building on the Maria Theresienstrasse side. Affixed to this agreement was Freud's card, listing him as a "Dozent" of the University in "nervous diseases," and, in his own hand, his current address of "I (designation for the first, or inner, district) Rathausstrasse 7."

97 Private communication, Friedrich Schmidt Archive, Museum of the City of Vienna, various dates, 2015–2016.

98 Administration des k. Stiftungshauses Wien. Papers.

99 Bernays, "My Brother, Sigmund Freud," 146. See also Siegfried Bernfeld and Suzanne Cassirer Bernfeld, "Freud's First Year in Practice, 1886–1887," in *Freud as We Knew Him*, ed. Hendrik M. Ruitenbeek (Detroit, MI: Wayne State University Press, 1973), 252–265.

100 This quote is from a letter from Freud to his friend Carl Koller, of October 18, 1886. Hortense Koller Becker, "Carl Koller and Cocaine," *Psychoanalytic Quarterly* 32 (1963): 358.

101 Letter to Minna Bernays, August 25, 1886. Ernst Freud et al., *Sigmund Freud: His Life in Words and Pictures* (New York: W.W. Norton, 1998), 131.

102 Martin Freud, *Sigmund Freud: Man and Father* (New York: Vanguard, 1958), 24.

103 The police records regarding the death of Pauline Silberstein have been lost and the only surviving accounts, in some instances quite conflicting, occurred in the various newspaper reports in the days after her death (see n115). The only other record that offers any insight is the log from

the ambulance company that brought her body from the Sühnhaus to the morgue (see n118).

104 Sigmund Freud, *Letters of Sigmund Freud to Eduard Silberstein:1871–1881*, Arnold J. Pomerans, ed. (Cambridge, MA: Belknap Press of Harvard University Press, 1990). The introduction by Walter Boehlich offers a summary of the friendship; information on Pauline occurs at the conclusion, in a note by Silverstein's granddaughter, Rosita Braunstein Vieyra, 190–194. For a reference to her conversation with Anna Freud, see 192.

105 *Freud-Fliess Letters*, 48, May 15, 1893.

106 John Forrester, *The Seductions of Psychoanalysis: Freud, Lacan and Derrida* (Cambridge; New York: Cambridge University Press, 1990), 38.

107 This date is consistent with various newspaper accounts and the report from the ambulance service.

108 Freud, *Letters of Sigmund Freud to Eduard Silberstein*, 192.

109 Ibid., [xiii]–xv.

110 Rubén Gallo, *Freud's Mexico: Into the Wilds of Psychoanalysis* (Cambridge, MA; London: MIT Press, 2010). For specific discussions of Pauline Silberstein, refer to Gallo, "Freud's Spanish: Bilingualism and Bisexuality," *Psychoanalysis and History* 11, no. 1 (2009): 23–26.

111 Daniel Boyarin, "Fliess's Baby, Freud's Maybe," in his *Unheroic Conduct: The Rise of Heterosexuality and the Invention of the Jewish Man* (Berkeley, CA, CA: University of California Press, 1997), 189–220.

112 Freud, *Letters of Sigmund Freud to Eduard Silberstein*, 192.

113 James W. Hamilton, "Freud and the Suicide of Pauline Silberstein," *The Psychoanalytic Review* 89, no. 6 (2002): 889–909.

114 Ibid., 906.

115 Sigmund Freud, "Contributions to a Discussion on Suicide," *SE* 11, 1910, 231–232. There was a second suicide, of a recent patient of Freud's, that he does acknowledge, very much in passing, in a letter to Fliess of April 25, 1900: "The patient whom I treated for fourteen days and then dismissed as a case of paranoia has hanged herself in a hotel room (Mrs. Margit Kremzir)." *Freud-Fliess Letters*, 411. An obituary notice for Margit Weiss de Szurda Kremzir appeared in the *Neue Freie Presse* on April 21, 1900; the death had occurred the day before. All of her family, including a husband and two children, appeared to be from Budapest, although she, like Pauline, was buried in Vienna's Zentralfriedhof. *Neue Freie Presse*, April 21, 1900, 4. My thanks to Adele Tutter for calling my attention to this passage in Freud's letter.

116 Translated by Hamilton, 890. Other newspaper accounts include *Fremdenblatt*, no. 133 (May 15, 1891), 4, where she was reported to have recently arrived from Romania; *Illustriertes Wiener Extrablatt*, Nr. 133, 15. 5. 1891, 4 (her name is given as "Caroline"); *Wiener Tagblatt*, Nr. 133, 15. 5. 1891, 5 and, as cited subsequently, *Die Presse*, where Freud's name is misreported. Ingrid Ramirer of the library of the University of Vienna was of invaluable help in finding these reports; thanks also to Maya

McKechneay for sharing her research into the history of the Sühnhaus and the buildings on the site before and after it.

117 *Die Presse*, May 15, 1891, 5.

118 The report of the transport of Pauline's body by Wiener Freiwillige Rettungsgesellschaft (Vienna ambulance service) from the Sühnhaus to the Schottenring morgue indicates that she was being treated at an institution for nervous disorders in Hacking, a section of the thirteenth district. Archives of the Rettungsgesellschaft, entry dated May 14, 1891, 16:45 (4:45 p.m.). It was called the "Bellevue" sanatorium, and an interesting coincidence was that Freud would go on, four years after Pauline's death, to privilege a guest house of the same name, on the periphery of Vienna, as the place where he would claim to have understood the "secret of dreams" (see Chapter 5). All records of the clinic have been lost, but its senior physician at that time was Holländer, who held a similar university position in the same medical specialization as Freud, and had been a friend of Freud's for a number of years (his name appears in letters written to Martha during their engagement). It is thus likely that Freud recommended this place, and Holländer, to the Silbersteins. Among the Freud biographies, Crews's offers the most detailed discussion of Pauline Silberstein's death, characterizing it as "a skeleton in his [Freud's] closest," yet one that, without a "smoking gun," will not allow us to know the extent to which Freud was in any way culpable. *Freud: The Making of an Illusion*, 255–257. He refers to the possibility that Pauline herself lived in the Sühnhaus, but evidence citing her residence at the Hacking Sanatorium, along with no mention of the Silberstein name in a roster of the residents there in 1891, would suggest this was one of numerous reporting errors surrounding the case.

119 Freud, *Letters of Sigmund Freud to Eduard Silberstein*, 192.

120 Ibid., 56.

121 Gallo, *Freud's Spanish*, 26.

122 Freud, "An Autobiographical Study," *SE* 20, 1925, 18.

123 Administration des k. Stiftungshauses Wien. Papers.

124 For all the literature devoted to Freud's working spaces at Berggasse 19, those familiar rooms were only in use after 1908. When the family moved in there from the Sühnhaus in 1891, Freud established his office in a different area on the same floor as his later rooms, but would move downstairs as the need for space grew with the births of three more children. In 1896, he relocated to the ground floor, where his office remained until his sister Rosa and her family moved out of their apartment, next to the Freuds, enabling him to move back upstairs in 1908, where he saw patients and wrote for the next thirty years. Little has been written about the ground floor office, although it does figure in Papapetros's essay on the treatment of Freud's patient Ida Bauer ("Dora"), which took place there. Refer to "*Drop* Form: Freud, Dora, and Dream Space," in *Private Utopia: Cultural Setting of the Interior in the 19th and*

20th Century, ed. August Sarnitz and Inge Scholz-Strasser (Berlin; Boston: DeGruyter, 2015), 83–86, floorplans of the offices, 85, figs. 4.8, 4.9.

125 On November 22, 1896, Freud writes to Fliess that he is "the first person to whom I am writing from my new quarters." *Freud-Fliess Letters*, 203.

126 Ibid., letter of December 6, 1896, 214.

127 Mayer, *Sites of the Unconscious*, 156–160.

128 Christfried Tögel, "Freud, die Couch und Familie Benvenisti," *Luzifer-Amor: Zeitschrift zur Geschichte der Psychoanalyse* 59 (2017): 172.

129 The extended Benvenisti family were dealers in rugs and interior furnishings. See *Handels- und Gewerbs-Schematismus von Wien und dessen nächster Umgebung* (Vienna: Förster and Bartelmus, 1885), 12.

130 Lydia Marinelli, ed., *Die Couch: Vom Denken im Liegen* (Munich: Sigmund Freud Privatstiftung/ Prestel, 2006). Also, Marinelli, "Die Couch: Vorstellungen eines Mobels," in *Tricks der Evidenz: Geschichte psychoanalytischer Medien*, ed. Marinelli and A. Mayer (Vienna: Turia+Kant, 2009), 251. More recently, Nathan Kravis has located the presence of the couch in Freud's psychoanalytic practice within an impressive historical and visual review of the significance of "recumbent speech." See *On the Couch: A Repressed History of the Analytic Couch from Plato to Freud* (Cambridge, MA; London: The MIT Press, 2017).

131 Sigmund Freud, "L'Hérédité et l'étiologie des névroses," *Revue neurologique* 4, no. 6 (1896): 161–169. An English translation appears as "Heredity and the Aetiology of the Neuroses," *SE* 3, 1896, and contains the first published mention of psychoanalysis, 151.

132 For two excellent essays on Freud's relationship to his working spaces at Berggasse 19, see Diana Fuss (with Joel Sanders), "Freud's Ear: Berggasse 19, Vienna, Austria," in Diana Fuss, *The Sense of an Interior: Four Rooms and the Writers That Shaped Them* (New York; London: Routledge, 2004), 71–105, and Susan Bernstein, "Housing Freud" in *Housing Problems: Writing and Architecture in Goethe, Walpole, Freud, and Heidegger* (Stanford, CA: Stanford University Press, 2008), 89–120. Contemporary implications for these rooms, as a museum without its original contents, is thoughtfully considered in Joanna Morra's "Seemingly Empty: Freud at Berggasse 19, a Conceptual Museum," *Journal of Visual Culture* 12, no. 1 (2013): 89–127.

133 *Friedrich von Schmidt*, 78, fig. 1.34.2.

134 Ibid., 78, fig. 1.34.3.

135 Freud, "The Aetiology of Hysteria," *SE* 3, 191–221.

136 *Saxa loquuntur* was a phrase known to appear in Latin texts, but it was appropriated into popular usage considerably later. Ubiquitous are references to the term, by the nineteenth century, as a moniker for the study of classical inscriptions. Schmidt offers an interesting revisioning of this, as his speaking stones are architectural rather than epigraphic.

137 *Freud-Fliess Letters*, 150, November 8, 1895. Freud wrote that after being quite abstemious with his cigar smoking, he "overindulged out of sheer joy on the day of Lueger's nonconfirmation."

138 For the dates of its serialized appearance, see the preface to "Aetiology,"
 SE 3, 189.
139 Ibid., 192.
140 Rachel B. Blass and Bennett Simon, "Freud on His Own Mistake(s):
 The Role of Seduction in the Etiology of Neurosis," *Psychiatry and the
 Humanities* 12 (1992): 160–183. See George Makari, "Towards Defining the
 Freudian Unconscious: Seduction, Sexology and the Negative of Perversion
 (1896–1905)," *History of Psychiatry* 8 (December 1997): 459–485, for an
 excellent overview of the currents in sexology discourse on adult abusers
 and incest that influenced Freud's convictions, in 1896, of the veracity of
 such abuse. For another important perspective, see Larry Wolf, *Child Abuse
 in Freud's Vienna: Postcards from the End of the World* (New York; London:
 New York University Press, 1988), esp. 204–210.
141 There is some confusion as to the precise date of the lecture, for, as
 Strachey notes in his "editor's note" preceding the "Aetiology" essay in the
 Standard Edition, a citation in a Viennese medical review noted its date
 as May 2, but as Strachey notes, Freud's correspondence with Fliess would
 support an earlier date, as Freud mentions to Fliess that he will deliver
 a talk on April 21, and then a week later, in two letters, reports on its
 poor reception. If that is the correct date, then it occurred literally at the
 moment of Lueger's election to the mayorship of Vienna. Several days later,
 negotiations between Lueger and the emperor about his appointment as
 mayor took place, and although Lueger would acquiesce, the selection of
 Josef Stol (with Lueger as vice mayor) was widely regarded as tantamount
 to the emperor's confirmation, which would occur a year later.
142 Sigmund Freud, "Heredity and the Aetiology of the Neuroses," *SE* 3, 1896,
 143–156; and "Further Remarks on the Neuro-Psychoses of Defence," *SE* 3,
 1896, 162–185.
143 Freud, "Heredity and the Aetiology of the Neuroses," 149.
144 Ibid., 152.
145 *Freud-Fliess Letters*, 184.
146 Ibid., 185, letter dated May 4, 1896.
147 Sabine Hake, "*Saxa loquuntur*: Freud's Archaeology of the Text," *boundary
 2* 20, no. 1 (1993): 146–173.
148 Ranjana Khanna, *Dark Continents: Psychoanalysis and Colonialism*
 (Durham, NC: Duke University Press, 2003).
149 Richard H. Armstrong, *A Compulsion for Antiquity: Freud and the Ancient
 World* (Ithaca, NY; London: Cornell University Press, 2005), 113, 114–117
 (Schliemann); 117–120 (Löwy).
150 Ibid., 117–120; for the most detailed discussion of Löwy's archaeological
 experiences in Turkey, see Hubert D. Szemethy, *Die Erwerbungsgeschichte
 des Heroons von Trysa* (Vienna: Phoibos, 2005); various references in the
 text, brief biographical essay, 327, photographs, pls. 22.1, 33.1.
151 "The Aetiology of Hysteria" *SE* 3, 192.

152 Armstrong, *A Compulsion for Antiquity*, 114–117, offers the most nuanced reading of Freud's relationship to Schliemann.

153 Gilbert Wiplinger, Gudrun Wlach, and Kurt Gschwantler, *Ephesus. 100 Years of Austrian Research* (Vienna: Böhlau, 1996), 14–16.

154 Pausanias, *Guide to Greece*, trans. P. Levi (Baltimore, MD: Penguin, 1971), 43.

155 For a fuller consideration of these empiricist strategies within the discourses of Austrian archaeology at the close of the nineteenth century, see my "Mapping the Unconscious: Freud's Topographic Constructions," *Visual Resources* 23, nos. 1–2 (2007): 109–113.

156 Vassiliki Kolocotroni, "'Writers among the Ruins': Freud, Conrad, and the Psychomythology of Memory," *English* 59, no. 225 (2010): 154–173.

157 Ibid.

158 Diane O'Donoghue, "Negotiations of Surface: Archaeology in the Early Strata of Psychoanalysis," *Journal of the American Psychoanalytic Association* 52, no. 3 (2004): 653–671.

159 Slavoj Žižek, *Looking Awry: An Introduction to Jacques Lacan through Popular Culture* (Cambridge, MA; London: MIT Press, 1991), 118.

160 Ibid., 126.

161 Spyros Papapetros, *On the Animation of the Inorganic: Art, Architecture, and the Extension of Life* (Chicago, IL; London: University of Chicago Press, 2012), 213.

162 Salman Akhtar, "The Compulsion to Betray and the Need to Be Betrayed," in *Betrayal: Developmental, Literary, and Clinical Realms*, ed. Salman Akhtar (London: Karnac, 2013), 117–118n2.

163 Ibid., 133n2.

164 Ibid., 132.

165 Jacques Lacan, *The Ethics of Psychoanalysis, 1959–1960: The Seminar of Jacques Lacan, Book VII, 1959–1960*, ed. Jacques-Alain Miller, trans. Dennis Porter (New York: W.W. Norton, 1992), 136.

166 Ibid.

167 Ibid., 135.

168 Ibid.

169 Tom Conley, "The Wit of the Letter: Holbein's Lacan," in *Vision in Context: Historical and Contemporary Perspectives on Sight*, ed. Teresa Brennan and Martin Jay (New York; London: Routledge, 1996), 48–52.

170 Lacan, *The Four Fundamental Concepts of Psychoanalysis: The Seminar of Jacques Lacan, Book XI*, ed. Jacques-Alain Miller, trans. Alan Sheridan (New York; London: W.W. Norton, 1981), 92.

171 Lacan, *The Ethics of Psychoanalysis, Book VII*, 74.

172 Ibid.

173 Papapetros, *On the Animation of the Inorganic*, 268–270.

174 Ibid., [269], fig 6.3. Original source, refer to Sigmund Freud, "Project for a Scientific Psychology," *SE* 1, 1895, 314, fig.13; 324, fig. 14.

175 Papapetros, *On the Animation of the Inorganic*, 272.

176 Sigmund Freud, *Briefe an Wilhelm Fliess: 1887–1904*, ed. Jeffrey Moussaieff Masson and Michael Schröter, 2nd ed. (Frankfurt am Main: S. Fischer, 1999), Letter of May 2, 1897, 253.

177 *Freud-Fliess Letters*, 238–252.

178 William J. McGrath, *Freud's Discovery of Psychoanalysis: The Politics of Hysteria* (Ithaca, NY; London: Cornell University Press, 1986), particularly his fourth chapter, "The Architecture of Hysteria," 152–196.

179 Ibid., 191–196.

180 *Freud-Fliess Letters*, 237, letter dated April 28, 1897.

181 Ibid., 239, letter dated May 2, 1897.

182 McGrath, *Freud's Discovery of Psychoanalysis*, 191.

183 The work of Carl Schorske has been decisive in framing Freud's work after 1897 as part of a "social and intellectual withdrawal" enabling him to "detach psychic phenomena from the anatomical mooring" of the contemporary discourses. *Fin-de-Siècle Vienna: Politics and Culture* (New York: Vintage Books, 1981), 185–186.

184 Ibid., 183.

185 Michael Steinberg, "'Fin-de-siècle Vienna' Ten Years Later: 'Viel Traum, Wenig Wirklichkeit,'" *Austrian History Yearbook* 22 (1991): 158.

186 Franz Baumann, *Vom älteren Flussbau in Österreich* (Vienna: Springer, 1951).

187 *Brockhaus' Konversations-Lexicon*, 14th ed. (Leipzig: Brockhaus, 1892), 632.

188 Ludwig von Förster was the editor of a large series of reports under the title of *Allgemeine Bauzeitung* ("General Building Newspaper") on architectural projects in Vienna. For a discussion of the "*Schutzbauten*" in the period of Freud's youth, refer to vol. 30 (Vienna: R. von Walheim, 1887), 227.

189 Freud's use of the word *Abwehr*, usually translated as "defense," was particularly evident in his earlier writings, where the term appears in the work of the 1890s, frequently in work on hysteria. For the best overview of his usage, see entries for "defence" in J. Laplanche and J.-B. Pontalis, *The Language of Psychoanalysis*, trans. Donald Nicholson-Smith (New York; London: W.W. Norton, 1973), 103–111. The etymology of *Abwehr* is noteworthy: "*Wehr*" can refer to arms or a weapon, but it is also the term that translates as a "weir" or a dam in English. In this usage, it is synonymous with *Schutzbauten*, as both are protections against water.

190 Freud noted using words that served as a "protective formula" with one of his early patients, Fanny Moser ("Emmy von N)." See Sigmund Freud, *Studies on Hysteria*, SE 2, 1895, 49.

191 "Draft K: The Neuroses of Defence (A Christmas Fairy Tale)" was appended to a letter on January 1, 1896. See *Freud-Fliess Letters*, 162–169. Larry Wolf suggests that the subtitle followed a grim precedent in a recent issue of the *Neue Freie Presse*, an article on an infamous case of child abuse, the "Kutschera case," with excerpts from Snow White and Cinderella (Wolf, *Child Abuse,* 204–205).

192 *Freud-Fliess Letters*, 234.
193 All quotes to follow that relate to the letter and accompanying "Draft L" of May 2, 1897 are from *Freud-Fliess Letters*, 238–242.
194 Laplanche and Pontalis, 222.
195 Freud, "Project for a Scientific Psychology," *SE* 1, 297.
196 Frank J. Sulloway, *Freud, Biologist of the Mind: Beyond the Psychoanalytic Legend* (New York: Basic Books, 1979; Cambridge, MA; London: Harvard University Press, 1992), 387–388.
197 For the original usage, see Sigmund Freud, "Der Mann Moses und die monotheistische Religion," *GW* 16, 1939, 206, 208. Translated as "experience of our ancestors," it appears in *Moses and Monotheism, SE* 23, 1939, 99, 101. For Freud's use of the related phrase "archaic knowledge" (*archaischen Erbschaft*), also appearing in this portion of the text, see Strachey's comments, 102n1.
198 Ibid., 99 [English].
199 *Freud-Fliess Letters*, 202; *Freud-Fliess Briefe*, 213.
200 *Freud-Fliess Letters*, 230–231.
201 Patricia Cotti, "Freud and History before 1905: From Defending to Questioning the Theory of a Glorious Past," *Psychoanalysis and History* 10, no. 1 (2008): 11.
202 *Freud-Fliess Letters*, 225. Eric Kandel, in his far-ranging analysis of Vienna's role as a nexus of scientific and cultural exchange, considers that the death of Jacob Freud was the traumatic "personal context" in which "the progression of Freud's thinking from a biological to a psychological exploration of mind began." See *The Age of Insight: The Quest to Understand the Unconscious in Art, Mind, and Brain from Vienna 1900 to the Present* (New York: Random House, 2012), 63.
203 For a discussion of this issue, refer to Masson's note, *Freud-Fliess Letters*, 225, n2.
204 Freud, *The Interpretation of Dreams, SE* 4, xxvi.
205 *Freud-Fliess Letters*, 243, letter dated May 16, 1897.
206 Didier Anzieu, *Freud's Self-Analysis*, trans. Peter Graham (Madison, CT: International Universities Press, 1986), 221.
207 *Freud-Fliess Letters*, 205, letter dated December 4, 1896. For an early discussion of the epigraph as it appears in *Die Traumdeutung,* see Walter Schönau, *Sigmund Freuds Prosa: Literarische Elemente seines Stils* (Stuttgart: J.B. Metzlersche, 1968), 61–73, with a later analysis offered by Jean Starobinski, "Acheronta Movebo: Nachdenken über das Motto der 'Traum-deutung,'" in *Hundert Jahre "Traumdeutung" von Sigmund Freud*, ed. I. Grubrich-Simitis (Frankfurt am Main: Fischer, 1999), 11–48.
208 *Freud-Fliess Letters*, 241, letter dated May 2, 1897.
209 Stefan Zweig speaks of this practice as an alternative to having the sons of a household engage with prostitutes; see his *The World of Yesterday* (Lincoln, NE; London: University of Nebraska Press, 1964), 81; reproduced from the first edition, Viking Press, 1943.

210 Sander L. Gilman, *Difference and Pathology: Stereotypes of Sexuality, Race, and Madness* (Ithaca, NY; London: Cornell University Press, 1985), 57.

211 *Freud-Fliess Letters*, for "Draft M" and accompanying letter, 245–248.

212 Whitney Davis, *Drawing the Dream of the Wolves: Homosexuality, Interpretation, and Freud's "Wolf Man"* (Bloomington; Indianapolis, IN: Indiana University Press, 1995), 82–83.

213 All quotations in this paragraph are found in "Draft N" and the accompanying letter. *Freud-Fliess Letters*, 249–253.

214 Ibid., 249, letter dated May 31, 1897.

215 Ibid.

216 Ibid.

217 Anzieu, *Freud's Self-Analysis*, 222.

218 *Freud-Fliess Letters*, 250.

219 Ibid.

220 Ibid., 251.

221 Harald Weinrich, *Lethe: The Art and Critique of Forgetting*, trans. Steven Rendall (Ithaca, NY; London: Cornell University Press, 2004), 3.

222 *Freud-Fliess Letters*, 251.

223 Ibid., 254, letter dated June 22, 1897.

224 Ibid., 255, letter dated July 7, 1897.

225 Ibid., 261, letter dated August 14, 1897.

226 Ibid., 262, letter dated August 18, 1897.

227 Ibid.

228 Ibid., 263, letter written in Siena and dated September 6, 1897.

Phantasmal Fragments

During the course of 1897, in both Freud's aesthetic and analytic aspirations, we can identify a turn away from an earlier privileging of what he posited as "historical memory," one that had consistently located its precipitates in external phenomena, whether the cultural factors that informed the visual creation of objects or the reconstruction of the exquisitely painful scene of childhood abuse. These new ways to approach artistic and psychical productions were not precisely concomitant, however. Freud voiced his new understanding of visual culture in late August and early September 1897. It would be from Siena, in a letter dated September 6, that he would write to Fliess of his desire to erase his previous attachments to historical details, freeing him to experience the "art of Italy" afresh. The next letter he wrote would be immediately upon his return to Vienna, on September 21, and it is here that he reveals his decision to leave aside the psychical equivalent of "cultural–historical interest." In arguably one of the most consequential pieces of all of Freud's voluminous correspondence, he announces here to Fliess that he is abandoning his belief in the veracity of early sexual assault as the origin of hysteria.[1] Rather, he will give voice to what had been already evident in his structural transitions of the May before: he will now ascribe these stories to the workings of the patient, and sexual fantasy that "invariably seizes upon the theme of the parents."[2] Thus, what had been previously imagined as what he termed "genuine," and involving the pernicious impact of external desires upon another, is now directly solely onto the child, whose fantasies and desires will, from now on, be the focus of the psychoanalytic project. Yet, it is important to note, as cited in the previous chapter, that Freud in fact never fully abandoned his belief in the traumatic events of childhood; rather, the transition here is better posited as a shift in the assigning of value, one that after the autumn of 1897 would be dictated by new criteria for what would be privileged as psychically meaningful.

This chapter will conclude with a discussion of the letter of September 21, prefaced by a narrative—the missive's visual prologue perhaps—that, despite the vast and impressive bibliography that arose from this document, has not been discussed in relation to one of the most fundamental turning points in Freud's understanding of psychical life. Freud inaugurated something else,

just a bit earlier that month. It is from his Italian holidays that we have the first record that he "purchased antiquities" (*Altertümer eingekauft*, he writes in a postcard to his wife),[3] beginning a collection that would eventually fill virtually all the surfaces of his working spaces at Berggasse 19.

If Freud had wished for a "punch" from Lethe during his time in Italy, perhaps he had his strongest draught in Orvieto. Not only would he encounter a depiction of this amnesic river on the walls of the Duomo there, but he would later reenact its powers when he could not recall the name of the artist, Luca Signorelli, whose face stared out at him just above the lunettes that depicted Dante's journeys in hell. We will turn to that incident in Chapter 4, as it forms the basis of Freud's first published work on the actual functioning of the unconscious; its subject is the "psychical mechanisms of forgetting."[4] But there is another incident that connected, for Freud, the drinking of classical waters with this Umbrian town, and like the Signorelli "parapraxis," it occurred after his visit. It appeared—in the guise of what he would characterize as among our "mental antiquities"[5]— in a dream. Freud would recall, in the months after his visit, that he had experienced the sensation of thirst while asleep, and dreamt that his wife offered him a drink.[6] While Freud characterizes this image as "appropriate" to the desire to satiate such a need, the vessel handed to him was far from

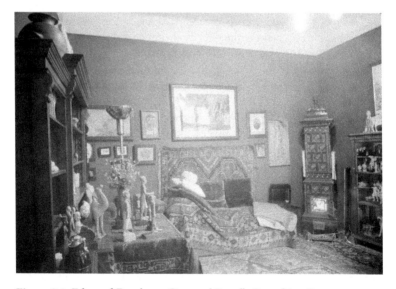

Figure 2.1 Edmund Engelman. Sigmund Freud's Consulting Room, Berggasse 19, May 1938. ©1976 Thomas Engelman.

typical. Although there was a glass of water "standing on the table by my wife's bed," in the dream she hands him an "Etruscan cinerary urn" whose ashen contents make the water taste "so salty" that Freud is obliged to wake up. Thus, he contends, although he can dream of having this physical need met (unlike, he notes, "my thirst for revenge"), its unsatisfying content actually functioned to rouse him; perhaps then he sought out that water glass nearby. This memory, appearing quite early in *The Interpretation*, was introduced as evidence that wish-fulfillment lay at the core of dreaming; Freud cites a rare doctoral dissertation on dreams, published in 1893 by Wilhelm Weygandt, to support the frequent "occurrence of thirst dreams,"[7] and in 1914 adds a far earlier source, appending a quotation of biblical origin that "a thirsty man dreamth, and, behold, he drinketh" from the book of Isaiah.[8] Interestingly, he does not pursue any of the dream's possible classical associations, although his Italian travels in 1897—prefaced by a wish to drink from other death-laced waters—resulted in the Etruscan vessel that figures here.

Indeed, this dream provides the only record of what appears to be the origins of Freud's collection of antiquities—of a material rather than psychical kind—although the blurring of these boundaries, as shown in this example, is certainly suggestive. In Freud's desire in *Die Traumdeutung* to fulfill another need—for an incontrovertible example of his master mechanisms of the dream work—he leaves other issues occasioned by the appearance of this significant object unaddressed. One of the most provocative was literally enacted in the dream itself: the way this early object, in coming into his possession, could function to satisfy a pressing need, one strikingly unrelated to its intended purpose. This dream may introduce not only the first of Freud's "antiquities" but also the way such an acquisition functioned to produce, as seen here, the mechanisms of fantasy. But by this is meant something that differs from the usual reading of Freud's relationship to his collection, often posited as an exemplar of what Richard Armstrong terms Freud's "compulsion for antiquity."[9] Indeed, the image on the cover of Armstrong's study of this name—the well-known etching of 1914 by Max Pollak of Freud seated at his desk with some of his objects surrounding him—certainly suggests this. But within the pages of Armstrong's important and original contribution to an understanding of Freud's relationship to historical constructions, the genealogy of his "antiquities" is not addressed as a consequential participant in his emerging construction of psychoanalysis. As Ellen Handler Spitz aptly observes, it would be a "naïve project" to attempt to find direct correlations between Freud's references to mythological narratives in his psychoanalytic formulations and the objects he collected, although she acknowledges that "deep currents bind them."[10] As we will see, the correlations are less about an

object "illustrating" a Freudian idea, as Handler Spitz notes, than about the fragmentary, phantasmic qualities in which the "antiquity" participated in Freud's formulations at the start. That Freud's inaugural gesture of ownership, directed toward objects of the distant past, occurred at the moment of his turn to the privileging of early fantasy life would appear to be a coincidence certainly worthy of attention.

By considering the possibility of a relationship between these occurrences, a new space of inquiry opens in the discourse of Freud's collection, the latter a topic that already possesses a considerable bibliography and can rightly be considered a rather well-trodden path.[11] In this chapter, I offer a prologue to this literature, and focus exclusively on the purchase of the cinerary urn of Freud's dream and how its acquisition can be located, as mentioned earlier, within Freud's formulations of psychical life in the autumn of 1897. Although the Etruscan vessel will be sited within the transitions occurring in the Freudian unconscious, this does not mean it will be removed from the world of external transactions. Rather, I will argue that Freud's processes of crafting a theory of early sexuality, built around the fragmentary memories and associations offered as evidence of the powerful inner workings of fantasies, were indebted to the manner in which material "antiquities" were selected and assigned value in the marketplace. Thus, the arrival of this early object informed the actual construction of acceptable content within the psychoanalytic project, rather than serving as a visualization of some shared, and often very amorphous, notion of the preservation of the past.

<p style="text-align:center">*****</p>

At the Hotel of the Fine Arts, where you will inevitably go, you will find three other tourists, probably German, sitting silently in a vast room, waiting for dinner, which is the only thing the tourist does after he has seen the Cathedral.

W. L. Alden, "Pleasant Idling Places: Orvieto," 1893.[12]

This account goes on to include another notable distraction, perhaps to be enjoyed on a postprandial stroll. William Livingston Alden—a journalist whose range of writings earned him Mark Twain's respect as a humorist and, as a foreign correspondent, an appointment as the American consul general in Rome—suggested visitors watch for an especially intriguing local souvenir. He recounts, quite erroneously, that the Etruscans who had made this hill town their capital in the eighth century BCE were in the habit of acquiring Greek pottery only to smash it to bits. These fragments, he alerts readers, can be seen in various sleepy curio shops in town, but there is only

one establishment with any activity—and the most beguiling sherds—and that belonged to the "dealer in antiquities."[13] Alden goes on to describe the seemingly diffident young man who presided over this shop. If enough interest was shown in the fragments offered for sale there, he would deign to summon the owner, and the prospective buyer would then be presented with more intact objects. From the shop's own workshop came vessels that were entirely created by these fragments, of both local Etruscan and Greek manufacture, melding into a pastiched surface where "a Greek column unexpectedly turns into an Etruscan woman and ends in a war chariot."[14] The charm of such inventions, the American visitor contends, would seduce even the most jaded antiquarian. But Alden flatters himself here; these fabrications were shown to those tourists the shopkeeper thought would be unwilling to pay for actual objects of Etruscan date, housed in another room; that space of exchange was reserved for those able to afford a more authentic encounter with antiquity. Alden assumed his "idler" in Orvieto to be a male, and in these scenes of antiquity and exchange the only women were the Etruscan figures on the fabricated vessels. But there is evidence of numerous female tourists; extant photographs suggest that groups of women and men were commonly photographed alongside the tombs below the cliffs of Orvieto, where the objects in the shops had previously resided.

Although the Etruscans were known to have willfully broken household vessels in a ritual that would end their life in this world at the death of their owner,[15] such a practice was far from ubiquitous, and not done as a rebuke to the Greeks, as Alden suggests. The fragments that found their way into Orvieto's shops were more likely the result of the deterioration of wooden ceilings that covered the stone sepulchers of a large cemetery complex nestled against the base of the rocky outcropping that had held the center of the town since Etruscan times.

The necropolis, a complex of burials that belonged to about ninety families and dated from 550 to 500 BCE had been yielding objects for two decades before Alden wrote of them. It was in the middle of the 1890s, however, when he visited, that there was increased activity at the site and an ambition to have the material unearthed at the necropolis sold far beyond the antiquity dealer's house off the main square. The purveyor of the fabricated vessels, summoned by his assistant to make a sale, and the excavator of one of the largest and most important Etruscan burial sites, were the same person: Riccardo Mancini, who had been excavating the Etruscan burial sites since 1870s. Mancini was a native of Orvieto whose early life remains essentially unknown, although Lucio Riccetti, in a recent work coauthored with Tiziana Tafani, focuses upon Freud's relationship to Orvieto, and offers valuable insights into Mancini's later pursuits.[16] He may

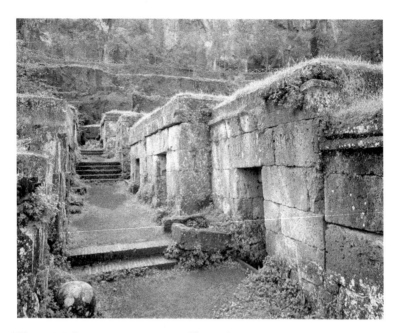

Figure 2.2 Etruscan cemetery site of "Crocifisso del Tufo," Orvieto. (Photo: K. E. DiCero.)

have inherited some property, covered in vineyards and olive groves, and perhaps added more hectares through marriage; it was in these fields that he unearthed a large Etruscan burial complex, dated by inscriptions to the sixth century BCE, beneath a tract of farm land in an area colloquially known as *Crocifisso del Tufo* (The Crucifix of Tuff).[17] The site that would yield such significant pre-Roman finds lay undisturbed and unknown for more than two millennia; the place name dated to the period of Signorelli and thus to Catholic, not Etruscan, Orvieto. A piece of the local stone-like amalgam of lava and ash called *tufo* ("tuff") was found in the shape of a cross during the sixteenth century and became an object of veneration for the local residents, who built a small chapel in the field, located below the rocky outcropping of a long-extinct volcano that held the center of the town. At least part of the site's name would be applicable to what Mancini unearthed there, which is why he probably retained it: the burials, like the cross, were fashioned from the gray igneous material that had formed the landscape of the region in a far earlier epoch.

Mancini was an engineer and excavator by trade,[18] and it was in all likelihood in that capacity that he first uncovered evidence of this cemetery.

By virtue of his unearthings at Crocifisso del Tufo, and other sites in Orvieto in the decade to follow, he would claim serious archaeological credentials, and indeed, by the 1890s, he kept quite thorough records of the tombs that he and his workers uncovered; his reports, arguably quite detailed, on those tombs constitute much of the extant history of the Etruscan presence at Crocifisso del Tufo. However, his excavation activities were not without their detractors in his day, from those who faulted the lack of visual documentation in his reports (perhaps to allow for objects to be dispersed with less accountability) to far more stinging critiques. Gian Francesco Gamurrini, one of the most erudite authorities on Etruscan objects in this era and, as a commissioner of Etruscan antiquities, a forceful advocate for the control of their sales beyond Italy, decried Mancini's practices as scandalous, claiming that the sole motivation for his endeavors was to achieve a quick "financial advantage."[19] Indeed, despite his attempts to create respectable excavation reports, Mancini's decisions frequently betrayed his ultimate motive, that of profit: he often would dig under fallen roofs and stone blocks to reach into the chamber itself, completely disturbing the environment in order to get to the salable grave goods, and, if there was a demand for them, the skeletal remains as well. Most of what was deemed valuable would be taken to Mancini's home, and dispersed from there. If part of the tomb—notably one carved with epitaphs in the enigmatic Etruscan language—was considered of interest to prospective buyers, then it too would be removed and offered for sale.

Recognizing the tourist value of displaying at least a few furnished tombs, Mancini left a series of adjoining burials intact, and cleared the path in front of them. The configuration of Etruscan tombs of this period was distinctive, with an interior that could be entered as though a domestic space, with the bodies (cremation was only sporadically practiced in Etruscan Umbria) placed on stone benches with an array of funerary goods usually gathered together on another bench at the back of the tomb.[20] A decade after Freud visited, Douglas W.B. Sladen, an Oxford-educated travel writer, in his *The Secrets of the Vatican*, described the context from which the Etruscan objects in the Papal collection originated:

> Where a tomb has not been disturbed, armour, jewels, even the soles of shoes, which are made of wood with bronze casings, are found, lying just as they have sunk when the body they contained mouldered away. Some times [*sic*] the bones are left. All sorts of articles of domestic use are found either on the couch or on the ground within reach of it, or suspended by nails from the walls and roof, as we hang articles from a kitchen dresser. There is a tomb belonging to Signor Mancini at Orvieto,

which has been left with everything lying and hanging just as it was found, as an exhibit to make money out of tourists. Signor Mancini owns an Etruscan cemetery, and whenever he makes five hundred francs out of admissions, or selling Etruscan curios, he excavates another tomb. He has turned his curious little palace into a curio shop, though, like the best ladies hat shops, there is nothing to reveal its business outside.[21]

It was very likely that Mancini was in his role as guide at this Etruscan tomb at the time of Freud's visit from September 8 to 10, 1897; letters written to Mancini by a prospective American agent, Arthur L. Frothingham, suggest that he was in Orvieto at that time.[22] Perhaps Freud was expecting to meet him, as Mancini's name and shop were probably already known to him from his travel preparations, whose itinerary differed considerably from the rambles of Alden. The latter's piece about Orvieto for the well-known British journal of humor, *The Idler*, encouraged the guise of tourist as *flâneur*, strolling about with few systematic routes or intentions beyond observing the local landscape and architecture, and partaking in the pleasures of the local food and wines. This impressionistic narrative was in stark contrast to the guides authored by Karl Baedeker, the indispensable travel companions for nineteenth-century German tourists (and in their many later iterations and translations for generations, from many nations, to follow). Freud may well have had a Baedeker volume in hand when he, his brother Alexander, and Felix Gattel, a physician who had come from Berlin to study with Freud,[23] arrived in Orvieto on the evening of September 8 for a two-night stay; he mentioned it as his companion on his previous trip to Italy the year before.[24] A reconstruction of his visit would suggest that he adhered rather closely to Baedeker's suggested itineraries. He was, in certain ways, among those German tourists who Alden noted at the "Fine Arts" Hotel, the Belle Arti, but it would seem that Freud spent little time there. On his first morning, he viewed the cathedral and other sights in the center of the town, and in the afternoon ventured beyond; these details were recorded on two postcards he sent to Martha Freud during his stay. He followed the guidebook's advice to take a side trip to the small village of Bolsena, once an important Roman city, with a stunning lake, only reached after a rather challenging carriage ride from Orvieto.[25] And it would have been in its pages that he may have been first alerted to the excavation activities at the necropolis—highly recommended by his Baedeker—and to the name so inextricably linked to it, as Mancini was cited there as a dealer in antiquities, along with his home address.[26]

Freud would return to Orvieto two more times, in 1902 and 1907, motivated, it would appear, by the wish to acquire more Etruscan objects.[27] After his final visit, he wrote Martha from Rome that he had seen "my

friend Mancini" while in Orvieto.[28] By that time, the laws governing the sale of "antiquities" were changing, and Italians were being restricted from trafficking in them. This may have been the reason that Mancini made Freud an odd offer: the latter reports to his wife that his friend suggested he actually buy fields ("olive and wine groves") where many Etruscan tombs lie undisturbed, presumably so that he could procure the objects as a foreigner, and thus remain beyond the reach of the local legal system. Freud demurred, reporting what he probably told Mancini: he had other work to do. But in his current labor within his psychical terrain, the world of antiquity was certainly not absent; in May 1907, he had completed his lengthy psychoanalytic essay on *Gradiva*, a novella by Wilhelm Jensen.[29] In it, an archaeologist is beguiled by a classical relief of a striding female figure, only to see her come to life as a young woman, who turns out to be a companion from childhood, walking among the ruins of Pompeii. Several days after writing from Rome of his visit to Mancini, Freud will have something of the reverse *Gradiva* encounter, after reading Jensen's popular book and meeting there Zoe Bertgang, the contemporary counterpart. Freud was delighted ("Just imagine my joy")[30] to see the sculptured panel on which Jensen based his story modestly displayed as a part of a set of fragmented reliefs in the Museo Chiaramonti in the Vatican.[31] On this same day, he would have seen a number of Etruscan objects that were far less surprising—those sold to the papal collection by his friend from Orvieto. When Freud speaks at this time of his preference for labors that appear to be quite different from digging beneath the olives trees, there was considerably less distance between the two than this remark would suggest. Not only had he just completed his study of a text where the edges of the physical and psychical fragments blur—the archaeologist, Norbert Hanold, dreams of the relief in his study as Freud dreamed of his urn—but what he came to privilege as the content of his "work" could not be so fully extricated from the early objects embedded in its genealogy.

Freud's activities during his 1897 visit to Orvieto were recorded in two earlier pieces of correspondence sent to his wife, a pair of postcards both dated September 9.[32] These cards would have been local purchases; Baedeker noted that Armoni's photo shop, across from the Duomo, sold souvenirs, maps, and tickets.[33] Images of local sights were popular and were the work of both Armoni, who had earned a certificate in photography in 1879, and his son-in-law, Luigi Raffaelli, who also acquired some technical training prior to his marriage to Adele Armoni.[34] Her father had received a commission to photograph the interior of the Duomo for its six-hundredth centenary in 1889 and from that created folios offered for sale in his shop. Among them was a set devoted to images of the Signorelli cycle executed by another young local photographer, Mario Morelli. Freud purchased one of these, now in the

Freud Museum in London, as well as several postcards featuring scenes of the town taken by Raffaelli. He sent the first one, a panoramic view of Orvieto, on the morning of the ninth, and he described to his wife how the town was built on its rocky perch, accessible by a funicular from the train station below. He mentioned the colorful façade of the Duomo, with its mosaic programs illuminating its exterior. But he also makes another remark about color, one that referred to the town's current residents: "the present inhabitants are as black as 'gypsies' (*Zigeuner*) of ancient Etruria."[35] It is unclear how Freud formed his notions of the appearance of the "Etrurians," the Latin name for the Etruscans, and their elision with communities that had dotted Europe since the fourteenth century, and were derisively called *Zigeuner* in German (a term to be discussed later) and "gypsy" in English. Within these communities themselves, various self-identificatory terms were used, but the pervasive use of the term "Romani" to describe their language was then often shortened to "Rom" or "Roma."[36] Freud had not made an association to these people in other towns of the region; it was as though such a comment was reserved for coming to a location that was known to be an important site of the "pre-Romans," and where such incontrovertible evidence of this ancient occupation would somehow manifest itself in the racial and ethnic alterity of its contemporary citizenry. Certainly, his Gymnasium curriculum would have included accounts of the Etruscans by Ovid and Seneca, and while he speaks in his next post of "*Etruskergräber*" ("Etruscan graves") he uses the Latin designation when he speaks about the current occupants, comparing them to those of "*alten Etrurien*." Had Freud posited an association between the "black" Etruscan descendants and those living in Africa, that melding might have derived from the work of the Viennese Egyptologist, specializing in Coptic scripts, Jacob Krall. In 1892, Krall identified the inscriptions on the linen shrouds of a mummy, long thought to be of Ethiopian origin, as written in Etruscan, raising questions of the relationship between the cultures. It is not known how much contact Freud would have had with the Krall discovery; a point in favor of his familiarity with it is that the shrouds, originally from the National Museum in Zagreb, had been brought to Vienna by Krall in 1891 and were known there.[37]

However, Krall never suggested any connection between the Etruscans and the Roma peoples, whose origins were thought then as now to lie in India, rather than in the continent bordering the southern Mediterranean. The conflation probably speaks to a shared attribute that joined them in the popular imagination of nineteenth-century Europe: practices of divination.[38] Both the Etruscans and Roma, certainly in the dominant cultures of Western Europe by the nineteenth century, were imagined to have special aptitudes in predicting the future, earning these groups' pride of place within the world of

divination: each is associated with a version of tarot. The Etruscan tarot was popular in Freud's time, but the "Zigeuner Tarot" was considered the "bible" of the Roma and very much associated with them; some believed that the game originated in Romani culture. This view was espoused in a widely read book—*Tarot der Zigeuner: Der absolute Schlüssel zur Geheimwissenschaft* (The absolute key to the science of the occult).[39] It is well known that Freud's fondness for cards extended to the Austrian derivative, known as *tarock*, and would suggest that he would have known the popular representations of tarot. While the *alten Etrurien* and *Zigeuner* may have a common shared legacy in this game, they occupied very different positions beyond it. The Etruscans were considered mysterious and powerful; their objects had been taken from their tombs for centuries, and entered into large collections in the Napoleonic era. But the reception of the Roma, who lived throughout western Europe in Freud's time, had far less positive associations, as their German name suggests. Susan Tebbutt, in examining the usages of the verb *zigeunen*, identifies how its meaning—to move about, often in a disordered manner—melded with the notion of unscrupulous behaviors when applied to these residents.[40] Such an association is still perpetuated in popular European imagery and terminologies today, and as Tebbutt starkly shows, remains in currency in ways that would no longer be as publicly permissible for other groups historically subjected to similar degradations—the Africans, Turks, and the Jews. Freud was himself encountering his own version of marginalization just as he was labeling the "black gypsies," as he experienced the discriminatory practices of the Ministry of Education in Vienna, where his application for a university professorship, along with those of many other Viennese Jews, was repeatedly deferred. Yet he certainly appeared to find no empathic connection with this ancient race; his comments upon arrival were typical of first "encounters" that appeared in the literature that Freud would have read, whether called archaeology, adventurism, or travel. But Orvieto's *Zigeuner* were not so easily cast aside it seems; as we will see later, they return in a dream whose content revisits Freud's actual encounter with the precinct of the ancient Etrurians.

Freud's second postcard was written at the close of day on September 9, and featured an image from Crocifisso del Tufo, with a single male figure, his back to the viewer, strolling along the path lined with the graves that Mancini had kept intact.

Such souvenirs of the necropolis, popular sellers in Armoni's shop, exerted influence on the representation of the site beyond the souvenirs themselves.

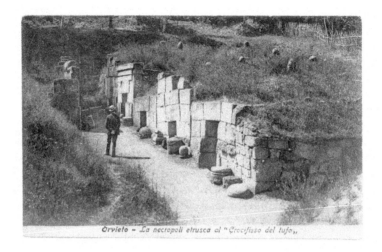

Figure 2.3 [Luigi Raffaelli]. Orvieto—La necropoli etrusca al "Crocifisso del tufo," postcard, *c.* 1900. (Private collection, Vienna.)

The widely read travel volume on Etruscan culture *The Cities and Cemeteries of Etruria* by George Dennis, a British adventurer who spent several years hiking in areas of Umbria and Tuscany, published in London in 1883, devotes part of the discussion of Orvieto to Mancini's excavations.[41] The latter is described as "the happy man who owns these tombs"[42] and the text is accompanied by an etched illustration, based on a photograph and postcard by Raffaelli, depicting the same area of the site featured in Freud's purchase.

In this version, a bearded figure, presumably a tourist, shields himself from the Italian sun with a parasol as he enters at the lower right.[43] He walks into a scene where two men, seemingly workers, toil at the entrance to one of the tombs, with a third companion seated atop one of the sepulchers, holding a basket ready to receive fragments. From these, Mancini will select those suitable for his composite vessels; others will be sold as fragments, while many, remains of the ubiquitous unpainted urns like Freud's, would be discarded. There is a fifth figure in the scene—a man seated at the far end of the cluster of tombs, cradling a rifle. He would appear to be one of Mancini's guardians of the cemetery, whose presence suggests that we are not only at the scene of archaeology, but also among valuable commodities, and at that nexus was the creation of "antiquities."

The bearded tourist featured in the etching in Dennis's book bears a passing resemblance to Freud, and one imagines that the scene here was not

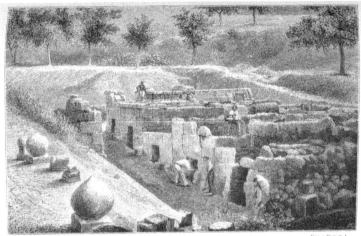

ETRUSCAN TOMBS EXCAVATED BY SIGNOR MANCINI, BENEATH THE WALLS OF ORVIETO.

Figure 2.4 "Etruscan Tombs Excavated by Signor Mancini, beneath the Walls of Orvieto." From George Dennis, *The Cities and Cemeteries of Etruria* (London: John Murray, 1883), p. 43.

too different from what he would have encountered upon visiting the site. The opportunity to enter into the furnished burial, perhaps at the behest of Mancini, was not lost on Freud, and it seems to have remained quite vivid for him. Two years after seeing this tomb, in 1899, he would have a dream in which its distinctive interior would reappear.[44] But when he entered it this second time, his body was stunningly altered. The dream opens with Freud having already dissected his own pelvic region, leaving much of his viscera exposed; he had done this at the instruction of former teacher Ernst Brücke, in whose Institute of Physiology Freud had worked when he was a medical student. Throughout the dream, which Freud named "Dissecting my Own Pelvis," there is the sensation of his body in motion, moving across "a changing landscape"—here he passes by a group he thinks may have been the "gipsies"—and trying to manage on his own or being carried by another, then ultimately reaching a wooden house. He sees two men lying there, sleeping on wooden benches, each with a child beside him. He realizes that his exit from this enclosure, which he first thought possible by the wooden planks, could occur in a far more dramatic way: by walking over the children. This causes him to wake "in a mental fright." There are additional facets to the dream, to be examined in a subsequent chapter on the Signorelli parapraxis,

but in the context of our present discussion, Freud's associations to the final portion of the dream are worth citing here:

> The "wooden house" was also, no doubt, a coffin, that is to say, the grave. But the dream-work achieved a masterpiece in its representation of this most unwished-for of all thoughts by a wish-fulfillment. For I had already been in a grave once, but it was an excavated Etruscan grave near Orvieto, a narrow chamber with two stone benches along its walls, on which the skeletons of two grown-up men were lying. The inside of the wooden house in the dream looked exactly like it, except that the stone was replaced by wood. The dream seems to be saying, "if you must rest in a grave, let it be the Etruscan one." And, by making this replacement, it transformed the gloomiest of expectations into one that was highly desirable.[45]

Thus, in this revisiting of the grave at Crocifisso del Tufo, Freud could assuage his fears of death by representing the tomb as a place he had already inhabited and which he had survived. His mortality was certainly a concern for him, and he alluded to this anxiety in letters to Fliess several times at this point in his life. But it is very curious that he never returns in his associations to the experience that actually seems to cause him distress— the image that appears just before he notes his feeling on awakening, that "the crossing was not possible on the boards but on the children." What is striking is what is enacted here: Freud's self-exposure, and his ability to survive this highly vulnerable state by walking over children. That seems to be what roused him from the dream, with the affect of "mental fright." One wonders if the scene might give us some insight into what meanings he attached to the Etruscan burial, and the moment in his work when he visited it, two years later. When he returned to Vienna from the scene of burials, with souvenirs of his funerary journey, he was able to overcome a place where, as he recalled here, grown men were sleeping with children. The placement of children with adults in Etruscan tombs was rare, as Marshall Becker's work on skeletal remains has argued;[46] depending on the age, they were buried in separate cemeteries or in another part of the burial area for adults. And the only passing reference to children in Mancini's reports was to burials in Crocifisso that he presumed, due to their small size, were those of children,[47] but these were not among those shown as his display tombs. Who, then, were these "Etruscan" children? In his letter to Fliess in the days after Orvieto, Freud would see giving up his trauma theory—one that exposed his father and potentially, with the Malthide dream, himself—as arriving, as we will see, at a cost to his offspring's financial security. But perhaps these

were other children, those whose experience as abuse victims he would no longer privilege, over whom he could walk and go on to survive. In either case, this dream strongly suggests that the visit to the Etruscan grave held a more specific set of meanings that extended beyond the wish to survive death. Freud mentions, almost as an aside as he concludes his associations, that it may relate to surpassing one's father, although he does not elaborate upon that. One assumes that he reads one of the reposing adults as a paternal figure who was not able to move on from the tomb. But in surpassing him, Freud would, a few days after the visit to the burial, actually save his father (perhaps imagined as here with the children) from any further scrutiny. In his letter of September 21, he will distance himself from the possibility that exclusively fathers—"not excluding my own"—were the perpetrators, concluding that "surely such widespread perversions against children are not very probable."[48]

There is something else that survived the burial at Crocifisso del Tufo, and Freud was to encounter it soon after he stood among the remains in Mancini's show tomb. In his showroom were the objects that the excavator selected to exist outside the precincts of the dead, to have a new identity, where much of what had originally informed their creation and use could be cast off. Here, as we will soon see, a prosaic food container could be transformed into a mysterious funerary vessel—one that could be acquired, and along with its presumably human remains, taken home. Perhaps for Freud a restoration of wholeness came with the possibilities offered by the fragment. The dream suggests that by leaving the grave, he would be able to escape and survive; perhaps he could redress the feeling of extreme exposure that he visualized here and may have felt—both personally and professionally—that came with continued adherence to his beliefs concerning the etiology of hysteria. The children in the grave and under his feet were not to continue with him on his journey. They, like the fathers sleeping with them, are left behind.

On the back of that second postcard, Freud tersely summarized for Martha the activities of his day, reducing a series of consequential encounters to a simple list. Concerning his visit to the place of Signorelli's work, he writes a single word: *Dom*. He then pens a phrase that joins the Etruscan graves (*Etruskergräber*) with what probably followed immediately after: *Altertümer eingekauft*. He writes of his acquisitions in the plural, although we are only given evidence of one of the objects that he bought on September 9. In recalling his dream with the cinerary urn, Freud noted that he had given the vessel away by the time he imagined drinking from it; that dream was thought to have occurred in 1898, so the object left his possession within a year of its purchase. Perhaps the dream was a way to bring it back to his possession, he muses, although we have evidence that, in the case of another

early vessel—"an antique bowl, round which there are *eyes* painted"[49] (italics original)—he appeared to specifically purchase this as a gift for a Viennese ophthalmologist (in all likelihood, his friend Leopold Königstein). These distinctive, wide-mouthed "eye cups" would not have been the cinerary urn mentioned in his dream, and the fate of the latter vessel is difficult to ascertain. It may have been given to his old friend, Emanuel Löwy, an art historian and archaeologist who at this time was a professor at the University of Rome.[50] He and Freud exchanged gifts and it is known that Löwy would later assist Freud in selecting material for his collection. In a letter to Fliess, dated November 1897, Freud writes that Löwy had visited, during his annual trip to Vienna, and that they stayed up conversing until the middle of the night.[51] Löwy, who had known Freud since he, Löwy, was a Gymnasium student in Vienna (Freud was a year older, and may have met Emanuel through an older Löwy brother), is frequently cited as the role model for Freud's understanding of archaeology and its methods. But as we will see in the next chapter, by the time they were in sharing ideas in 1897, Löwy was practicing little in the way of excavation; instead, he was working among objects that had been removed from various sites and was himself involved in the antiquities trade. Löwy had also become interested in psychological factors that influenced the history of representation in Greek art, especially that of space and the body. Like Freud, he accorded considerable importance to childhood experiences; Löwy was fascinated by the "memory pictures" that guide young artists; such unmediated image-making, based on verbal descriptions of what they see in their imagination rather than styles of visual representation, would yield to the pressures of external conventions as they matured.[52] Freud was making new meaning of his own childhood images and wondering how psychical narratives of early sexuality shaped a child's internal representation of his or her own body and the familial landscape. There was probably also conversation about the shared loss of parents; Freud's father had died a year before and Löwy's mother about six months before their meeting, in February of 1897. The urn was in all probability in the company of these exchanges; Freud would have surely shown his recent acquisition to his friend, who knew the Etruscan objects from Orvieto very well, having written about them a decade before.[53] Löwy also knew Mancini, and although Freud appeared never to realize that, as a "funerary" object, his purchase was a fraud, it is very likely that his friend did. Löwy, whom Freud described to Fliess after that visit as an "honest and decent human being," may have at some point suggested that he take the vessel in order to replace it with something whose attribution was less spurious. If this conjecture is correct, it would be very unlikely that Löwy ever told his old friend the reason.

The vessel, long gone, cannot be identified today from among the many other objects, including a number with an Etruscan provenance, that followed it into Freud's rooms, first in Vienna, and then London, accompanying him when he fled there after the Nazification of Austria in 1938. Yet it is possible to determine what this urn looked like, and that Freud did purchase it directly from Mancini. His designation of a "cinerary urn" would suggest a type of object that has been found in a number of Etruscan graves from the sixth century—a lidded box-like ceramic (*cippi*) vessel, often embellished with surface imagery, in which the ashes were placed.[54] This style had replaced the earlier canopic jars for holding cremated remains, with their distinctive elaborated lids. Frothingham mentions several small sarcophagi for sale from Crocifisso del Tufo; when he uses the term "*cippi*," however, he is referring to square stone markers that were commonly found in tombs.[55] None of these funerary goods would have been remotely related to an object from which one could drink. There was a far more common and less elaborate vessel quite ubiquitous in Etruscan burials: called *olla*, it was a clay container with a full body and handles, usually about ten inches in height, and primarily used for holding food, in life and in death. But there is also evidence that on occasion—perhaps among those unable to afford the more lavish container—*olla* also served to hold human ashes, although the practice does not appear common in Crocifisso del Tufo.[56] That said, Frothingham, the American dealer who acted as a purchasing agent in Italy for various art institutions, sold to the museum at the University of Pennsylvania an *olla*-shaped vessel that he described as a "cinerary urn" that he had acquired through Mancini, with whom he transacted numerous purchases.[57] This object, still in the museum collection, was probably the same type of object sold to Freud in 1897.

Its size and handles would make it possible to imagine both as an "urn" and also as something from which one could have taken a drink. The Penn urn also arrived with ashes in it, akin to those Freud recalls tasting. Later testing at the museum identified these remains as bits of burned leaves and twigs, suggesting that Mancini transformed the common food vessel into what may have been a more salable and costly commodity by placing the plant ashes within it, transforming it into a "cinerary urn."[58] Thus, the *olla* became a phantasm nearly from the moment of its unearthing, its original purpose rendered utterly forgettable.

Letters that Frothingham wrote to officials at Penn document his time in Mancini's home in the autumn of 1897, providing evidence of the various objects offered for sale in his storeroom, and giving some insight into what Freud might have seen there six weeks earlier. An existing photograph by Frothingham shows an assemblage of *bucchero*—the name given to burnished

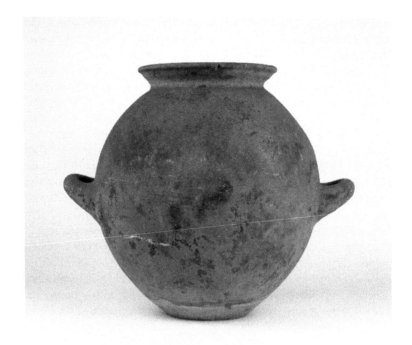

Figure 2.5 Etruscan jar (*olla*) from Orvieto, sixth century BCE, H: 11.4 inches. University of Pennsylvania Museum. Courtesy of Penn Museum, MS3201.

black funerary ceramics, which make an appearance in yet another of Freud's dreams with an Etruscan association[59]—that are being offered from the graves of Mancini to his clients in Philadelphia.[60]

They are lined up on several shelves covered in a white cloth; it would appear that this photograph was in the Mancini home, where one could survey the current holdings and make a selection. In the weeks around the time that Freud visited Orvieto, Frothingham was pressing Penn to purchase a sizable group of objects that included, among others, a number of painted vessels, bronze weights, a stone sarcophagus, and, as the most prized offering, an inscribed lintel from a burial at Crocifisso del Tufo. The Etruscan script, based on the Greek alphabet, was still something of an epigraphic mystery at this time, and Frothingham urged the stone's sale. He wrote that it was "beautiful and, at $15.00, very cheap."[61] The cinerary urn, unearthed by Mancini in 1896, arrived in Philadelphia two years later, along

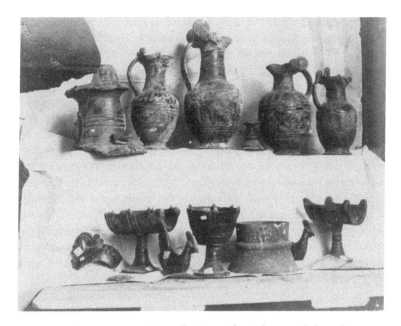

Figure 2.6 Storage room at Riccardo Mancini's residence and shop. Orvieto, 1896. Etruscan ceramic objects (*bucchero*). Objects now in the collection of University of Pennsylvania Museum. Courtesy of Penn Museum, image 148998.

with another cache of material whose provenance Dennis called "Mancini's pickaxe."[62] The transformed *olla* was probably among the least expensive of the items in what was called a "storeroom," a term that Frothingham uses in his correspondence, which suggests that Mancini presented the space less as a gallery than as a site for storage and dispersal—in Italian, a "*desposito*." One wonders what Freud imagined as he surveyed this strange scene of commerce and displacement, with many of the same kind of objects that he had just seen in situ at the necropolis. Where their companion pieces still functioned as a totality of a historical moment of "Etruria," here the objects were wrested free of that dependence, poised to be disseminated as objects of intrinsic value, "antiquities," in their own right.

Just as Freud's experience in the burial must have remained vivid for him, the scene at Mancini's home also appeared to have its impact. Soon after returning to Vienna, Freud embraced the quest for his own ancient fragments, in the intensification of his "self-analysis," as he searched for remains that

would fit within his new model of childhood sexuality. His quest met with almost immediate success, as he was able to recall to Fliess in early October an incident that would provide the proof test for what would soon become his "Oedipal" construction. In the next chapter, that fragment, in which he recalled his first arousal of desire for his mother,[63] will be examined in detail. Once that metanarrative was put in place, then shards of memories began to accumulate, aided, Freud tells Fliess, by conversations with his mother. By the end of October, Freud reports that he can access such prehistory readily, although "everything remains obscure"; nevertheless, there is "a comfortable feeling that in it one has only to reach into one's storeroom (*Vorratsräume*) to take out what is needed at a particular time."[64] Although this term for a place of storage is rarely used in Freud's writing again, the concept was powerful enough to suggest to Lacan, incorrectly citing Freud's word choice as *Vorratskammer*— although they are arguably very close in meaning—that it was to become the Freudian unconscious.[65] Lacan returns to this word on several occasions; in the case of dreams, he sees psychical fragments as they "reemerge" from a space that he visualizes as a "bric-a-brac, this cluttered storeroom."[66]

The timing and choice of this imagery suggest that Freud was miming Mancini, whom he had seen retrieve early treasures not long before, from a space that Frothingham's account would suggest was cluttered indeed. Neither Freud nor Mancini was accumulating recent provisions, as that would have been another type of "larder." For both, the material was very mutable; like the cinerary urn that transformed into a drinking vessel, these psychical antiquities were apparently there to serve the function at hand. This process of retrieval does not aspire to excavate and reconstruct. Rather, the meaning of the past emerges from an assemblage of selected "antiquities," objects that can be possessed and endlessly displaced, accruing meaning and value far from the place of origin, but as Forrester describes in his writing on Freud as collector, forming at Berggasse 19 a scene of "partial contiguities."[67] Here, the early site yields its treasures, and, emptied of them, much of its meaning is irretrievably lost. But the content of the *Vorratsraume*, and what is selected to be preserved there, grows ever more splendid to behold. In closing the letter where he reveals his Oedipal memory, Freud would exclaim to Fliess that "I cannot convey to you any idea of the intellectual beauty of this work."[68]

Although his visit to Crocifisso del Tufo appears to be Freud's first experience at an extensive and ongoing excavation, the story recounted earlier does not figure in any discussion of the impact of archaeology upon his formulations of psychoanalysis. Perhaps what can be reconstructed of this visit has always

remained too elusive; after all, certain experiences about Etruscan Orvieto were only preserved in Freud's dreams. Antiquity and fantasy melded closely here, thus defying the appeal to empiricism that Freud himself espoused when aligning psychoanalysis with acts of excavation at various times in his texts. It has been over half a century since the term "archaeological metaphor" was applied to these passages,[69] and a rich literature about the nature of this connection has emerged since then. The abiding concepts that would appear to join these discourses—that of systematic unearthing, of readable stratigraphy, and of returning to meaning what was considered long lost—certainly held appeal for Freud. But it remains difficult to rigorously interrogate the importance of such a relationship and it is necessary to be mindful that despite Freud's gesture, in the opening passage of his "Aetiology," to his reliance upon empirical connections, that reliance never existed. Andreas Mayer contends that "one has to insist that, while the archaeological metaphor recurred in Freud's writing, the concrete results of archaeological research did not have a decisive impact on his psychoanalytical interpretations."[70] That said, productive spaces of inquiry have emerged in the past decade, with sustained work that addresses cultural meanings of archaeology as a discourse—for Ranjana Khanna of colonialism, for Richard Armstrong of the ethos of neoclassicism, and for Cathy Caruth (see n69) as an originary site to trauma— in which Freud participated. None of these investigations address, however, these intersections within the actual structuring of the Freudian unconscious, although it was around this concept that much of the language, and ideology, of excavation was applied. But this is hardly to be faulted; if the significance of archaeology for Freud's interpretations is open to question, then certainly his decisions about what actually constituted psychical meaning would make the role of this field even more difficult to quantify.

Given what we know about the excavations at Crocifisso del Tufo, it is possible to enter into this territory, and consider how an excavation site may have influenced Freud's notion of how the unconscious operates at the particular moment of September 1897, although the very notion of the "concrete results" of archaeology is confounded here. Mancini's motivations dictate privileging certain content over others, selecting objects that were destined to leave both the necropolis and then his home, and begin a journey of displacements and exchanges. In such a scenario, the archaeological activity itself becomes quite forgettable; it is the objects that are brought forth from the site, and chosen to participate in the motility and metonymy of the aestheticized fragment, whose meaning gestures back, not to a historical moment, but to the totalizing discourses of art and the marketplace. Freud's assemblage of the contents of the unconscious, emerging immediately upon returning from Italy, operated on a similar premise; those remains from the

Vorratsraume derive meaning because they can acquire value as evidence of "fantasy concerning the parents," that, like the concept of beauty he evokes to describe this process, is cast as a preoriginary construction. This strategy for assigning worth allowed the rest of Freud's early life to avoid scrutiny, as it could be unspoken and, more significantly, unmissed.

Many years after Freud imagined a process of self-analysis that could choose its fragments, psychoanalyst Wilfred Bion introduced the notion, in *Second Thoughts* (1967), of the "selected fact" as a way to understand how the analyst organized her thoughts and subsequent interpretations about a particular patient.[71] Indebted to Henri Poincaré's *Science and Method* (a text written in 1908, less than a decade after *The Interpretation of Dreams*), Bion was drawn to its suggestion that "some fact, among an accumulation of facts, arrests the attention of the scientist in such a way that all the others fall into a pattern or configuration by virtue of their relationship to this selected fact." This process suggested to Bion an empirical methodology that could serve to validate the analyst's reliance on determining what was of importance among a vast array of material introduced in a session. Three decades later, Ronald Britton and John Steiner offered another term, "overvalued idea,"[72] to the discussion of Bion's earlier concept. While the latter considered the process of selecting and privileging a certain "fact" in psychoanalytic interpretation to be a legitimate methodology, Britton and Steiner located it in close proximity to their concept, one that serves the "defensive needs of the analyst," providing "a sense of integration to otherwise disparate and confusing experiences." They argued that while Bion's notion of a selective idea can be viewed as creative and contributory, it can often not be distinguished from their "overvalued idea," which they consider to be "delusional." While they hold these as different constructions, they also suggest that at the moment of making an interpretation, the distinction between them "may be small."

The context for this discussion of omission and containment was the analyst's interpretation, and what transpired within the analyst's internal processes. Overvaluing and selecting were given an earlier genealogy in the material introduced earlier, where we suggested that such actions were essential to creating the content on which the psychoanalytic process operated. Before any later choice was made by an analyst, Freud had circumscribed the analytic "sphere," and in the autumn of 1897 he found what would arguably become among his most powerful "selected facts," those of infantile sexuality and fantasy. But, following Britton and Steiner, this is an example when selection and worth cannot be distinguished. Using this terminology, we can argue that Freud defensively overvalued this idea as a way to disavow the importance of other early childhood experiences that

brought a sense of vulnerability and "confusion." By deciding instead to focus upon the libidinal desires that remain within the subject, he could ensure that the dramas suffered in early life were, nevertheless, dramas he had chosen.

Freud returned to his desk in Vienna, after his Italian holidays, on September 20. As we have no evidence that his collection was ever displayed in any other rooms of the Freud household, one can imagine that the first objects, like the over two thousand to follow, were installed in the adjoining rooms that were used as his consulting room and library. His earliest acquisitions may have been his first witnesses, and perhaps, as suggested earlier, even something of *agents provocateurs*, to a dramatic change in the autumn of 1897. His first act of writing, as he announced to Fliess, was his letter to him, dated September 21.[73] He opens by telling his friend that he is about to reveal "a great secret" that had been percolating for "the last few months," and he is now ready, it appears, to share it with his most trusted interlocutor at the time. In what would come to be cast by some as a stunning discovery and others a scandalous abandonment, Freud informs Fliess that he "no longer believed" in what had been a central tenant of his understanding of hysteria: that it resulted from sexual abuse suffered in childhood. A year before, in the spring of 1896, when he had first introduced his belief to his medical peers, he opened the "The Aetiology of Hysteria" with his archaeological scenario. In the course of the paper, he would invoke the distant past again, as he announced that he had made a discovery akin to finding the "source of the Nile." Hence, the in situ reconstruction made visible the edifices of memories commemorating earlier scenes of history, which Freud presented as analogous to the repressed "scenes" of sexual assault. Several months after publishing his lecture, it would appear that he had read the stones more precisely: Freud tells Fliess it was always the father who was the abuser, thus implicating his own parent, who had died several months before this revelation. But we also know that by the final draft on hysteria in late May, Freud was increasingly blurring memory and fantasy. That this change had been "percolating" for the last few months would suggest that the "architecture of hysteria" series may indeed have been the point when his turn had begun.

Now, in September, it would seem that the structuring of traumatic response lay in fragments. While his fantasy of excavation, like his evocation of the source of the Nile, was presented as a striking achievement, he now tells Fliess that he could not bring one such case to completion. But perhaps there was really nothing to complete, at least as a historical reconstruction.

He now doubts that fathers, including his own, were the responsible party, since the incidence of hysteria suggested that such "widespread perversions" were improbable. He had attained "the certain insight" that the realm he had pictured previously as a buried city of the unconscious was in fact not ruled by the scenes of recoverable history that he had relied upon for his psychical unearthing. Rather, "there are no indications of reality" there—not the usual dilemma at an excavation—and that the distinctions between "truth and fiction" were to be very seriously questioned. It will be a statement that then follows as a parenthetical aside—"there would remain the solution that sexual fantasy invariably seizes upon the theme of the parents"—that will prove especially compelling in effecting this turn from trauma.

Resonances of Freud's own early history can be detected in the letter of September 21, although they have been rendered virtually inaudible by the focus upon the impact of this change of course on the subsequent history of psychoanalysis. It is the missive's role as the harbinger of the realm of unconscious fantasies that garners attention, with little interest paid to the presence in his text of conscious ones. Yet, Freud tells Fliess what he had imagined was at stake around "whether or not hysteria would come out right." These fantasies included "eternal fame," along with "wealth, complete independence, travels." But it is the final wish that is perhaps the most telling: "lifting the children above the severe worries (*schweren Sorgen*) that robbed me of my youth." Thus, Freud has hoped that the circumstances that marked his childhood in Vienna would not be revisited on his children. The theory of hysteria's origins would therefore ensure that he would protect them from his experience of youthful sorrows. There are actually then two traumas circulating through this letter: the pervasive tragedy of the sexual assault of young children, now being questioned, and Freud's own articulation of his "stolen youth." The first would be replaced, substituted by an alternative model of psychical functioning that relocated the desiring subject from an adult to a child. But what of the second? Freud would never use this phraseology—"severe worries" or being "robbed of youth"—again in his work. But can we just dismiss such an obvious reference to childhood feelings that speak to issues that could not be fully reconciled or replaced by his theory of childhood sexuality? It would seem appropriate to inquire as to what became of these issues when Freud turned, in the weeks after this letter, to an intense review of his childhood, as he searched for traces of his own early erotic attachments and competitions. It would appear that they never were enunciated. The only clue would be their characterization, in the veiled autobiographical passage in "Screen Memories" of 1899, where Freud described his first years in Vienna, from ages three to six, as long and hard, and said of them, as noted previously, that there was nothing

worthy of recollection ("*Dann kamen lange harte Jahre; ich glaube, sie waren nicht wert, sich etwas daraus zu merken*").[74] Although Strachey translates this as "nothing was worth remembering," the verb Freud uses here—*zu merken*—differs from the more usual descriptor that he will use as the verb to remember, "*erinnern*." The subject of Freud's essay is the mechanism that he calls "*Deckerinnerungen*" (screen memories); it functions as a veil, where one set of memories is covered by another, with the less accessible, repressed material of more psychical meaning and analytic value. This kind of memory formation differs from remembering as indicated by the verb "*merken*." This latter word suggests a very conscious action of marking something as worth remembering: it is commonly used to warn children to remember not to touch a hot stove, for instance. Thus, when Freud speaks of a difficult early life where nothing is worth remembering, it is clear that he is in possession of many memories and has determined that they are not valuable enough to warrant any mention, let alone any scrutiny. Psychoanalysis has focused on the processes of remembering and forgetting as crucial elements of the unconscious, while the role of very deliberate exclusions from meaning, as demonstrated here, has been little examined. This is the realm of the "forgettable," whose erasure allows for the privileging of Freud's emerging notions of sexuality, yet whose function needs to be understood as a possible defense against other, less easily mythologized narratives, of his early, and by his own admission, "hard" childhood.

Freud would later write that unconscious fantasies frequently began as conscious ones; these always would be for him sexual in nature, notably those that accompanied youthful masturbation and that risked becoming— if one did not move on to a presumably normative erotic relationship— repressed and pathological. I argue that the genesis of Freud's construction of unconscious infantile fantasies also began in a conscious version—not of the children themselves but rather of Freud—with a desire for a narrative of childhood that was confined to a specific realm contained within the predetermined dynamics of universalized sexual dramas. He would need to create a story that was not his own, one where one could not be robbed of one's childhood by external factors. His theory of early fantasy was thus an intrapsychical rescue story—one that protected subjectivity, rather like his own Oedipal narrative that shielded him from the disruption and dislocation that marked that moment, among the unspoken thieves of his childhood.

In this chapter, Freud's experiences in Orvieto are posited as exerting an influence on how he conceptualized a psychical structure informed by his ability to identify the workings of fantasy. There was a comfort, as he noted to Fliess, in being able to take what one needed from one's reserves, and the act of selecting would reiterate the power to make such choices. This action was a

form of remembering that was predicated upon a previous removal—not only the taking out from the storeroom but what constituted its contents in the first place. This initial gesture was, however, made invisible by the enunciation of value, whether in the content of the *desposito* or the *Vorratskammer*. That which was not included there was, by both Freud's and Mancini's reckoning, worthless. The totality of memory was determined not by a plentitude of an excavation, but as exemplification. The gesture in his archaeological imagery was to a temporality that could be established in a stratigraphic fashion, with the most hidden layers moored to the earliest traumatic event. The memory of internal wishes and desires of childhood did not require that turn back to an external referent; akin to how one imagines that Mancini's inscribed lintels could be sold to those who found the imagery intriguingly beautiful, with little concern that it served as a record of the grave owner's name. In situ such details were valued, as they attested to the historic and cultural specificity of the place. However, once moved, these stones began to speak different language, one with a syntax that was both archaeological and the acquisitive. We see this in Freud's later articulation of "old and distant lands," in a letter to Fliess in 1900. Along with assembling the material that would become his *The Psychopathology of Everyday Life*, he wrote that, "otherwise I am reading Greek archaeology and reveling in journeys I shall never make and treasures I shall never possess."[75] Thus, archaeology has become indivisible from ownership; an elision that would not have occurred five years earlier, when acts of unearthing and reconstruction—and not the objects themselves—were accorded primacy. It was the turn to becoming a collector that melded these two actions, and attests to his capacity to quite literally grasp what is desired of the distant past—a gesture reminiscent of drinking the water of his cinerary urn, the image that opened this chapter. We have traced here how such an assertion of agency over the past was so formative for Freud in the fall of 1897, and how enactments of selection and possession brought him his first antiquities that would ultimately fill the psychoanalytic space. But we have also extended the trajectory of these actions, as determinants of what filled the space of the psychoanalytic treasure house, and as we will now see in the next chapter, examples of what would not be worth remembering to place there.

Notes

1 Sigmund Freud, *The Complete Letters of Sigmund Freud to Wilhelm Fliess, 1887–1904* [hereafter cited as the *Freud-Fliess Letters*], trans. and ed. Jeffrey Moussaieff Masson (Cambridge, MA; London: Belknap Press of Harvard University Press, 1985), [264]–266.

2 Ibid., [264]–265.

3 Sigmund Freud, *Unser Herz zeigt nach dem Süden: Reisebriefe, 1895–1923*, ed. Christfried Tögel and Michael Molnar (Berlin: Aufbau-Verlag, 2002), 85.

4 Sigmund Freud, "The Psychical Mechanism of Forgetfulness," *SE* 3, 1898, 289–297.

5 Sigmund Freud, *The Interpretation of Dreams*, *SE* 5, 1900, 549.

6 Freud, *The Interpretation of Dreams*, *SE* 4, 124.

7 Ibid., 124n1. Weygandt's privileging of the role of external stimuli in the activities of dreaming informed much of his dissertation, titled *Entstehung der Träum* (Origins of the dream). Weygandt, a German psychiatrist, had written his thesis in Leipzig under the direction of Wilhelm Wundt, whose interest in physiological psychology, extending to dreams, was deemed by Freud to be reductive and questionable. But the work of Wundt's student Weygandt piqued Freud's interest in the very pursuit that he derided in his teacher: claims to empirical psychical evidence gleaned through an exclusively somatic response. For a synopsis of Weygandt's work, see Michael Schredl's "History of Dream Research: The Dissertation '*Entstehung der Träume* (Origin of dreams)' of Wilhelm Weygandt Published in 1893," *International Journal of Dream Research* 3, no. 1 (2010): 95–97. Online DOI: http://dx.doi.org/10.11588/ijodr.2010.1.507. Weygandt may have gotten the last—or at least certainly the better known—word of disdain. Decrying what he considered the overly sexual content of Freud's work, he declared at a medical congress in 1910 that such material had no place in "a scientific meeting; it is a matter for the police." Ernest Jones, *The Life and Work of Sigmund Freud, 1901–1919: The Years of Maturity*, vol. 2 (New York: Basic Books, 1955), 109.

8 Freud, *The Interpretation of Dreams*, *SE* 4, 124, n1, passage cited from the book of Isaiah 29:8.

9 Armstrong's opening chapter of *A Compulsion for Antiquity: Freud and the Ancient World* (Ithaca, NY; London: Cornell University Press, 2005)—"Compulsive Situations"—skillfully frames Freud's susceptability to "antiquity" as overdetermined by his cultural moment, informed by the "Darwinian revolution, the growing visibility of ethnographic and anthroplogical discourse, the professionalization of historiography and archaeology" (31). One of the most intriguing aspects of Armstrong's work in this area is his attention to the particular identifications with classicism inculcated in gymnasium-educated Jewish males of Freud's era and the impact that had in shaping their distinctive *Weltanschauung*, an idea that he expands in "Marooned Mandarins: Freud, Classical Education, and the Jews of Vienna," in *Classics and National Cultures*, ed. Susan A. Stephens and Phiroze Vasunia (London; New York: Oxford University Press, 2010), 34–58.

10 Ellen Handler Spitz, "Psychoanalysis and the Legacies of Antiquity," in *Sigmund Freud and Art: His Personal Collection of Antiquities*, ed. Lynn

Gamwell and Richard Wells (London: Thames and Hudson, in association with the Freud Museum, 1989), 154–155.

11 The vast majority of the collection is now in London, Freud's final, short-lived residence from the spring of 1938 until his death in the autumn of the following year. His daughter Anna returned a few items for display to Berggasse 19, when it was opened to the public as the Freud House Museum in 1971. Shortly before the Freud family's departure in May 1938—leaving four of Freud's then-elderly sisters who remained and were murdered in the Shoah—a visual record was made by the young photographer Edmund Engelman. His work was commissioned by some of Freud's colleagues who hoped to restore the rooms posthumously, when what was then expected to be a far shorter and less catastrophic "storm" had passed. As none of that was to occur, Engelman's images remain the only detailed visual record of the collection in situ. Engelman, also a Viennese Jew, was forced to leave not long after the Freuds and was only reunited with the negatives of his photographs at Berggasse 19 many years later. The first edition of his Berggasse folio was published in 1976 as *Berggasse 19: Sigmund Freud's Home and Offices, Vienna 1938* (New York: Basic Books); for more biographical details on Engelman, refer to Arnold Werner, "Edmund Engelman: Photographer of Sigmund Freud's Home and Offices," *International Journal of Psychoanalysis* 83 (2002): 445–451. Since the opening of the Freud Museum in London in 1986, a considerable amount of attention has been paid to the collection and its implications: *Sigmund Freud and Art*, ed. Lynn Gamwell and Richard Wells; *Excavations and Their Objects: Freud's Collection of Antiquity*, ed. Stephen Barker (Albany, NY: State University of New York Press, 1996); *Le Sphinx de Vienne: Sigmund Freud, l'art et l'archéologie*, ed. Eric Gubel (Liege: Massoz, n.d.); *"Meine.... alten und dreckigen Götter" : aus Sigmund Freuds Sammlung*, ed. Lydia Marinelli (Frankfurt/Main: Stroemfeld, 1998); Janine Burke, *The Sphinx on the Table: Sigmund Freud's Art Collection and the Development of Psychoanalysis* (New York: Walker, 2006); Diana Fuss and Joel Sanders, "Berggasse 19: Inside Freud's Office," in *Stud: Architectures of Masculinity*, ed. Sanders (Princeton, NJ: Princeton Architectural Press, 1996), 112–139.

12 W. L. Alden, "Pleasant Idling Places: Orvieto," *The Idler Magazine* 2 (1893): 40–41.

13 Ibid., 41.

14 Ibid., 42.

15 Jean M. Turfa, "Votive Offerings in Etruscan Religion," in *The Religion of the Etruscans*, ed. Nancy Thomson de Grummond and Erika Simon (Austin: University of Texas, 2006), 95n.

16 Tiziana Tafani and Lucio Riccetti, *Freud e Orvieto: Alle origini della psicoanalisi* (Orvieto: Intermedia Edizioni, 2016), 77–81.

17 There are two detailed historical accounts of the excavations at the Crocifisso del Tufo complex: Beatrix Klakowicz's *La Necropoli anulare di Orvieto: Crocifisso del Tufo—Le Conce* (Rome: "l'Erma" di Bretschneider,

1972) and, more recently, Paolo Bruschetti's *La necropoli di Crocifisso del Tufo a Orvieto: contesti tombali.* Monumenti etruschi 10 (Pisa; Rome: Fabrizio Serra editore, 2012). In David Ridgway and Francesca R. Ridgway's review of Klakowicz's study, Mancini is characterized as "an indefatigable local dilettante, whose motives were clearly not limited to the simple desire to make money." They acknowledge that the author bypasses "the innumerable questions provoked by this fascinating work." *The Journal of Roman Studies* 69 (1979): 212. Bruschetti is far less reticent in this regard, engaging in what W. V. Harris characterizes as "[cataloging] the depredations of Mancini" and other early excavators. *Bryn Mawr Classical Review* (2012.12.14: http://bmcr.brynmawr.edu/2012/2012-12-14.html, online review). Considerable work has been done at Crocifisso del Tufo post-Mancini, as Bruschetti details, in which far more rigorous standards of good practice were followed. Important mid-twentieth-century excavations were conducted by Mario Bizzarri and described in his *La Necropoli di Crocifisso del Tufo in Orvieto,* 2 vols. (Orvieto: Fondazione per il Museo "Claudio Faina," 1963, 1966). Bizzarri's son, Claudio, also an archaeologist, continues work there today. My thanks to him for assistance during my visit to the site.

18 A. Satolli, "Il giornale di scavo di Riccardo Mancini (1876–1885)," *Quaderni dell' Istituto Statale d'Arte di Orvieto* 5–6, 1985 [1991]: 17. For a more complete inventory of Mancini's excavations, see Klakowicz, *La Necropoli anulare di Orvieto,* and Bruschetti, *La necropoli di Crocifisso del Tufo a Orvieto.* Also, Tafani and Riccetti, *Freud e Orvieto,* 77–78.

19 Giuseppe M. Della Fina, *Storia di Orvieto, I: Antichità* (Perugia: Quattroemme, 2003), 30.

20 Paolo Bruschetti, "The Etruscans in Umbria," in *The Etruscans Outside Etruria,* ed. Giovannangelo Camporeale, trans. Thomas Michael Hartmann (Los Angeles, CA: J. Paul Getty Museum, 2004), 198.

21 Douglas W. B. Sladen, *The Secrets of the Vatican* (Philadelphia, PA; Lippincott; London: Hurst and Blackett, 1907), 456.

22 Letters between Arthur Frothingham and Riccardo Mancini, September 1897. Box One. Arthur L. Frothingham records from the Etruscan tomb groups excavation. University of Pennsylvania, Penn Museum Archives.

23 Gattel had come to Vienna at the suggestion of Wilhelm Fliess and initially was warmly received by Freud. But in letters leading up to their travels, Freud began to express concerns to Fliess about Gattel and would eventually look upon him with considerable wariness. Despite that, during their Italian holiday there may have been conversations of professional consequence between them concerning the etiology of hysteria. Gattel, as George Makari recounts, worked on clinical data that posed a possible challenge to Freud's conjoining of hysterical pathologies and childhood sexual abuse. Freud may have seen these results as bolstering what he was already creating as a way to distance himself from the scene of paternal incest he had asserted in the previous months. George Makari, *Revolution*

in Mind: The Creation of Psychoanalysis (New York: HarperCollins, 2008), 99–100. It is noteworthy that soon after the journey, and Freud's renunciation of his earlier position, he would go on to question Gattel's character, calling him "a wayward son" with shortcomings: "I must accept his disgrace as mine." One wonders if this could also be read as a self-reproach. *Freud-Fliess Letters*, 276. Letter dated October 31, 1897.

24 Freud complained to Martha, in a postcard written from Florence and dated September 6, 1896, that the night sky was not as described in his Baedeker (Freud, *Unser Herz zeigt nach dem Süden*, 64). For a fascinating discussion of the role of this text in Freud's thinking about place, travel, and modernity, consult Paul-Laurent Assoun, "L' 'effet Baedeker': note psychanalytique sur la catégorie de guide de tourisme," *In Situ* 15 (2011), online URL: http://insitu.revues.org/582; DOI: 10.4000/insitu.582

25 Karl Baedeker [Firm], *Italien: Handbuch für Reisende, Mittel-Italien und Rom*, 11th ed. (Leipzig: Verlag von Karl Baedeker, 1896), 86.

26 Ibid., 85.

27 Freud, *Unser Herz zeigt nach dem Süden*, 152, 155 (visit in August 1902); he details his later visit, September 1907.

28 Ibid., 216.

29 Freud, "Delusions and Dreams in Jensen's *Gradiva*," *SE* 9, 1907, 7–95.

30 *Letters of Sigmund Freud*, 267, letter to Martha Freud, September 24, 1907.

31 For an excellent discussion of that encounter, see Andreas Mayer's "Gradiva's Gait: Tracing the Figure of a Walking Woman," *Critical Inquiry* 38, no. 3 (2012): 554–578. Also, Mary Bergstein's "Gradiva Medica: Freud's Model Female Analyst as Lizard-Slayer," *American Imago* 60, no. 3 (2003): 285–301.

32 Freud, *Unser Herz zeigt nach dem Süden*, 84–85.

33 Baedeker [Firm], *Italien*, 82, 84.

34 Diego Mormorio and Enzo Eric Toccaceli, *Tre fotografi a Orvieto: Armoni, Raffaelli, Moretti* (Palermo: Sellerio Editore, 1989). For Raffaelli's images from Crocifisso del Tufo, see pgs. 32–33. Examples of Mario Moretti's photographs from the folio that Freud purchased of the Signorelli paintings appear on 36–37.

35 Freud, *Unser Herz zeigt nach dem Süden*, 84.

36 *The Role of the Romanies: Images and Counter-Images of "Gypsies"/Romanies in European Cultures*, ed. Nicholas Saul and Susan Tebbutt (Liverpool: Liverpool University Press, 2004), [53]–56.

37 "Nachruf: Jacob Krall," in *Zeitschrift für ägyptische Sprache und Altertumskunde*, ed. A. Erman and G. Steindorff, vol. 42, no. 1 (Leipzig: J.C. Hinrichs, 1905), 86.

38 Nancy T. de Grummond, "Haruspicy and Augury: Sources and Procedures," in *The Etruscan World*, ed. Jean MacIntosh Turfa (Abingdon, Oxon; New York: Routledge, 2013), 539–556.

39 Klaus-Michael Bogdal, *Europa erfindet die Zigeuner: Eine Geschichte von Faszination und Verachtung* (Berlin: Suhrkamp, 2011), 81.

40 *Sinti and Roma: Gypsies in German-speaking Society and Literature*, ed.
 Susan Tebbutt (New York: Berghahn Books, 1998), 91–106.
41 George Dennis, *The Cities and Cemeteries of Etruria*, vol. 2 (London: John
 Murray, 1883), 42–48.
42 Ibid., 46.
43 Ibid., plate on [43].
44 Freud, *The Interpretation of Dreams, SE* 5, 452–455.
45 Ibid., 454.
46 Marshall J. Becker, "Coming of Age in Etruria: Etruscan Children's
 Cemeteries at Tarquinia, Italy," *International Journal of Anthropology* 27,
 no. 1/2 (2012): 63–86.
47 Klakowicz, *La Necropoli anulare di Orvieto*, 253, n173.
48 *Freud-Fliess Letters*, [264].
49 Freud, "On Dreams," *SE* 5, 1901, 639. The vessel that Freud mentions is
 most likely an "Athenian (or Attic) eye cup" and while these certainly
 originated in Greece, where the distinctive pattern of eyes on their surface
 was likely apotropaic in origin, they were one of many object types that
 made their way into Etruria. For a detailed study of these objects, see
 Sheramy D. Bundrick, "Athenian Eye Cups in Context," *American Journal
 of Archaeology* 119, no. 3 (July 2015): 295–341.There are records of them
 found in Orvieto, although they are more prevalent in other Etruscan
 areas, so it is probably the case that Freud did not purchase this object from
 Mancini.
50 Emanuel Löwy died on the eve of the *Anschluss* and many of his archives,
 including his beautifully rendered drawings of objects and fragments,
 once housed in the Institute for Classical Archaeology at the University of
 Vienna, have been lost (Dr. Gudrun Wlach, private communication). Only
 in recent decades has his importance been recognized and, with that, a fuller
 consideration of his connection to Freud. The first comprehensive treatment
 of Löwy's work appeared in a collection edited by Friedrich Brein: *Emanuel
 Löwy: Ein vergessener Pionier* (Vienna: Verlag des Clubs der Universität
 Wien, 1998). The title is telling—Löwy is called a "forgotten" pioneer—a fate
 perhaps, in no small part, orchestrated by those who wished to marginalize
 him. For Löwy's role in the Austrian-sponsored excavations at the start of his
 career, refer to Szemethy, previous chapter, n150. Armstrong provides a good
 summary of the Freud–Löwy relationship, characterizing the latter as "Freud's
 Alternative Ego," 117–120. Löwy's activities, focusing on his years in Rome,
 are the subject of an impressive recent collection of essays, *Ripensare Emanuel
 Löwy: Professore di archeologia e storia dell'arte nella R. Università e Direttore
 del Museo di Gessi*, Studi Miscellanei, vol. 37, ed. Maria Grazia Picozzi (Rome:
 "L'Erma" di Bretschneider, 2013). Very little of Löwy's private life emerges
 in this literature, however, and his struggles with Viennese anti-Semitism
 and the possible ramifications of his life as a gay man—never publicly
 acknowledged—seem to continue to remain "forgotten." A rare glimpse

into these issues is offered in correspondence written on Löwy's behalf by a German friend and colleague with ties to Rome—Walter Amelung—to the highly respected classical philologist Ulrich von Wilamowitz-Moellendorff. Amelung writes of the delays in Löwy's appointment, on his return to Vienna from Rome, necessitated by the First World War, and clearly identifies the cause as anti-Semitism. William Calder, in publishing the letter, also suggests that the reference made by one of Löwy's most distinguished students, Ernst Gombrich, that his teacher was "twice an outsider," refers to Löwy's sexuality. William M. Calder, "Walter Amelung to Ulrich Von Wilamowitz-Moellendorff on Emanuel Löwy: An Unpublished Letter," in *Noctes Atticae: 34 Articles on Greco-Roman Antiquity and its Nachleben, Studies Presented to Jørgen Mejer on His Sixtieth Birthday, March 18, 2002*, ed. Bettina Amden et al. (Copenhagen: Museum Tusculanum Press, 2002), 60–66.

51 *Freud-Fliess Letters*, 277–278.

52 Marco Galli, "'Immagini della memoria': Teoria della visione in Emanuel Löwy," in *Ripensare Emanuel Löwy: Professore di archeologia e storia dell'arte nella R. Universit. e Direttore del Museo di Gessi*, Studi miscellanei, vol. 37, [141]–188. Also, Mary Bergstein, *Mirrors of Memory: Freud, Photography, and the History of Art* (Ithaca, NY; London: Cornell University Press, 2010), 135–144.

53 Emanuel Löwy, "Schale der Sammlung Faina in Orvieto," *Jahrbuch des Deutschen Archäologischen Instituts* 3 (1889): 139–144. In the opening passage to this essay, Löwy mentions that the objects he will discuss had been excavated by Mancini (139). In an effort to have some of the material from Crocifisso del Tufo remain in Orvieto, a wealthy local family, the Faina, purchased material from Mancini for a museum they created in one of their villas, located in the main piazza, across from the Duomo. It is now called the Museo Claudio Faina e Museo Civico.

54 Teresa Huntsman, "Hellenistic Etruscan Cremation Urns from Chiusi," *Metropolitan Museum Journal* 49, no. 1 (2014): 141–150.

55 Letters from Arthur Frothingham and Sara Yorke Stevenson, October 29, 1897. Box One. Arthur L. Frothingham records from the Etruscan tomb groups excavation. University Art Museum Archives, University of Pennsylvania.

56 Marshall Joseph Becker, "An Analysis of Human Skeletal Remains from an Etruscan Urn in the Detroit Institute of Arts," *Etruscan Studies* 12 (2008–2009): 61–72.

57 Letters between Arthur Frothingham and Sara Yorke Stevenson, October 1897. Box One. Arthur L. Frothingham records from the Etruscan tomb groups excavation. University Art Museum Archives, University of Pennsylvania.

58 Private communication, Jean M. Turfa, University Art Museum, University of Pennsylvania.

59 The dream, known as "Castle by the Sea," is replete with visual imagery from Freud's days with Martha in Venice, just prior to her return to Vienna

and Freud's continuing on, with his brother and Gattel, to other sites, including Orvieto. The dream mentions an association to the distinctive Etruscan blackware known as *bucchero*; Freud notes seeing this type of ceramic in "museums in the Etruscan towns." But it is very likely he also saw it in Mancini's showroom, as the photograph of his *Vorratsraume* taken by Frothingham shows two shelves of this kind of pottery, and Frothingham mentions its abundance there in his correspondence dating to this period. See Freud, *The Interpretation of Dreams, SE 5*, 463–468.

60 Letter between Frothingham and Stevenson, October 29, 1897.

61 Ibid.

62 Dennis, *The Cities and Cemeteries*, 46.

63 *Freud-Fliess Letters*, 268.

64 Ibid., 276.

65 For a discussion of the *"Vorratskammer"* see *The Ethics of Psychoanalysis, 1959–1960: The Seminar of Jacques Lacan, Book VII*, ed. Jacques-Alain Miller, trans. Dennis Porter (New York; London: W.W. Norton, 1992), "Pleasure and Reality," 26 and "Das Ding," 51.

66 This quote occurs in Lacan, *On Feminine Sexuality, The Limits of Love and Knowledge, 1972–1973, Encore: The Seminar of Jacques Lacan, Book XX*, ed. Jacques-Alain Miller, trans. Bruce Fink (New York; London: W.W. Norton, 1998), 88.

67 John Forrester, *Dispatches from the Freud Wars: Psychoanalysis and Its Passions* (Cambridge, MA; London: Harvard University Press, 1998), 113.

68 *Freud-Fliess Letters*, 269.

69 Freud never used the term "archaeological metaphor," although the phrase, when applied retrospectively to his constructions of psychoanalysis, has generated a considerable literature. For a comprehensive bibliography, see Cathy Caruth, *Literature in the Ashes of History* (Baltimore, MD; London: John Hopkins University Press, 1913), 117–118n4.

70 Mayer, "Gradiva's Gait," 574.

71 Wilfred Bion, "The Psycho-Analytic Study of Thinking," *International Journal of Psycho-Analysis* 63 (1962): 306–310. Reprinted as "A Theory of Thinking" in his *Second Thoughts: Selected Papers on Psycho-Analysis* (London: Heinemann, 1967).

72 Ronald Britton and John Steiner, "Interpretation: Selected Fact or Overvalued Idea," *International Journal of Psycho-Analysis* 75 (1994): 1069–1078.

73 *Freud-Fliess Letters*, [264]–266. Masson includes a reproduction of the original double-sided, four-page letter as a plate between 266 and 267.

74 Freud, "Screen Memories," *SE 3*, 1899, 312.

75 *Freud-Fliess Letters*, 427, letter dated October 14, 1900.

3

Libido Awakened:
In Transit and Enframed

To write the "prehistory" of Freud's collection of early objects requires resituating the inquiry from addressing an assemblage whose existence is presumed, to explicating its origin narrative. In the previous chapter, I argued that there is a strong claim for the importance of this pursuit, as Freud's first purchases coincided with a highly consequential moment in the history of psychoanalysis: just as he entered, quite literally, this new space of "antiquity," he was poised, in September 1897, to turn away from his belief in the primacy of sexual trauma as a determinant of hysteria, a position which had relied upon archaeological practices for support. In Orvieto, an object could move seamlessly, as we have seen, from the excavator's tomb to the dealer's room. The contents of the burials displayed at Crocifisso del Tufo were transformed, after a short journey up an ascending path, into highly marketable objects on view in Mancini's home. In the weeks after Freud returned to Vienna with his purchases, he began to amass another collection, one composed of the memories that he selected from the repository of his "self-analysis." This chapter will chart, through a series of letters he wrote to Fliess in the final months of 1897, how Freud began to choose what would become the essential constituents of his psychoanalytic constructions.

We will focus considerable attention on one of the first, and very highly prized, of these psychical fragments: a memory he quickly associated with the incestuous wishes enacted in the tragic saga of Oedipus. Freud's purported recollection was decisive in corroborating the construction of infantile sexuality that would soon follow, allowing him to replace his etiology of hysteria with a universal psychical struggle around early erotic wishes and their later vicissitudes. Like the objects in Freud's collection, his Oedipal observations were accorded a specific value, and assumed to be the discovery of a phenomenon for which his story was a crucial piece of evidence, an operation that effectively erases issues of circumstances and motives. No less an important link is that both the Etruscan urn and Freud's Oedipal "recollection" were themselves phantasms: Freud's cinerary vessel was, in its original function, a prosaic storage jar, and as I will argue here,

his desirous gaze upon his naked mother while traveling to Vienna, the evidence he offered that would quickly usher in the universalized presence of Oedipal longing in children, was also his own fabrication. This "memory," as we will soon see, may have been shaped by popular tropes concerning sexual dynamics within the train carriage, but it was the absent portion of the story, like the emptied interior of the Etruscan vessel, that actually gives the story its form, albeit by seemingly possessing no form at all. Both objects of history were presented in these enhanced ways to increase their value, and by so doing, eradicate the original circumstances in which they occurred. These omissions, while potentially adding to the Freud biography, are not presented in this chapter with that goal; rather, this material is introduced in order to examine how it was possible for Freud to essentially forget the circumstances in which this reported memory occurred. The moment of his "Oedipal" awakening was located amid the experience of early childhood disruptions that have eluded scrutiny and meaning, as though they were devoid of psychical impact. Freud's obvious satisfaction with what he had done in the weeks after returning from Italy was characterized to Fliess as the "*intellektuellen Schönheit*" of his current pursuits,[1] a choice of designation suggesting that the criterion of the beautiful was a productive part of how he was organizing his shards of history. In the discussion to follow, the beginnings of Freud's formulation of childhood sexuality will be considered a fragment of fantasy, not because it has come to emblemize Oedipal imaginings and their discontents as a psychical process, but because it was decisive for a story itself created by Freud, using a strategy he shared with Mancini, to give his nascent construction added veracity and intrinsic worth.

In Freud's use of such a phrase to characterize his work, Klaus Theweleit has read his intention to create a new, aestheticized space of meaning.[2] Freud may have taken this descriptor from Kant; even if this is not a direct appropriation of "intellectual beauty" as it appears in *The Critique of Judgment*, there are certainly Kantian inflections in Freud's strategy for experiencing *Schönheit*, the quality he was hoping to find in Italian art after his sip of the punch of Lethe. Forgetting does appear in various guises in Kant's work, and while that investigation exceeds the scope of this study, there is another, more personal and poignant, gesture involving Kant and the banishment of memory that deserves retelling in the context of this chapter. At the end of his life, the 78-year-old philosopher suddenly dismissed his long-standing assistant and closest companion, Martin Lampe. The circumstances remain mysterious, but evidence suggests that Kant's executor, Ehregott Wasianski, may have wished to install someone of his own choosing; to that end, the executor made slanderous accusations that turned the aging recluse against the man who had shared his life for decades. It was later discovered that

Kant had written himself a directive as a way to banish his companion from thought: "the name Lampe must now be completely forgotten."[3]

If the motivations for Kant's wish to so utterly obliterate Lampe from memory would appear ripe for further scrutiny, what about a statement of Freud's, discussed in the previous chapter, from his earliest days in Vienna that could easily be rewritten, from "nothing was worth remembering," to the self-command that "my early years in Vienna must now be completely forgotten"? I argue that for Freud, the latter command initiated the former statement; in other words, the wish to erase preceded an identification of unconscious repression, as we saw in the disavowal of content in the Hella dream, discussed in the last chapter. This desire to forget presaged the elaboration of the psychical mechanism of fantasy that reiterated that very action. In the material to be examined here, we will chart how Freud removed from view virtually every aspect of his early life in Vienna during the course of his intense scrutiny of his childhood in the fall of 1897, and went on, in the next year, to identify the workings of an amnesiac state that he contended veils nearly all of early childhood as a form of repression.

<p align="center">*****</p>

Soon after sharing his "great secret" with Fliess in his letter upon his immediate return from Italy, Freud had other hidden revelations to impart to his friend. He boasted, less than two weeks later, on October 3, of his ability to predict the continuity of his dreams by having them readily available, a practice he would soon characterize by his allusion to his storeroom, his claim exemplified by a series of dreams that he was able to maintain over several nights that featured a woman who had been his caretaker in his very early childhood in Moravia. He recalled her as an "ugly, elderly, but clever woman,"[4] the "*Urheberin*," or "primal originator," both of Freud's libidinal interest and, in sharp contrast to the devastating psychic consequences of childhood abuse, of a sense of self-worth and agency: she "instilled in me a high opinion of my own capacities,"[5] although the following night he reports a dream that cast his caretaker as "my teacher in sexual matters" who complained that he was "clumsy and unable to do anything."[6] The contradiction is striking, and Freud's description of himself as "clumsy" seems an attempt to create a viable narrative of an early sexual encounter that is not a scene of abuse, but rather one of initiation into what would be fully "awakened" in the presence of his mother. The reoccurrence of the *Ur* in this context marks that which is archaic, beyond, and prior to the woman who cared for him herself, as the exquisite specificity of his father's culpability is replaced by a far more universalized female imago. As Patricia Cotti exclaims

of this moment, "*Exit* the father!" (italics original).[7] But that banishment is only as the perpetrator; the paternal figure will remain as Freud develops his scenario of infantile sexuality according to Oedipus and become a rival. So, the paternal power of violation departs, replaced by a construction of fantasy driven by the wishes of the desiring child, whose forbidden longings must be repressed. This model of early sexuality seems to do what Freud, at the end of the letter of October 3, attributes to his early caregiver: provide him "with the means for living and going on living"[8] in the aftermath of giving up his trauma theory, which he claimed would have provided his children with the security he had lacked in his youth. But, as I have argued in the preceding chapter, while Freud suggests that his decision might impoverish his family, this choice conversely could protect him and his father; as his Orvieto dream suggested, his safety was achieved by walking over the bodies of children.

Soon after recalling his attachment to his Czech caregiver and his awareness of his maternal eroticism, Freud had a conversation with his mother that he shared in a letter to Fliess of October 15. He learned more details about the person we have come to identify as Theresa ("Resi") Wittek, who cared for him in Freiberg and whose name is recorded as the family's "maid."[9] She took the young Sigismund to church and apparently took other things as well—Amalia Freud tells her son that she stole money from the household and all of his toys, and eventually served time in prison.[10] He remembered a story of anxiety, after the incarceration of his nanny, when a confusion about her being "boxed up"—his elder half-brother's term for imprisoned[11]—led to his fear of his mother disappearing into a family wardrobe. But when he turns to the other revelation from the earlier letter, there are no particular details of what transpired after they left Freiberg; he does not reveal any more about the specifics of their time in Leipzig nor the time after their arrival in Vienna. Instead, Freud announces that the scene of value was his sexual awakening: "I now consider it a universal event of early childhood."[12] In this way, the "content" of the memory has been shifted from an individual occurrence to the repetition of a normative "prehistory." What is rendered forgettable are the events put aside to foreground the arrival of infantile sexual fantasy, but when these other experiences are brought back into the story, the role of the moment of awakening is amenable to another reading. In the alternative narrative, the memory is less a way to access universal experience than a device to jettison from meaning what could not be brought fully into the autonomous realm of childhood libido. What we will examine here are cast-offs from that point of passage.

Freud's turn to a fantasizing, rather than traumatized, subject required that he reshape his notion of the first years of life. Children defended against their primordial, autoerotic desires in ways that differed from individuals

struggling with the impact of sexual aggression. The primacy of an adult perpetrator faded in importance during the course of 1897, as fantasies and their repression, both for the suffering and the well, took hold of the workings of the Freudian psyche. With this shift also came what Freud would come to call in his *Three Essays on the Theory of Sexuality*, first published in 1905, "infantile amnesia,"[13] a term that would be used to describe the mechanism that prevented access to memories of one's earliest years. His first mention of this occurred in a letter to Fliess in March of 1898.[14] Still, in the previous autumn, he begins to turn to imagining a veil of forgetting spread over all the experiences of one's "prehistory," only certain experiences being subjected to psychical attention. These were sensations of the infantile body, somatic experiences that were self-contained and universalized as "normal sexual repression."[15] In this initial formulation, it was the "memory of excitation of abandoned sexual zones"—he specifies the mouth, throat, and anus—that was in need of being banished. He identifies our morality and shame as strategies to fend off this now repugnant eroticism: "to put it crudely," Freud continues to Fliess, "the memory stinks just as in the present the object stinks."[16]

The stench of libido spread over the first years of life, and, unlike the defense against a traumatic memory, did not necessitate a corollary in a discrete set of experiences. As we have seen with his model of fantasy, Freud increasingly granted intrapsychic mechanisms the power to determine how encounters with the other were parsed and assigned worth. This paralleled what Freud had done as he fashioned this construction in the first place, removing important aspects of his own memories and dreams in order to define the borders of meaning for psychical functioning. This is strikingly demonstrated in the recollection that Freud offers as the decisive evidence of infant sexuality and its presence in his erotic "awakening": when he saw his mother naked, also described in his letter to Fliess of October 3. But in the context in which this "memory" occurred—while the family traveled toward a new life in Vienna—the ground on which the content of the narrative rests completely receded. Freud's remembrance is very specific as to time and place; nevertheless, he fashions the narrative to extract any specifics, and significance, from this moment. He claims that he was "between two and two and a half years" when "my libido toward *matrem* was awakening."[17] He was actually nearly three and a half when, in October 1859, they traveled from Leipzig to Vienna, a journey "during which we must have spent the night together and there must have been an opportunity of seeing her *nudam*."[18] The legacy of this "insight" that even in his retelling is cast as conjecture, gleaned under the circumstances of a Jewish family's flight from a hostile Saxon city, would quickly come to be indivisible from a very different

narrative whose "gripping power" would be a universal experience. But the phrase "there *must* have been an opportunity"[19] (italics added) for this suggests that Freud only recalls his internal, libidinal response and none of the attending specifics. He adds them, as necessary pieces of the narrative, but they are simply presumed to have somehow existed.[20] In this way, the meaning of his response to his mother relies less on the individual specificity of the encounter than on its being an experience that he will argue could be recognized by all who witnessed the Sophoclean tragedy: "Everyone in the audience was once a budding Oedipus in fantasy,"[21] Freud wrote to Fliess on October 15, securing for posterity the mythic contours of what could be termed his "*Ursexualität.*" With all the suggestive power that this classical drama of familial sexuality may indeed awaken, its evocation also signaled an attempt to bury other issues: Freud imagines that everyone experiences a heteronormative response, and by deploying this gesture to universality, the particular circumstances surrounding his earliest maternal attachments are placed beyond a boundary and thus need not be articulated.

In his next letter to Fliess, dated October 27, Freud introduces another aesthetic reference, that of *Rahmenmotiv* ("framing motif"),[22] to describe how he conceptualizes these early dramas as universal themes; the particulars of an individual's experiences are then fitted within these framing motives as "fill-in" motives (*Füllmotiv*), a term he may have appropriated from the study of ornament[23]: "I am beginning to perceive in the determining factors large, general framing motives, as I should like to call them, and other motives, fill-in, which vary according to the individual's experience."[24] Freud's choice of the concept of a *motiv* to describe his new thinking about one's inner life warrants attention. In German, this word has the same meaning, as Rainer Nägele discusses in an essay on Walter Benjamin, as the English word "motive."[25] Nägele goes on to identify a strange disparity: while the Greek and Latin origins of *motiv* imply movement, its subsequent use as a descriptor of literary and aesthetic forms suggests quite the opposite, as it identifies something as fixed and repetitive. When he turns to the quote earlier from Freud, noting that the latter turned to the *motif/motive* "as psychoanalysis was taking shape,"[26] in the autumn of 1897, Nägele characterizes the functioning of the "framing motif" for Freud as "the material incarnation of the motive." One can use this formulation to articulate his intention to collapse a childhood psychical repository into the Oedipal motif, serving to fix something that could, as Nägele describes the *motiv* more generally, be "repeatable" and used for its "structural stability." Individual experiences then are placed so as to fill it in, with a hierarchy that is clear: the frame secures the phenomenon, and the particular evidence for it, arriving after the fact, will be accommodated within the preexisting borders. Returning momentarily to

Kant, through Jacques Derrida, Freud's *Rahmenmotiv* is reminiscent of the Kantian parerga, a "frame" that Kant considers as a supplement, a border into aesthetic judgment. Derrida recasts this as imposing a "logical structure" of *a priori* discernments—closer to Freud's imagining of archtypical narratives— but then goes on to examine what this exterior frame actually does. Kant may have seen the ornamental borders as something detachable, delineating the passage into something of importance, but Derrida recasts their function: "the frame is not at all an adornment and one cannot do without it."[27] It announces and contains the site of value.

<center>*****</center>

Freud's account of his erotic awakening, elicited by the supposed sight of his naked mother, is recounted to Fliess in the same letter as his recollection of his "prime originator," the nanny in Freiberg who preceded his mother in his affections. After his mention of the train revelation, Freud returned to thoughts of Moravia,[28] recalling negative feelings and jealousy toward the arrival of his brother, Julius, who was born one and half years after Freud, and who died about six months later. He also recalls another incident from the town of his birth: he joined his nephew John, the son of his half-brother Emanuel and only a year his senior, in having "behaved cruelly" toward John's sister—whose name was Pauline—and was the same age as her playmate uncle. These recollections conclude with an interesting statement: "You yourself have seen my travel anxiety at its height."[29] What is notable here is that Freud is referring to experiences he had with Fliess while traveling, as Laura Marcus points out, on some of the same lines, specifically the journey that took him to Leipzig via the city of Breslau, which he had passed through as the family left Freiberg.[30] This suggests that there are actually two stories being told here—one about Freud's experiences of maternal sexuality and competition, the stuff of the Oedipal drama, and the other about the residues of affect around the experience of childhood displacement and upheaval. Any investigation of the latter, as a psychically significant aspect of early life, however, would be overshadowed by the totality Freud constructed from his libidinal "memory." In my reading, the actual circumstances of his migration story will be foregrounded, suggesting how Freud may have selected the moment of sexual "awakening" to create an overly determined erotic scenario that could serve to subsume other experiences.

Within less than a month's time, in the autumn of 1897, Freud's emerging notions of a "psychical reality" were dramatically altering his understanding of the meaning and impact of the external world. The disclosure of his memory about his mother was pivotal in the process, for it provided requisite, and

seemingly indisputable, proof for his new conviction that libidinal longings for parents were a formative part of early life. This recognition would allow him to quickly universalize the experience, and bestow prediscursive status upon the unconscious fantasies that he saw as indivisible from the formation of normative heterosexuality. The power of these imaginings to produce symptoms of neurosis was not restricted to those labeled "hysterics"; indeed, if unrecognized and unresolved, such fantasies could adversely affect virtually everyone. These insights were revealed at such a rapid pace that the circumstances from which the decisive verification emerged—a child's experience of migration—were never elaborated, leaving only a singular memory of desire, isolated from everything but a still nascent understanding of the workings of an unconscious.

Freud would not supply more details about the incident that afforded him his "libidinal awakening" but he would go on to sexualize the power of the moving train. Along with the erotics of the forgotten zones, he introduces this as an important example of "Sources of Infantile Sexuality" in his chapter in *Three Essays* of 1905 that opens with his assertion of the "peculiar amnesia" of early life. Drawing upon the theorizing he began in the letters to Fliess in the fall of 1897, Freud recasts his own experience in transit here, and filters it through an over-determinedly somatic lens: "sexual excitation by rhythmic mechanical agitation of the body."[31] He cites this as a specifically masculine experience, noting the "fascinating effect" that railroads have upon "every boy." He links the production of fantasies during their "most active" time—a period that he sees here as "shortly before puberty"—with the train.[32] Here, he is speaking of more conscious reveries, but the residue of these associations, he notes, can return in the form of repression—manifested by travel sickness, exhaustion and, as he would often note himself, a sense of anxiety. In concluding this section, he gestures to issues related to "traumatic neuroses" but here they are not centered on what were then widely discussed issues related to rail travel and the psychical effects of various forms of accident. Rather, he speaks here of the combination of "fright and mechanical agitation" that produces a "severe" form of traumatic response.[33] He characterizes these as of small intensity but resulting in "a profound disorder in the sexual mechanism or chemistry." These final words were added in 1924,[34] but their genesis could be traced to considerably earlier, back to Charcot's belief, published during the time of Freud's work with him, in the mid-1880s, that "male" hysteria could result from the vicissitudes of train travel.[35] For Freud, the history of the railway gave this mode of transport particular associations with the production of neurosis, and thus of intrapsychic distress, rather than physiological ramifications occasioned by external injury.

As Marcus has argued, if Freud's purported memory of seeing his naked mother "founds the theory of the Oedipus complex," then it can also be said that "the railway journey 'founds' psychoanalysis."[36] This is a very provocative insight, because if indeed the rail journey is fundamental for Freud, its fuller retelling also encompasses the powerful presence, in its absence, of all the experiences that need to be excluded from the narrative and thus from the contents of the unconscious indebted to this incident.

It may not be coincidental that analogies to railway travel often occur within Freud's discussions in the autumn of 1897, when the effects of train journeys are posited to resemble those of internal experiences. But as Todd Presner suggests,[37] the presence of rail terminology can be seen in Freud's conceptualizations from his earlier work with Breuer on hysteria and, with the notion of the neural pathways, within his imaginings of his 1895 "Project for a Scientific Psychology." There the term is translated as "facilitations" (*Bahnung*), whose etymology extends from a path or roadway to, as Presner notes, part of the discourse of "transportation technology."[38] *Bahn* itself was commonly used as a word for the railroad. Recourse to this kind of image assumes that the pathways were fixed, as Papapetros noted earlier, related to the confinement of architecture as described by Lacan, following a "precise logic" that was one of the hallmarks of modernist modes of transport. Presner charts the appearance of rail imagery in Freud's work after 1897 as renouncing what he calls a "logocentric network of meanings and meaning production"; rather, he imagines that Freud, by the time of the publication of *The Interpretation of Dreams*, viewed unconscious processes as "acentric networks" that "branch out in every possible direction."[39] These ceaselessly create new connections that undermine the possibility of ever arriving at a single location, but instead are "mobile, contingent, and forever incomplete."[40] Returning to Nägele, one must ask how the rail *motiv* functioned as a motive, one that saw Freud create an alternative constellation of routes rather than subvert their existence. The process Presner describes literally attributed meaning to a new set of tracks, whose destinations, albeit along seeming circuitous routes dictated by repression, nevertheless remain circumscribed by the workings of what Freud deemed of value in psychical functioning. Thus, we can ask if meaning was allowed to branch out in every direction; as we shall see, Freud assiduously bypassed a number of paths. If we consider Presner's useful model, a step must be acknowledged between the move from the ordained route to one following multiple loops; this is the juncture at which Freud removed from certain "stations" the possibility of any mobility.[41]

One notable example of such an omission is discussed by José Brunner, who observed that the reason why Freud "did not deal with railway accidents

in his writing is that his theories allowed no conceptual room for accidents. In the unconscious, nothing is unintended or arbitrary."[42] This obviously envisages psychic structures quite differently from Presner's formulation. Rail injuries, whose physical and psychological ramifications were very much discussed in Freud's time, are characterized by Brunner as the opposite state to the psychoanalytic model of mind, because the former are determined by "an arbitrariness in the origins and effects of their violence."[43] One could compare the ramification of rail injury to Freud's conceptualization of sexual trauma, with its unwanted intrusion into the child's body and psyche. The turn to fantasy removed the primacy of this kind of unexpected shock visited upon a vulnerable victim—embodied in the word *Schreck*, which we will return to at this chapter's end—and thus the paths became, in this way, far more predictable and stable.

Brunner also notes that in the letter Freud wrote prior to leaving for his Italy holiday of 1897 (in the paragraph, incidentally, that prefaced his discussion of seeking the "absolute beauty" of Italian art) he speaks of anxieties very much deriving from the external world. The "daily reports of railway accidents" are instilling a fear in him, one he seems to turn away from as he imagines the pleasures of visual experiences.[44] Clearly Freud had concern about the potentially destructive power of this new technology. Brunner offers a very interesting dual explanation for this. The first derives from a canonical psychoanalytic reading, namely that this was a form of repression derived from the "Oedipal" longings that become associated with the railway due his experience with his mother. But he then suggests another reading: that the sexual fantasy is defensive, and instead "may cover up a secret anxiety about a non-sexual power in the present."[45] He does not pursue this any further, but it seems a very important observation and will be developed here. Brunner's interest is related specifically to rail accidents as an external threat that could be masked by Freud's revelation of his infantile sexual desire. But this suggestion of a defensive use of the Oedipal story can be extended further back in time.

We will remain in that early historical moment for Freud, but shift the perspective away from the hegemonic narrative of emergent desire that has become the lens through which this rail journey is rendered meaningful for psychoanalysis. A fuller reconstruction of the Freud family's travels is now possible, and archival evidence presents a compelling story that suggests that the journey to Vienna was not merely a backdrop for this fateful intrapsychic event, but may have functioned instead as the generative core of Freud's Oedipal narrative. That is, the turn to universal fantasy was predicated on disavowing the exquisitely painful, and specific, events that occurred around it; what was truly forbidden, and disavowed, was the revelation of affective

states and fragility that resulted from the circumstances of profound upheaval in Freud's early childhood. The particularity of this experience, detailed later, carried an overwhelming sense of uncertainty, which would be hidden by seeing the specific events as meaningful, only through the functioning of an *a priori* mechanism of infantile libidinal wishes. This would retell the story as dictated by Freud's desires, thus restoring agency to events over which he appeared to have very little control. The setting itself for his erotic awakening also may have been over-determined in a way that has not been examined in the past: his story may have relied upon tropes of forbidden sexuality associated with grown travelers, including voyeuristic possibilities thought to be particular to the railway car.

At the moment when the three-year-old Freud claimed his mother as his libidinal object, he was in the midst of physical and psychical disruptions to which he was poignantly vulnerable. In recalling the journey to Vienna as he did, he was able to privilege his autonomy as a desiring subject, while minimizing the vagaries, as we will see, of the world to which he was being subjected. In this way, he averted a different set of train anxieties, although those earlier disruptions seem to be hinted at as an etiology for disruptions he experienced in adulthood. What he retained from that early experience becomes a pristine moment of revelation, whose genealogy thus has proven very difficult to reconstruct. But in examining the fuller narrative of Freud's arrival in Vienna we see how the Oedipal story displaced his migration saga by privileging an isolated moment of imagined autonomy, and, following Brunner, a mechanism of defense, that comes to be articulated within his newly minted model of infantile desire.

In the rather transparently autobiographical "case" contained in "Screen Memories" of 1899, Freud would detail the life of a man who was "forced to leave" his birthplace, a move precipitated by the fact that "the branch of industry in which [his] father was concerned met with a catastrophe."[46] In Jones's biographical account, the Freud family "catastrophe" (as Jones would have understood it from Freud's retelling) resulted from the economic decline of the town's textile industries.[47] Freud laments the circumstances that necessitated his family's departure as a "*Zusammenbruch.*" Strachey translates this as a "smash," although "collapse" would appear to be a better choice (Freud had this "patient" in "Screen Memories" say, according to Strachey, "If only the smash had not occurred!").[48] The term can be used to designate economic, political, or personal ruin ("breakdown"); Freud uses the term in all three senses in his writings and his affective exclamation here would

suggest that perhaps all were at play. According to Jones, the catastrophe that Freud cites as the cause of the family's migration from Moravia, where Freud was born in 1856, was related to the decline of the traditional home-centered production of woolen goods (whose transport and trade were the primary source of his father, Jacob's, livelihood) and was compounded by Freiberg's distance from newly constructed rail lines.[49] Jones links these changes to a rise in sectarian tensions among tradespeople and an increase in localized anti-Semitism. Other Jewish wool merchants continued to prosper in Freiberg, however, and this reversal may thus have been the result of Jacob's inability to maintain a successful business in a changing economic milieu.[50]

Even if the textile industry did in fact continue to provide a livelihood in Freiberg for at least some Jewish merchants, as well as their Czech Christian counterparts, there was a circumstance that must have been regarded by all as a missed opportunity. Jones cites a factor in the general decline of industry in the town, and thus the Freud family troubles: "the new Northern Railway from Vienna had by-passed Freiberg."[51] Jacob Freud may well have credited this with his own financial decline; one assumes that Freud must have shared this with Jones. If so, then by Freud's reckoning the railway bypassed not only Freiberg but also his father, thus reiterating the belief that missing the train—a concern that he saw as evidence of his "travel phobia"—could, indeed, court disaster. There were also long-standing connections, as Marcus notes, with the Northern Railway as a "locus of nationalist and anti-Semitic politics."[52] This rail line that missed Freiberg, known as the Nordbahn, had been funded by several Jewish financial families, only to become the subject of a "nationalization campaign" in the 1880s, when it was characterized by a constituency that this racist movement hoped to restrict: the "Northern Railway Jews." Freud would mention several experiences of anti-Semitism in rail travel in his adult years.[53] It is certainly noteworthy that his desire awoke on the tracks of the Northern Railway en route to Vienna. In locating this event there, he could claim a power over the rail line that he imagined had exerted such a devastating influence on his early fate; by telling his story as he did, he could counter this pernicious force by recasting it as the mere backdrop to his own erotic journey.

In recent decades, important scholarship has made it possible to reconstruct the months immediately preceding the Freud family's arrival in Vienna.[54] Documents suggest that Jacob Freud traveled alone to Leipzig in the spring of 1859, seeking to establish residency there as an agent (*Commis*) licensed to bring goods into that city through his contacts in Russia and Moldavia. He expected to be associated with "Herren Samson and D. Fleischl," who had an established firm there.[55] The prospects must have seemed good, at least in Jacob's mind. In August, Amalia, Freud's mother,

traveled to Leipzig with Sigismund and his six-month-old sister, Anna, accompanied by Anna Hrazek, a Czech woman in her twenties described, as Resi Wittek (whom she possibly succeeded as the children's caretaker) had been earlier, as a *Dienstmagd* ("maid") in her travel papers; presumably the family intended to set up permanent residence there.[56] However, Jacob's application was denied; the reasons cited were a lack of credentials, an apparent misunderstanding of the level of support to be offered by the Fleischls, and an unspecified concern about his business ethics; the last word from the authorities in Leipzig to Freud *père* was certainly damning: "his past makes it seem advisable to protect our place from such businessmen."[57] An anti-Semitic subtext certainly could be detected here. As Eva Laible and Jan Hloušek, who also worked with the archival material in Leipzig, note, the Jewish community there was very small and extremely restricted in the mid-nineteenth century, representing only about one percent of the population; it is highly plausible that applications for residency were routinely rejected by officials wanting to limit the Jewish presence in the city.[58] But it is also the case that Jacob Freud's brother, Josef, who would ultimately be imprisoned in Vienna for passing counterfeit rubles when Freud was ten, had spent time in Leipzig and may have already been known to the authorities. The connections between the brothers at that time are unclear; at Josef's trial in 1865 evidence was introduced that tied him to his two nephews, Jacob's sons from his first marriage, then living in England.[59] There was never evidence of Jacob's involvement in the scheme, but it certainly took its toll on him. Freud recalls that his father's beard grayed overnight and one can only speculate on the part that Josef may have played in the family's earlier travails in Leipzig. The image of Uncle Josef appeared to Freud in a dream, to be discussed in this book's final chapter, that occurred as he was anxiously waiting to hear if he would receive an academic appointment. The taint of the criminality of his relative, and the shame and fear of complicity that accompanied it, may have brought Josef Freud, on his deathbed when Freud had the dream in early 1897, vividly back to life.

Documents reveal that the family was forced to leave Leipzig very soon after the final juridical decision was handed down.[60] Freud located the arrival of desire at a moment also marked by both this departure and another one. The family travel documents indicate that they journeyed overnight from Leipzig to Bodenbach, arriving in this town, located on the border of Saxony and Bohemia, on October 16.[61] From this station, trains went to Vienna via Prague, while another route led to various towns in Moravia. No records indicate that Anna Hrazek ever reached Vienna, so it is very likely that she disembarked at Bodenbach to return home. Freud never mentioned her in his writings, but the several months they spent together in Leipzig (and

possibly before in Freiberg) were undoubtedly consequential to him. In the time that the family lived in Leipzig, the young Freud was cared for in the midst of challenging circumstances: a seriously ill younger sister, a mother several months pregnant, and a father increasingly aware of the obstacles to securing a viable future there for his family.

In contrast to the moment of infantile sexuality while traveling from Leipzig, Freud's early experiences in the rooms that housed the Freud family there never figured in any accounts; it fact, he only refers to his time there in terms of transit, both arriving from Moravia and departing for Vienna. He recalls the sight of his mother as he departs from Leipzig, and, in a letter to Fliess several months after that revelation, in December 1897, as the two friends make plans to meet in Breslau, Freud writes of a fearful experience he recalled as he traveled toward that city, after leaving his Moravian birthplace. The gaslights in the rail station at the transit hub there, through which their train passed, reminded him of "spirits burning in hell."[62] Marcus concludes from this that Freud believed he was actually in hell,[63] and, as I have discussed elsewhere,[64] this image of burning damnation was one that appeared on a sculpture in Freiberg, which was made accessible to him through his Czech caretaker. It was journeys to see Fliess in Breslau that may have occasioned Freud's general comment about his travel anxiety, and he is indeed about to meet Fliess there as he pens this letter. The missive recalling his time in transit ends with Freud asking for a "sensible" response to what he has just written, whose contents he calls *meschugge* (Yiddish colloquialism: crazy, absurd).[65] This comment immediately follows his memories of passing through Breslau, suggesting that such thoughts were clearly disturbing; this affect was described in the language that evidence suggests was spoken by his mother.

In a letter to follow, dated December 12, 1897, Freud details his travel plans for Breslau: he will take a train in the early morning, wishing to avoid a night "in an overheated compartment." He looks forward to discussions with his friend, and wants to be clearheaded when they meet. He complains again of feeling very unsettled, of having "harbored the most *meschugge* matters in my head," and having no one with whom to share them. He concludes with an interesting refrain, seemingly as an antidote to his troubling thoughts: "once again, a draft of the punch of Lethe."[66] It is unclear exactly what it is that he wishes to obliterate from memory here; but if the "once again" refers to his previous use of this phrase to Fliess, when en route to Orvieto, he is asking to erase anxieties and distractions; in the earlier instance, its ostensible motive is to allow for an unfettered aesthetic experience. It would seem here that he is looking to wash away the discomfort that arose in his "self-analysis" as he returned to aspects of his early history; perhaps he was

wishing to efface whatever might intrude on what he had earlier exclaimed to be the "intellectual beauty" of his emerging construction of the unconscious. Among those aspects that he relegated to such an amnesiac state was perhaps a detail about his early, transitory life that may have returned in an alternative, and thus far unexamined, guise.

In the letter where Freud recounts to Fliess his experience of seeing the gas flames en route to Leipzig, he prefaces his memory by writing of his desire to meet his friend in Rome, a city he had yet to visit. He alluded to a dream of being there, walking the streets and being confused that so many of the signs were in German.[67] He suggests to his friend that perhaps the location was actually Prague, where they were to have met earlier in the year; this was the trip that eventually brought them, as discussed in Chapter 1, to Nuremberg and soon after to Freud's first articulations of the defensive structures of "hysterical fantasies." Like the structures that were to inspire the "architecture of hysteria," something was being protected by his inability to yet reach Rome, a destination that had been bypassed during all three of his previous Italian journeys. Freud acknowledged that his "longing" for that city was "deeply neurotic" and attributed his resistance to his boyhood identification with "the Semitic Hannibal," recalling that on his most recent journey in Italy, in the autumn of 1897, "I did not reach Rome any more than he did from Lake Trasimeno."[68] He probably traveled to this spot in the days after leaving Orvieto; the Baedeker guide suggests it as part of seeing the town of Cortona—that happens to be the birthplace of Signorelli and where his paintings could be seen in the local cathedral—where Freud visited in the final days of his travels. In *The Interpretation of Dreams*, he elaborates on the associations to this particular "Rome dream," one of a number that he reported during the final years of the 1890s. In his dream book, he attributes the odd appearance of German signs in Rome to the prevalence of that language in Prague in his youth, and from there a connection is made to his very early experiences with the Czech language, recalling a nursery rhyme that he could still remember when returning to his birthplace as an adolescent. He also noted here that in his dreams about Rome "there was no lack of connection with my early childhood."[69]

Freud then offers an anecdote his father told him on a walk in Vienna when he may have been "ten or twelve years old," though the narrative brings them back to Freiberg, and a moment in Jacob Freud's late teenage years there. Jacob was walking in town on a Saturday wearing a recently acquired "fur cap." The hat is suddenly knocked off and into the mud by a person Freud identifies only as a "Christian" who demands that the young man, addressed as "*Jud*," get off the sidewalk. To Freud's disappointment, his father obliged, and the youthful Freud—probably less than a decade younger than his father

was when the incident occurred—would register the experience as one of "unheroic conduct."[70] He appears to have managed his disdain by imagining a different scenario, one where Jacob Freud was replaced by Hannibal's father, who, in the early edition of *The Interpretation*, was mistakenly called Hasdrubal, actually Hannibal's brother, killed by the Romans as he attempted to join his sibling near Lake Trasimeno. In the 1909 edition, Freud changed it to the correct paternal name, Hamilcar Barca. Freud notes to Fliess that the father had insisted that Hannibal, his elder son, "swear before the household altar to take vengeance on the Romans." Thus, what is evident here is Freud's disavowal of circumstances that caused shame and anger, specifically related to Jewish vulnerability to a sudden, external assault over which a person has no control. As a way to manage his feelings about this, Freud subsumes his own historical moment beneath a family scene from the classical past (a strategy already in place with Oedipus), where Freud would identify so completely with the son that "to my youthful mind Hannibal and Rome symbolized the conflict between the tenacity of Jewry and the organization of the Catholic church."[71] As Jay Geller observes, Freud "saw in Hannibal and his war on Rome a model for Semitic tenacity in the face of oppression."[72]

But as Freud takes his childhood relationship to Rome into a register that extends to imaginary fathers as ancient heroes and from there to Jewish perseverance in the face of *ecclesia*, there is little discursive space for other, more specific, readings of his ambivalence. If indeed the first mention of what we might term his "*neurotica romana*" was in the letter to Fliess in which he also spoke of his journey to Leipzig, it would appear useful to investigate if there might be some associations with Rome that could be located within that period of his life. By forging the link to Hannibal—while discussing a dream that sees Freud walking in what he takes to be Rome but with German signs—Freud shifts attention away from what this discordant linguistic topography might mean. In turning attention to this aspect of the dream, it is possible to inquire about the meaning of such a hybridization of location for Freud and the possibility that he may have indeed experienced more than one Rome.

The contents of archives in Leipzig offer an intriguing revelation that deserves to be introduced into this discussion. Although we cannot locate with certainty where the Freud family lived there between August and October, it is quite plausible that they stayed where Jacob had lodged prior to his family's arrival. Restrictions on Jewish residency were stringent, as the family was to discover, and it was highly unlikely that Jacob would have been able to rent in Leipzig without residence papers. Thus, living in a residential hotel would be the only option, as confirmed by an announcement of his arrival, a common practice at the time of the storied (their recorded origin dates to the twelfth century) and widely attended merchants' fairs. Jacob

Freud would have been part of a considerable group of so-called "Fair Jews," merchants from various places who were permitted to reside in Leipzig only for the duration of these commercial gatherings; to alert participants to each other's attendance and where they were staying, it was common to pay for an announcement in a local newspaper. It is reported in *Leipziger Tageblatt* of Monday, May 9, 1859 that Jacob Freud was lodging close to the train station—the "Leipzig-Dresdener Bahnhof"—at a hotel whose name was Stadt Rom (City of Rome).[73]

In the section on Leipzig in a guidebook published in London in the year of Freud's birth, 1856, the Stadt Rom is suggested as a good "second-class" hotel,[74] with rooms considerably more expensive during the fair seasons; in those years occurring in spring and late autumn. Because, as the guidebook notes, the rates drop dramatically between fairs, one might imagine that Jacob stayed on (there was also a smaller "mid-summer wool fair" that year) and brought his wife, two children, and the Moravian nanny who accompanied them, to quarters there. Knowing this possibility, Freud's dream of Rome in what appears to be a German-speaking place takes on another interpretative twist, perhaps suggesting that the Eternal City was, at least in part, a possible screen for Leipzig. It is important to note that although Freud first mentioned his Rome dreams to Fliess in the months after returning from Italy, he had dreamt them as much as a year before, in the months after the death of Jacob Freud. There was little that seemed to connect his father to this Italian city, aside from the Hannibal story, but its appearance in his dreams at this time may suggest that they shared experiences in a different Rome.

Figure 3.1 Christian Adolf Eltzner. Leipzig rail station and Hotel Stadt Rom. Detail: *Panorama von Leipzig*, with Friedrich Salathé (Leipzig: Louis Rocca, 1864). Collection of Stadtgeschichtliches Museum Leipzig.

For all the many times that Freud wrote about Rome, both as he analyzed his dreams about it and then went on to write about various aspects of the city,[75] there is only one place where he uses the phrase *Stadt Rom*. Its appearance is in the opening line of his description of one of his dreams, known as "My son, the Myops," and its context is quite striking: "On account of certain events which had occurred in the city of Rome (*Wegen irgendwelcher Vorgänge in der Stadt Rom* …) it had become necessary to remove the children to safety, and this was done."[76] Freud identified as among the "relevant dream-thoughts" a number of things: "The Jewish problem, concern about the future of one's children, to whom one cannot give a country of their own" and concludes with the worry about one's progeny having the ability to "move freely across frontiers"; he attributes these to "a tangle of thoughts" occasioned by his recent attendance, in January 1898, at Theodor Herzl's play *Das neue Ghetto*.[77] However, in telling Fliess of this event, he wrote that they will attend in the next days, but that it has already influenced his dreams. Although the play's content, following the dashed assimilationist hopes of its upright and doomed hero, the lawyer Jacob Samuel, could certainly have provoked such concerns in Freud, there is no explanation for why these issues are associated with leaving Rome—a place that Freud had yet to visit. If Freud indeed had the dream before attending the theater, then one might concur that the thought of a "Jewish play" might have conjured imagery or stories of the departure from Stadt Rom, perhaps being recast here as motivated by a father's desire to protect his family, rather than as a result of his own father's questionable business dealings. We do not know how the time in Leipzig was framed for the Freud children, and what part the decree against their father's residency ever played in the story. It is noteworthy that in Herzl's play there is nothing about the safety of children and, indeed, they figure little in it.

In the dream, Freud imagines himself seated beside a fountain. He identifies it as placed in front of a gate that he imagined to be the medieval Porta Romana in Siena, the town from where he had first asked for his drink of Lethe in his letter to Fliess; Freud states that this location, by the gate in Siena, appears here as a substitute for Rome, although the meaning of this city, and a need to leave it in the dream, is never interpreted. He sits watching, on the verge of tears, as two young boys, one that he recognizes as his eldest son, are handed to another man by a female "attendant or nun." One of the children says "*Auf Geseres*" to her and then says, in what Freud experiences as the more familiar usage, the nonsensical "*Auf Ungeseres*" to Freud and the other man, presumably their father.[78] Any knowledge of the etymology of these phrases is disavowed by Freud, although he cites that he received philological assistance in determining that *Geseres* was based on a Hebrew verb and that

in "slang" it could refer to "weeping and wailing."[79] But as Ken Frieden, in his detailed discussion of this phrase in Freud's dream, notes, *Geseres* also would have been familiar to most Jews as referring to "anti-Jewish decrees and persecution."[80] An infamous example of this was the "Wiener Gesera" of the early fifteenth century, when in the throes of a blood libel slander against the Jewish communities in Europe that was common at the time, Austria's Jewish community suffered expulsion, murder, and the forced conversion of their children.[81] It would certainly be possible that the ruling in Leipzig would have been considered such an edict, and called as such by elders in the Freud family. *Ungereses* he takes to be Freud's "private neologism," although he notes that it was "the first word to catch my attention." He then suggests that the "un" would designate an opposite, such as the distinction between salted and unsalted. In this reasoning, *Ungereses* would relate to something joyous. The dichotomy then continues to "leavened" and "unleavened," and the associative train moves to the commemoration of the exodus from Egypt. In a recent discussion of Freud's "Rome dreams," David Meghnagi characterizes this move into the biblical realm as an attempt to place the content into a more "symbolic" interpretation, in part because of the impact, he argues, of the so-called "Dreyfus Affair," the trial and imprisonment of a French naval officer on a fabricated accusation of treason, imbricated with anti-Semitism. (We will return in Chapter 4 to the reverberation of the Dreyfus trial for Freud, occurring in the same year as this dream, 1898.)[82] The dream leads him to conclude that "dreams, then, are often most profound when they seem crazy." He based this particularly on what appeared to be the young boy speaking in contradictory phrases to the parties in the dream, yet this tendency to the nonsensical is a device that keeps hidden "any criticism, ridicule or derision"[83] that may reside at the latent level of meaning. Freud does not elaborate upon this, except for hints at the possibility that he would not be able to look after his children.

If we suggest that this is not a "Rome dream" but rather a *Stadt Rom* dream, then it is possible to offer an alternative reading, one that does not interpret the content as that of absurdist dream imagery. If the subject matter here is Freud's own childhood exile then the setting may be elsewhere. It is possible to suggest that the fountain and what appeared to be a gateway with double doors "in the ancient style" could also have been at the largest park in Leipzig, the Augustusplatz, not far from where the Hotel Stadt Rom stood in the middle of the nineteenth century. There is also a very telling possibility for the comparison with the Roman gate in Siena: before it was torn down a year after Freud lived in Leipzig there was a quite similar entrance, called the Peterstor, the last remaining of the four medieval gates that marked, in the center of the city, the famed site of intersection of the two great roads of

Figure 3.2 Carl Werner. *Das Alte Peterstor*, watercolor, 1859. Collection of Stadtgeschichtliches Museum Leipzig.

the Holy Roman Empire: the Via Imperii, moving in a north-south direction from the Baltic to Rome, and the Via Regia, traversing Europe from on the east/west axis, spanning the vast expanse linking Moscow to the Iberian pilgrimage site of Santiago de Compostela. The Peterstor was restored and enlarged in the early eighteenth century[84] but was removed in 1860 as it was considered an impediment to traffic.

When this occurred, it was the final of these grand entrances to Leipzig to disappear. The hotel "Stadt Rom" received its name as an acknowledgment of the city at the terminus of one of the royal roads that passed quite literally in front of it. Freud, on his sole American visit in 1909, famously characterized dreams as the "royal road" to the unconscious,[85] a term that he then included in the second edition of *The Interpretation*.[86] Freud's choice of this term has been

discussed in several studies involving dreams, where it is seen as indicative of Freud's notions of creating accessibility of the unconscious; Frank Scherer has focused on the implications of a "royal passage" as a descriptor whose familiarity to Freud may have come from biblical references, but Scherer also sees such a usage as part of Freud's own "orientalizing" appropriations within his work.[87] But the meaning may lie considerably earlier and be more particular: in this possible retelling of memories of his departure from Leipzig, the royal road to the unconscious implied the reverse of what Freud wished to suggest: the ability to interpret dreams allowed him to re-create the royal pathway, erasing the one that was actually about travel, not as conquest, but rather as the complex refiguring of attachments to people and places that occur when children are in transit.

While Freud read the woman, perhaps a "nun," who handed over the children to be perhaps his own children's nurse, the Czech (and presumably Catholic) Anna Hrazek would also be a possible figure here, as the two young Freud children leave her care. If Freud was to be delivered from Leipzig, he immortalized the journey in a way that allowed him to create an alternative narrative, one that buffered him from the losses and sorrows of the journey, and the ramifications of the *Geseres* handed down to his father.

Freud suggests that his libidinal awakening to his mother occurred when it did because he claimed he had the chance to see her naked in transit from Leipzig.[88] But the likelihood that such an event ever took place is very questionable. It is true that the journey would have taken place over a night,[89] but sleeper trains, as Freud would have known them in his adolescent and adult years, did not exist in 1859. At that time, the carriages were larger and would accommodate more passengers than a family of three (Jacob Freud, evidence suggests, did not arrive until December and may have first returned to Freiberg) and, for part of the journey, Anna Hrazek; it is very likely that the family traveled alongside strangers. Freud writes about much later experiences of being undressed while traveling by rail,[90] but accommodations affording that degree of privacy were not introduced on the Austro-Hungarian routes until 1872.[91] Freud's assertion that he "must" have seen his mother nude suggests that he was imagining a setting that differed significantly from the open seating cars of his earliest childhood. What he offered may be characterized as a fantasy of a fantasy, suggesting that rather than stumbling upon this memory, Freud went looking for it at a time when he was already reconfiguring his notion of childhood sexuality; he went into his imaginary "storeroom" to retrieve it. His choice of this setting of transit, rather than the more likely quarters of their Leipzig lodgings, or their home in Freiberg, as the site where he glimpsed his mother naked suggests that this "memory" served as a way to disavow other aspects of his migration story,

turning it into what he had already noted to Fliess: a universalizing of the budding Oedipus.

The gaze upon his naked mother at this moment of rail travel also brings to the reader of the event an assortment of cultural tropes that produced the meaning of a forbidden scopic and sexual experience. While it is posited as an internal awakening, the setting works to already create notions of viewership, transgression, and sexuality that meld with Freud's narrative in ways that both naturalize the assumptions of forbidden eroticism and, by association, his own maternal longings. The containment of the rail car, as Wolfgang Schivelbusch contended, created a new, enclosed and autonomous spatial environment, one of enforced intimacy that could hold potential for encounters, and dangers, of all sorts.[92] Marcus discusses the relationship between literature on trains from both implications of the phrase: as reading choices when traveling and as the presence of rail interiors as they figure, and, as she argues, helped shape, certain specific genres, notably those of detective and mystery novels.[93] Matthew Beaumont, in his discussion of this latter phenomenon, characterizes the "train compartment as the scene of a crime."[94] All of these authors offer evidence that interactions within the moving car carry a very specific and heightened meaning, including the scopic. The external dimension of the rail routes may have inspired Presner to cast them as highly diffuse, but the experience within the car itself was quite the opposite, creating a visuality that was intensely focused and prescribed.

There is a noteworthy reference of Freud's that does connect his early life and an incident of criminality on a train, appearing in his publication of the session details that accompanied his "Notes upon a Case of Obsessional Neurosis," of 1907, commonly known as the "Rat Man" case. In the course of their work, the patient reports that a relative of his—whom he acknowledges is an unreliable source—had reported that he found an article in "an old number of the [Neue Freie] Presse" that recounted that Freud's brother, a waiter, "had commited a murder in Budapest and was executed for it."[95] Freud notes following this that "he was referring, as I know, to a Leopold Freud, the train-murderer, whose crime dates back to my third or fourth year." Freud also notes, "I assured him that we never had any relatives in Budapest."[96] That Freud was readily able to associate the story to that of Leopold Freud—a waiter, not in Budapest but in the Moravian city of Brno (Brünn), not far from Freud's birthplace—would suggest that he had some knowledge of the case, although he reveals a striking "misremembering" here. The murder—Leopold was caught and confessed to slitting the throat of a wealthy businessman as he slept on a train—was indeed reported in the Presse, but it had occurred in the fall of 1874, when Freud was a beginning student at the University of Vienna, and not at the much earlier date that he recalls in his publication.[97] However,

the two Freuds do have a common connection, although there is no evidence of any familial tie: Freud mistakenly recalled being three or four at the time of the murder, when he was actually in his eighteenth year, but when he was three, he was traveling by train, from Moravia to Leipzig, on the very same tracks of the "Nordbahn" that much later would be the scene of Leopold's crime. Leopold, twenty-three at the time of the murder and later executed, was born in Lúky, a village in Slovakia, near what is now the city of Trenčín (Trentschin), not far from the Czech border. The case attracted considerable attention and Leopold Freud's brain was the subject of a detailed forensic examination in Moravia, as an example of the anatomical particularities of someone characterized as morally "insane," two years after the incident.[98]

Also, the patient may have been aware of Freud's Moravian roots, and when telling Freud the story of the "waiter" may have correctly identified— as it was widely publicized—that he worked in Brünn. There is no mention of Budapest in this case; perhaps Freud displaced one "B" location (in a subsequent chapter here, this letter figures in his arguments for such substitutions as a mechanism of psychical forgetting) where, as he says of Budapest, he has no relatives, to further distance himself from the crime and its location. As Freud enacts this separation from the train murderer, he actually aligns the two of them in ways that underscore the importance of these forgettable years, and the memories he may have associated with the upheavals and fears—recall his memory of mistaking the gaslights in the Breslau train station for "souls burning in hell"—as he traveled from Moravia on the Nordbahn en route to Leipzig.

The "optics of the compartment," with its capacity for danger and crime, thus had particular resonances for Freud; yet when he recalled his journey to Vienna he turns to representations of another sort: the voyeuristic possibilities of eroticism within the carriage. The railway car was, by the mid-nineteenth century, a highly sexualized locale. As Robert Dingley's essay, cleverly titled "Closely Observed Trains," reveals, the train's interior was a powerful erotic image; he discusses Freud's use of trains in the *Three Essays*, but goes on to make an observation that has particular resonance when applied to Freud himself—"psychoanalytic readings, however, in their quest for totalizing explanations, tend to neglect the cultural specificity of the subject matter they seek to address."[99] While Dingley's work focuses on the literary and visual culture in Britain, his characterizations are more generally applicable to a space "independent of local roots" within Victorian Europe more generally, and provided a liminal space of various hidden and forbidden sexual encounters and arousals. The sphere of travel allows for such possibilities, and before there was the privacy of sleeper cars, there was still the possibility of desire upon the rails. Dingley characterizes the heterosexual male gaze in

these narratives in a way evocative of Freud's scenario: "however intrinsically 'innocent'" the encounter may be, the act of looking upon a woman "acquires a sexual edge" because it involves the act of "spying" on another.[100] Locating Freud's "awakening" here then enhances the construction of the sudden, the unexpected, and the almost obligatory. Freud says that he "must" have seen his mother's unclothed body en route to Vienna, as though the very location of transit created the possibility for such a thing to occur quite predictably, even imperatively. That said, in the absence of any privacy in cars in 1859, and in her fifth month of her pregnancy with Freud's second sister, Rosa, Amelia would have been unlikely to disrobe. But decades later, as Freud constructed the story, the emphasis was on the singular direction of his gaze, and its libindinal implication—his agency as the center of the story—that has led few to consider the veracity of such a story from the perspective of Amalia Freud or the reality of the circumstances surrounding this memory. Freud's theory of sexual difference, before it constructs its masculinist privileging and prerogatives, a legacy so importantly critiqued for the past half century, was, it can be argued, foremost a story about what was not to be told. The Oedipal fantasy is akin to an illusionist print, where one can see what appears to be primary content only because it was created by all that surrounds it and yet, by focusing upon it, the reality of its production is obscured.

Also worth noting here is an interim experience, between his early journey to Vienna and his recollection of it, also implicating the pleasures of erotic viewing on trains. At age sixteen, Freud was again heading to Vienna, this time after his first visit to Freiberg since his departure thirteen years earlier. On returning home, in a letter to one of his friends there, Emil Fluss, written in the strictest confidence, Freud recounts an incident of watching another traveler, in this case a girl, seated with her mother in a compartment near enough to his, that carried several boisterous soldiers, to allow him to gaze secretly at her: "even the worst of the noise could not make me take my eyes off her."[101] This experience would follow his first "calf love," for a young woman—the younger sister, Gisela, of his friend Fluss—whose family had been friends with Freud's parents, and after the girl returned to school, as Freud would reveal only much later, he formed a deep attachment to her mother.[102] But the issues of place and loss that may have undoubtedly been experienced when he returned to Freiberg and its verdant surroundings—"a paradise without equal" as he described the picturesque medieval town of Hukvaldy (Hochwald) within walking distance of his birthplace[103]—are never subjected to any scrutiny. As in his earlier journey to Vienna, only the erotic moments are worthy of being remembered.

The turn to his mother, posited here as an awakening of intrapsychic desire, also masked the upset in family dynamics that frequently occasions

migration, as Freud was moving now to close proximity to his maternal grandparents, who, as discussed in Chapter 1, lived in Vienna; this transition also marked the time when his father's presence as family patriarch and financial presence would be gone, replaced by his grandfather (and near contemporary in age to his father) Jacob Nathansohn. It is believed that Jacob Freud and Sigmund's maternal grandfather had business contacts in some capacity and it was from this association that the introduction of Sigmund's future parents in all likelihood occurred.[104] Presumably, Jacob Freud now hoped to establish himself in Vienna, perhaps imagining a reconnection with, and support from, the Nathansohns. In Freiberg, Amalia, who, as we noted earlier, had lived in Vienna since her youth, entered into a family structure created by her husband, with two grown sons from a previous marriage, one with a young family; in Vienna, the scene reverses, as they will now reside within her family constellation and in the city of her girlhood.

Might the Oedipal revelation be better understood as a use of infantile longing, whose veracity was very much on Freud's mind at the time, to assert control of a narrative by evocations whose erotic content may have relied on popular tropes? His "awakening" to his mother in the period of his transition to Vienna is better framed as attachment, not excluding an erotic element, but as part of a larger sense of realizations concerning her. Recent scholarship on the particular ways that children negotiate issues of agency in the aftermath of geographical and cultural disruptions[105] would suggest that Freud's retelling of his arrival at Vienna, and the forgettable years that followed, were a restoration of centralizing his role. By casting the period as one organized through the lens of a child's desire, all the dynamism that filled this scene from external factors could be redirected into an intrapsychic, child-centered desire. Joel Whitebook's recent biography is distinguished by its attention to the ramifications of Freud's first years. Whitebook considered what he terms his "pre-Oedipal experience" as "too dangerous for Freud to explore," an inability to enter the "pre-Oedipal" world that, Whitebook emphasizes, "*centers on the infant's relation to the early mother*" (ital. original).[106] What results is "phallologocentrism" and Whitebook elaborates upon Freud's negotiations between the "devalued feminine" and his construction of what was its binary, in masculinist identifications and a correlative logocentrism.[107] My approach positions the inquiry outside of that *Rahmenmotiv* and considers how yet-to-be-reckoned-as-consequential experiences may have been decisive, yet by being in excess of an exclusively gendered episteme, hidden in plain sight.

In "Screen Memories" Freud recalls his age at his departure from Moravia as a year younger than he was; but it was probably at this earlier age that, in a recollection found in *The Interpretation*, he first sensed the complex parental

affect around their subsequent departure. He recalls that he mistakenly understands, from a conversation overheard between his parents, the word *Reisen*, for travel, as *Reissen*, meaning illness. But this might gesture to a broader series of miscommunications of various kinds, whose impact, as Laplanche argues from the sexualized messages, has profound significance.[108] Might this enigmatic conveyance be extended? Freud's anecdote has striking resonances with observations made by Naomi Tyrrell, who writes about the exclusion of children from parental discussions—the "everyday decision making within a family"[109]—in topics relating to relocation; in her case, the move involves contemporary transitions from rural to urban areas of Britain. She notes that such narratives are implicitly from an "adultist" perspective that has shaped and circumscribed the literature of families, like Freud's, who migrate for reasons of economic necessity. And although children are often the motivation for a move (a case could certainly be made that Jacob and Amalia Freud would have seen their children's future as decisive here) they usually remain apart from the process itself, especially those at a very young age. "It was apparent that younger children"—Tyrrell classifies this group as under six—"were often confused"[110] about what was occurring; an obvious example is provided in Freud's recollection. If, following Laplanche, early sexuality emerges as attempts at decoding, then perhaps that can be used to interrogate childhood inscriptions that carry other affective parental messages as well. The threats of illness and travel both suggest potential somatic vulnerabilities. There was also something quite prescient in Freud's error: their forced *Reise* from Leipzig to Vienna was postponed for two months, from August to October, because of the ill health of Freud's sister, then eight-month-old Anna. In her memoir, to be read cautiously, as noted earlier, as many of the details do not corroborate with other known accounts involving the family, Anna recalls that "there in the hotel I had scarlet fever that went unrecognized, and subsequently dropsy."[111] This provides the only reference to the quarters of the Freud family in Leipzig and while not from a completely reliable source, may suggest that "the hotel" was the one where her father had previously resided and where the family joined him.

Freud's placement of his sexual awakening in a train compartment further infused the story with a sexualized overlay that also shifted his readers' view, as it were, away from other implications of this location, especially for a child in transit, and thus he could elide to the spontaneous occurrence of "Oedipal" desire more persuasively. We will see this strategy repeated when Freud identifies the first workings of an unconscious functioning in the mechanism of "forgetfulness" in Chapter 4. In this latter case, he draws on cultural tropes of a colonialist kind, casting the "forbidden" sexual material that incited his repression as deriving from conversations, within another

version of a carriage, laden with ethno-cultural stereotypes, about the Islamic residents of an area along the Dalmatian coast where he would holiday in autumn after visiting Orvieto. In both cases, "sexuality" as the instigation for unconscious functioning is produced at scenes of a cultural production of erotically constructed encounters.

There was also a material object, holding a remarkable array of imagery, that must have made those rail journeys alongside the Freud family. It was an illustrated book that would be the mute witness to the transits from Freiberg, to Leipzig, and then to Vienna; the only possession we can, in confidence, claim made this passage was their copy of the so-called "Philippson Bible."[112] Jacob Freud's choice, made well before Sigmund's birth, for the family's *Tanakh*, the Hebrew Bible, was a work remarkable in its departure from Jewish scriptural tradition. The editors—Ludwig Philippson (1811–1889), a Reform rabbi and Berlin-trained classicist, and his physician-brother Phoebus (1807–1870)— created a literary and visual compendium to accompany the biblical text, including commentaries and illustrations drawn from an array of sources used to gloss the Hebrew and German verses.

It was initially issued in fascicles, beginning in 1839 and extending through the mid-1850s; a bound, three-volume set—a used copy of which Freud was to acquire later in life—was subsequently published in 1858–1859; an even later edition contained illustrations by Gustave Doré, who had also illustrated Christian Bibles.[113] The inclusion of illlustrations was arguably one of the most striking example of Philippson's belief in the *haskala* —the Jewish "Enlightenment"—that had been championed by his father, Moses Philippson. The elder Philippson, Saxon-born but descended from a lineage of rabbinic scholars from Krakow, authored a number of biblical translations in German, whose precedent certainly influenced the work of two of his sons. Although Freud recalled that his own father "did indeed come from a Chassidic background,"[114] by the time he subscribed to the Philippson version of the Bible, one assumes that he had abandoned certain strictures of his childhood. Jacob actually may have embraced *haskalic* values at quite a young age; Krüll suggests this took place at the time of his first marriage, in the early 1830s.[115] It would seem that the Freud family Bible remained in segments until Jacob, much later, had it bound in paper boards backed in cloth. What was contained within those covers were the first portion of installments—the Bible's inaugural five books—and fragments from the books of Samuel and the King of Kings. The occasion for this binding was Freud *fils'* thirty-fifth birthday, and Jacob wrote a dedication in Hebrew, citing the present as a

Figure 3.3 *Die Israëlitische Bibel.* Edited by Ludwig Philippson, Images of Egyptian Gods (accompanying Deuteronomy, 4:18) (Leipzig: Baumgärtner, 1858), vol. 1, p. 870. (Photo: Mary Bergstein.)

"memorial" and a "reminder," both of Freud's engagement with the text since childhood (Freud recalled that, with his father, he had learned to read from it) and as an object that would serve to recall Jacob to his son; the elder Freud would die five years later.[116] Jacob's inscription suggests the latter's belief in the sustaining power of the text, both in its content or also its materiality, one kept all these years in its original, now fragmentary, condition, which Freud's father cites as akin to the first presentation of the commandments on Sinai, calling them "the broken tablets of Moses" that he now offers, gathered up, to his son. The inscription dates the passing of the book to Sigmund's birthday—May 6—of 1891. We do not know precisely when Freud had it in his possession, and can only speculate if the volume was with him eight days after his birthday, on the day—May 14—of the death of Pauline Silberstein. How these events may have become conjoined cannot be discerned, but the evocations of these fascicles, as we will see, would remain literally in Freud's sight, surrounding him, contributing to a working space in which both the treatment modality and the space in which it occurred diverged so markedly from that of the "House of Atonement." There, his office had various instruments and devices that must have filled the space; in Berggasse 19, these would be replaced, first by the new *diwan* and then, surrounding it and filling both consulting room and library, the hypnotic effect of a different scientism, one that relied upon endlessly displaced, historized fragments. (Refer to Figure 2.1.) The evocations from a number of these objects were also of a singular past, as Freud would make choices, as we will see, strikingly akin to those evinced by the Philippson's illustrations.

As noted earlier, the parallel German and Hebrew texts of the Freud family Bible occupied only a fraction of a given page; in a nineteenth-century variation on the structure of Talmudic commentary, the scriptural passage was surrounded by extensive elaboration. These textual glosses were something of an antiphonal exchange between the Philippson brothers. Ludwig would expound upon historical and cultural issues relevant to the verses, while Phoebus often used the original narrative as a springboard for excursions into a variety of scientific areas. The Philippsons located their readers' spiritual legacy as part of a far broader construction of antiquity—one constructed by a melding of classical sources and colonialist visions of the *Morgenland* ("morning land"), a term used frequently in the Philippson Bible that was popularly synonymous with the "east"—areas of the so-called "Levant" of the eastern Mediterranean, Turkey, the Iranian plateau; but here extended to the classical Greece and Rome as well, locating the early history of Jews as one of its constituents. For the Philippsons, the "evening land"—*Abendland*—was not only the European "West," exemplified by Germany, but extended beyond a geo-cultural phantasm into the content of

the brothers' cultural and scientific commentaries; if the sacred text was the product of the Jews of the morning lands, these glosses were firmly based in its path of development that brought them into an enlightened evening. The editors' ethos was much shaped by a vision of modernity, far more developed in Ludwig's more journalistic writings and essays—he edited, for nearly a half century, Germany's most influential Jewish newspaper, the *Allgemeine Zeitung des Judenthums*—in which he, despite acknowledging the prevalence of anti-Semitic violence on the continent, believed the Jews ultimately would flourish. For him, the nineteenth century marked the ascent of the spiritual triumph of human rights over the evil forces of mass oppression: he considered the two greatest events of the century to be the liberation of the Russian "serfs" and in America the emancipation of enslaved persons of African origin.[117]

The text's purpose was to impart knowledge—religious, certainly, but one that coexisted here alongside cultural, scientific, and even aesthetic epistemes—and thus markedly departed from the traditional role of scripture, as Jacob Freud would have understood it in his youth, as the divine record of Mosaic revelation. Ludwig Philippson's historicist perspective cast Jewish history as progressive, east to west, and thus part of the Eurocentric view of progress and alterity.[118] That Freud filled his working spaces with objects, some indebted to those selected for the Bible, was in fact a materialization of Philippson's vision. It is, however, mistaken to see the relationship between Freud's collection of "antiquities" and the Bible as located only in discourses of history confined to the *Morgenland*. The assemblage was as much about the capacity of modernity to discern, assemble, and utilize these fragments in the service of fantasies about the past.

The Bible's imagery—over 500 illustrations appeared alongside the commentaries—was an unprecedented feature of a Hebrew Bible, where traditional prohibition against any form of religious imagery had hitherto prevailed. Although inspiration for this work was surely the popularity of illustrated Christian Bibles during this time, the visual representations here were strikingly different. The Christian renditions usually chose to illustrate, often with selections from the art historical canon of religious imagery or, in some cases, of contemporary artists, a very direct text/image relationship: the content of the written narrative was usually "shown" within the accompanying picture. The Philippson's visual production (as created with Baumgartner, their publisher in Leipzig) differed in two respects. The imagery came predominantly from "secular" subjects: manuals of flora and fauna, illustrations in museum collections, archaeological reports, travel guides. And the way in which these representations operated here was also markedly different. While the Jews were lauded by the Philippsons for their

distinctive capacity to survive, the editors repeatedly positioned them as part of the vast legacy that extended far beyond the Judean hills, to Egypt, Babylonia, and the classical Mediterranean.

The illustrations served to underscore this vision, as events in the text were almost always accompanied by an image from one of these other early cultural traditions, or of a natural phenomenon cited in the text. The accounts of funerals in the time of King David, found in the second book of Samuel, for example, were illustrated by scenes from the Egyptian Book of the Dead,[119] while the mention of a patriarch's use of a seal was paired with a picture of comparable Babylonian examples.[120] Pheobus's choice of imagery revealed his interests in the emerging field of evolutionary zoology; a contemporary rendition of an Egyptian frog appeared alongside the textual account of its forebears in the famous Exodus narrative.[121] Thus, the events in the biblical text were accompanied by representations that were elided visually with them; the latter were re-formed into a new assemblage, their meaning and value now serving a metanarrative of history in which the particularities of their origins or cultural specificity were far less significant than their capacity to serve some epistemological project in which fragments of the past could be deployed. This strategy would serve a similar function at the earliest site of the psychoanalysis, where an autonomous fragment, as argued in the previous chapter, wrested from the details of its historical production and meanings, appeared at the moment when Freud's turn to his own discernment of memories determined the constituency of the unconscious.

There is considerable evidence that certain of Freud's "antiquities" were strikingly similar to those that appeared among the Philippson's illustrations—groups of ceramic figures paralleling illustrations of the Egyptian Book of the Dead and Babylonian cylinder seals, both cited earlier, also appear at Berggasse 19—joining statuary, stele, and vases that can, as Ana-María Rizzuto has shown, demonstrate this connection.[122] Freud remarked that his early association with this text fostered his "deep engrossment in the Bible story."[123] There is also the possibility that the imagery had its effect on his childhood, suggested by the only example of a dream from his youth that Freud includes in *The Interpretation of Dreams*, and also evokes familial connections that he interprets here through the Oedipal lens that became the cipher for his childhood memories. It involves a scene whose source he attributes to "der *Philippson*schen Bibel" ("the Philippson's Bible");[124] the italics are original here, and appear to function to align with the name of a childhood companion, as we will see, who figures within Freud's associations to the dream. The representation he is recalling must reference the sole renditions of this theme among the Bible's images: the Egyptian funeral scenes aligned to the narrative in the book of Samuel, cited earlier.

394 2 Schemuel 3, 33—35. שצד שמואל ב ב׳ לג-לה

in Chebron, und der König erhob seine Stimme und weinete beim Grabe Abner's, und es weinete das ganze Volk. 33. Und der König stimmte ein Klagelied um Abner an und sprach: Mußte, wie ein Nichtswürdiger stirbt, Abner sterben? 34. Deine Hände waren nicht gebunden, und deine Füße nicht in Fesseln gelegt, wie man vor Ungerechten fällt, bist du gefallen! Und das ganze Volk weinete ferner um ihn. 35. Und das ganze Volk kam, David Speise zu reichen, da es noch Tag war, aber

בְּחֶבְרוֹן וַיִּשָּׂא הַמֶּלֶךְ אֶת־קוֹלוֹ וַיֵּבְךְּ
אֶל־קֶבֶר אַבְנֵר וַיִּבְכּוּ כָּל־הָעָם:
(לג) וַיְקֹנֵן הַמֶּלֶךְ אֶל־אַבְנֵר וַיֹּאמַר
הֲכְּמוֹת נָבָל יָמוּת אַבְנֵר: (לד) יָדֶךָ
לֹא־אֲסֻרוֹת וְרַגְלֶיךָ לֹא־לִנְחֻשְׁתַּיִם הֻגָּשׁוּ
כִּנְפוֹל לִפְנֵי בְנֵי־עַוְלָה נָפָלְתָּ וַיֹּסִפוּ כָל־
הָעָם לִבְכּוֹת עָלָיו: (לה) וַיָּבֹא כָל־הָעָם

v. 34. ‖ בנ״א 1

Bahre. Von einem Basrelief in Theben.

Bette sehr ähnlich ist; die Bahren bei diesem Volke waren, wie uns die Leichenbegängnisse an den Skulpturen zeigen, sehr oft mit ausgezeichneter Kunst gearbeitet; wahrscheinlich waren sie je nach dem Range des Verstorbenen von größerer oder geringerer Pracht, bei den Armen bedient man sich noch jetzt im Orient einfacher Tragen. Josephus erzählt von dem prächtigen Leichenbegängniß des Herodes: der k. Leichnam wurde auf einer bettschmählichen Bahre von Gold getragen, die mit kostbaren Steinen besetzt war, er lag auf purpurnen Kissen und war von einem Purpurmantel bedeckt, hatte eine Krone auf dem Kopfe, das Scepter in der rechten Hand. Die Bahre war von des Königs Söhnen und Enkeln umgeben, nach welchen seine Garden und fremden Söldlinge in Reihe und Glied kamen, gefolgt wiederum von 500 Dienern, mit Spezereien in den Händen. Vor der Bahre schritt das Gros des Armee her in militärischer Ordnung unter ihren Offizieren. Auch bei den Römern wurden die Leichen mit großer Pracht bestattet: goldene oder sonst reichgeschmückte Bahren, gefolgt von vielen Betten (6000 bei der Bestattung des Diktators Sulla), auf denen die Bilder der Vorfahren der Verstorbenen lagen, ein großes Gefolge u. dgl. Bei den Hebräern folgten insbesondere die Verwandten mit lautem Weinen und Wehklagen (vgl. Baruch 6, 31.), nachdem schon im Trauerhause Klagelieder ertönt waren (vgl. Jirm. 9, 17.), wozu noch der Mischna (Moed kat. 3, 8.) besondere Klageweiber gemiethet wurden. Im Talmud werden Hörner an Todtenbahren erwähnt, bestimmt, um die Leichen daran festzubinden. — 33. 34. Der Sinn ist: Abner starb wie ein Verbrecher, ohne daß man ihn eines Verbrechens überführen konnte. Solche Verbrecher legte man in Fesseln, ehe sie durch's Schwert gerichtet wurden, damit sie keinen Versuch zum Widerstand machen konnten. Dies war bei Abner nicht der Fall, weil er eben kein Verbrecher war und dennoch fiel er durch's Schwert vor ungerechten Menschen (בני עולה). — 35. Nach der Bestattung wurde eine Trauermahlzeit gehalten (vgl. Jirm. 16, 5. 7. Hos. 9, 4. Jechesk. 24, 17. 24.). In späterer Zeit gaben vornehme Familien zu Ehren ihrer Verstorbenen, selbst dem Volke, luxuriöse Mahlzeiten (Joseph. jüd. Kr.

Figure 3.4 *Die Israëlitische Bibel.* Edited by Ludwig Philippson "Bier. From a bas-relief in Thebes" (accompanying 2 Samuel 2:2) (Leipzig: Baumgärtner, 1858), vol. 2, p. 394. SCR 391 Philippson v.2, Andover-Harvard Theological Library, Harvard Divinity School.

The "Dream of the Bird-beaked Figures" is the last of Freud's in his compendium, a volume that we will discuss in detail in Chapter 5. From his childhood, it occurs in the final chapter of his "dream book," a section devoted to the "psychology of the dream-processes."[125] As Freud concludes his text, his choice to introduce material that exemplifies the difficulties of understanding "the mental processes of dreaming" would today constitute an inquiry into the neuropsychological structuring of the act of dreaming. In a book focused upon interpretation, there are examples where that issue may be secondary to determining "the essential characteristics that differentiate dreams from waking life." So, rather than the objective of the preceding chapters, which was to identify the "secret meaning of dreams" and discern the "means employed for concealing it," Freud will suggest examples that give a glimpse into the "mental processes" rather than the unconcealed, censored meaning.[126]

Freud had opened this final chapter with a striking example, also involving a child, that he attributes to a story told about it by a female patient, who had heard it in a "lecture" on dream interpretation.[127] Thus, it sits on the edge of credibility, as it has passed through several retellings, with the dreamer's identity long lost. But Freud obviously considered it valuable enough to include here; one might inquire if, because he had a final and important example to include, this one from his patient was used to preface the chapter. It is attributed to a grieving father who, after staying at his ill child's bedside, retires into his own room after the child (whose gender is never specified) dies, leaving the child to be watched, with tall candles standing around, by an "old man" whom he engaged to perform the obligation, in Jewish tradition of *shemira*, watching over and praying by the deceased until burial. The father falls asleep in the next room and dreams that his child is alive, touching his arm and "reproachfully" asking him: "Father, don't you see I'm burning?"[128] Freud notes that in fact there was an increase in light that fell into the man's room, that this must have awakened him and then he rushed to his child's side. Indeed, the *shomer* (the guardian) had fallen asleep and one of the candles had fallen, igniting the child's shroud and burning the boy's arm. Freud wonders "why it was that the dream occurred at all in such circumstances, when the most rapid possible awakening was called for."[129] The interpretation is that the child, by virtue of calling out, is still imagined as alive, which allowed for that illusion, that wish, for his child to exist, to extend a moment longer. Freud felt that this type of complexity in the functioning of dreams offered insight into their psychological causality, a topic he considered a little-known territory—where "every path will end in darkness."[130]

Freud introduces the recollection from his childhood as the other bookend that closes the chapter, and in a portion of this section devoted to how dream

"processes" function in what he calls "anxiety dreams."[131] But in these cases, there actually seems to be far less question about ultimate causation, as he clearly asserts that such examples all arise from "sexual sources."[132] Unlike the interpretation of the "burning child," the interpretative lens here focuses on demonstrating "the sexual material present in (the) dream thoughts."[133] This feels much closer to what has already been the primary focus of the text and its interpretative strategy. But there are some interesting evocations of the chapter's opening example in Freud's memory of the biblical illustrations, although these two dreams have not been considered in this light. Freud opens his description at the point of seeing his mother—"with a peculiarly peaceful, sleeping expression on her features." She is not lying on a surface, but he watches as she is borne aloft by an unusual pair (or perhaps trio) of people: "strangely draped and unnaturally tall figures with birds' beaks." She is then "laid upon a bed." Freud recalls that he "awoke in tears and screaming, and interrupted my parents' sleep." Freud's first association is Philippson's image of "gods with falcons' heads from an ancient Egyptian funerary relief."[134]

The interpretation then turns to sexual themes, with the anxiety cast not as concern about his mother's death, but as a preconscious revision under the influence of another anxiety—his Oedipal repression against "an obscure and evidently sexual craving that had found appropriate expression in the visual content of the dream."[135] This thus links the funerary bier directly to his mother, but the appearance was "copied" from the sight of his grandfather, as he lay in a coma "a few days before his death"[136] in 1865. Freud would have been nine at the time, and thus a bit older than he recalls here. But he goes no further in suggesting that the dream "thoughts" may have related to feelings toward his grandfather rather than his mother, and Freud, needing to supply the "sexual thoughts" that might underlay this dream, then shifts the focus away from the visual—that presumably gestures to death rather than sex— and to the linguistic: a referent to the sexual meaning is linked to one aspect of the image field that has no direct association with death: the word for bird (*Vogel*). But this, too, actually leads back to associations that can be related to Freud's relationship to his mother's parents.

As noted earlier, the Nathansohns lived in a comfortable, bourgeois building through Freud's early years in Vienna; at some point after his grandfather's death, in 1865, his maternal grandmother appears to have returned to her native Odessa, where she died "at a very great age."[137] In contrast to the Nathansohns' domestic stability, Freud and his family had considerable difficulty maintaining a permanent residence. Reunited as a family when Jacob joined Amalia and their two children in Vienna in December of 1859, that number soon expanded with the birth of another sister Rosa, in March 1860; three more girls and a brother arrived in the course

of the next six years. The increasingly larger family moved a number of times during the course of Freud's childhood and teen years. By the time that Jacob Nathansohn died, young Sigismund had lived, along with the time spent with his maternal grandparents immediately upon his arrival, in at least four different apartments and a residential hotel.[138] The family's first apartment was located just across the Danube and in view of the Nathansohns' home; it was, however, a world away. The family apparently lived as subtenants of one of Jacob Freud's relatives, Selig Freud, who is listed in a registry of that time as a brandy maker.[139] Krüll has suggested that the living conditions were harsh in places like this, with extreme overcrowding as the spaces were constantly divided to meet the needs of new arrivals.[140] The building that was the Freud family's first Vienna home was a large tenement and, by the late 1850s, quite run down. The structure was originally built as a residence for the employees of the steamship company that operated on the Danube and was well maintained in those days; with the introduction of propeller-driven ships, however, the demographics changed along the canal and the building had been taken over by the city for housing. In a photograph as part of an imperial project to document panoramic vistas of the city, taken in 1860 from atop St. Stephen's Cathedral, the building appears as a sprawling, nondescript structure, most notable for its large front lawn that was possibly a legacy from its earlier days.[141] It was torn down after the Second World War, and replaced several decades ago by a large commercial building. All that remains today from that period is the street that would have run along the side of the building and the canal—Dampfschiffstrasse (Steamship street). The original residents were predominantly Jewish both in Freud's childhood and the years to follow. But that came to an end in 1938: records contain the names of the final Jewish occupants of the building at 3 Oberweissgerberstrasse, the Spiegel family, who were taken from the residence later in the same year of Freud's final migration, to London. Their fate would not be as fortunate as his, as they were among a group of 1,200 Viennese Jews from that neighborhood who were deported to a small Polish village near Lublin and then murdered in the death camp of Bełżec.[142]

In the dream about his mother and grandfather, Freud associated the bird-beaked figures that he recalls from the illustrations in the Philippson Bible with another meaning associated with *Vogel* ("bird"), its slang variant of *vögeln* ("bird mating"). He recalls being instructed in sexual matters by a boy named Philipp, the child of "a concierge" (*Hausmeisterin*, indicating that this was a woman); the word for bird apparently also had sexual connotations, a connection that Freud sensed "from the look on the face of my young instructor."[143] He remembers that they played on the grass in front of his (Freud's) house as children. It is often assumed that this event took place

in Freiberg, but there would have been no concierge in the small two-story home there, where the Freud family rented rooms on the second floor from the building's owner, the locksmith Jan Zajíc, and his wife Monika, the latter another of Freud's early caregivers. Rather, this must have taken place later, in Vienna, probably on the expansive "garden" in front of the building, on Oberweissgerberstrasse. Freud says that this was his introduction to "the vulgar term for sexual intercourse."[144] It is with this association that *vögeln* then becomes elided with the falcon's head of the biblical imagery. Although the imagery may have spoken of anxiety about loss—his grandfather's—and perhaps fears of maternal abandonment as well, with the introduction of Philipp and his forbidden sexual knowledge, Freud immediately narrows his understanding of the dream's meaning to that of an "obscure and evidently sexual craving" for his mother.

Thus the dream's meaning becomes accessible exclusively within the Oedipal "framing motif," foreclosing any further discussion of his family relationships or his earliest memories of life in Vienna, the latter strikingly different from what he left behind in Moravia. It would make sense that he would associate the bird imagery with a place close to his grandfather's home, as the dream occurred near the time of his death. But the locational specificity is irrelevant for Freud here: the only memory that emerges from his associations involves sexual knowledge, with its interpretation gesturing back to his other early awakening of erotic understanding as he arrived in Vienna. By locating the only dream from his childhood in an exclusively Oedipal context, he effectively erases any possibility of reckoning the psychical significance of the various aspects of the story that deal with the harsh realities of life across the canal from his grandparents, or the meaning of the loss of the person to whom the young Freud may have looked for stability and support. Although this aspect goes unexamined in the literature, perpetuating Freud's silence, it would be useful to consider the shift in family dynamics beyond the contours established by Freud's reading of his dream. As Carola Suárez-Orozco[145] has pointed out in her work on children who experience shifts in family dynamics as part of a migration experience, it is not uncommon for certain members in this circumstance to be "demoted." Such a fate appears to have befallen Jacob Freud, who never attained the secure financial footing that appeared to always elude him in Vienna. As we have seen in Chapter 1, in the years after his grandfather's death, Freud was captivated by books wherein a young boy is saved from poverty by a generous, older male patron.

Returning now to the dream of the burning child, one might offer a very different reading of the dream with the Egyptian figures: did Freud imagine that expression, which seems to merge his mother and grandfather, as a

way, after the death of a man he may have imagined as his protector, to actually keep him alive a bit longer? The ritual that attended the young child would have been, in all likelihood, accorded to Jacob Nathansohn as well. Freud, at nine, had apparently visited his grandfather, close to his death, after which Jacob was buried in the Währinger cemetery—his grave was destroyed later by the Nazis when they dug up a section of the burial ground—soon after his death on October 3, 1865.[146] Could Freud's "anxiety dream" have been less about the loss of his mother and more about a wish to still have her father alive, akin to the parent of the dead child wishing to have him speaking to him at his side? The association might also explain why the childhood dream is present in this chapter in the first place, since it does in fact focus on unlocking hidden meaning and not, at least as Freud retells it, on the psychological function the dream might be serving. Freud's grandparent's presence seems to circulate through the story of the *Hausmeisterin*'s son, although the focus upon the "sexual content" foreclosed other layers of significance that may have been operating in Freud's choice of that story as a way to "unlock" the secret Oedipal meaning of the dream, albeit, as he admits, finding its source in this particular dream "obscure."[147]

There is another object on which one reclines that can be placed alongside the funerary litter and the child's deathbed and that of Jacob Nathansohn: the analytic couch. Surrounded by objects, a number replicating those of the Philippson Bible, there is one particularly notable example that can also be read within the dream of his childhood. In Edmund Engelman's photographs of Freud's office, we are able to see an attenuated statue of the bird-headed god Horus[148]—one whose acquaintance Freud made when standing among the gargoyles of Notre Dame. The wooden statue in his office is a forgery— not an unknown occurrence among his vast collection—and thought to have been acquired rather late in Freud's life.[149] From the photograph, it appears that Freud has placed the figure in such a way that it seems to be walking toward the *diwan*, the gift in the decade before *The Interpretation* was written, but decades after he had dreamt of such a bird-headed figure. In the early 1930s, when this object was thought to have been purchased, Freud was still accumulating material, perhaps purchasing this object as a group of such wooden figures.[150] In advancing age and declining health, with the political situation deteriorating around him, Freud continued to gather objects that spoke of his own antiquity and, as his vulnerabilities accelerated, they were still an assertion of his agency and ability, as with the Horus, to determine in what manner these bits of the past were to be used.

The railway car and the overcrowded apartment building—sites where Freud chose to enact moments of early sexual realizations—are also locations with content that was remarkably complex for the young Freud, yet unvoiced in his interpretations. Of the period between the incident on the train and the childhood dream—from one Oedipal proof test to another—Freud says almost nothing of his life in Vienna. In 1899, in "Screen Memories," he will recall that in the time after leaving Freiberg "my recollections grow scantier and less clear" during a period where, as noted previously, "long and difficult years followed."[151] His boyhood was simply effaced in this phrase, at the cost of essentially removing it from subsequent psychoanalytic interpretation.

Ken Corbett vividly traces this process of erasure as enacted in the case of a five-year-old, known as "Little Hans," who became, using Corbett's term, Freud's "*Ur*-boy."[152] Here we are able to see how Freud crafted the parameters of early childhood. Through "Hans" (Herbert Graf), Freud attempts to construct a genealogy for heterosexual masculinity, one defined exclusively within an Oedipal schema. The boy—the son of a follower of Freud, Max Graf—is portrayed as beset by fears and anxieties that Freud contends derive from his erotic passions for his mother. As Corbett recounts, Freud takes the myriad issues that surrounded this child's early life—the eroding marriage of his parents, the suicides of two maternal uncles, his mother's ongoing struggles after the arrival of his younger sister (who also would eventually commit suicide), and her various losses—and "parses and whittles" them until "this winnowing foregrounds and establishes Freud's normative Oedipal narrative,"[153] sustaining its "frame as symbolized and idealized."[154] From all this emerges the *Rahmenmotiv* of normative masculinity; yet, as Corbett charts the exclusion of the painfully particular dynamics and events of the Graf family, necessary for Freud's construction of "a boy," this has profound implications: "one could argue that the past century's psychological discourse on masculinity hinges on these very absences."[155] One can gain from his reconstruction of Herbert Graf's childhood important insights into how Freud winnowed his own boyhood. He chose in both cases not to consider the psychical price of tumultuous experiences that come upon a child, and loved family members, but instead privileged those generated from within the child's own inner realm. How different would the working of the Freudian unconscious look, and the institutionalizing of normative heterosexuality in its wake, if Freud had espoused an alternative framing motif, one that did not utilize sexuality defensively but instead regarded it alongside other early experiences that held the possibility of trauma and loss?

By the time he wrote about the young Graf, in 1909, Freud had already created a mechanism that would enact what we have been charting through this chapter—the rendering of early experiences as forgettable: this would

be the Lethe that he had hoped to find as he revealed his early life to Fliess in the autumn of 1897. In a letter to his friend in March 1898, noted earlier in this chapter, he first announces his awareness of infantile "amnesia," a pronouncement that equates this early repression with the origins of both one's dream life and the unconscious itself. The relationship between the forgetting of early life and dreams may have another dimension in that moment, unacknowledged to Fliess. At the time that he made this "discovery" Freud had his very well-known "Dream of the Botanical Monograph"—to be discussed in detail in Chapter 5—whose imagery and associations can be traced back to the time of the arrest of Freud's uncle Josef and a period of his early, and seemingly forgettable, life in Vienna. As we have seen with the "Hella" dream, unwanted content was subsequently theorized away by introducing unconscious structures that were presented as ahistorical and *a priori*. With Freud's formulation of infantile amnesia, we see a strategy repeating that of fantasy, where meaning fissures along a fault line that divides what was repressed and ostensibly forgotten but retrievable, from what was disavowed and washed away.

<p style="text-align:center">*****</p>

Freud's normative reading of amnesia, one not attached to physical trauma or illness, was a significant constituent of his first published work on psychical mechanisms: his essay on the forgetting of the name of the Tuscan painter, Luca Signorelli. His formulation of infantile amnesia and the functioning of a "parapraxis" both occurred in 1898, in the months after the revelations to Fliess about his past detailed here. In the period immediately after his return from Italy the year before, we have seen Freud move quickly to establish the libidinal capacities of a child, as he systematically embarked on a review of his early life. Frequently posited as an act of discovery, what resulted from this process is presented here as a more complex process that entailed simultaneous acts of revelation and deletion. Forgetting would become an important concern as a result of this strategy, as Freud increasingly developed mechanisms to assign value to what was retrievable by identifying what was repressed. Whatever else existed in early experience was subsumed under what Freud would later come to call the "veil of amnesia," and permanently removed from analytic meaning.

In the midst of those autumnal letters to Fliess in 1897, Freud offered little insight into the memories that did not later figure within his new model of mind. In the midst of his self-analysis in those months, there is, however, a moment when Freud does offer a rare glimpse of what this content might include; this occurs, one doubts coincidentally, in the same letter that contains his mention

of the use of framing and filling.[156] In fact, this insight into how the process of his self-examination—he calls it here his "inner work"—felt to him is immediately followed by the statement about determining what is "large, general" and contained by a *Rahmenmotiv*. But what preceded this is quite different, and far more specific: it speaks to experiences and circumstances soon to be lost from view, and subsequently from the language of psychoanalysis. Freud writes here that he feels as though "pulled" through "ancient times," with moods that he characterizes as very changeable, "like a landscape seen by a traveler from a train."[157] In this case, the reference to the rail is not that of autoeroticism, but rather a lack of self-determination, of a body moving in spite of itself. The somatic memory here speaks to an inability to focus, and multivalent moods, rather than the stasis and control of the libidinal gaze. Later, Freud will return to this image when he describes psychoanalytic technique, suggesting that the patient be listened to like a traveler describing what is seen out a train window. In this letter, of October 27, 1897, he also pens three lines (verses 10–12) from the "Dedication" that Goethe wrote to his *Faust*:

Und manche liebe Schatten steigen auf;
Gleich einer alten, halbverklungnen Sage,
Kommt erste Lieb' und Freundschaft mit herauf.[158]

(And with them many well-loved shades appear;
A half-forgotten distant intimation
Of those in early times I held so dear.)[159]

It is an interesting choice here, as these lines were written twenty-four years after the primary portion of the work was composed. By then, a number of people who had influenced Goethe's earlier life, and this work's creation, were either dead or estranged; this dedication speaks to the ability to conjure them back to life. The lines that follow these express this cost:

The grief returns, once more the lamentation
Of life's obscure and wayward course I hear
For those capricious fortune cruelly treated,
Who all too soon of joy and life were cheated.[160]

Freud does not include this remaining part of the stanza, but does provide his own version. He adds, "And also first fright [*Schreck*] and discord [*Hader*].[161] Many a sad secret of life [*traurige Lebensgeheimnis*] is here followed back to its first roots; many a pride and privilege are made aware of their humble origins [*bescheidenen Herkunft*]."[162]

Of these terms, the only one that appears in Freud's published works is *Schreck*, a word that, as Jonathan Lear points out,[163] is frequently misunderstood. Often regarded as synonymous with fear or anxiety, this erroneous reading implies that something dreadful is known in advance. However, Lear underscores a significant distinction: this word for "fright" speaks to a state of being "unexpectedly overwhelmed by dread." This affect is associated with a sudden, uncontrollable intrusion—in that usage, it should not be surprising that the word's most sustained appearance was in Freud's work on hysteria prior to 1897. In "The Aetiology of Hysteria," where it occurs several times, its associations suggest areas of experience that Freud will not continue to examine. Near the start of the paper, he associates traumatic scenes of "great fright" with a "railway accident" or the rape of a child.[164] He contrasts this with the "seduction" of a young girl or boy by a family member or caregiver, where the abuse is often ongoing and becomes intertwined with affection and dependence. This kind of insidious and familiar sexual behavior, visited by a trusted adult onto a child, became Freud's focus, which, after specifically identifying it with fathers, he would then recant. But here it appears that the "first" shock would suggest an arbitrary threat of violence, sexual or otherwise, that he appears to suggest was visited upon him. Whatever this was, he will not accord it any scrutiny in the months to follow, but one wonders if the circumstances of "collapse" and "breakdown," associated with his sudden loss of his first home—and what he will come to claim was his only homeland—might be what is actually being alluded to here. But what is noteworthy is that Freud may have misremembered a far more common phrase—*Streit und Hader* ("disputes and strife")—that occurs in *Faust* and various other sources, including German translations of both the Christian and Hebrew Bible. But Freud's substitution of *Schreck* provides the sense of trauma and dread not present in the more typical pairing.

Freud pairs *Schreck* with a word that will not figure in his later texts—*Hader*, a term that refers to quarrelling, discord, and the possibility of brawling. The same word had another, quite common meaning in Freud's time, when it was used as an expression for rags or someone in tattered clothing.[165] The word *Haderlumpen* referred to those who made a living carrying and trading in small portions of cloth. *Schreck* and *Hader* are an interesting pairing, especially in the dual usage of the latter, as they appear to exemplify Freud's "sad secrets," and are also connected here to the concept of "humble origins." These words weave together in what appears to be a moment of candor, immediately subsumed by mention of his use of motifs that turn the focus to grander themes. This is reminiscent of his revelation that the story told by his father about being humiliated in Freiberg was transformed into a more acceptable narrative of a father-son legend that allowed Freud to share in

heroic possibilities, rather than accept the less exalted behavior that his father recounted.

"Sad secrets of life" will not be a phrase that appears in Freud's published works; the closest is the singular use of the term "sad memories," appearing in *Studies in Hysteria* as part of his first published case, that of Fanny Moser ("Emmy von N").[166] The technique that Freud used on his patient was very distinctive: he attempted, through hypnotic suggestion, to erase sorrowful recollections completely, and refers to what he hoped would be an absolute removal as an "amnesia."[167] He neither attempts such an effacement again, nor speaks of the subsequent treatment of memories characterized in this way. But that it was Freud's own idiosyncratic treatment suggests some link to a belief in the possibility of the permanent removal of painful memories. His own childhood secrets seem to have met a similar fate, buried under what he will soon craft as his "infantile amnesia."

All of this suggests that the origin story of psychoanalysis includes a chapter that has never been integrated: the "first fright"; these are early experiences that, in Freud's disavowal, allowed for the displacement of what would become the founding narratives of the unconscious. In this chapter, I have attempted to bring some of this material back into visibility, to suggest the way in which one of the most decisive initiatory tropes, that of "sexual fantasy concerning the parents," served to subsume other affectively profound narratives of early relational life, as though echoing the legend of Oedipus not only in his incestuous desires, but in his unfortunate fate. The material introduced here is intended to offer insight into the range of experiences from his childhood that Freud may have chosen not to consider worthy of interpretation. But that does not mean they are not formative within the emerging psychoanalytic project; indeed, the desire to disavow should be reckoned as a decisive feature in Freud's motivation to fashion the structure of the unconscious as he did. In the previous chapter, we focused upon the moment when Freud selected his first antiquities, and here we have addressed how that gesture of selection operated upon what he presents as an early fragment of memory. Its value was determined by Freud's ability to access it through his self-analysis and to discern its worth. Long "forgotten," this fragment was returned to meaning and led to the first steps in the formulation of infantile forgetting. Freud initially announces his discovery of this phenomenon, and then articulates it as a normative and universal state in his *Three Essays on Sexuality*, selecting a term—*amnesie*—that already had a genealogy in his writings. It is a word that could evoke both what is imagined as a psychical mechanism, closely associated with repression, as commonly perceived as the infantile version, and what could be permanently erased from memory. As we will see in Freud's forgetting of the name of the painter

Signorelli, selective remembering became part of the earliest understanding of psychical functioning, occurring as he was "talking about pictures."[168]

Notes

1 Sigmund Freud, *The Complete Letters of Sigmund Freud to Wilhelm Fliess, 1887–1904* [hereafter cited as the *Freud-Fliess Letters*], trans. and ed. Jeffrey Moussaieff Masson (Cambridge, MA and London: Belknap Press of Harvard University Press, 1985), letter dated October 3, 1897.
2 Klaus Theweleit, "Young Mr. Freud; or, On the Becoming of an Artist: Freud's Various Paths to the Dream Book, 1882–1899," in *The Dreams of Interpretation: A Century down the Royal Road*, ed. Catherine Liu et al. (Minneapolis; London: University of Minnesota Press, 2007), 349.
3 Historically, Martin Lampe was cited in numerous biographical studies of Kant, although his presence, as would have certainly served the philosopher's later-in-life wishes, was confined to the margins. But in two more recent studies, both addressing the history and functioning of forgetting, Kant's wish to banish Lampe from his memory—a detail often excluded from studies of the philosopher's life—is accorded considerably more attention. See Harald Weinrich, *Lethe: The Art and Critique of Forgetting*, trans. Steven Rendall (Ithaca, NY: Cornell University Press, 2004), 67–68, and Douwe Draaisma, *Forgetting: Myths, Perils and Compensations* (New Haven, CT; London: Yale University Press, 2015), 242–244.
4 *Freud-Fliess Letters*, 268, letter dated October 3, 1897.
5 Ibid.
6 See Chapter 5, n20.
7 Patricia Cotti, "Freud and History before 1905: From Defending to Questioning the Theory of a Glorious Past," *Psychoanalysis and History* 10, no. 1 (2008): 11.
8 *Freud-Fliess Letters*, 269.
9 *Freud-Fliess Letters*, 270n1. For a discussion of Resi Wittek's relationship to Freud and his family, see Diane O'Donoghue, "Moses in Moravia," *American Imago: Psychoanalysis and the Human Sciences* 67, no. 2 (2010): 176, 182n8.
10 *Freud-Fliess Letters*, 271, letter dated October 15, 1897.
11 Ibid., 272, continuation of letter cited earlier.
12 Ibid.
13 Sigmund Freud, *Three Essays on the Theory of Sexuality*, SE 7, 1905, 174–176. Freud introduced the phenomenon of "infantile amnesia" as the opening section for his second essay in this text, titled "Infantile Sexuality."
14 *Freud-Fliess Letters,* 302, letter dated March 10, 1898.
15 Ibid., 279, letter dated November 14, 1897.
16 Ibid., 280.

17 Ibid., 268, letter dated October 3, 1897.

18 Ibid.

19 Ibid.

20 In two recent biographies, one can see the considerable disparity in how Freud's story of erotic "awakening" is regarded. In Élisabeth Roudinesco's *Freud in His Time and Ours*, trans. Catherine Porter (Cambridge, MA; London: Harvard University Press, 2016), Freud's account is unquestioned: "he was dazzled by her nudity" on a train journey "between Freiberg and Leipzig [*sic*]" (15). Crews is far more skeptical of this "questionable memory," considering it of Freud's own making: "Amalia wasn't likely to have stripped naked in a cramped train cabin." Frederick Crews, *Freud: The Making of an Illusion* (New York: Metropolitan Books; Henry Holt and Company, 2017), 536.

21 *Freud-Fliess Letters*, 272, letter dated October 15, 1897.

22 Ibid., 274, letter dated October 27, 1897.

23 Used in the course of the twentieth century to describe a structuring device in a literary, musical, or visual work, *Rahmenmotiv* had earlier currency as a late-nineteenth-century term in writing on medieval and Renaissance architecture. Freud may have encountered the descriptor in his reading on Italian art, perhaps preparing for his trip that summer. The year before Freud appropriated the term as a designation for the "large, general" determinant factors of psychical life, it appeared in an article in the November 28, 1895 issue of *Kunstchronik*, a widely read art weekly, edited in Vienna and Berlin. The subject was an architectural feature—the bronze doors—of Milan's Cathedral. Alfred Gotthold Meyer, "Der Wettbewerb um die Bronze-Thüren des Mailänder Domes," *Kunstchronik: Wochenschrift für Kunst und Kunstgewerbe* NS 7 (November 28, 1895): 106. Freud would visit the building in mid-September 1898, his first stop on a day that concluded with visiting Leonardo da Vinci's *Last Supper* in the refectory of the convent of Santa Maria delle Grazie. Letter to Martha Freud, September 15, 1898, *Unser Herz zeigt nach dem Süden: Reisebriefe, 1895–1923*, ed. Christfried Tögel and Michael Molnar (Berlin: Aufbau-Verlag, 2002), 120–121.

24 Freud may have encountered the idea of a "filler motive"—the term he uses for "the individual's experiences"—in discussions of classical ornament. The art historian Alois Riegl uses the term to describe imagery found in Pompeii, at a site where various usages of "motiv" were common in archaeological and art historical studies of that time. Appearing several years prior to Freud's comment to Fliess, Riegl's text, *Stilfragen: Grundlegungen zu einer Geschichte der Ornamentik* (Berlin: Siemans, 1893) may have been known by Freud. The two men were near contemporaries at the University of Vienna, where they each studied with the philosopher Franz Brentano, who may have introduced both students to the idea of a *motiv* in his work on medieval philosophy. There is, however, little documentation of their direct interaction, although there is certainly

evidence of shared influences and interests; Riegl's term of his own making "*Kunstwollen*" has been compared rather broadly to Freud's libido theories. A more focused analysis of shared concerns is offered in Margaret Olin's examination of Riegl's notions of attention: "Forms of Respect: Alois Riegl's Concept of Attentiveness," *Art Bulletin* 71, no. 2 (June 1989): 285–299.

25 Rainer Nägele, "The Poetic Ground Laid Bare (Benjamin Reading Baudelaire)" in *Walter Benjamin: Theoretical Questions*, ed. David S. Ferris (Stanford: Stanford UP, 1996), 123–124.

26 Ibid., 123.

27 Jacques Derrida, "Parergon," in *The Truth in Painting*, trans. Geoff Bennington and Ian McLeod (Chicago, IL; London: University of Chicago Press, 1987), 64.

28 *Freud-Fliess Letters*, 268, letter dated October 3, 1897. See also Siegfried and Suzanne Cassirer Bernfeld. "Freud's Early Childhood." In *Freud as We Knew Him*, ed. Hendrik M. Ruitenbeek (Detroit, MI: Wayne State University Press, 1973), 191–195.

29 *Freud-Fliess Letters*, 268, letter dated October 3. 1897.

30 This observation (45) is part of Laura Marcus's fine overview of the role of railroads in Freud's analytic constructions. See "Oedipus Express: Psychoanalysis and the Railways" from her *Dreams of Modernity: Psychoanalysis, Literature, Cinema* (New York: Cambridge University Press, 2014). Marcus cites Bertram D. Lewin here, who was the first to identify the impact of train travel on Freud's ideas of psychical space, memory, and analytic listening. See "The Train Ride: A Study of One of Freud's Figures of Speech," *Psychoanalytic Quarterly* 39 (1970): 71–89. Also see my note on the various issues raised by Freud's first journey to Vienna, "On the Training," *Journal for the Psychoanalysis of Society and Culture* 6, no. 3 (2001): 313–315.

31 Freud, *Three Essays, SE* 7, 68.

32 Ibid.

33 Ibid.

34 Ibid., n1.

35 For Charcot's work on male hysteria at the time of Freud's presence at the Salpêtrière, see Mark S. Micale, *Hysterical Men: The Hidden History of Male Nervous Illness* (Cambridge, MA; London: Harvard University Press, 2008), 235–237.

36 Marcus, "Oedipus Express," 45.

37 Todd Samuel Presner, *Mobile Modernity: Germans, Jews, Trains* (New York: Columbia University Press, 2007), 243–244.

38 Ibid., 244.

39 Ibid., 250.

40 Ibid.

41 I raised this question of pathways in a broader discussion of Freud's aversion to states of fluidity in my essay "Liquiphobie und des Schauplatz der Psychoanalyse," in *Verflüssigungen: Ästhetische und semantische Dimensionen eines Topos*, ed. Kassandra Nakas (München: Wilhelm Fink, 2015), 46, 51–54.

42 José Brunner, "The Naked Mother or, Why Freud Did Not Write about Railway Accidents," *Psychoanalysis and History* 9, no. 1 (2007): 78.
43 Ibid.
44 *Freud-Fliess Letters*, 262, Letter dated August 18, 1897.
45 Brunner, "The Naked Mother," 80.
46 Sigmund Freud, "Screen Memories," *SE* 3, 1899, 312.
47 Ernest Jones, *The Life and Work of Sigmund Freud, 1856–1900*, vol. 1, *The Formative Years and the Great Discoveries* (New York: Basic Books, 1953), 12.
48 Freud, "Screen Memories," 313.
49 Jones, *The Life and Work of Sigmund Freud, 1856–1900*, 1:12.
50 Marianne Krüll, *Freud and His Father*, trans. Arnold J. Pomerans (New York: W.W. Norton, 1979), 143.
51 Jones, *The Life and Work of Sigmund Freud, 1856–1900*, 1:12.
52 Marcus, "Oedipus Express," 46.
53 Marcus in "Oedipus Express" offers a good synopsis of these incidents, 46–48.
54 The unification of Germany allowed greater access to the city archives in Leipzig, making possible a much fuller reconstruction of the Freud family's brief, but consequential, stay there. Michael Schröter and Christfried Tögel offer the most complete accounting of the relevant material in "The Leipzig Episode in Freud's Life (1859): A New Narrative on the Basis of Recently Discovered Documents," *Psychoanalytic Quarterly* 76 (2007): 193–215.
55 Ibid., 201.
56 Anna Hrazek's name appears in Amalia Freud's travel documents, now preserved in the Freud Museum, London, that were issued in Moravia for her children Sigismund and Anna, and Hrazek to travel to Leipzig. She presumably left the family as they traveled to their new city, but no records have been found that suggest her fate. Diane O'Donoghue, "Lingua Flora: Deciphering the Dream of the Botanical Monograph," *American Imago* 62, no. 2 (2005): 176, n3. A search of civic and church records in Příbor did not reveal her name, either before or after the Leipzig sojourn, suggesting that she may have lived in another town, presumably nearby.
57 Schröter and Tögel, "The Leipzig Episode," 203.
58 Eva Laible and Jan Hloušek, "Sigmund Freud's First Emigration (1859)," in *Psychoanalysts in Exile—Elements of a History. Proceedings of the Ninth Meeting of the International Association for the History of Psychoanalysis*, ed. Alain de Mijolla (Paris: l'Association internationale pour l'histoire de la psychanalyse, 2003).
59 Nicholas Rand and Maria Torok, *Questions for Freud: The Secret History of Psychoanalysis* (Cambridge, MA: Harvard University Press, 1997), 154–155; for the implications of the criminal activities of Freud's uncle Josef, see my discussion in O'Donoghue, "Lingua Flora," 172–174.
60 Schröter and Tögel, "The Leipzig Episode," 206.
61 Ibid., 206–207.

62 *Freud-Fliess Letters*, 285, letter dated December 12, 1897.
63 Marcus, "Oedipus Express," 160–161.
64 O'Donoghue, "Moses in Moravia," 177–178.
65 *Freud-Fliess Letters*, 285, n3.
66 Ibid., 286.
67 Ibid., 284.
68 Ibid., 285.
69 Sigmund Freud, *The Interpretation of Dreams*, SE 4, 1900, 195–196.
70 Ibid., 197.
71 Ibid., 196.
72 Jay Geller, *On Freud's Jewish Body: Mitigating Circumcisions* (New York: Fordham University Press, 2007), 57.
73 Schröter and Tögel, "The Leipzig Episode," 197, n11. According to Dr. Ulrike Dura of the City Archives in Leipzig, the hotel was badly damaged in 1946 and torn down in 1969. There is a photograph in the archives (accession number 3633c), dated to August 1, 1969 that documents the demolition in progress; the current address of the location is Georgiring 12. The hotel likely predated its earliest known images, those of the train station that date to the 1830s, where the hotel can be seen as a prominent building nearly beside it. *Leipzig in acht Jahrhunderten*, ed. Helmut Arndt et al. (Leipzig: VEB Bibliographisches Institut, 1965), [130] (upper plate; hotel to the left).
74 John Murray [Firm], *A handbook for travellers on the Continent: Being a guide to Holland, Belgium, Prussia, northern Germany, and the Rhine from Holland to Switzerland*, 11th ed., corrected (London: J. Murray, 1856), 438.
75 Freud's complex relationship to Rome, whose origin narrative is being suggested here, has figured in many studies with a cultural perspective; especially notable among them are Richard H. Armstrong, *A Compulsion for Antiquity: Freud and the Ancient World* (Ithaca, NY; London: Cornell University Press, 2005), and Mary Bergstein, *Mirrors of Memory: Freud, Photography, and the History of Art* (Ithaca, NY; London: Cornell University Press, 2010), with Laurence Simmons, *Freud's Italian Journey*, Psychoanalysis and Culture 13 (Amsterdam, NY: Rodopi, 2006) providing detail about Freud's various Roman visits. A sampling of other approaches to the topic include Walter Schoenau, *Sigmund Freuds Prosa: Literarische Elemente seines Stils* (Stuggart: Metzler, 1968), 192–207; Ellen Oliensis, *Freud's Rome: Psychoanalysis and Latin Poetry* (Cambridge: New York: Cambridge University Press, 2009); David Meghnagi, "From the Dreams of a Generation to the Theory of Dreams: Freud's Roman Dreams," *International Journal of Psychoanalysis*, 92, no. 3 (2011): 675–694; Janice Hewlett Koelb, "Freud, Jung, and the Taboo of Rome," *Arethusa* 48, no. 3 (2015): 391–430, with a good accompanying bibliography.
76 Freud, *The Interpretation of Dreams,* SE 5, 441–444.

77 Freud mentions attending the play in a letter to Fliess of January 4, 1898 in upcoming days— "a Jewish play by Herzl" that, even prior to seeing it "had already played a role in my dreams." *Freud-Fliess Letters*, 293.

78 Freud, *The Interpretation of Dreams, SE* 5, 442.

79 Ibid. "According to information I have received from philologists, '*Geseres*' is a genuine Hebrew word derived from a verb '*goiser*,' and is best translated by 'imposed sufferings' or 'doom.'"

80 Ken Frieden, *Freud's Dream of Interpretation* (Albany, NY: State University of New York Press, 1990), 125ff.

81 The most detailed treatment of the Wiener Gesera (also spelled Geserah) remains that of Samuel Krauss, *Die Wiener Geserah vom Jahre 1421* (Vienna; Leipzig: W. Braumüller, 1920).

82 Meghnagi, "From the Dreams," 686.

83 Freud, *The Interpretation of Dreams, SE* 5, 445.

84 George B. Stauffer, "Leipzig: A Cosmopolitan Trade Centre," in *The Late Baroque Era: From the 1680s to 1740*, ed. George J. Buelow, vol. 4 (Houndsmills; London: Macmillan Press, 1993), 266.

85 The "Clark Lectures" were published in the year following their presentation as *Über Psychoanalyse*; several English translations that followed remained closer to that title, but Strachey's translation adopted the name "Five Lectures on Psycho-Analysis," *SE* 11, with the reference to the "royal road," occurring in the third lecture, on dreams, on 33.

86 Freud, *The Interpretation of Dreams, SE* 5, 608.

87 Frank F. Scherer, *The Freudian Orient: Early Psychoanalysis, Anti-Semitic Challenge, and the Vicissitudes of Orientalist Discourse* (London: Karnac, 2015), 75–77.

88 *Freud-Fliess Letters*, 268, letter dated October 3, 1897.

89 Schröter and Tögel, "The Leipzig Episode," 207.

90 Freud, "The Uncanny," *SE* 17, 1919, 248. In discussing the "uncanny effect of a double," Freud adds, in a footnote, a story of another overnight train journey, this one to Italy in late August 1902 (Simmons, *Freud's Italian Journey*, 37). When the train jarred, the lavatory door swung open; as a result, he mistook his own reflection in the door's mirror for an "elderly gentleman" in a dressing gown and cap and momentarily assumed that the person occupying the adjoining compartment was entering into his. In this case, Freud was obviously in a sleeping car, as he presumably was when he complained about the lack of a lavatory in the "Count Thun" dream.

91 Wilhelm Brandt's *Schlaf- und Speisewagen der Eisenbahn: Ihre Entwicklung und Geschichte* (Stuttgart: Franckh'sche Verlagshandlung, 1968) remains the most comprehensive history of the European sleeping car. For an example of the first such car, introduced in 1872, see 11. The notion of a sleeping car was such a novelty, and innovation, that an example manufactured in Vienna was featured in the World Exhibition held there in 1873, the year following its introduction on the continent (12).

92 See "The Compartment," Chapter 5, in Wolfgang Schivelbusch, *The Railway Journey: The Industrialization of Time and Space in the Nineteenth Century* (Leamington Spa; Hamburg; New York: Berg, 1986), 70–88.

93 Marcus devotes a chapter—titled "Railway Reading"—to these issues. *Dreams of Modernity*, 59–76.

94 Matthew Beaumont, "Railway Mania: The Train Compartment as the Scene of a Crime," in *The Railway and Modernity: Time, Space, and the Machine Ensemble*, ed. Matthew Beaumont and Michael Freeman (Bern: Peter Lang, 2007), 125.

95 Freud, "Notes upon a Case of Obsessional Neurosis," *SE* 10, 1907, 285. This was not the only time that a patient made reference to Freud's possible familial connection to Leopold. Five years after publishing the mention of the "train murderer" noted here, Freud complained to the Hungarian analyst Sándor Ferenczi that colleagues in Vienna were "attacking me from all sides." As an example, he recounted that a patient had been uneasy to reveal information learned about a Freud family member who had been executed "for murder or larceny." *The Correspondence of Sigmund Freud and Sándor Ferenczi*, vol. 1, ed. Ernst Falzeder, Eva Brabant, and Patrizia Giampieri-Deutsch, trans. Peter T. Hoffer (Cambridge, MA: Harvard University Press, 1993), 446. Freud's comments occurred in a letter dated December 23, 1912.

96 Ibid.

97 *Neue Freie Presse*, November 23, 1874, 4.

98 Arthur Willigk, "Das Gehirn des Raubmörders Leopold Freud," *Vierteljahrschrift für die praktische Heilkunde* 131 (1876): 16.

99 Robert Dingley, "Closely Observed Trains: The Railway Compartment as a Locus of Desire in Victorian Culture," *Cahiers Victoriens et Edouardiens* 553 (2001): 119.

100 Ibid.

101 Ernst Freud, "Some Early Unpublished Letters of Freud," *International Journal of Psycho-Analysis* 50 (1969): 419.

102 Freud discusses his attraction to the Flusses, *fille et mère*, in "Screen Memories," 313.

103 Freud, *Letters of Sigmund Freud to Eduard Silberstein*, 9. Letter dated August 9, 1872.

104 Krüll, *Freud and His Father*, 98.

105 *Everyday Ruptures: Children, Youth, and Migration in Global Perspective*, ed. Cati Coe et al. (Nashville: Vanderbilt University Press, 2011); for a review essay discussing three recent books that address this topic in various cultural environments, see Roy Huijsmans, "Child Migration and Questions of Agency," *Development and Change* 42, no. 5 (2011): 1307–1321.

106 Joel Whitebook, *Freud: An Intellectual Biography* (New York; Cambridge: Cambridge University Press, 2017), 50–51.

107 Ibid., 52–53.

108 Laplanche's work on an alternate narrative to Freud's infantile sexuality posits a communication in the course of the adult/infant relationship in which the adult conveys, unconsciously, his or her sexuality as indecipherable content to the child—thus constituting an "enigmatic message." The framework in which this conceptualization emerged for Laplanche is well drawn in his "Seduction, Persecution and Revelation," *The International Journal of Psycho-Analysis* 76 (1995): 663–682. For elaborations upon it, see the collection of his writings, *Essays on Otherness*, ed. John Fletcher (London: Routledge, 2005).

109 Naomi Tyrrell, "Children's Agency in Family Migration Decision Making in Britain," in *Everyday Ruptures: Children, Youth, and Migration in Global Perspective*, ed. Cati Coe et al. (Nashville: Vanderbilt University Press, 2011), 24.

110 Ibid., 32.

111 Anna Freud-Bernays, *Eine Wienerin in New York: Die Schwester Sigmund Freuds erinnert sich*, ed. Christfried Tögel (Berlin: Aufbau-Verlag, 2004), 9. Quoted in Schröter and Tögel, "The Leipzig Episode," 205.

112 Ludwig Philippson, ed. and trans., 1839. *Die israelitische Bibel, enthaltend den heiligen Urtext, die deutsche Übertragung mit Erläuterung und Einleitungen* [The Israelite Bible, containing the original sacred text, German translation with annotations and introduction], third ed. (Leipzig: Baumgärtner, 1858).

113 For a synopsis of the Bible's publication history, see Ana-María Rizzuto, *Why Did Freud Reject God? A Psychodynamic Interpretation* (New Haven, CT; London: Yale University Press, 1998), 107–109. Théo Pfrimmer's detailed study of the evidence of biblical influence in Freud's work provides many excerpts from the Philippsons's commentaries and insights into their sources. *Freud, lecteur de la Bible* (Paris: Presses Universitaires de France, 1982).

114 *Letters of Sigmund Freud*, 394. This observation was shared with A.A. Roback, a psychologist and Yiddishist, in a letter dated February 20, 1930.

115 Krüll, *Freud and His Father*, 90.

116 See Chapter 1, n17. For an interesting exchange of perspectives on Jacob Freud's inscription, see Yosef Hayim Yerushalmi, *Freud's Moses: Judaism Terminable and Interminable* (New Haven, CT; London: Yale University Press, 1991), 71–74 and Jacques Derrida's comments on it in *Archive Fever: A Freudian Impression*, trans. Eric Prenowitz (Chicago, IL; London: University of Chicago Press, 1995), 20–23.

117 Christhard Hoffmann, "Analyzing the Zeitgeist: Ludwig Philippson as Historian of the Modern Era" in *Mediating Modernity: Challenge and Trends in the Jewish Encounter with the Modern World: Essays in Honor of Michael A. Meyer*, ed. Lauren B. Strauss and Michael Brenner (Detroit, MI: Wayne State University Press, 2008), 116.

118 Ibid., 109–110.

119 Philippson, *Die israelitische Bibel*, 394.

120 Ibid., 592.

121 Ibid., 157.

122 Rizzuto devotes a chapter to this relationship. See "The Philippson Bible and Freud's Antiquities Collection" in Rizzuto, *Why Did Freud Reject God?* [105]–[133].

123 Sigmund Freud, "An Autobiographical Study," *SE* 20, 1925, 8.

124 Freud, *The Interpretation of Dreams, SE* 5, 583. The italics were not carried over into Strachey's translation, but they are consistently present in German editions.

125 Freud, *The Interpretation of Dreams, SE* 5, 583–584.

126 All quotes from Freud, *The Interpretation of Dreams, SE* 5.

127 Freud, *The Interpretation of Dreams, SE* 5, 509–510.

128 Ibid., 509.

129 Ibid., 510.

130 Ibid., 511. Lacan considered this dream, as the one chosen to begin Freud's final chapter of *Die Traumdeutung*, to be in "a category all its own, a dream suspended around the most anguishing mystery" (34), that which connects the living father to the corpse of his dead child. (See Jacques Lacan, *The Four Fundamental Concepts of Psychoanalysis: The Seminar of Jacques Lacan, Book XI*, ed. Jacques-Alain Miller, trans. Alan Sheridan (New York: W.W. Norton, 1981), 34.) Ellie Ragland suggests a Lacanian reading of what Freud argues as crucial here: the fulfillment of a wish. She sees this as unproblematized by Freud, the same fantasy that creates a wish for something, whose "resolution in pleasure is illusory, just as is the issue of where the fantasized dream object comes from in the first place." Instead, the dream speaks to the "partly graspable, but graspable only in parts" moment "a split second between speaking or thinking and memory." Here, Lacan's "parceled-out, broken-up, separated pieces of body, language, thought comprise the subject of the real." Ellie Ragland, "Lacan, the Death Drive, and the Dream of the Burning Child," in *Death and Representation*, ed. Sarah Webster Goodwin and Elisabeth Bronfen (Baltimore, MD: Johns Hopkins University Press, 1993), 90–91, 82. For a discussion of certain limits within Lacan's reading, see David Lee Miller, *Dreams of the Burning Child: Sacrificial Sons and the Father's Witness* (Ithaca, NY; London: Cornell University Press, 2002), 185–190. An evocative version of the dream text is an animation by Tim Reckart, part of Joseph Leo Koerner's documentary film *The Burning Child*, created for the Vienna Project; the film examines the complexities and "uncanniness" of Viennese interiors. https://vimeo.com/114245493.

131 Freud, *The Interpretation of Dreams, SE* 5, 573–587.

132 Ibid., 582.

133 Ibid., 583.

134 All quotes from Freud, *The Interpretation of Dreams, SE* 5, 583–584.

135 Ibid., 584.

136 Ibid., 583.

137 Krüll, *Freud and His Father*, [234]. Sara's daughter seems to have inherited her mother's longevity; Amalia Freud died at 95 years of age, in 1930.

138 These changes in residence can be reckoned through the address given on the successive birth registration information that was given by their father (Krüll, 148). For a map showing these locations, see Krüll, *Freud and His Father*, [149], Figure 13. There appears to be some confusion about the street name that Jacob Freud gave in one instance, perhaps suggesting his own uncertainty about the location of that particular residence. See O'Donoghue, "Lingua Flora," 176, n4.

139 Krüll, *Freud and His Father*, 148.

140 Ibid.

141 The complete set of the photographs is now part of the City Museum in Vienna. For the image that includes Freud's first residence, see Walter Öhlinger, *Rundblick vom Stephansturm: Panorama von Wien in Jahre 1860* (Vienna: Winkler-Hermaden, 2012), 31.

142 This information on the Spiegel family can be found online in a list of Jewish residents deported from this section of the third district of Vienna in 1938: http://www.steinedesgedenkens.at/index. php?c=Wei%C3%9Fgerberviertel

143 Freud, *The Interpretation of Dreams, SE* 5, 583.

144 Ibid.

145 Carola Suárez-Orozco, "Identities under Siege: Immigration Stress and Social Mirroring among the Children of Immigrants," in *Cultures under Siege: Collective Violence and Trauma*, ed. Antonius C. G. M. Robben and Marcelo Suárez-Orozco (Cambridge; New York: Cambridge University Press, 2000), 198.

146 Tina Walzer, *Der jüdische Friedhof Währing in Wien: Historische Entwicklung, Zerstörungen der NS-Zeit, Status quo* (Vienna: Böhlau, 2011), 168.

147 Freud, *The Interpretation of Dreams*, 584.

148 Edmund Engelman, *Berggasse 19: Sigmund Freud's Home and Offices, Vienna 1938* (New York: Basic Books, 1976), [38].

149 Lynn Gamwell and Richard Wells, eds., *Sigmund Freud and Art: His Personal Collection of Antiquities* (London: Thames and Hudson, in association with the Freud Museum, 1989), 58.

150 Ibid.

151 Freud, "Screen Memories," 312.

152 Ken Corbett, *Boyhoods: Rethinking Masculinities* (New Haven, CT; London: Yale University Press, 2009), 19.

153 Ibid., 20.

154 Ibid., 42.

155 Ibid., 35.

156 Ibid., 273–275.

157 Ibid., 274.

158 Sigmund Freud, *Briefe an Wilhelm Fliess: 1887–1904,* 2nd ed., ed. Jeffrey Moussaieff Masson and Michael Schröter (Frankfurt am Main: S. Fischer, 1999), 295, letter dated October 27, 1897.

159 Johann Wolfgang von Goethe, *Faust: A Tragedy,* trans. John R. Williams, in *The Essential Goethe: Johann Wolfgang von Goethe,* ed. Matthew Bell (Princeton, NJ; Oxford: Princeton University Press, 2016), 249. See also Sabina Prokhoris, *The Witch's Kitchen: Freud, Faust, and the Transference,* trans. G.M. Goshgarian (Ithaca, NY; London: Cornell University Press, 1995), 88.

160 Goethe, *Faust: A Tragedy,* 249.

161 *Freud-Fliess Letters,* 274, letter dated October 27, 1897. For the German, see Freud, *Briefe an Wilhelm Fliess: 1887–1904,* 2nd ed., ed. Jeffrey Moussaieff Masson and Michael Schröter (Frankfurt am Main: S. Fischer, 1999), 295.

162 Ibid.

163 Jonathan Lear, *Freud* (London; New York: Routledge, 2005), 154.

164 Sigmund Freud, "The Aetiology of Hysteria," *SE* 3, 1896, 194.

165 Both meanings of "*Hader*" were cited in an etymological dictionary of Freud's time, although the usage that refers to cloth and rags is less commonly found in German dictionaries now. Konrad Duden, *Etymologie der neuhochdeutschen Sprache: mit einem ausführlichen etymologischen Wörterverzeichnis* (Munich: Beck'sche, 1893), 158.

166 Sigmund Freud, "Frau Emmy von N," *Studies on Hysteria, SE* 2, 1895, 48–105.

167 Ibid., 61.

168 *Freud-Fliess Letters,* 327, letter dated September 22, 1898.

4

The Painting of Everyday Life

In one of Freud's most detailed constructions of the workings of an "unconscious," published in 1915, he asserts that repression "does not cover everything that is unconscious."[1] Instead, the unconscious "has a wider compass: the repressed is a part of the unconscious."[2] Salman Akhtar, commenting on this passage, argues that this "wider compass" includes, for Freud, "primal" phenomena, whose origins precede individual subjectivity and experience, existing *a priori* as the "phylogenetically transmitted memories of corresponding events in man's [sic] prehistory."[3] But what of an individual's very particular memories of early existence— whose importance was emphasized in previous chapters? By what process other than repression are memories made inaccessible? According to Freud, "infantile amnesia" shrouds most of our earliest life. This suggests another process operating psychically, a different form of forgetting in which the "forgotten" is lost to analytic discourse. It is significant that the relationship between the unconscious and repression is spatially construed in Freud's reckoning: his use of the term "compass" (*Umfang*) is deployed as an "encompassing" or circumscribed entity. To discover what beyond repression might be at work within the unconscious requires examining the latter's defining characteristic: what Freud would call *amnesie*.

Freud proposed several versions of amnesia in the 1880s and 1890s, which not only characterized but also *encompassed* the Freudian unconscious itself. It can be argued that the edges of the unconscious were not determined by what was conscious or "preconscious," but rather by what Freud chose to discount (the "forgettable"), which enabled what *could* be remembered to have its borders, its sites of repressions, and its prediscursive "primal" locations. These various forms of forgetting of unacceptable content shaped the analytic psyche, but the forgetting of other unwanted material, as we have seen in the preceding chapters, more broadly shaped what was accorded psychical value, and thus what came to be psychoanalysis itself: this is the created entity, noted previously, that "taught" Freud the mechanism of repression.

In the opening paragraphs of his 1896 "The Aetiology of Hysteria," recall that Freud pronounces an "advance"—enacted at what he pictures as an excavation site—by describing a failure of memory. He imagines a scientific investigator coming upon a group of "semi-barbaric" people who have forgotten the history of the ruins surrounding them. Freud uses the term *halbbarbarischen* to evoke their plight, a trope originating in the classical canon that remained in currency in Freud's time. Jason Moralee argues that such "phantasmal hybrids"[4] had been complex markers of the vicissitudes of empire for millennia, as exemplified in the narratives about the emperor G. Julius Verus Maximinus (173–238 CE), posthumously known as Maximinus Thrax ("the Thracian"). As Moralee revisited the appearance of this *semibarbarus* ruler in the various accounts of *Historiae*, it became apparent to him that these stories suggested something well beyond the fanciful, and often contradictory, tales of the "Thracian." The apocryphal biographies of Maximinus "reveal points of tension in the Roman imagination,"[5] making visible the anxieties and slippages that arise when authors attempt to contain and control delineations of "race" and cultural enfranchisement.

Halbbarbarischen came into German usage from both the Greek and Latin. As the Habsburg Empire absorbed lands in southeastern Europe that were once part of the Helleno-Roman hegemony, not far from the lands of Thrace, it perpetuated the concept there. In the first volume of the *Jahreshefte* of the Austrian Archaeological Society, published two years after Freud wrote his "Aetiology" preamble, a discussion of Ovid's location of the *semibarbarus* moves effortlessly from discussions of territories of the classical provinces to the "Balkans," a word of Turkish origin not used in classical times, which referred to territories of the Austro-Hungarian *imperium*.[6] This term for the "semi-barbarian" returned (not that it ever really went away) in the racist genealogical narratives of Aryanism in the 1930s and 1940s.[7]

Freud's production of such marginal figures as the "semi-barbaric" was organized around an inability to remember what was deemed meaningful to those entering their territorial frame—as excavators or analysts. As Cathy Caruth notes, after Derrida, desire at the archaeological scene is evidence of an "archival drive" that necessarily, from the Freudian perspective, carries with it both a capacity for unearthing past experience and for repressing it; "in the very act of interpretation" we have a repetition of "the ways in which the past has been erased."[8] But the erasure here is posited as an *a priori* manifestation—as forgetting—of unconscious functioning, rather than as a permanent eradication of meaning. Yet the figuration of alterity is needed to provide a dismissible "surface"—something from which meaning can be extracted—as an embodiment of the manifest, so the mechanism of repression, as the vast evidence of empire beneath it, can appear persuasive.

Recall that Freud's evocation of archaeology was intended to benefit from its modernist identity, especially as produced by the excavations at Ephesus. The imagined population at the scene stood in stark opposition to the latest empirical methods intended to help them: these figures, by being designated *halbbarbarisch,* occupied the very periphery of Western knowledges. In Freud's allegory, the amnesic subject was cast as suffering from a pathological condition of unknowing, suggesting "partially civilized" as a symptom. Freud must have considered it plausible to create a connection between these colonial shades and the "hysteric," whose behavior was on the edges of social acceptability, and whose childhood sexual traumas, as he would explain in a subsequent paper, made aspects of their past inaccessible to memory. In both the analytic and archaeological readings of such an encounter, as Freud's parable suggests, the arrival of the "scientist" brings the possibility of a cure through the restoration of a capacity to access historical memory. But, applying Moralee's insight, we can consider Freud's narrative of the *halbbarbarischen* as a revelation of the tension inherit in this topos: Freud extended this allegory so the scene slips into another, and for him, far more proximal site of ruins, of "barbarity" and forgetting: the landscape of contemporary Vienna, inhabited by the semi-civilized, unable to recall the past of a place now in the collective civic embrace of a reactionary local regime. This most personal layer of the narrative reflects Freud's own sense of betrayal by the contemporary scene, which he must have encountered each time he ventured out in those years, passing the Rathaus and other ruins whose original meaning and purpose those around him no longer seemed to recall.

It is noteworthy that Freud's first published explication of his nascent ideas of "unconscious" functioning, two years after his "Aetiology" paper, dealt with the "physical mechanism of forgetfulness,"[9] centering on an incident with notable resonances to his archaeological scenario. Freud was vacationing in the early autumn of 1898 in the Balkan regions of Bosnia and Herzegovina, politically contentious and culturally pluralistic holdings of the Habsburgs, when he became the one who was unable to remember. He would argue that this memory lapse resulted from a discussion with a traveling companion, in which he shared stories related to attitudes toward sexuality and death among the local—and, given the absence of female presence in the narratives, male—Islamic population. Freud would later claim that this content had activated prohibited associations that he repressed, an unconscious act only discerned when his attempted disavowal was exposed by his subsequent inability to remember the name of Italian artist Luca Signorelli, whose frescoes were part of a seemingly innocuous discussion of paintings. As we will see, Signorelli's images in the Orvieto Cathedral may have been more fraught for Freud than

he led his readers to think. As he recounted the story, he needed to create polarities—acceptable/repressed, manifest/latent, and Italy/Balkans—in order to make the mechanism of psychical "forgetfulness" plausible to his readers.

The incident probably occurred as he was traveling from the ancient seaside city of Ragusa (now Dubrovnik, in southern Croatia) to the town of Trebinje; Peter Swales has suggested this destination after a reconstruction of the options available to Freud, who only notes that the incident occurred on a carriage trip taken from Ragusa to "a town in nearby Herzegovina."[10] Freud left no record of his motive for the journey. The guidebook he probably had on the trip—the edition of the Baedeker guides that included these regions—makes only a very brief mention of Trebinje, noting it as a small village of about 800 inhabitants, where one could find a "Turkish bazaar and a mosque."[11] Swales, reading other sources, discovered that there were also the ruins of a women's quarters, and suggested that Freud's interest in this excursion included the chance to enter the prohibited realm of the seraglio,[12] which may relate to an aspect of the discussion he recalls from that day: sexual attitudes among "the Turks in Bosnia."[13] Dušan I. Bjelić, who accepts Swales's interpretation of Freud's itinerary, locates this first instance of psychical functioning as part of Freud's imaginary of the Balkans as one of the "dangerous geographies" that may "like, the libido, break through the walls of civilization (Europe)."[14] But the Ottoman ruins in Trebinje were not the only historic residues; the Romans left a far earlier mark, evidenced by inscribed milestones to mark distances along an ancient road. In fact, Sir Arthur Evans, the British archaeologist, whom Freud admired and who worked in the Roman "provinces" (although he was best known as the excavator of Minoan Crete), had taken this same route—from Ragusa to Trebinje—about ten years before Freud, as he believed it was an early Roman road in the province then known as Illyricum.[15]

Evidence for this small Balkan version of a "royal road" could be found in the stones bearing witness to the date and imperial reign when the passage was created. So Freud's own fateful amnesic moment took place in a land very much like that of those imagined as *halbbarbarisch,* where the local population was part of a continuation of a classical construction, an illusion perhaps fed by the fact that the road Freud traveled was created by, among others, Maximinus Thrax.[16] In 1896, and two years later, it could be said that Freud located unconscious functioning within a condition of colonialist othering, which suggests that the shaping of the unconscious, and by extension, of psychoanalysis, was deeply imbricated in fantasies of either the non- or peripheral European world, as Khanna has incisively argued, and as Bjelić details as specific to the Balkans.

While the concept of the partial "barbarian" is present in both early writings of Freud, these are arguably very different stories of forgetting.

In the two years between them, the cause of memory loss shifted from the ramifications of early trauma to the intrapsychic dramas emerging from normative, universal sexual fantasies in childhood. In 1896, it was those on the psychical and cultural edges—the "hysterics" and those considered "*halbbarbarischen*" —who were incapable of remembering. But in 1898, it was Freud whose forgetting revealed the untamed inner world of thoughts and desires that stood beyond culture's control, and thus had to be banished from awareness. Freud made such repression and displacement part of everyone's history; his essay on the incident on the road from Ragusa ultimately would become the first chapter of his *The Psychopathology of Everyday Life*.

His first published version of the story would appear in late September of 1898, when Freud would author a paper claiming that the cause of a normative "failure in recollection or a loss of memory"—in this case, the forgetting of a name—offered "a good example of the efficacy of psycho-analytic therapy, which aims at correcting the repressions and displacements and which removes symptoms by reinstating the genuine psychical object."[17] If recognizing this authentic "psychical object" was the goal of the analytic project, this implies an equally hegemonic ability to identify what would *not* be considered a stimulus for repression and thus beyond analytic retrieval.

In this chapter, the evolution of Freud's ideas about forgetting will be revealed as a series of highly conscious decisions whose result he then presents as an *a priori* psychical mechanism—a method of construction that resonates with those explicated in previous chapters. However, here it is Freud's memory of viewing a painter's self-portrait—if there were a "genuine" psychical object in this story, it would be his experience of that encounter— that becomes reduced to a faintly legible *pentimento*, covered by a well-applied layer enunciated as the revelation of the workings of repression. As we return the imagery and its surroundings back into view, various other passages of meaning within Freud's narrative—long lost from sight—will become vivid. What also emerges here is that the efficacy of this psychical revelation depended on the workings of two contrasting geo-cultural scenes. For one, Freud constructs a dangerous ground of sexual alterity and exotification, a naturalized location for the unacceptable "thoughts" required to fuel a repression, which manifests itself as a slip in the memory of a seemingly pleasurable experience of viewing paintings while on holiday. But I will argue that it was the unexpected encounter with a visualization of his own vulnerability and exclusion that was disavowed here, with the displacement operationalized by a colonialist phantasm that he enunciated as "*Bo* snia."

A year and a day after Freud wrote to Fliess upon returning from his travels in Italy in September of 1897, he would reference that trip—specifically his time in Orvieto—in another missive that would also prove decisive for the subsequent history of psychoanalysis. He had just concluded his late summer holidays in the Balkans and again in Italy, and acutely felt the contrast with his far less hospitable Austrian surroundings. Freud's letter of September 22, 1898 begins on a somber note: "the bad humor of '*Viennadom*' [*Wienertum*] has already descended upon me."[18] He goes on to lament that it is "sheer misery to live here and no atmosphere in which the hope of completing something difficult can survive."[19] *Wienertum* is better translated as "Vienneseness" rather than "Viennadom" as it refers specifically to the Viennese character, rather than to the city itself. A word in popular currency in Freud's time was likely extended here to the regime that he saw as embodying it, creating a place inhospitable for any work that he, as a Jew, might attempt to create: a city ruled by the strictures of a colluding church and state, stifling any aspirations beyond these borders.

But Freud's own model of structure—his "architecture of hysteria"—and the ascendancy of fantasy that emerged from it had yet to yield any new conceptual edifice for his nascent construction of the unconscious. He had not been able to publish any work, since abandoning his theory of hysteria's origins in sexual trauma the year before, that would demonstrate the mechanism for this new image of psychical functioning, one fueled by fantasy and repression. In an earlier letter to Fliess of August 31, just prior to his departure for his holidays, he complained that "my work now appears to me to have far less value, and my disorientation to be complete."[20] He comments that his project has foundered, and confides that "another entire year has gone by without any tangible progress in the theory."[21] He does take comfort in finding in the work of philosopher and aesthetician Theodor Lipps an affirmation that "all psychical processes are unconscious" —at a moment when that resonance must have been especially important—although he wonders if Lipps's idea was in fact closer than he would have liked. That said, Freud admits to having read only a third of Lipps's *Grundtatsachen des Seelenlebens*, suggesting his fatigue.[22] After resuming correspondence with Fliess upon his return nearly a month later, Freud appears to continue in this dispirited vein. But by relating a story involving a Tuscan-born painter named Luca Signorelli as he continues his letter, he suggests some evidence of worth: he may again have returned from his holidays, as in the previous year from Orvieto, with a valuable fragment that could stimulate his psychical project.

If *Wienertum* was seen as suffocating his work, Freud would find, within his narrative of another ecclesiastical structure, the unlikely possibility of revitalizing it. He used the word "Dom" infrequently in his published texts,

but when it occurred it always referred to the same church: Santa Maria Assunta in Orvieto. Rarely called by the name of its Marian patron, it was known simply as the Duomo ("cathedral"), a striking building, with origins dating to the late thirteenth century, that dominated the Umbrian town's main piazza.[23]

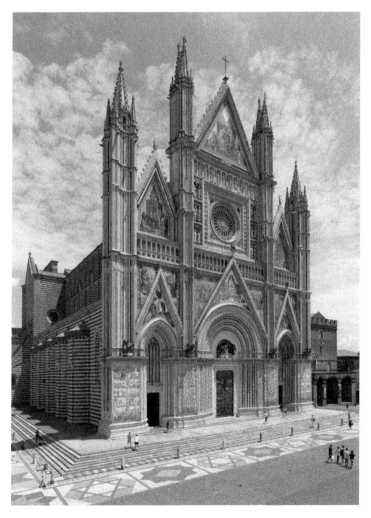

Figure 4.1 Massimo Roncella. Exterior of the Orvieto Cathedral (*Duomo*) *Cattedrale di Santa Maria Assunta*, begun 1290. © Massimo Roncella, Orvieto.

Prior to visiting the Etruscan tombs and purchasing objects from them, Freud had gone to this church on the morning of September 9, 1897; he wrote of its distinct façade, luminous with imagery created from brightly colored mosaic tiles, in a postcard to his wife.[24] We have already seen the potential importance of his encounter with Riccardo Mancini and his unearthed treasures available for acquisition: Freud would renounce the theory of hysteria's aetiology in childhood sexual assault immediately upon returning from this scene of exchange, inaugurating a shift that required a new criterion for assigning meaning and worth. Salable fragments, offering a model of an intrinsic value independent of "events" or location, may have provided Freud with a discursive frame into which, as discussed in a previous chapter, he could place the selected "collectables" of his self-analysis and dreams.

Now, a year later, it is his morning rather than afternoon activities that day in Orvieto that Freud mines for psychical utility. As he will share with Fliess in this letter of September 1898, he had an experience on this most recent vacation that involved forgetting the name of the artist responsible for the most celebrated of the interior wall paintings in the Duomo, executed in the years around 1500: Luca Signorelli, a native of Cortona, a town sixty miles north of Orvieto. In the letter that opens with a lament about the deadening effect upon his work of Vienna, Freud mentions something relating to the Italian cathedral that might energize both his wretched surroundings, which discouraged innovative effort, and his work, whose conceptual structure had yet to find a secure foundation:

I could not find the name of the renowned painter who did the *Last Judgment* in Orvieto, the greatest I have seen so far. Instead, Botticelli, Boltraffio occurred to me; but I was sure these were wrong. At last I found out the name, Signorelli, and immediately knew, on my own, the first name—Luca—as proof that it had been only a repression and not genuine forgetting. It is clear why *Botticelli* had moved into the foreground; only *Signor* was repressed; the Bo in both substitute names is explained by the memory responsible for the repression; it concerned something that happened in *Bos*nia [*sic*] and began with the words, "*Herr* (*Signor*, Sir), what can be done about it?" I lost the name of Signorelli during a short trip to *Herz*egovina, which I made from Ragusa with a lawyer from Berlin (Freyhau) [*sic*] with whom I got to talking about pictures. In the conversation, which aroused memories that evidently caused the repression, we talked about death and sexuality. The word *Trafio* is no doubt an echo of Trafoi, which I saw on the first trip! How can I make this credible to anyone?[25] (italics original)

There would be three different versions of the narrative of forgetting Signorelli's name: the first in this letter to Fliess, then followed by an essay Freud penned about it in the days to follow and published later that year, and a final account, accorded pride of place in the opening chapter of *The Psychopathology of Everyday Life,* a text appearing in 1901 that would enjoy, as Freud had hoped, considerable popularity.[26] Both successive recollections expand upon what is written in the letter, but equally important, each alters and deletes significant details. These changes in a story about forgetting, and the psychical mechanism that it reveals, thus relied both on remembering the incident and making forgettable—by what I argue are Freud's conscious omissions—what exceeded, and potentially compromised, the borders of what he is crafting here as the psychical frame. This chapter will go beyond this discursive boundary, bringing into the narrative the issues that haunted, as a spectral presence, the construction of what would be Freud's first published exposition of the working of the unconscious.

In his accounts of his inability to recall Signorelli's name that followed his letter to Fliess, Freud would contend that unsettling content could cause a memory lapse concerning any word—he came to term this a *Fehlleistung* (a "mis-attainment," called in Strachey's translation a "parapraxis"[27]). Such a logocentric construction appears to have all but removed—made forgettable— the experience of viewing specific paintings; by privileging the role of words over visual works in his intrapsychic formulation, Freud effectively erased the paintings' ability to act as a site of psychical efficacy here. Rather, the capacity to disturb and disrupt is reserved for thoughts prompted by the content of conversations directed to the more immediate, Balkan, surroundings. In crafting his account of the Signorelli lapse, Freud takes two incidents—seeing the paintings in the Duomo, and their recollection on a day trip in Herzegovina a year later—and reshapes them into a formulation that allows him to successfully "solve" the mystery of the memory slip. Extracting value from this omitted information and assigning it instead to the narrative and psychical workings that supposedly explicate forgetting can best be understood as the *originary* displacement within Freud's functioning of a psychical mechanism, yet one that posits such a removal as an intrinsic feature of its own.

In making my claim, it is necessary to examine what Freud consigned to an amnesic fate—a different sort of "repression," here not the marker of an always already unconscious, but of volitional acts of erasure at the site of its creation—as he retold the event in its three versions. Certainly, the published accounts both reveal attempts to shape the story in ways that he imagined allowed his evidence of psychical functioning to attain its "credibility." As we will see here, these omissions, when restored to view,

offer a striking panorama of the terrain of the Freudian forgettable. This will include returning to a material presence the increasingly obscured person with whom he had the conversation about the Signorelli paintings. We will also reckon other paintings by Botticelli, Boltraffio, and Signorelli, that hung together in an Italian gallery that Freud very likely visited in the days *after* his memory slip in Dalmatia,[28] as the decisive, yet utterly unspoken, experience determining the sequence of the three artists appearing in his narrative. In addition, insight is offered here into what may have been the actual source of the observations of topics on death and sexuality among "Bosnian Turks" that Freud suggests triggered his unwanted thoughts and thus his subsequent act of forgetting. In each case, Freud removed or recast content in order to shift the locus of value away from the site, which may be better understood here as an "achievement" failure itself: the paintings in Orvieto's Duomo.

I will contend that Freud's experience there included the intrusion, into his experience of viewership, of imagery rife with medieval and Renaissance anti-Semitic tropes that strikingly resonated with dangers and disenfranchisements of his own day. In the narrative that Freud subsequently crafted, the experience with the paintings was obscured by unacceptable content about sex and death occasioned by a conversation focusing on the local Bosnian population in whose land he was comfortably situated as a Viennese traveler, demonstrating his knowledge of Italian art, and thus removing any elements and affect that may have pierced that façade while he was in Orvieto. His mechanism of psychical functioning was not only about displacement, but can be posited as itself a displacement, obscuring what may have been a sudden reminder of the vulnerability and danger to which Freud—as a Jew forced to endure the strictures of *Wienertum*, as he decried to Fliess at the letter's start—certainly felt subjected. The two parts of this letter to Fliess may be more closely joined in content than has been previously imagined.

Freud thus enacts the forgetting mechanism that he "discovers" and then naturalizes it as an operation of the unconscious. As with fantasy, he builds an erasure function into the structure of the unconscious itself, announcing the mechanism after he has removed unwanted material from meaning. With repression, an operation of language reveals a transfer of action— forgetting a name, in this instance—onto what follows. What is striking about Freud's early psychoanalytic constructions is the power they accord linguistic contiguity—what follows or is beside—while other sequential orderings that may offer insights into the particularity of Freud's experience are removed from meaning. Freud never mentions the potential impact of seeing the chapel directly across from the one with Signorelli's paintings, which was devoted to a miracle involving a bleeding communion wafer

with images of Jewish and "Saracen" disbelievers and seen by Signorelli as the preface to his work.[29] Also, as noted earlier, Freud substitutes *another* painting by Signorelli, one that he encountered soon after the incident in Dalmatia as he traveled home through Italy, to help structure the story of three painters' names whose presence was crucial for interpreting his memory lapse.

In another striking instance of contiguity, Freud may have displaced aspects of the Signorelli story, revealing much about the circumstances surrounding his experience both in Orvieto and in his conversation during the carriage ride a year later, including material relating to anti-Semitism and blood libels. I maintain that this deferment occurs in the chapter that immediately *follows* the retelling of the Signorelli lapse in *The Psychopathology of Everyday Life*.[30] In addition, Freud had told Fliess in an earlier letter of 1898 of a similar experience, this time involving an encounter with a statue and the forgetting of a name.[31] He returned to this in passing in the letter about the incident during his carriage ride. However, in this unpublished prelude to the Signorelli incident, Freud offers a strikingly different motivation for the memory lapse—the unexpected encounter with the recognition of being stateless—that would resonate with his unacknowledged reminders of anti-Semitism that can be seen within the paintings that filled the walls on the chapel across the aisle from Signorelli's frescoes.

<p style="text-align:center">*****</p>

Freud was clearly concerned from the start about making his forgetting of Signorelli's name believable as more than a common memory slip—he declares in his letter to Fliess that it is not "genuine forgetting," suggesting a distinction that he creates between what he construes as a prosaic inability to recall a name, and the unconscious working of "repression." In the sentence immediately following his first account of the incident in his letter to Fliess, he asks, presumably his friend, but perhaps more compellingly himself, "how can I make this credible to anyone?"[32] To do so Freud would deploy two forms of authorizing representation: a narrative of the event that relied upon a naturalized scene of colonialist encounter, and a diagrammatic rendering of the story, included to serve as an empirical rendition of the workings of repression and displacement. Both depictions were actually versions of the same thing: Freud picturing the scene of unconscious functioning. They were also versions of Freud portraying himself: we can understand his narrative as a selectively rendered version of a self-portrait. He sketches a flattering image of an assimilated, cultivated tourist who can comment on, as he notes in his

later retelling, the "peculiarities" of the local population at one moment, and expound on Italian paintings at the next.

But before examining both of these constructions, it is important to note that forgetting Signorelli's name was the second slip in as many months that preceded the letter to Fliess. The earlier incident also concerned a name and a work of art, and telling it to Fliess leads to aspects of a dream that Freud decided not to publish. Both lapses address issues for Freud of cultural difference, but not as he will use them in his rendition of an exotified Bosnia; rather, these moments, both based on phenomena—slips and dreams—that Freud would come to see as crucial markers of the workings of psychical life, here speak to the ambiguities and disjunctures of subjectivity that relate to Freud himself.

After his assessment of the bleakness of his Vienna surroundings, and before he offers a narrative that might counter some of its debilitating effects, Freud notes to Fliess that the incident he is about to recount was "a second example of name forgetting [that] resolved itself even more easily."[33] He never elaborated on this earlier incident in published form, sharing it exclusively in a letter to Fliess of August 26, five days before Freud departed for the Adriatic.[34] In an interesting harbinger of his experience with the name of Signorelli, he wrote that he understood a "small point" that involves forgetting a name and, in attempting to retrieve it, substituting "part of another one for it." He recounted a recent experience with the "name of the poet who wrote *Andreas Hofer*,"[35] when he also could not recall a name, in this case, that of Julius Mosen, an Alsatian-Jewish writer whose patriotic anthem *Zu Mantua in Banden* ("To Mantua in Chains," usually called the *Andreas-Hofer-Lied*) extolled the nationalist sacrifice of an Austrian innkeeper-turned-partisan who was executed in that Italian city in 1810.[36] Hofer died seven years after Mosen—whose original name was Julius Moses[37]—was born. Freud could think of names with "au" in them, which may relate to Mosen's other well-known poem, included in a song cycle of Robert Schumann, *Der Nussbaum* ("The Nut Tree"),[38] and in trying to retrieve the name, he indeed comes up with words that contain these letters and seem related, such as Lindau ("linden tree") or Feldau ("field").

Freud then offers his insights into why the moment of amnesia occurred, relating his wish to repress "certain connections" he does not divulge. He also suggests that "infantile material played a part,"[39] most likely relating to his early childhood and relationship to his younger brother, whose two given names, as Franz Maciejewski has discussed,[40] were Julius Moses, and who died in infancy while the family still lived in Moravia.[41] When Freud recounted to Fliess, in the weeks after returning from Italy the previous year, his sexual awakening to his mother, he also recalled various incidents

from his time in Freiberg, including the jealousy and subsequent guilt concerning his late brother. As he grasps for Mosen's name, the choices— Lindau and Feldau—were both from one of these categories responsible for the repression: unidentified "connections" and memories of his early childhood. *Lind* and *Feld* gesture to the natural environment and might have been inspired by memories of the Moravian landscape; the mysterious other meaning, as we will see, also had associations with the land. Although Freud claims to Fliess that he was able to create an analysis that was "complete," "with no gaps left," he also claims that he would not be able to reveal it. "I cannot expose it to the public any more than my big dream."[42] Of this latter dream we have no surviving record, although he did share it with Fliess earlier that summer, in June 1898, and it appears that his friend cautioned against its publication.[43] In this case, the dream appeared to have content that was both personal—relating to Martha Freud—but also, and probably connected to the Mosen lapse, political. Freud writes that his banished dream addressed the absence of what Mosen's poem extols, something that Freud, confronting the intensification of institutional anti-Semitism in Vienna, must have felt as acutely at that moment: "my being without a fatherland" (*Vaterlandslosigkeit*).[44] Thus, the issue of national identity links the "great" dream and the Mosen slip, where Freud seemed to realize, in his inability to recall the poet's name, a disenfranchisement that Mosen himself, a cantor's son very committed to the possibilities of both Jewish and German identification, an aspiration of the Young Germany movement in which he was active, seemed to have been spared. Unlike Freud, Mosen seems to suggest a strong attachment to place: Mosen recalled his hometown in a well-known, elegiac poem called *Erinnerungen* (Memories).[45] The mention of either trees or fields might have evoked a sense of loss and distance from Freud's own birthplace, in whose earth his brother was buried. What Freud seems to be suggesting here is that his lapse was caused by a realization of his own vulnerability and statelessness, but he did not wish to reveal this relationship between such affects and an instance of amnesia. When he would claim to have another such slip, not long after, he would align its causes with a very different register of feelings, ones that appealed to far more universalized conditions of death and sexuality, while identifying himself as part of a western European milieu in which he could not, in fact, feel at home.

Not only did his two instances of forgetting occur quite close in time, but the circumstances of the Mosen lapse have certain resonances with those of the Signorelli forgetting. Both occurred when Freud was on holiday, the first instance in Austria, northern Italy, and Switzerland in early August of 1898, with his sister-in-law, Minna Bernays. This was the first of a number of trips the two took together, suggesting an intimacy that has been argued

to have extended from what was clearly shared lives to a sexual relationship. Living with the Freud family since 1896 and with no evidence of other major relationships beyond that of her family, Minna is often cast in Freud's biography as the more engaging and, with time and interest to expend on his work, more engaged of the two sisters—a problematic binary that inevitably portrays Martha, whose energies were by necessity focused upon the six Freud children, as considerably less appealing. Crews characterizes Freud's spouse as "frugal and dowdy," as having "neither the interest or capacity to accompany her husband."[46] That Minna was an important interlocutor for Freud is beyond question and the possibility of an increasingly erotic connection, certainly facilitated by their travels as a couple,[47] certainly was plausible. Minna seemingly replaced Wilhelm Fliess after Freud's once singularly intense attachment to him dissipated by 1900;[48] those who have carefully investigated the sources would argue that in that year the relationship between Freud and Minna intensified.[49] The pursuit of where Minna, or her sister, could stake rightful claims to the shaping of Freud's work is also an important, but regrettably far less determinable, undertaking. It is probable, for instance, that Freud's inability to recall Mosen's name occurred in conversation with his sister-in-law and they might have puzzled over that together, but we have no voice cited here other than his own—a narrative construction that he was to employ when recalling his "conversation" with a lawyer named Freyhan in which he forgot the name of Signorelli, just a few months later.

Freud and Minna, on the same trip that included the visit to Innsbruck, would briefly stop in Trafoi,[50] an alpine village on the Italian border that Freud mentions in his letter to Fliess as it relates to his memory of the painter Boltraffio, seemingly occurring to him in the moment that he struggled to recall the name of Signorelli. We will turn later in this chapter to a fuller discussion of Freud's experience in this mountain village and with the painter whose name he would associate with it. On August 6, several days before visiting Trafoi, he writes of seeing—interestingly during a carriage ride around Innsbruck—the statue of Hofer.[51]

It was a relatively recent installation, dedicated in 1893, and thus put in place only six years before Freud encountered it. Hofer's remains had been returned from Mantua to Innsbruck in 1823 and interred in an elaborately ornamented crypt in the city's Hofkirche.[52] The commanding bronze figure, intended to complement the burial monument, was created by the Austrian artist Heinrich Natter and culminated a long project to commemorate the nearby battle site, at Bergisel. It was here that Hofer had one of his great victories, leading a battle of the so-called "Tyrolean Rebellion" against Napoleonic forces, in which he, born in a village in this alpine region,

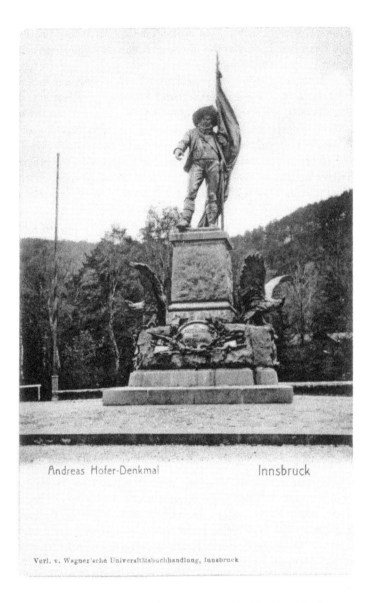

Andreas Hofer-Denkmal Innsbruck

Verl. v. Wagner'sche Universitätsbuchhandlung, Innsbruck

Figure 4.2 Heinrich Natter. *Andreas Hofer-Denkmal* (Andreas Hofer Monument), bronze, 1892, Bergisel, Innsbruck. Postcard (Private collection, Vienna).

was a key figure.[53] Natter created a heroic rendition of the patriot, shown confidently hoisting a banner; the artist died the year before the work could be completed, but it was cast in bronze from his specifications and is considered a posthumous work.[54]

Below the figure of Hofer was a medallion on which Natter had included three words: *Gott König Vaterland* (king, emperor, fatherland), a trio associated both with Hofer and with Mosen's poem, whose popularity had been very influential in keeping Hofer's memory alive. When Freud read these words, the trio in all likelihood suggested something far less positive. What he imagined this instance of forgetting shared with his "great dream" probably involved his inability to claim a national identity and its attachments—being, as he had said, bereft of a homeland. Freud's letter to Martha, written the next day, suggests that he came upon the statue while touring the city's well-known sites; it is probable that seeing the statue, recalling the poem, and then reading the cartouche all occurred unexpectedly, perhaps causing Freud to suddenly confront his own disenfranchisement at an unwelcomed moment that may have engaged his attention at the cost of being able to recall Mosen's name. When, in the letter to Fliess, Freud introduces the Signorelli lapse as contrasting with his forgetting the name of Mosen, he is crafting the former in a way that allows him to present a psychical explanation rather than one—no less deeply affective—exquisitely particular to him. While the elision of the Jews and "Moors" in the Duomo, themes within the chapel beside the Signorelli paintings, was itself a common trope, it can be said that Freud, in his narratives of forgetting, replaces the effects of one form of racism with those of another, deploying stereotypic exoticisms associated with the Balkans as a way to appeal to the "universality" of a provocation to "forbidden" thoughts and their subsequent repression.

Part of the reason why Freud could make a successful argument for the motivations underlying the otherwise unremarkable experience of forgetting Signorelli's name was the surroundings in which this incident of forgetting occurred: the lapse was more easily "solved" than the Mosen episode because Freud was able to exploit certain colonialist fantasies about the Balkans to create a narrative that served to buffer him from revealing any anxieties about his own vulnerability. It was far less revealing to locate the repression of thoughts stimulated by the sexual lives of the "Bosnian Turks" than to expose a memory slip occasioned by a confrontation with his own political and psychical vulnerability. It also allowed for an alleged universalizing of response, imagining, as he must have, that allusions to the erotic practices of the non-Europeans would readily elicit one's own "forbidden" thoughts, while also allowing him to leave unexamined his probable involvement in an illicit relationship himself. As Freud recounted to Fliess, the circumstance of

the Signorelli lapse was a recent trip to an area of the Habsburg Empire then known as the Kingdom of Dalmatia, now Croatia, neighboring the Balkan states of Bosnia and Herzegovina; he and Martha Freud vacationed there at several popular locations along the Adriatic in the first ten days of September 1898.[55] His conversation took place during a carriage ride from the Croatian city of Ragusa, now Dubrovnik, to the small Bosnian village of Trebinje about twenty miles away. He shared the journey with another traveler—a man named Freyhan, "a lawyer from Berlin"[56]—presumably in the absence of Martha, who was suffering from colitis at the time and appeared to have remained behind that day.[57]

The subject he discussed with the lawyer Freyhan, according to Freud's first published version, was characterized as a "natural" topic inspired by such a setting: "the conditions of the country (of Herzegovina and Bosnia) and the customs of their inhabitants."[58] Freud then specifies what this conversation entailed: "the various peculiarities of the Turks living there."[59] He wishes to assure his readers that his knowledge (and we have no sense of what contribution, if any, his fellow traveler made to this discussion) of these "peculiarities" was highly credible, as he attributed it to a colleague who lived as a physician in the area for a number of years.[60] After this exchange (described as "a little later on" in the letter, but "immediately" in the essay in *The Psychopathology of Everyday Life*), the conversation turned to paintings, with Freud recommending Orvieto's Duomo to his fellow traveler. He could recall the image of the painter but not his name—he refers here to remembering "with especial sharpness" Signorelli's face,[61] from the self-portrait of the artist with his predecessor in the project, Fra Angelico, at the edge of the painting of the *Preaching of the Antichrist*, and the symbolic bridge between that painting and those related to the chapel beside it. This adjacent sacellum is devoted to the miracle of a bleeding communion wafer, a revelation said to have occurred at a nearby village, one that Freud visited in the late afternoon of the day he went to the Duomo.[62] The town's name—Bolsena—provokes one to wonder where this "bo," in Freud's fractured syllogisms, might have belonged. It is noteworthy that he cannot recall the painter's name, but presumably associates it to two artists—Botticelli and Boltraffio—whose names also begin with these two letters.

Freud mentioned to Fliess that he and Freyhan "talked about death and sexuality"[63] during a conversation in which Freud recounted a colleague's perceptions of cultural habitus and difference in Bosnia. A phantasmic location emerges here through Freud's melding of a psychical and Adriatic topography: he designates this location in his letter to Fliess by writing it in a partial italic as "*Bo* snia."[64] This attention to the connection to the artists' names moves the significance from place to a placeholder, as both instigator

of forgetting and means by which the operation of forgetting can be made believable. In recounting the incident for the first time, in his letter, Freud did not reveal who said, "What can be done about this?" but one is led to assume it was a local speaker describing something that happened in Bosnia, and this was the trigger for Freud's repression and his slip. Freud claimed that the fragmentary "bo" tied the location of his memory lapse with the names of the other painters he cited, as he struggled to recall Signorelli. The unspoken possibility is the role played by Bolsena, whose depictions of the "miracle" there were imagined by both Signorelli and his patrons as presaging the Last Judgment cycle. The chapel containing the linen preserved from the divine intercession was both physically beside and historically before that of the Signorelli paintings. If we could posit this relationship in terms of the functioning of a Freudian *Fehlleistung*, the repression of the earlier chapel would return in the image of Signorelli, a vivid visual memory for Freud, and who stands, alongside the self-portrait of the artist, on the threshold between the two painterly programs.

The essay Freud wrote soon after giving Fliess a brief narrative amplifies this epistolary account, providing a fuller connection to the sex and death themes, as he offers more information about the circumstances of the phrase, "Herr, what can be done about it?" than he had shared with Fliess. In the paper, these words are spoken to his colleague by a "Bosnian Turk" who, on being informed of the impending death of a relation, said this, and added, "If he could be saved, I know you would help him."[65] This retelling brought to Freud's mind another conversation with this colleague, also concerning the latter's experiences with his patients; in this case, the story involved the "overriding importance these Bosnians attached to sexual enjoyments." That anecdote had a refrain that begins with "Herr" —a salutation decisive for the credibility of Freud's lapse, as it provided a connection to "Signor" (Freud claims to have been speaking Italian extensively during this time in this area). He chose not to share this narrative: "I suppressed the second one, in which the subject of sexuality was touched upon." As a result, "it was soon after this that the name Signorelli escaped me."[66] It is crucial to note the difference between this account of what was discussed in the carriage conversation and what Freud "suppressed." In the letter, the two men spoke about both death and sex "in the conversation" that evoked "memories that evidently caused the repression," manifested by the forgetting of Signorelli's name. These memories are replaced in his later accounts by the "suppression" of sexual content concerning the "Bosnian Turks." But in the first version, in the letter to Fliess, those memories might also refer to their conversation about paintings. It is unclear just what Freud is trying to forget here. This becomes far more apparent in his published accounts.

The attribution of knowledge of these local practices to a physician of Freud's acquaintance—presumably someone from the cultural milieu shared by him and his companion—appears in both published versions and is obviously intended to add an authorizing voice to these observations.[67] But Freud claims not to have revealed all that he had heard: contrary to his first retelling, in his published accounts, he recalled details to himself but did not share them with his companion. The taboo topic involved the "overriding" importance of sexual pleasures and the despair at their loss,[68] which Freud leads the reader to believe would have been gleaned from the intimate connections between his physician colleague and the latter's patients. The presumption is certainly that everyone involved here is male; we are told in the case of the imminent death that the response was spoken by the "father of the family." And the reference to sexual enjoyments was predicated upon the operation of the psychical mechanism that he assumed would be the normative responses of presumably heterosexual male readers; the capacity of these "themes" to provoke thoughts that would elicit credible acts of censorship thus relied on this. But the success of this repression may have relied more on Freud's own fantasy of a "Bosnian" perspective, than on the context of the original stories told to him. There is an additional, rather remarkable, erasure in each version of the accounts Freud created around this episode with Freyhan: Freud, at twenty-three, had been stationed, as a reservist, in Bosnia. The only surviving evidence of this is in a short postcard written to Eduard Silberstein, and while appearing in the German edition of their letters, it was not included in the English translation. Scherer has called attention to this, offering a translation of the brief missive that begins with "I marched across all of Bosnia,"[69] and goes on to say that, despite a fever, he is doing well. His duties did not involve any medical practice, but rather he was on a constantly moving foot patrol, part of a Habsburg presence in the region in the period after control had been taken from the Ottoman sultans. That this entered into his conversation with Freyhan can only be guessed, but its omission here serves to eliminate any particularity from the story and as such is another example of Freud's desire to contain the narrative within generalized, easily recognizable tropes.

But we are able to identify Freud's informant as Alois Pick (Freud revealed this in a footnote in the first published account),[70] a physician from a Jewish family in Prague, who completed his medical education in Vienna in 1883 and then served as a military doctor (*Regimentsarzt*) at the garrison in Trebinje, the destination of Freud's excursion with Freyhan. This was presumably abbreviated to "Herr" in Freud's story; "Herr Doktor" or the more official "Herr Regimentsarzt Doktor" were common designations for men in these roles.[71] Pick was three years Freud's junior, and it is likely that their paths crossed during their decades of professional life in Vienna.[72] In

1886, Pick authored an important paper on the etiology of an insect-born disease known as the *pappataci* or sandfly virus, which affected both the soldiers and the local population.[73] This may in fact be the fever to which Freud refers. Pick's article—published in Vienna, where he would return and enjoy a distinguished career—gives considerable insight into his work and involvement with his patients.[74] Freud chooses not to share either his friend's well-known epidemiological research in this region or recount stories of the populace that Pick, although assigned to care for the Austrian soldiers billeted in Trebinje, had come to know well. Had he done so, it may have suggested that the comments he recalled from Pick were not generalized assessments of local "character," but may have derived from conversations during the treatment of individuals and families suffering from a devastating disease. Had Freud particularized the story, however, the response might have been more empathic than erotic, and its effectiveness as an agent of repression thus undermined. Striking in Pick's article is his insight into the effects of this virus on the patient's affective life. Those suffering from the disease experience a "high grade of psychical depression and vagueness."[75] In the course of his article, one gets a feel for his patients and the debilitating effects of this illness, which Pick was the first to identify within a specific geographical locale, although it would later be associated with various regions of southern Europe and north Africa. If the "peculiarities" that Freud recounts were related to illness, that would of course remove much of the allure from the stories: a father may have been resigned to the death of a son, for instance, while maintaining his trust in the doctor who had treated him, or the loss of sexual energy might be a manifestation of physical or psychical results of the infection. It is impossible to reconstruct how much, if anything, Freud shared with his companion about Pick and his work, by then well-known and established. In any case, Freud cast Pick in such a way that the themes of sex and death in an Islamic community were the determinants of Freud's *Bo*-snia rather than his colleague's actual Balkan experiences.

It is also important to note that while Freud identified Pick's patients as Bosnian Turks, it is not likely that Pick himself would have done so. Ottoman rule of the region had ended some time before, and the actual number of ethnic "Turks"—rather than the originally Orthodox populations that had adopted Islam—was negligible by then.[76] Pick must have felt a connection to this town and its local community, as he would return to Trebinje in 1890, two years after Freud's visit, for what Swales characterized, based on an account he found in Pick's military records, as "refreshing his local knowledge." Swales suggests that this may have involved Pick's interest "in local anthropology,"[77] although there is no archival evidence given to suggest what this might have entailed. But whatever the nature of his visit, it was after

his military service had ended, which would suggest that Pick was visiting the town rather than the garrison. Although the area was no longer populated by "Bosnian Turks," Trebinje did have the remains of two Turkish mosques and other markers of this cultural past, including the ruins of a villa, along with its women's quarters. But it is noteworthy that the Baedeker guide for this region, mentioned in the previous chapter, in recommending the Ragusa to Trebinje trip, focuses on the merit of the route for the natural beauty of the region, mentioning the Turkish architecture in the town only as an aside.[78] We have already noted the considerably earlier historical presence in this locale, made visible by the work of Arthur Evans, who traveled between Ragusa and Trebinje a decade before Freud, as he reconstructed the traces of an imperial *via romana* here.

Freud's portrayal of this location seems part of his own phantasm, creating an emphasis on habits and customs that served to play into Islamic stereotypes widely held in areas to the north. Bjelić characterizes Freud's journey that day as one in which he hoped "to see himself surrounded with the elixir of Turkish sexuality,"[79] although it is difficult to prove that he was specifically headed to the ruins of a harem as he discussed—or did not—certain sexual matters relating to the Trebinje area with Paul Freyhan. In either case, it seems that Freud, in presenting Pick as he did, was relying upon a Habsburg imago of "Turks" to make his functioning of repression more believable. But this strategy, as Freud records upon returning to the stifling atmosphere of "*Wienertum,*" was not without its discomfort and ambivalence.

Freud offered evidence of this in a dream that occurred on the evening of September 18, 1898, and that he would include in *The Interpretation.* He wrote to Fliess about the Signorelli story on the 22nd.[80] In the preface to the dream's description, Freud notes that he had just returned from a journey— "tired and hungry" —after which "the major vital needs began to announce their presence in my sleep."[81] His reverie first places him in a kitchen, where he finds three women—the dream is given the name of the "Three Fates" by Strachey, replacing with classical gravitas Freud's more prosaic "Dream of Dumplings" —where one of the trio informs him that the dumplings she is preparing—and that he loves—are not yet ready. This opening of the dream, and the reading of the scene as one of sexual desire, has been the focus of most of the discussion about the "Three Fates."[82] As Freud notes, the dream content involved satisfaction of "vital needs," and thus the kitchen scene with women as veiled erotic longing seems plausible. But there is also the presence—in keeping with his thematics from the journey from which he is presumably returning—of death as well. The image of the rubbing of the hands together to make the dumplings remains him of a maternal lesson in which his mother, with a similar gesture, showed him the sloughings of skin

to recall our mortality—"we are all made of earth and must therefore return to earth."[83]

But the second portion of the dream is about another kind of encounter, and suggests the fulfillment of a quite different wish—one involving his professional work—and perhaps also speaks to a particular moment of discontent during Freud's recent holiday. In both cases, we are offered a glimpse into what was likely to have been one of Freud's preoccupations at the time of the dream: the desire, upon returning home, to create a credible piece of work about the Signorelli incident. The dream goes from a domestic scene to one involving the encounter with "a stranger with a long face and short pointed beard," who wished to remove a coat—"saying it was his"—that Freud had put on, covered in a "Turkish" pattern.[84] The implications of this aspect of the dream, and its enigmatic finale, where Freud and this man have a pleasant exchange, have been little examined. Freud, in his comments on the dream, will report that the bearded figure bore a resemblance to a merchant in Spalato (now Split)—the Freuds' destination immediately after Ragusa and also in Croatia—who sold his wife some "turkish stuffs" in his shop.[85] In his text, Freud italicizes, as an emphasis, *türkische*, presumably linking the merchant's wares to the overcoat in the dream. The shopkeeper is not Turkish himself, as we learn from Freud. He "digresses" a bit and pokes fun at what he appears to know was the shopkeeper's name—Popović—described by Freud as "suspicious" or "dubious" (*verdächtiger*). This questioning of the credibility of the name comes from the first two syllables, a double "po," a homonym—popo—for "a childish word for bottom." He then notes that through the interpretation of this dream he has played with "misusing" various names, an action he describes as "a kind of childish naughtiness."[86]

Freud's turn to associations that involve "misusing" names is worth noting here. The melding of names and their variants with part of the dream having a "Turkish" presence offers a rather striking contiguity to the experience during the carriage ride that occurred just three days before Freud met this man in Spalato. Freud's denigration of the name Popović was due to its meaning, in a fragmentary version, something childish and colloquial. It is strange that this would discredit the full version of the name. Popović is a well-known surname in the Balkans, and it is interesting that Freud didn't read the popo as "papa," its meaning in this region (he would have certainly heard this word in his travels). The name "Popović" in fact derives from the designation, in the Orthodox Church, "son of a priest." The most widely used dictionary of German and Serbo-Croatian was written and edited by Ivan Popović and published in Vienna,[87] where the name was fairly common. But perhaps as Freud tried to make credible his linguistic puzzle, what he calls the double appearance of the "bo" in the artists' names he recalls in trying to

recall Signorelli's name gets spoken as "bobo," itself also having associations with children's speech. To make his argument credible, Freud would have to convince his readers that his psychical mechanism was not merely a form of dubious, even juvenile, word play. His argument would need to rely on the power of the third bo—that of Bosnia, to elicit the readers' more serious attention.

While the merchant Popović is seen as having the suspicious name, it is he who, as the dream closes, expresses a wariness and mistrust of Freud. When Popović challenges Freud's wearing of the garment, the latter responds by pointing out the Turkish designs, seemingly offering that as the reason for his ability to appropriate it. Popović then asks, "What have the Turkish (designs, stripes...) to do with you?"[88] In light of Freud's thoughts at the time of this dream, such a question may have related to the obvious reliance Freud was placing on the "Turkish" content of his Signorelli slip. And the inquiry would be a sound one—what exactly, beyond the over-determined colonialist associations with the exotified other, would create enough repressed thoughts to fire the mechanism of the memory lapse? The last line of the dream suggests that Freud may have found it, or at least had that hope: "But we then became quite friendly with each other."

There is also another interpretation of Popović's question, one that may suggest an additional way that the construction of "Turkish" may have functioned for Freud in the days surrounding his conversation about Orvieto and its paintings. This possible link is also related to Popović's inquiry about Freud's relationship to a visual marker of "Turkishness." Perhaps it was mention of Orvieto that stirred "Turkish" thoughts in Freud, not about sex or exclusive to Bosnia, but about the fragility of his own subject position as a Jew who enacts the role of the bourgeois European tourist in a carriage, a setting strikingly akin to that of the Mosen lapsus, although here Freud can indulge in the "natural" discourse of a traveler viewing a distant, exotic landscape. This guise of the traveler may have been disrupted in the Duomo the previous year, as it may have been by encountering the Hofer statue, giving Freud an unexpectedly complex visual experience; in Italy that alterity had implicated and melded the Jews and the "Turks." There he also found presented pernicious imagery, falsely attributing various nefarious crimes to European Jewry; although the representations date to the Renaissance, emerging from an older lineage, they were chillingly present in the air of the late nineteenth century as well. Thus, what Freud reported when he returned to Vienna had not, so to speak, taken a holiday, but instead followed him, as much as he aspired to forget.

Freud's companion on this journey with its overdetermined *türkische* material becomes even more forgettable in his narratives than Pick. In his

letter to Fliess, Freud reveals him, by name, as "Freyhan." However, in the essay that he authored soon after writing the letter, Freyhan becomes "my companion"[89] and by the final version, in *The Psychopathology of Everyday Life*, his identity has been reduced to that of "a stranger."[90] While Freud may have chosen not to reveal Freyhan's name when he published his first account of the incident, Freyhan's treatment in the second published version is noteworthy. This would suggest that the presence of Freud's fellow traveler, other than as a foil for the conversation that led to the Signorelli lapsus, was deliberately obscured. In this way, Freyhan served a function akin to that of Signorelli; he is posited as part of chance circumstances that occasioned the discovery of this psychical mechanism, but he played no meaningful part in any of it. Freyhan and his voice thus remain external to Freud's crafting of their shared journey: he is all but erased.

Because he has been so obscured, there has been little curiosity about Freud's companion, apart from Swales's discovery of a "P Freyhan" listed in a Berlin lawyers' directory of this period.[91] This revelation would seem to confirm that what Freud had told Fliess was accurate, but a fuller consideration of this person comes to suggest something else: why his presence was increasingly minimized. Calling him *einem Fremden* ("a stranger") in the final version suggests that Freud had no knowledge of him, and nor did any connection emerge. The word *Fremden* is rather an unusual usage in this context, as it was most commonly applied to being unknown in a place rather being unfamiliar to another person. In using this term, Freud insinuates that his companion was a rather shadowy figure—the word can also suggest a questionable character—leading the reader away from imagining that he would be speaking with someone with whom he might have any meaningful connection. This choice of descriptor, *Fremden* is also a word that shares its first three letters with both Freud and his traveling companion. Lacan suggests that because Freud's first name contained the same first three letters as Signorelli's that he was in fact forgetting himself, an attribution that could also be suggested for his forgetting of Freyhan's name as well,[92] and may also speak to certain estrangements that the two men shared here. This connection was not to be acknowledged, and looking at Freyhan in more detail suggests that here the erasure of such details facilitated the believability of Freud's version of the scope of their engagement during the journey.

It is important to realize that the trip Freud and Freyhan undertook was not a short one: it covered nearly forty miles, over some difficult terrain, and took over seven hours.[93] During this time, it is probable that Freud would have come to know something of the person of Paul Freyhan, who was, as noted earlier, at that time an assessor—a term for a legal practitioner—with an office in central Berlin.[94] Prior to 1897, he had a similar position in Cottbus,

eighty miles south of Berlin,[95] where he would then return, in 1899, to begin his career as a district judge. In 1908, he appears on a legal register back in Berlin, now a circuit judge, and living in the affluent Charlottenburg district. Paul Freyhan seems to have died before the Shoah, but his wife Hedwig Steuer Freyhan was among those deported from Berlin and murdered.[96] Hedwig Freyhan was born in 1877, making her over twenty years Freud's junior, and it is probable that her husband was younger, too—although we lack a precise date of birth—as Freud seems to be presenting himself in the exchange (Freud was forty-two at the time) with a certain air of an older, more sophisticated traveler.[97]

Paul Freyhan had begun his life in Breslau, where his parents, Emanuel and Henriette (Haber), owned an oil processing factory.[98] This was a city that Freud knew well; it figured in one of the latter's earliest memories, that of his journey from Freiberg to Leipzig, and as a place to which he returned on various occasions as an adult.[99] The Jewish family name of "Freyhan" originates nearby, and has a clearly traceable history to a small Polish village, Cieszków, about thirty miles north of Breslau, that had previously also been known by its German name, that of Freud's companion. At the time of Freyhan's meeting with Freud, there were thirty-two families with that name living in Breslau,[100] but many of Freyhan's generation had left the city for professional training in Berlin, Vienna, and Leipzig. His name appears in legal registries in Berlin but also in indexes of non-fiction writers, where he appears as the author of work addressing medical rather than legal topics. Several years after the carriage ride, one can find a citation to an essay by Paul Freyhan on diseases of the lung.[101] This would suggest the influence of his elder brother Theodor, a well-known specialist on pulmonary diseases of the day. Theodor would publish a highly respected monograph on pneumonia in 1898, the same year as the carriage ride.[102] Since Freud's work had appeared in several medical publications in Vienna that also featured contributions by Theodor Freyhan, it is likely that they knew each other's work. Because Paul seemed to take an active interest in Theodor's research, Freud's work may even have been known to him. To create an even more intimate circle among the medical practitioners, Theodor Freyhan's doctoral thesis, completed in 1888 and on typhus meningitis, cited the work of Pick;[103] Pick and Freyhan thus appeared to share an interest in communicable illnesses.

Theodor Freyhan also had another colleague, Paul Fürbringer, one with whom he worked directly on infectious disease, and that adds yet another, especially significant, dimension to the story. Freyhan and Fürbringer, the latter a well-regarded clinician trained in pharmacology and chemistry, together authored an article in the field of bacteriology, addressing clinical practices in surgery, that has earned a place in the history of disease

prevention.[104] Both were on the staff of the large public hospital in Berlin, the Krankenhaus im Friedrichshain. Fürbringer was a person of wide-ranging interests, among them, male sexual health, likely a result of treating patients with sexually transmitted diseases. Freud owned a book he authored on the prostate in 1881.[105] Several years before Freud's carriage ride with Paul Freyhan, in 1895, Fürbringer would write a significant book on a topic Pick had discussed with Freud, and that Freud claimed he did not discuss with Freyhan: male impotence.[106] In Fürbringer's second edition, published in 1901, he in fact would cite a paper by Freud on sexuality and neurosis that appeared in several issues of a Viennese medical newsletter in January and February of 1898, the same year as Freud's conversation with Freyhan.

It is not only probable that Freud and Paul Freyhan had many people and interests in common, but that their conversation certainly might have included the "delicate topic" (Freud used this phrase to describe what he supposedly avoided discussing with Freyhan, a suppression he attributed to having been "in a conversation with a stranger"[107])—male sexuality—that he suggested was rife in the air of their Bosnian discourse, and in doing so allowed for the mechanism of the parapraxis to be constructed. By locating the sexual nexus in the implied erotics of the seraglio, even a discussion of the loss of such an "overriding" pleasure appeared to inhibit Freud from sharing these details with his companion. But if discussion between Freud and Freyhan about sex occurred, it may have had nothing to do with the "Bosnian Turks," but rather the plight of males in Berlin and Vienna. Indeed, Theodor Freyhan was mentioned twice in Fürbringer's book, where it was Freyhan's own work on impotence that was acknowledged.[108] In 1902, Freyhan wrote on the use of a particular chemical agent as a possible cure for impotence.[109] If in fact the prohibited topic of sexuality was discussed in the course of conversations with Paul Freyhan about the latter's brother and his colleagues, this would, as in the case of Pick's accounts, erode the element of exoticism—the necessary trigger for Freud's own "repressed thoughts"—and certainly undermine Freud's claim of self-censorship around that topic. But it is crucial to recall that the removal of the sexual topic was not suggested when Freud first wrote to Fliess; indeed, he reported that he and Freyhan *had* spoken of sex and death. Yet, for the parapraxis to operate, as Freud would present it in both published versions, he needed to present this as a "suppression" of the story, attributed to Pick, and one he claimed he chose not to mention.

The sequence of the topics—vital for the functioning of the "parapraxis" to operate—is also confusing. In his initial retelling to Fliess, Freud indicates that the conversation "about paintings" may have been the agent of the repression, rather than merely its circumstantial object; it also suggests that

the conversation about pictures *preceded* that about sex and death, although the functioning of the forgetting would require the opposite to occur. It may also indicate, now that we understand a bit more about Freyhan, that Freud is referring to—although not making this explicit—two different conversations: one about pictures; and then, in a discussion of shared medical interests, and perhaps Pick's stories, another about matters of sexual functioning. However, in the published versions, these details, and whether sex was a topic or not, were recast. But something Freud did put into print may shed more light on what he actually discussed with Freyhan and suggest a possible connection between material that Freud wished to disavow and the experience of "pictures." To find this, we must look at something that is hidden in plain sight. What could be understood as an enactment of what Freud called a *Fehlleistung* immediately follows the carriage conversation in the version of the narrative Freud created for *The Psychopathology of Everyday Life*.

The second chapter of his text, called "The Forgetting of Foreign Words" (*Vergessen von fremdsprachigen Worten*), was written to be read as a continuation of the book's opening pages;[110] even its title gestures to the "The Forgetting of Proper Names" (*Vergessen von Eigennamen*)—the Signorelli episode—that precedes it. Although long acknowledged to be addressing similar circumstances of lapses, these chapters echo each other so neatly that one might wonder if Freud is actually continuing the same story, and merely adding another example of forgetting. The circumstances in which the lapse occurs in the second chapter are strikingly familiar. Freud is "once again on a holiday trip,"[111] he writes, when—and this seems an interesting inclusion— "I renewed my acquaintance of a certain young man of academic background (*eines jungen Mannes von akademischer Bildung*) who is a member of the race to which we both belong" and they begin a conversation in which there is mention of an Italian church and, of course, an incident of forgetting a word.[112] In presenting himself as a fictional character in an essay on "Screen Memories," published the year after his conversation with Freyhan, Freud describes the autobiographical "patient" as a 38-year-old (Freud was forty-three at the time) "man of university education" (*akademisch gebildeter Mann*).[113] It would seem unlikely that Freud, in the previous year, would describe himself as youthful, and this suggests that there was a younger professional who inspired his function as Freud's interlocutor. Freyhan had a Doctor of Law degree and was cited as "Dr. Paul Freyhan" in a Berlin legal register published in the year of his meeting Freud.[114] Thus, Freud's use of the modifier *akademischer* appears to suggest a certain level of university education that doctors, as well as some lawyers, achieved, and thus would not be an inaccurate descriptor

of Freyhan. Freud's readers, however, would not necessarily recognize the overlap between the chapters, because Freyhan's identity was absent in the version of the story told just before this; he was merely a shadowy stranger, utterly forgettable. In this second chapter, the companion is more vividly drawn, seemingly safe from any possible connection with the previous interlocutor—although the second text could quite easily be read as picking up where the two acquaintances, on holiday, had left off or, far more likely, as being derived, at least in part, from the original conversation while they were in the Balkans together.

Prior to discussing this text, it is important to recognize that my aligning of the two narratives and my suggestion that the young man in the story, in part, might be the person present during Freud's previous trip run counter to previous scholarship on this chapter that has identified the second person as Freud himself. There is certainly precedent for Freud veiling his identity in the guise of another, such as the fictional patient in "Screen Memories,"[115] published a year after meeting Freyhan, and also the year before *The Psychopathology of Everyday Life*. This possibility in the latter text was first proposed by Swales and more recently elaborated on by Crews who identified the second decisive person in the story as another of Freud's traveling companions—Minna Bernays—and proposed that the cause of the forgotten word was concern over a possible pregnancy, ostensibly the worry of the young man in the story, speaking of his Italian lover, but actually Freud's own concern about his by-that-time intimate relationship with his sister-in-law.[116] Philip Kuhn would counter with the assertion that the pregnancy mentioned in the story was that of Freud's wife;[117] nearly twenty years after Swales's article appeared, Richard Skues would weigh both arguments around this aspect of the story in great detail, and suggest that Swales's reading was the more plausible.[118] Indeed, Swales's has become for many the accepted reading of this aspect of the text.[119]

What I argue here does not challenge that, but rather suggests that the acquaintance re-encountered on holiday is actually a composite: part Freud and part Freyhan. That said, the possibility that the pregnancy concern was Freud's own need not be discounted, but my emphasis will be on the parts of the story that precede his final pronouncement of the repressed reason for the forgetting. Although the possibility that this offers additional evidence of a sexual relationship with Minna is of course significant, my reading argues that there is another issue informing this constructed story. The "Signorelli" equivalent here—the object of the slip—is a Latin word, whose significance within the narrative introduces the possibility of reading it in a new way— as part of the conversation with Freyhan that included another recollection of Freud's 1897 visit to Italy. Reading the two chapters as intimately related

allows us to identify the inaugural chapters of *The Psychopathology of Everyday Life* as yet another reenactment of contiguity and displacement.

In this second conversation, in "The Forgetting of Foreign Words," it is the companion who experiences the forgetting: when quoting in Latin a line from Virgil's *Aeneid*, he is unable to recall one word, *aliquis* ("someone" or "somebody").[120] While Freud will focus on that lapse—indeed, this story is frequently referred to simply by this forgotten word—he actually opens the narrative by admitting to forgetting something else—a circumstance he does not attempt to interpret. "We had fallen into conversation" he writes, *"how I have now forgotten,"* (ital. added) yet about a topic whose significance would have hardly emerged by chance: "the social status of the race to which we both belonged."[121] Freud's companion was voicing his feeling about the "doom" of a generation of younger Jews who "could not develop its talents or satisfy its needs."[122] The younger man then follows this speech of "impassioned fervor" with a line that speaks of the wish for revenge taken from Dido's final words, in which, as Freud says, she "commits to posterity her vengeance on Aeneas" at the moment prior to her suicide: *Exoriar(e) aliquis nostris ex ossibus ultor* ("May you arise as the avenger, whoever you are, from our bones").[123] Freud readily provides the second word, which his companion failed to recall, and then asks him to associate to it— "hoping for a contribution to my collection."[124] Although Freud likely did not cite the Latin passage from its original source— certainly, as Armstrong has finely demonstrated, its sentiments would have had many levels of resonance for him[125]—but rather from its presence as the conclusion of a speech written by the political philosopher and socialist Ferdinand Lasalle, a text that Freud, as suggested in a letter to Fliess, had read in the summer of 1899.[126] Lasalle, like Freyhan, had been born into a Jewish merchant family in Breslau, and when he died, in 1864, he was buried in the Jewish cemetery there. It is interesting that Freud, in mentioning Lasalle in *The Interpretation of Dreams*, focuses on an association to Breslau,[127] a city that obviously had meanings for Freud as well. That Freud read those lines in 1899 is not in dispute, but that he would have seen the quote—perhaps also taken from Lasalle's famous speech—on a statue while en route to Orvieto, a year before reading Lasalle's text, opens up another possible way to read this second chapter of *The Psychopathology of Everyday Life*.

This specific phrase may have come to Freud's attention in the days immediately before he saw the Signorelli frescoes. It appears on the base of a bronze statue in Siena, the city that Freud had visited just before moving on to Orvieto. The sculpture on which it is carved is a monument to youthful sacrifice, the work of the Florentine sculptor Raffaello Romanelli, installed in the main courtyard of the city's storied university in 1893,[128] thus only four years before Freud's visit to city.

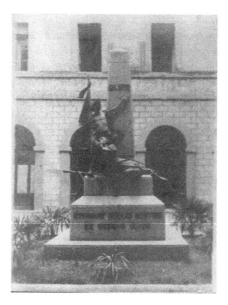

Figure 4.3 Raffaello Romanelli. *Monumento ai Caduti di Curtatone e Montanara* (Monument to the Fallen of Curtatone and Montanara). Bronze, Rector's Courtyard, University of Siena, 1893. Photograph: University Archives, University of Siena.

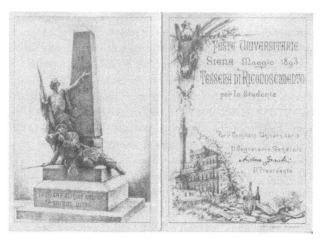

Figure 4.4 Program for the dedication of the monument, May 1893. University Archives, University of Siena.

The sculpture displayed the figure of a dying young soldier, gazing up at Nike, the god of victory, and, at its base, it bore an inscription in a manner not unlike that of the statue of Hofer. In Siena, the chiseled (Natter's cartouche was cast) phrase appears between the statue above it and an ossuary placed at the statue's base. The casket, added soon after the dedication, holds bones belonging to some of the fifty students and five faculty members who were killed in 1848 in a battle that pitted small contingents of fighters, many ill-equipped volunteers, in one of the early clashes of the first Italian war of independence from the Habsburgs.[129] The fighting took place at Curtatone and Montanara, in the province of Mantua; it was here that Andreas Hofer had been shot, nearly four decades before, for attempting something of a reverse rebellion, that in which the Habsburg Austrians rose up against the Napoleonic army. The connection between the context of the Siena inscription and Freud's story of his companion's act of forgetting is striking: both voice the ill-fated resistance of a youthful generation. As Freud was discussing Italian art with Freyhan, this recent addition to Siena's cultural landscape may well have been included. When, in that next year, he encountered the statue of Hofer, one wonders if he did not think of Romanelli's sculpture, as both extolled nationalist sacrifices and shared a common location on the soil of Mantua.

Freud will ultimately have his interlocutor associate to possible fears that his lover—who happens to be Italian—is pregnant, "solving" his act of forgetting by locating it within the syntax of forbidden sexuality and censorship. But the path that Freud leads the reader through to get there may have begun prior to this second chapter in *The Psychopathology of Everyday Life*, and thus read as a continuation of the story that precedes it. When Freud initially asks his companion to associate to *aliquis*, the younger man complies by breaking the word in two. This is strikingly similar to what occurred in the analysis of the "signor" in the previous chapter. Here, Freud has his companion do it seemingly spontaneously; indeed, he has his speaker admit that his impulse to create two words was a "ridiculous notion." But since he has offered it, Freud of course asks what "a-liquis" might mean, but the younger man demurs ("I don't know.") But he then says that "what comes next is *Reliquien* (relics), liquefying, fluidity, fluid."[130] The last trio of words are all possible synonyms for the "liquis" syllable. But the first word, relating to relics, seems quite inexplicable, unless in the context of the phrase as it appears in Siena, where it is placed just above what certainly could be termed a "reliquary." From the words associated with "liquis," the speaker goes on to describe visiting an Italian church associated with the country's most infamous "blood libel" case, thus aligning fluids and blood. Freud will, by a very circuitous route, thus get to the possible absence of blood as an

indicator of a pregnancy. But prior to that, the younger man associates, "with a scornful laugh,"[131] to the fracturing of a-liquis as it may relate to Simon of Trent, a fifteenth-century child "martyr" in a case of blood libel that resulted in the murder of a number of Jewish residents of the city. Although any fallacious culpability on the part of the Jewish community for the child's death was renounced by the papacy in the mid-eighteenth century, the cult of "Saint Simon" (although frequently called this, he was never canonized) continued.[132] The speaker claims to have seen the church two years earlier—this would have been when Freud visited Orvieto, assuming that this text was written in 1900, the year he did indeed visit Trent.[133] After mentioning Simon, the speaker then returns to contemporary persecutions: "I am thinking of the accusation of ritual blood-sacrifice which is being brought against the Jews just now."[134] Freud observes that this thought was not entirely "unrelated" to the conversation that had occurred before the slip occurred.

Freud may have recalled the terrible events that befell Jews among accusations of the desecration of the host and of blood libels in the Middle Ages here, but these activities were not, as his speaker noted, the exclusive domain of the distant past. Such anti-Semitic slander had returned, in the period of Freud's visit to Orvieto, with a vengeance. Some of this was fed by the pernicious "Dreyfus Affair," where the false accusation of treason against a Jewish career officer in the French army brought a return to claims of all sorts of insalubrious behavior on the part of Jews, in France and well beyond. Arrested and jailed in 1894, Dreyfus was ultimately exonerated and released in 1899. Freud's holiday in the Balkans and the journey he describes that followed would have occurred at a time when anti-Jewish sentiment was especially high, fueled by a claim of a "ritual murder" in the region not far from Freud's birthplace; this was one of the most distressing aspects of the year of Dreyfus's release, around the time the story conveyed here was to have occurred, as the book first appeared in July of 1901.[135] The period between 1880 and 1910 saw the return, after nearly a 300-year hiatus, of accusations of ritual murders, often accompanied by other claims of the abuse of religious objects and host desecration throughout Europe, several around the time of Freud's visit to Orvieto;[136] Robert Weinberg, in his study of the trial of Mendel Beilis for a "ritual murder" in 1911, notes that in Central Europe there were "seventy-nine ritual murder charges in the 1890s alone."[137]

While anti-Semitism and blood—two important elements of the "*aliquis*" story—do not appear relevant to the Signorelli lapse at first, the relationship becomes more compelling when we focus on the interior of the cathedral itself, what Freud would have encountered there, and how the one visual experience he does describe—seeing the self-portrait of Signorelli—functioned within the larger visual program. In Freud's text, the concern

about a woman's missed menstrual period was prefaced by the younger man's association to St. Januarius; Freud then goes on to discuss a relic involving the saint's blood that is kept in Naples.[138] As Skues has argued, this reference had a likely source in an article that was published in September 1900 in the *Neue Freie Presse,* which mentioned the cathedral in Naples where this relic is housed;[139] Freud would write to Fliess about "slowly writing" *The Psychopathology of Everyday Life* on September 24th,[140] the day after this piece appeared in his newspaper, so it is likely this detail was added to his text around that time; such an inclusion would obviously support the "latent" meaning of the repressed sexual implications and the missed menstrual cycle, Freud's intended denouement here.[141] But the conversation that may have begun with a line from Virgil—and focused on what was cast as the more "manifest" content of concerns about anti-Semitism that lead to the final "solving" of the forgotten word—may also lead to Orvieto's cathedral, where there was also a striking presence of miraculous blood.

It is notable that the only time Freud concedes that the visual imagery of Signorelli's paintings might relate to sex and death is not in the chapter of *The Psychopathology of Everyday Life* devoted to the Signorelli lapse, "The Forgetting of Proper Names," but in the one that follows, "The Forgetting of Foreign Words." In concluding the *aliquis* story, Freud contrasts it with the Signorelli parapraxis because its content "had no clear connection with the new topic containing the name Signorelli."[142] Although he says, "contiguity in time furnished the only relation between the repressed topic and the topic of the forgotten name" he contends that this placement would provide "enough" to allow a "connection in an external association."[143] But then he adds a footnote suggesting that such a connection might exist, because these topics were "by no means remote from the topic of the frescoes at Orvieto."[144] In the *aliquis* chapter, it was the conversation, argued here to be an extension of that between Freud and Freyhan, directly before—when the speaker "had been deploring the fact that the present generation of his people was deprived of its full right"[145]—that led to the word being forgotten. This seems highly reminiscent of the Mosen lapse (and its connection to his "Great Dream") and the disenfranchisement to which Freud attributed them; the relationship between the two statues—of Natter and Romanelli—and the patriotic evocations of their inscribed bases is quite striking. Such issues may have disrupted Freud's capacity, in Orvieto's cathedral, to adopt an aesthetic gaze when encountering the visual culture of Italy that he imagined would occur after the draught of Lethe, something he had aspired to achieve according to his letter to Fliess from Siena. The day after wishing for that, he wrote to his wife about visiting Palazzo Publico and seeing "many interesting things";[146] this is in the neighborhood of the university; as it was one of the oldest

in Europe, and mentioned in the Baedeker guide, it would seem probable that Freud visited it when in that part of the city; the then quite new statue was prominently displayed in the Rector's courtyard of the university. The fervor of the passage on Romanelli's monument, when applied here to the sacrifices in the *aliquis* story, thus connects to both sites of Freud's travels: Siena, where its inspiration in all likelihood lay, and also Orvieto. Inequities visited upon the Jews, lamented by Freud's younger colleague before citing this phrase, carried a particular poignancy, if we indeed identify this speaker as Paul Freyhan. Prior to being appointed to a prestigious judgeship, ten years after his conversation in Bosnia with Freud, he and his wife would convert to Lutheranism and their son, Rudolph, also born in 1908, received a Christian baptism;[147] perhaps this was his response to the exclusion of Jews from advancement and would certainly have been the case in high-level legal appointments. The specter of doom was, however, not eradicated by this for the Freyhans: Although Paul would die prior to the rise of Hitler, Rudolph was to leave Berlin in 1939 and settle in the United States, while his mother, despite her current religious affiliation, would ultimately, as noted earlier, be among the doomed, murdered after her deportation. If the *aliquis* narrative foreshadowed terrible events to come, it also evoked sentiments of the past, ones that were by no means remote from the walls of the Duomo. What Freud did not tell us in the Signorelli chapter may have returned, displaced and disguised, in what follows it.

In the postcard he wrote to Martha in the late afternoon of his first full day in Orvieto, September 9, 1987, showing the figure strolling by Mancini's excavated graves, Freud listed his three activities—the Duomo, the Etruscan tombs, and the purchasing of antiquities—and mentioned that he had just returned from a carriage ride—interestingly enough to a small village with a rich Etruscan and Roman past, Bolsena, where he saw a "remarkable" body of water—the volcanic lake there—by a country town, distinct from Orvieto.[148] He concludes by mentioning the arches—likely the remains of Roman buildings near the lake itself—as very pleasing. He makes no observations about the town, although his Baedeker would tie it securely back to the Duomo. The guidebook noted that the cathedral was actually built to honor "miracle of Bolsena"; it would be here that the altar linen, the "corporal," stained with the drops from the bleeding host, would be venerated.[149] Although the church's foundations actually predate this event—and the eleventh-century church in Bolsena, St. Cristina, where the miracle was said to occur, has remained in place—it would be Orvieto's cathedral, housing the

jewel-like enameled reliquary, the work of the goldsmith Ugolino di Vieri, that would become the site in which to honor this local, divine intercession.[150]

Although paintings, including a series that relate to Bolsena, abound within the Duomo, those of the chapel dedicated to the Assumption of the Virgin—at the right of the main altar, and at the terminus of the vast, soaring nave—have received the most lavish attention, and were the focal point for tourists in Freud's time as they are today. The project of what is now commonly known as the "Cappella Nuova" (the "new chapel," with the "Chapel of the Corporal" beside it, having been painted a century earlier) had been first commissioned in 1447 and given to the well-known painter Fra Angelico, who had begun with the painting of the ceiling, but left abruptly after only several months, the most convincing explanation being that the city ran out of funds to pay him.[151] The project remained virtually dormant—with Fra Angelico's scaffoldings still in place—for nearly fifty years. But the papal presence in Orvieto—home to Alexander II as he fled Rome and contesting Vatican politics—and the specific anxieties, as we will see, surrounding the arrival of a new century, along with the threat of local heresies, all prompted the commission to become available again.[152] It was awarded to Luca Signorelli, whose work was well regarded and perhaps most important for the practical minds in Orvieto, a painter with an excellent reputation who had successfully completed a number of projects in the past.[153] Signorelli finished the ceiling panels first, and then turned to executing a quartet of large lunettes—a *trompe l'oeil* device that encloses imagery within an illusory painted archway. These walls would display what Freud called "the four last things." The imagery was indebted to a description in the Book of the Apocalypse of the end of the world and focused upon a succession of events described in the text: the appearance of the Antichrist, the Last Judgment, the descent into Hades, and the welcoming of the blessed into Paradise.[154] Freud's only specific memory of this quartet involved its inaugural scene, called by Signorelli the "Rule of Antichrist," and while an integral part of the textual narrative, prior to the Orvieto frescoes, it had never been included in visual renditions of the "four last things."

Its appearance here relates to this opening story's own, locally constructed prolegomena, depicted on the walls of an earlier chapel across from it. It will be at the closest place to it in the "Cappella Nuova," at the corner of the Antichrist painting, that Signorelli chose to locate his self-portrait, and it is the artist's face that Freud can visualize while discussing the paintings with Freyhan.

The Antichrist panel will be the focus of our attention here, but the three paintings that follow it were, despite portraying quite a common theme among artists of the period, an especially stunning interpretation of the "Last

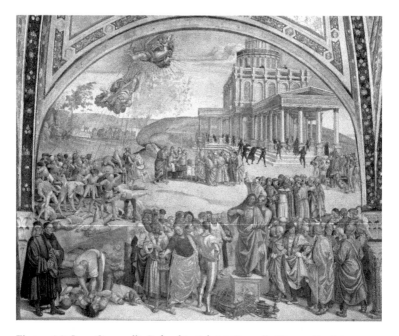

Figure 4.5 Luca Signorelli. *Rule of Antichrist*, Cappella Nuova, Orvieto, 1499–1504. © Opera del Duomo di Orvieto.

Things." Summoned forth from their burials, Signorelli's dead are depicted at the moment when they confront their eternal fates: the damned are those entangled bodies ushered to the entrance to the underworld by demonic guardians, while placid figures standing nearby appear in awe of their heavenly reward. These three apocalyptic scenes of resurrection, salvation, and damnation are, at their visual and conceptual core, a tumult of flesh. The emphasis upon the naked human form—prevailing among the damned and the saved—conveys the intensity of the final burst of physicality in this world; soon, the reality that had been the earthly body, called from the grave at the day of reckoning, will be no more. Margaret Owens, in her finely crafted analysis of this panel of Signorelli's quartet,[155] reads the stunning corporality in the painter's renditions of the resurrection scene as an assertion that "Christian orthodoxy valued embodiment."[156] She locates this in the numerous variations of what she calls "psychosomatic unity"—with skeletons and hybrid forms of robust flesh and emaciated cadaver—that create a striking rejection of heretic beliefs, rife at the time, involving the derealization of the body. Owens also suggests that Freud's dream of self-dissection, concluding

with his escape from the Etruscan tomb, may be indebted to the imagery of the Duomo. She cites the Etruscan grave, like the paintings, as a way to "tame" death.[157] In considering the same imagery, Richard Gottlieb offers a reading that situates the representational particularities of Signorelli's bodies in both historical and psychoanalytic dimensions, positing this work as exemplary of age-old narratives of cannibalism and bodily restoration; he argues that this is suggested by images of the resurrection that depict the actual regeneration of bodies once consumed by animals. His reading could also extend across the aisle, to the implications of the miracle of the Eucharist, an eating of the flesh in the guise of the wafer, that was restorative for those participating in the transubstantiation of the Mass. But for the Jews who reject this divine presence, there lay the fate of an annihilation that held no promise of redemption. In the medieval representations that heralded the paintings of the "Four Last Things," on the walls of the chapel across the nave—the Duomo's imposing central aisle—one found a visual genealogy of the "doom" that Freud's companion was to lament and that Freud himself would feel, only days after visiting the Duomo, when he returned to his life in Vienna.[158]

It is crucial to realize that as powerful as the Signorelli imagery was in itself, its visual program was dependent for its conception and iconographic cohesion upon this cycle of paintings that had preceded it in date. These surrounded a reliquary—arguably the most liturgically significant object in the church—in the older chapel of the "*corporale*," named for a type of altar linen. There, the worship of the Eucharist, so inextricably linked to this area of Umbria, promised the faithful triumph over heresies, most notably that of the anti-papist Orvietan Cathers,[159] but also extended more generally to perceived threats against the Corpus Christi doctrine by non-believers and fears of an impending eschatological reckoning.[160] The visual program of the "Cappella del Corporale" focused on the miraculous event in Bolsena, one that involved a doubting priest, whose distrust of the doctrine of transubstantiation (the Eucharistic conversion of the wafer and wine into Christ's body and blood) was countered by the assertion of divine presence through the appearance of the bleeding host, whose evidence would remain on the cloth used to cover it.[161] The pictorial representation of this story would be famously repeated, nearly two centuries later, by Raphael in his *Miracle of Bolsena*, painted over the entrance to the Vatican's *stanza*, the papal library. But it would be in Orvieto that we encounter the first appearance of this imagery; indeed, the scene of the miracle was accompanied by a distinctive series of paintings that occurs only here. On the chapel walls, surrounding the reliquary holding the corporal, was a visual program comprising "the most extensive series of Eucharistic imagery in existence in Europe."[162]

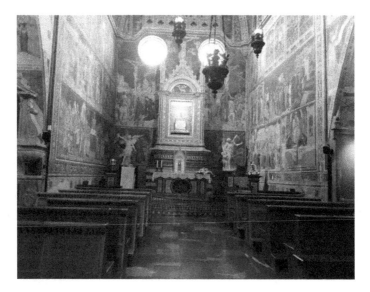

Figure 4.6 Interior view of the Cappella del Corporale, Orvieto, fourteenth century. (Photo: author.)

Although the miraculous event is attributed to the mid-thirteenth century, this date may actually mark the Church's first interest in having such a veneration; a miracle at Bolsena occurs in sources no earlier than the fourteenth century, although fairly recent archival evidence does suggest that the story originated in the century before (see n159). Thus, what is presented as the impetus for the creation of the Feast of the Corpus Christi—the veneration of the consecrated wafer itself—was in all likelihood given a date that aligned with the first papal celebration of the holy day. That event did take place in Orvieto in 1264 (the miracle is traditionally dated to 1262), at a papal mass offered by Urban IV, so that despite the problem of dating the event occasioning the Eucharistic miracle, the feast day and the doctrine of Christ's physical presence in the host were intimately connected to Orvieto from the start.[163] That the town's Dom would become the repository of the most compelling evidence of its divine presence certainly intensified the connection.[164]

As preaching on the concept of the Corpus Christi began to flourish, *exempla*—stories and sermons often rife with popular fabrications and stereotypes—increasingly addressed the divine presence, in the host, as beset by various dangers.[165] While there were factions within the Church

that opposed this new doctrine,[166] there emerged a tendency, as evident in the Corpus Christi iconography, to focus beyond these internal challenges, and redirect this opposition onto the phantasm of Jewish enmity toward the Eucharist, with triumph over their "heresy" achieved through conversion or death.[167] These themes were given their first large-scale visual program on the walls of the Chapel of the Corporal. The walls of the chapel were commissioned to Ugolino di Prete Ilario, a Sienese artist, who worked on the paintings from 1357 to 1364; later, in 1378, he also created the wall paintings behind the cathedral's main altar. At the time of Freud's visit to the church, this chapel's paintings, according to the Baedeker guide, had been recently restored, after centuries that left them darkened and damaged.[168] This chapel in Orvieto was the first place where a cycle of paintings was devoted to the Jews' purported antipathy toward the sacred wafer, and the punishments that resulted from it. As Dana Katz has discussed, in work focusing on the imagery of Jews in Italian ecclesiastical settings, other church painters in Italy, influenced by Ugolino, would also include depictions of alleged Jewish misdeeds and subsequent punishment as part of representations involving the Corpus Christi. In her important study of this topic, Katz examines the altarpiece by Paolo Uccello completed in 1468 for the church in Urbino, which shows both the burning of a Jew at the stake and images of host desecration: "Both portray the Jewish male as wicked and obstinate, the Jewish woman as subordinate to her husband and terrorized by his violent transgression, and the Eucharist and Christian faith as authentic and triumphant."[169] Katz contends that these accusations, along with their symptomology in institutional anti-Semitism, also were precipitated by the "external" threat from the Ottoman Turks, played out upon their local "internal adversary"—the Jewish community.[170]

But in the period of the Urbino imagery, one hundred years after the Corporale chapel was painted, and closer to the time of Signorelli, the Ottoman "threat" was considerably more immediate. At the time of Ugolino's commission, in the middle of the fourteenth century, the Islamic presence in Spain was selected to represent the "Saracen" threat, while the Jewish representations came from anti-Semitic stories of heresies that were, in some cases, from quite early in Church history. Indeed, Ugolino created the iconographic program, from a pastiche of "infidel" narratives all linked to the Eucharist, that others would follow. This would include Signorelli: non-Christian bodies from the earlier chapel were reiterated in his paintings, particularly of the lunette devoted to the "Antichrist," the painting that linked the Bolsena imagery to the Cappella Nuova, and whose figures both were cast as the agents of heresy and threat.[171]

Freud casts himself as the detached observer of "Turkish" habits while in Bosnia, but his experience viewing the representations associated with

Bolsena—and since we know that he visited the village in the afternoon of the day he went to the Duomo, it seems safe to assume that he had seen its most famous object and its surroundings while in the church—and then the paintings of Signorelli may have made the Jewish and Islamic connections far closer. The program of paintings preceding Signorelli's involved several stories of the Eucharist that focus on encounters with non-Christians. One features a legend from a town in Spain that was under Islamic governance in the thirteenth century: The "Moorish" ruler agreed to free a captured priest if his prisoner could visualize for him the miracle of the transubstantiation.

The decisive moment occurred at the consecration of the host, for as the priest elevated the wafer it transformed into the image of Christ as a youth. Not only was the cleric spared, but there were, as the text below the painting records, "the conversions of many Saracens that day,"[172] using a term common in medieval Latin to identify Muslims living in Spain and, more generally, throughout the Arabic-speaking world.

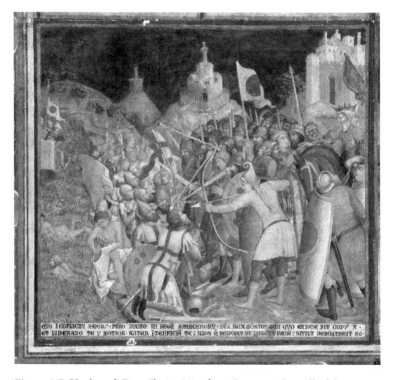

Figure 4.7 Ugolino di Prete Ilario. *Miracle at Caravaca*, Cappella del Corporale, 1357–1364. © Opera del Duomo di Orvieto.

The other register on this wall recounts the so-called "Miracle of the
Jewish Boy," a story that dates to the sixth century and first appeared in
Greek, as an *exemplum*, within an ecclesiastical history attributed to Evagrius
Scholasticus of Antioch.

Carefully parsed at the start of a book by Miri Rubin aptly called *Gentile
Tales*, this story of conversion, where Mary intervenes to save the child, is
the earliest extant narrative that linked Jews and the Corpus Christi.[173] In
Ugolino's rendering, a curly haired child is shown receiving communion,
having accompanied his Christian friend to church. In the next panel, his
enraged father is pulling him away and then tossing him into a fiery furnace.
He is miraculously saved by the intercession of Mary, and it is then his father
who meets his end in the flames; the child is embraced by his mother, who
in many versions of the legend joins him in entering into the Church.[174]
While early stories of conversions, especially of Jewish children, were not
uncommon, the relationship between Jews and the Eucharist became, by
Ugolino's time, focused on a more malevolent fabrication, that of host
desecration. The chapel also contains such an image—a group of Jews procure
a host "from a sinful Christian," a role usually given to a woman—and "they
abuse it violently; they are caught and punished."[175] The Jewish threat must
have been perceived as especially strong, as the artist chose to paint, over
the entrance to the chapel, a depiction of Judas—whose features Signorelli

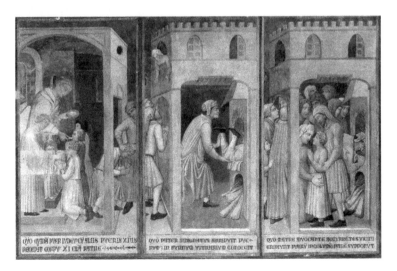

Figure 4.8 Ugolino di Prete Ilario. *Miracle of the Jewish Boy*, Cappella del
Corporale, 1357–1364. © Opera del Duomo di Orvieto.

appropriates for his "Jewish" figures—in the presence of "an advisory devil,"[176] a pairing that would foretell the portrayal of the Antichrist coupled with a demonic figure in Signorelli's painting across the nave.

We cannot ascertain what Freud had as resources of information on the chapel of the corporal—in the form of a guide or, beyond his Baedeker volume (where it is briefly described), a more detailed explanation of the

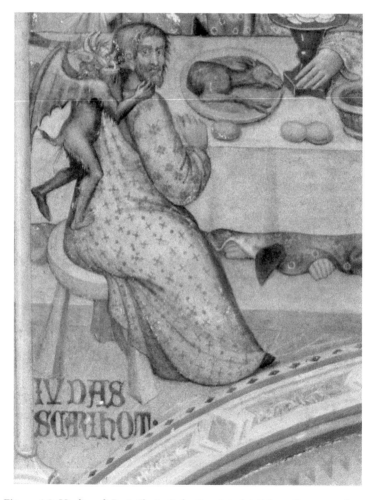

Figure 4.9 Ugolino di Prete Ilario. Judas Iscariot, detail from the scene of the *Last Supper*, Cappella del Corporale, 1357–1364. © Opera del Duomo di Orvieto.

sacellum. The well-known local archivist, Luigi Fumi, had written a book on the Cappella del Corporale in 1896 and that would surely have been quite readily available.[177] But since much of the interior, including the paintings in this area, had recently been restored, the visual program would have been quite readily apparent; one imagines that the depiction of "Saracen" horsemen or a stereotypic Jewish figure being thrown into an oven would be easily recognizable on their own. The anti-Semitic imagery here was especially freighted. Host desecrations were very much about blood—both on the altar linen here and with the accusations of ritual murder that were commonly associated with accusations of stealing or abusing the Eucharist in medieval times, slanders that had returned, as noted earlier, with menacing popularity in Freud's time.

Freud spoke to Freyhan of the "four last things," a quartet of events determined for Signorelli by an "established, orthodox theological pattern": "Antichrist, the End, Resurrection, Last Judgment."[178] Signorelli includes in this cycle his "Rule of Antichrist," whose arrival will preface the end of days. This most powerful and beguiling of apostates would mount an attack upon Christ and the Church; at his vanquishment, the Last Judgment would ensue.[179] This painting brings the imagery and content of the Corporale forward—it is the lunette located at the closest point to the Bolsena chapel—and then stylistically inaugurates the scene that will follow in the cycle. Like those in the Cappella Nuova, this scene abounds with Signorelli's dramatic figures, dynamic pockets of action reverberating through the pictorial field. There is a clearly delineated foreground where the Antichrist, a figure that, on first glance, would appear to share a certain resemblance to Jesus, addresses those gathered around him. Directly behind him is a demonic figure, curled around him and seductively whispering in his ear. Further back is a building with classical elements that dominates the deeper portion of the picture plane; here various battles ensue, as they do throughout the painting. There is a successive narrative here that differs from that told by the other paintings, as the scenes that follow the Antichrist's "rule" unfold: the Antichrist battles the angel Michael and is vanquished. These final moments are shown in smaller medallions above the foreground scene; while small in scale, their consequence is immense. With the imposter's defeat we are ushered into the world's finale, as those loyal to the Church are saved, and those who are seen as its enemies are eternally damned. The need to maintain the power of Rome and vigilance against all disloyalties to the Church are dramatically on view here, with the reassurance that, in the end, ecclesia will triumph over the heretic and infidel.

In his invaluable monograph devoted exclusively to this painting, Jonathan Riess characterizes Signorelli's treatment of the main figure, shown preaching to a group assembled around him, as "a composite

embodiment of heresy" that, in gesturing back to the infidels across the nave, is "working in league with his Jewish and Moslem allies to undermine the Christian order."[180] The doctrine of the Corpus Christi is a crucial aspect of ecclesiastical primacy here, sharing with it with the "eschatological sacrament of the Eucharist in the attainment of salvation."[181] But it also shares, as Riess convincingly details, a heretical threat—the host as "a symbol of Christ's suffering at the hands of unbelievers" and the response, in the Antichrist fresco, of the defeat of those who attempt to usurp his divine privilege. This connection to apostasy is also apparent in mimetic visual codes designated by Signorelli's imagery of Antichrist and those in the scenes of "non-Christians," who shared representational tropes such as exaggerated facial features and distinctive terracotta skin color that Signorelli—who gave his demons in other lunettes an array of bright body hues—reserved for them. These devices continued those used in the chapel across the aisle.

To underscore their alignment with malevolence, these physical attributes are also found in scenes of the most overtly evil of characters: the demon that wraps itself around the Antichrist and beguilingly whispers in his ear from behind. Signorelli places that pairing atop a small podium in the foreground that has a heap of gold objects at its base—censers, vessels, and coins. These are treasures that speak to pagan classicism and Judaism, and relate to the structure with columned porticos that looms in the background of the painting. Indeed, this was Signorelli's version of a building that features in the Antichrist story: the second temple in Jerusalem. This is the old "temple" that was linked to Judaism and, in this narrative, to all manner of evil. There would not be a new Jerusalem, for it was to be found in Christ himself, and in particular, the Eucharist. The building has various figures around it—the black-clad followers of the Antichrist and figures in turbans, marking them as non-Christian.[182] Riess noted that the recent Inquisition in Spain, of the earlier 1490s, had heightened the antipathy in Italy for the "heretic and the infidel,"[183] and imagery such as this may have been read as a visualization of such expulsions.

It is notable that in August 1499, just before Signorelli began his commission, there was a decisive Islamic victory in the ongoing conflicts between the Ottomans and the Venetians, with the Italians bested in a naval battle off of Cape Zonchio in the Ionian Sea.[184] There is an interesting parallel here to the moment when Freud would have seen this painting, as it was one year after the Turkish defeat of the Greeks—another startling upset—that had featured in Freud's "Hella" dream, mentioned in a letter to Fliess dated May 31, 1897.[185]

In addition to those coins at the feet of the Antichrist, other monies are being passed in the foreground; a man, wearing a turban, whose appearance closely resembles that of the Antichrist, places coins in the hand of woman who extends it toward him; this man and the Antichrist are the only bearded figures, and both share distinctively long, thin noses, and copper skin. These features, along with his colorful robes, might suggest that the figure with the coins fits an Islamic stereotype, but the six-pointed star of his money purse, from which he distributes coins to a woman as he looks up at the two figures, heretic and demon, would suggest one of Riess's "composite" figures—that of an Islamic and Jewish stereotype, which would have been very recognizable in Signorelli's time as a caricature of the "usurious Jew." The relationship of a Jewish male interacting with a "fallen" Christian woman has a genealogy in myths of host desecration, where procurement of the wafer was frequently depicted as having been achieved through "wayward" women willing to pay to secure them. Such a scene from the adjoining chapel is placed on the wall closest to the Antichrist painting.[186]

But between the Corpus Christi iconography and that of the money exchange are two figures that are a literal hinge between the two chapels. Placed outside the frame of the lunette, and thus closest to the viewer, the images of Signorelli and Fra Angelico serve to both initiate one cycle and connect it to another.

Directly to the right of them, as one moves into the action of the painting, and nearly tumbling out of the picture plane, is a friar being murdered by demonic figures; this is followed by two other foreground pairs—the man passing money to the women with outstretched hand, and the Antichrist and demonic accomplice.

Freud recalls Signorelli's face as he struggles to remember his name. This recollection gestures to that pivotal spot in the painting cycle where the artist's own pictorial presence serves as the conduit for the continuation from the other paintings in the chapel beside. What Freud so clearly recalled is the visualization of a threshold of the "Last Things": it can be said that by placing himself where he did, Signorelli claimed a stake in both pictorial cycles. Perhaps amid all this, Freud had a moment when the paintings—which Freud describes to Freyhan as "the most beautiful I have seen so far"—took on a less pleasing cast; rather than the suppression of his "Turkish" story from Pick, it was this evocation of an aesthetic judgment that was in fact the disavowal of the content of the conversation. Freud's ability to remember with unusual clarity the face of Signorelli and not his name may have resulted from a moment of unwanted recognition of content and motive that he recalled in front of the painting in which Signorelli placed himself as an assertion, Riess argues, of his "hatred for the Jews and Moslems and … his belief that

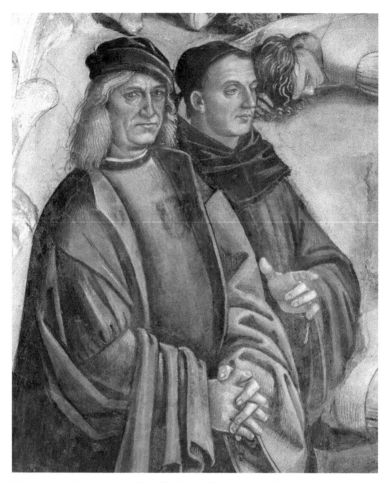

Figure 4.10 Luca Signorelli. *Rule of Antichrist,* detail of the artist with Fra Angelico, Cappella Nuova, Orvieto, 1499–1504. © Opera del Duomo di Orvieto.

the infidel is an ally of the Antichrist."[187] Such racism may be linked to the conversation in the *aliquis* story; if they were all part of the same extended discussion, perhaps Freud, in speaking of Orvieto, recalled the anti-Jewish imagery there but decided not to share it. Rather, he wanted to convey the experience of a detached, amnesic appreciation he had sought in the days before his visit to the Duomo; perhaps this was then enacted in his "slip."

However the lapse occurred, its elements, as the material for Freud's psychical creation, were to become shaped into something of profound consequence.

In his essay on the Signorelli incident, Michael Molnar effectively argued for the impact of this instance of forgetting on Freud's early analytic thinking, where in unraveling his failure to remember, Freud offered "the first detailed examination of unconscious processes ever to be published."[188] Molnar's argument appears to return meaning to the paintings themselves, whose presence within the resulting psychical revelations had "dissolved," as he observes, into words or their fragments.[189] However, his analysis is a formal one, locating the disquieting experience that resulted in the Signorelli lapsus not within the content of the paintings, but in the actual structuring devices used within the pictorial representation itself. Signorelli's use of innovative devices to create his illusionistic surfaces—"figures in violent motion, the trompe l'oeil, the startling perspective"—was "calculated to surprise the viewer." My contention is that the arresting experience for Freud was primarily content-driven, with the painterly devices cited by Molnar certainly potential factors in heightening the destabilizing effect of the work's reception.

The depiction of the painter's face had an inscrutable quality that, according to Molnar, points to the influence of Byzantine icons, where the focus on the figure reflects a worldview "infused with total consciousness."[190] For Molnar, Freud's inability to recall the name of this hyper-present image may have suggested his wish to posit as binary the workings of conscious and unconscious processes. He presents this as part of what he terms a "visual metapsychology" of the Signorelli paintings, leading Molnar to speculate that experiencing such compelling expositions of visual reception enabled Freud to better elucidate the operations of psychical life. But to equate the structuring of imagery with that of psychical functioning risks relegating the representational aspect of the work to merely its "manifest" surface, thus denying meaning to the paintings in the context of the broader iconography, and experience, of the Duomo.

Below the Antichrist panel, as repeated throughout the chapel, are additional paintings, forming the *zoccolo*—a base below the large lunettes. These feature smaller medallions, portraits with circular paintings fanning off from them. Below the Antichrist panel is the image of Cicero, thought to be a paragon of just government and a relentless critic of tyrannical rule. As one moves through the chapel, it is also clear that Signorelli drew much inspiration from Dante's *Divine Comedy*, and that writer's portrait is prominent here, surrounded by roundels depicting the first eleven chapters of *Il Purgatorio*. Dante's presence has particular significance, as the theme of purgatory was placed below the Antichrist scene, establishing a vertical

reading of the layers of the chapel wall. The imagery was intended to take the viewer through a "preparation" for the possibility of a heavenly reward.[191] Sheila Nayar has argued that Dante's work was particularly indebted to the doctrine of the Corpus Christi and its embrace of "double signification," that the act of the transubstantiation created "the consecrated wafer as being both one thing *and another"* (italics original). She reads the "multiple significations" that appear frequently in Dante's work as having a genealogy here, and along with the Eucharistic "fervor," allowing for the "*individual soul's* experience of God outside the Church's mediation"[192] (italics original). Dante's presence in the chapel takes on a prescient quality when considered alongside Freud's experience there. Signorelli's opening scene from the *Commedia*, paralleling the two artists' portraits, depicts Dante and Cato the Elder, the "guardian of Ante-Purgatory," at the start of a journey between heaven and hell. In one roundel, Dante and his companion pause at the shores of Lethe.

In the Christian reading of this scene, the libation would eradicate all of one's sins, permitting passage through Purgatory to the ultimate paradisiacal reward. Signorelli, by placing himself in the role that visually mimics Dante's, with Fra Angelico as his Cato, intriguingly suggests that there is a moment of forgetting on the threshold of another world. Signorelli relied on the widely read *Commedia* to offer his audience an accessible gloss to his eschatological program—and arranged its imagery to position the viewer as "a fellow traveler and not a bystander." It is likely that Freud would have recognized the Lethe scene, having cited the river only a few days before, in his letter to Fliess from Siena. What may have occurred here was not a liberation through forgetting, but rather an excess of recognition: a breaking through of the exquisite self-consciousness, in the painting of the confluence of anti-Semitism and alterity, of threats and "doom" that collapsed both temporal and spatial borders.

The *Fehlleistung* of the Signorelli lapsus can be cast as a failure of what Freud imagined as an "aesthetic" function, where he was not able to remain the detached viewer. Lacan suggested, as noted earlier, that in Freud's inability to recall the artist's name, Freud, as "Sig"-mund, was in fact enacting a forgetting of himself, and we can intensify that with his deletion of Freyhan's name as well.[193] But perhaps it could be framed in the reverse: Freud was confronted, in the Duomo and in conversation with his traveling companion, with remembering himself, not in the guise of the tourist and aesthete, but as the object of Signorelli's strikingly rendered scorn. In one moment of viewership, he could appreciate the qualities of beauty—this is what he recalled to Freyhan—but in the next, his visual reception may have been upended, turned back onto himself, and it is then, in recalling the disjuncture, that Signorelli's name was forgotten. Perhaps

what occurred in Freud's conversation with Freyhan was abundance rather than loss: Freud was too fully himself, so he could not extract a wider range of emotional responses to the work appropriate to the viewer he had aspired to be. But this was not the story he constructed for his readers concerning the Signorelli incident. Rather, he would strive to present the story as evidence of a universalizing inner mechanism crafted to create the credibility his narrative required, and which was constructed with that need in mind.

Freud would remain at home by himself for about ten days after his September travels in 1898, and he quickly devoted himself to transforming the incident initially constituting one paragraph of his letter to Fliess into a considerably longer piece. He wrote Fliess again five days later with the news that he had "turned Signorelli into a little essay" and had already sent it off.[194] The thought that preceded this update is worth noting, as he speaks about his holidays as "lovely"; he quickly adds that "this city really wounds the soul and once again lays bare everything that had begun to heal in two months."[195] Finishing the manuscript must have been seen as a strike against this feeling of oppression and malevolence. In the first paragraph of his Signorelli paper he also gestures to a connection, albeit rather a stretch, to his earlier neurological work; perhaps this was to serve as a nod to the journal's co-editor, whom he imagined to be among the first to read his submission. This connection occurs when Freud addresses the frustration we all feel when unable to recall a name: it produces an "unmistakable feeling of irritation, similar to that which accompanies motor aphasia."[196] His introductory paragraph closes with a rather over-determined example of substitutions that may occur as only the memory of "a single letter or syllable." He goes on to give an example: "we say, for instance, 'It begins with a B.'"[197] In adding this latter feature, Freud clearly is anticipating his own argument, as when he incorrectly remembers Signorelli's name as those of painters whose names begin with this letter. In fact, Freud observes, the actual name does not contain this letter. Whether this occurrence was in fact separable from the specifics of this story is unclear, although it is certainly presented as a common experience.

Freud sent off his essay about the incident to be published as an expanded, amended version of events entitled "Zum psychischen Mechanismus der Vergesslichkeit" (The Psychical Mechanism of Forgetfulness), accompanied by an illustration of the operation of his *Fehlleistung*.[198] The diagram does not actually reveal the workings of the mechanism of repression itself, but rather

the history of its retrospective assemblage, beginning, rather than ending, with the three artists' names.

It was Molnar who alerted us to the similarity between Freud's schema there and a diagram of the forgetting of a word that Freud included in his 1891 monograph on aphasia;[199] we will return to that in a moment. This visual connection would serve to shore up Freud's earlier contention, at the start of his essay, that the affect of "irritation" connected otherwise disparate experiences of forgetting a word.[200] This return would suggest that Freud was adapting a schema he had originally appropriated to elucidate a model of language functioning that did not, unlike other imagery he used in the 1891 text, employ a depiction of the brain. But in its content, too, Freud's specific reference to this earlier diagram indicates that he considered repression and forgetting part of an amnesiac continuum extending from neuropathologies to experiences of forgetting that were aspects of "everyday life."

Although Freud would accord far less significance to Signorelli's paintings in the Duomo than to the content that preceded them in his exchange with Freyhan, he nevertheless intended to persuade his readers of the existence of his proposed psychical mechanism of repression by how it was "pictured," schematically and empirically,[201] but also by recourse to the "behavior" of paintings on a wall, rather than words as a spontaneous sequence. As we will see here, Freud's experience with a group of paintings—including one by Signorelli, along with Botticelli and Boltraffio—soon after his conversation

Figure 4.11 Sigmund Freud. Diagram (*Schema*) of the forgetting of a name, *Monatsschrift für Psychiatrie und Neurologie* 4, no. 6, 1898, p. 436.

with Freyhan, exerted a potentially significant influence. But this encounter, occurring in a gallery near Milan, would be erased from any narrative of his relationship to his trio of Renaissance artists: the contiguity of their names was presented, in both his narrative and its visual rendition, as exclusively the working of repression, whose source was said to emerge from unconscious stirrings occasioned by a discussion of "Bosnian Turks." Here we will resituate as a very conscious strategy the stringing together of the three painters, an act whose authorizing source was a museum wall. These paintings were an assemblage of discrete objects, not unlike Mancini's collection, and Freud's encounter with them allowed him to create criteria for selection and value, where external factors—the Etruscan grave, the two chapels—could be forgotten.

Freud submitted his paper to a journal in Berlin that had just begun publication the year before; its other editor, along with Theodor Ziehen, was Carl Wernicke, someone Freud had known for some time. Freud had critiqued Wernicke's work, pivotal in neurophysiology, in his book on aphasia. But mutual respect remained, suggested by the fact that Freud would first turn to a publication under Wernicke's leadership for his essay on the Signorelli incident. Reflecting a calculated attempt to join this new work with his previous efforts in neurology is Freud's inclusion of the illustration noted earlier: a diagrammatic rendition of the *Fehlleistung*, charting the relationships among the various components he had shared with Fliess. We noted that the format of this diagram derived from illustrations in Freud's aphasia monograph, specifically one he reproduced from a text of Hubert Grashey, the German psychiatrist who had worked on various neurological pathologies.

Freud's choice of this diagram must have been informed by the specific process elucidated in his previous discussion of forgetting: what he had called Grashey's concept of "amnesic aphasia," where a patient could correlate an object with its written equivalent, but was "yet unable to find the sound impression for the object presented to him."[202]

Grashey's neurological charting of pathways had arrows suggesting the direction and dynamism creating a circular series of causes and effects. Freud did not add any such cursives until the later editions of *The Psychopathology of Everyday Life*, where he had initially reproduced the same version that he sent off to Wernicke that September.[203] Although Molnar only cites the later version, he notes the "topographic" sense of the formulation, with the realm of the unconscious at the lowest point on the picture plane, and the "conscious material at the top."[204] This arrangement is actually more plausible in the earlier rendition, illustrated here, where there are no circulating arrows, and one can read the image more stratigraphically, implying that

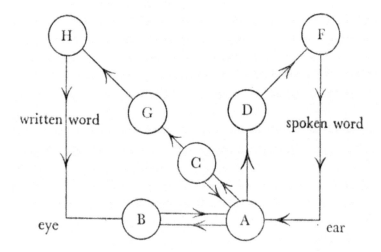

Figure 4.12 Hubert Grashey. Diagram of workings of amnesic aphasia. From Sigmund Freud, *On Aphasia: A Critical Study* (London: Imago Publishing, 1953), fig. 6, p. 35.

the scene should be read from top to bottom: words or phrases—such as the names of the artists—at the top, Herzegovina and Bosnia in the middle, and "repressed thoughts" at the lowest point. The original image is thus less diagrammatic and more pictorial. Freud would make changes to it in the later editions of *The Psychopathology of Everyday Life*, and this second version of the diagram, differing from that published in the essay of 1898, was adopted by Strachey for both articles published in the *Standard Edition*. But it is vital to refer to Freud's earlier diagram, which he included in both the *Monatsschrift* and the first editions of *The Psychopathology of Everyday Life*; Riccetti's recent study is rare in its inclusion of the earlier version.[205] Freud initially created a distinction between words, by placing some in italics. In the later version of the diagram, the entire image is shown this way, but the earlier one clearly shows a desire to mark a difference among these elements. The names of the artists and of Herzegovina and Bosnia are in standard type, suggesting the external, ordinary setting, and appearing as the upper and middle ground, while those aspects more generative of the inner landscape—"themes of death and sexuality"—are just below the ground line of the geographical designation, as if existing just under the Balkan surface. Below that is locutionary evidence of this dangerous ground: Freud's citation

of the comment beginning with "Herr, was ist." A vertical bar connects the "themes" with the deepest place on the pictorial surface, those inhabited by "repressed thoughts" (*Verdrängte Gedanken*). These distinctions within the illustration would probably have been less notable for Wernicke; Freud may have hoped he would be persuaded by a visual rendition familiar from other studies of language misrecognition. But more significant is how Freud himself chose to produce his first piece of "evidence," as Molnar terms the diagram, for his new model of the unconscious.[206] This is less a charting of a scientific discovery than a making visible of a new territory—one that Freud distinguishes in his letter to Fliess: "it concerned something that happened in Bo snia."[207]

Parallels can be made to an earlier landscape that Freud imagined, also when he introduced a highly consequential glimpse into psychical functioning. The "archaeological" scenario that begins "The Aetiology of Hysteria," revisited as it relates to this episode at the beginning of the previous chapter, offers some insight into Freud's picturing of internal processes in the guise of this "semi-barbaric" setting. When Freud came upon amnesic inhabitants in his 1896 essay, they languished, forgetful, on architectural remains—the surface of their distress and the site of its symptom, with the hint of what structures lay below. Freud now moves to a more normative sight of psychical lapse rather than trauma, so his surface of fragments, with his experience in Orvieto, is one of bits rather than a whole, in the pieces of words he comes to value the way Mancini did his Etruscan offerings. The three artists' names are broken into pieces on the "surface" of the scene of forgetting. The "Signor" of the artist's name, enframed and connected to the opening word well below, begins with "Herr," thus assuming a translation within the unconscious. It is striking that the three painters are shown as they would be displayed in a gallery; indeed, this was the precedent that anticipated Freud's choice of this arrangement. An exhibition installation would make sense here, as Freud makes no real distinction in the image between the name that cannot be recalled and the names that were remembered, albeit erroneously. He places them all as if on a wall and equally distanced. The only distinction is that while the Signor "fragment" is in a rectangular frame, the Bo of the other two names—Botticelli and Boltraffio—is encircled. All three painters' names have a region of Freud's travels just beneath them, as shown by a connecting line. Freud suggests more than a mere sonic connection; he uses a broken line when joining the last syllable of Signorelli and Botticelli, implying that this link is less psychically freighted, and has no connection to the signifier of place. Thus, the three Italian artists are now fragments of the surface of a symptom—that of Bo-snia.

As the archaeologist/analyst probed beneath the surface of hysteria, Freud offers his readers a glimpse under the Balkan ground, where unearthing scenes of history and commemorating traumatic events have been replaced by "themes of sex and death" located not far beneath the ground plane. In his illustration, these "Thema" seem to reside just under the surface, with a truncation of the phrase that Freud mentioned to Fliess—"Herr (Signor, Sir), what can be done about it?"—appearing beneath. This question is given more specificity in Freud's essay, where he recounts two anecdotes about "Bosnian Turks," the one whose opening phrase he noted in his letter, and another, that he claims not to have shared with his companion. In his first narrative, the only spoken words are a phrase addressed to the Signor. We will learn from his published account that this quote derives form a conversation concerning death, and that a similar query appears in a related discussion of sexual functioning. The second story, whose censorship Freud credited with the forgetting of what followed, is alluded to by the line connecting the themes to the repression that he either expressed or imagined just prior to the conversation about the paintings in Orvieto. It would appear that this theme is joined, although not shown as such, with the themes above it, and is a broader category leading further down to the repressed thoughts. But there is another connection, to the far right, that links this repressed material to another location—"Trafoi." In regular type, this word is at the lowest point of the right side and from it a line extends upward, forming that side of the diagram's frame, as it joins to "Boltraffio" at the upper right. This lower word is joined, at the bottom—Molnar's unconscious level—with repressed thoughts, and, as the deepest word, suggests itself as particularly generative. In Freud's letter, he mentions that the choice of the name of the artist Boltraffio—far less well known than the others[208]—was because "trafio" gave rise to thoughts of the Swiss village, Trafoi, where Freud had spent a brief period of one day during a previous vacation, in August 1898; this was the same holiday, with Minna Bernays, that had begun, as we noted earlier, with the experience in Innsbruck, three days before passing through Trafoi, of seeing the statue of Andreas Hofer.[209] Freud will elaborate upon this connection to the village more fully in each succeeding version of the story that followed the letter. Something happened in this mountain town—Freud claimed that he learned there of the suicide of one of his patients who had incurable sexual problems[210]—and although it is a good melding of the two themes, evidence suggests that it was a fabrication—we will return to this in a moment—probably designed to make some associative connection to the second part of Boltraffio's name.

Freud used the information he shared with Fliess to create a *Fehlleistung* as the scene of a colonialist encounter. The ground upon which the action

takes place is essential for the entire process itself to "function." Pieces of these painters' names are either remembered—as in the "bo" names—or forgotten, as in the example "Signor/Herr." The topography is clearly "thematized" with the non-specific, but certainly culturally implied, "underneath" of sex and death, assumed to be capable of producing unacceptable thoughts. Freud's earlier reliance upon a scene of trauma is here saturated with spaces of fantasy, with only the voice of a local resident as the event, one that sparks fantasies and repression. The "credibility" for this "forgetfulness" lies in imaging what surrounded the moment of lapsus itself; this conversation happened in a place where feelings could easily be stirred. "Bo-snia" is thus cast as psychically generative, as Bjelić has contended, and in carrying his insights further here, Freud makes this connection readily visible. Freud's dream of the Turkish encounter—occurring in the very days when his essay and illustration were being crafted—certainly suggests an appropriation of this cultural locality. But this dream also gestures to the complexity, for him, of such a strategy. Freud insists on donning the Turkish guise as his argument's raiment, relying upon the readers' associations to make the repression more believable, but he may also be revealing an instability: the moment when Islamic and Jewish subjects meet similarly frightening fates in Bolsena, and within the public discourse of his own moment. Molnar considers the diagram the "most persuasive of all"[211] the evidence for the workings of the parapraxis, and hence the emerging Freudian unconscious, in the paper, and thus a good place from which to enter the text itself; this visuality, securely under Freud's control, effectively replaces that of the painted chapels in Orvieto. Indeed, Freud's representation gives the narrative its scene and theme—the power of an imaginary land, created by phantasms that while they pervade the entire picture, appear to only live beneath the earth. Freud's later alterations of the diagram, adopted by Strachey and therefore far more commonly reproduced, show several changes suggesting how the Freudian unconscious moved away from its representation as a visual field governed by the acculturated experiences of viewing paintings and "foreign" peoples, from a gallery at the top to the landscape below. In the diagram's appearance in *The Psychopathology of Everyday Life* (one that was substituted by Strachey in his translation of the essay for the original version in the 1898 essay), Freud introduced Grashey's use of arrows, making the actions move in a circular pattern. He also shifted the location of the "themes," placing them under the phrase to which they are now connected, joining "death and sex" directly, and placing them in closer proximity to the repressed thoughts. They are also placed in parentheses to distinguish them, as the entire model is now rendered in italics. The move of "sex and death" is particularly notable, as it had originally been

closely aligned with Herzegovina and Bosnia; later it is moved closer to the unconscious itself. Earlier, the Bosnian-speaking subject had occupied that place. Also, arrows now lead from the deepest material to Trafio and then to Boltraffio. This suggests that Freud had developed a stronger case for this connection, one that he had worried about making credible in his letter to Fliess.

Trafio, or rather its somewhat homonymous "Trafoi," is most closely aligned with the workings of the repression, and Freud attributes this to learning of a patient's suicide when visiting that village with Minna Bernays several weeks earlier. Three days after the memory lapse in Innsbruck, he and Minna passed through the Tyrolean village very much in an area associated with Hofer. Minna added to the letter that her brother-in-law had written to his wife the day after they passed through Trafoi, giving her sister a number of details: the scenery was among the most beautiful she had seen, that Martha must visit there, that there was a charming inn in the village. Minna describes "Sigi" as in good spirits and enjoying the mountain vistas and local flora.[212] There is certainly no indication of any unexpected news, which to reach them in Trafoi would have required considerable logistical efforts and would have necessitated Martha's involvement, as she seemed to be the only source of their itinerary. Swales appears correct to assume that there would have been no more than a brief respite on a long day's journey, perhaps to look at the beautiful scenery and eat a midday meal, before continuing on a long day's journey of over eight hours of rugged mountainous terrain and passes that brought them from Prad to Bormio.

In the essay he wrote immediately after returning home in the month after this trip, Freud provides more about Boltraffio, noting that the "bo" was explainable, as these letters could be "accounted for, by their assonance with 'Bosnia'"[213] but he realizes that he will need to add more to that. He then goes on to refer to thoughts of "death and sexuality" that had "never engrossed me more than they had in a few weeks before, after I received a certain piece of news." The news reached him in Trafoi and "this is too much like the second half of Boltraffio not to have a determining effect on my choice of the latter." It will not be until *The Psychopathology of Everyday Life* that the incident is revealed—he learns of the suicide of a male patient "for whom I had taken a great deal of trouble" and who took his life due to "an incurable sexual disorder."

It is interesting that an event—the death of a patient—that seemed so present to Freud in the weeks leading up to his holidays is not mentioned in any of his correspondence, nor is there any male patient of Freud's who is known to have committed suicide during this time. Also, as noted, it would seem very implausible for Freud to have received this news in the Tyrolean

hamlet, during no more than a brief stop in transit. In Freud's first mention of the town to Fliess he associates it with his trip prior to the one to Dalmatia—when he indeed visited Trafoi—but makes no mention of the news he received there. As we have seen frequently through the Signorelli story, contiguities often move in a direction opposite to the one Freud directs us to follow. This would seem the case here as well: the relationship between the town and the artist should be read in reverse: Trafoi's association to "trafio" (and not many words could function in this role) was the motive for its inclusion here, not the other way around, as Freud indicated.

In order to make the parapraxis believable, Freud needed to have an event related to sex and death associated with this town. A celebrated murder case occurred in Trafoi in 1876, and a memorial to the deceased, an English citizen named Madeleine de Tourville, would have been visible in the town.[214] This story was sensational and widely publicized in Europe and the United States. The murderer was the victim's husband, Henry de Tourville, who was revealed to be a multiple killer, having pushed two wives to their death. Medical evidence ultimately convicted him, but what gave the case added sensationalism was that he maintained that Madeleine had committed suicide in Trafoi, throwing herself down the steep embankment along the road, although in his first statement to the police he had claimed that she had fallen while the two were walking along the mountains road, only later to claim she had taken her own life.[215] Whether any of this influenced Freud's report that he heard news of suicide in Trafoi is impossible to prove, but the coincidence of this pairing is worthy of note. The journey that Freud and Minna took, from Prad to Bormeo, was one suggested by the Baedeker guide; it would seem highly probable that this volume was with them and they first learned of the death from it. Indeed, as Freud was only twenty at the time of the de Tourville murder and occurring as it did, far from Vienna, while Minna was a teenage in Hamburg, it is likely that he first "learned" of the suicide-then-murder while in Trafoi during that brief passage through it. The guidebook notes that the plaque commemorating the murder of Madeline was visible from the road they would have traveled (and where she met her death). Freud's own experience of the suicide of a patient—Pauline Silberstein—was also through a fall, and perhaps the "incurable sexual problem" that he cites may have been, in some way, a reference to an aspect of Pauline's case, albeit never detailed, as well. Perhaps finding the link to the artist, Boltraffio, in this village's name, Freud created a pastiche of death and sex out of the village's history that could seem worthy of repression, and one that could be replaced onto this unnamed patient. Certainly Freud's relationship with Minna and the circumstances surrounding his treatment of Pauline and her death could both suggest places of discomfort for Freud.

But the associative train that somehow linked these incidents to the Milanese painter as Freud struggled to recall Signorelli's name in conversation with Freyhan can be argued to be apocryphal, as there is persuasive evidence that Freud did not add to the story, or perhaps even know, Boltraffio until after leaving the Balkans.

Only in this last version of the account does Freud mention how he gained knowledge of Signorelli's name—from a "cultivated Italian." In the first version of the story, we are told that he had to wait for "several days" before recalling the time—a time of uncertainty that he describes as "inner torment";[216] there is no mention in the first account of learning it from another source. Philip Kuhn has suggested that this revelation is actually not a person, as presented in *The Psychopathology of Everyday Life*, but rather a book. Kuhn identifies the source as Giovanni Morelli's posthumously published volume on Italian painters, *Della pittura italiana: Studii storico-critici di Giovanni Morelli (Ivan Lermolieff): Le gallerie Borghese e Doria-Pamphili in Roma*,[217] in which Freud would have found entries on all three of the painters associated with his parapraxis.[218] We know that Freud purchased a copy while in Milan; the existing book, in the Freud Museum, bears his name and the date of September 14, 1898, only a few days after his conversation with Freyhan. Freud encountered Morelli's work, under the pseudonym of Lermolieff, prior to this purchase, although he may not have realized the true identity until Morelli's death in 1891;[219] Carlo Ginsburg had noted that Freud had attributed investigative methods to him.[220] Freud notes that he had encountered Lermolieff long before his analytic interests, and the conduit have may been his teacher Brücke, who was brought up in a family whose father who was a painter, and it may have been his teacher who introduced Freud to various currents in art history.[221]

Along with meeting his "cultivated Italian" in the bookstore, Freud may have had the pleasure again when he spent a day in the small nearby town of Bergamo, where Morelli—a notable figure whose interests included medicine, politics, and art history—had bequeathed his important collection to the Accademia Carrara, a gallery and art academy established a century earlier.[222] The book Freud purchased made mention of the collection's home in Bergamo and that may have motivated Freud to go there while visiting the town on September 17. His Baedeker, for northern Italy, would have alerted him to the pleasant discovery that the gallery, usually only open on certain days of the month, was accessible daily in September, through the 18th.[223] As one of the great attractions for paintings there, it would seem highly improbable that he would not have included it on a full day of visiting. On the second floor of the villa, the Morelli collection was on view. As Swales discovered, the plan of the gallery display— one reproduced in the Baedeker guide—cites a wall where three paintings were

displayed in a row: a Madonna by Signorelli, Botticelli's portrait of Giuliano de' Medici, and a figure of Christ by Boltraffio. This evidence—whether Freud saw it in the gallery or encountered it reading the Baedeker, or in all probability both—does suggest how the three painters came to figure in the Signorelli story, most especially the otherwise inexplicable inclusion of Boltraffio. But it was not only this display that may have informed Freud's choice, but also the context in which he encountered the trio of names. When Freud discovered Boltraffio, the arrangement would have given him a sequence that could be reproduced as the first register of his model, but also the precedent of the gallery display. Here was a line of successive, discrete units of representation, joined by a certain connection but also operating as individual aesthetic entities. In this case, the order of paintings was not as meaningful as their being able to be arranged in some intelligible sequence as "works of art." Freud transformed them into "words" of art, still referencing the precedent of an exhibition space; like the construction of Bosnia beneath, this identified the values that would predicate the normative workings of the unconscious within an established common cultural milieu, thus establishing this psychical mechanism, which also produced aesthetics and alterity, as an *a priori* phenomenon. As Freud recounts his travels to Fliess in the letter of September 22, when he includes the story of the conversation with Freyhan, he makes no mention of his time in Milan and other sites in Lombardy, but in fact only focuses on "the episode in or near Trebinje."[224]

Although Freud's memory lapse was occasioned by looking at, and then discussing, works of art, the visual encounter is used only to stage his mise-en-scène of forgetting; his visual encounter amid this imagery, beyond its incidental role in manifesting the mechanism it revealed, will be summarily dismissed. Yet, the presence of imagery reverberates through this story, both in the potentially disturbing content of the paintings in the Duomo and, perhaps as a way to master that unwanted encounter, in another Signorelli painting that Freud appropriates to serve within a visual representation that he actually creates. This took the form of a diagrammatic rendition, appearing in somewhat different guises in the two published accounts, of how the process of forgetting Signorelli's name occurred and the workings of the psychical mechanism it revealed.

Freud has constructed the narrative of his forgetting so that his memories of the Duomo have no inherent value other than this accident of dialogic order, and the aesthetic ordering of the three painters in Bergamo has no presence here at all. Lacan, who mentions the Signorelli text a number of times, attributes this lapse to the functioning of a "word presentation" as compelling evidence of the linguistic basis for the operations of the unconscious, where shared attributes of displacement and condensation, which Freud would soon

privilege in the dream work, would be more fully realized. Anthony Wilden, in his overview of Lacan's engagements with the Signorelli incident, considers how Lacan more fully complicated the borders of the latent and manifest, so seemingly inviolate in Freud's interpretation here, where Signorelli "doesn't mean anything at all"[225]—and envisioned them inextricably bound up in their function. The absences in the manifest are "lacunae" where "drives" attach to representations; these are the gaps in the symbolic. Wilden states that although Freud's sharp memory of Signorelli's face was the "symptom of his anxiety," this visual encounter was rendered meaningless by Freud because "he could not put it into words."[226] The artist appears in the corner of one scene, standing, as Freud notes in this text, next to his predecessor in the project, Fra Angelico. "I was able to conjure up the pictures with greater sensory vividness than is usual for me," he observed in "Psychical Mechanisms," although that detail was omitted in *The Psychopathology of Everyday Life*.[227] Yet, privileging visual reception as psychically consequential in his experiences of spectatorship—seeing over speech—is quite immediately erased. Strachey, in a footnote to Freud's comment about the clarity of the pictures in his essay of 1898, casts this as evidence of something closely related to the site of repression, appearing very sharply "though unimportant and irrelevant."[228] This is in contrast to his *Fehlleistung* itself, where a fragment of language that was forgotten carried with it the potential—indeed, the necessity—of being retrieved and interpreted.

The "symptom" of the parapraxis was played out in the three artists' names, all linked by sound values, with no visual material present at all. In fact, even their names became fragmented, losing more relevance to any attribute of visuality, while still demonstrating Freud's capacity for aestheticized spectatorship. He could recite the names of the painters, even a relatively obscure one, fulfilling the function of locating—in fact, producing—his subjectivity, even as he was acutely aware of his fragile position. Recall his comments to Fliess about the pernicious environment of Vienna in the letter in which he describes his parapraxis. It is also important to note that the performance of Freud's visual discernments occurs in tandem with an assertion of his western European subjectivity, as he views those living in Islamic Bosnia, in a scene created from constructions of cultural difference, and uses this to serve as a credible catalyst for associations to the repressed thoughts ("I assume that the series of thoughts about the customs of the Turks in Bosnia, etc., acquired the capacity to disturb the next succeeding thought"). Those that follow then introduce the suicide of Freud's patient, which Freud then vaguely characterizes as the "melancholy event and everything related to it"[229] as clearly not in his conscious awareness when talking with his companion. The believability of the repression was based on

the operation of intrapsychic processes predicated on cultural assumptions and stereotypes, with their power to disrupt, although Freud remains quite oblique about this "melancholy event" and whatever other factors related to it. But as we have argued, with no extant evidence corroborating that such a patient's suicide actually occurred, we are left to wonder if the disturbance lay within the phantasm of "Bo-snia" or was actually elsewhere, in a space rendered invisible as Freud evoked the region's inherently unsettling "customs."

With this in mind, it may be useful to return to the question posed in Freud's dream by the merchant Popović—"What have the Turkish (designs, stripes...) to do with you?"—occurring soon after his return from his travels in the Balkans. Such an accusation can be framed as revealing Freud as he appropriated a Turkish guise for the "adornment" of his theory; he is questioned, after all, about his motive for donning this garment. But their closeness ("we became quite friendly with each other") at the dream's end may suggest that Popović understood one of two possible answers to his query: it is an acknowledgment of Freud's prerogative to use something Turkish to suit his needs— this appears to be what occurred in his construction of the Signorelli story— or that he understood that the Turkish clothing, as a non-Christian raiment, did indeed fit him. But in Freud's construction of difference, relying on the diagramming of the "pathways" and "laws" of psychical functioning in the Signorelli narrative, such oscillation was stilled. Gil Anidjar termed this strategy as Freud's attempts to create "unbridgeable doubling" in his text—"death and sex, Italy and Bosnia, forgetting and remembering, success and failure, Christian and Muslim, etc."[230] But for Anidjar, who posits the incident in Orvieto as "a haunting of and by religion," Judaism, Christianity, and Islam all "break out" and become a spectral presence at the site of unconscious formation. But they function here not as strict divides but rather in the "phantomantic shape of a *trait d'union*," the term Andijar uses to relocate the binary into a "dualistic disjunction,"[231] a haunting of each dyadic construction—remembering and forgetting most crucially—by that which appears to oppose it.

The ghostly traces can also be located at the Signorelli story's ultimate source, albeit rendered by the mechanism of the unconscious merely its surface: the paintings themselves. The three religions Anidjar cites also inhabit the imagery of the Duomo, their pictorial structure giving the illusion of the imagery "breaking out" of its frames, as Molnar so persuasively suggested. But for Freud these images—as content—also may have broken through time and space, bringing the blood libels and accusations tumbling from centuries past into the present day, intruding upon the comfortable distance that he had anticipated in an aesthetic experience. He had longed for the waters of

Lethe, appearing directly before him in Signorelli's chapel, but it would be up to him to create a condition in which the reality of his everyday life could be washed away. The "*trait d'union*" is more readily glimpsed in the story that follows the last version of the Signorelli lapsus, where the forgetting of the *aliquis* quotation occurs just after Freud's traveling companion laments the era in which they, as Jews, live—finding them "destined [Strachey translates this as 'doomed'] to atrophy." His affect not only follows the Orvieto narrative but, as argued here, is indivisible from it: the memory that Freud conjured was the painter as the join of two visions of Jewish bodies in the throes of damned destinies.

Freud would claim that "what I wanted to forget was not, it is true, the name of the artist at Orvieto but something else."[232] However, he concedes that he did not fully succeed; this attempt failed, resulting in a "mis-attainment": "my act of will missed its target and I forgot *the one thing against my will*, while I wanted to forget *the other thing intentionally*"[233] (italics original). I have argued that what Freud says he wished to banish (an act that Jean Schimek termed here as "motivated forgetting"[234])—"Turkish customs" and thoughts associated with "Trafoi"—were actually intentional acts of creation, fashioned to fuel the workings of repression. What if what Freud wished to remember and hoped to forget actually involved the same thing? He did not want to forget the painter's name, as he says, for it would have allowed him to continue speaking of works of art with his younger, perhaps less traveled, companion, portraying himself as a cultivated Viennese tourist. But this does not exclude the possibility that the memory he recalled when having this conversation actually interrupted and destabilized this role. Freud does not dispute that a disjunction occurred as he spoke to Freyhan of the Duomo, but he locates the causality of the incident, its psychical value, so far from the surface of the paintings that we would not consider that the slip of memory was also a slippage of subjectivity in the act of viewership—a dystonic moment between agency and vulnerability—provoked by one and the same thing: the images themselves.

Freud placed the walls of the cathedral beyond the reach of value for his mechanisms of "forgetfulness," casting them as merely innocent bystanders upon whom the action—whose consequence was a revelation of their inconsequentiality, their "insignificance" as Strachey observes—was directed. But this seeming devaluing also enabled Freud to retain his guise—presented with a degree of consistency not found in retellings of other parts of the Signorelli story—that the failure here was not an *aesthetic* one. His self-representation of that person who can speak so readily of Renaissance paintings, even referencing a far less-known artist, remains constant and unquestioned. Freud leads his readers to connect the first letters of the names

of the Italian artists he readily recalls—Botticelli and the more obscure Boltraffio—to that of his phantasm of "Bo-snia," while removing from the narrative the possible impact of the other, unspoken, constituent here: the far less tangential, and in fact strikingly contiguous, Bolsena. What Freud actually said about the Duomo's paintings and chapels to Freyhan will never be known. But we can reconstruct what was clearly hidden in plain sight, just beside Signorelli, and summon all the people, places, and objects that have woven through this chapter, most completely removed from view, as crucial participants in this scene of Freud's writing of the first workings of his unconscious.

Notes

1 Sigmund Freud, "The Unconscious," *SE* 14, 1915, 166.

2 Ibid.

3 Salman Akhtar, *On Freud's "The Unconscious"* (London: Karnac, 2013), 2.

4 Jason Moralee, "Maximinus Thrax and the Politics of Race in Late Antiquity," *Greece & Rome* 55, no. 1 (April 2008): 57.

5 Ibid.

6 In this inaugural volume of the *Jahreshefte des Österreichischen Archäologischen Institutes in Wien* (Vienna: Alfred Hölder, 1898), one finds a lengthy article by Anton von Premerstein: "Die Anfänge der Provinz Moesien." "Moesien," bordering on classical Thrace, was characterized by the author as the *"Landern der Barbaren"* (146). Von Premerstein includes a citation from Ovid about this region, then glosses it with reference to *halbbarbarisch* areas of the classical "Balkans," concluding with a discussion of Bosnia, a current geo-cultural entity, alongside the Roman provinces of the "Moesians and Thracians" (194).

7 Moralee, "Maximinus Thrax," 76–79.

8 Cathy Caruth, *Literature in the Ashes of History* (Baltimore, MD: Johns Hopkins University Press, 2013).

9 Sigmund Freud, "The Psychical Mechanism of Forgetfulness," *SE* 3, 1898, 289–297.

10 Ibid., 290.

11 Karl Baedeker [Firm], *Österreich-Ungarn: Handbuch für Reisende* (Leipzig: Baedeker, 1895), 326–327.

12 Peter J. Swales, "Freud, Death and Sexual Pleasures: On the Psychical Mechanism of Dr. Sigm. Freud," *Arc de Cercle* 1, no. 1 (2003): 7-8n[c][e].

13 Freud, "Psychical Mechanism," *SE* 3, 292.

14 Dušan I. Bjelić, *Normalizing the Balkans: Geopolitics of Psychoanalysis and Psychiatry* (Farnham, Surrey; Burlington, VT: Ashgate, 2011), 2.

15 Arthur Evans, "Antiquarian Researches in Illyricum, III and IV."
 Archaeologia 48, no. 1 (1885): 100. The road detailed on the map (plate 4)
 is the Roman route that approximates the one traveled by both Evans and
 later, Freud. Evans's presence was well known in this area, as he was very
 much involved in political activities in Bosnia. It is likely that Freud was
 aware he was traveling on Roman roads, as Evans had made this passage
 known through his writings, and local guides would have undoubtedly
 been aware of his travels in this rather rugged, sparsely populated area. See
 also Šačić, note 16, 155n3. For Evans's involvement in the Balkans, refer
 to John J. Wilkes's introduction to a reprint of the "Researches," as *Ancient
 Illyria: An Archaeological Exploration* (London: Centre for Albanian
 Studies, 2006), iii–xiv.

16 Amra Šačić, "Četiri do sada neobavljena epigrafska spomenika," *Godišnjak/
 Jahrbuch/ Centar za balkanološka ispitivanja* 43 (2014): 156–158. We cannot
 ascertain whether Freud learned of the road's imperial builder, but any
 carriage driver or guide would have surely known of Evans's travels and
 discoveries, and would likely have conveyed them to tourists traveling along
 this Roman *via*.

17 Freud, "Psychical Mechanism," *SE* 3, 295.

18 *Freud-Fliess Letters*, 326, letter dated September 22, 1898.

19 Ibid.

20 Ibid., 325.

21 Ibid.

22 Ibid.

23 Creighton Gilbert offers a concise introduction to the cathedral as his
 first chapter of *How Fra Angelico and Signorelli Saw the End of the World*
 (University Park, PA: Pennsylvania State University Press, 2003), [1]–21.
 In 1891, at the conclusion of a series of restorations that spanned several
 decades, the archivist Luigi Fumi, not shy in voicing his displeasure at
 some of the results, compiled a history of the Duomo that remains an
 invaluable resource: *Il duomo di Orvieto e i suoi restauri: monografie
 storiche condotte sopra i documenti* (Roma: La società laziale tipografico-
 editrice, 1891).

24 Sigmund Freud, *Unser Herz zeigt nach dem Süden: Reisebriefe, 1895–1923*,
 ed. Christfried Tögel and Michael Molnar (Berlin: Aufbau-Verlag, 2002), 84.

25 *Freud-Fliess Letters*, 326–327, letter dated September 27, 1898. In the
 English translation, cited here, Masson refers to the traveling companion
 as "Freyhau," although the most current German edition uses the
 correct spelling, "Freyhan." *Sigmund Freud Briefe*, 357. The error in the
 English translation comes from the first publication of the Freud–Fliess
 correspondence, *Aus den Anfängen der Psychoanalyse: Briefe an Wilhelm
 Fliess, Abhandlungen und Notizen aus den Jahren 1887–1902*, ed. Marie
 Bonaparte, Anna Freud, and Ernst Kris (London: Imago, 1950), 282. Since
 Freud told Fliess not only his companion's surname but his profession

in Berlin ("*Assessor*"), it has been possible to find someone named Paul
Freyhan with this legal occupation at this time; the discrepancy thus must
have arisen from a misreading of Freud's handwriting.

26 The first two versions have already been cited earlier, with the third
 appearing as the first chapter, "The Forgetting of Proper Names," in *The
 Psychopathology of Everyday Life, SE* 6, 1901, 1–7. For a discussion of
 the three versions, refer to Michael Billig, "Freud's Different Versions of
 Forgetting 'Signorelli': Rhetoric and Repression," *The International Journal
 of Psychoanalysis* 81 (2000): 483–498.

27 Strachey, in referring to the idea of *Fehlleistung,* notes that "it is a curious
 fact that before Freud wrote this book (*The Psychopathology of Everyday
 Life*) the general concept seems not to have existed in psychology, and in
 English a new word had to be invented to cover it" (*SE* 6, xiii, n1). Four
 decades after Strachey's efforts, the well-respected literary translator
 Anthea Bell presented a new version (as part of the "New Penguin Freud"
 series, edited by Adam Phillips), which Paul Keegan introduced with an
 assessment of Strachey's choice of word and its various "discontentors." *The
 Psychopathology of Everyday Life* (London: Penguin Books, 2002), xxxvii–
 xl, n19, 20. In Bell's translation, *Fehlleistung* is rendered simply as "slip,"
 a choice that was, as she explains in her preface, "for people like me who
 have no psychoanalytical training and do not find 'parapraxis' an instantly
 familiar term" (xlvi).

28 Swales, "Freud, Death and Sexual Pleasures," 17–24.

29 Catherine D. Harding, *Guide to the Chapel of the Corporal of Orvieto
 Cathedral* ([Orvieto]: Opera del Duomo di Orvieto; Perugia: Quattroemme,
 2004).

30 This chapter, the book's second, is entitled "The Forgetting of Foreign
 Words," *The Psychopathology of Everyday Life, SE* 6, 8–14.

31 *Freud-Fliess Letters*, 324. Letter dated August 26, 1898.

32 Ibid., 327. Letter dated September 22, 1898.

33 Ibid., 326.

34 Ibid., 324. Letter dated August 26, 1898.

35 Ibid.

36 Fred Frank Stapf, *Julius Mosen: Der Vogtländer Dichter des Andreas-Hofer-
 Liedes* (Lappersdorf bei Regensburg: Kerschensteiner, 1995), 91–99.

37 Ibid., 11.

38 Jon W. Finson, *Robert Schumann: The Book of Songs* (Cambridge, MA:
 Harvard University Press, 2007), 25. Finson notes that Mosen and
 Schumann had been friends from the time when both had lived in Leipzig.

39 *Freud-Fliess Letters*, 324.

40 Franz Maciejewski, *Der Moses des Sigmund Freud: Ein unheimlicher Bruder*
 (Göttingen: Vandenhoeck and Ruprecht, 2006), 11.

41 Julius Moses Freud's death was recorded as occurring on April 15, 1858 in
 the registry of the "Persons of Different Faith in Freiberg" (Moravia); see

Marianne Krüll, *Freud and His Father*, trans. Arnold J. Pomerans (New York: W.W. Norton, 1979), 91–95, Table 10, [245]. There is no extant record of his birth, but he is listed there as being six months old at the time of his death.

42 *Freud-Fliess Letters*, 324.

43 Ibid., 315, letter dated June 9, 1898.

44 Ibid.

45 Julius Mosen, *Erinnerungen*, ed. Max Zschommler (Plauen: F.E. Neupert, 1893).

46 Frederick Crews, *Freud: The Making of an Illusion* (New York: Metropolitan Books; Henry Holt and Company, 2017), 568.

47 In order to share a room, regardless of the degree, or lack, of physical intimacy, a man and woman were only permitted to register if they did so as a married couple. The publication of a registry from a Swiss hotel (where this stricture applied) in the course of the journey that included Innsbruck and Trafoi, records Freud's signature as "Dr. Sigm. Freud u Frau/ Wien." The registry came to light through the work of Franz Maciejewski. See "Freud, His Wife, and His Wife," *American Imago* 63, no. 4 (2006): 497–506. Martha Freud was aware of this practice, and evidence suggests that, despite the obvious inference that could be made here, it would be two years later when a probable sexual relationship may have begun. See Crews, *Freud: The Making of an Illusion*, 571–574.

48 Ibid., [563]–564; 573.

49 Ibid., 572–574.

50 Freud, *Unser Herz zeigt nach dem Süden: Reisebriefe*, 106, letter to Martha Freud dated August 10, 1898.

51 Ibid., 100, letter to Martha dated August 6, 1898. He writes of taking a carriage ride through Innsbruck and seeing "all the great attractions, including Andreas Hofer."

52 Rudolf Granichstaedten-Czerva, *Andreas Hofers alte Garde* (Innsbruck: Vereinsbuchhandlung und Buchdruckerei, 1932), 105–106.

53 Florian Kern, *Der Mythos "Anno Neun": Andreas Hofer und der Tiroler Volksaufstand von 1809 im Spiegel der Geschichtsschreibung (1810–2005)* (Frankfurt am Main: Peter Lang, 2010), 109–111.

54 Eugen Trapp, "Heinrich Natter," in *Neue Deutsche Biographie*, Band 18 (Berlin: Duncker & Humblot, 1997), 754.

55 Freud, *Unser Herz zeigt nach dem Süden: Reisebriefe*, 111–112.

56 *Freud-Fliess Letters*, 327.

57 Laurence Simmons, *Freud's Italian Journey* (Amsterdam, NY: Rodopi, 2006), 33. Freud mentions in a letter to Fliess, written five days after his account of the Signorelli story, that "Martha has colitis, which bothers her a lot" (*Freud-Fliess Letters*, 329).

58 Freud, "Psychical Mechanism," *SE* 3, 290.

59 Ibid.

60 Ibid. Freud repeats this attribution in *The Psychopathology of Everyday Life*, *SE* 6, 3.

61 Ibid., 291. Molnar notes that this observation concerning the vividness of Freud's memory of Signorelli's face was omitted in the third rendition of the narrative: "one can assume that this detail was rejected in the final text as a distraction from the essential argument which covers the distortions of the surname." See Michael Molnar, "Reading the Look," in *Reading Freud's Reading*, ed. Sander Gilman et al. (New York; London: New York University Press, 1994), 86. Strachey, in a note after Freud's inclusion of this memory in his earlier published account, remarks that this visual experience was one to which Freud attributes the "unusual vividness" of an "image," an experience that "is not the repressed memory itself, but which, *though unimportant and irrelevant*, is closely related to the repressed memory." "Psychical Mechanism," *SE* 3, 291, n1 (italics added).

62 Freud (*Unser Herz zeigt nach dem Süden: Reisebriefe*, 85), in a postcard to his wife dated September 9, writes that he had taken a carriage that afternoon to visit Bolsena.

63 *Freud-Fliess Letters*, 327. This is significant, as in the two published accounts Freud will claim that he consciously "suppressed" discussing the topic of sex in the course of his discussion of local attitudes toward death. The role of the paintings is also unclear here, as he cites that he repressed "memories" in a conversation that may reference the paintings or the discussion concerning Bosnia.

64 *Freud-Fliess Letters*, 327, letter dated September 22, 1898. Here, in Masson's English translation, the use of italics is extended to include the first three letters ("*Bos*nia"), which would make little sense in the context of Freud's argument for the connection between this location and his associations to Botticelli and Boltraffio. The German edition of the letters places only the first two letters in italics (*Freud-Fliess Briefe*, 357).

65 Freud, "Psychical Mechanism," *SE* 3, 292.

66 Ibid.

67 In his essay of 1898, Freud attributed the anecdote to a "colleague" from whom he heard this "years ago about the Turks in Bosnia" and he goes on to say how "doctors are treated with special respect." "Psychical Mechanism," *SE* 3, 292. In *The Psychopathology of Everyday Life* this is altered to "a colleague practicing among those people" (*SE* 6, 3).

68 Freud states in his first paper that "The same colleague had told me what overriding importance these Bosnians attached to sexual enjoyments." "Psychical Mechanism," *SE* 3, 292. In *The Psychopathology of Everyday Life* (3), this attachment is more strongly stated: "These Turks place a higher value on sexual enjoyment than on anything else."

69 Frank F. Scherer, *The Freudian Orient: Early Psychoanalysis, Anti-Semitic Challenge, and the Vicissitudes of Orientalist Discourse* (London: Karnac, 2015), 11.

70 Freud, "Psychical Mechanism," *SE* 3, 296n1. In this note, the only time in the three accounts where the source for Freud's reports about "these Turks" is identified, he chooses a very interesting way to introduce Alois Pick. Rather than mention any of the details that will be recounted in this chapter, Freud calls attention to his surname (whose meaning, in German, is a "spade") and mentions that at one point, when recounting these stories to yet another colleague, Freud could not recall Pick's name. Freud says that he had been playing cards, and that both Pick and Herz (hearts) are the names of suits. Freud seems to suggest that perhaps he recalls Herz in its place. Herz he associates to "Herzegovina and to the heart itself." He suggests that concerns for his own heart ailment may have been part of the repressed content—Freud was worried about this aspect of his health at the time—and we can assume that this may have occasioned concerning thoughts about death. But one wonders if this actually was a wish to forget Pick's name, just as he "allowed" Freyhan's to become utterly inaccessible in the published versions of the story. In *The Psychopathology of Everyday Life*, any way to link aspects of the account to those who were in some way involved in it—Freyhan and Pick—have been obviously "suppressed" by Freud.

71 M. Jantsch, "Alois Pick," in *Österreichisches biographisches Lexikon 1815– 1950*, Vienna: Verlag der Österreichischen Akademie der Wissenschaften, 2nd ed., vol. 8 (Vienna; Graz: Böhlau, 1979), 60. A compilation of military medical practices includes an acknowledgment of the work of Pick and a colleague, citing them as: "Herren Regimentsärzten Dr. Alois Pick and Dr. Alfred Zimmermann" in Karl Cron, ed. *Feld-Taschenbuch für k. und .k. von Militär-Ärzte* (Vienna: Verlag von Josef Šafář, 1897), v.

72 Like Freud, Pick lived into old age, dying at eighty-six in Vienna in 1945. It is unclear how he escaped deportation during the war years.

73 M. Jantsch and G.H. Marcus, "Alois Pick, der Entdecker des Pappataci-Fiebers," *Wiener Medizinische Wochenschrift* 111 (1961): 801–803.

74 Alois Pick, "Zur Pathologie und Therapie einer eigentümlichen endemischen Krankheitsform," *Wiener Medizinische Wochenschrift* 36, nos. 33 and 34 (1886): 1141–1145; 1168–1171. For a contemporary perspective on Pick's contribution, see Mirsada Hukić and Irma Salimović-Bešić, "Sandfly—Pappataci Fever in Bosnia and Herzegovina: The New-Old Disease," *Bosnian Journal of Basic Medical Sciences* 9, no. 1 (2009): 40.

75 Pick, "Zur Pathologie," 1169.

76 As Bjelić notes, in discussing Freud's journey to Trebinje, the Christian uprising against the Ottomans in 1876–1878 had caused a Turkish retreat from Bosnia and Herzegovina (Bjelić, *Normalizing the Balkans*, 38).

77 Swales, "Freud, Death and Sexual Pleasures," 7. This information was found in documents relating to Pick's military career that Swales located in the "Kriegsarchiv" in Vienna (see p. 72).

78 See previous chapter, n11.

79 Bjelić, *Normalizing the Balkans*, 38.

80 Sigmund Freud, *The Interpretation of Dreams*, *SE* 4, 1900, 204–208.

81 Ibid., 204.

82 The most detailed discussions of the "Three Fates" dream remain those of
 Anzieu, *Freud's Self-Analysis*, 362–371, and Alexander Grinstein, *Sigmund
 Freud's Dreams* (New York: International Universities Press, 1980), 161–
 193. In neither account does the author address the implications of Freud's
 identification with/appropriation of the "Turkish" content of his dream.

83 Freud, *The Interpretation of Dreams, SE* 4, 205. Diane Jonte-Pace, *Speaking
 the Unspeakable: Religion, Misogyny, and the Uncanny Mother in Freud's
 Cultural Texts* (Berkeley, CA; Los Angeles, CA: University of California
 Press, 2001), 54–57.

84 Freud, *The Interpretation of Dreams, SE* 4, 204.

85 Ibid., 206–207. Swales identifies these Turkish goods as medicinals for
 Martha, although I have not been able to locate any evidence to suggest just
 what the nature of the purchases might have been.

86 Ibid., 207. Bjelić, in *Normalizing the Balkans*, 37, reads this portion of the dream
 in strictly "Freudian" terms, that is, with the coat as a condom and the dream in
 this section about "wishful transfer of Turkish sexual character into himself."

87 Ivan Vasin Popović, ed., *Praktisches Deutsch-Serbisches Sprach- und
 Konversationsbuch* (Vienna: A. Hartleben's Verlag, 1890).

88 Freud, *The Interpretation of Dreams, SE* 4, 204.

89 Freud, "Psychical Mechanism," *SE* 3, 290.

90 Freud, *The Psychopathology of Everyday Life, SE* 6, 2.

91 Swales, "Freud, Death and Sexual Pleasures," 49.

92 Jacques Lacan, *The Four Fundamental Concepts of Psychoanalysis*, ed.
 Jacques-Alain Miller; trans. Alan Sheridan (New York; London: W.W.
 Norton, 1981), 27. In Adrian Johnston's reading of Freud's concern for his
 own mortality, Johnston reads this anxiety as marking an excess of sexual
 meaning that was so privileged in Freud's psychical project. Johnston turns
 to the Signorelli story, and Lacan's references to its treatment of death, to
 suggest that Freud's encounter in Orvieto was connected to his fears for
 his health. See "Sextimacy—Freud, Mortality, and a Reconsideration of
 Sexuality in Psychoanalysis," in *Sexuality and Psychoanalysis: Philosophical
 Criticisms*, ed. Jens De Vleminck and Eran Dorfman (Leuven: Leuven
 University Press, 2010), 38–49.

93 Baedeker [Firm], *Österreich-Ungarn*, 326–327.

94 *Jahrbuch der Internationalen vereinigung für Vergleichende
 Rechtswissenschaft und Volkswirtschaftslehre zu Berlin*, 3/1 (Berlin: K.
 Hoffmann, 1897), 915. The entry reads: "Dr. Paul Freyhan, Gerichtsassessor,
 Berlin, Altonaerstrasse 28."

95 *Jahrbuch der Internationalen vereinigung für Vergleichende Rechtswissenschaft
 und Volkswirtschaftslehre zu Berlin*, 2 (for 1896) (Berlin: Hermann Bahr's
 Buchhandlung (K. Hoffmann), 1897), 698. We assume that Cottbus must
 have been considered part of Berlin for the purposes of this directory.

96 "Hedwig Freyhan," *The Central Database of Shoah Victims' Names*, Yad
 Vashem, Jerusalem.

97 As a coda to our extant information on Paul Freyhan, it is interesting
 to note that in Freud's published accounts, he advised his unnamed
 companion to go to Orvieto. Whether the lawyer from Berlin ever
 encountered Signorelli's work in the Duomo cannot be determined, but
 we do know that Paul Freyhan's brother, Theodor, had a son, Robert, who
 was born in Berlin three years after the conversation between Freud and
 his uncle, and would become an art historian, specializing in the medieval
 and early Renaissance period. Among his best-known publications was
 a study of the visual representations of the virtue of charity as a woman
 nursing a child, and one of Umbria's leading examples is that of Signorelli's
 image of "charitas" in the Cappella Nuova. So, we can assume that at least
 one member of the Freyhan family did ultimately see these paintings.
 Robert Freyhan, "The Evolution of the Caritas Figure in the Thirteenth and
 Fourteenth Centuries," *Journal of the Warburg and Courtauld Institutes* 11
 (1948): 68–86.
98 Otto Glagau, *Der Börsen- und Gründungs-Schwindel in Deutschland*, 2
 (Leipzig: Paul Frohberg, 1877), 416.
99 For Freud's childhood experiences in Leipzig, see Chapter 3. The city
 appears in letters to Fliess and in *The Interpretation of Dreams, SE* 4,
 299–301, *SE* 5, 443.
100 "Freyhan," *Wrocław Surnames from 1874 to 1910*, Jewish Record
 Indexing—Poland (online database). http://jri-poland.org/psa/psawroclaw.
 htm
101 Felix Dietrich, ed., *Bibliographie der deutschen Zeitschriften-Literatur: mit
 Einschluss von Zeitungen und Sammelwerken*, vol. 13 (1903) (Leipzig: Felix
 Dietrich, 1904), 345.
102 T[heodor] Freyhan, *Über Pneumonie*. Berliner Klinik, vol. 117 (Berlin:
 Fischer's Medicin, 1898).
103 *Jahresverzeichnis der an den deutschen Universitäten erschienenen*, vol.
 3 (1887–1888) (Berlin: A. Asher, 1888), 7. Theodor Freyhan's name is
 followed by the designation *aus Breslau* ("from Breslau," indicating his
 home city). His dissertation was titled *Beiträge zur Kenntnis der Typhus-
 Meningitis* (Berlin: Gustav Schade, 1888).
104 Paul Fürbringer and Dr Freyhan, "Neue Untersuchungen über die
 Desinfektion der Hände," *Deutsche medizinische Wochenschrift* 23 (1897):
 81–85. For an assessment of their contribution see Thomas Schlich,
 "Asepsis and Bacteriology: A Realignment of Surgery and Laboratory
 Science," *Medical History* 65, no. 3 (2012): n78.
105 Fürbringer, *Über Spermatorrhöe und Prostatorrhöe* (Leipzig: Breitkopf &
 Härtel 1881).
106 Fürbringer, *Die Störungen der Geschlechtsfunctionen des Mannes* (Vienna:
 Alfred Hölder, 1895). In the 2nd edition of this work (1901), on p. 225,
 Freud's paper on sexuality and neurosis is mentioned as it appeared in its
 first version in the *Weiner klinische Rundschau* of 1898. See editor's note

that prefaces Strachey's translation of "Sexuality in the Aetiology of the Neuroses" in *SE* 3, 1898, 261.

107 Freud, *The Psychopathology of Everyday Life, SE* 6, 3. A note here (n1) alerts readers that Freud used the phrase "delicate topic" in referring to issues of sexuality, but dropped the first word in editions of this text after 1924.

108 Fürbringer, *Die Störungen*, 90, 145.

109 T[heodore] Freyhan, "Yohimbin Spiegel, ein neues Spezifikum gegen Impotenz," *Deutsche Ärzte Zeitung* (1902): 205–206. Known in English as "Yohimbine," this substance is a derivative of a tree bark found in Africa and continues to be marketed as medication to enhance male sexual functioning.

110 Freud, *The Psychopathology of Everyday Life, SE* 6, 8–14.

111 Ibid., 8.

112 Ibid., 8–9; for the original version of the passage cited here, see *Zur psychopathologie des Alltagslebens (Über Vergessen, Versprechen, Vergreifen, Aberglaube und Irrtum), GW* 4, [13].

113 Sigmund Freud, "Screen Memories," *SE* 3, 1899, 309. For the original version of the passage cited here, see *"Über Deckerinnerungen," GW* 1, 538.

114 See *Jahrbuch* cited in n94 above.

115 Freud, "Screen Memories," *SE* 3, 309–320. It is in this disguise that Freud offers the most detailed insights into his early childhood, and it is the only place where he speaks, albeit cursorily, of his first years in Vienna.

116 Peter J. Swales, "Freud, Minna Bernays, and the Conquest of Rome," *New American Review* 1, no. 2/3 (1982): 1–23.

117 Philip Kuhn, "A Professor through the Looking Glass: Contending Narratives of Freud's Relationships with the Sisters Bernays," *International Journal of Psycho-Analysis* 80 (1999): 943–959.

118 Richard A. Skues, "On the Dating of Freud's *Aliquis* Slip," *International Journal of Psycho-Analysis* 82 (2001): 1185–1204.

119 For a detailed account of this reading of the *aliquis* chapter, with summaries of Swales's argument, see Crews's chapter devoted to this "recollection" (*Freud*, [578]–589).

120 Freud, *The Psychopathology of Everyday Life, SE* 6, 9.

121 Ibid.

122 Ibid.

123 Richard H. Armstrong, *A Compulsion for Antiquity: Freud and the Ancient World* (Ithaca, NY; London: Cornell University Press, 2005), 240. My thanks to Professor Armstrong for his helpful clarifications.

124 Freud, *The Psychopathology of Everyday Life, SE* 6, 9.

125 Richard H. Armstrong, "Being Mr. Somebody," in *The Jewish World of Sigmund Freud: Essays on Cultural Roots and the Problem of Religious Identity*, ed. Arnold D. Richards (Jefferson, NC: McFarland, 2010), 35–50. For the significance of the *aliquis* story in the larger context of evidence of Freud's intimate relationship with Minna Bernays, see Peter Rudnytsky, *Rescuing Psychoanalysis from Freud and Other Essays in Re-Vision* (London: Karnac, 2011), 15ff.

126 *Freud-Fliess Letters*, 361, letter dated July 17, 1899.

127 Freud, *The Interpretation of Dreams, SE* 4, 299–300.

128 Giuliano Catoni, *I Goliardi senesi e il Risorgimento: Dalla guerra del Quarantotto al monumento del Novantatrè* (Siena: Università degli Studi, Feriae Matricularum, 1993), V.

129 Loretana de Libero, *Rache und Triumph: Krieg, Gefühle und Gedenken in der Moderne* (Munich: De Gruyter Oldenbourg, 2014), 44–45.

130 Freud, *The Psychopathology of Everyday Life, SE* 6, 9.

131 Ibid.

132 R. Po-Chia Hsia offers a detailed examination of the case in *Trent 1475: Stories of a Ritual Murder Trial* (New Haven, CT: Yale University Press; Yeshiva University Library, 1992). The epilogue (132–135) discusses the continuation of the Simon myth.

133 Freud, *Unser Herz zeigt nach dem Süden: Reisebriefe*, 129. Freud mentions visiting "Trient" in a letter written to Martha on September 1, 1900.

134 Freud, *The Psychopathology of Everyday Life, SE* 6, 10.

135 Blood libel accusations have been posited as influencing the rhetoric of the Dreyfus trial. Pierre Birnbaum, in *The Tale of Ritual Murder in the Age of Louis XIV: The Trial of Raphaël Lévy, 1669* (Stanford, CA: Stanford University Press, 2012), reminds readers that the "Dreyfus Affair" coincided with the killing of a young woman that led to charges against a 23-year-old Jewish man, Leopold Hilsner, of "ritual murder." The so-called "Hilsner Affair" had revitalized the accusations and the trial against Lévy, a well-known case in France in which the accused was burned at the stake, amid a resurgence of medieval slanders of child killing and host desecrations. Birnbaum observes that "few specialists in the Dreyfus Affair" have discussed its contemporaneity with Hilsner, although the murder of which he was accused occurred at the "the most intense phase" (137) of the Dreyfus proceedings. On April 1, 1899, the body of Anežka Hrůzová was discovered in a wooded area of the Bohemian town of Polná, quite near the Moravian border, and thus in the region of Freud's birth. Hilsner, poor and itinerant, was ultimately to receive an imperial Habsburg pardon and to settle in Vienna, where he died in 1928; the murderer of Anežka Hrůzová was never brought to justice. The Hilsner Affair would have occurred in the period between Freud's visit to Orvieto and his completion, in 1901, of *The Psychopathology of Everyday Life*, where the discussion of then-current ritual murder accusations occurred in the *aliquis* chapter.

136 Hillel J. Kieval, "Representation and Knowledge in Medieval and Modern Accounts of Jewish Ritual Murder," *Jewish Social Studies: New Series* 1, no. 1 (1994): 52–72.

137 Robert Weinberg, *Blood Libel in Late Imperial Russia: The Ritual Murder Trial of Mendel Beilis* (Bloomington; Indianapolis: Indiana University Press, 2014), 7.

138 Freud, *The Psychopathology of Everyday Life, SE* 6, 10.

139 Skues, "On the Dating," 1196.
140 *Freud-Fliess Letters*, 425. Letter dated September 24, 1900.
141 Skues's article is the source for this; see his "On the Dating," 1196.
142 Freud, *The Psychopathology of Everyday Life, SE* 6, 13.
143 Ibid.
144 Ibid., n1.
145 Ibid., 14.
146 Freud, *Unser Herz zeigt nach dem Süden: Reisebriefe*, 81, postcard to Martha Freud dated September 7, 1897.
147 Rudolph W. Freyhan, Papers. Butler Center for Arkansas History, Little Rock.
148 Freud, 85, postcard to Martha Freud dated September 9, 1897.
149 Karl Baedeker, [Firm], *Italien: Handbuch für Reisende; Zweiter Teil: Mittel-Italien und Rom*, 11th ed. (Leipzig: Karl Baedeker, 1896), 82.
150 Gilbert, *How Fra Angelico*, 3.
151 Ibid., 23–29. Gilbert details Fra Angelico's first phrase of the painting program at the "Cappella Nuova," extending over the summer months of 1447.
152 For the papal presence in Orvieto in the second half of the fifteenth century, see Gilbert's chapter "Intermissions, 1448–1499" (Ibid., [61]–70).
153 In the documents that accompanied the recommendation of Signorelli for the commission, one finds him called "the most celebrated painter in all of Italy," an assessment Riess (see note 154, 15) suggests was intended to shore up the slow process in replacing Fra Angelico: it was not until the final year of the fifteenth century that the jury was able to find a well-recognized painter to complete the project. But perhaps such an arguably inflated assessment also reflected a certain local pride. Signorelli was a native of Cortona, in neighboring Tuscany. He had remained connected to his home city, where his reputation for trustworthiness—he served in various administrative capacities there—was especially valued and appeared to extend to his commissions as well. Giorgio Vasari, whose *Lives of the Artists* was first published in Florence in 1550, lavished considerable praise on Signorelli's Orvieto cycle. See Vasari, *Le vite de' più eccellenti architetti, pittori, et scultori italiani, da Cimabue insino a' tempi nostri*, ed. Luciano Bellosi and Aldo Rossi (Turin: Giulio Einaudi, 1986), 504–508. In the work's second edition, appearing in 1568, Vasari adds that Michelangelo esteemed Signorelli's work "very highly" and that he used the precedent of the *Last Judgment* for his version in the Sistine Chapel. *Le vite de' più eccellenti pittori scultori e architettori: nelle redazioni del 1550 e 1568*, ed. Rosanna Bettarini, vol. 2 (Florence: Sansoni, 1966), 637–638.
154 Although Gilbert's monograph examines, as its title suggests, the idea of the world's end with the approach of 1500, Jonathan Riess's study provides the most detailed discussion of how these apocalyptic concerns relate to the content of Signorelli's paintings. See *The Renaissance Antichrist: Luca Signorelli's Orvieto Frescoes* (Princeton, NJ: Princeton University

Press, 1995). For a different perspective, one that links the content of the paintings to the liturgical cycle of the year, refer to Sara Nair James, *Signorelli and Fra Angelico at Orvieto: Liturgy, Poetry and a Vision of the End Time* (Hants; Burlington, VT: Ashgate, 2003).

155 Margaret E. Owens, "Forgetting Signorelli: Monstrous Visions of the Resurrection of the Dead," *American Imago* 61 (2004): 7–33.

156 Ibid., 19.

157 Ibid.

158 Richard M. Gottlieb, "The Reassembly of the Body from Parts: Psychoanalytic Reflections on Death, Resurrection, and Cannibalism," *Journal of the American Psychoanalytic Association* 55, no. 4 (2007): 1222–1233.

159 For an excellent discussion of the Cather community in Orvieto and its impact on local ecclesiastical and political institutions, see Carol Lansing's *Power & Purity: Cathar Heresy in Medieval Italy* (New York; Oxford: Oxford University Press, 1998).

160 The tendency among those writing about the Cappella Nuova and the Signorelli cycle is to locate their most decisive influences as those beyond the earlier history of the Duomo itself. The crucial importance of the cathedral's connections to Church doctrine and Eucharistic associations for those commissioning Signorelli's project are frequently overlooked. Riess has done an admirable job of restoring a number of lost precedents that informed Signorelli's imagery, and the role of the Eucharist, while not visible in his paintings, was essential to this. There were paintings near the altar relating to the Corpus Christi theme that were created at the same time as the Cappella Nuova, and Riess considers that "the Eucharist is the bridge" joining the "miraculous host displayed in the neighboring Cappella del Corporale" as "a symbol of Christ's suffering at the hands of unbelievers" with the revelation of the false Christ in the Cappella Nuova (*The Renaissance Antichrist*, 39). The sacred wafer, and specifically the miracle at Bolsena and the Feast of the Corpus Christi, were all imagined here as defenders against heresies and non-believers, and thus Signorelli's work became a visualization of these beliefs. Riess reported that a famous local play based on the Bolsena story was performed in Orvieto "contemporaneous with Signorelli's work" and was attended by "some 20,000 spectators" (*The Renaissance Antichrist*, 79).

161 The priest has been identified as "Peter of Prague," whose role in the actual events at Bolsena long seemed very questionable, as mention of him makes its earliest appearance in nineteenth-century sources of Orvietan origins. However, thirteenth-century records, published in 1991 by Jaroslav Polc, include notations that a Bohemian priest named Peter did visit Pope Urban in the year that the miracle was said to occur. It may be that he actually narrated to the Pope a story he had heard, and he ultimately became more fully drawn into the narrative as its protagonist much later. For the role of Orvieto in the creation of Eucharistic doctrine and practices, see Lansing,

Power & Purity, 161–165. Polc's research appeared as "Il miracolo di
Bolsena e Pietro de Praga: Un'ipotesi," *Revista di storia della chiesa in Italia*
45, no. 2 (1991): 437–449.

162 Christopher Kleinhenz, ed., "Miracle at Bolsena and Corpus Domini," in
Medieval Italy: An Encyclopedia (New York; London: Routlege, 2004), 805.

163 The transfer of the relic of Bolsena to Orvieto's cathedral secured its place
in the emergence of the Corpus Christi tradition. This association was
further strengthened by papal acknowledgment, most notably when a
new text was created for a specific Mass commissioned by Urban IV and
composed in Orvieto by Thomas Aquinas. This liturgy later became part
of Church doctrine. In each of these instances, the protagonists are male,
although the veneration of the host, and a call for the Vatican Church
to create a feast day for it, were the work almost exclusively of women.
Caroline Walker Bynum's essay "Women Mystics and Eucharistic Devotion
in the Thirteenth Century," *Women's Studies* 11, no. 1/2 (1984): [179]–214
offers an excellent analysis of the factors that created this focus on the
wafer itself, especially among nuns and female mystics in the century
preceding the punitive revelation at Bolsena. Bynum's work locates the
eating of the host as a direct experience of unification with Christ, and
as such a source of visions and mystical writings that focused on the
unmediated experience of Christ's presence. It was a Belgian prioress,
Juliana of Mount Cornillon (also known as Saint Juliana of Liège), who
first lobbied various bishops, eventually reaching Rome, for the recognition
of a Corpus Christi doctrine and the need for its own holy day (Barbara
R. Walters, "The Feast and Its Founder" in *The Feast of Corpus Christi*, ed.
Barbara R. Walters, Vincent Corrigan, and Peter T. Ricketts (University
Park, PA: Pennsylvania State University Press, 2006), 3ff. Female
representation in the imagery of the Corporale reflects the general *amnesie*
concerning the role of women as agents of doctrinal change. Here they
are exclusively cast in the contrasting roles of devotees or accomplices in
perfidious crimes.

164 Harding, *Guide to the Chapel,* 63.

165 For the most detailed discussion of role of *exempla* in medieval Eucharistic
teaching, see Miri Rubin, *Corpus Christi: The Eucharist in Late Medieval
Culture* (Cambridge; New York: Cambridge University Press, 1991),
108–129. For tales that relate to the "intended and malevolent abuse" of the
host, see 125–128.

166 Ibid., 177–180.

167 Miri Rubin, *Gentile Tales: The Narrative Assault on Late Medieval Jews*
(New Haven, CT; London: Yale University Press, 1999), 32–39.

168 Karl Baedeker [Firm], *Italien: Handbuch für Reisende; Zweiter Teil: Mittel-
Italien und Rom,* 11th ed. (Leipzig: Karl Baedeker, 1896), 80. The text
refers to Ugolino's recently restored paintings as "modernized frescoes"
(*modernisierte Fresken*).

169 Dana E. Katz, *The Jew in the Art of the Italian Renaissance* (Philadelphia, PA: University of Pennsylvania Press, 2008), 31.

170 Ibid., 37–39.

171 Jonathan Riess, *The Renaissance Antichrist: Luca Signorelli's Orvieto Frescoes* (Princeton, NJ: Princeton University Press, 1995), 80–81.

172 Harding, *Guide to the Chapel*, 68.

173 Rubin, *Gentile Tales*, 8ff.

174 Harding, *Guide to the Chapel*, 65–68.

175 Ibid., 65.

176 Riess, *The Renaissance Antichrist*, 118. The placement of Judas above the chapel's arched entrance "appears almost as a complementary image" to those that "decry the satanic-prompted questioning of the Eucharist" that appears, ushered in by the Signorelli and Fra Angelico portrait, within the Antichrist panel only steps from the earlier painting.

177 Luigi Fumi, *Il santuario del SS. Corporale nel Duomo di Orvieto: descrizione e illustrazione storica e artistica: ricordo del XV Congresso eucaristico di Orvieto* (Rome: Danesi, 1896).

178 Riess, *The Renaissance Antichrist*, 26.

179 Riess notes that "Signorelli's Antichrist is without artistic ancestors or progeny" (5) and thus an art historical discussion of the theme is arguably limited. For some of the broader liturgical and iconographic issues that informed the painting, see Riess's discussions on 5–8.

180 Riess, *The Renaissance Antichrist*, 6.

181 Ibid., 38.

182 Ibid., 60.

183 Ibid., 142.

184 The "Battle of Zonchio" is discussed by Simon Pepper in "Fortress and Fleet: The Defence of Venice's Mainland Greek Colonies in the Late Fifteenth Century" in *War, Culture, and Society in Renaissance Venice: Essays in Honour of John Hale*, ed. David S. Chambers, Cecil H. Clough, and Michael E. Mallett (London; Rio Grande, OH: Hambledon Press, 1993), 48–49.

185 The so-called "Hella Dream" was never published. As discussed earlier, what we know of it is only recorded in Freud's comments to Fliess, *Freud-Fliess Letters*, 249, letter dated May 31, 1897.

186 Riess describes this passage in the painting in *The Renaissance Antichrist*, 52–53, 118–119.

187 Ibid., 120.

188 Molnar, "Reading the Look," 77.

189 Ibid.

190 Ibid., 88.

191 Riess, *The Renaissance Antichrist*, 30.

192 Sheila J. Nayar, *Dante's Sacred Poem: Flesh and the Centrality of the Eucharist to the Divine Comedy* (London; New York: Bloomsbury, 2014), 41.

193　Jacques Lacan, "La psychanalyse et son enseignement," *Bulletin de la Société Française de Philosophie* 51, no. 2 (1957) (April–June 1957), 98. Lacan's comments on the Signorelli incident are on p. 75.

194　Freud, *Freud-Fliess Letters*, 328. Letter dated September 27, 1898.

195　Ibid.

196　Freud, "Psychical Mechanism," *SE* 3, 289.

197　Ibid.

198　Sigmund Freud, "Zum psychischen Mechanismus der Vergesslichkeit," *Monatsschrift für Psychiatrie und Neurologie* 4, no. 6 (1898): 436–443.

199　Molnar, "Reading the Look," 80–81.

200　Freud, "Psychical Mechanism," *SE* 3, 289.

201　Ibid., 294, fig. 1.

202　Sigmund Freud, *On Aphasia: A Critical Study*, trans. Erwin Stengel (London: Imago Publishing, 1953), 34–36.

203　For the Grashey diagram, see *On Aphasia*, 35, fig. 6. Freud's version appeared in *Monatsschrift* (see n198) and was then reproduced in the first German version of *The Psychopathology of Everyday Life* (also published in the *Monatsschrift* 10, no. 1 (1901): 4). Freud altered the diagram when it appeared in book form (published by Karger in Berlin, in 1904, with ten editions to follow) and when Strachey published "Psychical Mechanism" and *The Psychopathology of Everyday Life* as part of the *Standard Edition*, he used the later version in both texts.

204　Molnar, "Reading the Look," 80.

205　Tiziana Tafani and Lucio Riccetti, *Freud e Orvieto: Alle origini della psicoanalisi* (Orvieto: Intermedia Edizioni, 2016), 40.

206　In introducing the diagram in his essay, "Reading the Look," 79, Molnar accords it pride of place as "the most persuasive item of all, the famous schematic diagram." It is interesting that Molnar is actually referring to two different diagrams as the model shown in the original German version differed from that of later publications and all the English translations.

207　*Freud-Fliess Letters*, 327, letter dated September 22, 1898.

208　Much appreciated in his native city of Milan, Boltraffio was barely mentioned in the literature of his day. Refer to Swales, "Freud, Death, and Sexual Pleasures," 21. Freud claimed he had hardly known Boltraffio when recalling him to Freyhan, but Swales notes in all likelihood Freud "would not even so much as known the name Boltraffio" until he purchased the Morelli volume and spent time in Milan.

209　Freud saw the statue of Andreas Hofer on August 6, 1989. In a letter to her sister that Minna Bernays included with that of her brother-in-law, dated August 10th, she details their itinerary in the preceding days, mentioning a visit to Trafoi that would have occurred as the two traveled from Prad to Bormio, on September 9th. Freud, *Unser Herz zeigt nach dem Süden: Reisebriefe*, 97, 106.

210 The mention of receiving this news of a patient's death while in Trafoi only occurs in the final version of the story. In his letter to Fliess, he associated his mention of the painter Boltraffio to the "echo of Trafoi, which I saw on the first trip!" (*Freud-Fliess Letters*, 327). He is here referring to the journey taken just prior to going to the Balkans. It is interesting that he wrote of "seeing" Trafoi, a choice of word that would support his itinerary and suggest he experienced the locale in passing (*Freud-Fliess Briefe*, 357–358).

211 See n204.

212 Minna Bernays's letter was mailed in the same envelope as Freud's, written on August 10, the day after their visit to Trafoi, and sent from the Swiss lake-side town of Le Prese. *Unser Herz zeigt nach dem Süden: Reisebriefe*, 106.

213 Freud, "Psychical Mechanism," *SE* 3, 294.

214 Baedeker [Firm], *Südbaiern, Tirol und Salzburg, Ober-u. Nieder-Österreich, Steiermark, Kärnten und Krain*, 27th ed. (Leipzig: Karl Baedeker, 1896), 293.

215 The trial received attention in both the English and the German press. For a detailed synopsis of the case, see *Juristische Blätter: Ein Wochenschrift* 7 (Wien: Carl Fromm, 1878), 2–24.

216 Freud, "Psychical Mechanism," *SE* 3, 291.

217 Giovanni Morelli (Ivan Lermolieff), *Della pittura italiana: studii storico-critici*, intro. Gustav Frizzoni (Milan: Fratelli Treves, 1897).

218 Philip Kuhn, "The Cultivated Italian (or) Who Reminded Freud How to Remember Signorelli?" *Psychoanalysis and History* 2, no. 1 (2000): 119–122.

219 Sigmund Freud, "The Moses of Michelangelo," *SE* 13, 1914, 222.

220 Carlo Ginzburg and Anna Davin, "Morelli, Freud and Sherlock Holmes: Clues and the Scientific Method," *History Workshop* 9 (Spring 1980), 10–11. See also Ginzburg's *Clues, Myths, and the Historical Method*, trans. John and Anne Tedeschi (Baltimore, MD: Johns Hopkins University Press, 1989), 100–101.

221 Swales, "Freud, Death, and Sexual Pleasures," 16. Brücke, who was Freud's psychology professor, figures in Freud's dream of "Dissecting my Pelvis," which includes the images of his encounter with the Etruscan tombs, occurring on the afternoon of his visit to the Duomo.

222 Swales, "Freud, Death, and Sexual Pleasures," 17.

223 Karl Baedeker [Firm], *Italien: Handbuch für Reisende; Erster Teil: Ober-Italien, Ligurien, das nördliche Toscana*, 15th ed. (Leipzig: Karl Baedeker, 1898), 143.

224 Swales, "Freud, Death, and Sexual Pleasures," 23.

225 Anthony G. Wilden, "Freud, Signorelli, and Lacan: The Repression of the Signifier," *American Imago* 23 (1966): 333.

226 Ibid., 343.

227 Freud, "Psychical Mechanism," *SE* 3, 290–291.

228 Ibid., 291n1.

229 Freud, *The Psychopathology of Everyday Life*, *SE* 6, 3.

230 Gil Anidjar, *The Jew, The Arab: A History of the Enemy* (Stanford, CA: Stanford University Press, 2003), 136.

231 Ibid.

232 Freud, *The Psychopathology of Everyday Life, SE* 6, 4.

233 Ibid.

234 Jean G. Schimek, "The Parapraxis Specimen of Psychoanalysis," in *Psychoanalysis and Contemporary Science* 3 (1974): 210. This paper was reprinted under the title "Signorelli: The parapraxis specimen of psychoanalysis," in a collection of Schimek's writings, *Memory, Myth, and Seduction: Unconscious Fantasy and the Interpretive Process*, ed. Deborah L. Browning (New York; London: Routledge, 2011), 185–202.

The Magic of the Manifest: Paper Dreams

Freud would recall that on the night he returned from his travels to the Balkans and Italy he had a dream in which he encountered "a stranger with a long face and short pointed beard."[1] He associated this man, who challenged his motives for donning a coat with an overall "Turkish pattern," with the shopkeeper Popović, whom he and his wife met while in Spalato in the days just after his trip to Trebinje. If we follow Freud's chronology, he had the dream immediately upon arriving back in Vienna, two days before he wrote to Fliess about his conversation with another man, Paul Freyhan, where topics involving a different kind of Turkish pattern—putatively associated with the practices and values of Bosnia's Islamic residents—played a decisive role. In Freud's next letter to Fliess, five days later, on September 27, he announces that he has already "turned Signorelli into a little essay"[2] and sent it off to a prospective publisher. It is difficult to assess how Freud's anticipation of the task of presenting his memory lapse, which he hoped would break a stalemate in his ability to generate new mechanisms of the psyche, informed the content of what he recalled from sleep on the evening of his return to Vienna. However, continuing the discourses of contiguity that wove through the previous chapter, the potentially sequential occurrence of the dream and the essay hint at a relationship, albeit unacknowledged by Freud, between his first exposition of the workings of the unconscious and his ongoing work on his "dream book." This project began to take shape in early 1898 and became increasingly important as he turned his collection into *Die Traumdeutung*, which he completed by the close of the following year.[3]

Little has been made of this possible connection, perhaps because the content of the projects, although both concerned the mechanics of psychical functioning, was squarely located in two different registers: a phenomenon occurring in waking life, and the operations of mind inextricably bound to the realm of sleep. Yet both stake very strong, comparable claims for a dichotomized relationship between easily accessible visual memories and the workings of repression that they mask, an operation that Freud will go on to elaborate in his dream book. The Signorelli parapraxis seemed to presage this construction, installing this distinction as a hallmark of the unconscious, just at the time when Freud was grappling with the mechanisms that operate

in the dream. If we are to suggest that the preface to this particular aspect of the dream occurs amid the "surface" recollections of paintings and deeper, seemingly censored thoughts occasioned by the topic of "Turkish" sexuality, then we must address more directly why such a correspondence has been so little examined. The explanation offered here requires an unpacking of the originary sources—more varied than usually imagined—for what Freud would call "dreams."

Because Freud's work is so connected to dreams, it has been easy to see them as a singular, fixed phenomenon whose workings he unearthed, rather than, as I argue, a self-assembled bricolage, pieced together as his psychoanalytic project required. What if, as Freud invested more in their psychical value, what constituted the contours of a "dream" became increasingly malleable, extending beyond the borders of nocturnal revelry to the waking world, to the conscious, even the contrived? If the distinctions that were marked by the presence or absence of sleep were seen as more mutable, then Freud's insistence on the incidental value of the Signorelli imagery to the functioning of his memory lapse—an essential revelation for understanding the displacement—could prefigure his dismissive characterization of the imagery of the dream "thoughts." The resonances of the forgetfulness associated with his memories of the Duomo may be heard in an oft-cited observation Freud made prior to introducing his "Botanical Monograph" dream in *Die Traumdeutung*: "the application of our procedure for interpreting dreams enables us to disclose a *latent* content in them which is of far greater significance than their *manifest* one."[4] This divide is reiterated numerous times, allowing Freud to assign and contain the site of psychical worth and, by focusing upon the interpretative revelation of meaning, devalue any content that he did not wish to examine—as he disavowed the importance of his memory of paintings in the functioning of his parapraxis.

As Freud resumed his "self-analysis" that fall of 1897, he assumed the veracity of early events recalled from dreams; his search for evidence in this way would form the foundation of a new construction of childhood sexuality, one based on a child's libidinal desire for a parent rather than the reverse. Once convinced of the early workings of repression and fantasy, Freud would consider the abiding power of wishes, originating in infantile desires and then revisited upon adult aspirations, to be a guiding factor in understanding the dream function. Yet he would claim that this piece of the dream puzzle had been put in place nearly two years before, when analyzing his so-called "Irma's Injection" dream of 1895, to be discussed below. Many years later—in his account of the history of psychoanalysis that appeared in 1914[5]—he would claim that his understanding of dream functioning was complete by 1896, although evidence suggests that such an assertion was largely apocryphal.[6]

In fact, it can be argued that the various forms of "dreams" that Freud was examining in his correspondence with Fliess in the mid-1890s still lacked a mechanism to explain the disparity between the dream's psychical meaning and the imagistic content as recalled by the dreamer. The Signorelli essay not only gave Freud his first piece of innovative thinking about unconscious processes after a year of dormancy, but may have been central in establishing a way in which the visuality could be reckoned as incidental in dreams—he will use the term "indifference"—and thus readily set aside. In both instances, the "patient" is Freud himself—although he would cite patients' dreams in his text—which allows him to work freely with the material.

I will contend here that there was no single "dream" entity for Freud and that mechanisms he was beginning to formulate for waking experiences were ruled by forces of repression veiling valuable meaning behind visible yet ultimately worthless "content," a distinction easily transferred to an amalgam of memories and affect that Freud brought into a totality he called a dream. We will examine a group of dreams that Freud discussed in letters to Fliess predating his holiday in Bosnia, particularly one dating to the time of his father's funeral in the autumn of 1896. Here we can identify processes of the malleability with which Freud took a memory recalled from sleep and shaped it to suit his interpretative needs. Since there is abundant evidence of conscious crafting of the dream memories to result in certain readings of "latent" meaning, this offers insight into the fluid, and constructed, nature of a Freudian "dream" and the ways in which the manifest was managed in order to have it align with the desired interpretation.

Such an inquiry can lead in a number of possible directions, such as that charted by Kaja Silverman in her finely observed essay on the workings of the perceptual systems that Freud installs within the mechanisms of his dream work.[7] The path pursued here takes a genealogical turn, offering two sites of what could be considered a discursive history of the Freudian "manifest." The construction derived from the Signorelli narrative will inform this endeavor, as a model of the operation of an originary displacement—one that I have argued places Bolsena as the disavowed precursor to Bosnia and Botticelli—that stimulates the production of the psychical mechanism, but then disappears entirely from the enunciation of its operation. In this chapter, we will complicate the "Ur" dream of the latent and manifest bifurcation—involving a seemingly indifferent dream image of a "botanical monograph"—and chart the unseen content that circulates around the brief retelling of the dream itself. Just as there was a preceding visual experience, in an earlier chapel, that may have shaped Freud's memory of the Orvieto paintings, imagery—here in the form of an illustrated book—may have served a similar function: there was an earlier botanical monograph dating

from Freud's childhood that played a crucial role in this dream and its interpretative strategy, although its presence is completely inaccessible to the analysis.

Freud's rendering of "manifest content" as "indifferent" is related not only to his own history but to the contemporary cultural history of fin-de-siècle Vienna. Dream imagery as a producer of cultural and ideological meanings is a legacy, certainly within studies of Freud's work, all but erased when such imagery is posited only as an internal, hallucinatory mirage. The desire to firmly devalue the imagery of dreams might have served not just a personal function for Freud, but a political and social one as well. A genre of literature devoted to dream interpretation existing alongside *Die Traumdeutung*—a second version of an illustrated text—offers a strikingly different view of the meaning of the manifest: the contemporary phenomenon known as the "Egyptian dream books." These mass-produced pamphlets (the most popular version was published on Freud's street, just a few doors from his residence and office) bestowed on singular images considered common in dreams—such as a dog, gun, or a radish(!)—both a brief interpretation and a numeric value. The source was claimed to be an ancient "numerology," yet in reality these pamphlets were marketed for the sole purpose of advantaging lottery players: one could then bet on numbers aligned with one's dreams, relying on the popular perpetuation of biblical and classical belief in dreams as predictors of the future. Such claims to esoteric wisdom were of course an utter fabrication; these dream books were produced by those involved in the lottery as a way to enhance sales. But what might appear as no more than an ephemeral and inconsequential treatment of dreams in a particular subculture actually served as a powerful, and at times pernicious, device for "naturalizing" cultural norms, notably anti-Semitism. Dreams involving Jews and Jewish subjects occupied a considerable category, and the meanings were consistently negative: being cheated, experiencing ominous events, or various forms of business failings. Freud was certainly aware of these other "dream books"—he characterized them as "despicable"—and his insistence on devaluing the manifest content of dreams can be seen as part of another "wish" associated with them: that their interpretation and meaning remain distant from visual imagery, naturalized by its appearance in sleep, that referenced popular, stereotypic tropes. The earliest evidence of Freud's presentation of his work on dream interpretation suggested that he shared it with groups of Jewish non-specialists—an academic youth group and his B'nai B'rith society—rather than his medical colleagues. This may indicate that he regarded the topic, which he found sustaining at a time of professional isolation, in a way that differed from how he treated other aspects of psychical life.[8] This would indicate a desire to create a structural scaffolding that placed

dream interpretation in as much contradiction as possible to the ideologically freighted version pervading Viennese popular culture at the time.

To reconstruct such a genealogy of Freud's treatment of the content recalled from dreams, we need to subvert his determination of value and salvage several locations of *meaning*—the latter word usually the preserve of his formulation of the latent—for the manifest. Dreams discussed in letters to Fliess are an important originary source, as they offer insights into Freud's reading of imagery prior to its codification in *Die Traumdeutung*. As noted above, we will look in particular detail at the earliest description and analysis of a dream that Freud shared with his then confidant, from the days immediately after his father's funeral in 1896; this is an example, unlike the "Hella" dream of the following year, that ultimately will appear in his dream book. There are considerable differences discernible between the original and published accounts, allowing us access to ways in which the visual imagery and the particularities of lived events were then subsumed and erased by content better suited to the operations of Freud's interpretative strategies. Peter Rudnytsky, observing this transition in his important work on Freud and Oedipus, characterizes the funeral dream, in its published form, as "detached and impersonal."[9] Freud used it as an example of the challenges of representation—and actually altered the original description of his dream to emphasize this—within the psychical mechanism of the dreamwork. Yet, the initial dream's value appeared to be much less about identifying a larger principle, potentially operating among all dreamers, and more about revealing insights into a moment of life and loss far more particular and unmediated. These two versions of the dream from the time of Jacob Freud's death allow us to view the (un)making of the manifest.

The material to be discussed here is specific to those complex phenomena called dreams, but the structuring of psychical mechanisms that assign value and render categories of experience forgettable is a continuation of a process charted throughout this book. *The Interpretation of Dreams*, appearing as a new century commenced, offered various attributes of the unconscious that Freud had been developing since 1897. Indeed, it was the dream that survived, as he had predicted to Fliess in the letter of September 21, when so much else appeared to lie in ruins. In translating this passage, Masson expanded Freud's word to "dream (book)," suggesting that it was this project, first reported as an idea to Fliess in the spring of that year, that would be carried forward.[10] *The Interpretation of Dreams*, still in its infancy and not to appear for more than two years, may have been

an intended referent, but it is also useful to take Freud here at his (single) word, and consider how the phenomenon of the dream itself was to survive, and how fluid its form was in the autumn of 1897, moving between waking fantasies and sleeping imaginings. As noted, Freud penned his first lines about dreams, in a diagnostic volume, as a function of forgetting, but as time went on he would frequently enlist—or fashion—them as a way to remember.

Dreams offered an ordinary, normative occurrence that could still be rigorously examined as a psychical—and perceptually complex—experience. For Freud, the interpretations of narratives recalled from sleep weave fantasy, wishes, repression, and displacement—all aspects of his thought developed in the second half of the 1890s and whose genealogies we have discussed—into a first compendium of unconscious functioning intended to be read widely. The dream, perhaps most of all, provided persuasive evidence for the existence of the "latent," a phenomenon that, as I have argued throughout this book, could not have occurred without a *visual* presence, yet whose very existence within the dreamwork was, by Freud's reckoning, both necessary and ambiguous. Silverman's aptly titled "Apparatus for the Production of an Image" reconstructs the various places within *Die Traumdeutumg* where this tension resides, as Freud attempts an explication of what might be called the hegemony of the unconscious, whose operation for him, she notes, can "be said to derealize the manifest content of the dream."[11] The present discussion locates another site for "derealization": the disavowal of sources for the "manifest" that exceed Freud's intrapsychic self-generation altogether, yet can be posited as a constitutive aspect of the dreamwork by virtue of this originary gesture of omission.

In the weeks after his fateful letter of September 21, Freud would search for evidence of the "awakening" of his infantile sexual desires, whose veracity necessarily relied upon material recalled from childhood. In charting his use of dreams in this endeavor, we encounter their presence as part of a fluid composite that included supposed early memories and wishful imaginings, the latter different from what Freud considered as "day dreams." In Rachel Bowlby's review of this latter concept in Freud's dream text, she characterizes his day residues as "serv[ing] primarily as only the veil or excuse for the dream-thought."[12] Her discussion does not extend the role of his day dreams to the actual construction of the dreams themselves, but she concludes her overview with the assessment that the manifest must "wear their meanings on the surface," and as such allow for the unconscious forces of psychical life to remain "below and not on the surface of daily life." Her concluding statement describes the fate of these visual residues: "in the process, the other day can be casually forgotten."[13]

But that is the "day dream" of *The Interpretation*; what prefaced it were times when dreams of day and night seemed to comingle in a far less determinant and hierarchical manner. Freud's purported memory, highly doubtful as we have seen, of seeing his naked mother while en route to Vienna, occurred alongside other recollections, also recalled as "authentic" experiences, that he claimed to have accessed in dreams. Freud tells Fliess in the letter of October 3, in which he reveals his memory of seeing his mother naked, that "the last four days of my self-analysis, which I consider indispensable [*sic*] for the clarification of the whole problem" have had a "continuation" within his dreams.[14] These provided him with the "most valuable elucidations and clues."[15] He tells Fliess that he could always predict "where the next dream-night would continue,"[16] suggesting a prescient, waking awareness of a subsequent unconscious occurrence. From this interesting stew of sources—memories, dreams and their predictions, wishful day reveries—one notion is now vigorously asserted: his father played "no active part"[17] in his own neurotica, another confirmation of his abandonment of the fathers' role in sexual assaults on their children. Rudnytsky characterized this as "shifting responsibility for sexual arousal away from his father on to his own fantasies."[18] And this shift has another dimension: Freud introduces evidence of infantile eroticism by recalling a caregiver from his earliest youth in Moravia and designating her as his "prime originator" as discussed in Chapter 3.[19] He then turns to his memory—whose source, as a waking memory or a dream, is not specified—of his experience with his mother en route to Vienna, along with revelations of the jealous feelings he experienced toward his brother Julius, who died in Freiberg in infancy.

It is in this letter that Freud describes this process of gathering fragments of the past as work of considerable "intellectual beauty." What he suggests appears to be the ability to assemble shards of evidence, strongly shaped by his volition, and seemingly directed in both states of waking and sleeping. The next day, October 4, he reports that the night's dream occurred "under the strangest disguises" and provided evidence that the nurse was his "teacher in sexual matters."[20] In this way, his experience in her care served to preface the full "Oedipal" awakening of sexual longing for his mother. Recall that Freud reports that the Czech caregiver had found him clumsy and inadequate, contradicting what he had said just the day before. He associates this with his current feeling of professional impotence, although it is ironic that his work will be revitalized by his privileging of childhood sexuality—the powerlessness of the child to be fully erotically capable giving rise to both sexual and aggressive wishes—that will infuse the needed power back into his work. But to create this repositioning requires that Freud provide evidence of early libidinal attachment, and his dreams seem to offer a location from

which he could draw evidence to support this new model of the determinants of unconscious functioning.

In this dream, where his relationship to his nurse shifts to one of erotic entanglement, Freud reports to Fliess that he recalls his caregiver bathing him in a reddish water "in which she had previous washed."[21] He tells his friend that it is not difficult to interpret this—we assume this was her menstrual blood—although he does not provide any more details, other than the scene of a disquieting intimacy between them that certainly may speak to a sexually abusive situation and thus another site of his loss of agency, perhaps being retold here as an assertion of his own libidinal capacities on the train. What is also notable here is how he came upon this image: he found "nothing like it in the chain of my memories"; he does not assume that this representation in the dream is any form of disguise. Rather, "I regard it as a genuine ancient discovery." Thus this imagery was taken as an authentic fragment, and Freud used the dream image as though it were equivalent to a conscious recollection. He closes the letter by observing that "a harsh critic might say all of this was retrogressively fantasied instead of progressively determined." But he counters with the assertion that there are memories not available to consciousness. As Masson notes, Freud appears to suggest that the dream of his nurse and the bath water "revealed a lost memory," one that was "not part of his knowledge, nor was it a fantasy."[22] Once Freud creates enough evidence to formulate the framing motif of his new theories of sexuality, the dream content, much prized here, will lose any value as "genuine." When Freud writes about memories from childhood in *The Interpretation*, he emphasizes that such remembrances are "*invariably* represented in the dream by a mention of a recent but indifferent impression"[23] (italics original), suggesting that unmediated connection to childhood experiences in dreams does not occur; our access point to them is always through the veil of content that appears to divert us away from, rather than toward, the memories themselves. Thus Freud has constructed the mechanisms of the unconscious functioning, as we have seen in earlier chapters, by a reversal of course: attributing to psychical processes the very capacities that he deployed in order to allow for these "secrets" of the dream to be "discovered."

In his letters to Fliess during these weeks, Freud makes references to dreams, but does not elaborate. His nurse features in some of these reveries, where her acts of larceny—stealing coins and toys—were recalled, and although these events had apparently been long forgotten, they return to memory when they "then emerged in a dream."[24] In the midst of this, Freud verified certain recollections with his mother, and his accounts of these childhood experiences to Fliess oscillate among what he was told, what he claimed to have dreamt, and what he remembered as a conscious memory.

As he continues in his "self-analysis" he will complain that he "drags himself dejected because he understood nothing of the dream, of the fantasy, of the mood of the day."[25] These three phenomena—dream, fantasy, and mood—seem to function as a kind of singular psychical entity for Freud during these October days. While there are times when their meaning eludes him, there are moments when they appear to coalesce: "when a flash of lightning illuminates the interrelations and lets me understand the past as a preparation for the present."[26] It is thus crucial for the "past" to have a basis in affective and visual memories of events and feelings that Freud can offer as "genuine." The dream often carries memory in a specific way that gives Freud access to experiences with which he could then build a structure of early erotic life, because, as he states when introducing the "universal validity"[27] of the Oedipal drama within *The Interpretation*, "our dreams convince us that this is so."[28] But it is important to realize that by the time Freud pens this, the "dream" has become fixed as a psychical entity that is ultimately about the continued presence, albeit disguised, of infantile wishes, and not as a document of actual events that occurred—sexualized or otherwise—in early life. So what the dream convinces us, by the time of the publication of the *Die Traumdeutung,* is that early desires and aggressions toward parents are retained in every person's unconscious as part of its prediscursive structure. Thus it was no longer necessary to continually reaffirm this by supplying autobiographical evidence. By the publication of his dream book, Freud was convinced that the psychic structure was shaped by what he had begun to imagine as phylogenetic conflicts, whose imprint existed as a universal drama, originating before any individual's own parental dynamics. The evidence thus was transformed into an *a priori* formulation, although it had begun for him in evidence offered at an exquisitely particular moment of his childhood upheaval, far from the subsequent recasting.

A striking example of this transition is evident in his dual recollection of a dream involving his father's funeral. Upon Jacob Freud's death in October of 1896, Freud experienced the loss as an unexpectedly powerful one, leaving him feeling destabilized and bereft.[29] Famously, he later would characterize this as "the most important event, the most poignant loss, of a man's life,"[30] and indeed while his attachment to his mother would form a pivotal part of his emerging psychoanalysis, Freud would add the line cited here to the preface of the second edition of *The Interpretation*, crediting the "subjective significance" of the book to his reaction to his father's death. It is not clear what he meant by this, and it is noteworthy that in the two dreams to be discussed here, both with a connection to Jacob Freud, the particular details relating to him have been changed to accommodate the interpretative strategies and not, as Freud suggests here, the reverse.

The most explicit dream involving his father—although Jacob Freud does
not appear in it—focuses on his funeral, and is one that Freud would share
with Fliess in a letter about a week after his father's death, and then publish
in his text:

> I must tell you about a nice dream I had the night after the funeral. I was
> in a place where I read a sign:
>
> You are requested
> to close the eyes.
>
> I immediately recognized the location as the barbershop I visit every day.
> On the day of the funeral I was kept waiting and therefore arrived a little
> late at the house of mourning. At that time my family was displeased
> with me because I had arranged for the funeral to be quiet and simple,
> which they later agreed was quite justified. They were also somewhat
> offended by my lateness. The sentence on the sign has a double meaning:
> one should do one's duty to the dead (an apology as though I had not
> done it and were in need of leniency), and the actual duty itself. The
> dream thus stems from the inclination to self-reproach that regularly
> sets in among the survivors.[31]

It should be noted that Freud's mother would die over three decades later
(recall that she was a generation younger than her husband), and her son, then
in his seventies, would choose not to attend her funeral. His failing health was
some justification, but he admitted in a letter to his younger brother Alexander
that he disliked such ceremonies, although anecdotal evidence suggests that
he made the arrangements for her to have an Orthodox Jewish burial.[32]

This seems to reverse his behavior toward his father, where he attended
the funeral yet appeared to "simplify" the service, a comment he made to
Fliess that is usually interpreted as eliminating certain religious customs of
the kind that he, much later, sanctioned for his mother.[33] The dream, shared
with his friend in the days after his father's funeral, speaks to these omissions
and feelings of guilt; he nevertheless introduced it to Fliess as "*einen netten
Traum*," a phrase that may be read as a "nice" or "neat" dream, and might
suggest something of its pleasing manifestation, but it is noteworthy that
netten, in nineteenth-century usage, could also mean something clear
or unambiguous. But either descriptor seems to point to a dream whose
meaning was quite apparent and accessible. Like several other dreams shared
prior to the autumn of 1897, this one prominently features a written text;
recall that Freud saw a card with the name "Hella" in the dream noted above;
in another example, the so-called "Villa Secerno" dream, described to Fliess

in a letter of April 28, 1897, he dreams of a series of words that appeared like a telegram. In the case of the funeral dream, the text is a sign that Freud locates in the barbershop where he would go daily for a beard trim, and where he was delayed on the morning of his father's burial, on October 25 of 1896. He dates the dream very precisely—"I had the night after the funeral"—in a letter to Fliess of November 2. In it, he sees a sign hung in this familiar setting with a strange entreaty: "You are requested to close the eyes," and hence the name—the last three words here—that Freud would give to the dream in *The Interpretation*. He interpreted the sign in the barbershop as having two meanings: that "one should do one's duty to the dead (an apology as though I had not done it and were in need of leniency) and the actual duty itself."[34]

The former reading asked for others to accept an apology for what might be construed as filial disrespect, while the latter comment refers to the association, cited in biblical and classical sources, of the son's closing of the father's eyes with a source of closeness and a comfort to the deceased. Reference to closings of the eyes occurs in Genesis, in the story of Jacob—sharing the name of Freud's father—and his dream interpreter son, Joseph. In this narrative, it is God who instructs Jacob to go to Egypt, so that he will reunite with his long-lost child, who, when the time comes, will be able to "close his eyes."[35] It may also have related specifically to another prohibition, one that Freud had obviously violated: the practice of refraining from hair cutting or shaving in the period immediately after a close relative's—especially a parent's—death.[36] Thus, the rebuke that he felt from family members about being late may have come from indulging in an act that may have been construed by some as disrespectful. Freud does tell Fliess that his relatives—and we would assume his mother was chief among them—had initially been displeased by the simplicity and "quiet" of the ceremony. But it would appear that by the time he recounted the dream to Fliess, several days had passed, and he reports that everyone, by then, saw the efficacy of his choice.

What constituted the funeral ceremony over which Freud appeared to have had significant control is not clear. As Emanuel Rice notes, even the most observant Orthodox services would be able to occur, within the strictures of Jewish law, in about three minutes.[37] Rice believes that what Freud characterizes as the simpler choice may refer to his dispensing with certain rituals done to the body prior to the funeral. Traditionally in Judaism these rites were performed by the *chevra kadisha*, the "burial society," a group of individuals that cared for and remained with the deceased—this latter practice was noted earlier in discussing the "Burning Child" dream—from the time of death to the burial.[38] Among their duties would be the closing of the eyes, if not performed by a family member, usually the eldest son. Thus, if Freud had not had this group (which might be why he reported his

choice as a "quiet" one), the responsibility to close the eyes fell to him. One might assume that Freud, as attending physician, did this at the time of his father's death in any case, but the sign in his dream might gesture to the fact that, in the absence of the *chevra kadisha,* the responsibility, as a Jewish ritual practice, would fall to him.

Freud would sketch for Fliess the visual image of the dream—his letter contains an actual picture of a rectangular box surrounding the words that contain the command hung on the barber's wall.[39] He interprets the dream as a reproach—embodied in the sign—and evidence of the inherent guilt of those who survive. The retelling aligns the content and meaning rather closely, as evidence "about" feelings of guilt experienced at the time of a death, and its manifestation within a retrospective formation of a scene—the barbershop, being late, experiencing his family's various displeasures with him—derived from the day of the funeral. It would seem apparent that the imagery in the dream could only have occurred after the event, as Freud focuses upon responsibilities that may or may not have been fulfilled in circumstances that had already occurred.

It is a revelation to revisit this dream in the form in which it appears in *The Interpretation*, where Freud mentions it once, within a section of text on the "means of representation" within the psychical mechanism of the "dreamwork." The focus here will be "the process of transforming the latent thoughts into the manifest content."[40] He characterizes two processes—condensation and displacement—that operate to transform the unconscious material into that which is recalled upon waking.[41] Freud goes on to argue that the most complete interpretation would be only the latent dream thoughts themselves—and would result in the ability to "completely replace the dream and if there were no censorship in dreams, would be sufficient in themselves to replace it."[42] But since both restrictions occur from within the psyche and within the published interpretation he must resort to a synthesis. This requires that the manifest be part of the analysis but of lesser value and importance. Freud then equates the devaluing of the imagery of dreams to the historic limitations of pictorial representation. He goes on to note that before painting "became acquainted with the laws of expression by which it was governed," it had to resort to humbler devices to suggest content: "In ancient paintings small labels were hung from the mouths of persons" in order to present the viewer with the "speeches that the artist despaired of representing pictorially."[43] Freud will later cite the "small label" from his father's funeral dream, but he has chosen here to elaborate upon the simple enclosed cartouche that he had drawn for Fliess.

In discussing the problem of representation in dreams, Freud would preface his discussion of the "Close the Eyes" example by noting that multiple,

and often conflicting, feelings, cannot be contained within the content of the manifest "dream thoughts." Feelings are not depicted in dreams as they would be in text or speech, as "either/or" articulations, but appear as a combination of various possibilities, displayed at times as seemingly disparate things brought together. But this visual deficiency can have its advantages: Freud notes that it may allow various interpretative paths to be pursued. It would seem that the original version of the dream of the funeral was like an "ancient painting," with its simple message—one that referred to a familial burial responsibility—that could encompass another, but certainly not opposite reading; the two are closely related, as Freud offers a response to the Jewish custom through an interpretation addressing his decisions about the practice requested by "close the eyes." Both readings still remain close to specific Jewish funeral practices that placed responsibilities upon a surviving son.

Freud reports in *The Interpretation*'s version that this dream occurred "during the night before my father's funeral"[44] rather than the night after, and many particularities of that day—seemingly yet to occur—were erased. The sign was now associated to those found, seemingly generically, in a "railway waiting room"[45]—no hint of the barbershop here—and related to admonitions posted there against smoking, further distancing the content from the experiences of responsibilities involving the funeral. Thus, what Freud originally described to Fliess has been significantly transformed. Instead of a single sentence, which he also reports here as earlier—"you are requested to close the eyes"—he adds a second message: "You are requested to close an eye."[46] He diagrams the pairing, noting that "I usually write in this form:

the
'You are requested to close eye (s).'"[47]
an

What is meant by "usually" writing it in this manner is unclear, as we have no other surviving version of the dream beyond its original retelling to Fliess and what is cited here. The structuring of the sentence removed this even further from the small enclosure that he uses to visualize the earlier version of the dream. It has been clearly relegated to a realm of representation akin to his prehistoric paintings. The second version demonstrates psychical functioning, mechanisms that can elicit a parsing as a linguistic structure. But how are we to understand the earlier version of the dream? Was it a purely a "manifest" version, one that prefaces the later, more sophisticated account? If so, we wish to understand better the relationship that led to this transformation, which presumably resides beyond the frame of psychical

scrutiny, and yet seems to have been a strategy to account for this process as part of the construction of the unconscious.

The original "sign" is not given any further consideration; therefore, all the details that Freud offered to Fliess about his *netten Traum* have been eliminated. It is the second sentence, one that he suggests asks that something be overlooked or "wink(ed) at," that forms the interpretative path here. Freud introduced only one aspect related to his father's funeral: his choice of what he describes as the "simplest possible ritual," mentioning that he "knew my father's own views on such ceremonies."[48] Given the evidence that, five years earlier, his father had returned to him portions of his childhood Bible, with a lengthy inscription in Hebrew, it would seem unlikely that Jacob Freud would have objected to such traditions; Rice contends that Freud may have "overestimated his father's 'liberal' views on such matters."[49] But in constructing the dream in this way, all aspects pointing to any particularities of a Jewish funeral or of Freud's feelings about both the loss of his father and his relationship to the rituals contained in the original portion of the dream have been removed. Also, as the discord concerning the simplicity had been almost immediately resolved, it is noteworthy that Freud focuses upon this, but in a way that differs significantly from the earlier account. It is now seen as an imagined disgrace for his family, seemingly by other attendees, that resulted not from his countering the possible desires of his father but from upholding them. This wish to be recognized for his good "practice" would have echoes of the wish he attributed to another, far better-known dream, associated with a protagonist named "Irma," to which we will turn in a moment. Freud offers the funeral dream as depicting two opposing thoughts, articulated here as performing a funerary ritual and as the absence of such a rite, although only the latter is given any attention. Citing the original admonition only serves to provide the "either/or" example, and the apparent function of introducing this is to demonstrate the limits of the dream content's ability to represent *any* phenomena of causality; the surface imagery exists, after all, to mask the latent meaning and thus has no function beyond that. It can be argued that what we are encountering in "Close the Eyes" are two very different constitutive functions that were both announced by Freud to be a "dream."

Marthe Robert's analysis of this disparity, published over four decades ago, still remains an especially insightful treatment of the two narratives.[50] She notes that in the original edition of the Freud-Fliess letters, it was stated that the published version of the dream was the same as the one recounted to Fliess, but "in greater detail, obviously with the aid of notes."[51] But Robert counters this, and in doing so distinguishes her assessment from the analyses of those who have noted the dream's disparities but not investigated the

implications. Robert contends that rather than being more faithful to the original dream, the published version "appears to have been arbitrarily reworked."[52] She notes all that has been omitted, rather than added, and like Rudnytsky, characterizes the second version as being devoid of specifics relating to the details of that event, and reading as an "impersonal" example of the workings of representation in dreams. Her observation of what appears to be an arbitrary transformation of the dream should serve as a cautionary note to the reading of many dreams that Freud attributes to the period between his father's death and the publication of *Die Traumdeutung*. Instead of the feelings of guilt and ambivalence that coalesced on the day of Jacob Freud's funeral, what Freud created was a new phenomenon that focused on a wish: that those attending the funeral would "overlook" the choices that he made. What they were overlooking was that he did not "close the eyes"—that is, he didn't follow the ritual requirements by opting for what he interestingly characterized in the later, published version as a "puritanical" service.[53] But there is no discussion of the actual meaning of shutting one's father's eyes; any reference to Jewish tradition has been completely eliminated in the published version of the dream.

The opportunity to reflect on both versions of "Close the Eyes" allows us to see how Freud's privileging of the dream's representational content in his initial understanding created an interpretation that differed markedly from that which used dream thoughts as a basis to exemplify larger psychical mechanisms. In the end, it is the reader who is asked to look away, in the second version, from an affectively complex moment—by Freud's own admission the most poignant of losses. In relocating the dream to before rather than after the funeral, Freud can allow his psychical construction of the wish to be foregrounded here, since all remains in anticipation. This timing allowed for the powerfully embodied content that would accompany the burial of a parent to be eradicated; the events as imagined by Freud were thus far more fully under his control. The unconscious, as he constructs it here, generates a system of intrapsychic visual encodings that can claim primacy over the functioning of representation and its affects. And in doing so, the potential excess of content—such as allusions to specifically Jewish practices in the dream or the memory of the interior of the barbershop—is controlled and the narrative's borders thus fixed. Freud might have imagined this to have been possible, as he would have thought that only through the published dream would there be any access to knowledge of his father's funeral. It seems unlikely that he anticipated the content of his letter to Fliess, and thus the earlier description of the dream, becoming known.

As we will see in looking at the prime exemplar of dismissible dream imagery, Freud will fashion this dream as yet another example of asking

readers to dismiss what is offered as the "indifferent" manifest content. Perhaps underlying Freud's notion of the dream meaning is actually the desire, not to censor infantile wishes, but to divert our gaze from visual evidence that attested, as in this next case, to profound familial disruptions and childhood hardships, evidence right before our (closed) eyes.

<p style="text-align:center">*****</p>

Freud's exemplar of the latent and manifest bifurcation, the "Botanical Monograph" dream, includes mention of samples (*spezimen*) of dried plants, and so could claim to be a "specimen dream." However, this phrase is commonly translated as Freud's designation for the first example introduced at the start of *The Interpretation*, cited as his *Traummuster*—his specimen or model dream.[54] Titled in his text simply as "Dream of July 23rd–24th, 1895" it is most commonly known as the dream of "Irma's Injection" (or simply the "Irma dream"); although no name is given in the narrative of the dream itself for its female subject, Freud will assign this name in his interpretation. It has been the subject of considerable analysis, post-Freud's, involving issues of a patient's treatment, of the gender dynamics enacted here, and Freud's relationship to his colleagues. For that reason I will not detail its content here, but rather introduce it as a preface to an examination of the "Botanical Monograph" dream—far less discussed—and as another example of the malleability of how Freud constituted memories said to be derived from sleep.

The circumstances surrounding the dream, recounted by Freud as its "preamble,"[55] concern the course of a particular patient's treatment. The day before the dream, Freud's friend and family pediatrician, Oscar Rhie (dubbed "Otto" in the dream), had suggested to Freud that his patient (and family friend), Emma Eckstein, known socially to both of them, was not fully free of her afflictions—primarily stomach discomforts and a low-grade depression—that Freud had diagnosed as "hysteria." Some of the challenge in identifying "Irma" lies in the fact that she was likely, as Elisabeth Young-Bruehl and others have argued, a composite figure based on two of Freud's patients—Eckstein and Anna Hammerschlag Lichtheim—the latter also a woman with close ties to the Freud family.[56] In his preface to the dream, Freud reports that Eckstein's "hysterical anxiety" had improved under his care, but that not all her symptoms disappeared. He felt "annoyed" at the reported incompleteness of the cure, suggested by Rhie, whose connection with the patient's family also suggested to Freud that they shared this sentiment.[57] In the dream, the responsibility for "Irma's" continuing ill-health was attributed to the inadequate care of "Otto" himself, hence revealing the desire that he,

Freud, be exculpated from any blame, notably for allowing Wilhelm Fliess to operate on Eckstein, with deleterious results.[58]

For Freud, the importance of the "Irma" dream centered on his claim that it revealed an underlying mechanism: at the dream's core lay a wish, whose veiled, self-generated representation required an interpretative deciphering to understand its meaning. He would attribute enormous significance to this revelation, but only after his dream book was written; indeed, the first mention of this dream to Fliess is quite stunning, both in the value Freud assigns to it and the apparent silence he kept about it for nearly five years. In a letter of June 12, 1900, months after the dream book had appeared, Freud announced that the night of dreaming that resulted in "Irma's Injection" should be marked by a plaque at the place where it occurred: Schloss Bellevue, a hotel where Freud and his family were enjoying the first portion of their summer holidays, in the village of Grinzing on the outskirts of Vienna. Years after what was obviously a time of distress and professional concern, and after the realization of his dream book, Freud would commemorate the evening of this dream as one of great triumph: he tells Fliess that the plaque should read "Here, on July 24, 1895, the secret of the dream revealed itself to Dr. Sigm. Freud."[59] The text is created, of course, by Freud himself, but the fantasy is that such recognition comes from the external community that had for so long shunned him. Freud wanted a very conscious recognition for revealing the dream as an unconscious wish, and indeed this came to pass, although much later. On May 6, 1977, on what would have been Freud's one hundredth and twenty-first birthday,[60] his desire was realized when a plaque was placed at what had once been the site of this resort villa in the Vienna Woods.

But perhaps "Irma" was not only prototypical evidence of a dream— *Muster* means pattern or example, although usually translated in Freud's usage here as "specimen." Given its detailed narrative, particular details, and various participants, "Irma's Injection" may have emerged as much from the wish to create the exemplary model as to recount how its secret, as an unconscious wish, was rather magically revealed to him in Grinzing. That "discovery" may have resulted from an amalgam of sources: the dream memory, but also day dreams, whose relationship to their somnolent counterparts Freud would note in the decade after *The Interpretation* was published,[61] waking wishes and thoughts that perhaps emerged in writing up the case, and, as Jay Geller details, Freud's anxieties related to anti-Semitism and his status, both professionally and personally, as a Jewish male.[62] As Freud works through each portion of the dream in his interpretation, he reiterates his contention that it is a wish, but also gestures to it as an exemplar of condensation, unconscious representation, wordplay, and forgetting. This enables him to explore how an entity known as a dream—imagery and

affect from sleep, a totality of the unconscious function—operated. But as we will see, Freud's "dream" as an *a priori* entity was in fact a diffuse, fluid construction whose content and functioning were far less an autonomous process that he discovered, than one that he edited, altered, and merged with waking experiences.

Anzieu, in his lengthy discussion of the Irma dream, points out the many references to this dream appearing in *The Interpretation* that could only have been crafted considerably after that night in the summer of 1895.[63] But could not the same be said of the narrative itself? It would be difficult to determine whether the description of the dream, as published, was extensively revised, and we have seen a precedent in the "Close the Eyes" dream, strikingly altered between its recounting in a letter to Fliess and its appearance in *The Interpretation*. Had Freud chosen to share the content of the Irma dream with his friend at the time of its occurrence—in a period when, judging from the extant portion, written by Freud, their exchange of letters was very frequent—we would have a better sense of any disparities. Despite the momentous significance of the dream, Freud chose not to disclose anything about it, hinting at the possibility that it accumulated meaning as it became exemplary of a construction that later came into being. The first mention of the Irma dream in *The Interpretation* after its introduction suggests it is proof of the universality of dreams as wishes.[64] Freud then goes on to recount his dream of thirst and drinking from his Etruscan urn. More than three years had elapsed between his holiday in Bellevue and his visit to Orvieto. Although in *Die Traumdeutung* Freud says that he wrote the Irma dream down immediately, we will never know what he did or did not write upon waking from that fateful summer night.

Although "Irma" holds pride of place as the inaugural example in Freud's dream book and as revealer of its most profound "discovery," another dream challenges it for status as a "specimen" dream. But instead of that descriptor being an index of a "species" (perhaps to be named *Traum freudianus*), here "specimen" refers to actual botanical samples. Freud uses the word *Spezimen* (more commonly spelled now in German as *Specimen*), a synonym for *Muster*, but with a telling distinction. This latter word, as a descriptor of the Irma dream, usually means exemplary status—it can extend to the "ideal"—and refers to often generalizable attributes, such as the dream's primacy as an example of wish fulfillment. But *Spezimen*, introduced in the "Botanical Monograph Dream" (the name Freud gave it), has its referent in material, everyday properties: one of the most common uses of the word in Freud's day and profession would have been a urine "specimen." The "Botanical Monograph" focuses on a very simple narrative, in contrast to his *Traummuster*:

I had written a monograph on a certain plant. The book lay before me and I was at the moment turning over a folded coloured plate. Bound up in each copy there was a dried specimen of the plant, as though it had been taken from a herbarium.[65]

Here Freud merely recalls the action of looking through a book containing dried plants, whose specific material specimens will be dismissed. This is not to say that the dream is of little value. Rather, the botanical dream is offered as evidence of what Freud would consider his other great insight in *The Interpretation*: that the dream's manifest content, often indebted to residues of daily activities (specimen's of one's manifest existence), actually serves to mask its unconscious latent meaning; the dream's unrepresentable importance can only be revealed through associations and their subsequent analytic interpretation. As Silverman notes, this dream is "even more saturated with visual longing" than the Irma dream, "but here the force of denial is not nearly as powerful."[66] Indeed, as she points out, various illustrated books are cited in his associations,[67] although they seemingly lead farther away from the botanical book that forms the "indifferent" manifest component. But as we investigate the motivations that brought this descriptor of dis-interest to the visual objects in this dream, we discover that the reverse process of obscuring and revealing was actually taking place. Freud appears to be hiding the most psychically powerful, and personally difficult, material in plain sight, while announcing that what he recalled—a single image where he was turning the pages of a book of flowers—had little if anything to do with the latent meaning. This, he contended, concerned rivalrous relationships to colleagues and childhood Oedipal strivings, along with a secondary, and more current, wish to justify his acquisition habits, book buying among them. He makes an interesting pairing of this dream with that of Irma, claiming that both express a "plea on behalf of my own rights," presumably in one case of his right to make medical decisions and the other to pursue his hobbies.[68] The comparison may seem a stretch, but perhaps it is best understood in both cases as asserting Freud's self-determination to act according to his own wishes and counter the threat of vulnerability. Indeed the ability to make an interpretation, as an analytic prerogative, is itself an enactment of a desire for agency. In the "Botanical Monograph" dream, the book of dried plants—with its rather humble materiality—is the specimen of Freud's early years in Vienna, whose impact, within the construction of the dream work itself, he will attempt to disavow.

The dream from the time of his father's funeral expressed the wish to have others overlook something, and this desire may have extended well beyond this single example, and can be said to characterize the implications of Freud's theory of dream interpretation more broadly. In searching for the latent meaning, one must ultimately put aside what is before us—as the funeral-goers, in experiencing an abbreviated service, were asked to do. We are really being asked to turn a blind eye to what we see—the visuality of the dream content—and to consider it "indifferent" to the actual significance of the dream. It is interesting that the dream presented as the great exemplar of this schism—the example where the latent and manifest are first introduced—is also one where, in Freud's associations to its meaning, we encounter his father in Freud's childhood, "almost the only plastic memory that I retained from that period of my life."[69] This was when he was five, during the period of his "forgettable" early life in Vienna.

The "Dream of the Botanical Monograph," thought to have occurred in early March 1898,[70] appears in a section of *The Interpretation of Dreams* devoted to "recent and indifferent material," where Freud suggests that this dream was stimulated by his having seen a book devoted to a specific flower, the cyclamen, in a bookshop window earlier in the day.[71] Freud returns to the dream several times in his "dream book," and in each instance he foregrounds the "indifferent" nature of its manifest content. He is most emphatic in the section dealing with displacement; here this dream is offered as the first example of this phenomenon, where "what is clearly the essence of the dream-thoughts need not be represented in the dream at all."[72] It is notable that the term "displacement" had made its first published appearance, after frequent mention in Freud's abandoned meta-psychological "Project" of 1895 in his telling of the Signorelli episode, which appeared between the writing of "Project" and the dream book of late 1899.[73] Thus, while the central theme of the manifest content was the botanical monograph, the latent dream thoughts were, he suggested, concerned with "the complications and conflicts arising between colleagues from their professional obligations, and further with the charge that I was in the habit of sacrificing too much for the sake of my hobbies."[74] To allay any lingering doubt about the unimportance of the botanical element, Freud reiterates that it "had no place whatever in this core of the dream-thoughts, unless it was loosely connected with it by an antithesis—the fact that botany never had a place among my favourite studies."[75]

Despite this seemingly unequivocal opposition between the manifest and latent spheres of the dream, there are moments of slippage showing how the day residue may have held a hitherto unsuspected meaning for Freud. Reexamining the seemingly inconsequential floral "day residue" gives us in

fact a considerably fuller understanding of Freud's associations to the dream, which hint obliquely at a connection between his early childhood and the botanical monograph he glimpsed in the shop window in 1898. Use of an index of value derived from economics is notable here, as Stanley Palombo's analysis of this dream reminds us. In a section of *The Interpretation* devoted to "wish-fulfilment,"[76] Freud, as Palombo recounts, offers his assessment of the kind of remains of the day that are exemplified in this dream:

> "A daytime thought may very well play the part of *entrepreneur* for the dream," Freud immediately added, "but the *entrepreneur*, who, as people say, has the idea and the initiative to carry it out, can do nothing without capital; he needs a *capitalist* who can afford the outlay, and the capitalist who supplies the psychical outlay for the dream is invariably and indisputably, whatever may be the thoughts of the day, *a wish from the unconscious.*"[77]

But the day residue here, despite its seemingly inconsequential value, contains its own fascinating connection to monetary issues, but of a quite different kind than Freud invests in the obviously well-funded projects of the unconscious. It is not revealed in his text directly, but is accessible by way of a recollection that appears within his interpretation. Freud structures his analysis of the botanical dream using a retrospective series of associations that end with a memory he locates in his fifth year of pulling apart the pages of a book together with his sister Anna:

> It had once amused my father to hand over a book with *coloured plates* (an account of a journey through Persia) for me and my eldest sister to destroy. Not easy to justify from the educational point of view! I had been five years old and my sister not yet three; and the picture of the two of us blissfully pulling the book to pieces (leaf by leaf, like an *artichoke*, I found myself saying) was almost the only plastic memory that I retained from that period of my life.[78]

The trajectory of the interpretive chain would seem satisfactory and complete—from recent and incidental to early and presumably revelatory— had Freud not informed us that he was leaving the interpretation in abeyance: "For reasons with which we are not concerned, I shall not pursue the interpretation of this dream any further."[79] In the next reference to the dream, Freud is even more explicit, identifying this early memory as holding "the ultimate meaning of the dream" and telling us it has to do with something "which I have not disclosed."[80]

In the most detailed commentaries on this dream, explanations for Freud's self-censorship have consistently turned on imagined sexual memories from his early childhood. Alexander Grinstein attributes the gap to Freud's resistance to speaking of "forbidden incestuous feelings toward his sister Anna"[81] and, ultimately, to repressed desire for his mother. Anzieu's interpretation is more complex, attributing the omission to Freud's "recent disagreement with Fliess over bilaterality and bisexuality."[82] This reading takes into account Freud's allusion to "complications arising between colleagues," which he himself connects with his work on cocaine in the 1880s when, in Anzieu's words, the "ungrateful" Carl Koller "took all the credit for the discovery" of its use as an anesthetic in ophthalmic surgery. Because Freud's own father had undergone surgery for glaucoma in which cocaine had been administered, Anzieu proposes that Freud "identifies with his father."[83] But rather than develop this idea, he turns to the floral imagery, which, in his view, suggests "infantile and incestuous sexual curiosity about the female sexual organs."[84] Like Grinstein's reading, therefore, Anzieu's ultimately falls back on infantile sexuality and an assumption of normative heterosexuality: Freud would transform Fliess's theories of bisexuality "into a psychological phenomenon involving fantasies connected with the difference between the sexes."[85]

In contrast to such speculation, however, there is evidence to suggest that Freud disavowed the botanical element not primarily out of resistance to early sexual memories, but because of later associations relating to flowers and books about flowers that were even more problematic for him. In keeping with Jacques Derrida's proposal that one should adopt an interpretive strategy in which "meaning exceeds" rather than "resists analysis,"[86] I contend that floral referents evoked for Freud familial memories dominated by shame and secrecy, and that these were issues he would have been particularly loath to discuss in the late 1890s. This reading of the botanical significance is thus very particular to Freud, arguing, as in the previous chapter, that the manifest, as personal and revelatory, could be made psychically worthless through its role in the mechanisms of unconscious functioning. But while I will provide a genealogy for the significance of flora in Freud's early life and familial dynamics, it is important to acknowledge that this is not the only register in which a botanical presence can be located within this dream. Jill H. Casid's discussion of the dream in *Sowing Empire: Landscape and Colonization* places Freud's disregard for the botanical content—she terms it as the "displaced nodal point"—in the elision of botany with imperial practices and the ideologies of empire.[87] Casid suggests that the denigration of botanical materiality was a way in which Freud could construct psychoanalysis "as the antithesis of empire."[88] Yet, for all the psychical hegemony Freud accorded the workings of the unconscious, Casid contends that "at the center of psychoanalysis we find the material

trace." Thus, "like the plant specimen bound into the monograph," at the core is "psychoanalysis's imbrication in the historically contested ground of empire."[89] In my analysis, the pathways of transfer of plants and the products created from them have a specificity for the young Freud and a materiality that exceeds the frame of the analytic manifest. The botanical element creates a subversion of Freud's new inner world order decades before he claimed his new "colonizing of the terra incognita of the psyche."[90] That ground removed a dangerousness often lurking within the materiality and visuality that he attempted to render inconsequential. We turn now to the manner in which botanical imagery weaves through Freud's associations to his brief dream and then to the trajectory that can be charted from what remains unsaid.

Figure 5.1 Friedrich Hildebrand. *Die Gattung Cyclamen L. Eine systematische und biologische Monographie* (Jena: G. Fischer, 1898). Courtesy of: Library of the Arnold Arboretum, Harvard University, Cambridge, Massachusetts, USA.

In the initial analysis of this dream, Freud begins his chain of associations with the subject matter of the monograph seen in bookshop window—cyclamens, which were his wife's favorite flower (it is noteworthy that the most popular of the domestic variety was of Persian origin and the first botanical plate in this book indeed was of the *Cyclamen persicum*). Viewing the book, "I reproached myself for so rarely remembering to *bring her flowers*."[91] He then cites other events, many dealing with flowers and plants, including that he had written a monograph on the coca plant. In this connection, he mentions Koller's discovery of its anesthetic properties, which had been demonstrated in the surgery on his father's eye performed by Leopold Königstein, a friend and colleague whom Freud had again seen a few days earlier. Their conversation included words related to flora—particularly a woman's "blooming" good looks and someone with the surname Gärtner, or gardener.[92]

Freud then mentions having received a letter from Fliess in which he had imagined turning the pages of Freud's yet-to-be-completed book on dreams. Envying Fliess's "gift as a seer," Freud muses: "If only I could have seen it lying finished before me!"[93] This leads him to recall the interest he had had as a medical student in the color plates of monographs, and the ridicule that ensued when he sought to illustrate his first published papers with his own drawings. Then, in Freud's words, "there followed, I could not quite make out why, a recollection from very early youth."[94] Freud's puzzlement at this associative link seems disingenuous, as the incident he goes on to recount is the one involving his father and the tearing of the book, which follows naturally enough from the theme of "color plates" he had just discussed in connection with his years as a medical student.

After recounting the fate of the book on Persia, Freud calls to mind his "passion for collecting and owning books"[95] as a gymnasium student. The memory of this favorite pastime leads to the recollection of a recent experience of "being blamed" for absorption in "my favorite hobbies," which by then would have included his first acquisitions of "antiquities." After Freud speaks of this schoolboy interest in books and identifies himself as a youthful "book-worm," he makes a surprising statement: "I had always, *from the time I first began to think about myself*, referred this first passion of mine back to the childhood memory I have mentioned"[96] (italics added). One might have expected a note of irony or humor here, as this first experience, involving the destruction of a book, would hardly appear to be a harbinger of his later bibliophilia. In the next sentence, however, a reversal of meaning occurs, one that deflects from this first recollection: "Or rather, I had recognized that the childhood scene was a 'screen memory' for my later bibliophile propensities."[97] In a footnote, Freud refers to his paper "Screen

Memories," published in 1899. Contrary to the usual psychoanalytic reliance on originary explanations, he there defines screen memories primarily as indifferent *earlier* memories that mask emotionally charged *later* ones.[98] In keeping with this emphasis, Freud mentions in the "Botanical Monograph" dream that his book-buying habits in adolescence had led him to contract a debt from which his father had rescued him. This memory was revived when he spoke with Königstein about his hobbies.[99] This train of thought is what leads Freud to observe, in the passage cited in full above, "I shall not pursue the interpretation of this dream any further."

Between its introduction in the section on indifferent and recent material and its later reappearance in discussions of condensation and displacement, the "Botanical Monograph" dream also appears in a portion of the text devoted to "Infantile Material as a Source of Dreams." Here Freud notes that experiences from childhood can play a part in dreams "whose content would never have led one to suppose it."[100] As an example, he refers to a dream allegedly by a "colleague," but in actuality one of his own,[101] involving an odd scene in which he treated the Arctic explorer Fridtjof Nansen (1861–1930) for an attack of sciatica. Freud notes that an event from childhood "made the dream intelligible. One day, when he was a child of three or four, he had heard the grown-ups talking of voyages of discovery and had asked his father whether that was a serious illness. He had evidently confused 'Reisen' [voyages] with 'Reissen' [gripes], and his brothers and sisters saw to it that he never forgot this embarrassing mistake."[102]

Freud then turns back to the botanical dream and the fact that he "stumbled upon the childhood memory of my father" and the destruction of the book with colored plates (the title of which he recalls as *Reise in Persien*):

> It may perhaps be doubted whether this memory really had any share in determining the form taken by the content of the dream or whether it was not rather that the process of analysis built up the connections subsequently. But the copious and intertwined associative links warrant our accepting the former alternative: cyclamen—favourite flower—favourite food—artichokes; pulling to pieces like an artichoke, leaf by leaf (a phrase constantly ringing in my ears in relation to the piecemeal dismemberment of the Chinese Empire)—herbarium—bookworms, whose favourite food is books. Moreover I can assure my readers that the ultimate meaning of the dream, which I have not disclosed, is intimately related to the subject of the childhood scene.[103]

This last observation would appear to contradict what Freud had said only a section earlier, where he described the childhood memory as a "screen

memory" for his later interest in books. Here the reverse is being suggested: the ultimate meaning of the dream has to do with the earlier memory, which follows in a direct line of associations from the botanical monograph seen in the store window. He will not reveal the connection but assures his readers of its veracity. To fill this void have come the various commentaries noted above, most assuming that the latent content concerns a prohibited early sexual wish.

Attempts to establish the identity and meaning of the text called *Reise in Persien* have proven inconclusive. Peter Schwenger's reading of the "Botanical Monograph" dream stresses the power of the abstract notion of "the book" as it is threaded through Freud's narrative—the volume that he saw in the shop window, his work on cocaine, the book torn up in childhood, and, of course, *The Interpretation of Dreams* itself.[104] Schwenger suggests that the text on Persia may have existed only in Freud's imagination, citing the conjectures of both Grinstein and Elizabeth Grosz that the childhood scene of ripping the book may never have occurred. Grinstein considers its function to be allusive and points out that "pulling out" and "breaking off" were terms for masturbation.[105] Grosz regards it as a screen memory for Freud's later encounter with his childhood Bible, which she takes to rest on an equivalence between the book and the mother's body, resulting in "an epistemophilia that betrays its incestuous origins."[106]

Lydia Flem, on the other hand, does propose a specific identification of the text,[107] citing an article by Jean Fourton, who claimed to have located a copy of it in the Vienna City Library.[108] Fourton believes that Freud's memory concerns a book by the German Egyptologist Heinrich Brugsch (1827–94), *Reise der K. Pruessischen Gesandtschaft nach Persien 1860 und 1861*, published in 1862-3.[109] Flem, who tempers Fourton's categorical attribution by stating that Brugsch's is "probably" the book in question, characterizes the destructive act initiated by Freud's father as a "troubling experience," but again only in a sexual sense: "the happiness of transgression, touching what must not be touched: the book and the other sex. Page and flower." [110] She makes this equivalence even more explicit: "The feeling of crumpled pages under his fingers, the bright color of torn pictures, the exhalation of an equivocal shredding: his father's invitation authorizes and erotizes the games of coming to know. What is written is sexual."[111]

This privileging of young Sigismund's acts of "deflowering," however, deflects our attention from the content of the "Persian" book and its possible relevance to Jacob Freud. Neither Fourton nor Flem asks why Brugsch's book would have been in the Freud household in the early 1860s, apparently believing this question to be irrelevant compared to the psychic meaning of its physical destruction. In my view, however, Fourton and Flem are mistaken in

their identification of the torn text on Persia.[112] Once it is correctly attributed, it allows us to discern issues in Freud's early life that would otherwise remain below the horizon of an inquiry into this memory. This is not to suggest that the memory has no libidinal meaning, but simply that it cannot be read *a priori* as a signifier of infantile sexuality. As we have just seen, to insist on this reading has the effect of making the actual content—and, for some, the very existence—of the book destroyed by Freud and his sister irrelevant.

To be sure, Fourton did seem to track down a text that would confirm the veridical nature of Freud's memory. It militates against Brugsch's volume that it should have appeared when Freud was a year or two older than he was in his recollection, yet it was one of the first and best-known nineteenth-century German accounts of traveling to Persia. Although Brugsch's name is not well known today, he was a person of considerable stature in his day.[113] Freud's library had at least one of his volumes—*Die Aegyptologie: Abriss der Entzifferungen und Forschungen auf dem Gebiete der aegyptischen Schrift, Sprache und Alterthumskunde* (Egyptology: Outline of the Decipherments and Researches in the Field of Egyptian Writing, Language and Ancient Studies)[114]—and it is thus quite possible that he could at some point have become familiar with the same author's book on Persian travels. If that were so, however, it seems strange that Freud did not refer to this text directly.

But the attribution to Brugsch is challenged not only by its date of publication but also by the many botanical references in the course of the associations that lead to Freud's statement about the relationship between the manifest content of the dream and its "ultimate meaning." A more probable candidate for the honor of having been the book destroyed by Freud is one that was (and is) far less known: Fedor (Friedrich) Buhse's *Aufzaehlung der auf einer Reise durch Transkaukasien und Persien gesammelten Pflanzen in Gemeinschaft.*[115] Published in 1860, several years earlier than Brugsch's work, this book would have been available in Freud's fifth year. But what speaks most strongly in favor of Buhse's book as having been the volume of Freud's childhood is the fact that it is an illustrated botanical monograph.

Buhse (1821–98) was born in Riga and conducted botanical expeditions under the auspices of a number of European institutions. Published in Moscow, the 1860 book was a translation of a work that had first appeared as a volume of the Russian Imperial Society of Naturalists, suggesting the elision of flora and empire that Casid's work so deftly illustrates. A long-time resident of Persia, Buhse is best remembered for identifying a gum resin found there and along the southern shore of the Caspian Sea as galbanum, a plant known since biblical times. Cited in Exodus 30:34–35 as *chalbenah*, it was used in the production of incense; later, in the Islamic world, it was believed to have various therapeutic properties, from being a cure for skin

diseases to an ingested expectorant. Buhse and his French colleague Edmond Boissier (1810–85) are credited with initiating the plant's exportation to Europe as a pharmacological product in about 1850.[116] The lumpy and heavy-smelling resin could be diluted in alcohol to produce a substance that was marketed in the West in a variety of ways.

By 1851, the Czech-born chemist Heinrich Hlasiwetz (1825–75), working in Austria, had conducted experiments with distilled galbanum, first publishing on its properties in 1851. Ten years later, the year in which Freud and his sister tore up the book, Hlasiwetz published "Über das Galbanum" in the annals of Vienna's Academy of Science.[117] By then, he had been appointed to a new professorship—in "Chemical Technology of Inorganic Matter"—at what is now Vienna's Technical University.[118] He is credited with synthesizing resorcinol, a galbanum compound with a brilliant blue color that could be used as a dye both in the laboratory and in consumer products; indeed there had been courses on cloth dyeing in the curriculum of the "TU" since the beginning of the nineteenth century.[119] Galbanum also became a staple of printer's ink, making the use of various colors possible, and ultimately moved from its plant-based origins to a various of chemically produced resorcinol derivatives.[120] Although Buhse's work stimulated the exportation of galbanum to Russia and Western Europe, it had its greatest financial and chemical viability due to Hlasiwetz and his students during the 1850s and 1860s in Austria. A book published in Moscow about Persian plants, including marketable resins associated with dyeing, would not, therefore, be such an oddity in Vienna at this time.

In his dream, Freud observes himself turning over a folded color plate. This gesture eventually leads him to the early memory involving his father and sister. Both Brugsch's and Buhse's texts have a folded color plate, a map that charts the author's travels. But just as Buhse's work is literally a botanical monograph, so too it contains a legend displaying a shortened version of the book's title, which happens to be the exact phrase recalled by Freud: *Reise in Persien.*

This is where his childhood memory of confusing *Reisen* with *Reissen*—evoked by the dream about the explorer Nansen's illness—finds resonance. Perhaps the word *Reissen* carried an additional meaning for young Freud, as this term was frequently used for the act of tearing something up, including pulling pages out of a book.[121] In destroying the map, Sigismund may have been enacting both aspects of *Reisen/Reissen*: eliminating the visual record of a journey, as well as expressing the pain arising from his own childhood dislocations. Anzieu proposes that the incident of the misheard word dates to the period just prior to his family's departure from his birthplace of Freiberg: "the verbal confusion was probably connected with the preparations for a

Figure 5.2 Folded color plate: *Reise in Persien*, in Fedor Buhse, *Aufzaehlung der auf einer Reise durch Transkaukasien und Persien gesammelten Pflanzen in Gemeinschaft* (Moscow: W. Gautier, 1860). Courtesy of: Library of the Arnold Arboretum, Harvard University, Cambridge, Massachusetts, USA.

long journey (*Reisen*) which his parents discussed in front of him, and with the suffering (*Reissen*) that the prospect of leaving Freiberg must have caused him."[122]

Freud offers the richest account of his earliest life in "Screen Memories," albeit in the guise of a vignette about someone else. As discussed in Chapter 3, he recalls having spent his first three years in Freiberg, a world of verdant landscapes and ostensible financial security. He describes the family's uprooting from Moravia as involuntary:

I was the child of people who were originally well-to-do and who, I fancy, lived comfortably enough in that little corner of the provinces. When I was about three, the branch of industry in which my father was concerned met with a catastrophe. He lost all his means and we were forced to leave the place and move to a large town. (312)

It is at this juncture that he recalls that striking observation, noted earlier here, that "Long and difficult years followed, of which, as it seems to me, nothing was worth remembering."

If the book-tearing episode associated with the "Dream of the Botanical Monograph" took place during Freud's fifth year or thereabouts, then that makes it among his earliest recorded recollections of life in Vienna; he recalled a parade for the centenary of Schiller's birth, in 1859, but offers no details.[123] The memory of the book on Persia pierces the veil of amnesia that descended upon his first years in the city. Although Freud in middle age would write wistfully in "Screen Memories," "I never felt really comfortable in the town," his relationship with the city was considerably more complex.[124] The expanding Freud family lived in a number of residences during their first years in the Austro-Hungarian capital.[125] At the time of the book-tearing incident, they probably occupied an apartment in the third district, across the Danube canal from Amalia's parents.[126] Sigmund Freud's son, Martin, recalls that his grandfather was always in "dire financial straits."[127] As late as 1884, Freud wrote to Martha Bernays of running into his father on the street, "still full of projects, still hopeful."[128] Jacob may have gotten financial support, as noted earlier here, from both the Nathansohns and his own two adult sons from his first marriage, who had emigrated to England when he took his family to Leipzig; in Freud's letter to Martha, he went on to say that he must reprimand his half-brother Emanuel for not providing better for their father. In addition to whatever subventions he received, Jacob may have sought out business "projects," perhaps with his brother Josef and his older sons.

It can be argued that Jacob Freud acquired Buhse's book in an effort to learn more about plant materials, notably galbanum, that were associated with innovations in the use of dyes in Vienna—an activity that had been part of his livelihood in Moravia. The first Freud family residence, as discussed in an earlier chapter, was in a large apartment block directly across the canal from the Nathansohns' home, and may have contained a distillery, as noted in Chapter 3.[129] Perhaps Jacob hoped to process galbanum, which required distillation in alcohol, as he and his family transitioned to this new, urban setting; indeed, such an undertaking would seem in line with other such "projects" that continued to define his failed attempts to establish himself economically in Vienna. That said, it may have been predicated on his sense of having some expertise in this area, as he had dealt with naturally dyed wool products in his son's birthplace. Jacob's residency applications there stated that he "bought wool in Freiberg and its environs and had it dyed and finished in the locality and despatch [sic] it as merchandise to Galicia."[130] But the organic dyestuffs in these village workshops and homes were being increasingly transformed throughout Europe, including in the Habsburg lands, both in chemists' laboratories, such as that of Hlasiwetz, as well in large textile factories, including those producing printed cloth in Vienna.[131] Jacob Freud certainly was faced with the prospect of making a living in a

new city, and thus may have hoped to use his familiarity with colorants and dyes to make that possible. It is also worth noting here that his eldest sons, Emanuel and Philipp, were by then settled in Manchester, at that time among the most active centers of dye production in Europe, as it served the city's vast cloth industries.[132]

Georg Augusta, in doing the most in-depth archival work to date on Jacob Freud's professional activities during his son's childhood, has found his name on various business registers, with his consist characterization of himself as a wool merchant. But this took on various guises for him, including a rather short association with a firm specializing in *turkisches* or *orientalische Kappen*—("Turkish/oriental caps," i.e., fezes) and other wool products.[133] The fez was worn in parts of the Austro-Hungarian Empire, notably in Islamic Bosnia, but also in Jewish and certain Christian communities in the Balkans. While such caps were often fabricated and dyed in Vienna, there were other Habsburg locales that specifically focused on their production, notably in Moravia and Bohemia. The "World Exhibition" (*Welt-Ausstellung*) held in Vienna in 1873, as Freud was completing his gymnasium studies, included a display of *Kappen* that featured those made in Freud's birthplace. The firm of Russo and Finzi in Freiberg had products on view there,[134] having acquired the company from a family who had a factory there since the Freud family's residency. In an interesting postscript, Finzi and Russo would eventually sell out to Ignaz Fluss, who ran a hat manufacturing business in Freiberg and whose family was close to the Freuds.[135] Thus, Jacob may have hoped to parlay his knowledge of such fabrication and dyeing in Vienna, where Finzi and Russo had their offices (although we have no evidence that Jacob Freud was employed by them). His interest in such products may suggest one reason why a book on Persian plants, known to be used for dyes, may have made its way into Jacob Freud's possession.

Judging from Jacob's financial straits through his son's childhood, if any of these short-lived ventures did occur, they did not appear to meet with success. This would explain his strange behavior with an expensive book. His children were to tear apart an object that was no longer of any value to him and would have served, in its intact state, as a reminder of yet another forsaken scheme. The younger Freud may not have wished to expose the story in *The Interpretation of Dreams*, as it obviously created a very different portrait of his father from that of the generous (and presumably prosperous) man who later saved his son from financial humiliation at the hands of the bookseller.

It is also possible that Freud associated the book on Persia with more than a failed business prospect and that his memory, prompted by the dream, returned him to activities involving his family that had crossed over into

criminality. Freud remembers his action with the book as a tearing out of the pages leaf by leaf. When he speaks of his father's intention, however, he specifies that his father turned the book over to the children to be destroyed (*zur Vernichtung*). This word can refer to the willful destruction of a document, including criminal evidence, hinting that its possession, assuming that it is Buhse's monograph, may have been intended to learn about plant colorants for purposes that needed to be forgotten. The specter of illegal activity in the Freud family during this period is heightened by events involving Jacob Freud's brother Josef, whose arrival in Vienna in 1861 coincided with Freud's fifth year. Josef's presence is documented in court records of February 1866, when there were proceedings against him for "the circulation of counterfeit ruble notes."[136] The *Neue Freie Presse*, the newspaper that Sigmund Freud would read throughout his adult life, first reported the arrest of two suspects in late June 1865. The trial, eight months later, was also publicized in the Viennese press, which gave the names of Josef Freud and his accomplice, Osias Weich, and detailed the activities leading up to their arrest. Josef had been apprehended first, after selling counterfeit rubles to a member of the police. He confessed to having approached a business agent named Simon Weiss and solicited his help in finding a buyer for his forged notes. Weiss feigned interest, but reported the conversation to the police, who then set up a "sting operation" to entrap Josef Freud. After the ensuing arrest, according to the account in the *Neue Freie Presse* on February 23, 1866, he named Weich as the source of the money; in a countercharge, Weich said that the money had originated with Freud, "whose family lives in London," and who had used him "so as to be able to designate someone as the provider of the counterfeit money."[137] The court found neither story convincing, and both defendants received the maximum sentence requested by the prosecution, ten years in prison.

Jacob Freud is not mentioned in any of the above documents, but he does appear, unnamed, in an official document written between the time of Josef's arrest and his trial. In October 1865, a memorandum from the Austrian police minister Richard Belcredi to Count Mendorff, the foreign secretary, reveals more specifics about the case. The final paragraph is particularly relevant to Jacob Freud's family:

> Like the others, this third case leads one to believe that the real source of the counterfeit money is in England. This seems borne out by two highly suspicious letters sent from England by two sons, currently living in Manchester, of a brother of Josef Freud's. In one of these letters we are told that the brother's sons have as much money as there is sand in the sea and that, since they are being wise, clever, and circumspect, fortune

will not fail to smile upon them. In another letter, they ask him [Josef Freud] whether the good star of the Freud House has risen for him as well; they go on to ask him to find a bank for the merchandise where the turnover would be larger, faster, and more profitable.[138]

It is impossible to ascertain when Josef Freud or, by implication, Jacob's sons Emanuel and Philipp became involved in counterfeiting, whether they were only involved in disseminating forged money or in its production—processes that would require printing ink and, in many cases, colorants. The Russian Imperial Bank had been established in 1860 and production of paper currency, featuring several hues, had become more robust there and thus the demand would have increased just at this time.[139] Nor can one implicate Jacob in these activities, although evidence indicates that Jacob had business dealings with his brother before he arrived with his family in Vienna. Documentation places Josef in Leipzig at various times; Osias Weich was cited as having passed bad notes there "several years" before his conviction. One wonders if questions raised there about Jacob's "past" may have involved a connection with his brother and his brother's business associates. Prior to his move to Vienna, Josef was a long-time resident of Moldavia; Jacob Freud, in his petition for residency in Leipzig, named this area as a place, along with Russia, where he traveled frequently for business. Although Jacob Freud never visited his sons in England, records contemporaneous with the trial note that Josef, since moving to Vienna in 1861, had "made three trips to London, Manchester, and Birmingham."[140] In Moldavia, Josef listed his occupation as selling English "hardware," although it is not clear what business, if any, he had with England after settling in Vienna.

It is Sigmund Freud who offers us the only tangible insight into the impact of Josef's criminality upon his father. This record is contained in the associations surrounding another dream, "Uncle with the Yellow Beard," which Freud dates to February 1897; it is noteworthy that his uncle Josef died soon afterward, on March 5. In the dream, Freud relates, "my friend R. was my uncle" and "I had a great feeling of affection for him."[141] This is followed by the image of his friend's face, "somewhat changed." Freud recalls that "a yellow beard that surrounded it stood out especially clearly." The dream sequence consisted of these two thoughts, each accompanied by an image. Freud limits his analysis to the first dream thought, concerning his friend; the second, as well as its accompanying picture, he says, "I shall pass over." Of the first portion, he goes on to ask:

> What could that mean? I never had more than one uncle—Uncle Josef.[142] There was an unhappy story attached to him. Once—more than

thirty years ago—in his eagerness to make money, he allowed himself to be involved in a transaction of a kind that is severely punished by the law, and he was in fact punished for it. My father, whose hair turned grey from grief in a few days, used always to say that Uncle Josef was not a bad man but only a simpleton; those were his words.[143]

The dream had occurred hours after Freud had a conversation with Königstein, the ophthalmologist, who had also figured in his associations to the "Botanical Monograph" dream. Both men were candidates for university appointments; Königstein's nomination had languished for so long that he initiated a meeting with a member of the Ministry of Education to look into whether the delay was the result of "denominational considerations."[144] He reported to Freud that the encounter left him with clear confirmation of his suspicions. Like Freud, his "friend R.," Königstein, had a graying beard— an attribute the two men shared with Freud's father. Jacob's beard became white virtually overnight as the result of his distress over Josef's arrest. Legal action as a blot on one's record also appears in Freud's commentary when he mentions "N.," another colleague, whose appointment was complicated by his involvement in an earlier court proceeding. N. had related his legal woes to Freud a few days before the dream, at which time he had assured Freud that such an incident would never haunt him, as Freud had "an unblemished character."[145]

Freud interpreted the "Yellow Beard" dream to mean that one colleague, N., was a criminal, while the other, R., a simpleton; both attributes, it would seem, also pertain to Uncle Josef. The visual image that accompanied this portion of the dream combined features of R. with those of Uncle Josef, suggesting the kind of "composite photograph"[146] Freud associated with the work of Francis Galton (1822–1911). Although Freud does not elaborate on Galton, among his featured subjects were Jewish males and criminals,[147] both categories directly relevant to the dream and to the three male members of the Freud family associated with it. As Freud continues his explanation, he uses a strategy to which he resorts again in the "Botanical Monograph." He claims that he "had naturally never had any feeling of affection" for his Uncle Josef and that the positive affect did not belong to "latent content," but "stood in contradiction to it and was calculated to conceal the true interpretation of the dream."[148] Much about this "true interpretation" remains mysterious; Anzieu notes that "Freud felt a strong resistance against interpreting this dream."[149]

The legal proceedings against Josef Freud and their ramifications for his nephew's career are certainly at issue in this dream in which his uncle appears, both in what Freud reveals and in what he conceals. In light of our

present knowledge of the Freud family's circumstances in Sigmund's early years, it seems increasingly plausible that the memories of Jacob's business failure and the suspected criminal activities of Freud's half-brothers—and perhaps extending in some ways to his father—contributed to Freud's fears for the advancement of his own career in the late 1890s. These concerns in all likelihood underlie the botanical monograph dream as well, in which the shame at being exposed as an unwitting accomplice in Jacob's business failures in the otherwise perplexing destruction of an expensive book whose presence in the Freud household may have gestured to activities that were not only unsuccessful but illegal.

The connection between these family travails and Freud's dream with its hallmark of "indifferent content" becomes more persuasive when the layers of usage associated with the word *Blühten (Blüten)*—having to do with flowers and things botanical—are also considered. The source for this etymology is Daniel Sanders's *Wörterbuch der deutschen Sprache* of 1860, the same dictionary that Freud (1919) consulted for his discussion of the antithetical definitions of *heimlich* ("belonging to the house") in his essay "The Uncanny" *(Das Unheimliche)*.[150] The entry for *Blühten* reveals that, in addition to the more common association with flora, it is used in the "language of criminals" as a term for the production and distribution of counterfeit money.[151] Given that this is the case, Freud's repudiation of the "botanical element" becomes increasingly significant. The memory of the childhood experience with the book combined with the multiple meanings of "flowers" may have produced feelings of shame and anxiety that resulted in the disclaimers that run through Freud's discussions of the dream. By evoking the language of "manifest content," he is able to relegate this imagery to the same region to which he banishes his first memories of Vienna; in both instances, the reader is informed that there is nothing here worth remembering.

The reading of content as bifurcated from meaning enables the most significant material "specimen" in the dream—that of illustrated books, be it in a bookstore window, in his dream, and in his associations to childhood—to be hidden in plain sight. And while we are instructed by the enunciation of a prediscursive psychical mechanism to disregard them, indeed, perhaps the most profound thing is in striking contradiction to that: the "Botanical Monograph" dream is in fact *about* botanical monographs. Freud reveals two of them, and the other, his book on Persian travels, can be convincingly argued to make this a triad. How then do we locate these texts and the affective dimensions associated with them, as introduced here, as part of psychoanalytic "meaning?" The dream work as Freud puts forth in *Die Traumdeutung* mediates the day residues through mechanisms that return them to memory as "hallucinatory." Thus, their origin point

becomes melded to unconscious processes, any psychical efficacy derived from the experience of these objects, as material phenomena, is rendered inconsequential.

By reclaiming some of the territory relegated to that which is not latent we have been confronted through this book with affectively powerful "content"—as we saw in earlier discussions of Freud's "Oedipal" memory or of the writing on the Signorelli experience—that share, with the reading of his "Botanical" dream, a revelation of Freud's vulnerability, as child and adult, to the vagaries and inequities over which he had little control. If his structuring of internal processes could place desires and wishes as the defining agents of one's subjectivity, then we are offered an obviously contrasting narratological trajectory. In the case of dreams, in revisiting the latent as the primacy of the power accorded to the dream as wish, a privileging of the making of the manifest allows us to inquire as to where the "wish" is actually located. What if we were to posit that the ways in which Freud framed his articulation of the structure of the dreamwork was itself a wish, one that preceded any identification of a mechanism that would then go on to reflect his desire to shape his self-presentation and, more broadly, the location of value and worth of experiences? And that wish was also constituted by what was to be disavowed, erased—that is, not wished for, before it became absorbed into the totality of what appeared as the dream work; but actually it was how, for Freud, the dream *needed to work*. In suggesting such a way to read *Die Traumdeutung* as what Freud allowed to reach interpretation, one is able more readily to define his construction of the unconscious by its borders and limits; this operation also invites the possibility of seeing this formation as one necessitated by the absence of that which was to be beyond, and before, the terrain of psychical meaning.

The case can be made that not only is there a prehistory to Freud's interpretative schemata for dreams but that *The Interpretation of Dreams*, as a "dream book," also had its own predecessors. As mentioned at the beginning of the chapter, there was in fact another well-established type of literature that purported to give meaning to what was recalled from sleep. True, this genre was strikingly dissimilar to Freud's book; the former were modest booklets sold alongside lottery tickets in tobacconists' shops. Their popular and ephemeral quality has certainly accounted for their absence in studies of Freud's arguably far more substantive volume. There is another point of marked contrast, one that deserves acknowledgment: these popular dream books would elevate Freud's hallucinatory residues—dream images— to unquestioned primacy. Such texts proliferated in fin-de-siècle Vienna (and well before), surely always outpacing the sale of Freud's volume. Yet, as these so-called "Egyptian dream books" appear to inhabit the surface, the

street, they would seem as inconsequential as the manifest content in whose power they staked their claims of interpretation. Freud was certainly aware of these booklets—he speaks disparagingly of them in his book—and we risk ignoring an important chapter in his construction of dreams if we do not to accord them a place in our understanding of *Die Traumdeutung*. Although they are virtually forgotten now—Freud certainly had the last word on which Viennese dream book would survive into posterity—they are strikingly ideological documents, reinscribing ethnist and gendered stereotypes, all the while naturalizing these "meanings" as they seemingly arrived in sleep. The anti-Semitism that thwarted Freud, contributing to his disdain for Vienna by the 1890s, was very much in evidence here, and one cannot help but see how the processes of dreaming became a mirror for the politics that shaped Freud's daily life. This may have also contributed to an intentionality in his structuring of the dream work that would manage the imagery of the dream in a way that countered the ominous aspects of visual culture circulating around him.

As we saw in the previous chapter, the topics in the chapel beside the Signorelli panels in Orvieto were drawn from tales and popular stereotypes that were authorized through visualization of Church doctrine. These paintings rendered categories of persons as abject and threatening, sanctioned as such by their place within both the ecclesia and the Duomo, with its proximity to Bolsena, where, with its relic ensconced there, this chapel became an extension of the site of a miraculous event. The wall paintings' effectiveness, in both chapels, relied on popular attributes—facial features and skin tone, clothing, symbols, modes of habitus—that would readily distinguish, using common visual tropes of difference, members of the Church from their enemies. This public consumption of anti-Jewish imagery had a troubling parallel in what would seem an unlikely place in Freud's Vienna—in a popular form of literature that focused upon the visual imagery of dreams. Here we will introduce a form of public media that Freud will counter in his denigration of the dream's visual content. Although these inexpensive pamphlets may have proven less enduring in the literature of dreaming, the naturalization of the anti-Semitic (and, to a lesser degree, anti-Islamic) imagery that it produced must be reckoned as far from inconsequential: its content participated in the proliferation of hatred that reached its apogee in the catastrophes to follow, and would ultimately result in Freud's forced departure from a place whose presence had itself been a disavowed surface within his psychoanalytic project.

The realms of the phantasmagoric have long circulated around dreams, and Freud certainly imagined his work as instilling empirical meaning into an activity—dream interpretation—that was in his own time widely practiced in quite a different register. One need only compare the austere cover of *Die Traumdeutung*, whose design followed the common precedent for scientific works of the day, with those claiming a similar intention, yet resplendent with images of wizards and esoterica.

Figure 5.3 Cover, *Stock's kleines Persisch-Egyptisches Traum-Buch*. Vienna: Leopold Kutschera, n.d. [*c.* 1910] (Collection of the author).

One can scarcely imagine a subject whose presentation would cloak itself in two more differing raiments, but it is important to recognize that "magic" had a role in Freud's thinking about dreams as well; in fact, as we will see, it was present in his thinking about the functioning of dreams from the very beginning, in the early 1890s, when he first wrote of dreams in an entry on "amnesia" for a medical compendium.[152] Thus it is also important, in this genealogical discursus of the Freudian manifest, to include an examination of *The Interpretation*'s theurgical beginnings.

On April 9, 1866, Theodor Gomperz, a well-known Viennese philosopher and classicist, delivered a lecture at a symposium in his native city of Brünn (Brno), then one of the German-speaking centers of Moravia, now a part of the Czech Republic. His presentation, entitled "Traumdeutung und Zauberei: Ein Blick in das Wesen des Aberglaubens" (Dream Interpretation and Magic: A Look at the Nature of Superstition), suggested commonalities between practices presented as dichotomous in the cultural discourses of mid-nineteenth-century Europe.[153] Inquiries into the meaning of dreams had deep roots in both biblical and classical traditions, while *Zauberei*, also translated as "sorcery," was frequently used in colonialist literature to distinguish—and disparage—modes of thinking situated beyond the influence of these Western legacies. Gomperz challenged this opposition by casting dream interpretation in a new light, calling into question whether it could in fact be differentiated from "magical thinking."

For all its provocation, the lecture, published later that year as *Traumdeutung und Zauberei*, began conventionally enough, as Gomperz offered an overview of writing on dreams in antiquity, followed by a detailed discussion of Artemidorus of Daldis (second century CE) and his *Oneirocritica*, the oldest extant example of a "dream book." The classicist from Vienna offered a deft synopsis of this work and its author that highlighted Artemidorus's roots in Ephesus and Lycia, and his advocacy of a method of decipherment that relied on the interpreter's consideration of both the content of the dream and the status or circumstances of the dreamer. Gomperz did not cast Artemidorus in the role of a philosopher or person of science, but depicted him among "ordinary people ... in the streets and markets," where he would "interpret dreams for small sums of money."[154] He went on to deride the rise of charlatans and "swindlers" such as followers of the mystical practices of Pythagoras, and ended this section with a warning about "how narrow the borderline between truth and belief, between knowledge and superstition, had become!"[155]

Gomperz turned next to the realm of *Zauberei*, the defining feature of which he identified as a mistaken relationship between an object and its image. The examples of this "magic" that he went on to cite—effigies of animals

created by the Algonquin nation to enhance their hunting, dolls from India made in the image of those wished harm, and Thai clay puppets into which a patient's disease was cast—were all taken from the section on "theories of magic and sorcery" in Edward Burnett Tylor's disturbing *Researches into the Early History of Mankind and the Development of Civilization*.[156] In the colonialist discourse of disparagement, Tylor identified these practices, from current and historical sources, as characteristic of "races at a low mental level"[157] and used them as evidence of the cultural determinism he espoused, applying Darwin's evolutionary model to contemporary human populations. One of the most striking distinctions in this racist developmental process was, as Gomperz wrote, paraphrasing Tylor, between "civilized philosophy" and a mode of thought that made no distinction between what was conjured in the mind and what was "real."[158]

Then came the question that Gomperz had been building up to: was this not also the approach of Artemidorus? Gomperz mused on the ways that divining meaning about an external circumstance—here, another's dream—according to what it conjures in the mind of the interpreter should be acknowledged as virtually identical to the practices cited by Tylor. This suggested to Gomperz that the boundary between ancient dream interpretation and what in his time was identified as "magic" was tenuous indeed, and that a true understanding of dreams would require a new, more "scientific" method. His assertion called into question the classical tradition that had been so thoroughly assimilated into nineteenth-century intellectual life and formed the basis of the German model of gymnasium education. *Traumdeutung und Zauberei* concluded with the reminder that although science purports to refute it, superstition has been woven into the fabric of our cultural legacy. It was important to recognize this, Gomperz warned, if we were ultimately to "conquer the territory of the spirits."[159]

Ten years old at the time of Gomperz's lecture, Freud had spent his first three years in a town about seventy-five miles north of Brno. For all the later rhetoric surrounding his "discovery" of the meaning of dreams—no small amount, as noted earlier, generated by Freud himself—it is well to remember that a call for an empirical "conquering" of the realm of dream interpretation already resounded in the air of his childhood. Decades after the presentation of "Traumdeutung und Zauberei," Freud, while writing his own *Traumdeutung*, came to know Gomperz and his family. Indeed, Theodor's son Heinrich was one of the first readers of *The Interpretation of Dreams*, and his wife, Elise, was a patient of Freud's.[160] Freud's library held a number of Theodor Gomperz's works and Freud (1907) counted Gomperz's *Greek Thinkers* among texts that he listed in response to a request for his choices of "ten good books."[161]

But it was most likely that *Traumdeutung und Zauberei* had the greatest impact on Freud. The only work by Gomperz that dealt with non-European traditions, it was published soon after its presentation, and its content must have also been part of his university lectures. Writing to Elise Gomperz in 1913, the year after her husband's death, Freud recalled that he was a "young and timid" student when he first met Gomperz, and that soon after that he had "heard from him the first remarks about the role played by dreams in the psychic life of primitive men—something that has preoccupied me so intensively ever since."[162] Although this recollection allows us to date Freud's earliest interest in dreams, it is noteworthy that no mention of Gomperz's paper appeared in the first (1900), second (1908), or third (1911) editions of Freud's *The Interpretation of Dreams*. Not until the 1914 fourth edition did it appear, in a footnote (1900, 98n1) about Artemidorus and Gomperz's equation of the oneirocritic's dream interpretation to magic.[163] The association between *Traumdeutung* and "primitive" belief systems apparently became more compelling for Freud after he published *Totem and Taboo* in 1913[164] and as he continued to make the case for his procedure, which relied on the dreamer's associations rather than the interpreter's, as a scientific process. There, Freud described the secondary revision in dreams as the "prototype" for practices of "animism" that he associated with "primitive peoples."[165] The dream image was thus a vestigial function, akin to magical thinking, whose role in the elucidation of meaning Freud dismissed through recourse to the colonialist rhetoric of primitivism. To value the efficacy of the "dream-elements" was therefore to believe in magic, the very thing touted in the popular dream books.

Although Freud wished to distance his method of interpretation from that of *Zauberei*, there was still magic afoot, and in the very heart of the Habsburg realm. Within a few steps of the rooms in which Freud labored to surpass the limitations of the *Oneirocritica*, numerous descendants of that text flourished; indeed, one of the most popular examples of the "Persian-Egyptian dream books" was printed at a company located at the end of Freud's street.[166] With the exception of Lydia Marinelli's examination of psychoanalysis and popular culture,[167] very little attention has been paid to the relations between *The Interpretation of Dreams* and this rival genre of contemporary dream literature. By interrogating Freud's model of dream interpretation as a cultural formation, however, one can view with much greater skepticism his assertion that it was a "secret" that had "revealed itself" to him at Bellevue. It is also possible to identify what Freud effectively obfuscated by envisaging his method as he did: that both past and present practices of dream interpretation furnished templates for the promulgation of slander and stereotypes, often leveled at Jews. By devaluing, on principle, dream imagery as a dimension of psychical functioning, Freud eschewed

any obligation to address the particular power exerted by such content on the act of interpretation; this foreclosure can be read as a *repudiation* of the potential danger in investing meaning in the imagery of dreams rather than as a revolutionary insight into how the unconscious displaces such meaning. Once Freud had enunciated the concepts of manifest content and latent meaning, however, they quickly acquired the status of immutable realities. Even Derrida, whose critiques have definitively unmasked so many phenomena widely deemed to be "natural" as ideological productions, neglected to deconstruct this pivotal dichotomy, instead granting *a priori* validity to Freud's postulate of the "dream work."[168] He described Freud's dismissal of the manifest in dreams as a justified movement away from content, which had been the "excessive preoccupation"[169] of Artemidorus's *Oneirocritica* and its epigones, the popular dream books of Freud's day. For Derrida, the received focus on images during sleep, with their "insufficient concerns for relations, locations, processes, and differences,"[170] was the stuff of the external world, and thus inconsequential to those processes of displacement and distortion that, according to Freud, occurred intrapsychically. It is a remarkable irony that Derrida's willingness to follow Freud in equating the unconscious with these self-contained mechanisms precluded him from offering a more fully realized critique of the ontologizing mechanisms within Freud's construction of psychoanalysis.

Derrida was, however, one of the few scholars to have anticipated Marinelli in singling out dream books when characterizing Freud's devaluing of subject matter, and there is ample evidence that Freud was aware that his new method of dream interpretation would necessarily place him in an antagonistic relationship to this literature, both past and present. Soon after *The Interpretation of Dreams* was published, in a letter to Fliess, Freud concluded with "thanks for your cooperation in the Egyptian dream book."[171] It has traditionally been assumed that this reference was Freud's way of jokingly comparing his work with ancient texts,[172] but that is unlikely. The phrase "Egyptian dream books" was rarely used for medical papyri related to dreams, and in any case most of these Egyptian papyri did not become known in Europe until after 1900. "Dream books" was, however, a term for the pamphlets sold in Freud's day. In the popular imagination, Egypt was considered the originary soil of mysteries and magic, associations fostered by the imagery of German Romanticism, the rites of Freemasory, and a fascination with the occult.[173]

On several occasions in his discussions of manifest imagery, Freud mentions hieroglyphs, aligning them with his interest in more canonical studies in Egyptology, as noted by Mary Bergstein.[174] The dream content, Freud writes, is akin to early forms of writing in which meaning is "expressed

as though in a pictographic script" that requires translation "into the language of the dream-thoughts."[175] But Freud's interest in Egyptian culture, as clearly evidenced by objects in his collection and titles in his library, takes on a somewhat different coloring when it is seen to intersect with that "other" Egypt of fin-de-siècle fantasy. Freud added another footnote in 1914—the year he first cited *Traumdeutung und Zauberei*—in which he quoted the English physician James Sully, who regarded the dream as a "palimpsest" in which "traces of an old and precious communication" are found "beneath its worthless surface-characters."[176] Freud ratified that duality, equating the hidden meaning of the dream with sanctioned pursuits of antiquity, such as epigraphy and archaeology, and the manifest imagery with "worthless fragments of waking life."[177] In his autobiographical sketch of 1925, he again used the phrase from his letter to Fliess, this time indubitably as a form of disparagement, when he recalled a medical procedure from his early career that was revealed to be "the construction of fantasy" with "no more relation to reality than some 'Egyptian' dream book such as is sold in cheap book-shops."[178] The contemporaneous reference to his "Egyptian dream book" was therefore not intended to enhance the status of his work by giving it an ancient lineage, but was rather Freud's joking way of juxtaposing it with its competitors in the current marketplace of dream literature.

Self-deprecating humor aside, it was important for Freud to situate his dream book within a reputable genealogy of the genre. The first edition of *The Interpretation of Dreams* mentions Artemidorus on several occasions as part of an overview of the ancient method of decoding dreams. His predecessor's procedure relied on a "key" that correlated specific images in a dream with their predetermined meanings; Freud favorably contrasted this approach with the exegesis of the overall content of "symbolic dreams"[179] found in the Bible. But he observed that the greatest problem with the decoding tradition was the "trustworthiness of the 'key'—the dream book."[180] He nonetheless credited Artemidorus with a method that—as Gomperz had also noted—did not focus exclusively on "the *content* of the dream but also the character and circumstances of the dreamer"[181] (italics added). Freud praised this classical approach for being superior to contemporary dream books that relied solely on the "purely mechanical character" of a fixed inventory of dream topics and their corresponding meanings.

But though Freud mentions Artemidorus several times in the first edition of *The Interpretation of Dreams*, he does not discuss any specific examples from the *Oneirocritica*, as he did from the Bible—an omission that led Wolfram Kurth[182] to infer that he may not have read the work by 1900.[183] In a footnote added to the 1911 edition, Freud cited "the nicest instance of dream interpretation which has reached us from ancient times," one based

on "a play upon words," a feature he identified as significant in determining the "dream-elements."[184] He had first introduced the observation about word play two years earlier, in a footnote dated 1909, where he noted that this linguistic feature of dreams was already known in antiquity and took the opportunity to separate those early dream books from the ones in current use, disparaging the latter as "wretched imitations."[185]

The passage Freud added from Artemidorus recounts an incident from Plutarch's *Life of Alexander* in which the king consulted an oneirocritic about his dream of a "satyr dancing on a shield." The dream occurred during the long and discouraging siege of Tyre, and the interpreter understood that the appearance of a satyr—*saturos* in Greek—was a verbal rather than visual sign: *sa Turos*, meaning "Tyre is yours." Alexander was thus encouraged "to press home the siege so that he became master of the city."[186] Artemidorus may have selected this example as a gesture to his book's patron, the philosopher Cassius Maximus, who was also known as Maximus of Tyre.[187] Freud, in his *Introductory Lectures*, would return to this dream, contending that its underlying assumption—that the dream's visual imagery often results from a linguistic source—was "undoubtedly the right one."[188] By 1911 he certainly would have read the passage that directly preceded the satyr-on-a-shield story, which contained the first example that Artemidorus offered for the importance of word derivatives in dreams:

> [A] certain military commander dreamt that the letters i, k, and q were written on his sword. The Jewish war was being waged in Cyrene and the dreamer gained the highest distinction in that war. This was just what I predicted. For the *iota* signified the Jews, the *kappa* signified the Cyrenaena, and *theta* signified death. Before the actual event, the dream was impossible to interpret, but, once it actually came true, the interpretation was quite obvious.[189]

It is noteworthy that although Freud goes on to discuss Jewish resistance to Rome in a further chapter of his text, he never mentions this dream.[190] The "Jewish war" referenced here is the uprising begun in the autumn of 115 CE, fueled by defiance of polytheism and resistance to escalating Roman taxation of a well-established Jewish community in an old Ptolemaic city in present-day Libya.[191] Initially, the Jewish residents were successful, and numerous Greek and Roman temples were destroyed. As the Jews attempted a similar campaign against Alexandria, however, they met with defeat and brutal retaliation. The contemporary chronicler Dio Cassius, in his *Roman History*, contended that the Jews were decimated after the rebellion;[192] indeed, references to their once-vibrant communities virtually disappear

from Egyptian and Libyan sources after 117 CE.[193] These events occurred in Artemidorus's lifetime, and the interpretation of this dream appears to be his own. The dreamer in the story, who has not been conclusively identified, must have been killed at the beginning of what the Romans termed this "*tumultus*," when Jewish resistance was most formidable.[194] The atmosphere of the Hellenic world of this period, rife with anti-Jewish sentiment,[195] was reflected in the writings of Dio Cassius and others. Striking evidence of this sentiment can also be found elsewhere in the *Oneirocritica*:

> A synagogue, beggars, and all men who ask for donations, who lead wretched existences, and who crouch for alms indicate grief, anxiety, and afflictions of the soul for both men and women. This is because no man goes into a synagogue who is not concerned about something and, since beggars are thoroughly repugnant and helpless and there is nothing healthy about them, because [*sic*] they block every course of action.[196]

By Artemidorus's time, the term "synagogue" was widely used to designate the place of Jewish worship and meeting. It appears nearly twenty times in the acts of the apostles, written the century before *Oneirocritica*.[197] The synagogue in Artemidorus's home city of Ephesus was well known; it earned the distinction of an *archisynagogos*, one of the most important of such buildings, and dated from the late antique period.[198] Synagogues were used both for religious services and as community banquet halls and lodgings. Acts of the Apostles also records that non-Jewish men and women visited these synagogues, and it remains unclear how much Jewish missionary activity may have occurred in that context.[199] Artemidorus's pejorative statements would have resonated with his peers, who voiced concern about the populace's attraction to Jewish institutions. This may have fueled Artemidorus's desire to make visiting a synagogue appear as dangerous as possible by suggesting that even dreaming of such an establishment would negatively impact one's fate.

The connection between synagogues and beggars, coded in dream books as related subjects, reflects an association not uncommon in Roman popular culture. Food and lodging were often offered to mendicants in the synagogue precinct, and suspicion of this practice, combined, most likely, with resentment of Jewish prosperity, gave rise to a negative depiction that cast the Jews as beggars.[200] Juvenal, who in his *Satires* "pours the most scorn on the Jews as beggars,"[201] may well have served as a source for Artemidorus's dream-book key, as there is evidence that other interpretations of his were akin in content to the *Satires*.[202] Such connections illuminate the ways in which the ideologies of the day appropriated the realm of sleep and used them to represent widespread prejudices as normative. Thus, one of the

most pernicious aspects of the "decoding" method was its tendency to perpetuate stereotypes by making them the subject of a dream image and reinforcing them with negative associations and fears. That feature continued in the *Egyptische Traumbücher* of Vienna, with their numerous anti-Semitic messages.

This glimpse into some of the material that Freud would have encountered in the *Oneirocritica* may afford us additional insight into his lengthy footnote to Gomperz in the 1914 edition. Even as he credited Artemidorus with bequeathing the "most complete and painstaking study" of dreams from antiquity, he essentially undermined Artemidorus's efforts by noting, as Gomperz had, that his method was "identical with magic."[203] Freud added this footnote five years after one to the same paragraph that dismissed the dream books of Vienna as modern imposters. The contiguity appears not to be accidental, as the "wretched" copies of Freud's time used as their source spurious "lost manuscripts" attributed to Egyptian (sometimes also Persian or Chaldean) "magicians." Freud was thus aligning rival dream books, ancient and contemporary, with forms of *Zauberei*, adding credence to his assertion that, like the biblical interpretation of dreams, the decoding method cannot "be employed for a scientific treatment of the subject."[204]

Armstrong, in his review of Freud's use of Artemidorus in *Die Tramdeutung*, notes that by the time Freud added this 1914 footnote, "things had become more complicated" as a result of Freud's desire to identify with this classical predecessor while contending with the "inevitable narcissism of difference,"[205] but the complication also may be attributed to Freud's increasing awareness of the negative legacy of Artemidorus, an issue that he was to address soon after the 1914 edition of his *magnum opus*. In his section on dreams in the *Introductory Lectures*, Freud decried the fact that since the *Oneirocritica* the practice of interpretation had fallen into decline—that it "gradually sank to a level of superstition and could only survive among the uneducated class."[206] He then went on to address the Egyptian dream books of his day, and the peculiar function that had come to be associated with them. "The final abuse of dream-interpretation was reached in our days with attempts to discover from dreams the numbers fated to be drawn in the game of lotto."[207]

At least ten publishers were producing these texts in Vienna in 1900,[208] and the one that sold most widely, *Stock's kleines Persisch-Egyptisches Traum-Buch*, was, as noted, also a product of Berggasse, printed only a short distance down the street from Freud's residence and consulting room at 19. It is surely no coincidence that the adage Freud cited as embodying the attitude antithetical to his own—"dreams are froth"[209]—is found in the opening sentence of the preface to Stock's book,[210] which had already appeared in numerous

editions—but with seemingly no change—by 1900.[211] There, as in Freud, it is presented as a contention to be rebutted. While Freud traced his lineage to Artemidorus, Stock's dream book embraced a figure whose influence the Ephesian dream interpreter had decried: Pythagoras.[212] In the *Stock's* introductory essay, rather strangely titled "Die Zahl und ihre Bedeutung" (Numbers and Their Significance), considerable weight is accorded the Pythagorean dictum that "number is the measure of all things." The essay is attributed to Moritz Busch, who died in 1899 and was well known as a travel writer and biographer of Bismarck.[213] The relation between dreams and numerology is never elaborated in this essay, which ranges from classical and biblical citations, through excerpts from Busch's writings about his trips to Egypt and Persia, to dates of decisive battles. This pastiche was undoubtedly never intended to appear in Stock's dream book, where the editor's preface notes that Busch's erudition clearly evidences the power of numbers, which will be demonstrated in the pages to follow.

What in fact follows is "Auslegung der Träume sammt Lotterie-Zahlen" (Explanation of Dreams Showing Lottery Numbers). Nearly one hundred pages long, the "explanation" is an alphabetical listing of dream images, from *Aale fangen* (to catch an eel = you will receive good news),[214] to *Zwirn* (thread = you will make a new friend),[215] with each entry followed by one or two numbers ranging from 1 to 90. At the book's conclusion, each number is accompanied by an illustration that contains the images, usually six or seven, associated with it. These assemblages of images employ continuous horizon lines, along with shadows, that create an integrated visual field; the resulting illustrations are often bizarre pairings—a belt and a church, a nun and a pair of scissors—that feature contemporary objects. The fact that the majority of items represented never existed in antiquity is beside the point; the age-old act of dream interpretation, augmented here by magical access to meanings with a numerical equivalent, appears to compensate for the anachronism. These dream images had been appropriated, especially in Italy and the Austro-Hungarian realm, by lottery and gambling interests that marketed dreams as what Marinelli has called "a site of luck."[216] Like astrological tabulations, with which dreams had been associated for centuries, the images from sleep merged an individual experience with cosmological and collective meanings.

The purveyors of dream imagery as an avenue to good luck appeared soon after the first civic lotteries were created, in seventeenth-century Naples, where wheels of fortune and other devices for gambling based on numbers were instituted to defray the cost of orphanages and hospitals. In 1751 these practices were introduced in Austro-Hungary, and only a year later there was an office for state gambling in Vienna and a national lottery to raise funds

for a hospital. Successful marketing and the promise of handsome returns generated a desire for lucky numbers and secret formulas. In response, the lottery industry in Vienna introduced what had already become popular in Italy: sold alongside the tickets were pamphlets that contained supposedly ancient astrological and numerological tables to enhance the prospects of successful gaming. Since medieval times dream books had been included in astrological literature because the interpretations they offered depended on one's date of birth. However, they were outlawed by the Church in 1755, with the justification that dreams had "since ancient times"[217] had significance as predictors of the future and were not to be used for playing games of chance. The prohibition was enforced in Catholic Vienna as well, and books of this kind did not begin to be published there until after the middle of the nineteenth century.[218]

Playing the lottery and dreams as keys to success were at first considered the domain of women, who bet small sums to support a good cause and perhaps enhance their family's earnings. Dominant masculinist discourses of the day equated an interest in dreams and magic with women's propensity to "irrational thinking." This view of dream interpretation changed with the appearance of dream books, especially in Vienna, after 1850.[219] In the late nineteenth century publishers appealed to male dreamer/gamblers with imagery emphasizing hunting, drinking, and the military, which was not present in the earlier Italian versions. The books, however, retained their appeal to a clearly sectarian audience. Assuming a Catholic dreamer, the books offered numerous images of churches, priests, and ecclesiastical objects. The Christian overlay was also apparent in the anti-Semitism rife in these books. Dream topics listed under the rubric "Jewish" included rabbis, school, groups of men, wanderers, peddlers, and, in all of the lottery books, the dream that "one is a Jew." For this last image, the interpretation was unambiguous and unanimous: you will have trouble and discord. One recurring stereotype was that to have a "Jewish" dream predicted that one would be taken advantage of in business dealings. *Stock's* illustrates one of the Jewish entries, that of the *Handelsjude*—a Jewish peddler carrying goods on his back—with images of the wandering Jew that date to medieval times.[220] This depiction shares its number, sixteen, with what for a Catholic audience might have been considered an antidote to ill-fortune: a bishop. Also seen in this illustration are a wine cask, books, a dog, and a cliff; the cleric and Jewish figure appear to be confronting one another.

This suggests that even if one dreamt of bad luck, there was hope for divine intercession at the level of the magic number. The bishop, however, is characterized by the same designation of "trouble" associated with Jewish subjects, implying that both types of figures shared a connotation of distrust.

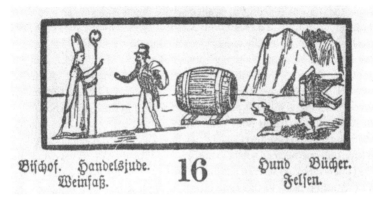

Figure 5.4 Detail, "Dream images representing the number 16," *Stock's kleines Persisch-Egyptisches Traum-Buch*, 91.

This yoking of apparent opposites is explicable because Vienna in 1900 was under the sway of the Christian Democrat mayor Karl Lueger, known for views that were both anti-Semitic and locally anti-clerical, although his election had been assisted by none other than the current pope himself.

Despite the massive popularity of these books, they were not without their critics. In 1898, just two years before *Die Traumdeutung* was published, the economist and social historian Siegmund Kanner wrote about the need to reform the national lottery system, noting that the focus on a "number lottery" produced "a predilection for numerological mysticism."[221] Kanner advocated implementation of the Prussian lottery practice known as the "class lottery," in which a bettor purchased a single ticket at prices that varied according to how many weeks (or classes) the player wished to stay in the drawings. This method offered no options for number selection and thus, according to Kanner, eliminated reliance on "the crudest sort of superstition."[222] The "most ridiculous"[223] example of this, for him, was the dream book, with its use of magical formulas. Kanner went on to discuss the inordinate popularity of number lotteries in Catholic countries, proposing that there may be a predilection to superstitious beliefs in this religious tradition. Gabriele Schmid suggests that Kanner's book, advocating the class lottery as a way to curtail superstitious practices in the gaming industry, voiced the position of many liberal jurists and economists in Vienna.[224]

There is no evidence that Freud read Kanner's text, although they express similar disdain for the use of dream interpretation in the service of games of chance and for the superstitious beliefs such pursuits fostered among

people they saw as different from themselves. Freud and Kanner would, in all likelihood, have had a common worldview. Both were the sons of Jewish merchants and attended the same gymnasium in the second district. Kanner, who shared a surname—although it is not clear if there was a familial connection—with Sally Kanner, Jacob Freud's first wife and the mother of Emanuel and Philipp, went on to study economics at the University of Berlin. Fifteen years Freud's junior, Kanner came of age at a time when the lottery practices, and the dream-book genre, were in full flower. The unmistakable anti-Semitism in these texts would not have been lost on either Freud or Kanner, and one need only follow the dream books after 1900 to see how the trend intensified. In the 1920 edition of *Stock's Traum-Buch*, the Jewish figure and the bishop faced in the same direction; what was once a peddler's sack had become a moneybag and the images were said to represent wealth and luxury.[225] By 1930, however, the religious imagery had all but disappeared, and the Jewish figure, now oversized, was caricatured as a *Hebräer* ("Hebrew"), whose exaggerated features were familiar from the increasingly virulent imagery of Jews that came with the rise of fascism. The association now was with ill fortune and personal catastrophe. But in historical reality, the disaster that loomed was, of course, not to emanate from Jews but to engulf them. By 1938, Freud was among the thousands of Viennese Jews forced to leave Austria when it became part of the Nazi *Reich*.

As the examples above so vividly suggest, under the guise of secret meanings repugnant and ultimately dangerous imagery and associations were disseminated. Gomperz's concern about the magical power invested in the mind of the classical oneirocritic foretold the arbitrary connections conjured by compilers of dream books in Vienna. As with Artemidorus's reading of the dream of a synagogue, those associations often derived from representations in popular culture, thus transforming an ostensibly intimate and solitary act into an extension of the public sphere. By the time Freud wrote *Die Traumdeutung*, the territory of dream interpretation was indelibly scored by economic and ideological interests. In offering his own "Egyptian dream book," Freud sought to reclaim the agency of the individual dreamer. In particular, a Jewish individual could now be the subject and not just the object of dreaming. Noting that all previous attempts "to solve the problem of dreams" had relied on the "manifest content as it presented in our memory," he introduced a "new class of psychical material" for "a new task which had no previous existence."[226]

Freud's interpretative strategy was predicated upon identifying the manifest content of dreams as a derivative of thoughts that were latent in the unconscious, and as such, the product of a censorious mechanism for inducing fallacious beliefs. His claim to innovation was a hermeneutic

method that purported to reveal a hidden reality that could never be accessed by reliance on the dreamer's memory of what lay on the surface. He identified two precedents—classically derived decoding and the biblical symbolic— but, after acknowledging these distinctions, Freud "proceeded to ignore the distinction and to refer to any non-associative or decoding methods of interpretation as 'symbolic.'"[227] It was not, however, until later editions that he devoted a specific section to symbolism in dreams, although even there the "range of things," as he noted in his *Introductory Lectures* "is not wide."[228] He goes on to assert that "the very great majority of symbols in dreams are sexual symbols"[229]; in this way, he allows himself a space of distinction from the popular dream "keys," whose translation of dream elements he characterized as concerned with *"everything"* (ital. original). In contradistinction to that, when dreams are interpreted through his associative method, additional manifest elements "never come to light."[230]

If the role of symbolization gains momentum over the course of subsequent editions, the problematics of "representability" appear in Freud's text from the start, where the dream's visuality is characterized as a kind of architectural deceit. As Forrester observes, "it is as if the dream is an inherently inappropriate form of expression ... once one accepts Freud's idea that behind the façade of the dream-images lie the non-visual thought from which the dream is constructed."[231] Certainly this was Freud's wish, and in constructing the dream in this way, he was able to distance himself from the totality of objects, experiences—and slanders—that were by then part of the "everything" associated with the traditional, and contemporary, dream books. Yet even as he wishes to exercise his own version of a psychical magic, creating a mechanism that could make a dream's visual significance, and thus power, all but disappear, the Vienna dream books were nevertheless a grim portent of what was not to be so readily banished.

This chapter has proposed sites productive for a genealogy of Freud's relationship to the dream as a mechanism that generates visual phenomena: it is an attempt to write an origin narrative of Freud's making of the manifest. But prior to that undertaking, it was crucial to question the creation of the dream itself. Unlike many other naturalized phenomena—sexualities, racial constructions, geopolitical entities—that have over the past decades been critiqued as discursive formations, the most fundamental of psychoanalytic properties often remain unexamined. The most notable of course is the unconscious itself, whose emergent properties and contours, as enunciated by Freud in the late 1890s, have been parsed throughout this book, accessible through our nodal points of visualities and value. The dream is among these *a priori* formulations that continue to remain as an unquestioned totality. We have looked at examples where we have access to Freud's mutable

memories of dreams, and his blurring of the borders that divide waking and sleeping imaginings. Freud's earliest understanding of dreams focuses on their normative, amnesic property; he imagined we remember little of what occurs in sleep. Later, his focus will turn to what is recalled from sleep, and the proposal of various interpretative strategies and psychical constructions that would render the visible as ultimately invisible. We have traced here how meaning came to be understood as an autonomous, intrapsychical activity of the unconscious experienced in sleep, and what was, for Freud, at stake in creating an unconscious capable of both generating imagery and rendering it inconsequential.

Notes

1 Sigmund Freud, *The Interpretation of Dreams*, SE 4, 1900, 204.

2 *Freud-Fliess Letters*, 328, letter dated September 27, 1898.

3 Freud's interest in the psychical efficacy of dreams predated much of what would become the realm of analytic inquiry; dreams were cast as a "normative" form of amnesia in his entry for Bum and Schnirer's *Diagnostisches Lexikon*, See "Amnesie" in Anton Bum and Moritz T. Schnirer, eds., *Diagnostisches Lexikon für praktische Ärzte*, vol. 1 (Vienna: Urban & Schwarzenberg, 1893), 98–99. One of his first references to the topic of "dream interpretation" occurs in a letter to Fliess of May 4, 1896, when he refers to a lecture he gave on this topic "to the youths of the Jewish academic reading circle." Although expressing his desire to share the content with his friend, "right now I am in no mood for presentations" (*Freud-Fliess Letters*, 185). This comment deserves note, as this letter was the first he wrote after his "Aetiology of Hysteria" lecture and its poor reception. After mentioning the lecture on dreams, Freud returned to the far less positive response to his other talk: "word was given out to abandon me, for a void is forming all around me" (185). When Freud himself would abandon, in the following year, the theory he was espousing that evening, he would assure Fliess—and perhaps in doing so, himself—that his dream studies were unaffected. In the void that would ultimately envelop his quest for an alternative theory, perhaps dream interpretation allowed him to continue with work that was initially centered upon himself, and non-pathological phenomena. The next mention of presenting work on dreams was December of 1897, this time to the B'nai B'rith group—perhaps the youth organization, of the earlier talk, was in some way related to this. About two months later, in February of 1898, he writes that he is "deep in my dream book, writing it fluently" (*Freud-Fliess Letters*, 298, letter dated February 9, 1898).

4 Freud, *The Interpretation of Dreams*, SE 4, 163.

5 Sigmund Freud, "On the History of the Psycho-Analytic Movement," *SE* 14, 1914, 22. Freud claims that *The Interpretation* "was finished in all essentials at the beginning of 1896 but was not written out until the summer of 1899."

6 Strachey offers a chronology for the completion of *The Interpretation*, suggesting that a first draft may have existed in the early months of 1898, but any further work on it then stopped, not resuming again until the spring of 1899. This would have been several months after the publication, in December 1898, of his Signorelli text (Freud, *The Interpretation of Dreams, SE* 4, xix–xx).

7 Kaja Silverman, "Apparatus for the Production of an Image," *Parallax* 6, no. 3 (2000): 12–28. A version of this paper also appeared the same year in Silverman's *World Spectators* (Stanford, CA: Stanford University Press, 2000), 75–100.

8 See n3. Also, it is useful to revisit Freud's memory, in "On the History of the Psycho-Analytic Movement," of how dreams functioned for him during the period of *The Interpretation*'s creation. In this text written considerably later, Freud notes that dreams "became a solace and support to me in those arduous years first years of analysis" (*SE* 14, 1914, 20).

9 Peter Rudnytsky, *Freud and Oedipus* (New York: Columbia University Press, 1987), 20ff.

10 *Freud-Fliess Letters*, 266, letter dated September 21, 1897.

11 Silverman, "Apparatus," 12.

12 Rachel Bowlby, *Freudian Mythologies: Greek Tragedy and Modern Identities* (Oxford; New York: Oxford University Press, 2007), 105.

13 Ibid., 123.

14 *Freud-Fliess Letters*, 268, letter dated October 3, 1897.

15 Ibid.

16 Ibid.

17 Ibid.

18 Rudnytsky, *Freud and Oedipus*, 57.

19 *Freud-Fliess Letters*, 268, letter dated October 3, 1897.

20 Ibid., 269, letter dated October 4, 1897.

21 Ibid.

22 Ibid., 270, n4.

23 Freud, *The Interpretation of Dreams, SE* 4, 180.

24 *Freud-Fliess Letters*, 271, letter dated October 15, 1897.

25 Ibid., 274, letter dated October 27, 1897.

26 Ibid.

27 Freud, *The Interpretation of Dreams, SE* 4, 261.

28 Ibid., 262.

29 Freud reported the death of his father in a letter to Fliess dated October 26, 1896, noting that the burial had taken place the day before, and that his father had died "during the night of October 23." After describing the various health conditions attending his father's death, and that it had

been made "easy" by the eventual cessation of his pulmonary function, he expresses its toll upon him: "I am really quite down because of it." *Freud-Fliess Letters*, 201.

30 Freud, *The Interpretation of Dreams, SE* 4, xxvi.

31 *Freud-Fliess Letters*, 202, letter dated November 2, 1896.

32 The content of the letter to Alexander Freud is cited by Peter Gay in his biography *Freud: A Life for Our Time* (New York: Doubleday, 1988), 573. The letter is housed in the Library of Congress, and is dated September 30, 1930 (Gay, 728).

33 Emanuel Rice, *Freud and Moses: The Long Journey Home* (Albany, NY: State University of New York Press, 1990), 110. Rice cites the sources as anecdotal evidence offered by a close associate of Freud, Herman Nunberg, 220n2.

34 *Freud-Fliess Letters*, 202, letter dated November 2, 1896.

35 Rice, *Freud and Moses*, 109. I also am grateful to Daniel Zinner for discussing this passage with me.

36 Ana-María Rizzuto, *Why Did Freud Reject God? A Psychodynamic Interpretation* (New Haven, CT; London: Yale University Press, 1998), 82. The prohibition cited in n7 derives from the compendium of Jewish law called the *Shulchan Aruch*, where the laws governing prohibitions during the period of mourning are detailed (in the section called *Yoreh De'ah*). At the death of a parent, the expectation was to refrain from shaving and cutting one's hair for three months, a considerably longer period of abstinence—thirty days—than for other family mourners.

37 Rice, *Freud and Moses*, 108.

38 Ibid.

39 The enclosing "sign" surrounding this phrase was not reproduced when the letter was published, so it is only visible within the original document, now in the Library of Congress: Sigmund Freud Papers: General Correspondence, 1871–1996; Fliess, Wilhelm; 1896; October-December (letter dated November 2, item #12).

40 Freud, *The Interpretation of Dreams, SE* 4, 310.

41 Ibid., 279–309.

42 Ibid., 311.

43 Ibid., 312.

44 Ibid., 317.

45 Ibid.

46 Ibid.

47 Ibid., 318.

48 Ibid.

49 Rice, *Freud and Moses*, 108.

50 Marthe Robert, *From Oedipus to Moses: Freud's Jewish Identity*, trans. Ralph Manheim (Garden City, NY: Anchor Books, 1976), 90–91. Robert was a literary critic, perhaps best known for her French translations of Franz Kafka.

51 Ibid., 91.

52 Ibid.

53 Freud, *The Interpretation of Dreams*, SE 4, 318.

54 Ibid., 96–121. Freud prefaces the actual discussion of the dream with a long excursus (96–105) on the method that will be exemplified here.

55 Ibid., 106. The "preamble" immediately prefaces the retelling of the dream.

56 Elisabeth Young-Bruehl, *Anna Freud: A Biography* (New Haven, CT; London: Yale University Press, 1988), 28. It is noteworthy that Anna Freud, born about about five months after Freud dates the night of the "Irma" dream, was named for Anna Hammerschlag Lichtheim (46).

57 Freud's comments in this paragraph were included in his "Preamble"; see n54.

58 The relationship that joined Emma Eckstein, Freud, and Wilhelm Fliess has generated a substantial literature, one that has seen shifts worthy of note. These issues are well drawn by Madelon Sprengnether, "Mouth to Mouth: Freud, Irma, and the Dream of Psychoanalysis," *American Imago* 60, no. 3 (2003): 259–284.

59 *Freud-Fliess Letters*, 417, letter dated June 12, 1900.

60 The *New York Times* reported on the installation the day following the event: Paul Hofmann, in "… and in Vienna, a Plaque and Memories," notes that "Vienna has indeed been tardy in acknowledging Freud's greatness." *NYT*, May 7, 1977, 27.

61 Sigmund Freud, "Creative Writers and Day-Dreaming," *SE* 9, 1908, 149. In a volume of writings devoted to this short essay of 1908, the relationship to dreams recalled from sleep was not accorded much attention, although Freud noted that the two phenomena were the fulfillment of wishes "in just the same way." This observation is cited, but little developed, by Ethel Spector Person in the introduction to *On Freud's "Creative Writers and Day-Dreaming,"* ed. Ethel Spector Person, Peter Fonagy, and Sérvulo Augusto Figueira (New Haven, CT; London: Yale University Press, 1995), xi.

62 Jay Geller, *On Freud's Jewish Body: Mitigating Circumcisions* (New York: Fordham University Press, 2007), 94.

63 Didier Anzieu, *Freud's Self-Analysis*, trans. Peter Graham (Madison, CT: International Universities Press, 1986), 151.

64 Freud, *The Interpretation of Dreams*, SE 4, 123.

65 Freud, *The Interpretation of Dreams*, SE 4, 169. The "Dream of the Botanical Monograph" is told in two places: first in "Recent and Indifferent Material" and in considerable detail (169–176), and second in a shorter version in "The Work of Condensation" (282–284).

66 Silverman, "Apparatus," 15.

67 Ibid.

68 Freud, *The Interpretation of Dreams*, SE 4, 173.

69 Ibid., 172.

70 Alexander Grinstein, *Sigmund Freud's Dreams* (New York: International Universities Press, 1980), 47. The dating is based on Freud's comment in his *Interpretation* (72) in which he refers to "a letter from my friend [Fliess] in Berlin the day before" having the dream in which Fliess apparently

comments on seeing Freud's dream book completed: "I see it lying finished before me and I see myself turning over its pages." This side of the correspondence has been lost, but Freud did comment on it in a letter of March 10. As Grinstein noted, Freud answered his letters to Fliess very promptly, and his letter of this date includes this comment: "It was no small feat on your part to see the dream book lying finished before you" (*Freud-Fliess Letters*, 301).

71 This book was first identified by Gaston Vandendriessche as *Die Gattung Cyclamen L. eine systematische und biologische Monographie* by Friedrich Hildebrand (Jena: G. Fischer, 1898). It is not clear whether Freud consulted the monograph after seeing it in the window; as Vandendriessche notes, the description (Mit 6 lithogr. Tafeln.) on the cover would alert the viewer to the presence of illustrations (Vandendriessche, "La relation entre la pulsion et la fonction cognitive dans le rêve de la monographie botanique et la souvenir-écran de la scène dans la prairie," *Revue française de psychanalyse* 36 (1972): 988). Alexandre Métraux cites Hildebrand's book as evidence of the increased popularity, by the period around 1900, of the cyclamen as a household flower (Métraux, "Einst träumte Sigmund Freud von einer botanischen Monographie über die Lieblingsblume seiner Frau Martha," *Newsletter des Sigmund Freud-Museums* 1 (2001): 8–21).

72 Freud, *The Interpretation of Dreams, SE* 4, 305.

73 Displacement is mentioned on a number of occasions in Freud's "Project," where memories were thought to create "pathways of displacement." Freud had not written this text for publication; it carried no title and was given the one now associated with the English version—"Project for a Scientific Psychology"—by James Strachey, who expanded the title it had upon its first appearance in print, in 1950, in German: *Entwurf einer Psychologie* (Sketch of a Psychology). It was written for Fliess's "criticism" (*SE* 1, 284). Freud sent his friend updates as he composed it in the autumn of 1895, only to banish it to a drawer, amid feelings of being "overworked, irritated, confused, and incapable of mastering the stuff" (Ibid.) The term "displacement" is used in a similar way in the Signorelli story, where recalling the incorrect names of other painters whose names begin with "bo" serves to "displace": "the line of displacement was laid down [NB: in a phrase found in the pathway concepts of the "Project"] by the names that were contained in the repressed topic."

74 Freud, *The Interpretation of Dreams, SE* 4, 305. It is noteworthy that this summation of the dream's latent meanings occurs at the start of a section in the text entitled "The Work of Displacement."

75 Ibid.

76 Ibid., 561.

77 Stanley R. Palombo, "Day Residue and Screen Memory in Freud's Dream of the Botanical Monograph," *Journal of the American Psychoanalytic Association* 36, no. 4 (1988): 882.

78 Freud, *The Interpretation of Dreams, SE* 4, 172.
79 Ibid., 173.
80 Ibid., 191.
81 Grinstein, *Sigmund Freud's Dreams*, 67.
82 Anzieu, *Freud's Self-Analysis*, 291.
83 Ibid.
84 Ibid., 292.
85 Ibid.
86 Jacques Derrida, *Resistances of Psychoanalysis*, trans. Peggy Kamuf, Pascale-Anne Brault, and Michael Naas (Stanford, CA: Stanford University Press, 1998), 4.
87 Jill H. Casid, *Sowing Empire: Landscape and Colonization* (Minneapolis, MN; London: University of Minnesota Press, 2005), 239.
88 Ibid., 240.
89 Ibid.
90 Ibid.
91 Freud, *The Interpretation of Dreams, SE* 4, 169.
92 Ibid., 170–171.
93 Ibid., 172.
94 Ibid.
95 Ibid.
96 Ibid., 172–173.
97 Ibid., 173.
98 For his discussion of the mechanism, see Sigmund Freud, "Screen Memories," *SE* 3, 1899, 316–320.
99 Freud, *The Interpretation of Dreams, SE* 4, 173.
100 Ibid., 191.
101 Anzieu, *Freud's Self-Analysis*, 354–355.
102 Freud, *The Interpretation of Dreams, SE* 4, 191. Although Strachey translates *Reissen* as "gripes," its most common translation in German and Yiddish is "tearing." A.A. Brill describes it as "gripes, tearing pains," which may be closer to Habsburg usage. See Sigmund Freud, *The Interpretation of Dreams*, trans. A.A. Brill (New York: Carlton House, [pref. 1931]), 67. Joyce Crick, in her more recent translation, cites *Reissen* as "aches." See Sigmund Freud, *The Interpretation of Dreams*, trans. Joyce Crick (Oxford: Oxford University Press, 1999). Supporting the interpretation of *Reissen* as acute pain, see Hugo Lang and Milton Kayton Meyers, *Lang's German-English Dictionary of Terms Used in Medicine and the Allied Sciences* (Philadelphia, PA: P. Blakiston's Son & Co., 1913), 408. "**Reissen**, v.t. & i. to tear, to pull, to drag; to ache. **Reissen**, n. tearing, pulling; acute pain; rheumatics; colic."
103 Ibid.
104 Peter Schwenger, *Fantasm and Fiction: On Textual Envisioning* (Stanford, CA: Stanford University Press, 1999), 27–34.
105 Grinstein, *Sigmund Freud's Dreams*, 66.

106 Elizabeth Grosz, *Jacques Lacan: A Feminist Introduction* (London; New York: Routledge, 1990), 110.

107 Lydia Flem, *Freud the Man: An Intellectual Biography*, trans. Susan Fairfield (New York: Other Press, 2003), 94 n2.

108 Jean Fourton, "Freud avec Börne, ou 'L'art de devenir un écrivain original en trois jours,'" *Littoral: Revue de psychanalyse* 2 (1981): 153.

109 Heinrich Brugsch, *Reise der K. preussischen Gesandtschaft nach Persien 1860 und 1861* (Leipzig: J. C. Hinrichs, 1862–1863).

110 Flem, *Freud the Man*, 94.

111 Ibid., 95.

112 My identification of the text as the one cited in Freud's work was greatly assisted by a comprehensive bibliography of works published in Europe in the nineteenth century that specifically focused on Persia, compiled by Doris Mir Ghaffari: *Europäische Reisende im Iran des 19. Jahrhunderts: eine Bibliographie* (Halle: Orientwissenschafliches Zentrum der Martin-Luther-Universität Halle-Wittenberg, 2003). By reviewing its entries, it was possible to eliminate virtually all texts cited there as not meeting the criteria necessary to have been the book mentioned in the associations to the "Botanical Monograph" dream.

113 Helene Bonnlander, *Der vermittelte Imperialismus: Der Blick auf aussereuropäische Lebenswelten von Alexander von Humboldt zu Heinrich Brugsch* (Frankfurt am Main; New York: Lang, 1998), 169–195.

114 Lydia Marinelli, ed., *"Meine … alten und dreckigen Götter": aus Sigmund Freuds Sammlung* (Frankfurt/Main: Stroemfeld, 1998), 161.

115 Fedor Buhse, *Aufzaehlung der auf einer Reise durch Transkaukasien und Persien gesammelten Pflanzen in Gemeinschaft* (Moscow: W. Gautier, 1860). I am indebted to Anthony Stadlen for our correspondence on these issues.

116 Elia Borszczow, "Die pharmaceutisch-wichtigen Ferulaceen der Aralo-Caspischen Wüste," *Mémoires de l'Académie impériale des sciences de St.-Pétersbourg* 3, no. 8, 7th series (1860): 30–37.

117 Heinrich Hlasiwetz, "Über das Galbanum," *Sitzungsberichte der mathematisch-naturwissenschaftlichen Classe der kaiserlichen Akademie der Wissenschaften* 43, no. 2 (1861): 477–484.

118 *Eine Sammlung von Ausserordentlicher Geschlossenheit: Die Rektorgalerie der Technischen Universität Wien*, ed. Juliane Mikoletzky (Vienna: Böhlau, 2015), 53. Hlasiwetz was appointed rector of the university in 1866.

119 Ernst Homburg, "The Influence of Demand on the Emergence of the Dye Industry: The Roles of Chemists and Colourists," *Journal of the Society of Dyers and Colourists* 99 (1983): 328.

120 Hans Dressler, *Resorcinol: Its Uses and Derivatives* (New York: Plenum Press, 1994).

121 In both "Screen Memories" (*SE* 3, 319) and *The Interpretation of Dreams* (*SE* 5, 348n2), Freud notes that cognates of the verb *Reissen* are German slang expressions for masturbation.

122 Anzieu, *Freud's Self-Analysis*, 357.

123 The parade was part of Vienna's "Schillerfest," activities to commemorate the centenary of the author's birth that took place over several days in November 1859, and within a few weeks of the Freud family's arrival there. Thus, Freud's recollection of seeing this would be his earliest published memory of living in the city. It is included among Freud's letters to Martha Bernays in *Die Brautbriefe: Warten in Ruhe und Ergebung, Warten in Kampf und Erregung*, vol. 3, ed. Gerhard Fichtner, Ilse Grubrich-Simitis, Albrecht Hirschmüller, and Wolfgang Kloft (Frankfurt a. M.: S. Fischer Verlag, 2015), 67.

124 Freud, "Screen Memories," *SE 3*, 312.

125 Marianne Krüll, *Freud and His Father*, trans. Arnold J. Pomerans (New York: W.W. Norton, 1979), 148.

126 Diane O'Donoghue, "Lingua Flora: Deciphering the Dream of the Botanical Monograph," *American Imago* 62, no. 2 (2005): 169, n4.

127 Martin Freud, *Glory Reflected: Sigmund Freud, Man and Father* (London: Angus and Robertson, 1957), 10.

128 Ernst Freud, ed., *The Letters of Sigmund Freud*, trans. Tania and James Stern (New York: Basic Books, 1960), 86.

129 Krüll, *Freud and His Father*, 148.

130 Ibid., 93. The imagery of weaving and cloth production is evoked in *The Interpretation* just prior to Freud's mention of the "coloured plate" in the second telling of the dream. See *The Interpretation, SE* 4, 283.

131 Agustí Nieto-Galan, *Colouring Textiles: A History of Natural Dyestuffs in Industrial Europe* (Dordrecht; Boston: Kluwer, 2001), 53.

132 Ibid., 194. Here one finds a price list for both "natural and artificial dyestuffs" available through a Manchester purveyor in 1870.

133 Georg Augusta, "'Dann kamen die langen, harten Jahre': zur Situation der Familie Freud nach ihrer Ankunft in Wien im Jahr 1859," *Luzifer-Amor: Zeitschrift zur Geschichte der Psychoanalyse* 56 (2015): 120.

134 *Officieller General-Catalog: Welt-Ausstellung 1873 in Wien* (Wien: Verlag der General-Direction, 1873), 476.

135 Václav Vlček, ed., *Osvěta: Listy pro Rozhled v Umění, Vědě a Politice*, vol. 37 (Prague: Tiskem dra. Edvarda Grégra, Nákladem Vlastním, 1907), 810.

136 Records pertaining to the case of Josef Freud are held in the National Police Archives in Vienna; all citations of these documents here are taken from the translations published by Nicholas Rand and Maria Torok in *Questions for Freud: The Secret History of Psychoanalysis* (Cambridge, MA: Harvard University Press, 1997), 146–155, 231–232.

137 Ibid., 153.

138 Ibid., 154–155.

139 John F. Chown, *A History of Monetary Unions* (London; New York: Routledge, 2003), 103.

140 Ibid., 154.

141 Freud, *The Interpretation of Dreams, SE* 4, 137–138.

142 It may be that Josef Freud was the most vivid of Sigmund's uncles, but he was certainly not, as Freud claimed, his only one. Seemingly forgotten here was Jacob's other brother, Abae, a merchant who resided in Breslau. His mother's brother Julius—after whom Freud's younger brother, who died in infancy in April 1858, was named—had died only the month before his nephew's birth. There also were three other Nathansohn uncles—Hermann and Nathan, who lived in Odessa, and Adolf, who appears to have resided in Vienna, dying in 1862 at thirty-two, leaving a wife, Laura Rosael Nathansohn, and two children. The year before this death, the name Adolf Nathansohn appears in a Vienna business directory as working in "money exchange" (*Geldverwechslung*). Refer to *Wiener handelsstands-Bericht* 5 (March 1861), 20. For a complete genealogical reckoning of the Freud and Nathansohn lineages, see Krüll, *Freud and His Father*, table 3. Élisabeth Roudinesco has an expanded version of this table, although the material for the Nathansohn family is very similar (*Freud: In His Time and Ours*, trans. Catherine Porter (Cambridge, MA: Harvard University Press, 2016), 560–561).

143 Ibid., 138.

144 Ibid., 139.

145 Ibid.

146 Ibid.

147 Mary Bergstein, *Mirrors of Memory: Freud, Photography, and the History of Art* (Ithaca, NY; London: Cornell University Press, 2010), 212–216. Also see Allan Sekula's "The Body and the Archive," *October* 39 (1986): 49, 52.

148 Freud, *The Interpretation of Dreams, SE* 4, 140–141.

149 Anzieu, *Freud's Self-Analysis*, 214.

150 Sigmund Freud, "The Uncanny," *SE* 17, 1919, 253ff.

151 Daniel Sanders, *Wörterbuch der deutschen Sprache,* vol. 1 (Leipzig: O. Wigand, 1860), 179.

152 Bum and Schnirer, *Diagnostisches Lexikon,* vol. 1, 98–99.

153 The paper was sponsored by the Schiller Foundation and was given as part of a symposium held while Gomperz was spending time in his birth city, on a visit to his mother. In a letter from Brno to his sister, in the weeks before his lecture, he mentioned that he did not arrive with a great deal of material, but this was not consequential, as he was very familiar with the topic. See *Theodor Gomperz: Briefe und Aufzeichnungen*, ed. Heinrich Gomperz (Vienna: Carl Gerold, 1936), 416.

154 Theodor Gomperz, *Traumdeutung und Zauberei. Ein Blick auf das Wesen des Aberglaubens* (Vienna: Carl Gerold, 1866), 5.

155 Ibid., 7.

156 Edward Burnett Tylor, *Researches into the Early History of Mankind and the Development of Civilization* (London: John Murray, 1870).

157 Ibid., 119.

158 Gomperz, *Traumdeutung*, 11.
159 Ibid., 21.
160 For a discussion of Freud's relationship to the Gomperz family, see Lydia Marinelli and Andreas Mayer, *Dreaming by the Book: Freud's The Interpretation of Dreams and the History of the Psychoanalytic Movement* (New York: Other Press, 2003), 16–17, 25–26, and Robin N. Mitchell-Boyask, "Freud's Reading of Classical Literature and Classical Philology," in *Reading Freud's Reading*, ed. Sander L. Gilman et al. (New York: New York University Press, 1994), 27–29. The impact of Theodor Gomperz's work on Freud's is detailed by Jacques Le Rider, "Philologie grecque et formation de la théorie psychanalytique: Sigmund Freud et Theodor Gomperz," *Essaim* 2, no. 7 (2001): 203–217.
161 Sigmund Freud, "Contribution to a Questionnaire on Reading," *SE* 9, 1907, 245.
162 Freud, *The Letters of Sigmund Freud*, 303.
163 Freud, *The Interpretation of Dreams, SE* 4, 98, n1.
164 Sigmund Freud, *Totem and Taboo: Some Points of Agreement between the Mental Lives of Savages and Neurotics, SE* 13, 1913, 1–162.
165 Ibid., 65.
166 *Stock's Persisch-Egyptisches Traum-Buch* (Vienna: Leopold Kutschera, various editions). The office of Kutschera publishing house was in the seventh district, but the firm used to print its *Traum-buch*, Elbemühl, was at located at Berggasse 31.
167 Lydia Marinelli, "Screening Wish Theories: Dream Psychologies and Early Cinema," *Science in Context* 19, no. 1 (2006): 95–96.
168 Jacques Derrida, "Freud and the Scene of Writing," in *Writing and Difference*, trans. Alan Bass (Chicago, IL: University of Chicago Press, 1978): 196–231.
169 Ibid., 209.
170 Ibid.
171 *Freud-Fliess Letters*, 366.
172 Ibid., n6.
173 Erik Hornung, *The Secret Lore of Egypt: Its Impact on the West*, trans. David Lorton (Ithaca, NY; London: Cornell University Press, 2001).
174 Mary Bergstein, "Freud's Uncanny Egypt: Prolegomena," *American Imago* 66, no. 2 (2009), 187–188.
175 Freud, *The Interpretation of Dreams, SE* 4, 277.
176 Ibid., 135.
177 Ibid., 174.
178 Sigmund Freud, "An Autobiographical Study," *SE* 20, 1925, 16.
179 Freud, *The Interpretation of Dreams, SE* 4, 97.
180 Ibid., 100.
181 Ibid., 98.
182 Wolfram Kurth, "Das Traumbuch des Artemidoros im Lichte der Freudschen Traumlehre," *Psyche* 4(1951): 490.

183 Marinelli, in "Screening Wish Theories" (96), suggested that Gomperz's
Traumdeutung und Zauberei, available as a published text since 1866,
was Freud's first exposure to Artemidorus. It may have been Gomperz's
knowledge of the Greek original that led Freud (1900), in a footnote to the
first edition of *The Interpretation*, to complain that the German translation
of the *Oneirocritica* withheld its "chapter on sexual dreams" (606n2). Jaap
Bos believes that Freud only read the book in earnest when he came into
contact with its translator, the Viennese "folkorist" Freidrich Krauss, who
became part of his circle in 1910; see Bos, "A Silent Antipode: The Making
and Breaking of Psychoanalyst Wilhelm Stekel," in *The Self-Marginalization
of Wilhelm Stekel: Freudian Circles Inside and Out*, with Leendert
Groenendijk (New York: Springer, 2007), 27–28. This would explain the
appearance of the only quote directly from Artemidorus in Freud's 1911
edition. Influence in the acquaintance with Krauss was reciprocal, as the
translator subsequently published the expurgated passages. Richard H.
Armstrong, in *A Compulsion for Antiquity: Freud and the Ancient World*
(Ithaca, NY; London: Cornell University Press, 2005), discusses this
revision and provides fascinating instances of the role of Freud's work in
"greatly improving the interest in Artemidorus' *Oneirocritica*" (263–64n3).
184 Freud, *The Interpretation of Dreams, SE* 4, 99.
185 Ibid., n1.
186 Ibid.
187 The *Oneirocritica* was written in five volumes, with the first three dedicated
to Cassius Maximus and intended for a broad readership. Books 4 and
5, created for his son and namesake, contained material for more private
use. Alexander's dream and the example that preceded it, from Book 4,
were written to supplement what Artemidorus shared publicly, giving
his son such insights as the linguistic connection and more explicit of
contemporary practices, including the problem of dream fabrication.
Winkler suggested that, despite the familial nature of these books, "the
shadow of the patron still looms" and added: "it seems plausible that
if Book 4 were to come into the hands of any other person besides
Artemidorus *fils*, it would be Maximus." John Winkler, "Geminus of Tyre
and the Patron of Artemidorus," *Classical Philology* 77, no. 2 (1982): 247.
188 Sigmund Freud, *Introductory Lectures on Psycho-Analysis, SE* 15, 1916, 236.
189 Artemidorus of Daldis, *The Interpretation of Dreams* (*Oneirocritica*), trans.
Robert J. White (Park Ridge, NJ: Noyes Press, 1975), Bk. 4.24, 200–201.
190 In a discussion of one of his "Rome dreams," Freud, in *The Interpretation*,
reflected on his childhood enthusiasm for Hannibal and his sympathies
with the Carthaginians (who, like the Jews of Cyrene, were from North
Africa). "To my mind, Hannibal and Rome symbolized the conflict
between the tenacity of Jewry and the organization of the Catholic church"
(*SE* 4, 196n1). The omission of the story about the Jewish revolt might
reflect Freud's desire not to call attention to his classical predecessor's anti-
Jewish sentiments, manifested more explicitly elsewhere in the text. He

preferred at that stage to focus on Artemidorus's recognition of the power
of linguistic content, which presaged his own.

191 Shim'on Applebaum, *Jews and Greeks in Ancient Cyrene*, Studies in Judaism
 in Late Antiquity, vol. 28 (Leiden: E.J. Brill, 1979), 272ff.
192 Dio Cassius [Second to third century CE], 1925. *Roman History*, trans.
 Earnest Cary, Loeb Classical Library (Cambridge, MA: Harvard University
 Press, 2005), 423.
193 Steven T. Katz, ed., *The Late Roman-Rabbinic Period*. Cambridge History of
 Judaism, vol. 4 (Cambridge; New York: Cambridge University Press, 2006),
 98.
194 Applebaum, *Jews and Greeks*, 308–309, 311.
195 Benjamin Isaac, *The Invention of Racism in Classical Antiquity* (Princeton,
 NJ: Princeton University Press, 2004), 478–481.
196 Artemidorus, *The Interpretation of Dreams Oneirocritica*, Bk. 3.53,
 174–175.
197 Lee I. Levine, *The Ancient Synagogue: The First Thousand Years*, 2nd ed.
 (New Haven, CT; London: Yale University Press, 2005), 116.
198 Ibid., 417.
199 Louis H. Feldman, *Jew and Gentile in the Ancient World: Attitudes
 and Interactions from Alexander to Justinian* (Princeton, NJ: Princeton
 University Press, 1993), 300ff.
200 Adam H. Becker, "Anti-Judaism and Care for the Poor in Aphrahat's
 Demonstration 20," *Journal of Early Christian Studies* 10 (2002):
 322–323.
201 Feldman, *Jew and Gentile*, 172.
202 Michael Carter, "(Un)dressed to Kill: Viewing the *Retiarius*" in *Roman
 Dress and the Fabrics of Roman Culture*, ed. Jonathan Edmondson and
 Alison Keith (Toronto: University of Toronto Press, 2008), 130.
203 Freud, *The Interpretation of Dreams, SE* 4, 98.
204 Ibid., 99.
205 Armstrong, *Compulsion for Antiquity*, 88.
206 Freud, *Introductory Lectures, SE* 15, 86.
207 Ibid.
208 The catalogue of the Austrian National Library offers the most extensive
 bibliography of these titles, and my reckoning of the number of publishers
 is based on its entries.
209 Freud, *The Interpretation of Dreams, SE* 5, 634.
210 *Stock's kleines Persisch-Egyptisches Traum-Buch*, 15th ed., n.d.[1900?] [i].
211 The first record of Stock's edition dates to 1878. The German book dealer
 Karl Georg, in a catalog dated to 1904 (listing titles from 1898 to 1902),
 lists thirteen entries for dream books, including Stock's. See Karl Georg,
 *Karl Georgs Schlagwort-Katalog: verzeichnis der im deutschen Buchhandel
 erschienenen Bücher und Landkarten sachlicher Anordnung*, vol. 4
 (Hannover: Verlag Gebrüder Jänecke, 1904), 1922.
212 *Stock's Persisch-Egyptisches Traum-Buch*, iii.

213 Helge Dvorak, "Moritz Busch" in *Biographisches Lexikon der Deutschen Burschenschaft*, Band I Politiker, Teilband 7: Supplement A–K (Heidelberg, 2013), 189–191.

214 *Stock's Persisch-Egyptisches Traum-Buch*, 9.

215 Ibid., 86.

216 Marinelli, "Screening Wish Theories," 95.

217 Edith Saurer, *Strasse, Schmuggel, Lottospiel: Materielle Kultur und Staat in Niederösterreich, Böhmen, und Lombardo-Venetien in frühen 19. Jahrhundert* (Göttingen: Vandenhoeck & Ruprecht, 1989), 315.

218 Ibid., 299–300, 309–312.

219 Ibid., 316.

220 *Stock's Persisch-Egyptisches Traum-Buch*, 91.

221 Quoted in Marinelli, "Screening Wish Theories," 96.

222 Siegmund Kanner, *Das Lotto in Österreich: Ein Beitrag zur Finanzgeschichte Österreichs* (Strassburg: C. & J. Goeller, 1898), 73.

223 Ibid., 40.

224 Gabriele Schmid, "Zahlenlotto und Klassenlotterie in der Habsburgermonarchie 1751–1918: Reformen und Widerstände" (master's thesis, University of Vienna, 2008), 81–83.

225 *Stock's Persisch-Egyptisches Traum-Buch*, 133.

226 Freud, *The Interpretation of Dreams*, SE 4, 277.

227 John Forrester, *Language and the Origins of Psychoanalysis* (London; Basingstoke: Macmillan, 1980), 71.

228 Freud, *Introductory Lectures*, SE 15, 153.

229 Ibid.

230 Ibid., 150.

231 Forrester, *Language*, 71.

Conclusion: Objects' Lessons

This book has offered accounts, as cultural and visual narratives, of certain ideas that would prove decisive for Freud's early formulations of psychoanalysis. Such an endeavor is predicated on the recognition that, in a construction intended to enframe an "inner life"—one that eludes conscious awareness and possesses its own distinctive mechanisms and functions—Freud actually reveals much about his engagement with his physical and material surroundings. We have accessed some of these experiences by returning to his origin stories of his psychical formulations, as he made them, to use his term, "credible," through much volitional effort in the service of making an unconscious. But the scaffolding of his edifice will disappear once the structure has been cast as a discovery, as if always standing beyond time and place, waiting to be revealed. There are many important reasons to turn Freud's project back to the moments of its emergence, among them the insight informing this book: that psychoanalysis, if viewed from another vantage point, can be as much a discourse on what Freud disavows, discards, and "forgets" as on what he reified. Granted, such an inquiry is not "psychoanalytic" as we know it—after all, that would defeat its purpose—but it provides important insights about Freud and his work, and helps chart, as part of a broader inquiry, how certain ideas come to matter and others, even though seemingly compelling and worthy, do not.

Here, the issues are addressed close to the ground. The topographies vary, extending from Vienna's Ringstrasse to the streets of Orvieto, a carriage in Bosnia, and a train car in Leipzig, but the focus is on details that grant vividness to objects, individuals, and experiences that have remained unexamined. Yet what Freud deemed dismissible was nevertheless generative within his structuring of psyche. I have offered here a preface to this, one located not in prediscursive constituents of the unconscious—his Ur-history of a primordial territory, with all the Eurocentric tropes that entailed—but rather in what preceded them: Freud's volition, intention, and motives. By locating the inaugural stimulus for psychical functioning there, with the help of visual culture, I have given these attributes a material history that had been rendered invisible.

We saw how Freud seemed to leave traces of his own footprints in the "architecture of hysteria," where he not only created the sketch, but enacted, in piecing together the workings of "hysterical fantasies," the mechanism of the removal of memory; he then announced this to Fliess as an intrinsic function. Several months later, in the autumn of 1897, as Freud turns away from a reconstructive model of traumatic "scenes"—whose fore-shadow was already being cast by the architectural image he had drawn—he must create another viable conduit through which the past, often from early life, can be reckoned as evidential. Like Mancini, who would determine what portions of a grave assemblage would be brought to the marketplace, the first gestures of what would be gleaned from Freud's thoughts of childhood in this period were carefully curated, and, also following a practice familiar in the antiquities trade, falsified when necessary to enhance them. This did not undermine their intrinsic value, for that was no longer dependent upon a particular "scene" of history—whether in the objects gathered for an Etruscan burial or the specificity of childhood details of an abuse victim.

The mechanism of repression, identifiable in the displacement and contiguity decisive for the workings of the Signorelli "parapraxis," was traced here as a secondary effect rather than, as Freud would say, a "primary process." His narrative and attendant diagram are themselves a transposition, made believable only after several replacements: imagery related to Bolsena, on the other side of the "crossing" in the main aisle, returns as the phantasmal "Bo-snia"; the source of his associative process featuring three artists' names displaces the originary sequence of paintings on a gallery wall; and a portion of the Signorelli narrative occurs in what follows it, in the second chapter of *Everyday Life*. In our discussion of "dreams," which I suggest was a fluid category for Freud, the presence of a wish, emergent from the unconscious and thus the latent meaning, was prefaced by an earlier wish making possible a construction by which the unwanted imagery of dreams and their associations could be extracted. In fact, the originary wish was to remove material from meaning, so "genuine" meaning could be enunciated.

Such doublings-back enable us to better understand where Freud's fault lines of analytic engagement lay and to illuminate why the model he espoused was so decidedly intrasubjective. In this book I have posited that this "one person" construction—largely superseded by intersubjective models in psychoanalysis, but nevertheless a decisive factor in its creation— was an assertion of agency, appearing as the workings of one's sexual and aggressive impulses. We have considered Freud's privileging of these latter drives as reflecting something other than their seemingly irreducible— virtually ontological—stature within psychical life, and instead have

regarded them to be a consciously crafted modality of self-protection. In viewing his project this way, the incontrovertible components of the unconscious are actually its manifest content, masking experiences of vulnerability and disenfranchisement, and Freud's attendant responses of dread, fright, and sorrow. These were accorded little significance in contrast to the extraordinary power Freud granted to factors exclusively generative of a psyche of one's own.

This may explain why Freud located his Oedipal awakening as he did. Since we can be quite sure its circumstances could not have occurred as he claimed, why did he locate it so specifically in that moment of disruption and transition? Perhaps because he could then contain it fully and exclusively as being about his own possession, *meine Libido*, something extractable from time and place. By doing so, he discursively obliterated the impact of those circumstances, removing them from meaning so that the coincidence of these two events would virtually escape notice, as indeed it has been the case. Thus, despite more than a century of florescence and critique within analytic theories and practices, there remain areas of genealogy that offer insights of both historical and contemporary relevance.

As we journey along the outer borders of Freud's psychical constructions, there is a change in language, as if we are entering a different geo-cultural territory. The early terminology of psychoanalysis, often of Freud's own making or appropriation, falls away at the edges, and the discourses can be articulated in terms and phrases whose resonances are found in our current moment: reactionary political regimes, discriminatory policies, both anti-Jewish and anti-Islamic representations, childhood instabilities and familial shifts, economic distress, insecurities around residency, lack of a "homeland," and the return of age-old, racist ideologies. But these issues inhabit an amnesic core rather than the periphery of the Freudian unconscious: their disavowal generates the capacity to designate a separable terrain, governed according to a rule of autonomy in profound, and at times poignant, contrast to the vulnerabilities and dangers residing just beyond the walls of Freud's fragment-filled rooms. But Freud's experiences, and the objects and people associated with them, inhabit, as its revenants, the psychical formulations that he espoused and, as such, continue to be part of its legacy. Certainly, the impact of these and related issues can be found in the scholarship and practice of many analysts today, but might it be possible to imagine an even more fully engaged involvement in civic as well as clinical discourses? The ramifications of all the endangerments cited above, for adults and especially children, are profound and multifaceted, with the threats to individual survival and agency reverberating through families and communities, nationally and transnationally. These concerns had a decisive presence within the earliest

shaping of psychoanalysis; in the twenty-first century, the field might return to them as it looks to grow and expand its work in the world.

This book has been about the lives of individuals, most notably Freud, but also about the lives of objects, and they are given the concluding word here. We have privileged certain physical presences as a means to revisit the formation of psychical concepts and mechanisms—a strategy predicated upon affective and ideological constituents indivisible from the visual cultures introduced here, imbricated within the reception of their materiality. As such, they were able to elicit from Freud a considerable range of responses that, whether embraced or disavowed, became part of his construction of an unconscious. Although this is only a small part of their histories, it is nevertheless a site of their significance. The making of phantasms is not exclusive to psychical functioning: it is part of what generates the meaning of a city's buildings, a cathedral's paintings, and a dealer's treasure trove. Recognizing this co-creation can extend the disciplinary reach of the fields in which these objects are most commonly situated, for, as we have seen here, they indeed have mattered elsewhere.

Afterword

As Freud and members of his family struggled to make arrangements, at times under extreme duress, to leave Vienna in the spring of 1938, they were hardly alone in their plight. Under the same roof, other Jewish families that lived at Berggasse 19 were experiencing similar upheavals, as made visible by Lydia Marinelli's 2003 catalog—*Freuds verschwundene Nachbarn* ("Freud's vanished neighbors")—for an exhibition held in the rooms of the Freuds' apartment. One of the most horrifying revelations was that the family's departure did not leave these rooms empty for long: the Freud apartment served as a holding place for Viennese Jews after they were seized for deportation. In 1942, seventeen people were living in there, all of whom were forced on to camps or, as the record described, to "ghettos"; in either case, every one of those confined at Berggasse 19 was eventually murdered. On the other side of the city, in another of these so-called "collective apartments," four of Freud's elderly sisters—Pauline Winternitz, Adolfine Freud, Marie Freud, and Rosa Graf, all of whom had remained in Vienna—were also held; they, too, all died in various camps after their deportations in 1942.

The destruction of Vienna's Jewish community was systematic and cruel, but not only the living were victims of inhumanity. Not far from Berggasse 19, and not long after some of the Freud family were able to escape to safety, the Währinger Jewish Cemetery, a large burial ground dating to the eighteenth century, was subjected to extreme forms of destruction. Thirty thousand people were buried there, and Nazi desecration affected a stunning number of them: many of the ten thousand headstones were smashed, graves opened, and remains removed. Some of this carnage was thoughtless barbarity, but for the most part it was carefully planned. A number of the remains were taken to the city's natural history museum to be studied for future installations on the imagined-to-be-exterminated Jewish "race." In 1942 a portion of the cemetery, with more than two thousand graves, was seized for the putative creation of a large bomb shelter, which was never built. Members of the ever-dwindling Jewish community hastened to remove and rebury as many individuals as possible; we have records that about 120 graves were moved to the Zentralfriedhof ("central cemetery") before the bulldozing began. The headstones were cast aside and the remains, along with the earth in which they had rested, were dug up and carried to various sites nearby. There, the soil and those interred in it were used to "repair" damage done

to the streets and train stations. Among those taken was the grave of Jacob Nathansohn, Freud's grandfather, who appeared several times in this book, providing, along with his wife Sara Wilenz Nathansohn (who eventually returned to Odessa and was buried there), what may have been Freud's most stable domestic space in the first years of his life in Vienna. It was seeing his grandfather on his deathbed, in 1865, that Freud recalled when he published the one dream belonging to his childhood.

Little has changed at the Währinger cemetery over the ensuing decades; it is still a site of numbing destruction today. Nearly a decade ago, I became involved in a descendants' advocacy group there, but it was only when finishing this book that I realized Jacob Nathansohn had been among those disinterred. Many tragic lessons can be learned from this place, but the fate of those two thousand individuals, whose remains are now incorporated namelessly into these streets, is particularly wrenching. It was as though the dead were not dead enough; they needed to disappear completely from what became a most dangerous ground. These remains taken from the Währinger cemetery, even today, are not buried deeply; they are closer to the manifest than to the latent. What is hidden is not their materiality, as fragile as that is now, but the stark narrative of brutality; this is a repression, not one that forgets a name, but a far greater pathology: one that forgets that any person ever answered to it.

Bibliography

Akhtar, Salman. "The Compulsion to Betray and the Need to Be Betrayed." In *Betrayal: Developmental, Literary, and Clinical Realms*, edited by Salman Akhtar, 117–134. London: Karnac Books, 2013.

Akhtar, Salman. *On Freud's "The Unconscious."* London: Karnac, 2013.

Alden, W.L. "Pleasant Idling Places: Orvieto." *The Idler Magazine* 2 (1893): 35–43.

Alofsin, Anthony. *When Buildings Speak: Architecture as Language in the Habsburg Empire and Its Aftermath, 1867–1933.* Chicago, IL; London: University of Chicago Press, 2006.

Anidjar, Gil. *The Jew, The Arab: A History of the Enemy.* Stanford, CA: Stanford University Press, 2003.

Anzieu, Didier. *Freud's Self-Analysis.* Translated by Peter Graham. Madison, CT: International Universities Press, 1986.

Appignanesi, Lisa, and John Forrester. *Freud's Women.* New York: Basic Books, 1992.

Applebaum, Shim'on. *Jews and Greeks in Ancient Cyrene.* Studies in Judaism in Late Antiquity, vol. 28. Leiden: E.J. Brill, 1979.

Armstrong, Richard H. "Being Mr. Somebody." In *The Jewish World of Sigmund Freud: Essays on Cultural Roots and the Problem of Religious Identity*, edited by Arnold D. Richards, 35–50. Jefferson, NC: McFarland, 2010.

Armstrong, Richard H. *A Compulsion for Antiquity: Freud and the Ancient World.* Ithaca, NY; London: Cornell University Press, 2005.

Armstrong, Richard H. "Marooned Mandarins: Freud, Classical Education, and the Jews of Vienna." In *Classics and National Cultures*, edited by Susan A. Stephens and Phiroze Vasunia, 34–58. London; New York: Oxford University Press, 2010.

Arndt, Helmut et al., eds. *Leipzig in acht Jahrhunderten.* Leipzig: VEB Bibliographisches Institut, 1965.

Artemidorus of Daldis. *The Interpretation of Dreams (Oneirocritica).* Translated by Robert J. White. Park Ridge, NJ: Noyes Press, 1975.

Assoun, Paul-Laurent. "L' 'effet Baedeker': note psychanalytique sur la catégorie de guide de tourisme." *In Situ* 15 (2011). URL: http://insitu.revues.org/582; DOI:10.4000/insitu.582.

Augusta, Georg. "'Dann kamen die langen, harten Jahre': zur Situation der Familie Freud nach ihrer Ankunft in Wien im Jahr 1859." *Luzifer-Amor: Zeitschrift zur Geschichte der Psychoanalyse* 56 (2015): 108–129.

Baedeker, Karl [Firm]. *Italien: Handbuch für Reisende; Zweiter Teil: Mittel-Italien und Rom.* 11th ed. Leipzig: Karl Baedeker, 1896.

Baedeker, Karl [Firm]. *Italien: Handbuch für Reisende; Erster Teil: Ober-Italien, Ligurien, das nördliche Toscana.* 15th ed. Leipzig: Karl Baedeker, 1898.

Baedeker, Karl [Firm]. *Österreich-Ungarn: Handbuch für Reisende.* 24th ed. Leipzig: Karl Baedeker, 1895.

Baedeker, Karl [Firm]. *Südbaiern, Tirol und Salzburg, Ober-u. Nieder-Österreich, Steiermark, Kärnten und Krain.* 27th ed. Leipzig: Karl Baedeker, 1896.

Barker, Stephen, ed. *Excavations and Their Objects: Freud's Collection of Antiquity.* Albany, NY: State University of New York Press, 1996.

Baumann, Franz. *Vom älteren Flussbau in Österreich.* Vienna: Springer, 1951.

Beaumont, Matthew. "Railway Mania: The Train Compartment as the Scene of a Crime." In *The Railway and Modernity,* edited by Matthew Beaumont and Michael Freeman, 125–153. Bern: Peter Lang, 2007.

Becker, Adam H. "Anti-Judaism and Care for the Poor in Aphrahat's *Demonstration* 20." *Journal of Early Christian Studies* 10, no. 3 (2002): 305–327.

Becker, Hortense Koller. "Carl Koller and Cocaine." *Psychoanalytic Quarterly* 32 (1963): 309–373.

Becker, Marshall J. "An Analysis of Human Skeletal Remains from an Etruscan Urn in the Detroit Institute of Arts." *Etruscan Studies* 12 (2008–2009): 61–72.

Becker, Marshall J. "Coming of Age in Etruria: Etruscan Children's Cemeteries in Tarquinia, Italy." *International Journal of Anthropology* 27, no. 1/2 (2012): 63–86.

Bedoire, Fredric. *The Jewish Contribution to Modern Architecture: 1830–1930.* Stockholm: KTAV Publishing House, 2004.

Beller, Steven. *The Jews of Vienna 1867–1938: A Cultural History.* Cambridge: Cambridge University Press, 1989.

Bergstein, Mary. "Freud's Uncanny Egypt: Prolegomena." *American Imago* 66, no. 2 (2009): 185–210.

Bergstein, Mary. "Gradiva Medica: Freud's Model Female Analyst as Lizard-Slayer." *American Imago* 60, no. 3 (2003): 285–301.

Bergstein, Mary. *Mirrors of Memory: Freud, Photography, and the History of Art.* Ithaca, NY; London: Cornell University Press, 2010.

Bernays, Anna Freud. *Eine Wienerin in New York: Die Schwester Sigmund Freuds erinnert sich.* Edited by Christfried Tögel. Berlin: Aufbau-Verlag, 2004.

Bernays, Anna Freud. "My Brother, Sigmund Freud." In *Freud as We Knew Him,* edited by Hendrik M. Ruitenbeek, 140–147. Detroit, MI: Wayne State University Press, 1973.

Bernfeld, Siegfried, and Suzanne Cassirer Bernfeld. "Freud's Early Childhood." In *Freud as We Knew Him,* edited by Hendrik M. Ruitenbeek, 188–196. Detroit, MI: Wayne State University Press, 1973.

Bernfeld, Siegfried, and Suzanne Cassirer Bernfeld. "Freud's First Year in Practice: 1886–1887." In *Freud as We Knew Him,* edited by Hendrik M. Ruitenbeek, 252–265. Detroit, MI: Wayne State University Press, 1973.

Bernfeld, Suzanne Cassirer. "Freud and Archaeology." *American Imago* 8, no. 2 (1951): 107–128.

Bernstein, Susan. *Housing Problems: Writing and Architecture in Goethe, Walpole, Freud, and Heidegger.* Stanford, CA: Stanford University Press, 2008.

Billig, Michael. "Freud's Different Versions of Forgetting 'Signorelli': Rhetoric and Repression." *The International Journal of Psychoanalysis* 81 (2000): 483–498.

Bion, Wilfred. "The Psycho-Analytic Study of Thinking." *International Journal of Psycho-Analysis* 43 (1962): 306–310. Reprinted as "A Theory of Thinking" in his *Second Thoughts: Selected Papers on Psycho-Analysis*. London: Heinemann, 1967.

Birnbaum, Pierre. *The Tale of Ritual Murder in the Age of Louis XIV: The Trail of Raphaël Lévy, 1669*. Stanford, CA: Stanford University Press, 2012.

Bizzarri, Mario. *La Necropoli di Crocifisso del Tufo in Orvieto*. 2 vols. Orvieto: Fondazione per il Museo "Claudio Faina," 1963, 1966.

Bjelić, Dušan I. *Normalizing the Balkans: Geopolitics of Psychoanalysis and Psychiatry*. Farnham, Surrey; Burlington, VT: Ashgate, 2011.

Blass, Rachel B., and Bennett Simon, "Freud on His Own Mistake(s): The Role of Seduction in the Etiology of Neurosis." *Psychiatry and the Humanities* 12 (1992): 160–183.

Bogdal, Klaus-Michael. *Europa erfindet die Zigeuner: Eine Geschichte von Faszination und Verachtung*. Berlin: Suhrkamp, 2011.

Bonnlander, Helene. *Der vermittelte Imperialismus: Der Blick auf aussereuropäische Lebenswelten von Alexander von Humboldt zu Heinrich Brugsch*. Frankfurt am Main; New York: Lang, 1998.

Borszczow, Elia. "Die pharmaceutisch-wichtigen Ferulaceen der Aralo-Caspischen Wüste." *Mémoires de l'Académie impériale des sciences de St.-Pétersbourg*, 3, no. 8, 7th ser. (1860): 30–37.

Bos, Jaap. "A Silent Antipode: The Making and Breaking of Psychoanalyst Wilhelm Stekel." In *The Self-Marginalization of Wilhelm Stekel: Freudian Circles Inside and Out*, with Leendert Groenendijk, 17–48. New York: Springer, 2007.

Bourneville, Désiré-Magloire, and Paul-Marie-Léon Regnard. *Iconographie photographique de la Salpêtrière*. 3 vols. Paris: Bureaux du progrès médical et Bibliothèque de la faculté de médecine, 1876–1880.

Bowlby, Rachel. *Freudian Mythologies: Greek Tragedy and Modern Identities*. Oxford; New York: Oxford University Press, 2007.

Boyarin, Daniel. *Unheroic Conduct: The Rise of Heterosexuality and the Invention of the Jewish Man*. Berkeley, CA: University of California Press, 1997.

Brandt, Wilhelm. *Schlaf- und Speisewagen der Eisenbahn: Ihre Entwicklung und Geschichte*. Stuttgart: Franckh'sche Verlagshandlung, 1968.

Breger, Louis. *Freud: Darkness in the Midst of Vision*. New York: John Wiley & Sons, 2000.

Brein, Friedrich, ed. *Emanuel Löwy: Ein vergessener Pionier*. Vienna: Verlag des Clubs der Universität Wien, 1998.

Britton, Ronald, and John Steiner, "Interpretation: Selected Fact or Overvalued Idea?" *International Journal of Psycho-Analysis* 75 (1994): 1069–1078.

Brockhaus' Konversations-Lexicon. 14th ed. Leipzig: Brockhaus, 1892.

Bronfen, Elisabeth. *The Knotted Subject: Hysteria and Its Discontents.* Princeton, NJ: Princeton University Press, 1998.

Brugsch, Heinrich. *Reise der K. preussischen Gesandtschaft nach Persien: 1860 und 1861.* Leipzig: J.C. Hinrichs, 1862–1863.

Brunner, José. "The Naked Mother or, Why Freud Did Not Write about Railway Accidents." *Psychoanalysis and History* 9, no. 1 (2007): 71–82.

Bruschetti, Paolo. "The Etruscans in Umbria." In *The Etruscans Outside Etruria*, edited by Giovannangelo Camporeale, translated by Thomas Michael Hartmann, 192–207. Los Angeles, CA: J. Paul Getty Museum, 2004.

Bruschetti, Paolo. *La necropoli di Crocifisso del Tufo a Orvieto: contesti tombali.* Monumenti etruschi 10 (Pisa; Rome: Fabrizio Serra editore, 2012).

Buhse, Fedor. *Aufzaehlung der auf einer Reise durch Transkaukasien und Persien gesammelten Pflanzen in Gemeinschaft.* Moscow: W. Gautier, 1860.

Bum, Anton, and Moritz T. Schnirer, eds. *Diagnostisches Lexikon für praktische Ärzte.* Vol. 1. Vienna: Urban & Schwarzenberg, 1893.

Bundrick, Sheramy D. "Athenian Eye Cups in Context." *American Journal of Archaeology* 119, no. 3 (July 2015): 295–341.

Burke, Janine. *The Sphinx on the Table: Sigmund Freud's Art Collection and the Development of Psychoanalysis.* New York: Walker, 2006.

Bynum, Caroline Walker. "Women Mystics and Eucharistic Devotion in the Thirteenth Century." *Women's Studies* 11, no. 1/2 (1984): [179]–214.

Calder, William M. "Walther Amelung to Ulrich von Wilamowitz-Moellendorff on Emanuel Löwy: An Unpublished Letter." In *Noctes Atticae: 34 Articles on Graeco-Roman Antiquity and Its Nachleben: Studies Presented to Jørgen Mejer on His Sixtieth Birthday March 18, 2002*, edited by Bettina Amden et al., 60–66. Copenhagen: Museum Tusculanum Press, 2002.

Camille, Michael. *The Gargoyles of Notre-Dame: Medievalism and the Monsters of Modernity.* Chicago, IL: University of Chicago Press, 2009.

Carter, Michael. "(Un)dressed to Kill: Viewing the *Retiarius*." In *Roman Dress and the Fabrics of Roman Culture*, edited by Jonathan Edmondson and Alison Keith, 113–135. Toronto: University of Toronto Press, 2008.

Caruth, Cathy. *Literature in the Ashes of History.* Baltimore, MD: Johns Hopkins University Press, 2013.

Casid, Jill H. *Sowing Empire: Landscape and Colonization.* Minneapolis, MN; London: University of Minnesota Press, 2005.

Catoni, Giuliano. *I Goliardi Senesi e il Risorgimento: Dalla guerra del Quarantotto al monumento del Novantatré.* Siena: Università degli Studi, Feriae Matricularum, 1993.

Charcot, Jean-Martin. *Neue Vorlesungen über die Krankheiten des Nervensystems insbesondere über Hysterie.* Translated by Sigmund Freud. Leipzig and Vienna: Toeplitz and Deuticke, 1886.

Chown, John F. *A History of Monetary Unions*. London; New York: Routledge, 2003.

Coe, Cati et al., eds. *Everyday Ruptures: Children, Youth, and Migration in Global Perspective*. Nashville, TN: Vanderbilt University Press, 2011.

Conley, Tom. "The Wit of the Letter: Holbein's Lacan." In *Vision in Context: Historical and Contemporary Perspectives on Sight*, edited by Teresa Brennan and Martin Jay, 45–60. New York; London: Routledge, 1996.

Corbett, Ken. *Boyhoods: Rethinking Masculinities*. New Haven, CT: Yale University Press, 2009.

Cotti, Patricia. "Freud and History before 1905: From Defending to Questioning the Theory of a Glorious Past." *Psychoanalysis and History* 10, no. 1 (2008): 3–19.

Crews, Frederick. *Freud: The Making of an Illusion*. New York: Metropolitan Books; Henry Holt and Company, 2017.

Cron, Karl, ed. *Feld-Taschenbuch für k. und .k. von Militär-Ärzte*. Vienna: Verlag von Josef Šafář, 1897.

Czerny, Wolfgang et al. *Wien: II. bis IX. Und XX. Bezirk*. Dehio-Handbook die Kunstdenkmäler Österreich: Topographisches Denkmälerinventar [Vienna]: Verlag Anton Schroll, 1993.

Datta, Ayona, and Abdul Shaban, eds. *Mega-Urbanization in the Global South: Fast cities and new urban utopias of the postcolonial state*. London; New York: Routledge, 2017.

Davis, Whitney. *Drawing the Dream of the Wolves: Homosexuality, Interpretation, and Freud's "Wolf Man."* Bloomington; Indianapolis, IN: Indiana University Press, 1995.

de Grummond, Nancy T. "Haruspicy and Augury: Sources and Procedures." In *The Etruscan World*, edited by Jean MacIntosh Turfa, 539–556. Abingdon, Oxon: Routledge, 2013.

de Libero, Loretana. *Rache und Triumph: Krieg, Gefühle und Gedenken in der Moderne*. Munich: De Gruyter/ Oldenbourg, 2014.

Della Fina, Giuseppe M. *Storia di Orvieto, I: Antichità*. Perugia: Quattroemme, 2003.

Dennis, George. *The Cities and Cemeteries of Etruria*. Vol. 2. London: John Murray, 1883.

Derrida, Jacques. *Archive Fever: A Freudian Impression*. Translated by Eric Prenowitz. Chicago, IL: University of Chicago Press, 1996.

Derrida, Jacques. "Freud and the Scene of Writing." In *Writing and Difference*, translated by Alan Bass, 196–231. Chicago, IL: University of Chicago Press, 1978.

Derrida, Jacques. "Parergon." In *The Truth in Painting*, translated by Geoff Bennington and Ian McLeod, 15–147. Chicago, IL: University of Chicago Press, 1987.

Derrida, Jacques. *Resistances of Psychoanalysis*. Translated by Peggy Kamuf, Pascale-Anne Brault, and Michael Naas. Stanford, CA: Stanford University Press, 1998.

Devadason, Ranji. "Place Attachment, Community Cohesion and the Politics of Belonging in European Cities." In *Social Capital, Political Participation and*

Migration in Europe: Making Multicultural Democracy Work? edited by Laura Morales and Marco Guigni, 238–261. Basingstoke: Palgrave Macmillan, 2011.

Didi-Huberman, Georges. *Invention of Hysteria: Charcot and the Photographic Iconography of the Salpêtrière.* Translated by Alisa Hartz. Cambridge, MA: MIT Press, 2003.

Dietrich, Felix ed. *Bibliographie der deutschen Zeitschriftenliteratur: mit Einschluss von Zeitungen und Sammelwerken.* Vol. 13. Leipzig: Felix Dietrich, 1904.

Dingley, Robert. "Closely Observed Trains: The Railway Compartment as a Locus of Desire in Victorian Culture." *Cahiers Victoriens et Edouardiens* 553 (2001): 111–139.

Dio Cassius. *Roman History* [Second to third century CE]. 1925. Translated by Earnest Cary. Loeb Classical Library. Cambridge, MA: Harvard University Press, 2005.

Draaisma, Douwe. *Forgetting: Myths, Perils and Compensations.* Translated by Liz Waters. New Haven, CT; London: Yale University Press, 2015.

Dressler, Hans. *Resorcinol: Its Uses and Derivatives.* New York: Plenum Press, 1994.

Duden, Konrad. *Etymologie der neuhochdeutschen Sprache: mit einem ausführlichen etymologischen Wörterverzeichnis.* Munich: Beck'sche, 1893.

Dvorak, Helge. "Moritz Busch." In *Biographisches Lexikon der Deutschen Burschenschaft.* Band I Politiker, Teilband 7: Supplement A–K, 189–191. Heidelberg: Universitätsverlag Winter, 2013.

Edmondson, Jonathan, and Alison Keith, eds. *Roman Dress and the Fabrics of Roman Culture.* Toronto: University of Toronto Press, 2008.

Ehmer, Josef, Annemarie Steidl, and Hermann Zeitlhofer. "Migration Patterns in Late Imperial Austria." Working Paper No. 3. KMI Working Paper Series. Vienna: Österreichische Akademie der Wissenschaften, 2004.

Engelman, Edmund. *Berggasse 19: Sigmund Freud's Home and Offices, Vienna 1938.* New York: Basic Books, 1976.

Evans, Arthur. "Antiquarian Researches in Illyricum, III and IV." *Archaeologia* 49, no. 1 (1885): 1–168.

Feldman, Louis H. *Jew and Gentile in the Ancient World: Attitudes and Interactions from Alexander to Justinian.* Princeton, NJ: Princeton University Press, 1993.

Fiala, Ferdinand v., ed. *Wiener Handels-und Gerwerbe-Schematismus pro 1867–1868.* Vol. 1. Wien: Leopold Sommer, 1868.

Finson, Jon W. *Robert Schumann: The Book of Songs.* Cambridge, MA: Harvard University Press, 2007.

Fleischer, Max. *Friedrich Freiherr v. Schmidt als Mensch, Lehrer und Chef.* Vienna: Selbstverlag des Verfassers, 1891.

Flem, Lydia. *Freud the Man: An Intellectual Biography.* Translated by Susan Fairfield. New York: Other Press, 2003.

Forrester, John. *Dispatches from the Freud Wars: Psychoanalysis and Its Passions.* Cambridge, MA; London: Harvard University Press, 1998.

Forrester, John. *Language and the Origins of Psychoanalysis*. London; Basingstoke: Macmillan, 1980.

Forrester, John. *The Seductions of Psychoanalysis: Freud, Lacan and Derrida*. Cambridge; New York: Cambridge University Press, 1990.

Förster, Ludwig von, ed. *Allgemeine Bauzeitung*. Vol. 30. Vienna: R. von Waldheim, 1887.

Fourton, Jean. "Freud avec Börne, ou 'L'art de devenir un écrivain original en trois jours.'" *Littoral: Revue de psychanalyse* 2 (1981): 151–159.

Freeman, Erika. *Insights: Conversations with Theodor Reik*. Englewood Cliffs, NJ: Prentice Hall, 1971.

Freud, Ernst. "Some Early Unpublished Letters of Freud." *International Journal of Psycho-Analysis* 50 (1969): 419.

Freud, Ernst et al. *Sigmund Freud: His Life in Words and Pictures*. New York: W.W. Norton, 1998.

Freud, Martin. *Glory Reflected: Sigmund Freud, Man and Father*. London: Angus and Robertson, 1957.

Freud, Martin. *Sigmund Freud: Man and Father*. New York: Vanguard, 1958.

Freud, Sigmund. "Address to the Society of B'nai B'rith." 1941 [1926]. In *The Standard Edition of the Complete Psychological Works of Sigmund Freud* [SE], edited and translated by James Strachey et al., vol. 20, 272–274. London: Hogarth, 1953–1974.

Freud, Sigmund. "The Aetiology of Hysteria." 1896, SE 3, 189–221.

Freud, Sigmund. "Amnesie" and "Aphasie." In *Diagnostisches Lexikon für praktische Ärzte*. Edited by Anton Bum and Moritz T. Schnirer. vol. 1. Vienna: Urban & Schwarzenberg, 1893.

Freud, Sigmund. *Aus den Anfängen der Psychoanalyse: Briefe an Wilhelm Fliess, Abhandlungen und Notizen aus den Jahre 1887–1902*. Edited by Marie Bonaparte, Anna Freud, and Ernst Kris. London: Imago, 1950.

Freud, Sigmund. "An Autobiographical Study." 1925. SE 20, 7–74.

Freud, Sigmund. *Briefe an Wilhelm Fliess: 1887–1904*. 2nd ed. Edited by Jeffrey Moussaieff Masson and Michael Schröter. Frankfurt am Main: S. Fischer, 1999.

Freud, Sigmund. "Charcot." 1893. SE 3, 9–23.

Freud, Sigmund. *The Complete Letters of Sigmund Freud to Wilhelm Fliess, 1887–1904*. Translated and edited by Jeffrey Moussaieff Masson. Cambridge, MA; London: Belknap Press of Harvard University Press, 1985.

Freud, Sigmund. "Contribution to a Questionnaire on Reading." 1907. SE 9, 245–247.

Freud, Sigmund. "Contributions to a Discussion on Suicide." 1910. SE 11, 231–232.

Freud, Sigmund. *The Correspondence of Sigmund Freud and Sándor Ferenczi*. Vol. 1. Edited by Ernst Falzeder, Eva Brabant, and Patrizia Giampieri-Deutsch. Translated by Peter T. Hoffer. Cambridge, MA: Harvard University Press, 1993.

Freud, Sigmund. "Creative Writers and Day-Dreaming." 1908. *SE* 9, 142–153.

Freud, Sigmund. "Delusions and Dreams in Jensen's *Gradiva*." 1907. *SE* 9, 7–95.

Freud, Sigmund. "Der Mann Moses und die monotheistische Religion." *GW* 16, 1939, [101]–246.

Freud, Sigmund. "Frau Emmy von N." *Studies in Hysteria*. 1895. *SE* 2, 48–105.

Freud, Sigmund. "Further Remarks on the Neuro-Psychoses of Defence." 1896. *SE* 3, 162–185.

Freud, Sigmund. "Heredity and the Aetiology of the Neuroses." 1896. *SE* 3, 143–156.

Freud, Sigmund. *The Interpretation of Dreams*. 1900. *SE* 4 and 5, 1–627.

Freud, Sigmund. *The Interpretation of Dreams*. Translated by A.A. Brill. New York: Carlton House [pref. 1931].

Freud, Sigmund. *The Interpretation of Dreams*. Translated by Joyce Crick. Oxford: Oxford University Press, 1999.

Freud, Sigmund. *Introductory Lectures on Psycho-Analysis*. 1916. *SE* 15, 83–239.

Freud, Sigmund. *Jokes and Their Relation to the Unconscious*. 1905. *SE* 8.

Freud, Sigmund. "L'Hérédité et l'étiologie des névroses." *Revue neurologique* 4, no. 6 (1896): 161–169.

Freud, Sigmund. *Letters of Sigmund Freud*. Edited by Ernst L. Freud. Translated by Tania and James Stern. New York: Basic Books, 1960.

Freud, Sigmund. *Letters of Sigmund Freud to Eduard Silberstein: 1871–1881*. Edited and translated by Arnold J. Pomerans. Cambridge, MA: Harvard University Press/Belknap, 1990.

Freud, Sigmund. *Moses and Monotheism: Three Essays*. 1939. *SE* 23, 7–137.

Freud, Sigmund. "The Moses of Michelangelo." 1914. *SE* 13, 211–237.

Freud, Sigmund. "The Neuro-Psychosis of Defence." 1894. *SE* 3, 45–61.

Freud, Sigmund. "New Introductory Lectures on Psycho-Analysis." 1933. *SE* 22, 5–182.

Freud, Sigmund. "A Note upon the 'Mystic Writing-Pad.'" 1925. *SE* 19, 227–232.

Freud, Sigmund. "On Dreams." 1901. *SE* 5, 633–686.

Freud, Sigmund. "On the History of the Psycho-Analytic Movement." 1914. *SE* 14, 7–66.

Freud, Sigmund, with Josef Breuer. "On the Psychical Mechanism of Hysterical Phenomena: Preliminary Communication." 1893. *SE* 2, 3–17.

Freud, Sigmund. "Preface to the Translation of Bernheim's *De la Suggestion*." 1888. *SE* 1, 75–85.

Freud, Sigmund. "Project for a Scientific Psychology." 1895. *SE* 1, [295]–398.

Freud, Sigmund. "The Psychical Mechanism of Forgetfulness." 1898. *SE* 3, 289–297.

Freud, Sigmund. *The Psychopathology of Everyday Life*. 1901. *SE* 6, 1–279.

Freud, Sigmund. *The Psychopathology of Everyday Life*. Edited by Adam Phillips. Translated by Anthea Bell. London: Penguin Books, 2002.

Freud, Sigmund. "Reisestipendiumsgesuch." *Gesammelte Werke* [*GW*]. Nachtragsband (Frankfurt am Main: Fischer Taschenbuch Verlag, 1999), 48–49.

Freud, Sigmund. "Report of My Studies in Paris and Berlin." 1886. *SE* 1, 5-15.

Freud, Sigmund. "Screen Memories." 1899. *SE* 3, 303-322.

Freud, Sigmund. "Sexuality in the Aetiology of the Neuroses." 1898. *SE* 3, 262-284.

Freud, Sigmund, with Josef Breuer. *Studies on Hysteria*. 1895. *SE* 2, 19ff.

Freud, Sigmund. *Three Essays on the Theory of Sexuality*. 1905. *SE* 7, 125-243.

Freud, Sigmund. *Totem and Taboo: Some Points of Agreement between the Mental Lives of Savages and Neurotics*. 1913. *SE* 13, 1-161.

Freud, Sigmund. "Über Deckererinnerungen." *GW* 1, [531]-554.

Freud, Sigmund. "The Uncanny." 1919. *SE* 17, 219-256.

Freud, Sigmund. "The Unconscious." 1915. *SE* 14, 166-214.

Freud, Sigmund. *Unser Herz zeigt nach dem Süden: Reisebriefe, 1895-1923*. Edited by Christfried Tögel and Michael Molnar. Berlin: Aufbau-Verlag, 2002.

Freud, Sigmund. "Zum psychischen Mechanismus der Vergesslichkeit." *Monatsschrift für Psychiatrie und Neurologie* 4, no. 6 (1898): 436-443.

Freud, Sigmund. *Zur Auffassung der Aphasien: Eine kritische Studie*. Leipzig: Franz Deuticke, 1891. *On Aphasia: A Critical Study*. Translated by Erwin Stengel. London: Imago Publishing, 1953.

Freud, Sigmund. "Zur Psychopathologie des Alltagslebens." *Monatsschrift für Psychiatrie und Neurologie* 19, no. 1 (1901): 1-32; 2: 95-143.

Freud, Sigmund, and Martha Bernays. *Die Brautbriefe: Warten in Ruhe und Ergebung, Warten in Kampf und Erregung*. Vol. 3. Edited by Gerhard Fichtner, Ilse Grubrich-Simitis, Albrecht Hirschmüller and Wolfgang Kloft. Frankfurt a.M.: S. Fischer Verlag, 2015.

Freyhan, Robert. "The Evolution of the Caritas Figure in the Thirteenth and Fourteenth Centuries." *Journal of the Warburg and Courtauld Institutes* 11 (1948): 68-86.

Freyhan, T[heodor]. *Über Pneumonie*. Berliner Klinik, vol. 117. Berlin: Fischer's Medicin, 1898.

Freyhan, T[heodor] "Yohimbin Spiegel, ein neues Spezifikum gegen Impotenz." *Deutsche Ärztezeitung* (1902): 205-206.

Frieden, Ken. *Freud's Dream of Interpretation*. Albany, NY: State University of New York Press, 1990.

Fumi, Luigi, ed. *Il duomo di Orvieto e i suoi restauri: monografie storiche condotte sopra i documenti*. Roma: La società laziale tipografico-editrice, 1891.

Fumi, Luigi. *Il santuario del SS. Corporale nel Duomo di Orvieto: descrizione e illustrazione storica e artistica: ricordo del XV Congresso eucaristico di Orvieto*. Rome: Danesi, 1896.

Fürbringer, Paul. *Die Störungen der Geschlechtsfunctionen des Mannes*. Vienna: Alfred Hölder, 1895.

Fürbringer, Paul and Dr Freyhan. "Neue Untersuchungen über die Desinfektion der Hände." *Deutsche medizinische Wochenschrift* 23 (1897): 81-85.

Fürbringer, Paul. *Über Spermatorrhöe und Prostatorrhöe*. Leipzig: Breitkopf & Härtel, 1881.

Fuss, Diana, and Joel Sanders. "Berggasse 19: Inside Freud's Office." In *Stud: Architectures of Masculinity*, edited by Joel Sanders, 112–139. New York: Princeton Architectural Press, 1996.

Fuss, Diana, (with Joel Sanders). "Freud's Ear: Berggasse 19, Vienna, Austria." In Diana Fuss, *The Sense of an Interior: Four Rooms and the Writers That Shaped Them*, 71–105. New York; London: Routledge, 2004.

Fuss, Diana, *The Sense of an Interior: Four Rooms and the Writers That Shaped Them*. New York; London: Routledge, 2004.

Galison, Peter. "Blacked-out Spaces: Freud, Censorship, and the Re-territorialization of Mind." *British Journal of the History of Science* 45, no. 2 (2012): 235–266.

Galison, Peter. *Einstein's Clocks, Poincaré's Maps: Empires of Time*. New York; London: W.W. Norton, 2003.

Galli, Marco. " 'Immagini della memoria': Teoria della visione in Emanuel Löwy." In *Ripensare Emanuel Löwy: Professore di archeologia e storia dell'arte nella R. Università e Direttore del Museo di Gessi*, Studi miscellanei, vol. 37, edited by Maria Grazia Picozzi, [141]–188. Rome: "L'Erma" di Bretschneider, 2013.

Gallo, Rubén. *Freud's Mexico: Into the Wilds of Psychoanalysis*. Cambridge, MA; London: MIT Press, 2010.

Gallo, Rubén. "Freud's Spanish: Bilingualism and Bisexuality." *Psychoanalysis and History* 11, no. 1 (2009): 5–40.

Gamwell, Lynn, and Richard Wells, eds. *Sigmund Freud and Art: His Personal Collection of Antiquities*. London: Thames and Hudson, in association with the Freud Museum, 1989.

Gay, Peter. *Freud: A Life for Our Time*. New York: Doubleday, 1988.

Geehr, Richard S., ed. *"I Decide Who Is a Jew!": The Papers of Dr. Karl Lueger*. Washington, DC: University Press of America, 1982.

Geehr, Richard S., ed. *Karl Lueger: Mayor of Fin de Siècle Vienna*. Detroit, MI: Wayne State University Press, 1990.

Gelfand, Toby. "Sigmund-sur-Seine: Fathers and Brothers in Charcot's Paris." In *Freud and the History of Psychoanalysis*, edited by Toby Gelfand and John Kerr, 29–57. Hillsdale, NJ; London: Analytic Press, 1992.

Geller, Jay. *On Freud's Jewish Body: Mitigating Circumcisions*. New York: Fordham University Press, 2007.

Georg, Karl. *Karl Georgs Schlagwort-katalog: Verzeichnis der im deutschen Buchhandel erschienenen Bücher und Landkarten in sachlicher Anordnung*. Vol. 4. Hannover: Verlag Gebrüder Jänecke, 1904.

Gilbert, Creighton. *How Fra Angelico and Signorelli Saw the End of the World*. University Park, PA: Pennsylvania State University Press, 2003.

Gilman, Sander L. *Difference and Pathology: Stereotypes of Sexuality, Race, and Madness*. Ithaca, NY; London: Cornell University Press, 1985.

Gilman, Sander L. *Freud, Race, and Gender*. Princeton, NJ: Princeton University Press, 1993.

Gilman, Sander. *The Jew's Body*. New York; London: Routledge, 1991.

Ginzburg, Carlo. *Clues, Myths, and the Historical Method.* Translated by John and Anne Tedeschi. Baltimore, MD: Johns Hopkins University Press, 1989.

Ginzburg, Carlo, and Anna Davin. "Morelli, Freud and Sherlock Holmes: Clues and the Scientific Method." *History Workshop* 9 (1980): 5–36.

Glagau, Otto. *Der Börsen und Gründungs-Schwindel in Deutschland*, 2. Leipzig: Paul Frohberg, 1877, 416.

Goethe, Johann Wolfgang von. *Faust: A Tragedy.* Translated by John R. Williams. In *The Essential Goethe: Johann Wolfgang von Goethe*, edited by Matthew Bell. Princeton, NJ; Oxford: Princeton University Press, 2016.

Gomperz, Theodor. *Theodor Gomperz: Briefe und Aufzeichnungen.* Edited by Heinrich Gomperz. Vienna: Carl Gerold, 1936.

Gomperz, Theodor. *Traumdeutung und Zauberei. Ein Blick in das Wesen des Aberglaubens.* Vienna: Carl Gerold, 1866.

Gottlieb, Richard M. "The Reassembly of the Body from Parts: Psychoanalytic Reflections on Death, Resurrection, and Cannibalism." *Journal of the American Psychoanalytic Association* 55, no. 4 (2007): 1217–1251.

Granichstaedten-Czerva, Rudolf. *Andreas Hofers alte Garde.* Innsbruck: Vereinsbuchhandlung und Buchdruckerei, 1932.

Greenberg, Valerie. *Freud and His Aphasia Book: Language and the Sources of Psychoanalysis.* Ithaca, NY; London: Cornell University Press, 1997.

Grinstein, Alexander. *Sigmund Freud's Dreams.* 2nd ed. New York: International Universities Press, 1980.

Grollman, Earl. *Judaism in Sigmund Freud's World.* New York: Bloch, 1965.

Grosz, Elizabeth. *Jacques Lacan: A Feminist Introduction.* London; New York: Routledge, 1990.

Grubrich-Simitis, Ilse. *Early Freud and Late Freud: Reading Anew Studies on Hysteria and Moses and Monotheism.* Translated by Philip Slotkin. The New Library of Psychoanalysis 29, ser. ed. Elizabeth Bott Spillius. London: Routledge, 1997.

Gubel, Eric, ed. *Le Sphinx de Vienne: Sigmund Freud, l'art et l'archéologie.* Liege: Massoz, n.d.

Haiko, Peter, and Renata Kassal-Mikula, eds. *Friedrich von Schmidt (1825–1891): Ein gotischer Rationalist.* Vienna: Museen der Stadt Wien, 1991.

Hake, Sabine. "*Saxa loquuntur*: Freud's Archaeology of the Text." *boundary 2* 20, no. 1 (1993): 146–173.

Hall, Stuart. "Political Belonging in a World of Multiple Identities." In *Conceiving Cosmopolitanism: Theory, Context, and Practice*, edited by Steven Vertovec and Robin Cohen, 25–31. Oxford: Oxford University Press, 2002.

Hamilton, James W. "Freud and the Suicide of Pauline Silberstein." *The Psychoanalytic Review* 89, no. 6 (2002): 889–909.

Handels- und Gewerbs-Schematismus von Wien und dessen nächster Umgebung. Vienna: Förster and Bartelmus, 1885.

Handler Spitz, Ellen. "Psychoanalysis and the Legacies of Antiquity." In *Sigmund Freud and Art: His Personal Collection of Antiquities*, edited by Lynn Gamwell

and Richard Wells. London: Thames and Hudson, in association with the Freud Museum, 1989.

Harding, Catherine D. *Guide to the Chapel of the Corporal of Orvieto Cathedral* [Orvieto]: Opera del Duomo di Orvieto; Perugia: Quattroemme, 2004.

Harris, W.V. Review of *La necropoli di Crocifisso del Tufo a Orvieto: contesti tombali*, Monumenti etruschi 10, by Paolo Bruschetti. *Bryn Mawr Classical Review* 2012.12.14. http://bmcr.brynmawr.edu/2012/2012-12-14.html

Hays, K. Michael. *Architecture's Desire: Reading the Late Avant-Garde*. Cambridge, MA; London: MIT Press, 2010.

Heer, Friedrich. "Freud, the Viennese Jew." Translated by W.A. Littlewood. In *Freud: The Man, His World, His Influence*, edited by Jonathan Miller, 1–20. London: Weidenfeld and Nicolson, 1972.

Hildebrand, Friedrich. *Die Gattung Cyclamen L. Eine systematische und biologische Monographie*. Jena: G. Fischer, 1898.

Hlasiwetz, Heinrich. "Über das Galbanum." *Sitzungsberichte der mathematisch-naturwissenschaftlichen Classe der kaiserlichen Akademie der Wissenschaften* 43, no. 2 (1861): 477–484.

Hoffmann, Christhard. "Analyzing the Zeitgeist: Ludwig Philippson as Historian of the Modern Era." In *Mediating Modernity: Challenge and Trends in the Jewish Encounter with the Modern World: Essays in Honor of Michael A. Meyer*, edited by Michael Brenner and Lauren B. Strauss, 109–120. Detroit, MI: Wayne State University Press, 2008.

Hofmann, Paul. "… and in Vienna, a Plaque and Memories." *New York Times*, May 7, 1977.

Homburg, Ernst. "The Influence of Demand on the Emergence of the Dye Industry: The Roles of Chemists and Colourists." *Journal of the Society of Dyers and Colourists* 99 (1983): 325–332.

Hornung, Erik. *The Secret Lore of Egypt: Its Impact on the West*. Translated by David Lorton. Ithaca, NY; London: Cornell University Press, 2001.

Hsia, R. Po-Chia. *Trent 1475: Stories of a Ritual Murder Trial*. New Haven, CT: Yale University Press; New York: Yeshiva University Library, 1992.

Huijsmans, Roy. "Child Migration and Questions of Agency." *Development and Change* 42, no. 5 (2011): 1307–1321.

Hukić, Mirsada, and Irma Salimović-Bešić. "Sandfly—Pappataci Fever in Bosnia and Herzegovina: The New-Old Disease." *Bosnian Journal of Basic Medical Sciences* 9, no. 1 (2009): 39–43.

Huntsman, Theresa. "Hellenistic Etruscan Cremation Urns from Chiusi." *Metropolitan Museum Journal* 49, no. 1 (2014): 141–150.

Hutton, Christopher. "Freud and the Family Drama of Yiddish." In *Studies in Yiddish Linguistics*, edited by Paul Wexler, [9]–22. Tübingen: Max Niemeyer Verlag, 1990.

Isaac, Benjamin. *The Invention of Racism in Classical Antiquity*. Princeton, NJ: Princeton University Press, 2004.

Jahrbuch der Internationalen vereinigung für Vergleichende Rechtswissenschaft und Volkswirtschaftslehre zu Berlin. Vols. 2 and 3, no. 1. Berlin: K. Hoffmann, 1897.

Jahresverzeichnis der an den deutschen Universitäten erschienenen Schriften. Vol. 3, 1887–1888. Berlin: A. Asher, 1888.

James, Sara Nair. *Signorelli and Fra Angelico at Orvieto: Liturgy, Poetry and a Vision of the End Time.* Hants; Burlington, VT: Ashgate, 2003.

Jantsch, M. "Alois Pick." In *Österreichisches biographisches Lexikon 1815–1950,* 2nd ed., vol. 8, 60. Vienna: Verlag der Österreichischen Akademie der Wissenschaften. Vienna; Graz: Böhlau, 1979.

Jantsch, M., and G.H. Marcus. "Alois Pick, der Entdecker des Pappataci-Fiebers." *Weiner Medizinische Wochenschrift* 111 (1961): 801–803.

Johnston, Adrian. "Sextimacy—Freud, Mortality, and a Reconsideration of the Role of Sexuality in Psychoanalysis." In *Sexuality and Psychoanalysis: Philosophical Criticisms,* edited by Jens De Vleminck and Eran Dorfman, 10–35. Leuven: Leuven University Press, 2010.

Jones, Ernest. *The Life and Work of Sigmund Freud, 1856–1900: The Formative Years and the Great Discoveries.* Vol. 1. New York: Basic Books, 1953.

Jones, Ernest. *The Life and Work of Sigmund Freud, 1901–1919: The Years of Maturity.* Vol. 2. New York: Basic Books, 1955.

Jonte-Pace, Diane. *Speaking the Unspeakable: Religion, Misogyny, and the Uncanny Mother in Freud's Cultural Texts.* Berkeley, CA; Los Angeles, CA: University of California Press, 2001.

Juristische Blätter: Eine Wochenschrift 7. Vienna: Carl Fromm, 1878.

Kandel, Eric. *The Age of Insight: The Quest to Understand the Unconscious in Art, Mind, and Brain from Vienna 1900 to the Present.* New York: Random House, 2012.

Kanner, Siegmund. *Das Lotto in Österreich: Ein Beitrag zur Finanzgeschichte Österreichs.* Strassburg: C. & J. Goeller, 1898.

Katz, Dana E. *The Jew in the Art of the Italian Renaissance.* Philadelphia, PA: University of Pennsylvania Press, 2008.

Katz, Steven T., ed. *The Late Roman-Rabbinic Period.* The Cambridge History of Judaism, vol. 4. Cambridge; New York: Cambridge University Press, 2006.

Kern, Florian. *Der Mythos "Anno Neun": Andreas Hofer und der Tiroler Volksaufstand von 1809 im Spiegel der Geschichtsschreibung (1810–2005).* Frankfurt am Main: Peter Lang, 2010.

Kerr, John. *A Most Dangerous Method: The Story of Freud, Jung, and Sabina Spielrein.* New York: Alfred A. Knopf, 1993.

Khanna, Ranjana. *Dark Continents: Psychoanalysis and Colonialism.* Durham, NC; London: Duke University Press, 2003.

Kieval, Hillel J. "Representation and Knowledge in Medieval and Modern Accounts of Jewish Ritual Murder." *Jewish Social Studies,* n.s. 1, no. 1 (1994): 52–72.

Klakowicz, Beatrix. *La Necropoli anulare di Orvieto: Crocifisso del Tufo—Le Conce*. Rome: "L'Erma" di Bretschneider, 1972.

Klein, A. "Die Identifizierung durch die Zähne bei Brandkatastrophen. Ihre forensische Bedeutung." *Schweizerische Monatsschrift für Zahnheilkunde* 38, no. 10 (1929): 607–628.

Klein, Dennis B. *Jewish Origins of the Psychoanalytic Movement*. New York: Praeger, 1981.

Kleinhenz, Christopher, ed. *Medieval Italy: An Encyclopedia*. New York; London: Routledge, 2004.

Knöpfmacher, Wilhelm. *Entstehungsgeschichte und Chronik der Vereinigung "Wien": B'nai B'rith in Wien:1895–1935*. Vienna: C. Pick, 1935.

Koelb, Janice Hewlett. "Freud, Jung, and the Taboo of Rome." *Arethusa* 48, no. 3 (2015): 391–430.

Koerner, Joseph Leo. *The Burning Child*. Animation. 2014. Uploaded by the Vienna Project. https://vimeo.com/114245493

Kolocotroni, Vassiliki. " 'Writers among the Ruins': Freud, Conrad, and the Psychomythology of Memory." *English* 59, no. 225 (2010): 154–173.

Krauss, Samuel. *Die Wiener Geserah vom Jahre 1421*. Vienna; Leipzig: W. Braumüller, 1920.

Kravis, Nathan. *On the Couch: A Repressed History of the Analytic Couch from Plato to Freud*. Cambridge, MA; London: The MIT Press, 2017.

Krüll, Marianne. *Freud and His Father*. Translated by Arnold J. Pomerans. New York: W.W. Norton, 1979.

Kuhn, Philip. "The Cultivated Italian (or) Who Reminded Freud How to Remember Signorelli?" *Psychoanalysis and History* 2, no. 1 (2000): 119–122.

Kuhn, Philip. "A Professor through the Looking Glass: Contending Narratives of Freud's Relationships with the Sisters Bernays." *International Journal of Psychoanalysis* 80 (1999): 943–959.

Kurth, Wolfram. "Das Traumbuch des Artemidoros im Lichte der Freudschen Traumlehre." *Psyche* 4 (1951): 488–512.

Lacan, Jacques. *The Four Fundamental Concepts of Psychoanalysis: The Seminar of Jacques Lacan, Book XI*. Edited by Jacques-Alain Miller. Translated by Alan Sheridan. New York; London: W.W. Norton, 1981.

Lacan, Jacques. "La psychanalyse et son enseignement." *Bulletin de la Société Française de Philosophie* 51, no. 2 (1957): 65–101.

Lacan, Jacques. *On Feminine Sexuality, The Limits of Love and Knowledge, 1972–1973, Encore: The Seminar of Jacques Lacan, Book XX*. Edited by Jacques-Alain Miller. Translated by Bruce Fink. New York; London: W.W. Norton, 1998.

Lacan, Jacques. *The Ethics of Psychoanalysis, 1959–1960: The Seminar of Jacques Lacan, Book VII*. Edited by Jacques-Alain Miller. Translated by Dennis Porter. New York; London: W.W. Norton, 1992.

Laible, Eva, and Jan Hloušek. "Sigmund Freud's First Emigration (1859)." In *Psychoanalysts in Exile—Elements of a History. Proceedings of the Ninth Meeting of the International Association for the History of Psychoanalysis*.

Edited by Alain de Mijolla. Paris: l'Association internationale pour l'histoire de la psychanalyse, 2003.

Lang, Hugo, and Milton Kayton Meyers. *Lang's German-English Dictionary of Terms Used in Medicine and the Allied Sciences*. Philadelphia, PA: P. Blakiston's Son & Co., 1913.

Lansing, Carol. *Power & Purity: Cathar Heresy in Medieval Italy*. New York; Oxford: Oxford University Press, 1998.

Laplanche, Jean. *Essays on Otherness*. Edited by John Fletcher. London: Routledge, 2005.

Laplanche, Jean. "Seduction, Persecution and Revelation." *The International Journal of Psycho-Analysis* 76 (1995): 663–682.

Laplanche, J., and J.-B. Pontalis. *The Language of Psychoanalysis*. Translated by Donald Nicholson-Smith. New York: W.W. Norton, 1973.

Lazar, Moshe. "The Lamb and the Scapegoat: The Dehumanization of the Jews in Medieval Propaganda Imagery." In *Anti-Semitism in Times of Crisis*, edited by Sander L. Gilman and Steven T. Katz, 38–80. New York: New York University Press, 1991.

Le Rider, Jacques. "Philologie grecque et formation de la théorie psychanalytique: Sigmund Freud et Theodor Gomperz." *Essaim* 2, no. 7 (2001): 203–217.

Lear, Jonathan. *Freud*. London; New York: Routledge, 2005.

Levine, Lee I. *The Ancient Synagogue: The First Thousand Years*. 2nd ed. New Haven, CT; London: Yale University Press, 2005.

Lewin, Bertram D. "The Train Ride: A Study of One of Freud's Figures of Speech." *Psychoanalytic Quarterly* 39 (1970): 71–89.

Leys, Ruth. *Trauma: A Genealogy*. Chicago, IL; London: University of Chicago Press, 2000.

Löwy, Emanuel. "Schale der Sammlung Faina in Orvieto." *Jahrbuch des Deutschen Archäologischen Instituts* 3 (1889): 139–144.

Lozanovska, Mirjana, ed. *Ethno-Architecture and the Politics of Migration*. London; New York: Routledge, 2016.

Maciejewski, Franz. *Der Moses des Sigmund Freud: Ein unheimlicher Bruder*. Göttingen: Vandenhoeck and Ruprecht, 2006.

Maciejewski, Franz. "Freud, His Wife, and His Wife," *American Imago* 63, no. 4 (2006): 497–506.

Makari, George. *Revolution in Mind: The Creation of Psychoanalysis*. New York: HarperCollins, 2008.

Makari, George. "Towards Defining the Freudian Unconscious: Seduction, Sexology and the Negative of Perversion (1896–1905)." *History of Psychiatry* 8 (1997): 459–485.

Marcus, Laura. *Dreams of Modernity: Psychoanalysis, Literature, Cinema*. New York: Cambridge University Press, 2014.

Marinelli, Lydia, ed. *Die Couch: Vom Denken im Liegen*. Munich: Sigmund Freud Privatstiftung/ Prestel, 2006.

Marinelli, Lydia "Die Couch: Vorstellungen eines Mobels." In *Tricks der Evidenz: Zur Geschichte psychoanalytischer Medien*. Edited by Lydia Marinelli and Andreas Mayer, 245–266. Vienna: Turia + Kant, 2009.

Marinelli, Lydia, ed. *Freuds verschwundene Nachbarn*. Vienna: Turia + Kant, 2003.

Marinelli, Lydia, ed. *"Meine … alten und dreckigen Götter": aus Sigmund Freuds Sammlung*. Frankfurt/Main: Stroemfeld, 1998.

Marinelli, Lydia. "Screening Wish Theories: Dream Psychologies and Early Cinema." *Science in Context* 19, no. 1 (2006): 87–110.

Marinelli, Lydia, and Andreas Mayer. *Dreaming by the Book: Freud's The Interpretation of Dreams and the History of the Psychoanalytic Movement*. Translated by Susan Fairfield. New York: Other Press, 2003.

Martens, Bob et al., *Wiener Synagogen: ein Memory=Viennese Synagogues: A Memory*. Vienna: Jüdisches Museum Wien, 2016.

Masson, Jeffrey Moussaieff. *The Assault on Truth: Freud's Suppression of the Seduction Theory*. New York: Farrar, Straus and Giroux, 1984.

Mayer, Andreas. "Gradiva's Gait: Tracing the Figure of a Walking Woman." *Critical Inquiry* 38, no. 3 (2012): 554–578.

Mayer, Andreas. *Sites of the Unconscious: Hypnosis and the Emergence of the Psychoanalytic Setting*. Chicago, IL; London: University of Chicago Press, 2013.

McGrath, William J. *Freud's Discovery of Psychoanalysis: The Politics of Hysteria*. Ithaca, NY; London: Cornell University Press, 1986.

Meghnagi, David. "From the Dreams of a Generation to the Theory of Dreams: Freud's Roman Dreams." *International Journal of Psychoanalysis* 92, no. 3 (2011): 675–694.

Meige, Henry. *Le juif-errant à la Salpêtrière: Étude sur certains névropathes voyageurs*. Paris: L. Bataille, 1893.

Merleau-Ponty, Maurice. *Phenomenology of Perception*. Translated by Colin Smith. London: Routledge and Kegan Paul, 1962.

Métraux, Alexandre. "Einst träumte Sigmund Freud von einer botanischen Monographie über die Lieblingsblume seiner Frau Martha." *Newsletter des Sigmund Freud-Museums* 1 (2001): 8–21.

Meyer, Alfred Gotthold. "Der Wettbewerb um die Bronze-Thüren des Mailänder Domes." *Kunstchronik: Wochenschrift für Kunst und Kunstgewerbe* NS 7 (November 28, 1895): 102–109.

Micale, Mark S. *Hysterical Men: The Hidden History of Male Nervous Illness*. Cambridge, MA; London: Harvard University Press, 2008.

Micale, Mark S. "The Salpêtrière in the Age of Charcot: An Institutional Perspective on Medical History in the Late Nineteenth Century." *Journal of Contemporary History* 20, no. 4 (1985): 703–731.

Mikoletzky, Juliane, ed. *Eine Sammlung von Ausserordentlicher Geschlossenheit: Die Rektorengalerie der Technischen Universität Wien*. Vienna: Böhlau, 2015.

Miller, David Lee. *Dreams of the Burning Child: Sacrificial Sons and the Father's Witness*. Ithaca, NY; London: Cornell University Press, 2002.

Mir Ghaffari, Doris. *Europäische Reisende im Iran des 19. Jahrhunderts: eine Bibliographie*. Halle: Orientwissenschafliches Zentrum der Martin-Luther-Universität Halle-Wittenberg, 2003.

Mitchell-Boyask, Robin N. "Freud's Reading of Classical Literature and Classical Philology." In *Reading Freud's Reading*, edited by Sander L. Gilman et al., 23–46. New York: New York University Press, 1994.

Molnar, Michael. *Looking through Freud's Photos*. London: Karnac, 2015.

Molnar, Michael. "Reading the Look." In *Reading Freud's Reading*, edited by Sander L. Gilman et al., 77–90. New York: New York University Press, 1994.

Moralee, Jason. "Maximinus Thrax and the Politics of Race in Late Antiquity." *Greece & Rome* 55, no. 1 (2008): 55–82.

Moravánszky, Ákos. *Competing Visions: Aesthetic Invention and Social Imagination in Central European Architecture, 1867–1918*. Cambridge, MA: MIT Press, 1998.

Morelli, Giovanni (Ivan Lermolieff). *Della pittura italiana: studii storico critici*. Introduction by Gustavo Frizzoni. Milan: Fratelli Treves, 1897.

Mormorio, Diego, and Enzo Eric Toccaceli. *Tre fotografi a Orvieto: Armoni, Raffaelli, Moretti*. Palermo: Sellerio Editore, 1989.

Morra, Joanne. "Seemingly Empty: Freud at Berggasse 19, a Conceptual Museum." *Journal of Visual Culture* 12, no. 1 (2013): 89–127.

Mosen, Julius. *Erinnerungen*. Edited by Max Zschommler. Plauen: F.E. Neupert, 1893.

Murray, John [Firm]. *A Handbook for Travellers on the Continent: Being a Guide to Holland, Belgium, Prussia, Northern Germany, and the Rhine from Holland to Switzerland*. 11th ed. London: J. Murray, 1856.

"Nachruf: Jacob Krall." *Zeitschrift für ägyptische Sprache und Altertumskunde*, edited by A. Erman and G. Steindorff, vol. 42, no. 1. Leipzig: J.C. Hinrichs, 1905.

Nägele, Rainer. "The Poetic Ground Laid Bare (Benjamin Reading Baudelaire)." In *Walter Benjamin: Theoretical Questions*, edited by David S. Ferris, 118–138. Stanford, CA: Stanford University Press, 1996.

Nayar, Sheila J. *Dante's Sacred Poem: Flesh and the Centrality of the Eucharist to the Divine Comedy*. London; New York: Bloomsbury, 2014.

Newald, Julius von et al. *Der Prozess über die Ringtheater-Katastrophe*. Vienna: Verlag Moritz Perles, 1882.

Nieto-Galan, Agustí. *Colouring Textiles: A History of Natural Dyestuffs in Industrial Europe*. Boston Studies in the Philosophy of Science. Dordrecht; Boston: Kluwer, 2001.

O'Donoghue, Diane. "Lingua Flora: Deciphering the Dream of the Botanical Monograph." *American Imago* 62, no. 2 (2005): 157–177.

O'Donoghue, Diane. "Liquiphobie und des Schauplatz der Psychoanalyse." In *Verflüssigungen: Ästhetische und semantische Dimensionen eines Topos*, edited by Kassandra Nakas, 45–56. München: Wilhelm Fink, 2015.

O'Donoghue, Diane. "Magic of the Manifest: Freud's Egyptian Dream Book." *American Imago* 66, no. 2 (2009): 211–230.

O'Donoghue, Diane. "Mapping the Unconscious: Freud's Topographic Constructions." *Visual Resources* 23, nos. 1–2 (2007): 105–117.

O'Donoghue, Diane. "Moses in Moravia." *American Imago:* no. 2 (2010): 157–182.

O'Donoghue, Diane. "Negotiations of Surface: Archaeology in the Early Strata of Psychoanalysis." *Journal of the American Psychoanalytic Association* 52, no. 3 (2004): 653–671.

O'Donoghue, Diane. "On the Training." *Journal for the Psychoanalysis of Society and Culture* 6, no. 3 (2001): 313–315.

Officieller General-Catalog: Welt-Ausstellung 1873 in Wien. Wien: Verlag der General-Direction, 1873.

Öhlinger, Walter. *Rundblick vom Stephansturm: Panorama von Wien im Jahre 1860.* Vienna: Winkler-Hermaden, 2012.

Oliensis, Ellen. *Freud's Rome: Psychoanalysis and Latin Poetry.* Cambridge: Cambridge University Press, 2009.

Olin, Margaret. "Forms of Respect: Alois Riegl's Concept of Attentiveness." *Art Bulletin* 71, no. 2 (June 1989): 285–299.

Owens, Margaret E. "Forgetting Signorelli: Monstrous Visions of the Resurrection of the Dead." *American Imago* 61, no. 1 (2004): 7–33.

Palombo, Stanley R. "Day Residue and Screen Memory in Freud's Dream of the Botanical Monograph." *Journal of the American Psychoanalytic Association* 36, no. 4 (1988): 881–904.

Papapetros, Spyros. "*Drop* Form: Freud, Dora, and Dream Space." In *Private Utopia: Cultural Setting of the Interior in the 19th and 20th Century*, edited by August Sarnitz and Inge Scholz-Strasser, 58–88. Berlin; Boston: DeGruyter, 2015.

Papapetros, Spyros. *On the Animation of the Inorganic: Art, Architecture, and the Extension of Life.* Chicago, IL; London: University of Chicago Press, 2012.

Patai, Raphael. *The Jews of Hungary: History, Culture, Psychology.* Detroit, MI: Wayne State University Press, 1996.

Pausanias. *Guide to Greece.* Translated by P. Levi. Baltimore, MD: Penguin, 1971.

Pepper, Simon. "Fortress and Fleet: The Defence of Venice's Mainland Greek Colonies in the Late Fifteenth Century." In *War, Culture, and Society in Renaissance Venice: Essays in Honour of John Hale*, edited by David S. Chambers, Cecil H. Clough, and Michael E. Mallett, 29–56. London; Rio Grande, OH: Hambledon Press, 1993.

Person, Ethel Spector, Peter Fonagy, and Sérvulo Augusto Figueira, eds. *On Freud's "Creative Writers and Day-Dreaming."* New Haven, CT; London: Yale University Press, 1995.

Pfrimmer, Théo. *Freud, lecteur de la Bible.* Paris: Presses Universitaires de France, 1982.

Philippson, Ludwig, ed. *Die israelitische Bibel, enthaltend den heiligen Urtext, die deutsche Übertragung mit Erläuterungen und Einleitungen.* Leipzig: Baumgärtner, 1838, 1858.

Phillips, Adam. *Becoming Freud: The Making of a Psychoanalyst*. New Haven, CT; London: Yale University Press, 2014.

Pick, Alois. "Zur Pathologie und Therapie einer eigenthümlichen endemischen Krankheitform." *Wiener Medizinische Wochenschrift* 36, nos. 33 and 34 (1886): 1141–1145; 1168–1171.

Picozzi, Maria Grazia, ed. *Ripensare Emanuel Löwy: Professore di archeologia e storia dell'arte nella R. Università e Direttore del Museo di Gessi*. Rome: "L'Erma" di Bretschneider, 2013.

Planner-Steiner, Ulrike. "Friedrich von Schmidt." In *Die Weiner Ringstrasse: Bild Einer Epoche*, edited by Renate Wagner-Rieger, vol. 8 (2), 1–71. Wiesbaden: Franz Steiner, 1978.

Polc, Jaroslav. "Il miracolo di Bolsena e Pietro de Praga: Un'ipotesi." *Revista di storia della chiesa in Italia* 45, no. 2 (1991): 437–449.

Popović, Ivan Vasin, ed. *Praktisches Deutsch-Serbisches Sprach- und Konversationsbuch* (Vienna: A. Hartleben's Verlag, 1890).

Premerstein, Anton von. "Die Anfänge der Provinz Moesien." In *Jahreshefte des Österreichischen Archäologischen Institutes in Wien*, vol 1, 145–196. Vienna: Alfred Hölder, 1898.

Presner, Todd Samuel. *Mobile Modernity: Germans, Jews, Trains*. New York: Columbia University Press, 2007.

Prokhoris, Sabina. *The Witch's Kitchen: Freud, Faust, and the Transference*. Translated by G.M. Goshgarian. Ithaca, NY; London: Cornell University Press, 1995.

Ragland, Ellie. "Lacan, the Death Drive, and the Dream of the Burning Child." In *Death and Representation*, edited by Sarah Webster Goodwin and Elisabeth Bronfen, 80–102. Baltimore, MD: Johns Hopkins University Press, 1993.

Rand, Nicholas, and Maria Torok. *Questions for Freud: The Secret History of Psychoanalysis*. Cambridge, MA: Harvard University Press, 1997.

Rice, Emanuel. *Freud and Moses: The Long Journey Home*. Albany, NY: State University of New York Press, 1990.

Ridgway, David, and Francesca R. Ridgway. Review of *La Necropoli anulare di Orvieto: Crocifisso del Tufo—Le Conce*, by Beatrix Klakowicz. *The Journal of Roman Studies* 69 (1979): 212–214.

Riegl, Alois. *Stilfragen: Grundlegungen zu einer Geschichte der Ornamentik*. Berlin: Siemans, 1893.

Riess, Jonathan. *The Renaissance Antichrist: Luca Signorelli's Orvieto Frescoes*. Princeton, NJ: Princeton University Press, 1995.

Ritvo, Lucille B. "Carl Claus as Freud's Professor of the New Darwinian Biology." *International Journal of Psycho-Analysis* 53 (1972): 277–283.

Rizzuto, Ana-María. *Why Did Freud Reject God? A Psychodynamic Interpretation*. New Haven, CT; London: Yale University Press, 1998.

Robert, Marthe. *From Oedipus to Moses: Freud's Jewish Identity*. Translated by Ralph Manheim. Garden City, NY: Anchor Books, 1976.

Roth, Michael S. *Memory, Trauma, and History: Essays on Living with the Past*. New York: Columbia University Press, 2012.

Roth, Michael S. "Remembering Forgetting: Maladies de la Mémoire in Nineteenth-Century France." *Representations* 26 (1989): 49–68. Reprinted in his *Memory, Trauma, and History*.

Roudinesco, Élisabeth. *Freud: In His Time and Ours*. Translated by Catherine Porter. Cambridge, MA: Harvard University Press, 2016.

Rouillard, A.M.P. *Essai sur les amnésies principalement au point de vue étiologique*. Paris: Le Clerc, 1885.

Rozenblit, Marsha. *The Jews of Vienna 1867–1914: Assimilation and Identity*. Albany, NY: State University of New York Press, 1983.

Rubin, Miri. *Corpus Christi: The Eucharist in Late Medieval Culture*. Cambridge; New York: Cambridge University Press, 1991.

Rubin, Miri. *Gentile Tales: The Narrative Assault on Late Medieval Jews*. New Haven, CT; London: Yale University Press, 1999.

Rudnytsky, Peter. *Freud and Oedipus*. New York: Columbia University Press, 1987.

Rudnytsky, Peter. *Rescuing Psychoanalysis from Freud and Other Essays in Re-Vision*. London: Karnac, 2011.

Ruitenbeek, Hendrik M., ed. *Freud as We Knew Him*. Detroit, MI: Wayne State University Press, 1973.

Šačić, Amra. "Četiri do sada neobavljena epigrafska spomenika." *Godišnjak/ Jahrbuch. Centar za balkanološka ispitivanja* 43 (2014): 155–166.

Sanders, Daniel, ed. *Wörterbuch der deutschen Sprache*. Vol. 1. Leipzig: O. Wigand, 1860.

Satolli, A[lberto]. "Il giornale di scavo di Riccardo Mancini (1876–1885)." *Quaderni dell'Istituto Statale d'Arte di Orvieto* 5–6 (1985 [1991]): 17–132.

Saul, Nicholas, and Susan Tebbutt. *The Role of the Romanies: Images and Counter-Images of "Gypsies"/Romanies in European Cultures*. Liverpool: Liverpool University Press, 2004.

Saurer, Edith. *Strasse, Schmuggel, Lottospiel: Materielle Kultur und Staat in Niederösterreich, Böhmen, und Lombardo-Venetien im frühen 19. Jahrhundert*. Göttingen: Vandenhoeck & Ruprecht, 1989.

Schäffner, Wolfgang. "Event, Series, Trauma: The Probabilistic Revolution of the Mind in the Late Nineteenth and Early Twentieth Centuries." In *Traumatic Pasts: History, Psychiatry, and Trauma in the Modern Age, 1870–1930*, edited by Mark S. Micale and Paul Lerner, 81–91. Cambridge: Cambridge University Press, 2001.

Scherer, Frank F. *The Freudian Orient: Early Psychoanalysis, Anti-Semitic Challenge, and the Vicissitudes of Orientalist Discourse*. London: Karnac, 2015.

Scherrer, Ferdinand. "S. Freud est-il l'auteur de l'article Aphasie (1888)? Remarques et réflexions à propos de la contribution de Freud au dictionnaire médical de Villaret, 1888–1891." *Essaim* 1, no. 9 (2002): 151–166.

Schimek, Jean G. "The Parapraxis Specimen of Psychoanalysis." *Psychoanalysis and Contemporary Science* 3, no. 1 (1974): 210–230. Reprinted under the title "Signorelli: The parapraxis specimen of psychoanalysis." In *Memory,*

Myth, and Seduction: Unconscious Fantasy and the Interpretive Process, edited by Deborah L. Browning, 185–202. New York; London: Routledge, 2011.

Schivelbusch, Wolfgang. *The Railway Journey: The Industrialization of Time and Space in the Nineteenth Century*. Leamington Spa; Hamburg; New York: Berg, 1986.

Schlich, Thomas. "Asepsis and Bacteriology: A Realignment of Surgery and Laboratory Science." *Medical History* 56, no. 3 (2012): 308–334.

Schmid, Gabriele. "Zahlenlotto und Klassenlotterie in der Habsburgermonarchie 1751–1918: Reformen und Widerstände." Master's thesis, University of Vienna, 2008.

Schönau, Walter. *Sigmund Freuds Prosa: Literarische Elemente seines Stils*. Stuttgart: J.B. Metzlersche, 1968.

Schorske, Carl. *Fin-de-Siècle Vienna: Politics and Culture*. New York: Vintage Books, 1981.

Schredl, Michael. "History of Dream Research: The Dissertation '*Entstehung der Träume* (Origin of dreams)' of Wilhelm Weygandt Published in 1893." *International Journal of Dream Research* 3, no. 1 (2010): 95–97. DOI: http://dx.doi.org/10.11588/ijodr.2010.1.507

Schröter, Michael, and Christfried Tögel. "The Leipzig Episode in Freud's Life (1859): A New Narrative on the Basis of Recently Discovered Documents." *Psychoanalytic Quarterly* 76 (2007): 193–215.

Schwenger, Peter. *Fantasm and Fiction: On Textual Envisioning*. Stanford, CA: Stanford University Press, 1999.

Seamon, David. "Place Attachment and Phenomenology: The Synergistic Dynamism of Place." In *Place Attachment: Advances in Theory, Methods and Applications*, edited by Lynne C. Manzo and Patrick Devine-Wright, Chapter 1. London; New York: Routledge, 2014.

Sekula, Allan. "The Body and the Archive." *October* 39 (1986): 3–64.

Silverman, Kaja. "Apparatus for the Production of an Image." *Parallax* 6, no. 3 (2000): 12–28.

Silverman, Kaja. *World Spectators*. Stanford, CA: Stanford University Press, 2000.

Simmons, Laurence. *Freud's Italian Journey*. Psychoanalysis and Culture 13. Amsterdam; New York: Rodopi, 2006.

Sisa, József. "Neo-Gothic Architecture and Restoration of Historic Buildings in Central Europe: Friedrich Schmidt and His School." *The Journal of the Society of Architectural Historians* 61, no. 2 (2002): 170–187.

Skues, Richard A. "On the Dating of Freud's *Aliquis* Slip." *International Journal of Psychoanalysis* 82, no. 6 (2001): 1185–1204.

Sladen, Douglas W.B. *The Secrets of the Vatican*. Philadelphia, PA: Lippincott; London: Hurst and Blackett, 1907.

Sprengnether, Madelon. "Mouth to Mouth: Freud, Irma, and the Dream of Psychoanalysis." *American Imago* 60, no. 3 (2003): 259–284.

Stapf, Fred Frank. *Julius Mosen: Der Vogtländer Dichter des Andreas-Hofer-Liedes*. Lapperdorf bei Regensburg: Kerschensteiner, 1995.

Starobinski, Jean. "Acheronta Movebo: Nachdenken über das Motto der 'Traumdeutung.'" In *Hundert Jahre "Traumdeutung" von Sigmund Freud*, edited by I. Grubrich-Simitis, 7–34. Frankfurt am Main: Fischer, 1999.

Stauffer, George B. "Leipzig: A Cosmopolitan Trade Centre." In *The Late Baroque Era: From the 1680s to 1740*, edited by George J. Buelow, vol. 4, 254–295. Houndsmills; London: Macmillan Press, 1993.

Steinberg, Michael. "'Fin-de-siècle Vienna' Ten Years Later: 'Viel Traum, Wenig Wirklichkeit.'" *Austrian History Yearbook* 22 (1991): 151–162.

Stock's Persisch-Egyptisches Traum-Buch. Various editions. Vienna: Leopold Kutschera.

Suárez-Orozco, Carola. "Identities under Siege: Immigration Stress and Social Mirroring among the Children of Immigrants." In *Cultures under Siege: Collective Violence and Trauma*, edited by Antonius C. G. M. Robben and Marcelo Suárez-Orozco, 194–226. Cambridge; New York: Cambridge University Press, 2000.

Sulloway, Frank W. *Freud, Biologist of the Mind: Beyond the Psychoanalytic Legend*. New York: Basic Books, 1979. Reprint with a new preface; Cambridge, MA; London: Harvard University Press, 1992.

Swales, Peter J. "Freud, Death, and Sexual Pleasures: On the Psychical Mechanism of Dr. Sigm. Freud." *Arc de Cercle* 1, no. 1 (2003): 4–74.

Swales, Peter J. "Freud, His Teacher, and the Birth of Psychoanalysis." In *Freud: Appraisals and Reappraisals: Contributions to Freud Studies*, edited by Paul E. Stepansky, vol. 1, 3–82. Hillsdale, NJ; London: Analytic Press, 1986.

Swales, Peter J. "Freud, Minna Bernays, and the Conquest of Rome." *New American Review* 1, no. 1 (1982): 1–23.

Szemethy, Hubert D. *Die Erwerbungsgeschichte des Heroons von Trysa*. Vienna: Phoibos, 2005.

Tafani, Tiziana, and Lucio Riccetti. *Freud e Orvieto: Alle origini della psicoanalisi*. Orvieto: Intermedia Edizioni, 2016.

Tebbutt, Susan, ed. *Sinti and Roma: Gypsies in German-speaking Society and Literature*. New York: Berghahn Books, 1998.

Theweleit, Klaus. "Young Mr. Freud; or, On the Becoming of an Artist: Freud's Various Paths to the Dream Book, 1882–1899." In *The Dreams of Interpretation: A Century Down the Royal Road*, edited by Catherine Liu et al., 337–355. Minneapolis, MN: University of Minnesota Press, 2007.

Tögel, Christfried. "Freud, die Couch und Familie Benvenisti." *Luzifer-Amor: Zeitschrift zur Geschichte der Psychoanalyse* 59 (2017): 171–173.

Torok, Maria. "A Remembrance of Things Deleted: Between Sigmund Freud and Emmy von N." In *The Shell and the Kernel: Renewals of Psychoanalysis*, edited by Maria Torok and Nicholas Abraham, vol. 1, 234–252. Chicago, IL: University of Chicago Press, 1994.

Trapp, Eugen. "Heinrich Natter." In *Neue Deutsche Biographie*, Band 18, 754. Berlin: Duncker & Humblot, 1997.

Turfa, Jean MacIntosh. "Votive Offerings in Etruscan Religion." In *The Religion of the Etruscans*, edited by Nancy Thomson de Grummond and Erika Simon, 90–115. Austin, TX: University of Texas, 2006.

Tylor, Edward Burnet. *Researches into the Early History of Mankind and the Development of Civilization*. London: John Murray, 1870.

Tyrrell, Naomi. "Children's Agency in Family Migration Decision Making in Britain." In *Everyday Ruptures: Children, Youth, and Migration in Global Perspective*, edited by Cati Coe et al., 23–38. Nashville, TN: Vanderbilt University Press, 2011.

Vandendriessche, Gaston. "La relation entre la pulsion et la fonction cognitive dans le rêve de la monographie botanique et la souvenir-écran de la scène dans la prairie." *Revue française de psychanalyse* 36, nos. 5–6 (1972): 987–998.

Vasari, Giorgio. *Le vite de' più eccellenti architetti, pittori, et scultori italiani, da Cimabue insino a' tempi nostri*. Edited by Luciano Bellosi and Aldo Rossi. Turin: Giulio Einaudi, 1986.

Vasari, Giorgio. *Le vite de' più eccellenti pittori scultori e architettori: nelle redazioni del 1550 e 1568*. Edited by Rosanna Bettarini. Vol. 2. Florence: Sansoni, 1966.

Vlček, Václav, ed. *Osvěta: Listy pro Rozhled v Umění, Védé a Politice*. Vol. 37. Prague: Tiskem dra. Edvarda Grégra, nákladem vlastním, 1907.

Walters, Barbara R. "The Feast and Its Founder." In *The Feast of Corpus Christi*, edited by Barbara R. Walters, Vincent Corrigan, and Peter T. Ricketts, 3–54. University Park, PA: Pennsylvania State University Press, 2006.

Walzer, Tina. *Der jüdische Friedhof Währing in Wien: Historische Entwicklung, Zerstörungen der NS-Zeit, Status quo*. Vienna: Böhlau, 2011.

Weinberg, Robert. *Blood Libel in Late Imperial Russia: The Ritual Murder Trial of Mendel Beilis*. Bloomington, IN: Indiana University Press, 2014.

Weinrich, Harald. *Lethe: The Art and Critique of Forgetting*. Translated by Steven Rendall. Ithaca, NY: Cornell University Press, 2004.

Werner, Arnold. "Edmund Engelman: Photographer of Sigmund Freud's Home and Offices." *International Journal of Psychoanalysis* 83 (2002): 445–451.

Whitebook, Joel. *Freud: An Intellectual Biography*. Cambridge: Cambridge University Press, 2017.

Wiener handelsstands-Bericht. March 26, 1861. No. 5. Wien: Leopold Sommer, 1861.

Wilden, Anthony G. "Freud, Signorelli, and Lacan: The Repression of the Signifier." *American Imago* 23, no. 4 (1966): 332–366.

Wilkes, John J. *Ancient Illyria: An Archaeological Exploration*. London: Centre for Albanian Studies, 2006.

Willigk, Arthur. "Das Gehirn des Raubmörders Leopold Freud." *Vierteljahrschrift für die praktische Heilkunde* 131 (1876): 15–26.

Winkler, John. "Geminus of Tyre and the Patron of Artemidorus." *Classical Philology* 77, no. 3 (1982): 245–248.

Wiplinger, Gilbert, Gudrun Wlach, and Kurt Gschwantler. *Ephesus. 100 Years of Austrian Research*. Vienna: Böhlau, 1996.

Wistrich, Robert S. *The Jews of Vienna in the Age of Franz Joseph*. New York: Oxford University Press, 1989.

Wolf, Larry. *Child Abuse in Freud's Vienna: Postcards from the End of the World*. New York: New York University Press, 1988.

Wrocław Surnames from 1874 to 1910, Jewish Record Indexing—Poland (online database) http://jri-poland.org/psa/psawroclaw.htm

Yad Vashem. *The Central Database of Shoah Victims' Names*. Jerusalem: The World Holocaust Remembrance Center. http://yvng.yadvashem.org

Yerushalmi, Yosef Hayim. *Freud's Moses: Judaism Terminable and Interminable*. New Haven, CT: Yale University Press, 1991.

Young-Bruehl, Elisabeth. *Anna Freud: A Biography*. New Haven, CT; London: Yale University Press, 1988.

Žižek, Slavoj. *Looking Awry: An Introduction to Jacques Lacan through Popular Culture*. Cambridge, MA: MIT Press, 1991.

Zweig, Stefan. *The World of Yesterday*. Lincoln, NE: University of Nebraska Press, 1964.

Index

Page numbers in italic type indicate illustrations.

Eckstein, Emma, 270–1, 309 n.58
Egypt, 156, 296–7, 300
 biblical exodus of Jews from, 139,
 151, 281
 Book of the Dead, 151
 "dream book" (*Traum-buch*), *292*,
 300–1, 302, 304
 Freud's antiquities from, 5, 297
 funerary relief, 23, 154
 gods, 24, *148*, 157
 hieroglyphics, 296–7
 Jewish rebellion, 298, 299
Egyptology, 296
Einstein, Albert, 2
electrotherapy, 41
Eltzner, Christian Adolf, *Panorama
 von Leipzig*, *137*
"Emmy von M" (Fanny Moser), 84
 n.190, 162
Engelman, Edmund, Berggasse 19
 photographs, 5, 41, 51, *88*, 114
 n.11, 157
Enlightenment, 53, 147
Ephesus, 47, *48*, 56, 177, 299, 301
epilepsy, 19
eroticism, 124, 125, 142, 143, 144,
 261. *See also* infant sexuality
 and fantasy
Etruscan antiquities, 6, 7, 89, 90–4,
 92, 96–9, *98*, *99*, 118 n.53
 blackware (*bucchero*), 103–4, *105*,
 119 n.59
 cinerary urn, 88–9
 eye cups, 102
 fabrication of, 6, 90–1, 102–5,
 106, 227
 Freud's self-analysis and, 121–2
 Freud's thirst dream and, 88–9, 272
 Mancini storage room, 105–6,
 105, 112
 olla, 103–4, *104*
 pottery fragments, 90–1
 tombs, 91, *92*, 99–101, 103–4, 208,
 210–11 (*see also* Crocifisso del
 Tufo)

"Etruscan Cinerary Urn" dream, 6,
 88–9, 90, 101–2
"Etruscan Grave" ("Dissecting My
 Own Pelvis") dream, 99–102,
 104, 124, 171 n.130, 210–11
Eucharist, *215*
 Corpus Christi doctrine, 211–18,
 219, 222, 248 n.160, 249 n.163
 host desecration and, 206, 208,
 209, 213, 215–19, 246 n.135
 imagery of, 211
 miracle of the wafer, 208, 211–13,
 214, 248–9 nn.160–1, 249
 n.163
Evagrius Scholasticus of Antioch, 215
Evans, Sir Arthur, 178, 195, 238 n.15
"evening land" (*Abendland*), 149–50
evolutionary biology, 151
excavation
 archaeological, 45–6, 47, 56, 106,
 107, 176, 177
 psychoanalytical, 46, 49, 107, 109,
 176
Exodus, 139, 151, 281

"facilitations" (*Bahnung*), 129
failure to remember. *See* forgetting
"Fair Jews," 137
fantasy, 1, 5, 21–2, 89, 180, 229, 263
 conscious, 178
 creation and function of, 54, 57,
 60–5, 135
 dreams and, 63, 159, 257, 260
 falsification of, 69
 Freudian model of, 63–5, 69, 141
 hysterical, 54, 59, 63, 64, 67, 68,
 69, 135, 320
 impulses and, 67
 memory blurred with, 13, 54,
 60–4, 67, 69, 122, 124, 261
 protective nature of, 59, 60–1
 repression of, 6, 125, 156
 unconscious function of, 54,
 109–12, 128, 178
 universality of, 68

hysteria and, 60
mental, 99, 100
Frothingham, Alfred L., 94, 103, 104,
 105, 106
Füllmotiv (framing motive), 126–7,
 160
Fumi, Luigi, 217, 238 n.23
funerary ceramics. *See* cinerary urn
Fürbringer, Paul, 199–200

galbanum, 281–2, 284
Galison, Peter, 2
Gallo, Rubén, 37, 39
Galton, Francis, 288
Gamurrini, Gian Francesco, 93
gargoyles, 20, 23, 24–5, *24*, 29–30,
 157
Gattel, Felix, 94, 116 n.23
gaze, 51, 143–4
Geller, Jay, 136, 271
gender
 bisexuality and, 276
 differences theory of, 144
 dream identification and, 302
 hysteria and, 18, 24, 45, 75 n.34
 "Irma's Injection" dream and, 270
 (*see also* masculinity; women)
Genesis, 265
German language, 135, 136, 137, 161
German Romanticism, 296
Germany, 149, 166 n.54
 merger (*Anschluss*) with Austria,
 5, 28 (*see also* Nazis)
Geseres, 138–9, 141, 168 n.79
Gilbert, Creighton, *How Fra Angelico
 and Signorelli Saw the End of
 the World*, 238 n.23
Gilman, Sander, 19, 64, 66
Ginsburg, Carlo, 232
Goethe, Johann Wolfgang von, *Faust*,
 160, 161
Gombrich, Ernst, 118 n.50
Gomperz, Elise, 294
Gomperz, Heinrich, 294

Gomperz, Theodor, 293–5, 300, 304
 Greek Thinkers, 294
 Traumdeutung und Zauberei,
 293–4, 295, 297, 300, 316
 n.183
Gothic, 25, 26, 34
Gothic revival. *See* neo-Gothic
Gottlieb, Richard, 211
Graf, Herbert (son). *See* "Little Hans"
Graf, Max (father), 158
Graf, Rosa Freud (sister), 323
grand nervosa. *See* hysteria
Grashey, Hubert, 225
 diagram of amnesic aphasia, *226*
"Great Dream," 187, 190, 207
Greece, 5, 90–1, 117 n.49
Greenberg, Valerie, 16
Grinstein, Alexander, 276, 280,
 309–10 n.70
Grinzing village (Vienna outskirts),
 271
Grosz, Elizabeth, 280
Gutmann, Wilhelm von, 28, *29*, 30
"gypsies" (*Zigeuner*), 96, 97, 99

Habsburg Empire, 12, 13, 14, 28, 47,
 57, 176, 177, 191, 195, 205, 295
Hader/Haderlumpen, 160, 161, 173
 n.165
Hades. *See* hell
Hafen (haven), 59
Hake, Sabina, *Saxa loquuntur*, 45
halbbarbarischen (semi-barbarians),
 43, 176, 177, 178
Hall, Stuart, 12
Hamilcar Barca, 136
Hamilton, James, 37–8
Handelsjude (peddler), 302
Handler Spitz, Ellen, 89
Hannibal, 135, 136, 137, 316 n.190
Hanold, Norbert, 95
Hansen, Theophil, 11
Hasdrubal, 136
haskala (Jewish Enlightenment), 147